THE LAST SUPPER

THE
LAST SUPPER

ART, FAITH, SEX,
AND CONTROVERSY
IN THE 1980s

PAUL ELIE

Farrar, Straus and Giroux
New York

Farrar, Straus and Giroux
120 Broadway, New York 10271

Grateful acknowledgment is made for permission to reprint lines from
"A Confession," "Caffè Greco," and "How It Should Be in Heaven," from *Collected Poems:
1931–1987*, by Czesław Miłosz, copyright © 1988 by Czesław Miłosz Royalties, Inc.
Used by permission of HarperCollins Publishers.

Library of Congress Cataloging-in-Publication Data
Names: Elie, Paul, 1965– author.
Title: The last supper : art, faith, sex, and controversy in the 1980s / Paul Elie.
Description: First edition. | New York : Farrar, Straus and Giroux, 2025. |
 Includes bibliographical references and index.
Identifiers: LCCN 2024049210 | ISBN 9780374272920 (hardcover)
Subjects: LCSH: Popular culture—History—20th century. | Popular culture—
 Religious aspects. | Culture conflict—Religious aspects. | Popular music—
 Religious aspects. | Art and popular culture. | Arts and religion. | Sex in popular
 culture. | Postsecularism. | Nineteen eighties.
Classification: LCC HM626 .E437 2025 | DDC 306.09/0904—dc23/eng/20250122
LC record available at https://lccn.loc.gov/2024049210

Designed by Patrice Sheridan

Our books may be purchased in bulk for promotional, educational, or business use. Please
contact your local bookseller or the Macmillan Corporate and Premium Sales Department at
1-800-221-7945, extension 5442, or by email at MacmillanSpecialMarkets@macmillan.com.

www.fsgbooks.com
Follow us on social media at @fsgbooks

1 3 5 7 9 10 8 6 4 2

For Jack, who knows the story;
and for Lenora, who has lived it

CONTENTS

THE LAST SUPPER

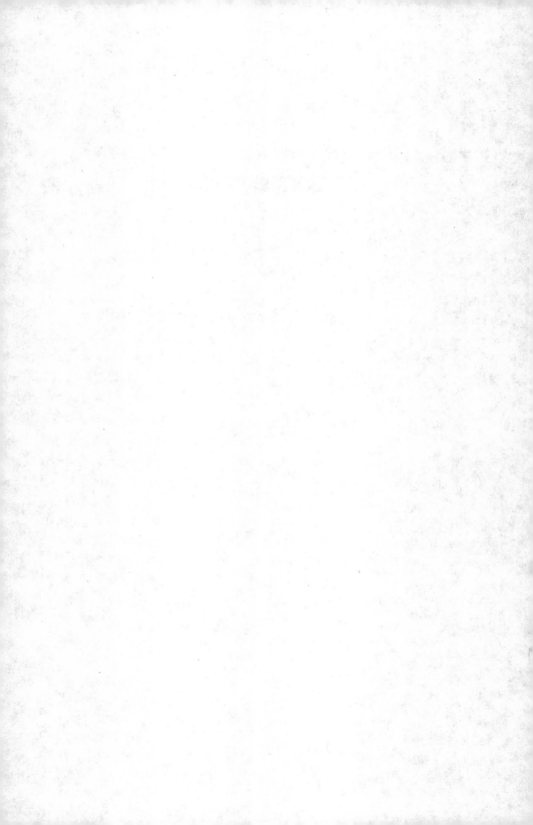

PROLOGUE

Bob Dylan's *Slow Train Coming* was released on August 20, 1979, in a parchment-colored sleeve that featured a woodcut of a man working on the railroad.

Right away the record gained a reputation twice over, as strong opinions developed on parallel tracks. On one track it was Dylan's breakthrough to a younger audience: the single, "Gotta Serve Somebody," featured a sleek, pulsing rhythm that slid nicely into the FM radio groove alongside Steely Dan and Dire Straits (whose guitarist Mark Knopfler was all over the record). *Rolling Stone*'s publisher, Jann Wenner, reviewed it himself, calling it Dylan's best record since the *Basement Tapes* of 1967.

On the other track it was a betrayal and a provocation. Dylan was *the* voice of the sixties counterculture. He was Jewish. He was a rebel, un-coöptable. But now he had become a born-again Christian, marking his conversion with a set of songs dealing with spiritual warfare and holy submission. "Rolling Brimstone," one review called it.

And he had done so at a moment when he could have been expected to set himself against Christianity, not affiliate himself with it. Strident new forms of Christian faith were emerging in American public life and in the mass media. As "Gotta Serve Somebody" played on FM, fundamentalist preachers on AM and cable TV were blaming the

counterculture for all that was wrong with America, and Ronald Reagan was preparing to run for president on a pledge to undo what the sixties had wrought. To become a born-again Christian in 1979 was to cross over to the dark side.

A voice rose up in Dylan's support: Bob Marley, whose songs, rooted in Rastafarianism, struck biblical notes of exodus, prophecy, and redemption. "Me like his song 'Serve Somebody' quite a bit . . ." Marley said. "I glad him do it, too, y'know, because there comes a time when the artist just cannot follow the crowd. If you are an artist like Bob Dylan, you got to make the crowd follow you. I can tell you that it doesn't mean anything to him that people might not like what he is doing. Him still do it."

On October 20, Dylan was the musical guest on *Saturday Night Live*. He came on around midnight, frizzy-haired, unshaven, dressed in white and faded denim. He did "Gotta Serve Somebody," and it sounded the way it did on the radio, the organ swelling behind the vocals. He strummed a black Stratocaster, but he didn't look like a rock star or like the silhouette on the poster at the headshop in the mall. He seemed pensive, preoccupied. He wasn't serving anybody.

He then played fourteen nights at the Fox Warfield Theatre in San Francisco, beginning a long tour. The show was a gospel-style revival. He did only *Slow Train Coming* and other new material. Between songs he preached or scolded the crowd. They booed, they hooted, they heckled, they turned their backs and walked out.

What was Dylan trying to do? Reinvent himself through a change of persona; express a sincere belief in Jesus; confound his cultlike following; tap into a deep current of American roots music—or all of the above?

He played seventy-nine shows, made a new album, took a break, and went back on tour in November 1980. Reagan had been elected president, backed by evangelicals and fundamentalists. Dylan's new album, *Saved*, had been savaged by reviewers. As the tour progressed, the audience changed: it was now split between Dylan freaks and Jesus freaks. "There was a guy with a cross, walking around the theater," the

guitarist Fred Tackett said of one show. "I don't know whether he was for us or against us."

What was Dylan trying do? It was impossible to say. The music he was making was soulful, the lyrics were biblical, and the motives behind it were cryptic.

Sinéad O'Connor encountered Dylan through *Slow Train Coming*. Growing up in a broken family in Dublin, she grounded herself through the records her mother and an older brother brought home. *Slow Train Coming* was released the summer she was twelve, and she was transfixed by Dylan—the young rake on the *Bringing It All Back Home* sleeve, the vulnerable elder singing "I Believe in You." She would become a singer, performing her own songs in Dublin and then in London. At age twenty, her head shaved, she was a rising star; by twenty-three, when she sang two songs from *I Do Not Want What I Haven't Got* on *Saturday Night Live*, she was a global celebrity.

She was outspoken, and with fame she became controversial. Nominated for a Grammy, she had the logo of Public Enemy razored into the stubble on one side of her head to protest the awards broadcast's lack of attention to rap music. She canceled an appearance on *SNL* in May 1992 after learning that the host would be Andrew Dice Clay, a comedian whose stand-up routine featured jokes about men beating up women; after she refused to let the national anthem be played prior to a show in New Jersey, Sinéad-haters piled her records in Times Square and smashed them to pieces.

She was back on *SNL* in October 1992 in support of *Am I Not Your Girl?*—an album of covers and standards. In the first hour she sang a version of "Success," by Loretta Lynn. In the second, she took the stage wearing a long white dress and with a Star of David around her neck. She stood unmoving in front of a rack of lit candles.

She sang Bob Marley's song "War" a cappella, the verses sounding practically medieval in her plangent voice. She slowed as she reached the last lines: "We know we will win / We have confidence / In the victory /

Of good over evil . . ." She produced a photograph of Pope John Paul II, held it up the way a priest elevates the Eucharist, and tore it in half and then again and again, scattering the pieces on the stage.

"Fight the real enemy!" she said, echoing Public Enemy's hit of two years earlier. She bowed and blew out the candles and stood on the darkened stage until the commercial break, her white dress now suggesting the vestments of an anti-pope.

Condemnation came overnight: newspaper editorials ("No Hair, No Taste"), denunciatory sound bites from spokesmen for Catholic values, TV news segments asking what-on-earth-was-she-thinking.

What was Sinéad thinking? It was impossible to say. Her tearing-up of the pope's image was cryptic, and the story of how she came to do it was so strange that it would beggar belief when she told it in a memoir thirty years later. But the judgment of the news cycle was swift and sure. Sinéad O'Connor was a heretic, a public enemy, and unladylike, besides. She was banished to fame's afterlife, a purgatory of notoriety.

Those two musical guest spots from *Saturday Night Live* bracket a moment in time that is this book's setting and its subject.

In that moment, figures in what we call popular culture engaged questions of faith and art and the ways they fit together with an intensity seldom seen before or since. They tested boundaries between sex and the sacred; they explored the controverted character of religion— its power to divide us inwardly against ourselves and to set us apart from one another in society. The work they made brought on public controversy: protests, boycotts, congressional hearings, pulpit denunciations, and claims that this song or film or photograph spelled the end of Western civilization.

Seen in retrospect, that moment is an early episode in an age we are still in—an age in which religious belief seems to be at once in steep decline and surging out of bounds; a span of time, with September 11, 2001, at its center, that has been shaped by religious controversy and by deadly acts of violence committed in God's name.

Dylan saw the moment coming around the bend; where he went

with *Slow Train Coming*, other artists were going—making work that was crypto-religious.

Crypto-religious is a term the poet Czesław Miłosz had used in an earlier era to define his outlook. Miłosz defected from Communist Poland while living in Paris in 1951. Eight years later, still in Paris, he received a letter from Thomas Merton, the Trappist monk and author, who had read his account of ways Polish intellectuals accommodated themselves to the Soviets, *The Captive Mind*, and they began a correspondence. Miłosz and his ancestors had been Catholics for centuries prior to the Soviet takeover, and his resistance to communism was rooted in the Catholic suspicion of spirit-denying ideologies, but he kept his distance from the Church: "I have always been crypto-religious and in a conflict with the political aspect of Polish Catholicism," he told Merton.

There, the term *crypto-religious* was informed by the Cold War and the repressive circumstances of the Soviet bloc, where secrecy about one's religion was a means of survival. More generally, it evokes the lives of the early Christians in the Roman Empire, who kept the faith in secret in crypts and catacombs beneath Rome.

In this book, *crypto-religious* is best understood in narrative terms. From novels, movies, songs, paintings, and photographs, together with the stories of how they were made, a sense of what it means emerges. In shorthand, it goes something like this: Crypto-religious art is work that incorporates religious words and images and motifs but expresses something other than conventional belief. It's work that raises the question of what the person who made it believes, so that the question of what it means to believe is crucial to the work's effect: as you see it, hear it, read it, listen to it, you wind up reflecting on your own beliefs.

Two novels from 1985 help to clarify the term. In *The Handmaid's Tale* Margaret Atwood envisioned a Christian theocracy overtaking North America and putting women in their biblical place. She started writing the novel in 1984 (a "forecast," the publisher called it), and as with Orwell's *1984*, many of its dread developments have come to pass. But *The Handmaid's Tale* was the opposite of cryptic. Obviously no believer, Atwood used religious imagery to make a definite case against religion.

In *White Noise*, by Don DeLillo, the status of religion is ambiguous. DeLillo, raised among Italian Americans, educated by Jesuits, spoke of his Catholic upbringing as imparting a keen sense of the four last things—death and judgment, heaven and hell—and his novel about the fear of death is thick with religion-as-metaphor. Jack Gladney devotes himself to the study of Hitler as to a deity; Murray Jay Suskind likens a supermarket to a Tibetan lamasery; an Airborne Toxic Event descends like a biblical plague. But the novel challenges the idea that religion-as-metaphor is less vital than "real" religion. Gladney winds up in an exchange with a black-habited nun who explains her order's calling as the maintenance of the superstructure of belief. "The nonbelievers need the believers. They are desperate to have someone believe," she tells him. ". . . It is our task in the world to believe things no one else takes seriously . . . The devil, the angels, heaven, hell. If we did not pretend to believe these things, the world would collapse . . ." "Your dedication is a pretense?" Gladney asks. She replies: "Our pretense is a dedication." Belief and disbelief are bound up inextricably, two approaches to the same mystery.

This book, then, is a sequence of tales of the crypto-religious—tales of art, faith, sex, and controversy at the beginning of our cultural present.

Andy Warhol creates a hundred works based on Leonardo da Vinci's *Last Supper*, attracting Jean-Michel Basquiat and Keith Haring as disciples. William Kennedy and Toni Morrison each make a cemetery the setting-off point for magic realism imbued with religious motifs. Leonard Cohen retreats to a Manhattan hotel room and writes the sacred songs that will reinvigorate his career. Patti Smith leaves the music business in a religious crisis and returns just as Robert Mapplethorpe draws scrutiny for photographs that blend sadomasochistic themes and satanic imagery. Wim Wenders takes an angel's-eye view of divided Berlin. U2 complicate the devotion of their early records through a collaboration with Brian Eno and a plunge into American roots music; the Neville Brothers deepen their work's always-present connections to the sacred traditions of New Orleans. Madonna and Prince mix carnal and spiritual

desire in videos that define the first decade of MTV. All the while, Martin Scorsese is at work on *The Last Temptation of Christ*, answering a call to make a personal picture about Jesus that he has felt since his boyhood.

Many of those stories are familiar in outline—from the recollections of the artists themselves, and through the work of an extraordinary cohort of biographers and critics. Presenting them here as episodes in a single story gives emphasis to a shared outlook and common themes. Greil Marcus's approach is a kind of model. With *Mystery Train*, his work of narrative portraiture about early rock and roll, Marcus sought "a recognition of unities in the American imagination that already exist"; with *Lipstick Traces* he followed the "traces" of the creative nihilism that crested when Johnny Rotten of the Sex Pistols sang that he was the Antichrist on "Anarchy in the U.K." At its strongest, the secret chord that resounds in the arts of the 1980s is akin to those unities—a crypto-religious theater of voices—and the stories of the work and the people who made it trace a kind of secret history.

The Last Supper, in the Christian scheme of things, is both an end and a beginning: the end of Jesus's time with his disciples, and the beginning of the religion established with the breaking of bread and the pouring out of wine.

The early eighties were both an end and a beginning, at least where the place of religion in American life is concerned. The "long sixties" were ending, and the unsettled relationships among beliefs, institutions, and society that define the present moment were beginning to make themselves felt.

"The long sixties" is a term coined by Fredric Jameson in 1984. The historian Eric Hobsbawm had identified a "long nineteenth century" extending from the French Revolution in 1789 to World War I in 1914. Jameson, a literary critic, then proposed that "the long sixties" extended from the late 1950s to "the general area of 1972," and the idea informed an emerging revisionist history of the decade.

If you consider the idea with reference to religion in America, "the long sixties" are even longer. They begin with the Montgomery bus

boycott in 1955, say, and end with the founding of the Moral Majority and the taking of hostages in Tehran in 1979.

Public life in the developed world in the 1960s is often seen as involving the breaking down of a traditional Judeo-Christian civic order through progressive social revolutions. There's truth to that sense of things. But in the United States committed Christians and Jews actually play powerful countercultural roles in those revolutions, through the civil rights and anti-war movements. In the seventies, Christianity is considered a moderate center—epitomized by Jimmy Carter, a Democrat and a Baptist, who is elected president to heal the divisions over civil rights, Vietnam, Watergate, and *Roe v. Wade*.

The center doesn't hold, though. By the end of the decade religion and society are in a fresh alignment. The "mainline" Protestant churches are closer to the sideline, and the Protestant fundamentalists are agents of disruption. The Carter administration is seen as captive to the Washington status quo, such that James Baldwin, in *The Nation*, observes that "the 'born again' today have simply become members of the richest, most exclusive private club in the world." When fundamentalists line up against Carter, a churchgoing, Bible-citing Christian from the deep South, and behind Ronald Reagan, a Californian whose piety is real but indistinct, the long sixties come to an end.

In those years, meanwhile, the populace has been changing in crucial ways. Through immigration from the Americas, Spanish-speaking Christians become a robust presence in the United States—at once supplanting Irish, Italian, German, and Polish Catholics in the parishes and establishing storefront Protestant *iglesias*. Immigration from Asia puts claims about the United States' Judeo-Christian character at odds with demographics and the life of the street; Muslims, Hindus, Confucians, and Buddhists are making the United States a multireligious nation. All this is taking place while the conventional wisdom is that the United States, like other developed countries, is growing inexorably more secular.

It isn't, not in any simple sense. The taking of the hostages in Tehran by Islamic fundamentalists in 1979 is a reminder that the rest of the world isn't becoming inexorably more secular. Neither is the United

States. Like Britain and France, it is becoming religiously more diverse. The emergence of a new religious right is partly a reaction to this change, as the fresh multireligious character of the U.S. prompts fervid white Christians to try to take "their" country back.

This is the "postsecular" age—as José Casanova, Jürgen Habermas, and many others will call it. It is an age in which religious forces and secular ones, rather than vanquishing one another, coexist in a relationship defined by controversy and marked by border skirmishes over territory that remains embattled and chaotic. It's an age "obsessed with religion as a question" in public life (as Casanova points out), and so one in which the forces of secularization can't be taken for granted. It's an age shot through with "religiously inflected disruption of secular constructions of the real" (John McClure observes); an age in which doctrine, speculation, and "lived religion" (Robert Anthony Orsi's term) are pressed together in works of art that combine "the enactment and the discussion of belief" (as Amy Hungerford puts it). In this age many people who are avowedly unreligious feel the "secular homelessness" James Wood has described. With the collapse of the Soviet empire and of Cold War categories—democratic and communist; Christian and atheist—the character of the "postsecular" age will emerge: mobile, polyglot, multireligious, anti-institutional; in the United States, Jesus Christ will be one god among many, the established churches will enjoy no special rights, and Christians in politics will style themselves a persecuted minority even as they claim to represent the majority.

At the beginning of the 1980s, the postsecular age is at hand.

It's at hand in New York City, especially. Always a liminal space, irreverent in spirit, a laboratory for what's new and what's next, New York circa 1980 is becoming a place where it seems that nothing is sacred—just as the televangelists say. It is made so not by decadence or immorality, however, but through dramatic changes in how the sacred is recognized and reckoned with, which make the eighties there a prelude to the present.

The city is the most diverse place in the United States, the once

and future portal to the next Americans, who now as ever are bringing their religions to their new country, often with greater fervor than in the country they left behind. There are Puerto Ricans, Dominicans, Haitians, and other Caribbeans. There are immigrants from India, Pakistan, and Bangladesh, from China and Korea. There are more Irish-born people than anyplace outside Ireland, more Jews than anywhere but Israel, and vast numbers of people who pay religion no heed.

There is a vibrant gay community. Large numbers of gay men and lesbians have settled in the city, taking lead roles in fashion, cuisine, and the arts.

And there is the Roman Catholic Church, which claims several million members in the New York metropolitan area. Postwar and through the sixties the chancery behind St. Patrick's Cathedral is known as the Powerhouse, where statesmen, businessmen, and clergymen seek Cardinal Spellman's favor. The Church's influence is diminished in the seventies; but when Pope John Paul II visits the United States in 1979 his first stop is New York City.

Catholicism's prominence in the early eighties conceals its vulnerability. The new religious diversity challenges the Church's sense of itself as *the* Church, a lofty entity that deserves special treatment from the government, the law, and the press. A generation after Catholicism claimed a central role in political life (through the Kennedy family, especially), the Church's leader, John Paul, is divisive as well as popular, and its U.S. bishops are entangled in a pervasive history of sexual abuse of young people by Catholic clergymen—a history, as yet largely untold, that they are determined to suppress.

In New York City the crises of American Catholicism and gay men's health converge. As HIV spreads, the gay commmunity is struck hard. The sense of an ending is strong. Men eating and drinking together, hugging and coupling, know that this could be the last time. But the still-hidden crisis of clerical sexual abuse will shape the bishops' response to the crisis of HIV/AIDS. Led by a new archbishop of New York, they'll rise to controversy, at once to claim the moral high ground and to change the subject. Catholicism, animated by conflicts both open and hidden, is suddenly a locus of strife.

Those conflicts arise in part due to the turn taken by John Paul—often called a counter-reformation to the reformation that was the Second Vatican Council. But they also are signs of the new age that is beginning, as the issues that convulsed American society in "the long sixties"—involving sexuality, the role of women, institutional authority, and war and peace—fully come to bear on the Catholic Church.

The conflicts are registered early and powerfully in the work of artists whose ties are to Catholicism. Warhol's silk-screen apostles, Scorsese's anguished Christ, the candlelit vignettes of Madonna's "Like a Prayer" video, Andres Serrano's radiant, excretion-immersed crucifix: these works deal with matters that at the time are rarely discussed openly, if discussed at all. They move questions of religion and sexuality from the unspoken to the topical. In the moment, they are genuinely shocking, and Catholic and fundamentalist Protestant leaders, historically at odds, draw together to denounce them.

For conservatives, this "disturbatory" work (the term is Arthur C. Danto's) spells the end of the world as they know it; for progressives, the stifling of artistic expression amounts to the same thing. Soon the works themselves are occluded by debates about the responsibilities of artists, public funding of the arts, the role of religion in government, and the power of the media. These are early skirmishes in the culture wars.

A decade later, Eric Hobsbawm would characterize the time from World War I to the fall of the Berlin Wall as a "short twentieth century," aka the Age of Extremes. Plenty of the extremes of the 1980s had a religious dimension. Irish Troubles . . . Islamist jet-hijackings . . . the pope and the ex-Nazi Austrian premier and the convent at Auschwitz . . . philandering televangelists . . . a priest-rapist in Louisiana: those years are full of religion-inflected controversies that have nothing to do with the arts. One line of the story set out here traces a shift from actual wars to culture wars, from conflicts involving religion to conflicts over how religion is represented.

The English word *controversy* comes from the Latin *controversus*, "turned against." The etymology is telling. Controversy isn't just the

tumult and strife that arise around public acts. It's a characteristic of certain works of art and of the people who make them. It's a turning against received ideas; it's a generative force, a source of creativity. And it's a personal state as much as a social one, rooted, for many of us, in the recognition that we are controverts—people turned against ourselves.

Prince catches this sense of things in "Controversy," from 1981. He can't believe "all the things people say," he sings as the song begins, and goes on: "Am I black or white? Am I straight or gay?" And then: "Do I believe in God? Do I believe in me?" Seven minutes, and it's all there: the conflicts over race, sex, and religion that will become the stuff of society-shaking conflict; the chatter and calumny about the person caught up in it—and the struggle between conversion and self-acceptance that runs through the process.

Controversy takes various forms among the crypto-religious. Warhol, Morrissey, Madonna, and Salman Rushdie are controversialists—drawn to conflict, inviting it, needing it for their work to have its full effect. Martin Scorsese is pressed into controversy by events. Prince at once thrives on conflict and insists that he'd rather be left alone to make music. Leonard Cohen and U2, who yearn for unity, dramatize the divides of the self—trying to dig out "the trenches within our hearts," as Bono put it in "Sunday Bloody Sunday."

The press coverage of the culture wars at the time typically foregrounded the evangelists and politicians rather than the artists. Not so in this telling of the story. Here the artists are the protagonists, and their work, controversial to its core, stirs public conflict because it deals with controverted issues that are just coming into view.

In some instances public controversy brings attention to work that might have been overlooked, or points up the work's religious motifs. But most of the work that figures into this book is seen, heard, read, discussed, and recognized when it comes out. It is popular. At the very moment when the neoconservative cleric Richard John Neuhaus is decrying a "naked public square"—public life stripped of religious points of reference—religious imagery is hiding in plain sight in popular culture and the arts.

What's striking in retrospect isn't just that artists are making refer-

ence to religion in their work. It is that they take the religious point of view seriously and personally. They aren't set against religious authority, at least not at first. They aren't anti-religious or irreligious. They're crypto-religious. For them prayer, scripture, image, and ritual are material they claim as their own via the imagination and seek to complicate and deepen, not to do away with. They forthrightly cite their religious roots; they count themselves as believers and regard their work as the expression of convictions formed through intense self-scrutiny. Seen as faithless or profane, they see themselves and their approach to religion as more faithful to the core truths of faith than the clerics and televangelists, and they hope the public will agree.

Leonard Cohen, speaking to a journalist friend in 1988, observes: "A lot of the information in our religious systems has been discarded, and people find themselves in predicaments that have the potential of being addressed from a religious point of view; but they lack the religious vocabulary to address it. This is unfortunate because although the secular approach to personality and the destruction of the self is valuable, it's one-sided. The fact is we do feel a real connection with the divine and sense the presence of a deep meaning that the mind cannot penetrate."

There, Cohen speaks for the group, in effect, and at once addresses the moment and offers an augury of the future. For the crypto-religious, religion isn't a structure of historic oppression or a bad influence to be opposed on principle. It is inheritance and legacy, underworld and promised land. It's a fact on the ground and a stumbling block. It is what it has been for a broad range of believers all along: a means of making sense of the world and our place in it.

If I look closely, I can locate myself in that moment: riding the D train with *The Village Voice* and Pascal's *Pensées* in a black messenger bag . . . going to Mass at Corpus Christi Church near Columbia University . . . brooding in the medieval rooms of the Metropolitan Museum—a Catholic dangling man, caught in the disjunct between belief as it was taught and written about and belief as it was enacted in the city. I played

"If I Should Fall from Grace with God" on the jukebox at the Dublin House, walked past picketers outside the Ziegfeld, bought *The Satanic Verses* in solidarity, read *Beloved* in a graduate seminar. No doubt I introjected the mood and spirit of the city in those years.

Plenty of others did, too. For no small number of people that controversy-heavy decade was formative, the way the civil rights movement, Vatican II, and the anti-war movement were for a prior generation. That moment formed us as crypto-religious, controverted to the core, and the story of that moment is the story of our ongoing quandaries of believing and belonging.

A third of a century later, many of the conflicts that arose in that moment are unresolved—some stuck where they were arrested at the time, others long since left behind. But the crypto-religious work of the moment is still with us, much of it as vital now as it was then. The secret chord sounds down the decades, intermittent but distinct; set against the certainties of the pulpit, the poll data, the home page, and the social feed, it calls us back to the undercurrents of the religion-burdened events from that moment up to the present.

This book, then—these tales of elders and precursors—is an effort to understand the age we are in by turning to its beginnings.

PART I

ENCRYPTED

1

PRESENCE IS EVERYWHERE

Andy Warhol's work is devoted to the ordinary: the apprehension of it, the celebration of it, and the effort to render the "presence" that he found in it, an effort that makes the work cryptically religious. But Andy Warhol, the man and the artist, was never ordinary—except for the day he met John Paul II.

It was in Rome in 1980. John Paul was still in the first bloom of his pontificate, and the image of him as a young, strong, independent-minded Pole had been burnished by a visit to New York City the previous fall: Mass at Yankee Stadium, a ticker-tape parade down Broadway. Warhol just then was an artist both famous and notorious, known as much for his blank stare and shock of white hair as for his images of Campbell's soup cans and electric chairs. It would have been no stretch, at the time, to call it an encounter of two icons—the pope and the Pope of Pop.

The photographs from that day show something different, though. They were taken in St. Peter's Square by a Vatican photographer. The two men are in a crowd of people, facing each other across a narrow barrier. John Paul is all in white, as you'd expect, tan and strong of jaw, his left hand in the artist's right. Warhol has on a white dress shirt and a striped tie and an olive-green down jacket, and he's holding a pocket camera. His skin has more color than usual; his hair looks natural, not

like a wig, with actual gray hair tufting out over the tinted frames of his eyeglasses. He's smiling, and the smile looks genuine. He looks like an ordinary person—just another pilgrim to Rome.

He looks like just another pilgrim because he *was* just another pilgrim. The story of how he wound up there, told in his diary, is a story of the popular artist inadvertently joining the populace.

In November 1979 a show of his *Portraits of the '70s* opened at the Whitney Museum in Manhattan. Silk-screen images of Mick Jagger, Truman Capote, Yves St. Laurent, and Golda Meir were mixed in with images of his mother and portraits of socialites he had done for the money. The show left him tired of portraiture and eager to move on to other things. But there was one person whose portrait he was still determined to "do": John Paul.

For Warhol, the Polish pope wasn't just another celebrity. He was practically kin. Born in 1928 in Pittsburgh, Warhol had been brought up in a close-knit community of immigrants from Ruthenia, near Poland's southern border. Through his boyhood he spent Sunday mornings gazing at Christ, the Virgin Mary, and the saints in the Ruthenian church, which followed the Byzantine rite—the priest hidden behind a wall of icons and chanting in Old Church Slavonic—and through religion he gained a sense of the power of images. As an adult he held on to religion through habits whose significance is hard to make out.

In mid-career he traveled to Europe often, and while in Italy in March 1980 to promote an exhibition in Naples he had his manager and confidant, Fred Hughes, arrange an audience with John Paul at the Vatican.

They left Naples at dawn. When they got to St. Peter's they discovered that their audience was the weekly general audience held for tourists and pilgrims to Rome. There were five thousand people in the piazza. Hughes approached a pair of Swiss Guards and said they had a private audience. The guards laughed.

Warhol was seated in the front row of pilgrims, a VIP after all. "A nun screamed out, 'You're Andy Warhol! Can I have your autograph?'" he recalled in his diary. "Then I had to sign five more autographs for

other nuns. And I just get so nervous at church. And then the pope came out, he was on a gold car, he did the rounds, and then finally he got up and gave a speech against divorce in seven different languages."

Finally John Paul clambered down the steps from the basilica. He moved along the row, blessing pilgrims in small groups and clasping hands with them one by one. Warhol stood waiting. He chattered to Fred Hughes. He fidgeted. He toyed with the camera he had brought. Now the pope was right in front of them. "He asked Fred where he was from and Fred said New York, and I was taking pictures—there were a lot of photographers around—and he shook my hand and I said I was from New York, too. I didn't kiss his hand." He extended his own right hand; the pope took it in his left. "The mobs behind us were jumping up and down from their seats, it was scary. Then Fred was going to take a Polaroid but I said they'd think it was a machine gun and shoot us, so we never got a Polaroid of the pope."

Warhol took an excellent shot of John Paul with his pocket camera— vertical, black-and-white, with Bernini's colonnade as a background— but he never turned it into a celebrity portrait. In effect, the Vatican photographs of John Paul and Warhol *are* the portrait. It's tempting to see the photos as symbolic: two Poles, two icons, two grandmasters of mass media and the public image. Their real power, though, is in their matter-of-factness. The two figures look strikingly natural and unguarded. In his clear plastic framed glasses and down jacket Warhol brings to mind the John Lennon of the New York years: a celebrity dressed down, out and about. John Paul, too, is more man than icon, still on the threshold of the fame that would affix to him as he celebrated Mass before vast crowds all over the world.

Back in New York, Warhol resumed his social regimen of openings, parties, and after-hours suppers, making new work at the Factory all the while.

He had dealt with religious imagery rarely over the decades. Now he kept returning to it. He made silk-screen images of skulls, memento mori–style. He made a series called *Guns, Knives, Crosses*. He tried some lurid knockoffs of works by Piero della Francesca, Raphael, and Paolo

Uccello. He dressed dolls as priests and nuns and photographed them. He did some pencil drawings made from Polaroids taken of a nubile young woman nursing an infant child.

This last is the *Modern Madonna* series, and it is a real departure. It evokes Christian imagery directly and without parody or irony, just Warhol's precisely laid down pencil lines. And it reflects a fresh interest in depicting the human body. These Madonnas are images in the Christian devotional tradition, but they are also nudes: even in pencil outline, the young mother's body is as three-dimensional, the breasts as heavy and rounded, as any body in Warhol's work.

There were open-air flea markets at many empty lots in Manhattan, and Warhol patronized them with a ritual devotion. On one outing, he found a terra-cotta rendering of Leonardo da Vinci's *Last Supper* in a secondhand shop near Times Square. He bought it, took it away, and set it up in the Factory.

To picture Andy Warhol at a flea market is to picture the double character of New York in the early eighties. The city was characterized by its celebrity nightlife: discos, launch parties, black limousines, lines of cocaine on the counters of mirrored bathrooms. And it was defined by squalor and decay: the crime rate surging, some men draped in black trash bags acting as would-be traffic cops, others swiping squeegees across the windshields of cars at the tunnel entrances and demanding a dollar for the service.

And yet those of us who had come from somewhere else were struck by the stone-and-iron solidity of the city more than by the signs of decay. New York City in that moment was as ancient-seeming as Rome. It was an unreconstructed place, free of the shopping malls and space-age sports arenas that had transformed the mainland. It was still in touch with the dark forces of clan and tribe and territory, of sin and retribution, and the Old World feel of the city was what set it apart from continental America.

It's remembered as two cities, rich and poor, white and Black, that

of the fleet finance elite and that of the racial and ethnic "minorities" who were actually the majority. To a striking degree, however, the two cities were still one city, made roughly equal by crime and the decrepit state of subways, streets, and public accommodations.

The city's recent history was marked by catastrophe: the collapse and municipal bankruptcy of 1975, bracketed by the blackouts of 1965 and 1977, which exposed the fragility of the city's infrastructure, the de facto separation of the races, and the contempt that Black people and white people felt for one another. Postwar, New York had fallen; for whole neighborhoods, the city had never recovered, and the sense of decline from a prior state was strong. And yet the old edifices were still standing. Outside of midtown, the city looked much the way it looked in the twenties and the fifties.

There was a religious dimension to the place and its aura of separateness. If you came to New York to live, you came for good, a conversion experience akin to being born again. To live in New York was to become a New Yorker, and to become a New Yorker was to disavow your past life—to put away childish things, to renounce the suburbs and all their works and pomps. Out went the chinos, replaced with black jeans; out, the puffy down jacket, on with a vintage overcoat and a long scarf; off with the college sweatshirt—you were a New Yorker now.

Manhattan was a symbolic landscape out of Dante, an island spoked by bridges and tunnels that were architectural features only (real New Yorkers didn't drive). Famed for hedonism, it was a hive of asceticism, too. On this rock many thousands of people lived alone, in single rooms with steel gates over the windows, scarcely speaking to their neighbors, whose names they did not know—urban anchorites held in place by rent control.

The city was powered by the shared belief that it was the center of everything and that being a New Yorker gave your life meaning and purpose. It was this belief that drew you there and held you there. And yet the city was colossally indifferent to your individual fate. Make it here, and you could make it anywhere, but the city didn't care whether you made it here; in fact it met your best efforts with a curse and a

shove. New York was proof of cosmic indifference, and you embraced its hard truth as a credo.

Andy Warhol had come to the city in the time-honored way—on a Greyhound bus. He was determined to make a name for himself and to make himself a New Yorker, and for him, as for so many others, the two aspirations were essentially the same. Virtually all of his work was produced in New York: tens of thousands of paintings, prints, films, and photographs. Its effects of novelty, glamour, and shock are set against the scrim of the fallen city. It is rooted in a running apprehension of the stuff of New York life—now exalting the familiar, now offering up the strange as nothing out of the ordinary.

In outline, his formation is likewise ordinary: the story of an artist, solitary, sensitive, queer, coming of age in an ethnic community suffused with religion.

Growing up, he was Andrew Warhola, youngest son of Andrej and Julia, Russo-Carpathian immigrants. They were called Ruthenians; their language was Rusyn, and their neighborhood was known as the Ruska Dolina. They were poor—"the poorest of the poor," a relative put it. And they were religious: Catholic Slavs, formally united with Rome but liturgically rooted in Byzantium. Their church, St. John Chrysostom, all gilt and marble, stood in contrast to the house where they lived (seen in a painting Warhol made in his teens), which was small and plain, with a sitting room whose furniture is oriented toward a crucifix on the mantel. A reproduction of Leonardo's *Last Supper* hung on one wall, and they would make the sign of the cross when they passed it. Julia Warhola was a gifted visual artist, and she drew angels, crosses, and cats in delicate pen and ink.

The crucifix on the mantel was a memento from the funeral for Andrej, a laborer, ill with tuberculosis, who died after gallbladder surgery in 1942. Andy Warhol was fourteen. At the time, he was suffering from Saint Vitus's dance—the spasmodic shaking of the body—and his mother made him stay home from the funeral, lest the grim rite trigger an outbreak.

At home, he was cosseted; at school, he was considered a prodigy. As his older brothers went to work to support the family, he studied fine arts on scholarship at Carnegie Tech. He graduated in May 1949 and left for New York the same day.

He rented a room on St. Mark's Place and sought freelance work as a commercial artist. After a few lean months, the work came to him: window dressings for Bonwit Teller, shoe ads for I. Miller, and Christmas cards for Tiffany's—delicate pen-and-ink drawings of stars, trees, and wreaths. He rose swiftly, and won an Art Directors Club prize. In 1960 he bought a row house on Lexington Avenue near East Eighty-Ninth Street.

He was still spasmodically religious. According to one account, in his first months on St. Mark's—where Eastern Rite churches abound—he went to church on some weekday mornings, portfolio in hand, before going uptown to pitch his work. (His biographer Blake Gopnik offers a contrary account.) Then, in 1951, Julia showed up from Pittsburgh. "Andy go to New York by himself," she recalled. "I prayed, God, oh God, help my boy Andy. He get no job. I help him with a little bit of money. Later I visit him. One time, two time, third time. I stay." Julia was devoted to two things, her boy Andy and religion, and she organized her life around cooking for him and going to church—on Sundays at the Greek Catholic church east of Union Square, other times at the Roman Catholic church of St. Thomas More, on East Eighty-Ninth Street, near the row house, where she lived in the basement flat, present but apart. Some Sundays he went with her.

He was thriving in the converging fields of advertising and commercial design when he made his first art meant expressly for exhibition: two paintings of Coca-Cola bottles. The Coca-Cola logo was featured on the facades of luncheonettes such as the Lexington Candy Shop, near the row house. The logo and the image of the curvaceous green bottle were emblems of the New York ordinary.

Warhol made two different Coca-Cola paintings. "One was full of Abstract Expressionist brushstrokes and drips of paint," his biographer and longtime associate Bob Colacello explains, "the other as pure and flat as an ad." Warhol asked the agent who represented his work to tell

him which one to go to a gallery with. The flat one, the agent said, and Warhol did.

That was in 1961. The New York art scene then observed something like a religion of abstraction, with "Thou shalt not show" as the first commandment. A painting was an event, or an expression of the artist's roiling inner state, or a meditation on color. What it was not was an image of anything, especially a worldly object.

Warhol would take a different approach. His art would feature recognizable imagery, treated matter-of-factly. He painted dollar bills and cans of Campbell's soup. He made silk-screened images of Marilyn Monroe and Elizabeth Taylor, repeating the faces in gridded rectangles, like contact sheets or sheets of postage stamps.

Already he was a controvert, defining himself in opposition to others, so that the conflict would be about the definition of art itself. "The Pop artist did images that anyone walking down Broadway could recognize in a split second," he later said, ". . . all the great modern things that the Abstract Expressionists tried so hard not to notice at all."

Pop Art is often presented as a wised-up refutation of Abstract Expressionism's claim to sublimity, and Warhol seen as a commercial artist who exploited the booming art market of the sixties. But that way of putting things—the sublime overtaken by the slick—misses the key to Warhol's early work: that he, too, in his own way, laid claim to sublimity. Warhol saw his images as possessing the same transcendent qualities that the Abstract Expressionists believed they expressed through the mystic splattering of paint. In an interview with *ARTnews* in 1963, he said: "I've viewed most of the paintings I've loved—Mondrians, Matisses, Pollocks—as rather dead-pan in that sense. All painting is fact, and that is enough; the paintings are charged with their very presence."

As the word *presence* suggests, Warhol's art had a religious aspect. And the conflict between Pop Art and Abstract Expressionism reprised a controversy from the religious past: the iconoclastic crisis of the eighth and ninth centuries, which turned on the question of whether art can represent the sacred, or is profane by definition.

From the beginning, Warhol's exegetes have called attention to his Byzantine upbringing and depicted him as a contemporary iconogra-

pher: a maker of strong, clear, bright images redolent of the supernatural. In that interpretation, he offers a quasi-sacred cosmology as social commentary. Pop culture is our society's religion. Consumer goods are our sacraments. Celebrities are our saints. Fame is immortality. Headshots are icons, for Elvis, Marilyn, Liz, and Mao are personages in the heaven of notoriety. Warhol himself is the celebrant, elevating and consecrating images through art.

That interpretation scants the quality Warhol himself singled out in his work—the quality, obvious from the 1964 shows onward, that irked some people and perplexed others. This is its attention to "presence." The quality he described cryptically to *ARTnews* is not specific to works of art or created by the artist. It is an inherent quality, found in abundance in everyday life. Ordinary objects and images are "charged with their very presence"; the more ordinary they are, the stronger their presence.

Warhol saw and felt presence everywhere. He made the omnipresence of presence a first principle for his work. He would wrest presence from the bare white rooms of Abstract Expressionism and show that it was there to be found in the New York City of Madison Avenue, Checker cabs, Coca-Cola signs, and tabloid newspapers. In effect, he would oppose the Abstract Expressionists (and their iconoclasm) by making strong images, drawn from the profane world of commerce, that radiated presence. Where they had turned inward, calling forth painting from the depths of the unconscious, he turned his attention outward, to the ordinary.

A Boy for Meg, from 1962, is a demonstration of this approach. It is a four-by-six-foot rendering of the front page of the *New York Post* of Friday, November 3, 1961. The headline refers to Princess Margaret, sister of Queen Elizabeth, pictured in a necklace and a fluffy hat (she had given birth to a son, David, the day before). On top is a blue call-out for an excerpt from a new book about "Sinatra and His Rat Pack," and a photo of the singer in a fedora. A square to the left gives the Weather ("Fog tonight, in the 60s"); one on the right points to the Latest Stock Prices. The price is 10 cents. Royalty, celebrity, nightlife, money, and the weather: they're all here, in clear images and bold type. Where Picasso and Braque had incorporated newspapers into Cubist

compositions, and Robert Rauschenberg had used newsprint as the surface for collage, Warhol made the front page an image of a day in the life of New York City.

The celebrant of the ordinary is a familiar figure. Many of us are such persons ourselves. For us ordinary life is full of meaning, present from moment to moment. And for us—as for Andy Warhol—the sense that presence is everywhere is the vestige of a religious upbringing. Firm beliefs have softened, rituals been left behind, faith in a personal God thinned out or chipped away—but the sense of a supernatural presence remains, often made more intense by its separation from formal religion.

Warhol's attention to the "presence" of the ordinary was the root of his identity as a popular artist; and it put him squarely in a line of twentieth-century writers and artists with Christian preoccupations—made him traditional, not outré.

Traditionally, Christianity upholds the ordinary as holy. The story of the Gospels is one where God becomes man, lives an ordinary human life, and is put to death as a common criminal, wherepon his followers affirm a "priesthood of all believers" and recognize a fisherman and a tentmaker as their leaders. The sacraments affirm the goodness of the things of the world and the rituals of everyday life: water and oil, used in baptism to wash the new Christian clean and anoint his or her body, are means of regeneration; bread and wine, consecrated by the priest, are the body and blood of Christ. The saints, often heroes or martyrs, are just as often holy people from ordinary backgrounds whom the faithful ask to intercede in everyday matters—a lost object, a big test.

For the reformers of the sixteenth century Catholicism's ease with the commonplace, its willingness to bless worldly extravagance, was one of the qualities that made it in need of reform. Protestantism sought both to re-root Christianity in ordinary things—plain churches, scripture and liturgy in the language of everyday life—and to embolden believers to stand apart from the ordinary run of things for the Gospel's sake. In response, Catholic artists turned their attention to the ordinary—Caravaggio training a divine light on a tax collector, or on

the rump of the horse from which a saint struck by God has been thrown. Then, after the Council of Trent in 1566, the Catholic hierarchy took an approach rooted in *contemptus mundi*: contempt for the world. The lives of ordinary people were held to be less significant than those of priests and nuns. The things of the world were deemed "occasions of sin"; the world itself was "this vale of tears."

With the modern age, official Catholic contempt for the world became contempt for modernity—and the basis for controversy. For modernists, the modern age was the age of the common man—of ordinary people waking and sleeping, working and earning, and making sense of their lives without the superstructure of revelation. For Popes Pius IX and Pius X the age's supposed diminishment of the supernatural aspect of life was a form of heresy. Those popes set the Church against "Modernism" in theology (intepretation of scripture), politics (democracy, women's suffrage), morality (sex before marriage), and culture (novels, cinema). They promoted the idea that to be a Catholic was to be in the modern world but not of it—to live "over against" modernity.

All this put twentieth-century Catholic artists in a paradoxical position. As moderns, they affirmed the integrity of ordinary experience, in defiance of the Church; as Catholics, they saw the ordinary as imbued with a supernatural presence, in defiance of modernism in the arts. This led them to express their Catholicism furtively—and cryptically.

James Joyce is the vividest example: in his career, the varieties of crypto-Catholic artistry converge. There's the artist as an exile from his churchy upbringing, who has put away beliefs as childish things; the artist as a priest of the imagination, who consecrates the commonplace; the artist as at once a rebel and a religious pioneer, who follows the spirit to places where ecclesial institutions forbid it to go.

Joyce's life story corresponds with the pattern he set out in *A Portrait of the Artist as a Young Man*: a conversion away from religion and toward literature, and a vow of "silence, exile, and cunning." Like "stately, plump Buck Mulligan" in the opening scene of *Ulysses*, who improvises a Mass with razor and lather atop a signal tower outside Dublin, Joyce repurposes Catholic rituals and symbolism in his fiction. For him, religion is "ineluctable," a force that can be evaded but not escaped. And the

ineluctability of Catholicism is an artistic advantage. Irish Catholicism is an aspect of Joyce's experience, which he transmutes in the "smithy" of art.

Even as he breaks with Catholicism, then, Joyce cleaves to Catholic ideas, and he constructs each of his works (except the last, *Finnegans Wake*) according to a Catholic pattern. *Dubliners* is lit up by the motif of the "epiphany"—named for the feast day in which the Magi come to behold the child Jesus. *A Portrait of the Artist as a Young Man* is a conversion narrative with a Jesuit retreat at its center. *Ulysses* is a mock classical epic, yes, but one infused from page to page (as that opening Mass emphasizes) with the Catholic sacramental practice of consecrating ordinary things for sacred purposes.

Ordinary life in Joyce includes the life of the body. The passages in *Ulysses* that led the book to be banned as obscene weren't scenes of grand sexual passion. They were scenes of ordinary desire: a young woman's legs rustling, an older woman masturbating to fulfillment. In this, too, Joyce is an exemplar. In the crypto-religious work of the next generations sex would be the site for the convergence of religion and the ordinary.

At the close of the *Portrait*, Stephen Dedalus says: "Welcome, O life! I go to encounter for the millionth time the reality of experience and to forge in the smithy of my soul the uncreated conscience of my race." The conscience-forging claim is crucial, but the stress on "the reality of experience" is just as important. As Joyce's biographer Richard Ellmann explains: "The epiphany did not mean for Joyce the manifestation of godhead, the showing forth of Christ to the Magi (although that is a useful metaphor for what he had in mind). The epiphany was the sudden 'revelation' of the whatness of a thing, the moment in which 'the soul of the commonest object . . . seems to us radiant.' The artist, he felt, was charged with such revelations, and must look for them not among gods but among men in casual, unostentatious, even unpleasant moments."

Joyce's nearest American heirs were writers who were superficially unlike him, and whose debts to his work were overlooked in their time.

One was James Baldwin. Born in Harlem in 1924, Baldwin char-

acterized himself as "a black creation of the Christian church," and it's no stretch to see his body of work as an exile's cunning effort to figure out what the church had done to him.

He was the eldest of nine children in a family where the father (not his biological father, it turned out) was a preacher, and turned him into a preacher, too. At age thirteen, he entered the pulpit of a Baptist church at 136th and Fifth, and he soon gained local fame as "the young brother Baldwin." He thrived at DeWitt Clinton High School in the Bronx, and meanwhile pursued a sentimental education in Greenwich Village. He was brilliant, artistic, ambitious, queer. Claiming himself as a man and as an artist meant escaping the pulpit, the church, the neighborhood, the city, and finally the United States.

In 1948 Baldwin left New York for Paris, as Joyce had left Dublin for Paris. It was in Paris that Baldwin read *A Portrait of the Artist as a Young Man*, and Joyce's bildungsroman evidently gave shape to the manuscript he'd brought with him, then called *Cry Holy*—a novel about a young man's struggle to climb out from under the influence of his upbringing and of racism together. "The need to do battle with religion and his own oppressed nation, some of whose members were unhappy with his novel and his attitudes; the need to go into exile; the need to create a voice and a mode of perception for a sensitive, literary young man: these were Baldwin's needs as they had been Joyce's," Colm Tóibín has written. So was the need for an "objective" structure to give shape to his experience, and the one Baldwin found was akin to the one Joyce had pioneered in *Ulysses*: a third-person narrative relating the protagonist's movements in a city on a single day. *Go Tell It on the Mountain* is a coming-of-age story as a conversion-away-from-formal-religion story, in which the writer casts away the childish things of faith but lays claim to the language and imagery of faith for literary purposes—the way Baldwin repurposed the title of a Negro spiritual announcing the birth of Jesus and made it a declaration of his rebirth as a young man and an artist.

Baldwin's next two works had biblical titles: *The Amen Corner, Another Country*. The essays in *Notes of a Native Son* and *Nobody Knows My Name*, typically rooted in travels in the United States but written in

Paris, struck the note of the prophet—the outsider who understands his society by standing apart from it.

In 1962 a long essay of Baldwin's was published in *The New Yorker*. "Letter from a Region in My Mind" was a thirty-thousand-word sermon about Christianity's role in the bondage of Black Americans, and Baldwin's analysis of the racial situation turned on his apprehension of the "presence" of the ordinary.

The essay opens with an account of the "religious crisis" Baldwin had undergone at age fourteen (an account made opaque by the fact that his struggle to accept himself as queer is never named). Full of religious ardor—mixed with half-acknowledged sexual desire—he suddenly saw and felt Harlem as a fallen place, brought low by racism: "For the wages of sin were visible everywhere, in every wine-stained and urine-splashed hallway, in every clanging ambulance bell, in every scar on the faces of the pimps and their whores, in every helpless, newborn baby being brought into this danger . . ." Terrified, he "fled into the church" and was "saved."

The Harlem of Baldwin's coming-of-age was a place where the ordinary was malevolent. And yet racism there had given rise to an "ironic tenacity" whereby Black people embraced the ordinary in a way—*sensual* was Baldwin's term—that whites feared and envied without understanding it. "To be sensual, I think, is to respect and rejoice in the force of life, of life itself, and to be *present* in all that one does, from the effort of loving to the breaking of bread." Baldwin writes of sharing a meal in Chicago with Elijah Muhammad, leader of the Nation of Islam—who blamed Christianity, with its stress on redemptive suffering, for its role of reconciling Black people to their fate. "'I left the church twenty years ago, and I haven't joined anything since,'" Baldwin tells him. "It was my way of saying that I did not intend to join their movement, either.

"'And what are you now?'

"I was in something of a bind, for I really could not say—could not allow myself to be stampeded into saying—that I was a Christian. 'I? Now? Nothing.'"

His writing said otherwise. "Letter from a Region in My Mind" took its first words from the spiritual "Down at the Cross," brooded

on the fate of Christianity all the way through, and concluded with a warning from another spiritual: *"God gave Noah the rainbow sign, / No more water, the fire next time!"* The essay was published in a short book: *The Fire Next Time.*

Baldwin and Andy Warhol were four years apart in age, and there are obvious parallels in their careers: the religious upbringing, the alternately bold and oblique expressions of homosexuality, the flight from the religious ghetto to artistic bohemia, the persona that threatened to overtake the work itself. But Baldwin's handling of belief is so unlike Warhol's as to be its inverse. Where Warhol's detachment and uncritical way with imagery make it hard to know just what he believes, Baldwin is an artist of *attachment* who spends his days setting out what he believes on the page. He probes the break with faith over and over; he measures the aftershocks; and he quarrels with the religious authorities so eloquently that he winds up seeming more religious than they are.

After *Time* put Baldwin on the cover in 1963, he was famous. Writing about the civil rights movement, he observed: "I find myself, not for the first time, in the position of a kind of Jeremiah." With fame and the prophetic mode would come a waning of his attention to the ordinary, and his work, more and more, would depict a region of his mind.

As Baldwin was coming of age in Harlem, another of Joyce's underacknowledged descendants was coming of age in Morningside Heights: Jack Kerouac, who reverenced the ordinary at his typewriter through the ecstatic experience of automatic writing, which he made a sacred rite.

Kerouac spent his childhood in Lowell, Massachusetts, speaking French at home and going to Mass at the church of St. Louis de France. He shook free of the Quebecois community and went to New York—to the Horace Mann School and Columbia University, on a football scholarship—only to find that family and religion trailed him there. He got hurt, lost his scholarship, dropped out, and spent time with Allen Ginsberg, William S. Burroughs, and other emerging writers near Columbia. He joined the Navy but was discharged for "schizoid

tendencies." He returned to New York and got an apartment in Ozone
Park, Queens, where his mother, a devout Catholic, joined him.

At age twenty-five, Kerouac felt a commission to write a "lyric
epic" that would "explain everything to everybody." His first novel,
The Town and the City, drawn from his boyhood in Lowell, was 380,000
words. He sent it to Robert Giroux, an editor with Harcourt, Brace,
who, like him, was a French-Canadian Catholic who had gone to Co-
lumbia. Just then—spring 1949—Giroux had his first bestseller: *The
Seven Storey Mountain*, by another Columbia graduate, Thomas Merton,
whose restlessness had led him (via Joyce's *Portrait*) to become a Catholic
and enter a Trappist monastery. Giroux signed up *The Town and the City*
and reduced it by a third. It got mixed reviews.

Kerouac went west, met Neal Cassady, crisscrossed the country
high-spirited and empty-pocketed—he and Cassady talking all the
while—and returned to New York determined to write a book that
would put on the page "the great raw bulk and bulge of my American
continent."

That book is *On the Road*. But the oft-told story of its making has
diminished the religious dimension of Kerouac's approach: the mystic
attention to everyday life, the wish to include "everything" and "every-
body," and the writing of fiction as the living-out of a personal credo in
which art and life converge. That approach, for Kerouac as for Joyce, was
indebted to his Catholic upbringing. He sketched crucifixes in the mar-
gins of his diaries. He saw the novel-writing process as a confession to an
ideal reader. Before settling at the typewriter for an all-night session, he
would light a candle, kneel, and pray. He wrote without stopping, sure
that "once God moves this hand, it doesn't turn back."

The term "Beat" was a riff on "beatific," and Dean Moriarty and
Sal Paradise in *On the Road* are seekers after the beatific vision. Kerouac
characterized the novel as "really a story of two Catholic buddies roam-
ing the country in search of God. And we found him . . ." Sal, getting
to know Dean, falls under the spell of "a kind of holy lightning": sud-
den, unbidden, crackling with energy, alternately manic and mystical.
During an overnight drive the "holy lightning" overtakes Dean like a
drug and sends him on a jag about the existence of God, a self-evident

truth to those who are on the road. Sal sees Dean as "a kind of saint, lean, intense, and all-seeing," and Kerouac's account of their journey is lit up with the sense that "life is holy and every moment is precious."

On the Road was published in 1957, seven years after it was written. As it became an object of controversy for its celebration of life without limits, the Beat expositor John Clellon Holmes stressed its religious aspect in a long article for *Esquire*. Sure, the characters were obsessed with cars, sex, jazz, weed, and other "kicks"—but they were young people "mad to live, mad to talk, and mad to be saved." He went on: "Their real journey was inward; and if they seemed to trespass most boundaries, legal and moral, it was only in the hope of finding belief on the other side."

The ethnic boyhood, the giant step to the city, the high-concept artistic breakthrough, the surge of fame (and the clinging mother): Jack Kerouac's career and Andy Warhol's developed on adjacent tracks. And just when Warhol became the avatar of Pop Art, Kerouac was made the figurehead of the Beat movement in coffeehouses and on college campuses. Superficially, the two movements are opposites: one scruffy, the other silky; one disdaining commercial culture, the other celebrating it. But both maintained that it was outside the artistic establishment that "presence" was to be found.

Warhol had his first New York solo show in November 1962 at the Stable Gallery on East Seventy-Fourth Street: a series of silk-screen photo-portraits of Marilyn Monroe, done in different colors, with the most striking one setting a small head of blond-haired Marilyn against a large gold ground. In a review the critic Michael Fried struck the religious note: he named Warhol as the best of a group of "painters working today in the service—or thrall of—a popular iconography," and praised the photo-portraits of Marilyn Monroe as "beautiful, vulgar, heart-breaking icons."

Warhol then made a series of Photomat instant photographs of artists and people he knew, and a set of identical Mona Lisas called "Thirty Are Better Than One." The Mona Lisa series was a riff on Leonardo's

Mona Lisa, which was shown at the Metropolitan Museum in February 1963 and seen by a million people in three weeks—a Renaissance masterpiece as a work of twentieth-century popular art.

That September Warhol and three associates put mattresses in the back of a Ford Falcon station wagon and set out for California—four "nellie queens" (as one of them put it) going on the road. Four days later they reached Los Angeles, and the opening of a Warhol show (his second) at the Ferus Gallery. The show featured forty-eight images from an Elvis Presley movie screened on silvered canvas, and ten Liz Taylors. That November John F. Kennedy was assassinated. Warhol was unmoved by the killing ("Let's go to work," he said). He soon produced dozens of silk screens based on a photograph of Jackie Kennedy and exhibited them alongside silk-screened flowers.

He had established a workspace in a former shoe factory at 231 East Forty-Seventh Street, near the United Nations. This was the Factory. Among the first works made there were the *Brillo Boxes*: four hundred plywood boxes, on which he and several associates (among them Gerald Malanga, his boyfriend at the time) painted or screened the Brillo soap pad logo—white, blue, bright orange—side by side by side.

The *Brillo Boxes* show opened at the Stable Gallery on April 21, 1964—the boxes "stacked head high and wall to wall," Blake Gopnik writes in his biography, "like supplies amassed for long-term storage." There was a party at the Factory afterward—artists and socialites upstairs, Pinkerton guards at the door. Warhol was now notorious.

"I have the most vivid recollection of that show," Arthur C. Danto later wrote, "and of the feeling of lightheartedness and delight people evinced as they marveled at the piles of boxes . . ." He was a philosophy professor at Columbia and a part-time painter, and the show was a conversion experience. He felt at once that Warhol was "out on the living edge of art history," where art became philosophy. With the paintings of soda bottles and soup cans, dollar signs and front pages, Warhol had been "celebrating the vernacular in paintings that appropriated the flat colors and heavy outlines of commercial art." With the *Brillo Boxes* he demonstrated "the possibility that two things may appear outwardly the same and yet be not only different but momentously different."

That two things may appear outwardly the same and yet be momentously different was a tenet of modern art since Duchamp. It was a tenet of Catholicism, too. As spelled out in the catechism, it was the basis for the doctrine of the Real Presence in the Eucharist: consecrated by the priest in the Mass, the bread and wine become the body and blood of Christ while their outward appearances remain unchanged. It was the basis for baptism and the other sacraments, each seen as an "outward sign of an inward grace."

Danto, who was Jewish, used a religious term to describe Warhol's approach, calling it "the transfiguration of the commonplace." He took the term from *The Prime of Miss Jean Brodie*, a novel by Muriel Spark, a Catholic convert from Judaism, who herself took it from the Gospel episode known as the Transfiguration, in which Jesus, up a mountain with three disciples, appeared to them as a figure of pure, dazzling light.

That Warhol had the sacraments in mind when he made the *Brillo Boxes* is no sure thing. The notion that he was definitely religious is definitely an exaggeration. And yet the view that because Warhol was not definitely religious he wasn't really religious scants the very aspect of Warhol's religiosity that makes it interesting: its cryptic quality.

The Stable Gallery shows made Warhol a celebrity and led him to engage a new dealer, Leo Castelli, a potentate of the New York art world. The Los Angeles shows had a profound effect on many artists; one was Corita Kent, a pioneer in postwar Catholic art.

Kent was a Sister of the Immaculate Heart of Mary, an order traditional in its rituals but progressive in its views on the role of women and the place of the arts. As a girl in Iowa, she was already a gifted visual artist, and after joining the order she continued to draw and paint, making figurative works depicting scenes from the Gospels, and earned a master's in art history at USC. While teaching art at the order's small college in Los Angeles she introduced students to an A-list of guest speakers: Alfred Hitchcock, Buckminster Fuller, John Cage, and others. She brought a group of students to the Ferus Gallery to see the Warhols. Soon afterward she changed direction in her own work: she shifted from

painting to silk screen, and began to produce art that frankly made use of Pop Art imagery and techniques to represent the Catholic spirit of the moment.

The moment was that of the Second Vatican Council. Just when Warhol and the other Pop artists were turning the New York art world toward the vernacular, the council fathers in Rome were turning the Church toward the vernacular and toward the modern world—"opening the windows," as Pope John XXIII put it, "to let some fresh air in."

Vatican II was a giant step away from absolutes and toward the contingent—in religion, history, politics, and ordinary life. It was a recognition of the breadth of human experience and of the modern world as the place where God's presence was to be sought.

The council took place in four autumn sessions and drew together twenty-five hundred Catholic bishops and assorted observers, presided over by Pope John, who died in 1963, and by his successor, Paul VI. It replaced the Latin Mass with Mass in the language of everyday life ("the vernacular"), turned the priest so that he faced the people and placed the altar between the priest and people to evoke the table at the Last Supper, and put the Catholic Church in dialogue with other churches and other religions.

The controversies over those changes dominated the press coverage of the council and its aftermath. But for most Catholics in the United States, the council mainly brought a fresh apprehension of the things of everyday life—the ordinary and commonplace. Through rituals, rules, and real estate, the Tridentine church had drawn sharp distinctions between the sacred and the profane. Now the church abruptly affirmed that ordinary life was a site of transcendence, and that the practice of faith was an effort to be alive to the presence of the sacred from one situation to the next.

Warhol understood the change because he was implicated in it. The journey he had made from a working-class religious subculture to the culture of commerce, mass media, and prosperity was the journey made by tens of millions of Americans in those years: Jews, African Americans, white Protestants, Catholics. For him, as for many of them,

religion was a sense of sacred presence as much it was a worldview or a way of life. As a popular artist, he kept in touch with the religious aspect of his character, which joined him to people whom his fame, wealth, sexuality, and Manhattan address put at a distance. And as an artist attuned to the spirit of the age, he recognized the age's religious aspect.

In October 1965, with the final session of Vatican II beginning in Rome, Pope Paul made an "apostolic visit" to New York City. He was the first pope to set foot in the Americas. Warhol was transfixed. The visit—a single day—involved a trip to Manhattan and the United Nations, followed by Mass at Yankee Stadium in the Bronx and a visit to the World's Fair in Queens, where Michelangelo's *Pièta*, loaned by the Vatican, was on view. The motorcade took the pope along East Forty-Seventh Street, right past the Factory. Some of the Factory people went up to the roof to launch giant, phallic silver helium balloons—and drew the attention of police protecting the motorcade. Warhol himself watched the events on television, amazed that the pope was in the vicinity. "I mean, the *Pope, the* Pope . . . It was the most well-planned, media-covered personal appearance in religious (and probably show business) history," he recalled. "Never Before in This Country! One Day Only! The Pope in New York City!"

That account—ghostwritten, Blake Gopnik suggests—is itself a marvel of Pop style, from its distillation of Paul's message at the United Nations ("essentially he said, 'Peace, disarmament, and no birth control'") to its exegesis of the pre-departure press conference: ". . . when the reporters asked him what he liked most about New York," the pope said "'Tutti buoni' ('Everything is good'), which was the Pop philosophy exactly."

Andy Warhol was a Vatican II Catholic before the fact. Corita Kent recognized this, and the work she made in that moment formed a link between the council's breakthroughs and the art world where Warhol was on the leading edge. One silk screen featured a loaf of Wonder Enriched Bread, a frank reference to the Eucharist; another took the curvaceous G that was the General Mills logo and worked it into a slogan: "The Big G Stands for Goodness." Where Warhol had affectlessly rendered the presence inherent in ordinary objects, Kent repurposed

the slogans of marketing as religious exhortation. Two years later Kent made a silk screen encapsulating the "spirit of Vatican II": a grainy image of Paul VI, and the printed slogan LET THE SUN SHINE IN— the anthemic refrain from the musical *Hair*, which was playing in New York City.

Kent would leave the Sisters of the Immaculate Heart of Mary soon afterward to be a full-time artist. In the next decade—the 1970s—her bright, bold, open work of the sixties would become a template for American Catholic ecclesial art (vestments, banners, prayer books), as parishes sought to imbue the liturgy with the spirit of Vatican II. And in the seventies Warhol's early Pop Art works would be adopted as American archetypes—images as familiar as the products and celebrities they enshrined.

2

OUT OF THE ORDINARY

"People Who Died," by the Jim Carroll Band, was *the* New York–themed song of 1980, a sonic burst of the here and now. The skinny, pale, funereally dressed speaker-singer; the robotically chugging guitars, thumping bass, and up-and-down pogo rhythms; the fluorescent colors on the sleeve: this was a fight song of the New Wave, sounding out alongside the Pretenders, Graham Parker, and Joe Jackson. Carroll's album was called *Catholic Boy*, and the sleeve photograph (by Annie Leibovitz) was of him with his parents, a square-looking couple. Feature articles set out his street credentials: the descendant of three generations of New York barkeeps, he had been a heroin addict through his teens, all while he played basketball for a posh day school and supported his habit by "turning tricks for homosexuals" (the press's way of establishing that he wasn't actually gay), chronicling it all in a journal published as *The Basketball Diaries*.

With a chiseled chin and haircut, Carroll looked like a rent-control David Bowie, a thin black-clad duke of downtown. But the real point of reference for his story was the New York bohemia of the late 1960s, not the skinny-tie New Wave. He was thirty-one years old; his finishing school had been Andy Warhol's Factory, and "People Who Died" was a revved-up elegy for the lives lost in the sixties' aftermath.

His moment ended swiftly, but it points to a general truth. So much

of the work that now stands for the New York of the late 1970s was made by figures who were formed in the New York of the 1960s. It's work of the "long sixties," that is.

Much of it is crypto-religious. Through Vatican II, the Catholic Church had recognized that "presence is everywhere" and that the ordinary is site of the extraordinary. These figures, having come of age during the tumult of the sixties, took those propositions as givens; then, in early adulthood, they inverted those propositions, making work which proposed that the extraordinary was ordinary. They sought to reconcile the hard promises of their religious upbringings with the sixties' sense of freedom and possibility, and to square the sixties ideals of bohemia and artistic community with the hard edges of down-and-out New York City.

Martin Scorsese found the extraordinary in the movies, to which he brought a consecrant's devotion. From his boyhood in Little Italy, the constants in his life were the Church, the movies, and the neighborhood. The Mass was akin to a picture show; the cinema was a kind of church; the neighborhood was territory fought over by gangsters, cops, and priests. By the mid-sixties he was was training to be a director, a calling that in the seventies would lead him back to the neighborhood as a setting for his pictures—and eventually out to the dusty world of the New Testament and the early church.

The story of his upbringing is now familiar. He was born in 1942, the younger grandson of immigrants from Sicily. Asthma kept him indoors, away from the playgrounds and the streets. His father, a presser in the garment district, didn't make much but always had enough money to take him to the movies (where the air-conditioning helped his breathing). A local TV station broadcast European films on Friday nights. He grew up watching the key works of Italian neorealism shortly after their release, many with a strong Catholic dimension—such as Roberto Rossellini's *Rome, Open City*, in which a priest is executed by the Fascist government for cooperating with the Resistance.

The vast interior of St. Patrick's Old Cathedral on Mott Street was a

contrast to the family's apartment on Elizabeth, the Latin Mass a counter-point to their mealtime banter. "I think fast, I move fast, and I think it has something to do with the medication I was given for asthma," Scorsese recalled. "It affected the way I breathe, the way I think. I needed to pull back. Film did that for me, and so did the church. They slowed me down. They allowed me to meditate. They gave me a dif-ferent sense of time."

A young priest assigned to the neighborhood brought faith and film together. Scorsese had become an altar boy, and the priest—Fr. Francis Principe—would take the altar boys to a movie and sit and talk about it with them afterward on the steps of the rectory on Mulberry Street. They went to the Roxy near Times Square to see the Gospel drama *The Robe* and then heard his critique. "Father Principe detested Christian sentimentality or comic-book religious aspects. 'Oh, it's so cliché,' he said, meaning the thunder when Judas mentions his name—'My name is Judas,' and there's the thunder in stereophonic sound. To this day I haven't heard thunder as good as that." But Scorsese had conceived of the wish to do it differently, "to take the biblical epic to another place."

He had started drawing storyboards, and he made some for a life of Christ—"set on the Lower East Side, in the tenements, in modern dress. And the crucifixion would be on the West Side docks, and in black-and-white, and with the NYPD involved." He'd noticed that Jesus in the Gospels spent his days with the down-and-out. "What about where I grew up, in the Bowery? What about the people who were dying in front of me, the alcoholics who were dying in the streets? What about the underworld? What about the people who wound up doing bad things, but they're really genuinely good people?"

The questions persisted as he went from minor seminary (he dropped out) to Cardinal Hayes High School in the Bronx to New York Univer-sity, across Houston Street from Little Italy, and then to its film school. There he saw Pier Paolo Pasolini's *The Gospel According to St. Matthew*. Pasolini was the Italian poet who'd been sought out by Federico Fellini as a guide to the city's underworld of hookers and gangsters. Marxist, modernist, homosexual, he was set against the Roman church; but the religious feeling left over from his Catholic upbringing was quickened,

during Vatican II, by an overnight stay in Assisi, where he read Matthew's Gospel straight through. "If you know that I am an unbeliever, then you know me better than I do myself," he would say, cryptically. "I may be an unbeliever, but I am an unbeliever who has a nostalgia for a belief."

The Gospel According to St. Matthew opens with a credit sequence set to the whoopings of a Brazilian street choir, culminating with a dedication: "to the dear, joyous, familiar memory of John XXIII." What follows blends neorealism's poverty of means with Fellini's focus on people living apart from conventional society. The action is shot on location in southern Italy; except for Jesus (a fine-featured Spaniard), the actors are local peasants or friends of Pasolini's. The soundtrack is a skein of biblically inflected classics, from Bach to Blind Willie Johnson. A gorgeous tableau conveying Jesus's conception and birth gives way to packs of men swarming the village with swords drawn. When the man Jesus finally appears, to be baptized by John at the base of a waterfall, you feel him as a figure set apart; and his calling of the apostles—fitting a name to a face twelve times over; drawing them out of their everyday lives through the look in his eyes—has the effect of making you, too, an onlooker who is drawn into his story.

Scorsese was drawn in—was made a disciple of Pasolini's way of seeing. "Once I saw *The Gospel According to Matthew*, it changed everything . . . I was moved and crushed at the same time by the Pasolini film because in a sense it was what I wanted to do." The setting was the rural Italy his grandparents had left behind, and the aesthetic was akin to the one taking shape in his own work. In his films—pictures, he called them, using the idiom of an earlier time—everyday life would be transfigured by cinema and shot through with violence, a force at once extraordinary and commonplace.

Andy Warhol had become an impresario, presiding over the Exploding Plastic Inevitable, a series of rock concerts featuring the Velvet Underground and Nico, enhanced by light shows and drugs—a New York

counterpart to the "happenings" in California. In 1968 he moved the Factory to the sixth floor of a Moorish building on Union Square, closer to the action. The new site was still a studio where silk-screen prints were produced, but as his fame grew it also became, more and more, a site of countercultural devotion, where artists, dilettantes, and misfits were drawn together.

With fame, Warhol's attention shifted away from the presence inhering in modern life and its objects and toward the presence inhering in figures like himself. His belief that "everything is good" likewise shifted, becoming the belief that behavior conventional society treated as out of the ordinary should be seen as ordinary. He had set the tone for this with his films of a few years earlier, going to ever greater lengths to insist on the presence found in outré behavior. He'd made *Blow Job* about a blow job. He'd made one called *Tub Girls*, and one called *Taylor Mead's Ass*. He'd made one showing the Empire State Building through an entire night, the iconic character of the spotlit building at once heightened and flattened over eight hours and five minutes. He made *Chelsea Girls* about the goings-on at the Hotel Chelsea. The "Pope sequence" drew the most attention: Warhol's early consigliere Emile de Antonio drinking himself stuporous while comparing Warhol's dealer, Leo Castelli, to the pope: "A well-known Pope who scratches his balls every time he talks to you. It's sort of a sin to scratch your balls when you're the Pope."

The Factory denizens referred to Warhol as the Pope, and an outsize number of them were Catholics in flight from church and family. One was a man who dressed in a sailor suit to go cruising for sex, getting drunk first to keep from feeling guilty; another was a Puerto Rican cross-dresser who "knew it was a sin to be in drag" but reasoned that if God "really hated him, He would have struck him dead."

Warhol had become cryptic about his own sexuality, squiring handsome young men about town and arranging for them to live with him, serially monogamously, while denying that he was gay. The best known of his "superstars," Edie Sedgwick, was called his "girlfriend" in the press. But the films had linked Warhol with the gay subculture. The

titular act of *Blow Job* is man-on-man. The images of Joe D'Alessandro in *Flesh*, shirtless, hairless, sculpted as a Renaissance marble, are plainly homoerotic.

Sex in Warhol's scheme of things was paradoxical. Like the films, it was banal and repetitive, with no transcendent quality. It wasn't an aspect of love or a surrender of the self. It was just something the people at the Factory did. And yet the ways they did this thing they did made them extraordinary—made them deviants and outlaws.

In the Catholic milieu, too, the Vatican II conviction that presence inhered in the ordinary was disclosing its flip side. The debate over the Vietnam War brought the tension between different apprehensions of the ordinary to the fore. Circa 1968, the Catholic peace movement was torn between nonviolent resistance and "direct action"—between the ordinary and the extraordinary.

The movement for nonviolent social change brought to fruition by Martin Luther King Jr. in the campaign for civil rights sought to dramatize the need for reform through "passive resistance"—the refusal to vacate a lunch counter or a seat in the front of a city bus. Symbolically, it relied on the transfiguration of the commonplace: the turning of the act of riding a bus or eating a meal into acts of witness against injustice. But a war being fought in a distant land offered few opportunities for passive resistance.

Direct action also relied on the transfiguration of the commonplace. But the means of transfiguration, while nonviolent in the strict sense, symbolically evoked violence, as when a number of draft-age young men, members of the Catholic Worker movement on the Lower East Side, burned their Selective Service cards in Union Square.

Daniel Berrigan, a Jesuit priest and a chaplain at Cornell University, was the de facto leader of the Catholic peace movement. Berrigan had gained acclaim in the late fifties for a book of poetry, and in the sixties he became a Catholic counterpart to Allen Ginsberg—for whom (as Amy Hungerford has observed) poetry was a "spiritual practice." Nonviolence

was another such practice. For Daniel and his brother, Phil, who was ordained and then left the priesthood, nonviolence was the heart of the Gospel, and the mechanized violence of the U.S. campaign in Vietnam warranted going past "petitionary nonviolence" to a frankly extraordinary response. So they began to take direct action. Daniel Berrigan performed an exorcism outside the Pentagon (he was arrested and spent five days in jail). Philip Berrigan and three others carried jars of their own blood into the U.S. Customs House in Baltimore and poured it on draft files—seeing this as "a sacrificial and constructive act" of bloodshed. They would be tried, found guilty of the destruction of government property, and sentenced to prison.

Martin Luther King was shot and killed by a white segregationist in Memphis on April 4, 1968. The assassination, and the righteous anger it called forth—protests, riots, lootings, and arson from Newark to Los Angeles—suggested that nonviolence had failed and more dramatic resistance was needed. Six weeks later the Berrigans and seven others burst into a Selective Service office in Catonsville, near Baltimore; seized draft files; put them in wire trash baskets in the parking lot; set them alight with homemade napalm; and formed a circle, held hands, and prayed the Our Father aloud as reporters and photographers watched. The action was reported worldwide, as were the events that followed on it: their trial, conviction, and sentencing; Daniel Berrigan's flight from the FBI, and his capture three months later; and the staging of a play he wrote in prison, *The Trial of the Catonsville Nine*. The play was published as a book with a cover by Corita Kent—an orange-and-black silk screen of the draft files aflame in a trash basket.

Berrigan was Andy Warhol's radical double: elfin, tricksterish, a master of the mass media, always ready with an apt comment. He wore a beret with his clerical blacks, a peace medallion in place of a pectoral cross; he celebrated Mass by consecrating sliced bread and jug wine, using a coffee cup as a chalice. He was an avatar for the anti-war movement the way Warhol was to the art crowd: he embodied not just an outlook or a stance but a way of life, and he gathered around him people—young, sophisticated, rebellious—who bent cultishly to its service. The

Catonsville action made him Catholicism's most notorious controvert, and it turned religious protest into the kind of boundary-breaking act that was coming to be called performance art.

Warhol's assassin struck on June 3, 1968. Valerie Solanas, a performance artist, was angry because Warhol had declined to produce *Up Your Ass*, a play she'd written. She went to Union Square, took the elevator up to the Factory, stepped off, spied Warhol, drew a pair of guns, and opened fire. She shot Warhol, and shot the curator Mario Amaya, who was there that day. Warhol, wounded in the chest, was taken to Columbus Hospital uptown, where he expired during open-heart surgery before the doctors revived him. When he was discharged, he had a thick purplish scar running straight down his chest. The scar would be with him ever after, a reminder that he was not a walking, talking, camera-wielding, speed-taking icon but a man with a body.

Richard Avedon made a portrait photograph of Warhol in August 1969. The black leather jacket Warhol is wearing is pulled up to reveal the scar. The image evokes the Crucifixion, in which Jesus's torso is poked with a spear by a soldier as he hangs on the cross. It also recalls images of St. Sebastian—a saint of the third century who is typically shown shirtless and pierced by arrows.

As Warhol recuperated, he made a vow to go to church every Sunday. He would keep the vow in his own fashion. Mass was too long, he thought, too "boring"—so, as Bob Colacello recalls, ". . . he would 'run to church' for a few minutes between masses, or after the last one, kneel down at the pew, make the sign of the cross, and pray."

Colacello was one of a fresh cohort of fallen-away Catholics at the Factory. Donald Lyons and Paul Morrissey were Fordham graduates who had made an 8 mm movie about a priest who pushed an altar boy off a cliff after Mass; Colacello and Glenn O'Brien were graduate film students at Columbia who had roomed together at Georgetown. After contributing freelance film reviews to *The Village Voice*, Colacello got

a call from a Warhol associate at the Factory, inviting him to write for *Interview*. He then reviewed Morrissey's film *Trash*, produced by Warhol and set at the Factory. "A great Roman Catholic masterpiece," he called the film, which dealt with drugs, sex, infidelity, and impotence— whereupon Morrissey reached out and invited him to the Factory.

Jim Carroll worked for Warhol, "doing odd jobs for short money" at the Factory and then on the Bowery, at a "boy-beaver movie house" called Andy Warhol's Theatre—Boys to Adore Galore. The diaries he'd written in his teens were circulated among the arts crowd, and he was keeping a diary of his time in the Warhol milieu. He characterized himself as "a Catholic on hiatus," and between days of "field work" on the Bowery and nights at Max's Kansas City he would duck into a "strange church" for hours at a time "to rest, to absorb some silence":

> The sides are lined with small grottoes where crescent rows of candles burn before statues of saints, many of them rather obscure. Today I deposit a pair of quarters in a small black box, light a candle before the life-size image of St. Jude, the patron saint of hopeless causes, and sit in the pew beside it. I play with the idea of prayer, but quickly lay the notion aside . . . like a package I have set on my lap as I sit, then place beside me.

Carroll, observing the doings at the Factory, thought of the relationship of "the faithful" to Warhol as a quasi-religious submission to authority. "The image of an artist's loft as a medieval abbey fits Andy like white on rice . . ." he wrote in his diary, but "Andy himself doesn't quite fit in as the abbot-head. He is more like some pope-in-exile, given sanctuary here after offending the empire. He hovers about, giving his blessing to the novitiates' good work with one hand and extending his ring with the other, usually to the envoys of wealth and power. He accepts commissions rather than handing them out; the switch is simply a concession to his own century."

Warhol moved the Factory into a larger cast-iron space at 860 Broadway, just off Union Square. He made himself available as a society portraitist (which "brought in a big share of his annual income,"

his aide Pat Hackett recalled). And he started *Interview*, a magazine that covered the New York nightclub scene where he now spent much of his time. The managing editor would be Bob Colacello, who had become an adept of the downtown scene. Colacello later recalled his father's reaction: "I worked so hard to get you kids out of Brooklyn and put you through Georgetown and now Columbia, so that you could end up working with that *creep* Andy Warhol?"

When Patti Smith gave a poetry reading at St. Mark's Church in 1971, Colacello was there. So was Robert Mapplethorpe, who shared a loft with Smith in Chelsea. Colacello met him and recognized him as kin. "We were two of a kind: rebel Catholic boys who had fled middle-class Long Island suburbs . . . and come to 'the city'—Manhattan—to make it," Colacello recalled. "We started spending long afternoons walking around the Village, trading childhood stories . . . Robert loved hearing about how I spit out my First Communion wafer because the nuns had done such a good job of convincing me that it was the actual flesh and blood of Jesus."

Mapplethorpe had been raised in a strict Catholic family in a thoroughly ordinary Queens neighborhood where the parish bore the out-of-the-ordinary name Our Lady of the Snows. His determination to be an artist was a rebellion against parents, church, and clan, but he was stuck with a Catholic childhood as he was with an outer-borough accent. "You know, I was a Catholic boy. Went to church every Sunday," he later told an interviewer. "A church, especially in the context I was brought up in, but really in any context, has a certain magic or mystery for a child. I think the way I arrange things is very Catholic. It's always little altars; it's always been that way." To Colacello he observed that if you were a Catholic boy growing up in the 1950s, "the only place you ever saw a naked male body was at Mass: Christ on the cross, hanging over the altar. 'And he had a crown of thorns, and there was blood,' he'd say. 'No wonder we're perverse.'"

As he moved to Brooklyn to study art at the Pratt Institute, what Mapplethorpe retained of Catholicism was a keen sense of the malevo-

lent forces the Church opposed. ("He seemed to believe in all the devil stuff," a boyhood friend told his biographer Patricia Morrisroe, "and one time he told me, 'There's this clock in Hell that chimes every hour, "You'll never get out . . . you will never get out . . ."'" He once spent an acid trip raving, "I'm the devil, I'm the devil . . .") He eventually dropped out of Pratt and moved, with Patti Smith, into the first of the series of apartments they shared.

The story of their life together is now a New York legend: two young would-be artists, sleeping together, sharing clothes, creating found-object assemblages—and seeking out Andy Warhol and his coterie at Max's Kansas City, near Union Square. So is the story of Smith's own first act, a run of incantatory poetry readings at St. Mark's, an Episcopal Church at Second Avenue and Tenth Street—solo at first, and then accompanied by Lenny Kaye on electric guitar.

Smith's work was grounded in a religious disposition she'd had since childhood. "I was raised a Christian . . . yet questioned . . . I questioned everything," she recalled. Her father, a UFO hunter, was also a Bible reader, and so was she: she got "stoned on the Bible . . . it made my heart beat harder . . . but a few things disturbed me"—such as the Tower of Babel and the notion that God would punish his people by making it impossible for them to communicate. "The artist in me was already aroused" by this—aroused to communicate; and she identified with Satan, "the first absolute artist . . . the first to have a vision of existence beyond what was imposed on him." From her mother, an on-and-off Jehovah's Witness, she acquired habits of piety. At night she knelt at her bedside to pray while her mother stood smoking a cigarette. She progressed to "mouthing long letters to God" and hiding "*Foxe's Book of Martyrs* beneath my pillow." She collected "religious artifacts I rescued from Catholic trash bins: old holy cards, worn scapulars, plaster saints with chipped hands and feet." As she began to read on her own, she turned to "a different kind of prayer, a silent one, requiring more listening than speaking." Books opened her to "the radiance of the imagination," and her piety turned mystical.

She had been addressing the spirit world ever since. She was especially devoted to the spiritualized literary bohemians of the nineteenth

century: Verlaine and Rimbaud and Gérard de Nerval in France, and
William Blake and Robert Louis Stevenson in Britain. She saw Map-
plethorpe as their kin: defiant of convention, consecrated to art.

When she and Mapplethorpe moved into the Hotel Chelsea, their
bond—fraternal, sexual, collaborative—found expression in a shared
love of ritual. Her birthday was December 30, and as a gift he made
her an Advent calendar with little doors that opened to reveal pictures
of her. His most elaborate work was an altar-like assemblage: "a Sacred
Heart, a crucifix, and a skull." ("[H]e had an incredibly refined aes-
thetic that made everything he did look beautiful," Kenny Tisa, a Pratt
classmate, recalled. "But I thought he was wasting his time with the
crypto-religious pieces.") At the loft he and Smith took over on West
Twenty-Third Street, the altar—not for sale—caught the attention of
art patrons who came to see his handmade jewelry.

Mapplethorpe's recognition that he was gay opened a gap between
them. So did Smith's recognition that she wasn't just a poet; she was a
rock and roller. "She seemed to write with a rhythm section starting
and stopping in her head . . . Her work was resolutely demotic, even
as she played with the imagery that Rimbaud drew from the Bible and
Eliphas Levi and fairy tales and illustrated geographies . . ." Luc Sante
(now Lucy Sante), who followed her from the beginning, recalled. After
Smith and Mapplethorpe went separate ways, she devoted herself to the
"new rock underground" based at CBGB, and he hurled himself with
a zealot's energy into the rituals of the Manhattan gay subculture—the
bars and bathhouses and half-converted industrial spaces where men
would go for sadomasochistic sexual pleasure, enacting elaborate dra-
mas of dominance and submission.

Meanwhile, the Catholic Church of mystery and the forbidden that
had shaped Carroll, Mapplethorpe, and Colacello was being covered
over, Pompeii-like, by the reforms enacted after Vatican II. In the 1970s
American Catholicism became thoroughly ordinary, the old works
and pomps yielding to trapezoidal churches, felt banners, leisure suits,
strummed guitars, Palm Sunday processions around the parish parking

lot, and confession brought out of the booth and into folding chairs. So did the lives of American Catholics—the women going to work, the men no longer cowed by priests, couples having sex with the intercession of a condom, a diaphragm, or a birth-control pill.

Those Catholics who felt fully at home in the new this-worldly church hadn't lost their desire for the otherworldly and the extraordinary. Even as they embraced Vatican II's affirmation of the ordinary, they looked elsewhere for religious experience that was exalted and life-altering. Some sought it in the "charismatic movement," which engaged in Protestant practices—ecstatic prayer, speaking in tongues—with a Catholic acccent. Some sought it in the New Age: evolving consciousness, divinization of the self through psychedelics, through chakras, or in the sweat lodge. Others sought it in Latin America: in Puebla, San Salvador, and La Paz; in the plazas of Mexico City and the favelas of Rio de Janeiro—like Sister Justin Feeney, the idealistic young American nun drawn to the fictional country of Tecan in Robert Stone's novel *A Flag for Sunrise*. For the Catholic left, the people's church in Latin America was a point of convergence between the underground Christians of the catacombs and the church of Vatican II (the "people of God" on pilgrimage in time). There, "presence" was still a distinctly Catholic phenomenon. There, Catholicism was at once ordinary and extraordinary: it permeated people's lives; it inspired Christian "base communities"—small groups of believers praying and working together—and popular uprisings against the dictatorships propped up by the "institutional church." There, religion was truly controversial—a life-and-death challenge to the principalities and powers.

The stress on the ordinary also led plenty of formerly firm believers to go underground. Where once the irresistible force of faith had met the immovable object of the church, with religious fervor sparked by the encounter, now the force of faith met the flexible, this-worldly church; and the would-be believer, finding no firm object of belief, found the dramas of good and evil, exile and self-sacrifice, outside religion—in music, or politics, or social-reform movements, or in the consumer society whose signs and wonders Don DeLillo would decipher in *White Noise*.

Martin Scorsese depicted the old neighborhood as an underworld where the eternal verities of fall and redemption were still in play. The way Fellini had treated his upbringing in *I Vitelloni*, Scorsese treated the coming-of-age of the young Italian Americans he knew. The film was *Mean Streets*, shot in 1972 in Little Italy and in Los Angeles. A scene featuring Harvey Keitel going to confession in the old cathedral on Mott Street marked Scorsese's outlook as crypto-religious; this film about would-be gangsters and tough guys posed the biblical question: Am I my brother's keeper? And the Keitel character's recognition that he was going to have to work out the terms of salvation or damnation in the mean streets, not in the cool quiet of the church, introduced the grand theme of Scorsese's work in the decades to come.

Scorsese was then drafted to direct *Alice Doesn't Live Here Anymore*, filmed in Hollywood and Arizona. He met Paul Schrader, whose early life was a heartland Protestant parallel to his own. Schrader had been raised by strict Calvinists in Michigan but had found his way to California and into UCLA's film school. In his thesis he'd treated "trancendental style," a term of his own devising. "Transcendental style seeks to maximize the mystery of existence," Schrader proposed. "It does so precisely through style," using "sparse means"—the long take, the unexpected cut, occasional sound and music—to draw the viewer away from the "abundant means" of commercial cinema and into an "other world" where the transcendent abides and "the parallel lines of religion and art meet and interpenetrate."

Schrader had written a script about an "anonymous angry person" driving the streets at night; with Scorsese directing, it became *Taxi Driver*, starring Robert De Niro as the agitated New York cabbie Travis Bickle, haunted by flashbacks of violence and death in Vietnam. The film, much of it shot in the crime-ravaged Hell's Kitchen in the summer of 1975, amplified Scorsese's vision of Manhattan as a place where the ordinary and the extraordinary mixed. And it deepened his sense of the religious dimension of urban violence. He saw Bickle as a descendant of Dostoevsky's underground man, raging at bourgeois society from the margins and acting as an "avenging angel."

Taxi Driver would draw wide attention, giving Scorsese greater

power to choose his own material. With success, he would initiate two new projects. One was *Raging Bull*, adapted from an ex-prizefighter's memoir that De Niro had pressed on him. The other was *The Last Temptation of Christ*, based on Nikos Kazantzakis's 1955 novel. He started reading the novel, put it down, picked it up again, put it down. "It took me six years to finish it!" By the time he did, he knew he would adapt it for a picture.

Andy Warhol sought to see and feel the presence of Latin American Catholicism firsthand. In Mexico City for a show of his work, he went with Bob Colacello to the basilica of Our Lady of Guadalupe. The place was all gilt and flame, thronged with pilgrims in various states of mortification: backlashed, bleeding, thorn-crowned. "We stood there, both appalled and dazzled, not knowing quite how to behave like tourists or believers," Colacello recalled. "Then Andy said in a hushed voice, 'I think we should kneel.' We followed him to the last pew, through what he sometimes called 'all the Catholic things'—taking holy water, genuflecting, kneeling, praying, making the Sign of the Cross . . . It was the first time I had been in a church with Andy, and I realized then that his religion wasn't an act, something that sounded good in a cover story."

Julia Warhola had died, but Warhol was still going to church, keeping the vow he'd made. He had moved to a town house on East Sixty-Sixth Street, and he would duck into St. Vincent Ferrer, a Gothic church on Lexington Avenue, or into St. Patrick's Cathedral, at Fiftieth and Fifth. In his biography Blake Gopnik, skeptical of arguments about Warhol as a believer, nevertheless presents Warhol as "regular churchgoer" and his Sunday churchgoing as a "mandatory" ritual that he carried out even when it vexed his associates.

His sexuality was likely a reason he remained on the outskirts of Catholicism. His dealings with the Church were furtive in part because the Church itself was furtive. Its leaders couldn't speak frankly about the body and sexuality, especially homosexuality.

Why, then, did he go to church at all? He went for the reason that many people on the outskirts still go: because there's something to be

found there that can't be found anywhere else. Religion in his life was the one thing that was out of the ordinary. From the beginning of his career it was said that his work is all surface, no depth, and his celebrity seemed to confirm this: he lived in public, in character, and chronicled his life in print and film and in the diary he started to keep (dictating it by phone to Pat Hackett each morning). His religiosity was different. It was untouched by his mix of art and celebrity, like the bedroom in his town house, a fantasia of Baroque Rome: a fringed canopy bed, an oil painting of the Madonna and Child, a carved crucifix befitting a prince of the church. Religion was a realm apart, a last redoubt of interiority.

"Apocalyptic romanticism" is how Robert Christgau described Patti Smith's approach in a rave review of *Horses*, her first record. Robert Mapplethorpe's cover photograph of her in white blouse and black tie defined a style that would inspire a thousand punkettes. But it was Luc Sante's view that her work in that moment was powered by transcendence more than style—by the combination of her belief in the world of spirits and her belief in herself as the channeler of those spirits: ". . . she manifestly believed in her mission as much as anyone who had ever picked up a microphone," and her belief was contagious. Sometimes "its religiose affectations" were just too much, but she was a rock-and-roll priestess, full stop.

Smith's ardor owed more to traditional Christianity than the music press let on. She didn't just believe in a spirit world inhabited by *poètes maudits* and difficult artists. She believed in God and the devil, in scripture and prayer and wrestling with the angel. "Jesus died for somebody's sins, but not mine": in the time-honored way, the vehemence of her rejection of Jesus actually serves to make the question of whether he died for our sins a matter of life and death. Her line "Come on, God, make a move" captures the mood of it: aggressive, demotic, taking the existence of the spirit world for granted while questioning the purposes angels and devils have been made to serve.

Her second record, *Radio Ethiopia*, was a work of apocalypticism without the romance—from the dervish-like prayer of "Ask the An-

gels" to the manifesto printed on the inner sleeve. There, she evoked a vision of Mexico during Holy Week (". . . a mean procession emitting all the sensuous conceit of Catholicism . . ."), and saw the participants as precursors of the still-young urban bohemians whose celebrant she was. In the past artists "seduced by the exotic dogmas of the church" had produced astonishing work: "the spectacular creatures of the bible, the madonnas of the sienese, the easter frescoes of giotto," and so on. That world was gone: "No longer will the artist serve under popes and kings . . . rock n roll needs no other patron but the people."

The record was panned, and John Rockwell of the *Times*, reviewing a Patti Smith Group show at the Bottom Line, suggested that she was walking the line between "art and insanity." When she fell and broke her neck during a stage-dive and stopped touring, it was hard to tell whether the move was simply medical or was more akin to Dylan's when he disappeared to Woodstock after a motorcycle crash in 1966—an escape act by an artist who had ridden the "wild mercury" line of electrified utterance as far as a skinny human body could bear.

So the hit single "Because the Night," from *Easter*—it was all over the radio in the spring of 1978—was at once a breakthrough and a comeback. It connected her to the early-sixties girl groups; it connected her to Bruce Springsteen, who had written it—another New Jerseyan who had been blinded by the light. The *Easter* sleeve showed Smith in a tank top with hands crossed at the wrists over her head, a pose that suggested both crucifixion and resurrection—but mainly the latter, said the photographer, Lynn Goldsmith, because Smith had undergone months of physical therapy after breaking her neck and the simple ability to raise her arms again was a kind of rebirth.

Pope Paul VI died in August 1978 after a long decline. In the conclave of cardinals, Albino Luciani of Venice was elected pope, taking the name John Paul to express the "double" character of Vatican II—brought into being by the open and spontaneous John XXIII and implemented by the pragmatist Paul VI. Then the new pope died, mysteriously, after less than a month in office. Another conclave elected Karol Wojtyła,

archbishop of Kraków. He took the name John Paul II, suggesting that he, too, would seek balance and continuity in the spirit of the council.

The new John Paul was the first non-Italian pope since the sixteenth century, and, at fifty-eight, one of the youngest: athletic, trim, polyglot, a skiier and hiker. Orphaned as a teenager, he had joined the Polish resistance to the Nazis in World War II. As a young bishop, he had been an expert observer at Vatican II; as the archbishop of Kraków, he had maintained the independence of the Church in Poland under the anti-religious Soviet Communist regime. His story was truly extraordinary, in striking contrast to the emphasis on the everyday in the Church in the United States.

Patti Smith was making a new record in Bearsville, near Woodstock, when Luciani's death was reported. She was transfixed by the drama of papal succession in the weeks that followed. "I was writing a poem on the death of John Paul I, so unexpected, when I saw the photos of Pope Wojtyła published," she recalled. "It immediately transmitted a feeling of strength and peace and I immediately had faith in him, in his determination to defend peace. My sadness became joy, and hope in the future."

The poem became "Wave": the last track on the new record, and the title track. Over an atmospheric, droning backing, she murmured free-associatively, joining waves on a beach to the wave of the pope from an open window, and the whitecaps to the white papal vestments and the dead pope's white-sounding name, Albino. "Wave to the city / Wave . . ." she intoned. "Goodbye, papa."

After *Wave* was released—with a striking, feminine sleeve photograph by Robert Mapplethorpe—Smith took part in an remarkable interview. It was with William S. Burroughs, whose novels about drugs and guns made him a counterculture hero, an outlaw in a three-piece suit. They met at Burroughs's windowless loft on the Bowery, known as the Bunker. Smith was ground down by the rock-and-roll business and by record-company executives' efforts to shape her image. "I feel like I've just pulled out of a time of temptation," she began. "I don't feel like I've sold out or done anything that I'm ashamed of, but I feel that I have entered into a period of temptation." The success of "Because the Night" had left her determined to maintain her sense of purpose in

the face of people "who have a very different definition of success than I do." It had left her "in almost a psychic kind of war, between myself and the people who are helping perpetuate my records."

All that, she might have said to any rock journalist. But with Burroughs, a wise elder, she went further. She had kept a Bible at her bedside during her recovery from the neck injury; at the Bunker—a confessional booth, bohemian style—she likened the psychic war she was in to Jesus's temptation by the devil in the desert in the Gospels, flecked in her case by the temptation of belief itself.

"I like to think of those forty days when—I've talked to you about this before. The idea of Jesus. I haven't completely accepted that thing in my mind. I'm still, I can't just . . . the day that I totally accept him is going to be a very wonderful day, if it happens, but I have to think about it still. I'm still exploring that guy. But one of the stories that I really like is when he, just at this period of time, went into the desert for forty days and wrestled with the Devil, you know, when they actually had a verbal and physical battle. Forty days of someone woodpeckering your spirit, is pretty . . ."

"Yeah, it's pretty harrowing," Burroughs said.

"And he came out of it. And so for me, whenever I think that I have it tough because I have to fight radio stations, or a record company or anything, I get pretty ashamed of myself when I think that this guy had to spend forty days without food or drink in the middle of a desert with the Devil . . . It doesn't seem like it's as painful as I make it out to be. But it does get to you."

Was she about to become a Christian? It seemed so, even if she considered such a prospect unspeakable in the rock world. "I don't have any desire to live on a planet that has no heroes, and no angels, and no saints, and no art," she told Burroughs. "I'm not ashamed to say it. It's not very fashionable to think that way, I suppose, but the more unfashionable it becomes, the more angry, and the more strong I become in my position."

The interview (set aside unpublished for two decades) was the last one Smith would do for a while. She was in love—with Fred "Sonic" Smith, who had played guitar in the MC5 in Detroit in the late sixties

and then left the record business. She would leave the music business herself, settle in Detroit, marry Sonic, become a mother, and raise their children. It was seen as a bohemian's embrace of domesticity. But in the interview Smith had framed her imminent withdrawal in crypto-religious terms—as a retreat into solitude at once to escape forces of temptation and to wrestle with them; as a desert anchorite's encounter with the unspeakable.

Martin Scorsese, too, was going through hard times. He was making *New York, New York* and *The Last Waltz* simultaneously. He was addicted to cocaine, which made him manic and edgy. Divorced, he lived in an empty house on Mulholland Drive in Hollywood, furnished with a television in every room and, over his bed, Peter Biskind reports, "a seventeenth-century wooden crucifix concealing a dagger." He scarcely slept. "I wanted to push all the way to the very very end, and see if I could die. That was the key thing, to see what it would be like getting close to death."

In time, he collapsed from exhaustion—and from an allergy to quinine, used in gin-and-tonics—and wound up in the hospital in Manhattan. A doctor told him he was bleeding internally and was on the verge of a cerebral hemorrhage. Friends told him he was risking his life through excess and jeopardizing his hope of having a long career like those of the directors he idolized. He himself was torn up inside—wounded by harsh reviews of *New York, New York*, and unsure whether he was meant to be a commercial Hollywood director or a "personal" filmmaker.

He brought his inward struggle to the film he was making. "I'd been harboring a lot of anger and rage, and I think it just explodes in *Raging Bull*," he later said. "The motive became to achieve an understanding of a self-destructive lifestyle—of a person who was destructive to the people around him and to himself—who finally eased up on himself and on those other people, and somehow made peace with life," he recalled. "I used *Raging Bull* as a kind of rehabilitation."

The picture was recognized as one of a kind, struggled at the box

office, and was nominated for eight Oscars, winning two. Scorsese got to work on *The King of Comedy*, but he saw no clear way forward for his career: he "had refused to get with the program" of Hollywood, Biskind observes, "had made an anti-*Rocky*, thumbed his nose at *Star Wars*, and he would pay for it." During a trip to Italy in support of *Raging Bull* he considered moving there and making a series of lives of the saints. He was hospitalized for pneumonia in Rome, and spent "six or seven weeks" in bed; although he had quit cocaine, he had worked himself to exhaustion again.

This second rehabilitation had a deeper and more lasting effect. Scorsese would attribute his survival to the forces of mercy that he—still self-identified as a Catholic—dramatized in his movies. "And believe me," he recalled, "sometimes God picks you up and tells you, 'You've been messing around now. You're going to have to stop this, stop that, but I'll give you another chance.' And you wonder why you're given another chance. It must be for something; it must be to celebrate life."

One way he would celebrate life was by making *The Last Temptation of Christ*. Filming *Taxi Driver* in Hell's Kitchen had revived his desire to make a life of Christ set in the city. "Eighth Avenue and 48th Street, the block where we shot *Taxi Driver* at night," he recalled, at the time was "a very dangerous area where there are drug pushers and pimps and prostitutes—it's my vision of Hell. If you were to go there, those ten blocks from 42nd to 52nd Street on Eighth Avenue, and say, 'Blessed are the meek for they shall inherit the Earth,' you'd get robbed, or beaten up, or killed."

With Paul Schrader, he developed a script; he secured funding from Paramount Pictures and Gulf + Western. *The Last Temptation of Christ* would be his entry in a species of movie he'd had in mind since seeing *The Robe* in Times Square. It would reimagine the biblical epic as a personal film, roiling with inward controversy—the inner life of Jesus himself.

John Paul II was fêted in New York City and profiled by the newsweeklies as a forward-looking, convention-defying figure. In his travels—

four trips to seven countries in the year after his election; trips to six African countries and to Brazil in the first part of 1980—his doctrinal traditionalism was offset by his gifts as a communicator. Here was a man who had grasped how to express the Catholic point of view through strong images—images of himself, the Holy Father—reproduced in the mass media.

But the man whose hand Andy Warhol clasped in St. Peter's Square that April was instituting a heavy-handed traditionalism in Church affairs. He revoked the teaching license of the Swiss theologian Hans Küng, a participant in Vatican II who saw centralized papal authority as contrary to the spirit of the council. He had the Vatican open an investigation of liberation theology and sent a bishop to El Salvador to "check on" Óscar Romero, archbishop of San Salvador, whose homilies, broadcast by radio across the country, urged Salvadorans to resist the ruling military junta, which had long presumed the support of the Church. On March 24, 1980, Romero was assassinated by government snipers as he said Mass at a hospital chapel. The Vatican had been working to remove him from office by other means.

John Paul was particularly traditional on matters of human sexuality. At the weekly general audiences, he set out a "theology of the body." It was philosophically lofty but was rooted in a simple dichotomy about the nature of sex. On the one hand, there is sex between unmarried persons, driven by lust and using sex for sheer physical gratification; on the other, there is the mutual gift of sexual consummation within Christian marriage, open to the birth of a child and the prospect of parenthood, where alone the sexual act is properly extraordinary.

At a general audience in 1981 a gunman shot John Paul as he moved through the crowd. The pope survived, and eventually visited the attacker in prison, offering forgiveness. John Paul gained in stature and aura through the episode. By surviving, he somehow transcended mortality, becoming an image as much as a man with a body.

During his recuperation he named Archbishop Joseph Ratzinger of Munich the prefect of the Church's doctrinal office, the Congregation for the Doctrine of the Faith, and the Vatican began to enact John Paul's traditionalism and then to enforce it. For the next few years

Catholicism in the United States would have a double character, as progressives and traditionalists jostled each other, each side possessing considerable power and authority. Progressive theologians pushed the limits the Vatican had set, framing a theology of the body distinctly different from John Paul's and weighing the moral questions surrounding masturbation, contraception, abortion, and homosexuality—practices once deemed "deviant" that were now becoming ordinary.

With the rise of the Solidarity movement, rooted in the Church in Poland, John Paul had emerged as the world's most prominent anti-Communist. President Reagan was a close second. Reagan's foreign policy was shaped by Catholics—the secretary of state, the CIA chief, the national security adviser—who were determined for the Church and the United States to work together to suppress Marxist revolutionaries in the Americas. But the U.S. bishops—appointed before John Paul was elected—resisted a simple alliance of pope and president. In a pastoral letter on war and peace in 1983 they denounced the U.S.-Soviet arms race, the nuclear weapons buildup, and the proposed "Star Wars" missile defense system, and their stance drew wide attention. They also criticized U.S. military operations in Central America: the archbishop of Washington, speaking to a bipartisan congressional commission, called the U.S. support for the Nicaraguan counterrevolutionaries—the contras—"unwise, unjustified and destructive."

Martin Scorsese cast the lead roles for *The Last Temptation of Christ*, and scouted locations in Israel. The picture was set to go. Then, after meeting among themselves and with Scorsese in 1983, the studio chiefs backed out. The problem was religion, as Thomas R. Lindlof sets out in a book about the controversy.

Kazantzakis's novel was notorious for a sequence where Jesus, mid-crucifixion, dreams of coming down from the cross in order to live as an ordinary man: marrying Mary Magdalene, making love to her, fathering their children. Prior to Vatican II, it was a book Catholics were forbidden to read without permission. That was enough for the new Protestant fundamentalists—notably Rev. Donald Wildmon, a Falwell

ally who ran a newsletter-and-mailing-list outfit called the National Federation of Decency. Wildmon and others organized letter-writing campaigns against the as-yet-unmade film, claiming it showed the film industry's hostility to their faith. More than that, they insisted it was part of a plot to undermine Christianity on the part of a "Jewish cabal" in Hollywood. They pressured the studio chiefs (Martin Davis, Barry Diller, Michael Eisner, and Jeffrey Katzenberg) to drop the film. And they succeeded.

Scorsese was distressed and angry. "I began to think the film couldn't be made in Hollywood, by which I mean with major funding from a major company," he recalled. Certainly his approach to *The Last Temptation of Christ* was provocative: the script involved Jesus in a frankly carnal sex scene with Mary Magdalene. And yet he envisioned the film as a devotional work—an affirmation of life and of his desire, as he'd told the studio chiefs in the beginning, "to get to know Jesus better."

Alongside those controversies, another was emerging. It had to do with the Church and gay people. In his homilies on the theology of the body at the weekly general audience—a hundred and twenty-nine of them— John Paul mentioned homosexuality only once, inter alia, discussing it alongside bestiality as an expression of the sin of lust.

The Congregation for the Doctrine of the Faith had more to say, however. The office in 1975 had issued a document in response to "those who . . . have begun to judge indulgently, and even to excuse completely, homosexual relations between certain people"—both those who have such relations out of ignorance, habit, and bad example, and those with "a pathological constitution judged to be incurable." Pope John Paul and Cardinal Ratzinger set out to arrest this development, in the Church at least—through the appointment of traditionalist bishops and emphatic restatement of the Vatican's position.

The problem with homosexuality, from the Vatican's point of view, was that it was becoming ordinary. Doctrinally and rhetorically, the Church treated sexually active gay men as deviants, perverts, sodomites.

So it was not surprising that the gay community that had emerged in the United States after the Stonewall Inn uprising of 1969 included no small number of Catholics driven to the margins by the Church's approach. That gays congregated and settled in historically Catholic neighborhoods—the Castro in San Francisco and the lower West Side of Manhattan—was not lost on the priests who staffed parishes in those areas. The fact that some priests were gay, and pursuing sex "outside the vow," led to something like an entente cordiale between the institutional Church and the gay community in the seventies. When John McNeill, a Jesuit priest, published *The Church and the Homosexual* in 1976, after two years of back-and-forth with the Vatican, his Jesuit superior in New York gave it an imprimatur ("nothing stands in the way"), and McNeill declared that he was gay—but celibate—on the *Today* show.

In the eighties this state of things began to change. John Boswell, a Yale historian, brought out a book proposing that homosexuality had been treated as something like ordinary among Catholics in the Church's first millennium. Boswell read or spoke seventeen languages. He was a gay man who had lived with a partner since graduate school. And he was a Catholic, a convert active in Dignity, a movement of gay Catholics founded in 1970 in San Diego.

The book, *Christianity, Social Tolerance, and Homosexuality*, had the subtitle "Gay People in Western Europe from the Beginning of the Christian Era to the Fourteenth Century"—a rejoinder to the conventional view that there were no gay people in the early Church. Boswell rejected "the common idea that religious belief—Christian or other—has been the *cause* of intolerance in regard to gay people," proposing rather that Christianity showed tolerance to homosexuals from antiquity into the medieval period, and that the Church's subsequent harshness to gay people was rooted in popular prejudices that were lent authority by the Church. And he proposed that "normative" Church teaching is muddled and contradictory: it maintains, for example, that homosexuality is unnatural because it isn't found in animals, but also that it is essentially animalistic behavior unworthy of men guided by reason and self-discipline.

The book jacket featured a photograph of the youngish, handsome,

preppy author, standing before a work of medieval art, Oxford shirt unbuttoned past the sternum. The book itself got wide attention, sold strongly, received a National Book Award, and stirred controversy. A number of Church historians rejected Boswell's assertion that homosexuality was long tolerated; gay historians saw that assertion as a tortured gay Catholic's effort to gain acceptance by letting the Church off the hook. Boswell insisted that the book was not an argument with the Church he adhered to but a historian's account of the Church's argument with itself. That is, the Church was inwardly controverted over homosexuality, and the controversy was finding expression in the fracas over his book.

In that moment, homosexuality was a matter of controversy in New York City government. The mayor's office in 1980 had issued an executive order mandating that social service agencies holding contracts with the city refrain from discrimination in hiring on grounds of "race, creed, color, national origin, sex, age, handicap, marital status, sexual orientation or affectional preference." The order put the city in conflict with the Church. The Archdiocese of New York, through its social service agency, Catholic Charities, held tens of millions of dollars' worth of contracts with the city: for day-care centers, orphanages, programs to aid sick people and the elderly. After the order went into effect, the archdiocese quietly renewed its contracts—in effect, pledging to obey the law and not refuse to employ openly gay people or discriminate against them in the workplace.

Gay men engaged with the city and its hospitals and social service agencies more than usual in the months that followed, due to the spread of a disease they had evidently contracted through sex with other men. It was called the "gay cancer," and then GRID: gay-related immune deficiency. Dozens, hundreds, thousands of men came down with its symptoms: blotchy skin, severe weight loss, difficulty breathing, death.

St. Vincent's Hospital, on West Twelfth Street, was the flagship of the New York archdiocese's fleet of hospitals. In the seventies it had been the first hospital in the city to establish a nondiscriminatory policy

toward gay patients. In the eighties, because of its West Village location, it became the hospital of first and last resort for gay men who had contracted the human immunodeficiency virus—who had AIDS.

"AIDS hit the Factory early, when it was still called 'the gay cancer,'" Bob Colacello recalls.

Sex was central to everyday life in Warhol's circle. Ten years after the run of films including *Blow Job* treated fellatio as nothing out of the ordinary, sex in various forms was as much a part of life at the Factory as Pop Art was. All the while, there was some question as to whether Warhol himself had ever had sexual intercourse.

In 1981 Warhol fell for Jon Gould, who worked at Paramount Pictures. Gould, who was twenty-seven, responded, and Warhol, fifty-two, was in a passionate relationship without precedent in his life. He sent Gould roses and Valentine's Day candy. He photographed Gould voraciously: at parties in a pinstripe suit, showing off his gym-chiseled body in a striped Speedo on the beach at Montauk. He went with Gould to spend Thanksgiving with Gould's parents in Massachusetts (with a Factory staffer, Paige Powell, along as Warhol's "girlfriend"). Gould moved into Warhol's town house for a time, sleeping on a different floor. They went to Aspen, to the Caribbean, to Palm Beach. All the while, Gould presented himself as straight, not gay; and he forbade Warhol to make comments about him in his diary.

One reason was AIDS. The effects of the "gay cancer" were being felt swiftly and gravely in the Manhattan scene. Two fashion designers Warhol knew fell ill. So did Sam Wagstaff, who was Robert Mapplethorpe's lover and patron, and Mario Amaya, the curator who'd been shot alongside Warhol at the Factory in 1968. Two *Interview* editors developed symptoms of AIDS.

At the time, the disease was terminal. As hospitals and health agencies were slow to respond, if they responded at all, gay men and lesbians organized responses: the Gay Men's Health Crisis, founded by the playwright Larry Kramer; God's Love We Deliver, founded by the social

worker Ganga Stone to bring hospice care to homebound men. Little changed in the short term. Gay men showed symptoms, became ill, went to the hospital, died.

Newsweek published a cover story about AIDS in 1983, and it became a template for the discussion of gay life among the general public—a public in which three-quarters of people polled said that they "had never knowingly met a lesbian or a gay man." The article explained that AIDS spread in the bloodstream through sex, intravenous drug use, blood transfusions, or other conditions. It reported that more than 1,300 people were infected with AIDS in the United States, a large number of them gay men. And it quoted Rev. Jerry Falwell, evangelical pastor and founder of the Moral Majority, who spoke of AIDS as a form of retribution for the immoral act of gay sex, citing a verse from Paul's letter to the Galatians: "Do not be deceived: God cannot be mocked." Falwell quoted the last part, making the most of the double entendre: "A man reaps what he sows."

AIDS, never ordinary, became recognizable, familiar, omnipresent. As the disease overtook the West Village, stricken men went to St. Vincent's. David France, in *How to Survive a Plague*, sets the scene:

At St. Vincent's, the emergency room is visible behind enormous windows on the corner of West Eleventh Street and Seventh Avenue. Before the crisis exploded, how many hundreds of times had I walked past the window oblivious to the small *Kabuki* dramas enacted there? Now I found myself choked with panic anytime I came near. One sticky afternoon, I slowed to measure the epidemic through the plate glass, praying to see only strangers. Three-quarters of the seats were filled. Scanning the rows I could see that every third or fourth man had "The Look"—sunken cheeks, sparse hair, eyes that showed fear, shoulders that bent in pain. One, all spots and bones, balanced painfully on a pillow he'd brought along from home. Another seemed to be dozing; his head was cocked backward onto a companion's arm, and his mouth and eyes were both wide open . . . A cab pulled up beside me. A healthy man, first out the door, bent to carefully extract his frail companion from the

backseat, an operation as ordered and precise as origami. I held open the hospital door and, blinkered by their mission, they walked past me without a nod. They were no older than I was . . .

France witnessed the scene at St. Vincent's as a gay man, but it was visible to all. That part of Seventh Avenue, near the intersection of Greenwich Avenue, is one of the busiest stretches of Manhattan. The Fourteenth Street subway station lies beneath, with exits on every corner. To come up from the subway and walk past the hospital was to know that gay life was more complicated than the "gay ghetto" idea allowed. There through the window of the emergency room was AIDS in Catholic terms—the gaunt men in the waiting area overseen by the gaunt man who hung on a cross mounted on the wall.

Under John Paul II, the entente cordiale between gay men and the Church became distinctly uncordial. Five years into his pontificate, John Paul was appointing traditionalists like himself as archbishops, and in January 1984 he named Bernard Law archbishop of Boston and John O'Connor archbishop of New York.

O'Connor was a churchman who was also a military man: a native of Philadelphia, he had served as a chaplain in the Navy (rising to rear admiral) and then earned a doctorate in political science from George-town, advised by Jeane Kirkpatrick, whose work framed arguments for U.S. support of authoritarian regimes. In 1983 he had gotten a few months' local experience as the bishop of Scranton, Pennsylvania—while Kirkpatrick, who had advised Reagan's campaign, served as U.S. ambassador to the United Nations.

John Paul posted O'Connor to New York with a clear brief: to affirm Catholic traditionalism in the Church's public life, from foreign affairs and military policy to sexuality. It was said that he had declared, "I want a man just like me in New York."

O'Connor took the approach to homosexuality characterized in parochial school terms as "Hate the sin, love the sinner." He supported the care for AIDS patients at St. Vincent's and at St. Clare's, in midtown,

as each hospital arranged a hospice for people with AIDS—at once to provide care for them and to quarantine them, lest their tainted blood contaminate the general population. At the same time, he acted against homosexuality so as to affirm that in the view of the Church it was in no way acceptable, tolerable, normal, or ordinary. In this, he ignored the distinction between homosexual orientation and homosexual acts. When a fresh draft of New York City's gay rights ordinance came up before the City Council in June 1984 he declared that the Church would be compelled to shut down its several hundred schools and hospitals if required to employ openly gay people in them. He insisted it was a matter not of discrimination but of fidelity to the Church's teachings—of religious freedom. "[I would] close all my orphanages rather than employ one gay person," he told the *New York Post*, in a stroke equating gay people with child molestation and implying that the Church's vast social-service network was his personal fiefdom. It worked: the ordinance was overturned.

O'Connor thrived on controversy. He held press conferences after Sunday Mass at St. Patrick's Cathedral, thus communicating the Church's view through the *New York Post* and the *Daily News*. He presented himself as a loyal subordinate of John Paul, steadfastly doing his duty. "The Holy Father strongly encouraged me to continue to present the position of the church on each of these issues," he wrote in the archdiocese's weekly newspaper, *Catholic New York*. "The Holy Father has the very strong conviction that when you teach the truth about such matters it is more charitable in the long run."

And now events were making religion a matter of controversy in daily life and in the next day's tabloids.

In President Reagan's first term Catholic neoconservatives and evangelical Christians, foes since forever, joined together against legal abortion, representing a "moral majority." The emerging "Reagan Democrats" included several million Catholics. White populism took on a Republican cast, and suddenly the American Catholicism of labor unions and ward bosses was half-hitched to the religious right.

Andy Warhol was a fan of Reagan's. He gave the president's daughter-in-law, Doria, a job at *Interview*, and put Nancy Reagan, the First Lady, on the magazine's cover. He took an interest in the president's son, Ron Jr., a dancer, who was rumored to be gay. "I'd been hating the Republicans so much . . ." he told his diary, "but I'll really change my mind today if we find out that Ron Jr. was able to get an interview with his father for *Interview*. For the January cover. I mean, wouldn't that just put *Interview* on the map? I'd even vote Republican."

He was spending nights out with Jean-Michel Basquiat, the young artist and scene-maker, who was working as his assistant. At twenty-four, Basquiat had already done plenty of living and art-making. With his friend Al Diaz he had emblazoned New York sites with the cryptic slogan SAMO—the name, he said, for a fake religion (one tag read SAMO: AN ALTERNATIVE TO GOD). He had found an expressive approach to painting, thick with words and symbols, like a scratchboard for his inner life. Many were Christian: a cross, a halo, a twisted crown of thorns to offset the royal crown he made his signature. He had done a portrait of himself as the devil. He had gotten to know Warhol (a goal of his all along) and had become a kind of disciple.

But Warhol was still preoccupied with Jon Gould. Gould had contracted pneumonia, which was associated with HIV, and had spent nearly a month in New York Hospital in 1984. Warhol (Blake Gopnik reports) visited him nightly. After his discharge, Gould, spooked by the episode, took a position at Paramount's office in Los Angeles—"vice-president in charge of inter-office memos," one Factory associate said derisively. He bought a house there and decorated it with crystals, hoping they would ward off AIDS. Warhol saw him while in Hollywood; he pined for him in New York; but Gould had moved on. The next year, Gopnik observes, "Warhol ended a day's diary entry with real bitterness: 'I went to sleep, facing life alone.'"

Down Madison Avenue, Archbishop O'Connor, now a cardinal, was shaping the Church's position on AIDS. The position was paradoxical, even self-contradictory. At the AIDS hospices inside St. Clare's

and St. Vincent's, patients, nurses, orderlies, family, friends, and lovers created a spirit distinctly unlike that of the unforgiving city. Priests sat with grieving families. Family members added the names of the sick to the list of people whose struggles were commended to God at Mass in the Prayer of the Faithful. At the same time, the churches of the archdiocese denied funeral Masses to men who had died of AIDS.

At St. Francis Xavier, the Jesuit church on West Sixteenth Street, the Dignity community, diminished by AIDS, established the church as one open to gay people, and the Jesuit priests, not under the direct supervision of the archdiocese, held funerals for gay men. Meanwhile, the friends and families of Catholic men who had died of AIDS joined with the gay community and began to devise their own memorial rites— using pop music, poetry, and art to say what the Church couldn't say.

One was William Hart McNichols, a Jesuit artist. The son of a governor of Colorado, a survivor of sexual abuse by a family friend in childhood, he had come to New York after ordination to do graduate work in fine arts at the Pratt Institute in Brooklyn. He became involved with Dignity, celebrating Masses and making art as a testimony to the epidemic. For a Dignity AIDS Liturgy, he made a flyer featuring a sketch of a hand marked with the stigmata—a cryptic close-up of Christ's suffering on the cross. He made the first of many images of St. Aloysius of Gonzaga, the sixteenth-century Italian noble who joined the Jesuits in his teens, cared for sick Romans during the plague of 1591, and then died of it himself, age twenty-three.

The Church would be slow to grasp the plague that was AIDS, but Bill McNichols—Jesuit priest; Catholic artist—took it in hand from the beginning.

The Factory had moved into its most substantial space yet, a disused power station on East Thirty-Third Street. It became the base of operations for a wide spread of projects: art, television (*Andy Warhol's 15 Minutes*), and *Interview*. Warhol himself had a small office and a large painting studio there, and he also maintained his studio at 860 Broadway. Once the Factory moved uptown, the Broadway studio felt to him

like the kind of place where painters had worked when he came to New York—"like the loft I always wanted."

He was offered a commission that enabled him to fulfill the possibilities of the space. It came from Alexander Iolas. A Greek, Iolas had been one of Warhol's earliest gallerists. Warhol had done a silk-screen portrait of him in 1972. Iolas had since established a network of galleries in Europe, only to close them one by one. He was gay, and the Greek press was fixated on his wealth and his flamboyant way of life.

Iolas had arranged for the use of a grand building on the Piazza della Grazie in Milan—across from the convent where Leonardo's *Last Supper* was on view, seen by several hundred thousand tourists a year. He envisioned a group show that would feature work making reference to Leonardo by Warhol and other living artists. He proposed a fee of a million dollars, payable in a combination of cash and classical statuary from his collection. A million dollars was a huge sum. Warhol took the commission. The other artists were never brought in. It would be a solo show.

"I'm doing the Last Supper for Iolas," he told his diary, and mentioned another commission. "So I guess I'm a commercial artist. I guess that's the score."

The terra-cotta *Last Supper* Warhol had found in a secondhand shop near Times Square was modeled on treacly nineteenth-century knock-offs of Leonardo's. It was set on a small table in the Broadway studio. To it he added other *Last Supper* images: a holy card that had belonged to his mother, an outline from an old encyclopedia of famous paintings, some prints bought in shops near the chapel of Our Lady of Guadalupe, on West Fourteenth Street, a site of Mexican-American Catholic devotion in the city.

The Last Supper was in the air, too. Leonardo's masterwork was under restoration in Milan, and the approach the conservators were taking was a matter of controversy. Corita Kent had produced a series of *Last Supper* works frankly indebted to Warhol—and now (as Blake Gopnik sets out) Warhol drew on her work just as frankly. A young artist had sent Warhol the plan for a project that involved recontextualizing *The Last Supper*, hoping to get his blessing.

"Went to church," Warhol told his diary—Sunday, September 29, 1985—and added: "I always go for five minutes. Ten or five minutes. It's so empty, but sometimes there's a wedding. Then cabbed it down to Sixth Avenue and 26th Street to the flea market (cab $6). It was such a pretty day."

Jon Gould was in Los Angeles, healthy but not in the clear. Bob Colacello had quit as editor of *Interview*. Fred Hughes, Warhol's business manager, was showing symptoms of a malady later diagnosed as multiple sclerosis. Warhol, never quite alone, was on his own as fully as at any time since his first years in New York City.

In his studio, he began to come up with concepts for a series of works—drawings, paintings, objects, and prints—based on the world's most famous religious painting.

3

DEVOTION VS. DESIRE

Partway through, the singer went to one side of the stage and came back holding a long pole with a white flag on it. As the rest of the band played a clanging, rat-a-tat-tat riff, over and over, one minute, two, the singer entered into a drama with the white flag. He stabbed the pole into the stage territorially. He brought it to the lip of the stage and drooped it over the crowd, the flag flapping in space. He climbed the lighting rig, holding the pole like a lance, and stuck the flag to the top. He clung there a moment, hardly older than the people below, but a rock star: Bono Vox, up close and vulnerable.

It was a spring-weekend show at the state university in Albany, but U2 were welcomed like locals made good. As Dublin teenagers, they'd played their first U.S. show in New York City (the Ritz, near Union Square). Touring steadily, they had played Albany (J. B. Scotts, on Central Avenue) three times in twelve months. *Boy* and *October* were key records in the "new music" playlists of WLIR, a Long Island radio station whose signal reached New York City. Now *War* had broken through to FM radio nationwide and the New York teenagers who had discovered U2 via WLIR were students at the university upstate. A stage and scaffold-like lighting rig was erected on the campus. Tickets were eight dollars. Eight thousand of us showed up. We drank beer from plastic cups until the band came on. We sang along with "New

Year's Day" and "Sunday Bloody Sunday." During "I Will Follow," we loudly indicated that we would follow. And we were there looking up as Bono, in black jeans and T-shirt and high leather boots, scaled the scaffolding and staked his claim.

U2 played New York City a few nights later (the Palladium, near Union Square). Nightclubs and spring flings belonged to their past; the last leg of the *War* tour was booked into marqueed movie palaces, arenas, and outdoor amphitheaters.

An image of a white flag became the logo for the tour, silk-screened on T-shirts and programs. Bono made the encounter with the flag a nightly act of daring. At the US Festival, in California, he climbed to the top of the proscenium arch and knelt beneath the flag while camera operators shot him in silhouette. At Red Rocks, in Colorado, with torches blazing and tape rolling for a live album and video, he did it again. The silhouette of man, pole, and flag against a blood-red sky was featured on the LP sleeve. The scene played ceaselessly on MTV—the defining first image of U2 for many people.

What did the white flag mean? Bono described it as a flag of no color, distinct from the green of Catholic Dublin and the orange of Protestant Ulster. It had other meanings. Traditionally, the white flag was a flag of peace. It was a flag of surrender.

Forty years later, the white flag, whatever else it is, is a sign of crypto-religious devotion—the spirit that powered U2's work in the early eighties and that called forth the unease and condescension some people have felt for them from the beginning.

Devotion is the religious impulse in its purest form. It's a strong feeling for something outside of oneself. It longs for the loss of self, yearns for surrender to some other. Often it stems from religious belief; just as often, it's a character trait that is prior to belief, so the devotee is drawn to religion as a space where devotion is encouraged and put to lofty purposes. Religious devotion—unlike hysteria, say, or fanaticism—is personal and possessive, such that when devotees mass together the spirit is qualified as "collective devotion." And devotion finds expression in rituals—called devotions.

As the story goes, early rock music was a blend of country and

western (rooted in the hymns sung in white churches) and rhythm and blues (rooted in the spirituals sung in Black churches), and it gained its power from the repurposing of religious devotion for soulful self-expression. That story scants the thefts of Black sounds by white performers, and it presents the taking-over of sacred styles as an act of liberation. In fact, the sacred was subsumed, not left behind, and rock music ever since has been rooted in rites of devotion.

That was true of punk. The press typed punk as nihilistic rebellion, but for many of the people involved it was the basis of pure devotion. The Sex Pistols and the Clash, the Ramones, the Jam and the Buzzcocks, Joy Division and Bad Brains: these bands that looked and sounded unlike one another had a devoted following in common. The bands and their fans were outsiders together; you felt a devotion to them that you couldn't feel for Fleetwood Mac or Van Halen—felt a devotion to their thrift-shop clothes and hard-to-get guitars that you couldn't feel for the stuff at the mall.

U2 weren't punks. For some, that was the problem. They were devotees. They recognized punk's uplift—in the Clash and the Ramones—and they channeled the devotion they felt for punk into their first songs, which also draw on sources of devotion from outside the music world. Self-surrender is front and center. God, liturgy, verses, and signs are all there. So are good and bad, right and wrong, duty and calling. U2 are wide open to the spirit; they're devoted to the cause. At the same time—just out of their teens—they're trying to figure out what the spirit is and what the cause might be.

All this is present in "Gloria," from 1981, which served to introduce both U2 and MTV, an acronymic pair. MTV ("all music, all the time") went live on cable TV in August 1981. *October* came out that October, and MTV seemed to show the "Gloria" video every hour that fall. Even if you'd heard "I Will Follow" the year before and had read about them in *NME* and *Trouser Press*, your first sight of U2 in live footage was likely the "Gloria" video, in which U2's spirit of devotion and attraction to the grand statement come together.

Opening, the camera ascends through water onto slushy silhouettes. Then it breaks the surface, and things are clear. They're on a barge in an

industrial wasteland. "Four guys with funny haircuts," Bono later called them—and they're shown in close-ups: poufty blond 'do, Doc Martens, hands on a shiny guitar, a mouth on a microphone, soft cheeks flushed red. Just looking, you could dismiss them as another trendy band from the ever-changing U.K. music scene.

With the TV volume turned up, though, they are the opposite of superficial. The song is full of meaning, overloaded with it. The structure is three chords reduced to skeletal essentials. The guitar riff is a real live wire. The singer is a young man awkwardly exposed: "O Lord—If I had anything—anything at all—I'd give it to you . . ." And then the singer—Bono Vox—goes into Latin, along the lines of a monastic chant: "*Gloria—in te Domine—Gloria exultate . . .*" After Vatican II, Latin was as strange as Gaelic; for some of us, this "Gloria" was the first sung Latin we'd ever heard.

U2's "Gloria" is poised uncertainly at the site where rock and roll and religion meet, and it put them in touch with several strands of rock-and-roll roots at once. "Gloria," by Van Morrison and Them, from 1964, turned a word sung every Sunday in the Latin Mass into a celebration of a woman the band members knew in Belfast and a sing-along in every pub with a jukebox. The Doors, from Los Angeles, covering Them's "Gloria" on tour in 1968, slowed it down, stretched it out, and stripped it of transcendence, making it a semi-coercive sex act—Jim Morrison telling Gloria what he wants her to do ("wrap your lips around my cock, baby") in liberated-sixties detail.

Patti Smith put the religion back in. Her "Gloria" was also semi-improvised—a combination of the garage-rock anthem, the rebel vamp, and her early poem "Oath." She began, over a brooding piano figure, with that unasked-for, annunciatory rejection of religion: "Jesus died for somebody's sins, but not mine." Then, step by step, she took the spirit of devotion out past religion and into sixties-reverent rock and roll; she turned the jukebox-familiar chorus of a woman's name into a cry of androgyny, with a rough mix of devotion and defiance that was distinctly her own.

U2's "Gloria" is unlike both of those. It's an anthem of self-surrender. Bono isn't defiant. He is ardent. The devotion he feels involves some-

thing larger than himself, and he's trying to empty himself of everything that is not it.

The video makes the effort cinematic. The barge is floating in a dockworks—warehouses, concrete quays, a power plant—as if the power station on the dystopian sleeve of Pink Floyd's *Animals* has become the scene for mystical illumination. There's a small crowd watching from the quayside, and a camera effect merges the band with the crowd. Then Bono pries open a door to reveal an old stone church on the horizon. The band is playing a funky breakdown, complete with slide guitar, the song almost coming apart; then, as they all surge into the final chorus—the singer spreading his arms, the hymnodic thirds of the major chords coming through at last—the video cuts to a vast aerial shot of the band on the barge afloat on the water. U2 are entering the mainstream, but they will do so on their own terms. The barge is their stage, their church, their Ireland-apart island, a place where Latin is still sung and God is still exalted.

The strange Latin chorus is the key to the effect. U2's "Gloria" is as devotional a rock song as there is: and yet it is crypto-religious, not openly so, kept oblique by the dead language of the catacombs.

"Gloria" suggested that the members of U2 were Irish Catholics, raised in the "priestridden" Ireland Joyce had written about. In fact, their religious backgrounds were complicated, and the complicatedness of it all actually fed their spirit of devotion.

Paul David Hewson—Bono—is the son of a "mixed marriage" between a Catholic father and an Anglican mother who actually went to different churches on Sundays; after he was baptized in an Anglican church, his Catholic grandmother did the rite over again in the kitchen sink. Dave Evans—the Edge, or just Edge—is ethnically Welsh, born in London, his father a Presbyterian church elder, his mother a singer in a Baptist choir. Larry Mullen's father spent seven years training to be a Catholic priest before leaving the seminary for a life of work and family. Adam Clayton, raised nominally Protestant, was not religious. The band members met in their teens as students at Mount Temple

School. "A nondenominational, coeducational experiment," Bono calls it in his autobiography, *Surrender*, "remarkable for its time in conservative Ireland"—remarkable because it wasn't under Church supervision.

For them, then, more than for most Irish at the time, religion was something freely chosen, a threshold to adulthood. At Mount Temple, Bono, Edge, and Mullen took part in prayer meetings led by a religious-education teacher—a woman—whose account of a loving God who knew "every hair on your teenage head" Bono found inspiring. As the band was coming together, they fell in with a Dublin evangelical Christian movement called Shalom—Hebrew for "peace"—but kept their involvement hidden from Adam, the bassist. Their fervor deepened along with their commitment to the band as they took on a manager, made *Boy*, and toured Ireland and the U.K. On the road, they would read the Bible and pray together before going onstage.

What happened next is a canonical episode in U2's oft-told story. Shalom's leaders sought a stronger and stronger commitment from them. "Was our music ephemeral, transient? Wasn't the real calling to preach the gospel? How real was our faith? How ready were we to be pilgrims?" Bono recalls in *Surrender*. ". . . Over months, the questions from Shalom began to wear us down."

The songs for *October* had a religious edge: "We had this notion, early on, that we didn't want to be the band that talks about God," Bono remembered, "but then we made an album that spoke of little else." During the recording sessions, Edge told the others that he felt called to quit music and devote himself to Christian living, whatever it might involve. Bono was ready to disband U2 rather than go on without him.

A crisis of faith: that is what U2's "Gloria" is about. The lyrics—Latin chorus and all—are words that came to Bono semi-spontaneously at the microphone during a recording session. He tries to speak up, to sing, to stand, to find his feet, but he can't: "Only in you / am I complete. *Glooooooria . . .*"

The band dealt with the crisis in a band meeting. The new record was set for release; a tour was booked. The manager, Paul McGuinness, argued that to pull back from the band for faith's sake was to betray the

faith that other people had placed in the band: record label, promoters, crew, fans—spelling out the rock-and-roll understanding of faith as a promise kept, a compact established between a band and its audience.

Edge was persuaded. The members of U2 committed themselves to U2. And yet they went on tour in support of *October* with a strong sense that their time was running out. Bono: "Here I am, age twenty-two, with a head full of gothic dread, looking around at a world where there's millions of unemployed or hungry people, and all we've used the technology we've been blessed with is to build bigger bombs so no one can challenge our empty ideas. Christendom is telling us that God is dead, but I'm thinking Christendom is dead and our little combo has been hired to play at the funeral."

The crisis might have led U2 to keep clear of religion. It did the opposite: it brought religion, and religious controversy, front and center.

War makes such controversy a figure for the inner life. The Troubles in Ireland are akin to the undeclared civil war in the soul (those "trenches dug within our hearts"), the struggle between Bloody Sunday and Easter Sunday. Questions of what to do and how to live are put in moral terms: "I don't know my right from my left / Or my right from wrong . . . I don't know if it's black or white / There's others see it red."

The white flag was an emblem of that inward controversy—of the struggle between devotion and its opposites: skepticism, domination, and nihilism. It was an emblem of the band's struggle to find what Joshua Rothman calls "a sensibility that had been unreachable in their religious lives—a kind of militant surrendering."

On *War* the struggle is at once grand and personal. Not for the first time, U2 were strident and self-serious. They were ambitious for success as the world reckons it: power, fame, wealth, adulation. Devoted as they were, they could be maddeningly coy about *what* they believed, so that it often seemed they and their fans were mostly devoted to the spirit of U2. But their struggles with belief were, and are, deeply recognizable.

With the white flag Bono marked the spot where many of us find ourselves. Religion has let us down, but the religious yearning is still there, stronger than we might expect. The language of belief speaks

to us more than it ought to. The broken world gives off a supernatural charge. U2's early songs are sensitive to all this (with the awkward vulnerability the term *sensitive* implies). They register aspirations that aren't rooted in the natural world, or the body, or sports or politics or technology. They arise from the part of us that is made for transcendence, the spirit per se.

"40"—the last song on *War*—is the anthem of those aspirations. The title is shorthand for the song's source—a few verses from Psalm 40. The lyrics are the psalm stripped to its core. The singer is standing upon a rock. The Lord has put him there. The Lord has heard his cry— this song—and has brought him out of the pit to sing it. So he does, alternating between exhortation and lamentation. "I will sing, sing a new song," he vows, and then asks: "How long to sing this song?" In the latter, sung over and over, the I, the self, is cryptically left out—left behind.

On *War*, "40" is spacious and ambient: throbbing bass, softly malleted drums, cresting waves of distorted electric guitar. On tour— campuses, arenas, festivals—it was usually the last encore. "40" made the audience a giant congregation, drawing together the energy of revival, rock show, football match, and political rally around the paradox of the psalm: the yearning to sing a new song and the calling to sing the old song once more. Edge and Adam Clayton swapped guitar and bass and played with DIY simplicity. Bono brought out the white flag, unhitched from its pole. He draped it over his shoulders; he wrapped it around himself, a cloak of crypto-religiosity.

There *was* a full-on Irish Catholic band in that moment, but most of us in America, at least, didn't realize it, because their name kept their Catholic roots hidden, the way Declan Patrick McManus had done by taking the stage name Elvis Costello.

They were the Smiths, from Manchester. The Smiths' early songs reached the United States twice over: on *The Smiths* and on the *Hatful of Hollow* compilation. By the time those records arrived at Rocks in Your Head on Prince Street, the Smiths had been consecrated as the next great

English guitar band, who were picking up the pieces left by the breakups of the Clash and the Jam in London and Joy Division and the Buzzcocks in Manchester. At the same time, Morrissey's gay persona meant they were seen as a gay band—Pet Shop Boys with guitars. The sleeve of *The Smiths*, showing a shirtless, well-muscled man (Joe Dallesandro from Warhol's Factory), dispelled any doubts.

They *were* a great guitar band, and a pathbreaking one in that the gay-seeming singer was front and center. And they were also Irish Catholics to a man. The generic English moniker the Smiths gave cover to their generic Irish names: Morrissey, Marr (shortened from Maher), Rourke, and Joyce. Their sound had no trace of Irishness, nor of the Celtic mysticism of the Waterboys (whose single "The Big Music" had a sound meant to suggest the marks of "God's signature in the world"). And their way of dress, a blend of psychedelia and Wildean dandyism, glammed them up and out of Irish Catholic expatriate Manchester and placed them in post-postpunk London, where they'd moved after signing to the London label Rough Trade.

What most import-record devotees in the United States knew about Manchester was that it was in the north of England and the sun never shone there. Less well known was that Manchester was a straight shot across the Irish Sea from Dublin, that its population had been one-fifth Irish all through the Industrial Revolution, and that in the eighties it was home to tens of thousands of recent immigrants who had reconstituted Irish Catholic life root and branch in its streets, going back and forth to Eire regularly on the cheap-and-easy ferry.

It took Morrissey's and Marr's autobiographies, published in this century, to make clear how Irish their Manchester was and how deep their Catholic roots ran.

John Maher was the first child of a young couple who had emigrated to Manchester from County Kildare. There were five children on his father's side, fourteen on his mother's. Born in Manchester when his mother was eighteen, John was an "Irish twin": a sister, Claire, came eleven months later. Growing up, he went to Catholic schools: St. Aloysius's, Sacred Heart, and then St. Augustine's. "Mass was never missed, and at our front door there was a font with holy water," he recalled. "I

spent a lot of my early years among statues and crosses and prayers, and there was a constant backdrop of religion in our house that felt very mysteriously and deeply otherworldly." The neighborhood, Ardwick Green, was thoroughly Catholic, too, and his first band held their early practices in the Sacred Heart auditorium. He would take the ferry to Ireland with his parents to see the family they'd left behind.

Where John Maher seems unmarred by his upbringing, Steven Patrick Morrissey is one of Irish Catholicism's walking wounded. Morrissey's Manchester is a grim workers' ghetto where "the sixties will not swing" and "birds abstain from song," and the Church there is a stifling force he fights to escape. He succeeds, but just barely: its influence is such that, describing it half a life later, he uses the present tense.

He, too, goes to Catholic schools all the way through, and the account in the autobiography is grim: corporal punishment, molestation, derision, cruelty, envy, and all the rest. His grammar school, St. Wyclif's, is in a foundry that was marked for demolition in 1913 but is still in use in the late sixties. It is staffed by "monastic sheepish priests," nuns dressed in "post-volcanic black," and lay people who are "unmarried, or possibly untouched by human hand." The faculty resent the "new race of youth" and strike and whip and berate them with relish. Things are better at home, where Morrissey's parents are music lovers who like singing and dancing. "We Irish Catholics know very well how raucous happiness displeases God," Morrissey explains, "so there is much evidence of guilt in all we say and do, but nonetheless it is said and done."

In upper school—"St Mary's School for the Daft," he calls it—he sees the warped drama of resentment and abuse play out all over again, and this time sexual desire is in the mix. Morrissey, at once arrestingly handsome and sexually set apart, is the target of cruelty and coercion, and sometimes both. The conflict comes to a head when Morrissey goes to see Roxy Music at the Stretford Hardrock and shows up at school the next morning with a dyed yellow streak in his hair. ". . . and YOU'RE another one not content with the hair color given you by Christ," a teacher snaps, and Morrissey—never the least bit religious, by his own account—is "unshackled from God" once and for all.

Steven Morrissey would do what James Joyce had had Stephen Dedalus do in the *Portrait*. He would forge a conscience all his own—as the singer for the Smiths. Johnny Marr's bright, sharp electric music would offset his words, which were gloomy, haughty, self-regarding, and semi-scrutable, the monologue of a young controvert.

Morrissey is usually compared with other flamboyant, brooding, genre-defying singers: David Bowie, Bryan Ferry, Patti Smith. But the more telling comparison is to the other mononymous Irish singer of the early eighties—to Bono, that is. In that moment, Bono and Morrissey are secret sharers, approaching the quandaries of devotion and desire in distinctly Catholic terms but in strikingly different ways.

Bono, twenty-three in 1984, is a young man on a search. He is looking for something to devote himself to. What it is he isn't sure. As he searches, though, he seems to know who he is. He's roiling with inner controversy, but his sense of self is strong—at times off-puttingly so. His questions aren't about who he is. They are about what he should do with himself. To what should he surrender—give himself over? What cause, what force of spirit, is a proper object of his devotion?

Morrissey, a year older, is still struggling to accept himself. The power of the Smiths' early records comes from the tension between the ringing confidence of Johnny Marr's guitar riffs and the shaky instability of Morrissey's voice and outlook. His struggle to figure himself out is happening at the microphone. It plays out in Catholic terms, as he tries to unshackle himself from Catholicism song by song, line by line.

Morrissey is a pure controvert. For him, the self is *the* site of controversy. In the Smiths, the question of who he is—this self shaped and maimed by religion—is worked out in public so that the rest of us, half-hidden from ourselves, can recognize it.

The question of the great early song "Still Ill" comes straight out of the Catholic moral philosophy taught at places like St. Augustine's and St. Mary's: "Does the body rule the mind, or does the mind rule the body?" It's the perennial question about the source of human desire. Morrissey's answer: "I dunno . . ." Desire is complicated.

"Accept Yourself" is another song focused on a moral question—
"When will you accept yourself?"—which Morrissey sings over and
over. In that moment, the nature of the question as it pertained to him
seemed obvious. The Smiths were putting out records in sleeves featur-
ing photos of gay icons. The U.K. rock tabloids were fixated on Mor-
rissey's sexual orientation. The stinging riff–driven "Handsome Devil"
had carried the anger of a young man who was in thrall to another
young man, and who was full of thwarted desire—who was angry that
he couldn't openly have an experience that he wasn't yet ready to have
even if he had been permitted by society to have it. The question for
Morrissey seemed to be: When will you accept yourself as gay?

The question of sexual self-acceptance was front and center in Cath-
olic schools, and beneath the Church's approach to the question was the
paradox that bedevils its approach to sexuality now as it did then.

On the one hand, the Church urged a young man like Morrissey to
accept himself—to recognize that each of us is a distinct character with
particular traits: male or female, brown-haired or blond. Look, young
man, the Church said to the Steven Morrisseys of the moment, you
should be content with the hair color "given you by Christ," not go run-
ning after David Bowie on the path of promethean self-transformation.
On the other hand, the Church held that some "given" traits—notably
homosexual desire—were unacceptable, and urged a young man like
Morrissey to refuse to accept himself as gay. Yes, lad, you were born this
way. God made you this way. Apparently this aspect of your character
defines you—as the taunts that trailed you all through Catholic school
made plain. And yet it is not acceptable: this is a trait you must suppress.

When will you accept yourself? That is the question posed, in that
moment, by Catholicism and sexuality together.

"Please, Please, Please Let Me Get What I Want" is Morrissey's
answer. The song comes last on *Hatful of Hollow,* as a wistful coda, less
than two minutes long. It takes the form of a petition—a late-adolescent
beg to the heavens, the kind you make before a first date or a big test.
"Please, please, please . . ." Morrissey makes it in a quavering voice over
a guitar fingerpicked in 6/8 time, with bass and high mandolin-like
strumming as background. With it, he puts his questions in another's

hands. Am I still ill? Does the body rule the mind, or does the mind rule the body? When will I accept myself? He doesn't know—not yet. So could he please sidestep the questions of who he is and what governs his desires and get what he wants, just this one time?

The song belongs to a long line of petitionary pop songs. "You *cannot* petition the Lord with prayer," Jim Morrison howled on the Doors' *The Soft Parade* in 1969—but plenty of singers have tried. When Morrissey makes his petition, fifteen years later, it's not clear whom he is petitioning. It is cryptic. He sings "please" over and over, sings "let me" over and over, and then adds: "Lord knows it would be the first time."

The Smiths' rise coincided with the first long break in U2's career, a time when the band members, now adults, pulled their lives together. Bono married his girlfriend from school days—Alison, or Ali—in a ceremony led by a teacher who'd become a cleric in the (Anglican) Church of Ireland. Edge married *his* school girlfriend—Aislinn—in a Catholic rite in Blackrock, outside Dublin ("We went with tradition and opted for the bride's church," he recalled). As a fourth record took shape, U2 made another pairing, persuading Brian Eno to produce it; and the changes in their circumstances sharpened the questions they faced about the notion of calling and the nature of devotion.

Eno was an unlikely collaborator for a band prone to stadium-ready exuberance. He was devoted to the inscrutable. Playing with Roxy Music in the early seventies, he was outré even in that band of dandies and eccentrics. As a solo artist, he made layered, wordless "ambient music": *Discreet Music, Music for Airports, Music for Films*. As a producer, he was visionary and anti-popular. He joined David Bowie at the height of Bowie's fame to make three records of doomy musique concrète in divided Berlin. Over three records with Talking Heads, he pushed that most daring of bands, and especially its singer, David Byrne, out to the avant-garde frontier so far that his approach turned off the other members. "Whenever we'd do something great while working with him he'd say, 'No, that sounds too good.' If it sounds good it must be commercial, therefore it can't be art, therefore it must be bad," the bassist, Tina Weymouth,

complained. And yet the records Talking Heads made with him were popular music: acclaimed, loved, danced to.

Eno was the once and future King Cryptic. His name—an anagram of "one"—suggested how singular he was. He wore his hair very short (he was balding) and dressed in the plainclothes-minimalist uniform of the international avant-garde. He was detached, but not ironic; he was anti-ironic, committed to Art without apology. He was a "process artist," and his process was called Oblique Strategies. "The Oblique Strategies began as a list of aphorisms intended to check the headlong flight down the path of least resistance by suggesting side roads that might prove more interesting," he explained. "The first one I wrote was 'Honor thy error as a hidden intention.'" Others were like it: *Overly resist change. Emphasize the flaws. Mechanicalize something idiosyncratic.* Eno got the strategies printed on decks of cards, 115 in all. He explained their use in a long conversation published in *Interview*. Over time the Oblique Strategies took on a Tarot-like mystique as an enabler of recording-studio otherworldliness, with Eno as a knob-twiddling shaman. In an echo of a London graffito about Eric Clapton, an expression made the rounds: ENO IS GOD.

The pairing of U2 and Eno would turn out to be an apt joining of opposites: Bono/Eno, overt/oblique, anthemic/ambient, popular/arty. In the moment, however, it was more akin to an act of surrender. U2 were in search of mentors, craving higher education. "We didn't go to art school . . . we went to Brian," Bono recalled. They would learn from him, would submit to his mysterious process. In doing so, they would deepen an aspect of their music that Eno's music shared: the crypto-religious aspect.

Eno had grown up in Suffolk in a Catholic family who kept the faith for centuries in spite of fierce English anti-Catholicism. (When John XXIII was elected, he recalls in *A Year with Swollen Appendices*, they "all clustered round the only Catholic TV in the neighbourhood to see the new pope. And my Auntie Rene fell to her knees before the TV.") Brian was schooled by Christian Brothers; he sang in the choir. When the brothers urged him, at confirmation time, to do something dramatic to reflect the order's influence, he took as his confirmation name the full

name of their French founder, adding it to his own, and became Brian Peter George St John Baptiste de la Salle Eno.

At art school in the late sixties he became an atheist but remained fascinated with religion: "Religion comes with a superstructure of belief, which I wish I could jettison," he later explained. His creative process had a religious dimension. The Oblique Strategies are like devotional practices: they invite the devotee to go against habit and custom—against ordinary human nature—so as to break through to an extraordinary other realm of experience. His ambient records were efforts to attain the self-surrender he associated with religion. ("I didn't yet have the word 'surrender,'" he later recalled. "I just knew I wanted something that induced calm . . .") Tellingly, his breakthrough record with Talking Heads was their cover of "Take Me to the River," by Al Green, the great soul singer who had left the music business to become a Pentecostal minister shortly after his own version was released. Together Talking Heads and Eno transformed Green's funky plunge into the baptismal waters into a slowed-down, drawn-out drama at the water's edge. "Take me to the river / drop me in the water . . ." David Byrne sings— and the recording submerges him in an ambient river of Eno's creation.

The full breakthrough was Eno's collaboration with Byrne, done in sessions between the Talking Heads records *Fear of Music* and *Remain in Light*. This is *My Life in the Bush of Ghosts*. Bright, kinetic funk is glazed with "sampled" vocals, and the voices come from the world of ecstatic religion. There are Lebanese praise singers, evangelical preachers, and an exorcist. The preacher in "Help Me Somebody" proclaims a God who is present always and everywhere : "He's so low you can't get under Him! He's so wide you can't get around Him! . . . He's *every*where!" The exorcist in "The Jezebel Spirit" matter-of-factly asks, "Okay, are you ready to be delivered?"

A third of a century later, it's hard to convey how strong and strange those voices sounded to a rock audience. They weren't threatening. They were fascinating. As U2's "Gloria" was for many of us a first encounter with Latin chant, so *My Life in the Bush of Ghosts* was a first encounter with heartland hellfire-and-brimstone preaching.

Eno himself first heard those voices during a trip to Ibiza, where the

radio brought in broadcasts from North Africa, and then via shortwave from the American South. The record is brimming with the energy of discovery—and with all the vexing issues of condescension and appropriation the term *discovery* raises.

There's definitely an ethnographic aspect to the *Bush of Ghosts* approach to religion, the outlook of urban sophisticates drawn to the folkways of supposedly primitive people. But what's striking—at the time, and more so in retrospect—is that the record presents the devotional spirit without the self-insulating forces of animus or irony. It treats religious experience as real and desirable, even fashionable.

The photographs of Eno in that moment—in nightclubs, with Byrne in the studio, in that minimalist loft—are perfect slices of downtown avant-garde life. And yet Eno was onto something else. "Brian, the atheist iconoclast," had ". . . a secret penchant for Russian icons and gospel music," Bono recalls in *Surrender*. Eno would go to a Black church in Brooklyn and sing in the choir, carrying forward his childhood love of spirituals and hymnody into the bush of ghosts that was the New York City of the time.

Eno was a postsecular figure, a leader of the spiritually curious avant-garde. To listen to the records he produced was to know that the sixties were finished and unsolved mysteries still remained. To work with him, to be with him, was to be onto something larger than music. It was to step baptismally into a river of pure sound.

Eno's work as a producer and his use of the synthesizer (he was an early adopter of the Yamaha DX7, introduced in 1983) situated his records within rock music, but his emphasis on the physical and spatial qualities of sound more than on melody and harmony put him in the company of musicians who would come to be called post-classical—who were striving to create large-scale sonic works rooted in the Western art-music tradition but bearing some of the clarity and power of rock music. In that moment, the post-classical music that found receptive audiences was crypto-religious.

Arvo Pärt's "Tabula Rasa" is a twenty-six-minute work for two

violins, (amplified) piano, and chamber orchestra: spacious, insistently tonal, at once serene and pulsing. Its sound is a concise expression of an approach that Pärt, an Estonian living in Berlin, a convert to the Orthodox Church, had developed over a decade of quasi-monastic withdrawal from public music-making. This approach drew on the low, slow, rolling pattern of Gregorian chant; the sound of silence itself; and the resonant overtones of "ringing church bells," which gave it its Latinate name, *tintinnabuli*. ECM Records, in Zurich, arranged to bring out a live recording—a departure from its progressive jazz offerings. Pärt came to New York for a performance of "Tabula Rasa" and other works ("Red Composer at Tully Hall," the *Daily News* reported). The record inaugurated ECM's New Series, which defined the post-classical approach, and Pärt at once deepened his commitment to Orthodox Christianity and composed a series of works (*Te Deum*; *Stabat Mater*) rooted in the Latin Mass, whose suggestions of the timeless and ineffable found listeners drawn to its devotional character.

Philip Glass's *Akhnaten*, staged at City Opera in November 1984, was the third of his operas about great men of history, following *Einstein on the Beach* and *Satyagraha*, about Mahatma Gandhi and his kin in nonviolence Leo Tolstoy and Martin Luther King Jr. Less obviously, it was a culmination of Glass's interest in religion. Raised Jewish, schooled in the Great Books at the University of Chicago, Glass had practiced yoga since the late fifties (when there was no dedicated yoga studio in New York City) and made a pilgrimage to holy sites in India and Nepal in 1966 (crossing paths with George Harrison). In the seventies and early eighties, as his bright, sharp, relentless, "minimalist" music became notorious and then popular, he traveled to India yearly and deepened his practices of hatha yoga and Tibetan Mahayana Buddhism. He was drawn to "the idea of 'the other world,' the world that is normally unseen, the premise being that the unseen world can be brought into view." His interest in Akhnaten—King Tutankhamen's father—involved Akhnaten's role in introducing monotheism into Egypt, an act so disruptive that it led devotees of the old gods to dethrone him and erase him from history.

The three-hour score of *Akhnaten* featured a setting of Psalm 104, in Hebrew. This re-joined Glass to Steve Reich, his friend, rival, and

fellow minimalist pioneer. Three years earlier Reich, in a work called *Tehillim*, had set psalm texts for a quartet of plangent voices and a mixed instrumental ensemble—his first piece of expressly vocal music, and the first in which he engaged directly with his Jewish roots. For those of us used to hearing psalms set to churchy hymnody, the work had a distinctly different effect, capturing the spare, dry, sunlit landscape of the biblical near East. (By 1984 he was carrying those impulses forward in a longer work, a cantata—the religious form perfected by Bach—called *The Desert Music*.) In *Tehillim*, the use of Hebrew enabled Reich to foreground the musical origins of the psalms (many said to be written "for the lyre"); the clapping of hands and the beating of a tambourine suggested the psalms as street-corner music of the people of Israel—as popular music.

When Brian Eno went to Dublin to meet U2, he brought another producer with him: Daniel Lanois, his collaborator on a series of ambient records. They, too, were an unlikely pair. In the seventies, while Eno was playing with Roxy Music and David Bowie, Lanois was a workaday musician in Canada. He ran a recording studio outside Toronto with his older brother, Bob. To pay for new gear, he toured with "show bands," playing a circuit of roadhouses in the Canadian north. At the studio, he worked with all comers, sharpening his skills as an engineer and producer. In his own work, made in the midnight hours, he evoked the sonic landscape of his childhood.

He had spent his first years in Quebec, one of four children, speaking French and hearing their father and grandfather play violin, and the communal quality of Quebecois life shaped him strongly: "the house of God"—the Catholic Church—"as a house of cooperation," and the family house as a place full of food and live music late into the night. In English-speaking Ontario after his parents' divorce, he was schooled in French by nuns in a collapsing school not unlike Steven Morrissey's—"a big old place soon to be knocked down." An altar boy, he was primed for the priesthood but went in for music instead: pennywhistle, slide guitar, and then electric guitar.

Life in the Church left him with a strong intuition of God, and this intuition was at the root of his approach to the recording process. In his memoir, called *Soul Mining* (a pun on coal mining), he explains: "A godly moment may be sparkling in only a tiny way—too small to make a difference in its singular form—but stacked up with others the sparkle begins to build shapes. The shapes are the instigators of sound, and soul, and dreams." He layered "sound on sound" in order to create a sonic depth of field. He drew on a stash of gospel LPs for short bits of sound that he called "traps"—samples. And he pulled it all together with the drone of the pedal steel guitar: a wooden console with ten strings, which he thought of as his "church in a suitcase."

After a chance meeting, Eno arranged to make a record at the Lanois studio in Toronto. "Eno arrived with a suitcase full of bells, acquired on Canal Street in New York," Lanois recalls. "The first thing he said to me was that he wanted to record the bells as he walked around the studio for forty-five minutes, the idea being that the bells would ring through-out the entire record" as a quasi-liturgical counterpoint to soft, textured piano, played by Harold Budd. The record, *Ambient 2: The Plateaux of Mirror*, was credited to Budd and Eno, but it also represented the merging of Eno's and Lanois's approaches, each a vestige of an intense Catholic up-bringing. "It had stillness, acceptance, and premonition. It had patience, subtlety, and refinement," Lanois recalls.

Eno asked Lanois to go to Dublin with him—asked him, Lanois surmised, because Eno, eager to get back to his own projects, planned to introduce Lanois to U2 and then hand off the production duties to him. It didn't turn out that way. Lanois recalls: "We found ourselves crammed in a car with all the U2 guys and Eno and I in the backseat, cassettes being played at full volume, Bono shouting melodies and making up choruses. Bono's enthusiasm was contagious, and even though we didn't hear fin-ished songs, there seemed to be enough to go on."

There was more than enough. Their collaboration would last ten years, implicating all involved in making what Bono would call "hymns for the future."

Fame had enabled U2's manager to renegotiate their record contract, and Bono, newly flush, had bought some real estate—an old stone tower on the Irish coast, akin to the tower where Joyce set the opening episode of *Ulysses*. As the band worked up new songs for the new record there, they were drawn to the idea of making the record in an evocative setting rather than a studio. The idea appealed to Eno's "ambient" aesthetic. The band rented Slane Castle, a neo-Gothic edifice north of Dublin whose grounds were the site of summer rock concerts, and made it a base for recording. At Slane Castle, Brian Eno's Oblique Strategies, Daniel Lanois's commitment to sonic depth and space, and U2's mix of devotion and desire came together in *The Unforgettable Fire*.

The sleeve art plays up the on-site effect: a castle photographed in sepia, all shadows and ivy. But *The Unforgettable Fire* doesn't sound like a record made in a castle. It's a solitary record, best heard on headphones, which accentuate the ambient production: the smears and swoops of electronic effects, the drums as light as bongos, the guitar harmonics sharp as acupuncture needles at the junction of brain and spine.

On "Sunday Bloody Sunday," Bono had sung of inner division as civil war. On this record, U2 sought a sound for such division. The ambience is that of the interior life. The divisions are those of the individual, which Bono represented with his voice and persona.

Bono, too, is a controvert—but unlike Morrissey, he is growing into the role. Morrissey from the beginning is characterized by his conflicts, which he wears like a string of beads around his neck or unbuttons his shirt to show us, Sacred Heart–like. Bono takes on the controvert's stance as part of his calling. Suddenly famous, he makes his persona a staging ground for controversy, using his voice and songs to access inner conflicts that U2—and their audience—might never have dealt with otherwise.

For Bono and U2, those inner conflicts have a religious dimension, and the ambient production is spiritual and mystical. Where Morrissey (and so many like him) wanted to unshackle himself from religion, U2 sought to complicate their devotion.

The ambience would be hard to reproduce onstage; but *The Unforgettable Fire* yielded several set pieces for U2's live show.

With "Pride (in the Name of Love)" U2 dramatized controversy in religious terms, taking pride in selfless love by identifying with the modern person who best embodied that quality: Martin Luther King Jr. "Danny [Lanois] liked to work from the bottom up," the drummer, Larry Mullen, said, and "Pride" is an anthem upended, beginning with a snare-drum riff that could have come from a street procession and working up through pulsing guitars to the battle-cry chorus. There's actually only one verse about King, the third, and it gets the details of his death wrong—the "shots ring out in the Memphis sky" in the morning, whereas King was killed in the early evening—but it's a lie that wound up telling a truth. Released in September 1984—at a moment when conservative Christians were coupling images of faith with Ronald Reagan's campaign rhetoric of "morning in America"— "Pride" evokes a violent, nation-dividing American morning.

"Bad," about a friend lost to a heroin overdose on his twenty-first birthday, is an antidote to piety. Built on a ringing guitar figure that surges and subsides over six minutes, it echoes the most powerful drug song of all—"Heroin," by the Velvet Underground—and it shows U2's acquaintance with the wild side. And it shows the band loosening up conceptually—pushing past perfectionism. "Bad" is "something we had done with Brian as a sort of 'improv' piece," Bono said, "and he wouldn't let us replay it or change anything, so the improvisation stands pretty much as is."

The real breakthrough was the title track. In Chicago during the *War* tour, Bono had visited the Peace Museum, in a brick building west of the Loop, and had seen *The Unforgettable Fire*, an exhibit of art by survivors of the atomic bombs the United States dropped on Japan. "The image of that catharsis . . . stuck in Bono's mind," Edge recalled. As the story of Bono's visit circulated, it was assumed that "The Unforgettable Fire" is about a man on the run in a world wasted by fire. And it was assumed that the "unforgettable fire" was a reference to pentecostal fire, and that the title track is about the band's crisis of belief, with Bono crying out to God, "Don't push me too far."

There's something to each of those interpretations. But the expression "unforgettable fire" doesn't actually figure into the lyrics, and the

song evokes something else—the subject of so many rock songs before and since. Bono is out with a lover. They're at a carnival, a little drunk, reeling in a kaleidoscopic swirl of sounds: plonked piano, pinged guitar. Now he's truly drunk, and it's a desert. He's giving himself away ("here I am"); he's begging to be taken away from himself ("Come on, take me home"). He's so into the moment that it wouldn't matter to him if a mountain would slide into the sea. And then the music takes over, Eno and Lanois bringing in the most old-school of effects—a string section—to capture the human feeling the song is about.

Desire is the unforgettable fire; it is devotion up close and personal. For the first time in U2's career, passion is sexual passion first of all, and the spirit of devotion is shot through with desire.

U2 inspired collective devotion; to follow the band whose first great song was "I Will Follow" was to belong to a following that grew evangelically as the word spread.

Not so the Smiths. To follow the Smiths was to belong to a secret society. You found out about the Smiths through college radio or via word of mouth. Their music spoke to you directly and exclusively. ("There weren't 'casual' Smiths fans" in the United States, Chuck Klosterman notes, just a "fey underground.") You would confide their secret only to a special few. Your devotion would be debased by their popularity.

In the U.K. the Smiths were top of the pops and Morrissey was the face of young, white, Tory-detesting discontent. His line "England is mine, and it owes me a living" had gained the ring of prophecy. Three straight singles—"What Difference Does It Make?," "Heaven Knows I'm Miserable Now," and "William, It Was Really Nothing"—placed in the top twenty, and the band made a splash at Glastonbury. Morrissey was famous.

With the latter two singles in the charts, the Smiths left London and returned to Manchester, hoping to escape the pressure. Morrissey and Marr bought houses in the city. They did publicity there, including an event at Marr's old grammar school, Sacred Heart. (Pupil: "Why

did you call yourself the Smiths?" Morrissey: "Because it was the most ordinary name, and I think it's time that the ordinary folk of the world showed their faces.") And they recorded songs whose lyrics, as Tony Fletcher observes, communicated with "absolute clarity" convictions Morrissey had held since he was a student at St. Mary's.

One is "The Headmaster Ritual," a condemnation of corporal punishment and sexual abuse in the schools the band members had grown up in. In Morrissey's autobiography, the abuse comes from lay teachers—such as Mr. Kijowski, who teaches phys ed. "Young and unmarried, he is obsessed with homosexuality—that it should be traced and uncovered, named and shamed," Morrissey recalls, ". . . and yet the most obvious homosexual behavior reveals itself in Mr. Kijowski himself, as each PE lesson closes and the obligatory communal showering is enforced. This is always the time when Mr. Kijowski will conduct any sub-plot to demand that all showering boys *'freeze'* and remain still until a fantasized misdemeanor of some kind is admitted to, with the familiar threat that 'no boy will move until the culprit owns up,' as Mr. Kijowski pushes his way through this cramped room of naked boys."

Another PE teacher, a Mr. Sweeney, "stands and stares and stands and stares at showering boys when neither standing nor staring is necessary." One day Morrissey falls and sprains a wrist during PE, and Mr. Sweeney shows concern for him: he "takes me into his private office, whereupon he proceeds to massage my wrist with anti-inflammatory cream. At fourteen, I understand the meaning of the unnecessarily slow and sensual strokes, with eyes fixed to mine, and I look away, and the moment passes." It is not an isolated awkward incident. It is part of a pattern. "Shortly thereafter, drying myself off after a shower," Morrissey recalls, "Mr. Sweeney leans into my mid-region to ask, *'What's that scar down your stomach, Steven?'*—but his eyes are lower . . ."

Those moments passed but remained etched in memory. Ten years later, with the Smiths commanding a huge audience, Morrissey entered them into the public record—in "The Headmaster Ritual"—with a clarity that no government report or Church-commissioned study could have matched. Taking the short lines of Robert Herrick's poems as a model, he piles up short, angry lines to report what happened: "He

grabs and devours / he kicks me in the showers . . . / I wanna go home
/ I don't want to stay."

Today his complaint seems the soul of common sense: Who would
blame him for wanting to get out of the place? But when he kicked
back at St. Mary's in his student days, the Catholics who ran the place
did blame him—blamed all the kids who recognized abuse for what it
was. Now it was his turn to blame. At Sacred Heart, he said: "I think it
should really be a lesson for our present-day teachers—that they really
have to treat their pupils with maximum care, because who knows, in
the future all the pupils of the world will get signed to record companies
and get their revolting revenge."

"The Headmaster Ritual" is the first song on *Meat Is Murder*, driven by
"a live-wire spitfire guitar sound that takes on all-comers," as Morrissey
later described it. The opening lines—"Belligerent ghouls / run Man-
chester schools"—put its topic front and center. Harsh corporal pun-
ishment had been recorded in Catholic fiction and memoir for half a
century. Sexual abuse, however, was still an open secret, one that many
Catholics knew firsthand but few talked about. In Ireland it was kept un-
spoken through the Church's hold on politics and the law. In the United
States the Church had managed the problem bureaucratically—shifting
abusive priests from one parish to another, sending them to treatment
centers to emerge "cured." At a time when priests, bishops, teachers,
headmasters, journalists, and police wouldn't confront the problem, the
Smiths did.

Morrissey grasped that the experience of abuse couldn't be separated
out from Catholic experience generally. Abuse wasn't just a few bad
men acting badly. It was an operating principle: it broke young men in
the name of God. In his autobiography, he declares that Catholicism
"damaged me forever." Of St. Mary's, he says: "Look for one boy who
left the place feeling spiritual and complete. You will never find him."

On *Meat Is Murder*, however, he is still unshackling himself from
Catholicism. He scorns his churchy upbringing, and yet he is prone
to twisted, contrarian devotion. No lover of any particular person, he

is committed to love in principle: as he puts it in "Rusholme Ruf-fians," "My faith in love is still devout . . ." Alone in his bedroom, he knows what love is. Soon he will write "There Is a Light That Never Goes Out"—the best-known Smiths song of all, some say, and one that Tony Fletcher calls "a love song of such perfect devotion that it could only have been written by someone who had himself experienced the boundless yearning of one human heart for another."

Meat Is Murder went straight to number one in the U.K. Morrissey claimed that fame was all he wanted. Through the Smiths, fame found him overnight. Self-acceptance would come later, the path made straight by fame. For him, the spirit of devotion would turn into devotion to the self (much as the priests had predicted). He would fashion the cult of Morrissey around the creed of "self-belief" (as Fletcher calls it) and defy the press and the public. In that moment, however, he was still the singer for the Smiths, and his answer to the question running through their music—"When will you accept yourself?"—was a distinctly Cath-olic one. He said that he had embraced a life of celibacy.

4

WHAT ARE ROOTS?

"You have two choices. One, you can marry a no-good Indian, bear his brats, die like a dog. Or two, you can give yourself to God."

The speaker was Sister Leopolda of the Convent of the Sacred Heart; the hearer was Marie, a "reservation girl" equipped with "the mail-order Catholic soul you get in a girl raised in the bush." The story, in *The Atlantic* in March 1984, was called "Saint Marie." The author was Louise Erdrich. And who was she? "*Louise Erdrich is a Turtle Mountain Chippewa*," an italicized bio reported. "*Her first novel, Love Medicine, will be published later this year.*"

"Saint Marie" is magic realism with a Catholic accent, rooted equally in the writers of El Boom and the Flaubert who wrote "The Legend of St. Julian Hospitator." The setting is a place "where the maps stopped. Where God had only half a hand in the creation. Where the dark one had put in thick bush, liquor, wild dogs, and Indians." The convent atop a superintending hill is "a place for nuns that don't get along elsewhere." Sister Leopolda is a figure out past caricature: her body thin from fasting, her fingers "like a bundle of broom-straws," her nose hooked like the forked stick she uses to prod and goad the students in the parochial school where she teaches—the forked stick she uses "to catch Satan by surprise." Marie is her devotee, a girl "who could breathe only if she said the word." Faced with a grim choice of piety or maternal servi-

tude, Marie takes a stab at convent life, and the nuns' battle to get past Satan becomes a battle between the two extravagant females—the nun who makes obedience a form of torture and the girl who has visions of flagrant, torturant disobedience: "I was rippling gold. My breasts were bare and my nipples flashed and winked. Diamonds tipped them. I could walk through panes of glass. She was at my feet, swallowing glass after every step I took. I broke through another and another."

Love Medicine would be acclaimed as a breakthrough novel by a Native author (*The Washington Post* headlined its review "Indian Love Song"). The Catholic material stranded through would be treated as evidence of a powerful synthesis of Christian and Native cultures—now clashing, now intermingling. It *was* a breakthough, and a striking act of synchrony. But the "Sister Marie" chapter was also a hidden-in-plain-sight account of Catholic clerical abuse. Amid the convent exotica and imagery of mystic submission, before the switchback whereby the story lifts off into miraculous mode, episodes of abuse are set out with the vividness and acuity that suggest firsthand experience. The wicked sister throws her forked stick at Marie on the suspicion that the girl is harboring Satan—and nearly spears her. The sister pricks the girl with the stick, forcing her to crawl on the floor beneath a blazing oven to find a lost cup. Finally, appallingly, the sister scalds the girl's back with boiling water in a bid to expunge the devil and threatens to douse her ear, saying: "I will boil him from your mind if you make a peep."

"Perhaps she had scarred someone else, the way she had made a mark on me," Marie observes. Her story was, and is, an extraordinary piece of writing, the opening of Louise Erdrich's multitudinous career (a career spent "revising, rejecting, appreciating, parodying, and performing Catholicism," as Nick Ripatrazone puts it in a strong exegesis). But "Sister Marie" was also a work of cryptic augury. As would soon emerge, the world of institutional abuse that it evoked in lurid, distended imagery was all too real, and not just on the reservation.

The 1984 Pulitzer Prizes were announced in April. The surprise winner of the fiction prize was *Ironweed,* by William Kennedy, published by

Viking. The novel had been turned down by thirteen other publishers; the author was an ex-newspaperman in his fifties—who, the *Times* reported, became a grandfather the same day he got the prize.

Ironweed, too, is a work of Catholic-accented magic realism. In it Irish Catholicism takes on archetypal significance—in ways that, as in life itself, are only intermittently evident to the characters and the reader. For them, and for the novel, and for the readers of the novel—for us—it is present as substratum, the site of roots.

The title is the nickname of the main character, Francis "Ironweed" Phelan, who is a "drunk," a "bum," and a prodigal son and father. As the plant is named (an author's note explains) for "the toughness of the stem," so Francis is named after it for the toughness of his character: he is physically fearless, stubborn, hardy, hard to keep down. The earthy title suggests the depths of the novel, which is rooted in the Irish Catholic culture of the greater New York area—in Albany, Newark, and Hartford as in the city itself.

The novel's epigraph is the opening lines of the *Purgatorio*: "To course o'er better waters now hoists sail the little bark of my wit, leaving behind her a sea so cruel." The first episode takes place at St. Agnes Catholic cemetery outside Albany, where Francis goes (riding in the bed of a pickup truck) to make a little money digging graves. The date is October 31, 1938: Halloween, the day prior to All Saints' Day, the Catholic feast day when the boundary between living and dead is as permeable as freshly turned earth.

At the cemetery, Francis finds himself in the company of his dead father, Michael, and his dead infant son, Gerald, buried there after Francis, drunk, dropped him while trying to change his diaper—a fall that broke his neck, killing him.

Francis had not seen Gerald's grave, had not attended Gerald's funeral. His absence that day was the scandal of the resident population of St. Agnes's. But here he was now, walking purposefully, and with a slight limp Michael had not seen before, closing the gap between father and son, between sudden death and enduring guilt.

Michael signaled to his neighbors that an act of regeneration seemed to be in process, and the eyes of the dead, witnesses all to their own historical omissions, their own unbridgeable chasms in life gone, silently rooted for Francis as he walked up the slope toward the box elder . . .

Francis is a failure whose actions have placed him just this side of hell, and the purgatorial outline of his story is apt and authentic. Asprawl on the grave, he is seeking mercy—from the infant son whose death he brought on, and from the God recognized by the Irish Catholics of Albany. And he's hoping for the "regeneration"—a change in the way he is living—that would be mercy's practical effect.

The dead son sets the terms for his father's regeneration. "Denied speech in life, having died with only monosyllabic goos and gaahs in his vocabulary, Gerald possessed the gift of tongues in death," and on finding that Francis was at his grave, Gerald, like a priest in the confessional, "imposed on his father the pressing obligation to perform his final acts of expiation for abandoning the family."

The main line of the novel follows Francis Phelan's unsteady regeneration. He stops drinking. He helps a drunken woman out of the cold. In a mission toilet, he tries to wash "his own uncanceled stink" off his body. During a confession to another ne'er-do-well, he speaks of Gerald's death and confesses another act of violence: the killing of a strikebreaker years ago with a baseball bat. Finally, he goes home to his wife and children, whom he fled after Gerald's death; he feels the blessing of a hot shower ("a sprucin'"), dons fresh clothes, and sits with the whole family to dinner for the first time in decades. He will backslide—return to drinking, turn violent, and wander again—but not before he gains a sense of the calling that will be his path out of this limbo.

Viking's publication of *Ironweed* was Kennedy's last chance to escape the limbo of the little-read writer. He had grown up hearing Irish Catholic men tell their stories; fifteen years of Catholic education in parochial schools and the Franciscan college near Albany had left him ready to be done with imposed religion—"with the restricted philoso-

phy of Catholic theologians and Catholic philosophers, and with the formalized imposition of religious dogma," as he later put it. "But it's not easy to shed those beliefs . . ." He went to work as a newspaperman, covering the state capital's Irish Catholic political machine. A piece he read about *On the Road* in *Time* magazine in 1957 made him feel all at once that he should be writing novels (plural), and he spent nights doing so in Albany, Havana, and Puerto Rico, where he worked on the *San Juan Star*. He got nowhere. After he took a writing course with Saul Bellow, laureate of city life, his first novel was published and disappeared. *Legs* and *Billy Phelan's Greatest Game* were published but overlooked. *Lemon Weed* was signed up by Viking and then canceled when the acquiring editor left the firm. Kennedy revised the last as *Ironweed* and tried again. The novel went through a "roundelay of rejections." Publishers said it was "a depressing book, set in the Depression, about a bum, a loser, a very downbeat subject." Kennedy felt "like a leper." Then Bellow stepped in; he suggested to Viking (his publisher, too) that they publish three of Kennedy's novels as a trilogy—a pair of paperbacks pulled into the public eye by a hardcover—and Viking did.

The Pulitzer sparked Kennedy's own reputational regeneration. He was awarded a MacArthur "genius" grant and got a movie deal for *Ironweed*. Hector Babenco, a rising director in South America, had fallen under the spell of the "Albany cycle"; he snagged Jack Nicholson and Meryl Streep to play Francis and his paramour, Helen. Kennedy went downriver for a few months to work with Francis Ford Coppola on his screenplay for *The Cotton Club*, a movie about Manhattan in the 1920s.

The stress on the "Albany cycle" served to suggest that *Ironweed* wasn't just another work of Irish Catholic fiction. And it wasn't. It was a work of crypto-Catholic fiction. Ingeniously, Kennedy moved the action off the grid of the institutional church—so present as to be a character in so many Irish Catholic novels, whether in Ireland, Britain, or the United States. No priest darkens the door of the Phelan house; no catechismal formulae are recalled. Francis gets a hot meal at a Protestant mission and works for a Jewish peddler. Catholicism—as the cemetery opening makes clear—is a deep background for character, author, and reader alike. It is understory and roots.

Bellow's intercession on behalf of Kennedy served to obscure the influence of another novelist: Gabriel García Márquez, whom Kennedy had come to know when they both were working as journalists in Havana. With *Ironweed* Kennedy, departing from the city-room realism of his previous novels, created a magic-realist Catholic cemetery indebted to García Márquez no less than to Dante—a place where the dead still speak and a child's posthumous reproaches haunt the father who caused his death.

Francis Phelan's situation was the situation of countless American Catholics in that moment, who had wandered away from religion (some of us prodigally) only to find that it remained as roots. With *Ironweed*, Kennedy found a structure, an imaginative space, and a verbal music for this situation, so that the cryptic quality of the Catholic inheritance actually makes its claims more real rather than less so—and the novel suggests how sturdy such roots can be and how deep they can go.

At SUNY Albany, Kennedy shared a small office in the English department with another novelist: Toni Morrison, author of *Song of Solomon* and *Tar Baby*. She was there in the heady months in 1984 after *Ironweed* was awarded the Pulitzer and he was awarded the "genius" grant. He then used the grant as seed money to found a state Writers Institute that would bring noted authors to Albany and give a platform to the novelists who were teaching at the university—Morrison in particular.

The outlines of Morrison's career, now well known, were still an emerging story. Girlhood as Chloe Wofford in Lorain, Ohio, west of Cleveland; honors student at Howard University, and graduate study in English at Cornell; work as a textbook editor, and then as a literary editor at Random House, in New York, where she acquired and edited books by Black writers while raising two sons and writing fiction at night; leaving publishing to devote herself to writing, a decision vindicated when *Song of Solomon* and *Tar Baby* hit bestseller lists and were brought out as mass-market paperbacks, the very emblem of popular fiction. She also taught writing—at Howard, at Syracuse, and at Albany, where she was the Albert Schweitzer Professor of the Humanities.

Less well known, even now, is that she had once embraced religion with the ardor of a convert. As a girl, she'd worshipped in an African Methodist Episcopal church with her mother, a "church woman" whose name was Ramah, chosen for her after a village in the book of Joshua. (On her mother: ". . . she would fuss and say, 'The least they could have done was choose a person instead of a city.'") But cousins and friends were Catholics, students at St. Anthony of Padua, a Franciscan parish school near Lake Erie. At age twelve Chloe decided to become a Catholic herself. She took instruction, as was said then ("I had a Catholic education," she later recalled), and was confirmed, choosing the confirmation name Anthony, after St. Anthony. As a student at Howard a few years later, she began to call herself Toni Wofford after other students mispronounced the name Chloe. A few years after that, newly married and taking her husband's surname, she became Toni Morrison. So it was that even as her conversion receded, the name on her books was a reminder of the patron saint of lost souls and the poor, and of Catholicism broadly—even if her Catholic bona fides were so rarely discussed as to be a secret.

The university was a couple of hours' drive north of her home on the Hudson River, outside New York City. When in Albany she taught, lectured, hosted writers at an apartment near Washington Park, and involved herself in a local rep company's production of a play she'd written about the lynching of Emmett Till.

And she began a new novel. Its first scene would take place in a cemetery, the protagonist leaning against an unchiseled headstone: "pink as a fingernail it was, and sprinkled with glittering chips." Sethe, who has killed her two-year-old daughter—cut her throat—is determined to give the girl a proper burial and an engraved headstone. The monument dealer has his price: ten minutes for the seven letters B-E-L-O-V-E-D. Sethe submits to the man—"rutting among the headstones with the engraver, his young son looking on, the anger in his face so old; the appetite in it quite new." She thinks arranging for the headstone will be a sufficient act of expiation for what she had done. But it won't be. "Counting on the stillness of her own soul, she had forgotten the other one: the soul of her baby girl. Who would have thought that a little old

baby could harbor so much rage?" For Sethe—as for Francis Phelan—the graveyard act is only the beginning of expiation.

"Toni and I talked about *Beloved* and *Ironweed* from time to time: they were our new books, how could we not?" Kennedy recalled. "But we never compared notes or plot lines or method." Influence aside, *Beloved* sits collegially beside *Ironweed*, a literary next of kin. Here, too, ghosts, reproaches, and the veil between the living and the dead would convey the pressure of the past on the present. Here, too, a child killed by a distraught parent would communicate from the grave, a figure of purity and prophecy. Here, too, the dead child would disturb the living through a supernatural presence.

Seamus Heaney had likewise chosen limbo as his setting, and was working purgatorially—in the sequential long poem "Station Island."

At age forty-five, he was the very type of the Irish poet: the tousled hair, the rough wool coat, the strong accent, and the brown-ink pen he used to inscribe his books. For readers in the U.K., he was a poet of *Northern* Ireland: raised in the Catholic community in Belfast, a city riven by the Troubles between Protestants and Catholics, between the Royal Ulster Constabulary and the Irish Republican Army—the IRA. The Troubles had made "Catholic" so thoroughly political a category that Heaney, even after ten years' living in Dublin, had struggled to access Catholicism imaginatively in his work. "Station Island" was an act of redress—a poem rooted in Dante, in the Irish pilgrimage site known as St. Patrick's Purgatory, and in the Stations of the Cross. "It was the first time I turned my face towards the actual Catholic deposit in myself," he later said. "The poem is not particularly religious, but the site does a good bit of the work. It says: this is the place of meditation, of self-examination, of penitential retreat, so your personal venture adheres to generally accepted forms of thought. It's a much more naked thing than anything I've done before."

The *Selected Poems* Heaney was putting together suggested that he had dealt in Catholic imagery and themes all along. A number of poems evoke the house wakes and funeral rites still common in the rural

Ireland of his boyhood. A hoary local in "The Other Side" deems a patch of field "as poor as Lazarus, that ground." "Cloistered" tells of Catholic boarding school (the "calloused" light in chapel, the "gold-barred thickness" of the missals), "Incertus" of the nickname he gained there (Latin for uncertain), "The Stations of the West" of a trip to the rugged coast, where Gaelic was spoken and the towns—"Rannifast and Errigal, Annaghry and Kincasslagh"—bore "names as portable as altar stones." The tart tone of these poems concealed the sense of grandeur he'd gained from the tradition behind them. "I'm coming to believe that there may have been something far more important in my mental formation than cultural nationalism or the British presence or any of that stuff: namely, my early religious education," he recalled. "From a very early age, my consciousness was always expanding in response to the expanding universe of Catholic teaching about eternity and the soul and the sacraments and the Mystical Body and the infinite attentiveness of the Creator to the minutiae of your inmost thoughts. I didn't have to wait to read the *Paradiso* to understand the vision it enshrines."

The Troubles made funerals collective political rites and made religion a tribal signifier. "In the late '60s and early '70s the world was changing for the Catholic imagination," Heaney later said, suggesting that this, in part, led him to leave Belfast for Dublin: "I felt I was compromising some part of myself by staying." He was traveling in Europe in 1969 when street conflicts broke out in Belfast and Derry. "Suffering / Only the bullying sun of Madrid," he "sweated my way through / The life of Joyce"; he "retreated to the cool of the Prado," and there saw Goya's painting of Spanish resistance to Napoleon, made "as history charged." Those verses, like the incidents they describe, established the position Heaney would take: that of the artist who registered the convulsive events of his time and place principally as an artist.

This position combines a native speaker's fluency in Catholicism with a craftsman's detachment from it. From its title onward, his 1975 poem "'Whatever you say, say nothing'" was a record and a commentary on the furtive self-conduct induced by undeclared civil war. ("Religion's never mentioned here," one stanza began.) "The Road to Derry," about Bloody Sunday, was vividly metaphorical, envisioning justice as

an acorn that would "sprout" in some future Derry. But the hunger strike of twelve IRA fighters held in Long Kesh prison in 1981 made Catholic suffering at once literal and sacramental; the funeral for Bobby Sands, one of ten men to die by self-starvation, drew a hundred thousand mourners. "The fact is that, during the hunger strike, some form of terrible sacred drama was being enacted," Heaney recalled.

His life changed in the eighties. He took a teaching job at Harvard (beginning "as a kind of altar boy, scuttling in and out of the Harvard sanctuary"), spending the spring in the United States. With his father dead, he attended to his mother's decline. And he wrote "Station Island." The poem arose from a sustained reading of the *Divine Comedy*. He didn't set out to draw on Dante. "All I needed was a journey, a place that would be a realistic setting and a congregating area for all kinds of shades. And then Lough Derg did come to my mind . . ."—St. Patrick's Purgatory, where he'd gone years earlier, a journey distant enough that it had "a certain dreamlike quality" in his mind.

The poem (which became the title poem of Heaney's next book) has twelve sections, or stations, each involving a figure from his past, or Ireland's: a tinker from his boyhood; a seminarian "doomed to do the decent thing"; two boarding-school masters; a girl he'd been sweet on—and James Joyce, leaning on his ashplant, who lays on him the obligation to leave behind "that subject people stuff" and strike his own note—to "fill the element / with signatures on your own frequency, echo-soundings, searches, probes, allurements, / elver-gleams in the dark of the whole sea."

It is Heaney's least plainspoken work: impacted in diction, thick with blind references, deriving its realism from the sense that the exchanges it enacts between the poet and the "shades" are happening in situ and are being overheard by the reader. It's as if the conceptual clarity of the *Commedia* as an example enabled Heaney to be cryptic.

Thirty thousand books were sold in the U.K. alone. The *London Review of Books*, *The New York Review of Books*, and *The New Yorker* all ran laudatory, career-defining reviews. At Harvard, the onetime "altar boy" was on his way to being "a celebrant, at the middle of the liturgy."

The experience, along with his mother's death (at her bedside, the

priest "went hammer and tongs at the prayers for the dying"), led him back to his Catholic upbringing: "the sense of the universe you're given, the sense of a light-filled, Dantesque, shimmering order of being. You conceive yourself at the beginning as a sort of dewdrop, in the big web of things, and I think that this is the very stuff of lyric poetry." Now he was "re-entering my baby-language" of faith. "After my parents died, the words which my secular education had taught me to be afraid of, words like 'soul' and 'spirit,' came back and I said, 'Damn it, these words have to be used—they mean something. And I felt that this dimension of reality, which I had in a sense schooled myself out of, must be risked somehow." The man who had begun with the vocation-naming poem "Digging," now the Boylston Professor of Rhetoric and Oratory, was returning to his roots.

Bruce Springsteen was convinced that he had none. In a gap between records, he set out on a road trip from New Jersey with a boyhood friend, driving south and west in a 1969 Ford XL convertible—"white ragtop, sea green and Cadillac long." The glove box was loaded with geographically themed mixtapes: rockabilly for Tennessee, country blues for Mississippi, Professor Longhair for New Orleans, and so on.

Mid-journey, he had an "epiphany," and the episode, in a small heartland town, would become the skeleton key to his autobiography four decades later. "In the blue light of dusk, there is a river. By the river, there is a fair. At the fair, there is music, a small stage, filled by a local band playing for their neighbors on a balmy night. I watch men and women lazily dancing in each other's arms, and I scan the crowd for the pretty local girls. I'm anonymous and then . . . I'm gone. From nowhere, a despair overcomes me. I feel an envy of these men and women and their late-summer ritual, the small pleasures that bind this town together."

He envies them their rootedness. As a touring musician, he is prone to run; as an artist, he prizes detachment and tends to observe rather than to involve himself except when onstage. Those traits, formed in a harsh childhood, have been sharpened by fame. He and the friend drive out of town, and then go back: "We travel with the western sky black and

pressing in around us, then I see the lights. I need this town. Right now, it's the most important town in America, in my life, in God's firmament. Why, I don't know. I just feel a need to get rooted *somewhere* . . ."

It's a striking episode, because in that moment Springsteen was American society's very image of rootedness. His live shows had established him as a performer steeped in postwar pop music of all kinds: the greasy-sax records of the fifties, the pop operettas of Roy Orbison, Stax and Motown, and the sixties rock played in the bars along the Jersey shore. With *Nebraska*, a demo recording he made at home with an acoustic guitar, he had joined himself to the hobos and troubadours of heartland America. The title, packaging, and lo-fi sound together suggested a set of postwar lost songs—Dust Bowl ballads by way of the New Jersey Turnpike. In *Rolling Stone* he mentioned that the songs owed something to Flannery O'Connor's stories—the "nihilism" of them.

In the same interview (published in December 1984) he traced the arc of his work in crypto-religious terms: "I guess in *Born to Run* there's that searchin' thing; that record to me is, like, religiously based, in a funny kind of way. Not like orthodox religion, but it's about basic things, you know? That searchin', and faith, and the idea of hope. And then on *Darkness*, it was kind of like a collision that happens between this guy and the real world. He ends up very alone and real stripped down. Then, on *The River*, there was always that thing of the guy attemptin' to come back, to find some sort of community."

The interviewer let the "religiously based" remark pass. That was no surprise. Springsteen's current record, *Born in the U.S.A.*, had turned him into an inadvertent poster boy for *American* roots. Steinbeck's fiction, film noir, Scorsese's New York movies, the Vietnam-vet stories stranded into Ron Kovic's *Born on the Fourth of July*: these were works that connected Springsteen to the sources of his music beyond his own coming-of-age in New Jersey in the sixties. But the roots that he was uncovering in that moment would run deeper than music, region, country, or generation.

U2's early records, heavy with religiosity, were light on references to the musical past. This was due in part to how young the band members

were when they started, and in part to the punk imperative to scuttle the past and make things new. Then, after *War*, as U2 were adopted by the sixties-guitar-band brotherhood, they sought to acquaint themselves with the tradition whose future they were said to represent. They sought to get in touch with their roots.

But how? Bono saw the process as a challenge to be met through encounters with their elders—Bob Dylan, first of all.

This was at Slane Castle in Ireland. After recording basic tracks for *The Unforgettable Fire* there the band members and Daniel Lanois shifted work to Dublin, but Bono stayed on at the castle. With Dylan set to headline a triple bill with Van Morrison and Carlos Santana on the grounds, the editors of the Dublin magazine *Hot Press* saw an angle. Faxes went between Dublin, New York, Los Angeles, and Slane Castle, and a star-on-star interview was arranged. Per instructions, Bono waited backstage.

When Dylan arrived, Van Morrison was with him. Bono was thrilled. "They were the two masters, and I was the student," he recalled. He brought up the obsession that had led him to the castle: the sound of actual spaces and the loss of the got-live-if-you-want-it feel of classic records. Dylan, known to be impatient with fussy production, agreed with him that old records sounded better than new ones: "Even if you go in and record it live, it's not gonna sound the way it used to sound, because the studios now are so modern, and overly developed, that you take anything good and you can press it and squeeze it and squash it, and constipate it and suffocate it . . ." Bono agreed: "What I've been trying to do is find a room that has life in itself."

A cathedral, Dylan suggested. You could record in a cathedral.

"That's a good idea. I'd love to record in a cathedral," Bono said. ". . . But you can't go backwards, you must go forward. You try to bring the values that were back there, you know, the strength, and if you see something that was lost, you've got to find a new way to find that same strength. Have you any ideas on how to do that?"

Recalling the encounter later, he described Dylan challenging him. "You've got to look back," Dylan said. "You've got to go back. You've got to understand the roots."

A crowd of forty thousand people had come together on the castle

grounds. Morrison and his band played. Santana and his band played. Then Dylan took the stage with his band, featuring the ex–Rolling Stone Mick Taylor.

There's an amateur video of the show. Toward the end of Dylan's set, Bono strides out in a sleeveless jean jacket and a black top hat. He joins in on "Leopard-Skin Pill-Box Hat"—hollering background vocals, hopping up and down, as excited as anyone in the crowd. He introduces the next song: "It's 'Blowin' in the Wind'!" He sings along with the chorus, and then tries out some improvised verses on his own: "I wanna see your hands raised / I wanna see your soul in flames . . ." The sound is more passionate than musical, as he joins his voice to the voice of the sixties as if for the first time.

You've got to understand the roots: Dylan's offhand remark had landed with the weight of a command, one that Bono set out to fulfill with an acolyte's devotion. Sartorially, he went from airbrushed to vintage, donning a ten-gallon hat, cowboy boots, and a Gretsch guitar like the one the rockabilly rebel Gene Vincent had played. He took instruction from Keith Richards, asking questions as Keith spun old records in a hotel room.

The Unforgettable Fire was released that October. The band played New Zealand and Australia, Europe and the U.K., and the United States and Canada, a hundred and twelve shows in all. Bono was in full mullet; Edge wore a starched white shirt buttoned at the collar, Eno-style. They played sports arenas more than concert halls, including Madison Square Garden (bringing family to New York City from Dublin). They adapted their sound for the larger venues, making it bolder and more spacious. At the Nassau Coliseum, a hockey rink on Long Island, the sound rattled the steel rafters. It was clangorous, not mysterious. It was the opposite of ambient.

They were in a quandary: they were trying to connect with the roots of rock and roll at a moment in their career when the requirements of a large-scale rock tour were all but designed to estrange them from the music's roots.

———

What *were* the roots? Just then the nature of American roots music was a matter of controversy. U2's effort to answer the question led them back to the religion at the root of so much roots music. It led them at once to extend their musical roots and to deepen their religious roots. And it showed them how to broaden their devotion and join it to desire, because a main theme of American roots music—arguably *the* theme—is the tension between devotion and desire and the different ways people reconcile the two.

In that moment, the music press that had tracked U2's rise presented popular music as deeply divided. The divide was framed as one between past and present—between the "classic rock" of the sixties and seventies and the "new music" seen in videos. In new music, it was framed as a divide between acts featuring synthesizers and acting doomy or superficial and acts emphasizing guitars and trying to refresh sixties-style idealism. Classic rock, or new music? Free-form FM stereo, or MTV? Those arguments got lots of airtime and ink, and U2 were at the center of them. The basis of the band's appeal in America (bolstered by several features in *Rolling Stone*) was that they were seen as bridging the gap between stereo and video, old and new.

Meanwhile, roots music was becoming a marketing category. This development was prompted, in part, by punk's commitment to take music back to basics—which, for the Clash, especially, had meant back to the roots, whether rockabilly, early reggae, protest music, even gospel (with "The Sound of Sinners," on *Sandinista*). It followed on the success of Springsteen's *Nebraska*. And it was prompted by the emergence of the compact disc, which enabled record companies to reissue old music in new packaging, using B-sides, live versions, and rarities to fill the seventy-four minutes of a CD.

Plenty of artists confounded the roots categories—some by striking mystical and spiritual notes. Peter Gabriel had been the singer for Genesis in the prog-rock seventies, but the sounds of his eighties solo records (synths, polyrhythms, a processed "stick" bass) were as new as new music came, and the concert ritual involving "Lay Your Hands on Me" invoked biblical frenzy: he would step off the lip of the stage and let fans pass him through the crowd hand-over-hand. Young, pale, English

Kate Bush was marketed as a post-punk experimentalist, but the "Running Up That Hill" video cast her in a lushly photographed balletic romance, singing about a "deal with God" in an operatic soprano.

R.E.M.'s first two records were a strummed pilgrimage through the kudzu South; on *Fables of the Reconstruction* they used more pointed lyrics and twangier guitars to reconstruct "myths and legends" from the territory they called Little America.

Those shifts of style were parsed endlessly in the music press. But the real division in popular music, obviously, was Black and white: between the canon of Black pop music and that of white pop music. Thirty years after country and rhythm and blues came together as rock and roll and was taken across the Atlantic to Britain by U.S. servicemen—so went the foundation story of rock and roll—"Black" music and "white" music were as far apart as they had ever been, kept that way by the music industry.

Hip-hop developed partly as a response to this divide. The Black-run record labels whose artists had reached mixed audiences in the sixties and seventies were now owned by white-run music divisions of media companies, which repackaged the music of Motown, Stax, Philadelphia International, and other labels as oldies—as roots. Recent Black music had been swiftly emulated by white musicians: early rap by the Clash and Blondie, Fela Kuti by Talking Heads, Chic by Bryan Ferry, township music by Paul Simon (who was making *Graceland* in Johannesburg with the Boyoyo Boys and other South African musicians). But as rap developed into hip-hop and was embraced by white listeners as well as Black ones, it resisted easy emulation by white musicians.

One reason, as Kelefa Sanneh spells out in *Major Labels*, was hip-hop's ever-changing stress on staying authentic—true to the Black street. Another was its antipathy to traditions, which it broke down more than it folded them into itself. "What happened in the Bronx really was different from what came before," Sanneh observes, and a key difference was the absence of religion as a training ground or a point of reference for hip-hop's pioneers. (*Major Labels*'s rangy, inclusive, superbly learned section on hip-hop—by a writer as fluent in religion as in music—makes no reference to religion, and is none the worse for it.) Hip-hop,

fashioned from recordings, shaped by the precedents of Pan-Africanists
and spoken-word poets and reggae and dub "toasters," was arguably the
first form of Black pop music without obvious roots in the music of the
Black church.

As hip-hop developed, the racial divide deepened rather than nar-
rowed. "Radio had long since calcified into racialized formats—Album-
Oriented Rock for whites, Urban Contemporary for Blacks," Jeff Chang
observes in *Can't Stop Won't Stop*. "Rap was the most exciting new mu-
sic to come along in years, but there was no room for it in either. MTV
had burst onto the scene by championing rock and new wave, and all
but excluding Black artists. Only after Columbia reportedly threatened
to boycott the young network in 1983 did MTV begin airing Michael
Jackson videos"—and once MTV did, *Thriller* sold thirty million records
and made Jackson the performer who defined the music-video format.
("Any sketch of *Thriller*" as a strong-selling record, Questlove remarks
in *Music Is History*, "reads like an explosion at a calculator warehouse . . .
Its commercial domination was so striking that it came to eclipse every-
thing else about it.")

The racial divide in popular music was obvious at Live Aid, held
from dawn to midnight on Saturday, July 13, 1985. An outgrowth of the
holiday charity single "Do They Know It's Christmas?," Live Aid was
meant to raise money for relief of a famine in Ethiopia through a pair of
concerts: one at Wembley Stadium in London before seventy thousand
people, the other at JFK Stadium in Philadelphia for ninety thousand,
both broadcast live to a global TV audience, with graphics urging view-
ers to call and donate.

The aggregation for "Do They Know It's Christmas?" had included
a smattering of Black performers: the soul singer Jody Watley, members
of Kool & the Gang, and the bassist Tony Butler of Big Country. But
there were no Black headliners in the show at Wembley. In Philadephia,
there was a set by Ashford and Simpson, the post-Motown soul duo, and
one by Teddy Pendergrass, a Philadelphia-soul stylist; Tony Thompson,
drummer for Chic, played alongside Phil Collins in a reconstituted Led
Zeppelin. Prince, who had declined to join, sent a video of a perfor-

mance. At a giant event meant to bring money and attention to a famine in Africa, that was it for Black musicians.

Jack Nicholson, tanned and in shades, the emcee of the concert in Philadelphia, introduced U2, shown taking the stage in London, as "a group whose heart is in Dublin, Ireland, whose spirit is with the world, a group that's never had any problem sayin' how they feel . . ." It was as large a show as U2 had played. The white flag was not involved, but Bono, extending the stagecraft he had developed on those college tours, went off script and ventured out into the vast shoulder-to-shoulder crowd. When he climbed back onto the stage, he was a global rock star. "Crap sound, crap haircuts, and we didn't wind up playing the hit 'Pride (in the Name of Love)' because the singer fucked off into the crowd—band wanted to fire me as a result—and it turned out to be one of the best days of our life," he recalled. "Explain that. Ask God, he probably knows."

The band returned to a hotel in London after the show to watch the American segment on TV. Twelve hours after the London show began, Bob Dylan closed the Philadelphia show, joined by Keith Richards and Ron Wood, all three of them strumming acoustic guitars. Bono was put off by what he saw: Dylan, strung out after a long day in the sun, knocking out a few numbers with his friends. The sight of Dylan "out of it," he recalled, left him concerned. "Bob Dylan was the lightning rod in my spiritual quest as a musician. There was just myself and Ali in the room and I got out of bed and down on my knees. It was a very real moment, the end of a very big day." It was a very strange moment, too: Bono, age twenty-five, praying that Dylan, age forty-five, hadn't lost it.

Meanwhile, the roots category was hardening into a white-music category—thus re-establishing the mid-century color line that had cordoned off folk, country, and early rock from blues and rhythm and blues, and anticipating the genre known as Americana.

One consequence of this was that the band whose American roots ran the deepest and spread the widest was overlooked. This was a band

of brothers, steeped in the sound of their place of origin, carnal and spiritual at once, and inspiring devotion in their audience, even as the music they made was essentially popular and open to all comers.

The band was the Neville Brothers. Art, Charles, Aaron, and Cyril Neville had been born and raised in New Orleans (Uptown; the Thirteenth Ward), and had grown up playing music—each on his own, in pairs, or working together informally. They had scattered in adulthood, putting in time in the club scene, as session musicians, on the national R&B circuit, in Harlem and California, in the Meters, the Funky Meters, and the Uptown Allstars, and then had come together formally as a group in New Orleans in 1977. In the years when the four members of U2, a generation younger, were coming together in Dublin, the Nevilles, night after night, were finding what U2 would wind up looking for: a sound and a way of life rooted equally in devotion and desire.

The Nevilles were actual brothers, not just mates, and in New Orleans the music they made was taken to be more than just music. It was the sound of the city where Black and white, Catholic and Protestant and voodoo, funeral and parade and street party were jumbled together. It was the sound of Mardi Gras, where the Nevilles were royalty: their uncle George Landry was Big Chief Jolly (or Jolley), a beaded-and-feathered Indian at the head of the Wild Tchoupitoulas, a krewe named for Uptown's main street, itself named for "the tribe that lives near the river."

Outside New Orleans the Nevilles were a cult band, a secret held close among initiates. Friends would return to New York from NOLA and tell you they'd seen the Nevilles at Tipitina's, or at Jazz & Heritage, or at an open-air concert on the bank of the Mississippi, the crowd stoked with booze and weed, bodies sweating and jiggling in the heat— live music the way it was supposed to be. The guy behind the counter at Sounds on St. Mark's would tell you that *Fiyo on the Bayou* was one of Keith Richards's favorite records—hard to find, but right there in the R&B bin, and you should get it while you can. The Lone Star Café, on lower Fifth Avenue, where the Nevilles played one weekend a season—eight musicians on the small stage—became a northerly outpost of Tipitina's.

That the Nevilles were a cult band was part of their appeal. You

wanted to encounter them in a packed, steamy, smoky club, world-class musicians you could see and hear and feel up close. For the Nevilles themselves, however, the small scale was a trial. They'd come of age professionally on a local scene where musicians had to fight to get paid; they'd been stiffed by managers and promoters. They were now in midlife. Musically, they reached transcendence onstage night after night, but they were still struggling to establish themselves commercially— and to find an approach that pointed up their music, so unbounded and improvisatory, as classic and permanent.

The Nevilles were seeking a breakthrough; and they found one, in part, by going deep into the conviction at the root of New Orleans's roots music, the creed, cult, and dogma of the scene there: the belief that music is the bearer of extramusical spirits.

By the eighties the Nevilles carried a whole local musical tradition in their repertoire. The New Orleans tradition includes barrelhouse piano, harmony-vocal music, blues, early jazz, work songs, and sing-alongs. It includes pop and novelty songs like "Mardi Gras Mambo"—a hit for the Hawketts, sung by Art Neville, still in high school in 1954. And it includes religious music: spirituals, hymns, gospel, and the like. New Orleans piano stylings came out of the churches—Catholic, Baptist, Methodist, and Spiritual (a branch of Protestantism that incorporated Indian rituals). So did the earliest jazz—until the archbishop of New Orleans, in 1907, issued an edict that Catholic church music should conform to the Roman standard set by Pope Pius X. For this, and for other reasons, a distinctive form of religious music developed out in the streets: the music for funeral processions, made by loose-limbed brass bands and a "second line" of congregants at once mourning, singing, and dancing to celebrate the life and spirit of the deceased. After World War II, hymns and spirituals were updated, recorded, and promoted through the harmony tradition known as rhythm-and-gospel.

All this music was in the nightclubs and on the radio as the Nevilles came up: Art (born in 1937), Charles (1938), Aaron (1941), and Cyril (1948). Their mother's family were Catholics whose forebears had come

to New Orleans from Martinique; their father's family were Method-ists. The Nevilles—parents, grandmother Maw Maw, the four brothers, and two sisters—lived in a house on Valence Street and in the Calliope housing projects. The home, too, was full of music. "My mother sang all the time around the house . . . Sarah Vaughan and Dinah Washing-ton," Aaron recalls in his autobiography. Their father would sing Nat King Cole in the bathtub. "Before we were born, Mommee and Uncle Jolly were the best song-and-dance team in New Orleans"—but their mother, Maw Maw, forbade them to go on the road because Jim Crow made the life of a touring Black musician dangerous.

Art was introduced to his instrument, the Hammond B3 organ, at the Methodist church on Valence Street, tagging along with his auntie Cat as she tidied up the place. "We were cleaning the pulpit when I noticed the big pipe organ," he recalled in *The Brothers Neville*, a re-markable oral history shaped by David Ritz. "I hit a key and—*boom!*— the sound nearly knocked me down. What I heard wasn't the voice of God, it was the voice of music—but it might as well have been the same thing." He learned to play at St. Monica's, a segregrated parochial school for Black Catholics—as did James Booker, the celebrated local pianist, and Allen Toussaint, a world-class songwriter and producer.

Charles Neville was stirred by the piety at St. Monica's but was put off by the racism present there: one time a nun, who was white, took the class to a music store but sat apart on the segregated bus, refusing to acknowledge her own students, who were Black. Aaron, three years younger, saw a better side of the nuns and grew devoted to the Virgin Mary. "The 'Ave Maria' stuck in my head, made me feel peaceful," he recalled; so did the prayer called "Lovely Lady Dressed in Blue," which he recited from memory in sixth grade as his classmates looked on. The consecrated spaces of the old Latin church framed an inwardness he felt in boyhood and retained as roots as he grew up. "Everywhere I went, I felt God protecting me . . ." he recalled.

That he did suggests just how powerful his faith was, because the lives Aaron and his brothers lived as young men were so hard that it's re-markable they got through. Charles was arrested for possession of "two skinny marijuana cigarettes" and served three and a half years at Angola

prison, later exposed as a hellhole of racist violence. On the outside, he got addicted to heroin, along with George Landry, who eked out a living playing blues piano. "In addition to being my uncle, Jolly was also my running partner," Charles recalled. "We had a history of hustling and shooting up together."

Aaron stole a car: he was caught, and spent six months incarcerated. He was seventeen. The same year, he married Joel Roux, who was a student at Xavier Prep, a Catholic high school for Black students, and then at Xavier University, and they would have four children.

Cyril, half a generation younger than the others, grew up in New Orleans amid their comings and goings, with his aunt Joel Roux, Aaron's wife, as a second mother. He was taken up by a local preacher, son of a politician who had interceded with the law on his brothers' behalf. On his fourteenth birthday, the preacher came on to him sexually and then, rebuffed, whipped him fourteen times—"one for every year of my life." When Cyril told his parents what had happened, they refused to believe him.

Family helped the Nevilles keep their lives and careers from collapsing. In Aaron's case, religion did, too. Looking back, he told his story as a conversion story, in which God's amazing grace found him, a lost cause, and saved and set him free.

Charity Hospital, founded in 1736, was the oldest hospital in New Orleans. All through the twists of Aaron's career—the touring, the addiction, the late nights, the odd jobs—Joel, his wife, worked in the business department at Charity and raised their children. When Aaron was on tour as a sideman with Larry Williams, the other musicians schemed out a robbery in Hollywood. The police arrived, and Aaron was arrested as the others fled. He took it as a sign. "At the moment when I should have felt the most fear, I felt something else. I felt gratitude— gratitude to God," he recalled. "Today . . . I believe it was the Lord who wanted me caught." From New Orleans, Joel and his mother, Amelia, sought help for him: they wrote letters to the judge in California, and they began a devotion to St. Jude, patron saint of hopeless causes, at the Shrine of St. Jude on North Rampart Street. "We asked Jesus, too," Aaron recalls in his autobiography. They went to St. Ann's, on Ursuline

Avenue, a shrine with a grotto modeled on the one in Lourdes. "In the middle is a long staircase that's a copy of the Holy Stairs in Rome, and you go up the steps on your knees, praying on each step. At the top, in the open air, is a life-size statue of Jesus on the cross with Mary and John standing on either side and Mary Magdalene kneeling down between them. We three did a lot of praying in both places that month."

He was sentenced to one-to-fourteen in San Quentin, but the judge reduced the sentence to probation and a year of community service in California. Standing in the courtroom, Aaron was astonished. "Thank you, Your Honor, and thank you God, and thank you St. Jude," he said. He fulfilled his obligation by fighting forest fires on a work gang. He sang while he worked: "Musically, the highlight of my life during those days was singing 'Ave Maria' to the birds. That's when I felt most free."

He returned to New Orleans, reunited with Joel, worked as a longshoreman, roofer, and house painter, and often walked their children to St. Stephen's school in the morning. He also went back to using heroin. He was arrested for possession of marijuana—thirty joints—a violation of his probation that he expected to lead to a sentence of hard labor in Angola. He, Joel, and Mommee prayed to St. Jude and climbed the steps of St. Ann's again. The arrest, mysteriously, was thrown out.

He was performing intermittently, and his recording of an R&B song by two friends—"Tell It Like It Is"—became a hit in 1966, first in New Orleans and then nationally. He toured with the Marvelettes, Stevie Wonder, and Otis Redding, and then on his own, backed by his brother Art. Jimi Hendrix, famous from the Monterey Pop Festival, sat in one night in Tampa. On the road, his addiction to heroin deepened. "Artie got sick of me being deep in the dope," as Aaron recalls in the oral history, and so he went back to New Orleans, where Aaron joined him. When the record company folded without paying him royalties for his hit, he went back to the double life of "working on the docks all day, gigging at night, and watching the promise of 'Tell It Like It Is' slip away." He was arrested on a dubious charge of heroin possession and put in jail, where he remained for several months. Released, he fell in with the shady characters involved in the drug trade in New Orleans.

In 1973 Joel moved out, taking the children to live with her parents, who forbade him to come around. He moved in with his mother. One night she found him conked out in the bathroom with a syringe in his arm; she iced him back to consciousness and took him to pray. Another night, he wound up in the gutter outside a strip of bars on Lyons Street. "I was in a bad way, confused, and all of a sudden I thought of 'Ave Maria,'" which he knew from Mass at St. Monica's during his boyhood. "I never knew what the words meant until later—it was in Latin—but every time I heard it, it did something to my heart and soul . . . I would get a cleansing feeling. That sound of praising the Blessed Lady was like a saving grace for me, especially when I was at the bottom of a pit, like I was at that moment."

He wasn't ready to be clean yet. He bought a bus ticket to New York, where Charles had settled, playing on the Harlem soul scene: he went cold turkey on the bus north, sweating and vomiting all the way. But heroin was omnipresent in Harlem; Charles was using; once there, Aaron started using again.

Meanwhile, Uncle Jolly was playing with the Wild Magnolias, who made two albums rooted in the music of the Mardi Gras Indians. Art Neville was keyboardist and bandleader for the session band the Meters, who played taut, sensuous R&B on dozens of records. The Meters wound up opening for the Rolling Stones on a tour of Europe. Art was awed: there he was, in the crowd at a bullfight in Seville, under a full moon. He was deep into heroin, and Keith Richards was a running partner: "For three straight months, I was high with no danger of running out of stash."

Walking from the bus stop to her job at Charity Hospital one day, "Mommee" Amelia Neville was struck by a moving van. She died in the hospital. Aaron, Art, Cyril, and her brother George "Uncle Jolly" Landry were there. "I sat beside her and held her hand," Art recalled. "Finally she said, 'This is it.' Her last words to me were 'Keep them boys together.' 'Keep them boys together' was a phrase that would live inside me. I couldn't forget those words."

Her funeral, at St. Stephen's Church on Napoleon Avenue, drew a

huge congregation. Now the brothers were on their own—except they weren't. Uncle Jolly had gotten clean, and sobriety, Charles recalled, "also enabled him to grow into a spiritual force."

Now "Uncle Jolley became the surrogate patriarch," Jason Berry records in his lyrical history of New Orleans music. "And, as a musical force, Landry was moving deeper into the Indian currents swirling around his nephews. For months before Carnival, Chief Jolley's house, a shotgun shared by Aaron and his family in the adjacent apartment, came alive with Indian activity. Rooms filled with pieces of costumes, feathers, beads, and sequins. Weekly Indian rehearsal sessions were held in small bars near the river. The Nevilles began to see their uncle in a different light. The crusty cast of an aging bluesman bathed his aura as he spent hours playing piano. Moreover, as Big Chief Jolley of the Wild Tchoupi-toulas, he had become a neighborhood folk hero . . ."

Uncle Jolly urged the brothers to band together as the Wild Tchoupi-toulas and make an album with him. Art recalled, "Jolley's concept was simple: he wanted music that would express the heart and soul of his Uptown tribe."

Charles returned to New Orleans from Harlem. Cyril "was deep in the streets, but the call had me zooming to the studio like a rocket." Aaron felt Jolly's prompt "like a call from God. God was reuniting me and my brothers. Here we were—I was thirty-six, Charles thirty-nine, Artie forty, and Cyril thirty—and we'd never been together in the studio as a family, not once." He went on: "After years of separation, I was also getting back together with Joel and the kids. Healing was coming from all sides."

The record the brothers made, *The Wild Tchoupitoulas*, is a NOLA roots record with the churchy stuff left out, as Big Chief Jolly and the Nevilles and a posse of tribal members blend the strains of New Orleans music that are typically mixed rough in the bars and on the streets. There's call-and-response, the chief's gruff voice up front and loud. There's the lilt of the Caribbean in "Meet de Boys on the Battlefront," an evocation of Carnival: sun, friends, firewater, and then prayer. There are hints of funk and reggae in the lilting bass and scratch guitar. There's

the harsh side of city life in "Brother John," about the murder of the singer John "Scarface" Williams on Rampart Street.

The Nevilles and Big Chief Jolly are original precisely because they are devoted to their ancestors. Big Chief sings homage to the "Injuns" because "They won't bow / They won't kneel" to the white man and his traditions; this record is the sound of the Nevilles bending the knee to their own traditions (the krewe, the chief with his golden crown) and celebrating the doings of the Mardi Gras Indians as a kind of folk religion—"the Native American–Negro connection," Cyril explained, ". . . finally culminating into something more magical than I could have ever imagined."

The Wild Tchoupitoulas musicians went on a brief tour in full regalia, but a dispute over payment soured Uncle Jolly on the project. So his nephews reaggregated as the Neville Brothers and found their sound during a long residency at a club in Dallas. With a small insurance settlement from their mother's death, they established the group as a business, making Valence Street a base. "All the brothers moved back into those shotgun bungalows from the deepest part of our childhood," Charles recalled. "In order to move forward, we had to move back"—back to the roots.

They were still struggling individually: Aaron and Cyril with heroin, Charles with heroin and compulsive sex. Uncle Jolly was slowly overtaken by lung cancer. "I'd go to the hospital and pull up a chair next to his bed," Aaron recalled. "He'd take my hand and say, 'Baby, let's pray.' Jolly called all his nephews and nieces 'baby.' The sound of that 'baby' had more love in it than any word I'd ever heard." He died at age sixty-three.

Big Chief Jolly's funeral was another grandly populated affair: a Catholic Mass, a mournful trumpet sounding in the street outside the church, and a second-line procession. "When the parade reached Valence Street," where the family had lived for so long, Art recalled, "one Wild Tchoupitoulas dressed all in yellow did an intense dance before

dropping to his knees and kissing the sidewalk, all out of respect to his fallen leader. Long into the afternoon, long into the night, you could hear the sound of singing, 'Brother Jolley's gone . . . Brother Jolley's gone . . .'"

They grieved the hard way. Aaron shot up to ease the pain. Charles never made it to the funeral in the first place—he spent the day on the streets, trying to score.

Their personal struggles were one reason the producer Joel Dorn brought in session musicians and guest artists for *Fiyo on the Bayou*. The soul singer Cissy Houston is here, joined by her teenage daughter, Whitney, still an unknown. So is the pianist Mac Rebennack, who had dropped out of Jesuit High School in New Orleans and reinvented himself as Dr. John, the Night Tripper. So are the Persuasions, an a cappella quartet from Brooklyn, who had just toured with Joni Mitchell, backing her in an austere version of her spectral hymn "Shadows and Light." Like the Nevilles' live shows, *Fiyo on the Bayou* mixes funk, R&B, gospel, and roots music. It takes its title from an old Meters LP and reprises the song "Brother John" from *The Wild Tchoupitoulas*. At thirty-eight minutes, it feels abbreviated. And yet if you shuffle the songs—hard to do in 1980, easy now—it can be heard as a journey back to the roots of the Nevilles' music and outlook, the point where desire and devotion converge.

Funk gets things rolling: "Fiyo on the Bayou" and "Sweet Honey Dripper," two end-of-the-seventies throwdowns to establish that the Nevilles can pump a groove as deep as Parliament and Earth, Wind & Fire were doing. "Hey Pocky Way" and "Brother John" locate the sources of the funk—in the exuberance of Mardi Gras, and in what Cyril called "that weird mixture of violence and beauty that was part of our r&b street life." The latter segues into "Iko Iko"—a chant about the clash of two tribes that became a girl-group hit in 1964—and the old song, since sung in ten thousand street processions, captures the exuberance-in-mourning that runs through New Orleans and its music.

Then the lights go down and the spotlight tightens on Aaron for a pair of songs in which he tells of sexual desire in the language of religious devotion. "The Ten Commandments of Love," first done by the

Moonglows in 1959, is as straightforward as its title, Aaron imploring his beloved to be faithful and keep their vows, with the Persuasions as a semi-heavenly choir—and their harmonies take the song back beyond its street-corner origins to the history of sacred choral music. "Mona Lisa" goes there, too: in Aaron's treatment the Nat King Cole classic, heard in a thousand red-sauce restaurants, brings to mind a Renaissance palazzo, all trick windows and trompe l'oeil marble.

"Mona Lisa" was the Neville parents' favorite song, and Aaron said singing it put them in mind. Now they are gone, though, like Brother John and Uncle Jolly, and gone, too, is the world where love was a commandment and character could be seen in a smile. Now the brothers are going forth together in a harsh and unforgiving New Orleans.

That's the city of "Run Joe." Sung by Cyril, it updates a Louis Jordan calypso number with congas and West African–style horns. Mo and Joe run a candy store, selling cocaine "behind the door." The police come: they take Mo, who calls out, "Run, Joe, run, Joe, as fast as you can . . ." One is taken, one is left—but Mo spells out how Joe can beat the rap for them both. It's a gangland episode akin to the ones Bob Marley sang about—with the upbeat, major-chord harmonies softening the blow of the outcome.

"Sitting in Limbo," in effect, is Mo's side of the story. It's a Jimmy Cliff tune, featured in the soundtrack to the reggae epic *The Harder They Come*; it caught the ear of Jerry Garcia of the Grateful Dead, who performed it in solo sets from 1980 onward. No matter who is singing and playing it, it's a pop spiritual as perfect as they come: the singer, waiting for the dice to roll, facing resistance, but trusting that his faith will lead him on—as the languid, circular backing holds him in the limbo whose end he longs for.

On *Fiyo on the Bayou*, it's sung by Art Neville, who had fallen into heroin addiction just as his brothers were clawing their way out. Sitting in limbo, he might be Mo in jail, urging his buddy to spring him, plotting a getaway of his own, but meanwhile stuck in place, and knowing—here Art stretches the word out—he *"steeell* got a little time to search my soul." There's half a century of New Orleans grit and glory in his voice, and in the record as a whole. Behind the smooth recording,

the piety and devotion, the New Orleans romance-of-the-local, is the long experience of living. These are men who know their way around the street, the nightclub, the bedroom, and the church.

Fiyo on the Bayou, musical breakthrough though it was, didn't find an audience beyond deep-roots connoisseurs. A next record drawn from two nights at Tipitina's was cut in half, issued late, and packaged so as to downplay its selling point: finally, a live album from one of the best live bands in the world. The Nevilles were still in limbo.

For Catholics from elsewhere, New Orleans was itself a kind of limbo—a place suspended outside of time and impervious to the forces of modernization and so-called renewal that were altering so much of the country. "If I had to live in a city I think I would prefer New Orleans to any other—both Southern and Catholic and with indications that the Devil's existence is freely recognized," Flannery O'Connor had told a friend after a trip there in 1962, putting forth an image of the city as bold and succinct as a tattoo, and a generation later such a vision of New Orleans still prevailed among Catholics who had never been there. If you'd grown up Catholic in the suburbs, where the immigrant church structure had been shattered by flight from city neighborhoods, a close-knit Catholic community was something out of legend—lately departed and already frothed up with nostalgia, and seen mainly in the movies. But there was one place where the Catholic center was still holding as South Philly, the north Bronx, and the North End of Boston changed. It was New Orleans. In the disenchanted United States, New Orleans was still enchanted. There, it was said, different folks mixed it up together—Black and white, French Canadian and Afro-Caribbean, storefront Pentecostal and voodoo—but somehow everybody was Catholic, too. There the culture was a hearty gumbo, people were in touch with their roots, and the whiff of the illicit lurking around the old showplaces was what made them funky. There devotion and desire mingled at ease, not held back puritanically from each other. Music was in the streets, people dancing, horns a-honking in a jazz funeral parade. There Mardi Gras—Fat Tuesday—still meant something, and so did

Lent, parishes holding a Friday fish fry so the people could take pleasure in abstaining from eating meat. There, in the mossy cemeteries and the low-lying neighborhoods and the saloons that never closed—there, the ordinary was recognized as extraordinary, and to the celebration of this truth New Orleans was united in devotion.

The notion of NOLA as a place apart made its sensory-rich Catholicism attractive for people who were leery of the Church in the places where they lived. And yet the presence of the devil in the low parts of Louisiana was a matter of fact, not fancy. The clergy there were as the clergy everywhere; in rootsy Louisiana clerical evil thrived.

Lafayette, a couple of hours' drive west of New Orleans, had been overtaken by a priestly sex scandal. About two-thirds of the people in that part of Louisiana were Catholics, and the Church had operated schools and involved itself in public affairs since the eighteenth century. The scandal centered on Rev. Gilbert Gauthe, who was accused of raping and sexually abusing several dozen boys over a decade, evading detection as he was transferred from parish to parish by the bishop of Lafayette (who knew something of his behavior) before he resigned "for reasons of health."

The boys' families filed civil suits against the diocese, which settled them with payments upward of $4 million—an unusual arrangement at the time. Even more unusually, Father Gauthe faced criminal charges, with a jury proceeding set to begin in 1985. For the first time in memory, the Church would be on trial, and the mysterious ways its hierarchs dealt with priestly sex crimes would be exposed to scrutiny.

Jason Berry would do the exposing. Jesuit-educated, working as a freelance writer, he pitched stories about the trial to the national media but was turned down, so he arranged to cover it for *The Times of Acadiana* and the *National Catholic Reporter*. While his writing about New Orleans music could be celebratory, even devotional, in his writing about the trial he would push against the habits of hushed reverence that the Church, in Louisiana as elsewhere, cultivated and deployed to keep its secrets.

Aaron Neville had decided to kick heroin once and for all. He signed up for a rehab program at DePaul Hospital in New Orleans but first decamped to New York, crashing with a friend. In *The Brothers Neville*, he tells what happened next:

> I sat at his piano, thinking about my future and singing about the past, singing all the old stuff, the Soul Stirrers' "Any Day Now," "Touch the Hem of His Garment," "Be With Me, Jesus," "Jesus, Wash Away My Troubles." I played those old songs over and over. I knew I needed to make my transformation, needed to get back to the place where I was a little boy who believed in the goodness of God and the power of prayer. I remembered the Catholic Church of my childhood. Now I needed to remember how to pray. My fingers ran over the keys on the piano as these words poured out: "Lovely lady dressed in blue / Teach me how to pray / If God was just your little boy / Then you know the way . . ."

He would use that song—"Lovely Lady Dressed in Blue"—to join his past and his present, spirituals and Tipitina's, by finding their common roots. After decades spent pursuing a devotion to desire, now he had a desire for devotion. He went into the rehab program at DePaul Hospital and stayed three weeks—two weeks longer than required. "When I left, I left clean," he recalled. "With God's help, I've kept that vow."

Charles Neville's recovery came later, and also involved a mystical experience. Racked by withdrawal symptoms (seizures, vomiting) after twenty-nine years of addiction, he had "a vision of the Calliope projects where we lived as kids." He was visited by a figure full of light who touched his forehead and said, *Remember the children.* "I could see children in the park, playing in the swings. I could hear their laughter and see their smiles. It was an epiphany that comforted and calmed my soul."

Cyril got on the path to recovery through a new partner, Gaynielle, whose presence he took as the answer to a prayer he had heard since childhood in Percy Mayfield's 1950 ballad "Please Send Me Someone to

Love." He quit heroin, going cold turkey, and got through withdrawal by listening to Bob Marley's "No Woman, No Cry" over and over: Marley's music, steeped in Rastafarianism, suggested a way forward for Cyril's life and music—an approach in which the spiritual was political and vice versa.

Through all this, the four were performing as the Neville Brothers. As their lives changed, they worked some spirituals into their set. Aaron would sing "Amazing Grace" a cappella, and then the band would kick in for "Down by the Riverside"—the Nevilles' religious sincerity catching the sweaty and sexed-up revelers off guard. Aaron began wearing a St. Jude medallion as an earring (the tattoo of a dagger on his left cheek was often taken for a cross). On Christmas Eve, he sang the "Ave Maria" during Mass at the Shrine of St. Jude, the oldest church in New Orleans—a practice that became a Crescent City tradition overnight. His falsetto was a natural instrument for sacred music—a gift from God, some said.

After the Nevilles opened some shows for the Grateful Dead, Bill Graham, the promoter who had created the large-scale rock concert scene out of San Francisco—the Dead, Santana, the Band—took them on as artists with his management company. Soon they were thriving in a double way. They spent part of the year as a well-compensated opening act, playing for crowds who had come to hear someone else—Huey Lewis and the News, say—and part of the year in Tipitina's and like-spirited clubs, playing for people who came to hear them on a roots-music pilgrimage.

This time the Nevilles would seize the moment as the moment had seized them. Through the production company set up after their mother's death they arranged roots-style CD anthologies of the music they'd made separately, so that the Meters, the Funky Meters, the Wild Tchoupitoulas, and the Neville Brothers could be heard side by side. Aaron began working up a solo set of devotional music. And through Bill Graham they signed on to a short tour, scheduled for the next summer, to benefit Amnesty International's work on behalf of political prisoners, organized by Bono and U2.

On New Year's Eve 1985 the Nevilles played a through-the-night

show with the Grateful Dead at the Oakland Coliseum Arena, capacity
fifteen thousand. In retrospect, the pairing seems providentially apt: a
double bill of two bands committed to revelry at its most complex, one
with a cult following and the other with a vast following, but with a
common devotion to music as a way of life—the band as family of sorts
and their performances as an ongoing rite for a community of initiates.

There's a video: The Nevilles play a set short by their Tipitina's
standards—with their instruments and club-size sound rig set up in front
of the Dead's elaborate array of amplifiers. Closing with the rousing
funk of "Fiyo on the Bayou," they then go straight into the spirituals—
surprising the Deadheads, who are primed for New Year's good vibes.
It's a sublime moment. Aaron sings "Amazing Grace" in falsetto over a
delicate backing, with his brothers making a quartet; Cyril sings "Down
by the Riverside" from behind the congas, wearing an embroidered vest
and a knit Rasta cap. Aaron works in a verse of "This Little Light of
Mine," and then the four brothers sing together, applying their call-
and-response techniques to the chorus of "Amen—amen—amen" until
the crowd is a shouting, clapping congregation. "I believe you got the
spirit now," Cyril tells them, and falls to his knees like a preacher—and
like James Brown at the Apollo.

The show is a turning point in the Nevilles' career and in the race-
haunted history of American roots music. In it, the Nevilles' fiyo on
the bayou is joined to the Dead's fire on the mountain, and the spirit of
this New Orleans musical family is joined to the devotional rites of the
band whose cult stretches all across the land.

5

OLD SOULS

Leonard Cohen was born in 1934: five years before Marvin Gaye, six years before John Lennon, seven before Bob Dylan and Otis Redding and Aaron Neville, eight before Aretha Franklin, nine before Joni Mitchell, eleven before Bob Marley. Compared with them, he got a late start as a musician, making his first record when he was thirty-three. Once he shifted from poetry to songwriting, he worked steadily and stayed the course; he wrote and performed as his voice grew into his songs, dropping over the decades from a dry, nasal rustle to a solemn incantation to an oracular basso profundo—whereupon he started over again, writing and singing on a deeper level of originality and mystery.

In retrospect, his is the model of the sustained career. But when he was booked to play Carnegie Hall in May 1985 his career looked shaky and haphazard. The show would be the first one he'd played anywhere in North America in ten years. It was pegged to a record, *Various Positions*, that Columbia, his label since 1967, had declined to release in the United States. And his new songs featured the synthesizer, whose clacky rhythms were the antithesis of his music's gravid authenticity. Never popular, not even a critical darling, Cohen was as out of sync with the music business as a major recording artist could be. It was reasonable to think that the show would be a last waltz by a weary fifty-year-old ready to return to poetry.

The show was on a Sunday evening. Tickets were $15.50. The hall, capacity 2,800, was sold out. The *Times* had run a profile in Friday's paper—the critic Stephen Holden exulting about *Various Positions*, and Cohen's music generally, in crypto-religious terms. The "most ambitious songs" on the record were akin to "Old Testament fables secularized as troubadour song-poetry." Cohen was a solo practitioner of "the Jewish blues"—a genre he called "a combination of country and western music and synagogue liturgy." And he was a role model for the next generation of doomy, minor-key musicians: the Smiths, Suzanne Vega, Joy Division, and Nick Cave.

That mid-eighties New York moment is now recognized as the turning point in Cohen's career. Out of sync with the music business, he is in sync with the convergence of art, belief, and desire that is taking place in the city. He hunkers down in a hotel room near Times Square and bends the sacred arc of his songs to a full expression that now seems the key to his work. While U2 are working with Brian Eno to make their religious yearnings more textured and enigmatic, and the Neville Brothers are reconnecting with spirituals as the music of their roots, Leonard Cohen breaks through to big-boned, room-filling anthems by embracing a crypto-religious conception of his calling—that of an artist in midlife striving toward the holy via a tower of song.

Cohen was born in Montreal, a descendant of rabbis who had come to North America from Lithuania (Wylkowyski on his father's side, Kovno on his mother's). By the mid-1970s he had been many things: dutiful Jewish son in Montreal's Westmount district and bohemian expatriate on the Greek island of Hydra; author of a book of poems called *Flowers for Hitler* and of a novel so filthy it was not sold in stores; early explorer in the realms of hallucinogens; composer of elegant, chiseled songs; trim, swarthy, dashing, beguiling ladies' man. "Poète, chansonnier, écrivain" is how he was billed at an early performance, and the range of his pursuits was part of his appeal.

Then he sought to explore in another way. To his sojourns on Hydra, in Montreal, in New York, in the south of France, and in Israel, he

added those in a Buddhist monastery on Mount Baldy, a smog-shrouded hill in Los Angeles, near where he had an apartment. Wrapped in a robe, he sat zazen and kept silence.

Along with all the other things he was, Cohen was a religious man. As a young poet with a strong sense of calling, he had felt a kinship with those "angelheaded hipsters," the Beats. "One of the things I always liked about the early Beatnik poetry—Ginsberg and Kerouac and Corso—was the use of the word 'angel,'" he later said. "I never knew what they meant, except that it was a designation for a human being and that it affirmed the light in an individual." But his religious sense was more reverent and less rebellious than theirs. Even when far from a synagogue he would say the Sabbath prayers, light the candles, and keep the holidays in his own fashion. His life on Hydra was what Philip Roth, in another context, called that of "an unchaste monk": plain rooms, simple meals, steady work, Friday fasts, all sustained on about a thousand dollars per annum. He spoke of religious insight as the goal of worldly experience (such as psychedelic experience). He made music of interiors—"songs from a room"—but he disdained the life of an ordinary bourgeois man whose uprightness walls him off from transcendence. Of such a man, he observed: "He's never soared, he's never let go of the silver thread, and he doesn't know what it feels like to be a god. For him, all the stories about holiness and the temple of the body are meaningless." He saw himself as a "cantor—a priest of a catacomb religion that is underground, just beginning, and I am one of the many singers, one of the many priests, not by any means a high priest, but one of the creators of the liturgy that will create the church."

Religion made Cohen grave, sagacious, outwardly detached, so fixed on inward controversy as to seem unmoved by controversy in the world. It made him an old soul.

The old soul is a figure in whom several crypto-religious traits come together. This figure moves through ordinary life with an access to the extraordinary that the rest of us lack. Such access is gained and articulated through a firm grasp of the roots—artistic, cultural, religious—that most of us have lost touch with. It finds expression in habits of devotion; and it calls forth devotion from those of us who are

merely ordinary—devotion that, often enough, takes the form of sexual desire.

Cohen's old-soulfulness was a source of his sex appeal. His many lovers were devoted to his devotion. Joni Mitchell wrote "Rainy Night House" about going with him to his childhood home in Montreal and staying the night. "You are a holy man . . ." she sang—one who fled the bourgeoisie to "see who in the world you might be."

That sensibility is here, there, and everywhere in his work. Turn the pages of his *Selected Poems and Songs* and the religious terms present themselves unbidden: messiah, psalmist, virgin; Jerusalem, Jezebel, and the Ark; miracles, holy places, and the Eternal City; angels, saints, idolators, and blessed women who reduce men to prostration. In conversation with David Remnick of *The New Yorker*, Cohen maintained that his sense of things was essentially ancestral—he'd grown up among relatives in the synagogue built by their forebears—and in his handling the material of sacred history has the feel of origin stories, narratives near at hand.

"Story of Isaac," on his second record, from 1969, is a telling of the Abraham and Isaac episode from Isaac's point of view. It's excruciating to listen to, such is the foreboding you feel as father and son go up the mountain together. There's a biblical force to the verses, so strong that you can fail to grasp that "Story of Isaac" was written as a topical song—a cry against fathers sacrificing their sons to a lost cause in Vietnam. "Last Year's Man," from two years later, is more pointed; it sets the tumult of the sixties against the rivalry and betrayal found "in pleasant Bibles / Bound in blood and skin."

It's apt to regard Cohen as a latter-day Jewish sage; his Jewish learning, though worn lightly in his work, ranged across scripture, Talmud, midrash, Kabbalah, diasporic Jewish lore, and the modern theology of Martin Buber. And yet the biblical strain in his songs is Christian as well as Jewish—and he actually outdoes most artists from Christian backgrounds in the use of New Testament reference and imagery. Jesus shows up regularly in his early songs. There he is, walking on the water ("forsaken, almost human") in the breakthrough song "Suzanne," and transfixing waiting women in "Last Year's Man"; there he is, transfixing Cohen himself in the live recording "Passing Through"—a country-

western dialogue between the singer and the savior, who, hanging on the cross, mordantly observes that he's just passing through.

Catholic imagery is there, too. The novel *Beautiful Losers* turns on regional religious lore: the narrator, a man much like Cohen himself, conceives a strange sexual longing for Kateri Tekakwitha, the Iroquois virgin and convert to Catholicism—since canonized a saint—whose story figures into the Jesuit missionary exploits in early French Canada. "James Joyce is not dead. He is living in Montreal under the name of Cohen," one reviewer declared. The novel, from 1966, has dated badly; it suggests that his pursuit of bodily transcendence was as crude as those of the chauvinists of Catholic stereotype.

When he turned to music in earnest he was living in the Hotel Chelsea, a swinging New York scene to beat all, but his early songs are dipped in the French Catholicism of Quebec. A bird on a wire is like "a drunk in a midnight choir." The lover Marianne holds on to the singer "like I was a crucifix" as they crawl on their knees in the dark. Joan of Arc rides into battle, trailed by flame. Two women he meets in a storm are Sisters of Mercy (like the nuns of old) as he chastely cedes his hotel bed to them.

Those are familiar images, and that's part of their effect. Whether he was in Montreal, in New York, on Hydra or elsewhere in Europe (where his records sold well), Cohen the old soul dwelled imaginatively in an Old World of candlelit churches and troubadours, heaven and hell, agony and ecstasy—the very imagery of European Christendom that American Catholics were trying to do away with in the years after Vatican II. He drew on that imagery as matter-of-factly as he did on the Hebrew Bible and Greek myth. Judy Collins, who sparked Cohen's career by recording his songs, later said she was amazed by "the fact that a Jew from Canada can take the Bible to pieces and give the Catholics a run for their money on every story they ever thought they knew."

It's the definiteness of Cohen's crypto-religiosity that gives it its power. He's not in a quarrel with religion like Joyce, or given to spasms of religiosity like Kerouac. Religion, for him, is less an object of personal belief than an objective frame of reference, as fixed and familiar as the domed oratory church on the hill overlooking Montreal. An old

soul, he sees classical mythology, the Hebrew Bible, the New Testa-
ment, and the Buddhist precepts as all of a piece—as a many-roomed
house of the spirits. He is not bent on remaking religion. Like the seeker
in the Velvet Underground's "Jesus," from 1969, he is trying to find his
proper place in it.

His albums suggest this. The titles are plain: *Songs of Leonard Cohen*,
Songs from a Room, *Songs of Love and Hate*, *Live Songs*. One sleeve after
another shows a headshot of Cohen, handsome but unadorned. *Here
I am*, they seem to say, Moses-like. Here is a man as men have been
down through the ages. Desire in him takes the forms it has taken in
men across the ages (lust, envy, longing, drive for union) and their op-
posites (spite, indifference, contempt). He has lived his life in his own
way, and yet he has understood it in the way of his forebears. Some-
times it is the way of the Hebrew scriptures, full of forbearance and
lamentation. Sometimes it is retro-medieval, the troubadour courting
self-sacrifice. Sometimes it is the detachment of the Buddhist sitting
apart from the ever-changing changelessness of existence. This man is
a limited creature. All possibilities aren't open to him. He is who he is.
And yet he *is*. He is alive, and he has the basic human wholeness, carnal
and spiritual, body and soul.

If Cohen's outlook was so fully achieved and artfully expressed from the
beginning, why didn't his work speak to a broad public then the way it
does now? Why did the records he made in the early eighties wind up
in the cutout bins?

One reason those records were overlooked is that he ceased to tour
the United States in support of them. Another is the love-it-or-leave-it
quality of his voice and skeletal guitar-playing. But the reason of reasons
is precisely his crypto-religiosity. Cohen had maintained a religious
outlook all along, and it put him out of step with the spiritual, com-
munal energies of the sixties (and the sixties-devout music press). As he
got older he gave more attention to transcendence, rather than leaving
it behind as an early-adulthood enthusiasm the way, say, sixties rock
stars seemed to do. He brought his *roshi* on tour. Traveling, he got to

know the backup singer Jennifer Warnes, who had grown up a staunch Catholic. Her given name was Bernadette, after the young woman in nineteenth-century France who saw visions of the Virgin Mary, a story popularized by the 1943 film *The Song of Bernadette*. Between shows—on buses, in hotel rooms—Cohen and Warnes wrote a song together. As she told it later, "Song of Bernadette" is a working-out of archetypes, Cohen style: "I was given the name Bernadette at birth. But my siblings preferred the name 'Jennifer,' so my name was changed one week later. In 1979, on tour in the south of France with Leonard Cohen, I began writing a series of letters between the 'Bernadette' I almost was, and 'Jennifer'—two energies within me. One innocent, and the other who had fallen for the world."

The song is a departure for Cohen: direct, exposed, untouched by irony. "We've been around, we fall, we fly / We mostly fall, we mostly run / And every now and then we try / To mend the damage that we've done . . ." With the plural pronoun, Cohen accesses parts of himself that are usually hidden even from him. The solo artist, independent above all, here speaks for humanity collectively. The old soul gains and gives voice to an innocence, strange to him, that belongs to him even so.

Warnes's career was on the rise through her vocals on theme songs for movie soundtracks. She was a songbird, like Linda Ronstadt or Stevie Nicks, poised to express grand passions for large audiences. As her duet with Joe Cocker, "Up Where We Belong," went to number one, she used her fame to muster record-company enthusiasm for a passion project: an album of her singing Leonard Cohen songs.

Cohen liked to say he lived simply, needing only a room with a window, a chair, a table, a notebook and pen, a guitar—and the means to buy plane tickets so that he could live simply anywhere in the world. In the mid-eighties his anywhere was often a room near Times Square. His manager booked time in a recording studio at Forty-Eighth and Seventh, and he set up at the Royalton Hotel, on West Forty-Fourth Street, for weeks at a time.

Times Square was still a destination for the down-and-out. The

shabby old movie palaces and vaudeville houses along Forty-Second Street showed shoot-'em-ups and soft porn. The Port Authority Bus Terminal was a portal for the drug market and a place to flop for worn-down arrivals on Greyhound buses. Hookers worked the on-ramps to the Lincoln Tunnel. In the West Forties, Father Bruce Ritter, a Franciscan friar, ran Covenant House, an always-open shelter for teenage runaways and homeless youth.

Times Square, accordingly, was the emblem of what the religious right thought of New York: the capital of decadent culture, ruined by desire run wild—a diagnosis they saw confirmed by AIDS. The underground gates of the bus terminal were the gates of Sodom, drawing in the youth of America and initiating them into the city's wicked ways.

This was the place Cohen chose as the site for his mid-career renewal. At an electronics store on Broadway, he bought a Casio keyboard (black-and-white plastic, a hundred dollars) and set it up in his hotel room. Working slowly, he composed songs for a record. He wrote verses and discarded them, at times going down on his knees. He quarried melodies in the sub-basement of his voice, which had been lowered another register by age and smoke. He used the keyboard's plunky tones and stiff rhythms (ballroom, waltz, cha-cha-cha) to force him into new forms. "If the guitar had been the instrument with which to write songs that played out like diary entries," Liel Leibovitz observes, "the Casio was a portal to a higher plane of consciousness."

When he considered the songs ready, he went into the studio with a band his manager had put together. The objective was salvific, nothing less. "I had to resurrect not just my career," Cohen said, "but my self-confidence as a writer and a singer."

The religious term—*resurrect*—was apt. With evangelical Christianity firmly seated in Washington and the heartland, Cohen, the least rebellious of the sixties singer-songwriters, was making music that was truly countercultural in New York.

The new songs were grand statements, orchestral in their breadth and spaciousness. They were made on a device that most people of his generation considered a plaything, not a musical instrument. And they were were frankly, fundamentally religious. The titles—"Anthem,"

"Hallelujah," "If It Be Your Will"—made that clear. Even the "straight" songs were thick with religious motifs, such as "Night Comes On" (in which ". . . locked in this kitchen / We took to religion") and the jailhouse confession "The Law," with its adage that you don't ask for mercy while you're still on the stand.

"Anthem" is a credo for the adept's apprehension of the broken world. The lines are short. The tempo is slow. The mood is dark. The set of lines about a dove—traditionally an image of the Holy Spirit—is grim, bringing the bird on a wire out of Greece and into New York in the eighties: "The holy dove, she will be caught again / Bought and sold and bought again / The dove is never free." But the world's brokenness, as he reckons it, betrays an opening: the proverbial insight that it's the crack in everything that lets the light in. It's an old soul's postlude to his peers' darkly spiritualized records of the late seventies: Marianne Faithfull's "Broken English," Lou Reed's "Teach the Gifted Children," Roxy Music's "More Than This." But when a studio engineer botched a completed take, Cohen decided not to do it over again: it hadn't yet reached its fullness.

"If It Be Your Will" *had* reached its fullness. It is a perfect song, and the recording Cohen made of it in the Times Square studio is the distillation of all of his religious tendings to that point. There's the old and the new: synthesizer and fretless bass filling the gaps left by the plucked Spanish guitar. There's the masculine and the feminine, the solitary man and the enchanter of women, in the pairing of Cohen's deep voice and that of Jennifer Warnes—whose voice is double-tracked to form a compact choir. There's the form of prayer, addressed unambiguously to God (no lover's prayer here) and echoing the Yom Kippur service. There's both resignation and aspiration, as in the lines "I will speak no more / I shall abide until / I am spoken for / If it be your will . . ." Those lines set out, in the way of art, the convictions at the heart of Cohen's unlikely career: the belief in songwriting as a sacred calling, and the faith that the singer is a figure bidden to give voice to the song despite the limitations of his particular voice.

"Hallelujah" is also a perfect song, but its perfection was far from obvious at the time. It wasn't clear to Cohen himself, who wrote dozens

of verses, filling notebook after notebook (eighty, by one account) with variants on the theme. And it was obscured by the recording he made at the Times Square studio. This, the most frontally exposed of Cohen's songs—of anybody's songs—was dressed in a slick, synthesizer-heavy arrangement as if in a suit with padded shoulders. The production is tacky, and it makes the profound religious feeling at the core of the song sound impersonal and insincere.

In a way, "Hallelujah" is more than perfect. Cohen's process of swapping verses in and out suggests this. Where "If It Be Your Will" is an etched composition, "Hallelujah" is open-ended and incomplete. It includes more, goes further. And it joins religious desire and sexual desire as few songs have done before or since. The song is framed as a song of David: poet, king, sexual adventurer, archetypal Jewish artist, who composed the Psalms on a lyre. The line "And remember when I moved in you" is as plainly sexually descriptive as anything in pop music—and as adult, too. Cohen, old soul, artist of carnal love, sets up the line sexually ("There was a time you let me know / What's really going on below") and lets it land as a sexual line before adding, "The holy dove was moving too / And every breath we drew was Hallelujah." Again, he steered away from the obvious—not "every breath we took" (as in the Police's "Every Breath You Take," which was playing all over New York in that moment) but "every breath we drew"—at once carnal and spiritual in the sense of the breath of life, the Holy Spirit.

"Hallelujah" is a Whitmanesque cry of a man in his fullness. In it Cohen goes to the outer rim of transcendence where devotion and desire meet and consort together.

One of the few people who fully grasped the art and power of Cohen's new songs at the time was Bob Dylan.

Dylan's conversion to Christianity had left Cohen upset and confused. Jennifer Warnes, speaking to Cohen's biographer, Sylvie Simmons, recalled him at his house in Los Angeles, "wringing his hands

[and] saying, 'I don't get it. I just don't get this. Why would he go for Jesus at a late time like this? I don't get the Jesus part.'"

In this, Cohen was akin to Dylan's audience. And with the two albums Dylan made after *Slow Train Coming* in 1979, his conversion, initially controversial, had come to seem willful and disordered. The songs went from crypto-religious to overtly religious. The album titles (*Saved*) and sleeve art (for *Shot of Love*, a benday Pop explosion) trumpeted the gospel message. The recording process undid the supple cohesion of Dylan's band, which had broken in the songs onstage in dozens of shows. Dylan said his new songs weren't about religion. They were about Jesus, just Jesus.

Columbia Records was still leery of Dylan's Christian music. But Dylan was the artist who defined the label. In 1983 Columbia signed him to a new five-record deal, committed a big budget for him to make the first at the Power Station in Manhattan, and planned a new kind of greatest-hits package: a three-CD "box set" stuffed with rarities.

The new record, *Infidels*, released that October, suggested that Dylan had stepped back from the brink of religious fanaticism. The sleeve featured a headshot of him in stubble and shades. The title cut both ways, at once casting aspersions on the faithless and intimating that Dylan was one of them. The first single, "Neighborhood Bully," faulted the foreign-policy aims of Israel and the Christian right. "I and I" suggested religious ambivalence: "Someone else is speakin' with my mouth, but I'm listening only to my heart . . ." Dylan's biographer Clinton Heylin later observed that the record seems to "mark his passage out of Christian orthodoxy, and into a faith based on responsibility and accountability." The thrust of the reviews at the time was simpler: Dylan was back.

A truly great song from the *Infidels* sessions was left off the record but was circulated by his devotees, bootleg-style. This is "Blind Willie McTell," named for the gospel bluesman of mid-century. It exists in two versions, each on piano: one with Mark Knopfler playing twelve-string acoustic guitar (as McTell did) and one with Mick Taylor playing electric slide guitar. Both are sublime. The song is moody and rooted in place: New Orleans and East Texas as well as "the new Jerusalem."

It's rich with twists of phrase that are purely, perfectly, offhandedly de-scriptive, like the one of an owl hooting over an empty revival tent, the stars over the tree line his audience. There's a full cast of characters amid the sweet magnolias: soldiers, martyrs, a young squire toting bootleg whiskey, "charcoal gypsy maidens" strutting their feathers.

After all this, the song returns to the biblical. The last verse is etched like an epitaph: "Well, God is in his heaven / And we all want what's his / But power and greed and corruptible seed / Seem to be all that there is . . ." After a sojourn in the land of the religiously explicit, Dylan brings it back home to encrypted territory.

There things stood when Leonard Cohen hunkered down over his Casio at the Royalton and composed songs that were poised on the ful-crum of belief and unbelief. As Dylan turned away from religion, Co-hen turned toward it—turned toward it in full awareness of the power and danger of the religious perspective.

Cohen was in France when Dylan passed through on the *Infidels* tour, and the two of them spent an afternoon together. *Various Positions* was finished but had not been released. "Dylan and I met in a café in Paris to compare lyrics," Cohen recalled. ". . . Dylan and I were exchanging lyrics that day. I admired a lyric from *Slow Train Coming*. I said, 'That's really beautiful,' and he said, 'Yeah, and I wrote it in fifteen minutes.' He was admiring 'Hallelujah' and I told him, 'It took me a year to do that!' Some people write lyrics in the back of a taxicab. For me, it's always been one word at a time."

He did a short promotional tour for *Book of Mercy*, a volume of poems and meditations—a "secret book for me," he called it. *Various Positions* had not yet been released in part because Columbia had stood aside from it, planning to issue the record in Europe only. Like Dylan, Cohen was a legacy artist: every one of his albums had come out on Columbia Records. But his was a legacy that didn't sell. It's a measure of his detachment that he apparently didn't ask Dylan to intercede with the label.

Columbia released *Various Positions* in Europe but licensed the North

American rights to Passport, a small independent label, which released it early in 1985. Cohen and band played the May concert at Carnegie Hall. Stephen Holden, following on his *Times* profile, struck the religious note again in a review, noting the "prayer-like diction of his lyrics" and the "chant-like intonation" of his low voice. "So devoted is Mr. Cohen's flock," he observed, "that his sold-out Carnegie Hall concert on Sunday night had an almost revivalist intensity, as worshipful acolytes deposited flowers on the stage and standing ovations brought the singer back five times for encores."

Various Positions sold modestly even by comparison with Cohen's other records. It was a letdown even for a practitioner of detachment. Cohen had rolled the dice long kept in his pocket—a set of frankly religious material—and the strategem had actually worked against worldly success. It had cost him five years. He was past fifty. "I will speak no more . . . if it be your will," he had put it. At the monastery on Mount Baldy he had found, in Buddhism's elected silence, a way to speak no more. Now he found another way. Jennifer Warnes was making her record of his older songs. He shared some new songs with her, singing and playing one of them to the producer over the phone. The next Leonard Cohen record would be delivered in a different voice.

In northern California, another old soul had roosted in a hilltop aerie. This was Czesław Miłosz: poet, essayist, anatomist of communism, Nobel laureate. At a house on Grizzly Peak Boulevard, above the Berkeley campus, Miłosz, having attained the biblical threescore and ten, was exercising a youthful ardor, with his body and with his poetry.

One of his new poems was called "A Confession." In the English translation he made with Robert Hass, it begins: "My Lord, I loved strawberry jam / And the dark sweetness of a woman's body," and goes on to catalog other earthly delights: vodka, olive oil, cinnamon, cloves. Sonnet-like, it then turns to self-interrogation: "So what kind of prophet am I? Why should the spirit / Have visited such a man? Many others / Were justly called and trustworthy. / Who would have trusted me? For they saw / How I empty glasses, throw myself on food, / And

glance greedily at the waitress's neck. / Flawed and aware of it." The poem ends on the tension between his "desire for greatness" and the limits of his talents, but it is built on a more basic tension—between the spirit and carnal desire.

Miłosz's habits of devotion had been at once enlivened and put to the test as developments in Eastern Europe (and the Nobel Prize) put him in the public eye. His crypto-religious sense of himself was distinctly different from the role the Western press had assigned to him: lofty humanist of Eastern European resistance. But in fact the religious currents in his work shaped the humanist ones, and his stance against state repression was rooted in his rejection of communism's unspiritual view of human nature.

He had come of age in a Polish-speaking Catholic family in Vilnius, Lithuania (a vital center of Eastern European Judaism), and then in Warsaw; a much older cousin, Oscar Miłosz, was a noted poet, writing in French. He witnessed Nazi atrocities in Poland and was involved in Polish resistance to Soviet domination, which was completed by the West's postwar concession of Poland as belonging to the USSR's "sphere of influence" at Yalta. Although he did not join the Communist Party, he accommodated himself to the new regime, serving as a cultural attaché in New York and Washington, but the accommodation did not last. He was recalled to Poland, leaving his wife, Janka, who was pregnant, and their son in the States. He was posted to Paris, close enough to Warsaw for the Party to keep watch over him. Then he defected—"the first writer and intellectual of . . . distinction to defect from the Soviet bloc," Cynthia L. Haven observes in her short, strong book about Miłosz's life in the West. He spent five years in France, apart from his family. He became friendly with Albert Camus; he studied at the Institut Catholique, site of the neo-Thomist revival led by Jacques Maritain. He wrote *The Captive Mind* (1953), an account of the ways the men of his generation collaborated with, enabled, and exalted state communism as a substitute faith.

A modernist, he stood aside from the Church as it allied with Polish nationalism in the war years and after. His experience of state communism had made him suspicious of "today's longing for any, even the

most illusory, certainty"; and it had made his religiosity at once more intense and harder to make out. "[F]ew people suspect my basically religious interests and I have never been ranged among 'Catholic writers.' Which, strategically, is perhaps better," he told Thomas Merton during the exchange of letters in which he described his outlook as "crypto-religious." He explained: "We are obliged to bear witness. But of what? That we pray to have faith? This problem—how much we should say openly—is always present in my thoughts."

Miłosz left France in 1960 for a position teaching Slavic literature at Berkeley, and Janka and their two sons joined him there. On the far edge of North America he was at a distance from Europe (his "native realm") and the Polish language (his "faithful mother tongue"), but not from the forces of History (capital H) or Religion (capital R), which churned controversially within him. He kept writing in Polish, rather than French or English, and he produced Polish renditions of the Psalms and the book of Job.

For Miłosz, to be "crypto-religious" was prudent, tactical: in Soviet-run Poland, as in imperial Rome, one risked one's life in confessing one's faith. But it was also a distinct position, even a calling. The crypto-religious artist—he had explained to Merton—finds himself "groping . . . toward completely new images" of faith and trying to "grasp religion again as a personal vision." This artist tries to "trace the limits of mystery and state clearly where the unsolvable contradiction of existence starts."

The expression also captured the displacement he felt in California—and the gap between the lush surroundings of the Bay Area and his roiling inner life. In California, he felt something like the first fallen man in Eden. There, his complex and ambigious cleaving to Catholicism's Old World verities was a form of dissent from New World optimism—a setting himself against the "impotent negation" of American intellectuals, and against "all the good causes" rooted in "unlimited love for humankind." There, his keen sense of the religious horizon made him a controvert outwardly, too. He disliked the vernacular Mass introduced at the Newman Center on campus. As one progressive movement after another swept through Berkeley, he kept his own counsel in the house

in the Berkeley hills and framed his religious outlook in the form of sober self-interrogation.

In Miłosz's work from the decades in California it is the self that abides and the world that changes. This self, even as it holds steady, is controverted: religious but not spiritual, a carnal man with a Catholic imagination and sense of last things. In him, opposing impulses don't mingle congenially—they are at war with each other. "If only this could be said: 'I am a Christian, and my Christianity is such and such,'" Miłosz mused. But he cannot overcome "the difficulty of labeling oneself a Christian." So he remains crypto-religious, and he keeps his two souls in constant communication. "One passionate, fanatical, unyielding in its attachment to discipline and duty . . . identifying sex with the work of the Devil. The other: reckless, pagan, sensual, ignoble, perfidious." He brings his two souls to church—not to profess his faith, but to be rescued from his aloneness.

His closest readers recognized the religious dimension of his work. Donald Davie observed that he "circled around the central tenets and claims of the Christian Revelation" as if to "defeat any attempt to affix any one label: 'agnostic,' 'atheist,' 'lapsed believer.'" But Miłosz, writing to Merton, had affixed to himself the label he favored.

He was awarded the Nobel Prize in Literature in October 1980, just when Solidarity, the Polish trade union, was creating an opening in the Soviet bloc—an opening encouraged by the new Polish pope. Many people "believed the Nobel committee had chosen [Miłosz] to honor Solidarity" indirectly, Steph Burt observes. The poet Robert Pinsky recalls Milosz taking "sardonic pleasure in a Polish newspaper photograph of people lined up for a block, around a corner from a bookstore in Warsaw, where the Soviet regime had banned his book for decades."

Among the telegrams of congratulation for the Nobel was one from John Paul II, and Miłosz's return to Poland in 1981 echoed Wojtyła's triumphant return two years earlier. The Solidarity movement had taken him up as a fellow traveler: the movement's tall stone monument to shipyard workers killed in a strike, erected in defiance of the Communist authorities, carried some verses from his translation of Psalm 29. The head of the Catholic Church in Poland, Cardinal Stefan Wyszyński, had

lionized him as an embattled defender of the faith. The press referred to a heroic troika: Wojtyła-Wałęsa-Miłosz.

On the visit (his first in three decades) Miłosz went to Gdańsk to meet Lech Wałęsa and see the monument, and to Lublin to receive an hononary degree from the Catholic university there. He used the degree ceremony to spell out his position vis-à-vis religion in a country where an overt profession of faith still made a person an enemy of the state. He told the audience that he was leery of the "professional Catholics" prominent in Poland. He proposed that he was something different: a "medium, a voice from a certain specific civilization which, due to its Christian origins, set a sharp divide between good and evil." In Poland, that civilization was Catholic. "Nonetheless, I feel a duty to declare that I am not a Catholic poet. Those who use this epithet in relation to literature often categorize others as non-Catholic, which in my view is a questionable practice which clashes with the meaning of the word *katholikos*, which means 'universal.'" He sought solidarity with all those who were "devout in the broadest sense of the word."

The Soviets instituted martial law in Poland soon afterward. Miłosz was shown in a film about the resistance, along with Ronald Reagan and Margaret Thatcher. In his Nobel address he had spoken of the strange situation he found himself in: "There is a paradox inherent in the poet's calling. Savagely individualistic, pursuing goals which are visible only to his few intimate friends, he grows accustomed to be branded as difficult and obscure, only to discover one day that his poems constitute a link between people and that he must assume, whether he wants it or not, a symbolic role."

As if in response to the public recognition, he affirmed the personal and the sensual in his new work. The house on Grizzly Peak Boulevard became a gathering place for a group of younger American poets—Robert Hass, Robert Pinsky, and others—who helped translate his poems into supple, idiomatic English. A next book, *Unattainable Earth*, written in Polish, was translated right away, as were his new poems.

Since his solo years in Paris Miłosz had been involved with women other than his wife, and so he was after receiving the Nobel. He was traveling widely, and Janka had Alzheimer's disease, which overtook her

slowly. At age sixty-five he'd felt "as if I ceased to exist"; in his seventies, he felt invigorated. A friend (he noted in his journal) told him that he had "the face of a forty-year-old man, a lined face, to be sure, the face of someone *qui a beaucoup vécu*." He had something else, too: "And the magnetism between me and women still functions, and women know, of course, if someone is still in the game or beyond it." He flirted with female colleagues and students. He had a three-year relationship with Renata Gorczyńska, a young Polish writer and editor who sometimes traveled with him. As Janka declined, he felt the guilt of the survivor, insisting he was "faithful to her only" even as he coupled with others, "bound by an oath through good and ill."

The new poems juxtaposed meditations on prayer and wisdom with sketches of a man set free in the "garden of earthly delights" of California and free Europe. In one, he recounted going to Mass at the Church of St. Mary Magdalen in Berkeley on his seventy-fourth birthday. "A reading from the Gospel according to Mark / about a little girl to whom He said: 'Talitha, cumi!'—'rise, get up!' This is for me . . ." In another he told of the night somewhere in Europe when he and a lover coupled (with "vehemence and triumphant laughter") and then went out into the old city, where they were dumbstruck by the "worn-out stones and the great door of the cathedral." He declared, "I was not a spiritual man but flesh-enraptured, / Called to celebrate the Dionysian dances . . ."—there using the language of vocation both to capture the ardor he felt and to situate his sexual adventures in his calling to be alive to the sensual experience of his time.

Miłosz is the crypto-religious poet par excellence. A generation older than Leonard Cohen (whose roots were in Poland and Lithuania), he seems to grow into himself in the 1980s, as Cohen did. Like Cohen, he becomes in his body the old soul he has been in spirit all along, and wears his complicated outlook as a kind of charm. In Eastern Europe, secularism had come by force; with the atrophy of Soviet authority in the eighties, the submerged currents of religion could be seen and felt again—and are felt in Miłosz's work, where they have been running all along. To be alive to them is to be an old soul, and no poet of the era is more alive to them than Miłosz.

The inner controversy Miłosz registers in his work isn't just a matter of body and soul, the carnal and the spiritual. It is the division between faith and doubt—a division that has been enacted in mid-century Europe, divided by war and ideology. He is a person whose life is divided by exile, whose country was divided by the great powers. For him, the divided self is a historical fact, not a diagnosis. It is not for him to join what others have torn asunder, only to undergo the consequent inner controversy as a spiritual exercise—and to represent it in the "hymns and odes" of his poetry.

On the Upper West Side of Manhattan, meanwhile, an aura of wisdom had come to surround a writer whose poetry was overtly religious, and yet whose Catholicism was cryptic even to those in the Church: Daniel Berrigan, still notorious as the Jesuit who had gone on the run after pouring blood on draft files at Catonsville.

Outwardly, Berrigan, too, was a paradoxical figure. Self-identified as a poet, he was known instead for statements, protests, arrests, and courtroom oratory—for everything but his poems. Due to the Catonsville action, he was the one of the most recognizable priests in the United States; but he was an outrider in the Church, typically found beneath a placard on a sidewalk in turtleneck, thick sweater, and watch cap.

Where Leonard Cohen undertook a long act of intercourse between the sacred and the profane, and Czesław Miłosz was divided carnally-spiritually right down to the spine, Berrigan had an inner unity, resolutely maintained through controvertings with the Catholic hierarchy and the government's military-industrial "war machine."

Post-prison, Berrigan had settled at Ninety-Eighth Street and Broadway, where some rent-stabilized apartments housed a community known as the West Side Jesuits. He wrote, taught, and mentored younger Jesuits and peace activists, a high-repute itinerant—"lecturing and teaching in Europe, Canada, Detroit, Berkeley," he observed, "commuting for three months to Yale, venturing also for several semesters into the South Bronx, to offer courses at a unique college of, for, and by the poor people of the city." He pitched in at a homeless shelter run by the

Franciscan parish nearby and paid bedside visits to terminally ill can-
cer patients at St. Rose's Home—founded by Nathaniel Hawthorne's
daughter, Rose Hawthorne Lathrop, a convert to Catholicism—on the
Lower East Side.

As fame receded, his aura grew. He was still the high priest of the
Catholic anti-war movement. The name Catonsville now rang with
tragic grandeur, like Appomattox or Antietam. Likewise King of Prus-
sia, outside Philadelphia, the site of the first direct action by the Plow-
shares movement, in 1980. Pounding hammers against the nose cones
of missiles at a General Electric weapons plant under cover of night—
beating swords into plowshares, as Isaiah had prophesied—Berrigan and
seven other radicals, among them his brother Phil (who had persuaded
him to join), had updated direct action for the Reagan era and had given
the Catholic peace movement a name with a heartland accent.

Berrigan could be sighted saying Mass at the New York Univer-
sity chapel on Washington Square or giving a lecture about Jeremiah's
prophetic poetry on the Fordham campus in the Bronx. He was in his
mid-sixties, and the controversy over the Catonsville action had made
him a survivor—an old soul. Like Leonard Cohen, he had grown out of
the sixties—whose stress on youth and optimism had never fit him—and
into a maturity that was manly but not fatherly. He was still trim and had
a head of stiff gray hair. He wore either a black shirt and Roman collar or
a collarless cotton shirt. No matter how he was dressed, he was cloaked
in his notoriety. William Hart McNichols, the Jesuit artist, likened it to
the scriptural coat of Joseph—a sign of favor that stirred envy among his
brothers and led them to scorn him and strike out at him.

Berrigan's efforts to shake off the encumbrances of his public im-
age were in line with the Catholic peace movement's efforts to rid the
Church of the accommodations it had made since Christianity became
the religion of the Roman Empire. The Plowshares radicals identified
with the early Christians of the crypts and catacombs, taking the Gos-
pel at its word and trying to live with apostolic purity and simplicity.
"Our plight is very primitive from a Christian point of view," Berrigan
had told the judge at the trial for the King of Prussia action. "We are
back where we started. Thou shalt not kill. We are not allowed to kill.

Everything today comes down to that—everything." The Plowshares Eight were found guilty but remained free while the case was on appeal.

In the eighties, then, stealth, for Berrigan, was a strategy and a spiritual discipline. He was a consensus-decrying figure within the institutional Church. He strove to bear witness against war and for peace—provocatively, creatively—without bending the knee to the hierarchy, the fifty million "ordinary Catholics" in the pews, or the mass media.

He pursued his stealthy calling in several ways. One was by writing an autobiography. The fifth of six children in a Catholic family rooted in Minnesota and upstate New York, he traced his faith to the influence of his parents: his father domineering, his mother pacifying, but both of them free people with a basic integrity—who lived according to their consciences and weren't "owned" by anyone. And he described his radicalism as a conversion experience that had overtaken him on a long-awaited trip to Europe in 1963. He was forty-two and had just made "final vows" as a Jesuit. After spending some time in France, he recalled, "I felt a fierce beckoning to go farther"—to Eastern Europe. But the Cold War had walled off the countries to the east—sites of Christianity for twelve hundred years—and had bred an enforced ignorance about the "mysterious hooded Christians" there. "Christians of those unknown regions, we were told, were hostages, martyrs, prisoners, internal exiles, nonpersons." But the Soviets alone didn't drive those Christians underground. They were aided by Western European nations and the United States, which promoted the Cold War for the sake of world order—and by the Church in those nations, which propagandized for the Cold War as a defense of Catholic values.

Berrigan had gotten permission to go to Prague; arriving on Christmas Eve 1963, he saw the effects of state atheism firsthand. Christmas "was a work day like any other," with "not a ragtag decoration"—this in a city resplendent with religious architecture. He traveled on to South Africa, and then returned to France haunted by the experience. "I had moved among Christians who lived their faith with steadfastnesss, un-

der a shadow of disrepute and disenfranchisement . . . through the freedom with which they embraced an edgy existence." He identified strongly with their surreptitious believing, even as he despised the force that made it necessary: the Cold War–sustaining war machine—which was now engaging in a proxy war with communism in Southeast Asia.

In Prague again as an observer at a peace conference a year later, he decided the peace process there was rendered a charade by Vietnam. On returning to the United States he had taken a position with *Jesuit Mission* magazine, based in an "old shabby mansion" on East Seventy-Eighth Street. New York was a city whose "Catholics were led, by all intents, by a warmaking Cardinal," Francis Spellman. Berrigan had come to see silence in the face of war as complicity in global warmaking. "Thus what might be called my real life, episodes that would set me, for good and ill, on a lifelong quest, were shortly underway."

Daniel Berrigan was Czesław Miłosz's crypto-religious doppelgänger. Like Miłosz, he set himself against "political Catholicism" that identified the Church with state or nation. Where Miłosz anatomized the "captive mind" of Eastern Europeans under Soviet domination—who made capitulation into an ersatz faith—Berrigan railed against the "captive minds" of American Catholics who propped up a version of the Church that was united against communism but violated the plain truths of the Gospels.

Berrigan, unlike Miłosz, played the game of tu quoque, insisting that the free countries of the West were as criminally violent as the police states of the Soviet bloc. In the sixties, he had merged with the times; now he stood back from them. In his sense of things—prophetic to his admirers, grandiose to those opposed—he saw the Reagan administration's fresh military buildup as just one more episode in the eternal struggle between good and evil. No matter who was president, "it all went on": war, poverty, famine, the desperate wanderings of peoples displaced from their homelands by the principalities and powers. The only sound response was to maintain one's own freedom by acting with integrity. "If there is a God, and if nonviolent resistance is God's work, then the outcome is in hands other than ours," he reflected. But every

human act "takes on the dignity of an end in itself; and must be carefully weighed and judged as such."

That was where protest came in. Every Friday he joined a protest on West Forty-Second Street, outside the headquarters of Riverside Research, a site of missile defense work. And he joined Phil; his wife, Liz McAlister; and the community of Catholic radicals at Jonah House in Baltimore, in reflections on what forms subsequent Plowshares actions should take. Berrigan was wary of the idea that actions should be seen as accomplishing something—such as the destruction of a quarter-million dollars of military property in the King of Prussia action. Actions were justified by their rightness, not by results. Their impracticality—their futility, as critics saw it—was a form of integrity.

And yet the actions were framed for the public eye. The filmmaker Emile de Antonio produced a docudrama about the King of Prussia action and trial, with Martin Sheen playing the judge and the Berrigan brothers playing themselves. CBS News sought permission to film a Plowshares action for a *60 Minutes* profile of Dan and Phil. "They want clips of you in NYC; of we here, of the prayer gatherings, of the hammers raised," Phil told Dan in a letter. Dan replied with questions, set out as bullet points. Would all the participants have a say? Were the reporters and crew really willing to risk arrest? Might a profile "blow a lot of cover for the future, increase surveillance everywhere?" Above all, what was the goal? "Even if it all goes + *60 min.* shows what it wants," he asked, "so what serious effect on the arms race? I dunno."

All the while, Berrigan was following another calling, out of the public eye. He served as chaplain and caregiver for gay men with AIDS. "New York had become, in the space of a few years, a concentrated center of AIDS," he observed in the autobiography. So he had decided to get involved—"as a volunteer. Nothing dramatic, no great thing. But I had a sixth sense, residing somewhere in the bones, that I could be of help."

Unknown to most, he had been associated with the gay rights movement since the sixties. At Cornell he lent his name to the petition of a

group of gay students seeking university recognition—and was warned that to support the group was to declare himself gay. In federal prison after his flight from the FBI, he heard the nightly farrago of a "veritable *cage au folles*" of "urban gays"—"like every endangered species, skilled in the arts of survival." He recognized the conflicts of his fellow Jesuit John McNeill as akin to his own. When the Vatican, responding to the attention paid to *The Church and the Homosexual*, sought to forbid McNeill to comment on gay issues, Berrigan wrote an article drawing on the correspondence between McNeill and their Jesuit superiors so as to enter the controversy into the record. McNeill was silenced anyhow.

There are different accounts of how Berrigan came to work with AIDS patients. Fr. Bill McNichols recalled that he recognized the other Jesuit on the Fifty-Ninth Street subway platform while en route to St. Vincent's Hospital. He introduced himself and spoke during the ride downtown of his ministry to men with AIDS, and Berrigan was brought into the work that way. Berrigan himself wrote of getting involved after a nun whose nephew was dying of AIDS asked him to visit the man at St. Vincent's, and he did so. In his account (written with disapproving superiors in mind), he framed the work as a spontaneous response to a pressing need rather than as a new space for radical action.

Either way, accompanying AIDS patients was a next step from his bedside visits at St. Rose's on the Lower East Side. And it was an occasion for writing—a kind of rhetorical reportage, which he entered into a journal rather than publish right away: "Luke's hospital room was altogether familiar. I could have entered it blindfolded." Luke, too, was grimly recognizable: "A face pressed by an unseen hand into a new form, new contours of bone, cheek, socket . . . I thought not of death but of Yeats and 'the face I had before the world was made.'"

Luke's parents were there, then and in the days afterward, and Berrigan, in the journal, put himself in their place: "As far as could be judged, there was no God around to tell them the score . . . There was only ruin, disaster, blighted hope.

"And the priest standing there, what of him?"

Seeing himself through their eyes, Berrigan recognized that he, too, was walking in darkness, in a world where the signs of divine presence

were cryptic at best. "He knew nothing of the why of God, or the why of AIDS. And he came to the hospital, and stood with the parents and their dying son. There was a strange kinship here, of ignorance. He knew nothing as they knew nothing; or as near nothing as to make no difference."

The situation put him in the face of a merciless God: "the God of silence, of turning aside . . . who bore with extermination camps and torture rooms and the disappeared." It turned him away from trying to answer the question of why, and toward acccompanying them, mother, father, son, and trying to "frame the question aright" in the process. "Have You really abandoned us, left us to our sorry resources and sorrier outcomes? Or are You really here, in our midst, helping us to find our way together?"

Luke was discharged from the hospital, and Berrigan visited him at his apartment in Chelsea. Luke was a chef, trained in France. They shared a wedge of Brie, and Luke told Dan about his efforts running a restaurant in Brooklyn. A few days later Luke was back in the hospital, and they both knew he would not be discharged. Dan kept visiting. One day he arrived as a nurse lectured the patient—a French chef—on how to put butter on his chicken. "She departs. We grin like two goblins in the night." Another day he showed up and found Luke sleeping. "His poor sunken eyes opened and slowly focused. I was wearing a white shirt, Indian fashion, against the heat of the season.

"'Good God,' he quipped hoarsely. 'That beautiful shirt! I thought for a moment we'd both made it.'" To heaven, he meant; he was near death. "Within days he was in better hands than ours."

As more men in New York City were diagnosed with AIDS or showed symptoms, Berrigan spent time with them. He took the subway from the Upper West Side to the West Village to sit alongside them at the St. Vincent's AIDS hospice or visit them at their apartments— "arriving with flowers or cookies, books, a milkshake, a container of clam chowder," Carl Siciliano, a gay man, a Catholic Worker, later wrote. Those strong enough to get around were invited to the weekly group meal at the West Side Jesuit Community.

In time Berrigan preached at Masses organized by Dignity at St.

Francis Xavier, a short walk from St. Vincent's. And yet in his AIDS work he sought to downplay his presence as a priest, and a renowned one. He thought of himself, rather, as a "listener of last resort"—"the one who is near enough, and distant enough to be trusted with matters generally held secret." (He added: "Invariably, the talk centers on memory and religious faith.") He would present himself as a Catholic cleric, albeit without collar or stole, and would make himself present to the pain, the anger, and the grief of dying men whose suffering was made worse by the contempt of so many in the Church.

In this way the most notorious priest in the United States went underground again.

Berrigan spent much of 1985 in South America as an adviser to *The Mission*, a movie about Jesuit missionaries in the 1740s. He went on location in the rainforest to give spiritual direction to Robert De Niro, Jeremy Irons, and Liam Neeson (and to play a small role). While there, he read *One Hundred Years of Solitude*, and found that its magic-realist effects made a "mockery of time." When he returned to New York, all but one of the men with AIDS he had accompanied had died. "I was like a stunned calf, hearing the news: name after name, all gone . . . Had I been away fifty years or five months?" AIDS, taking the young so swiftly, was a mockery of time.

The Archdiocese of New York, for its part, carried on with a two-handed approach. On the one hand, Cardinal O'Connor spoke approvingly of the efforts being made at St. Vincent's and at St. Clare's, in midtown; he would go to St. Clare's for a couple of hours on a weekday to visit the bedsides of people with AIDS. On the other, he took a hard line against gay people in the Church. He joined a Vatican effort to remove John McNeill from the Jesuits. And he engaged in open conflict with Fr. Bernard Lynch, founder of the archdiocesan AIDS ministry, who had been named to a mayoral task force on AIDS. Fr. Lynch's efforts drew attention at the school where he taught, Mount St. Michael's Academy, in the Bronx: some faculty members sponsored a group called SAFE—Students Against Faggots in Education. After Lynch expressed

his support for the city's executive order upholding gay rights over O'Connor's opposition, he was forced to resign, and in 1985 the archdiocese began an investigation into him.

The Catholic conflicts over sexuality involved the same questions that had shaped the anti-war movement, and that had animated the life of the Church since the second Vatican Council: questions of authority and individual conscience, of collective belonging and personal calling. The old dualistic energies were going into fresh controversies, the hierarchs again dividing the world into two sides.

Daniel Berrigan's turn to AIDS patients was a recognition of this change. An old soul, he could see the change coming—the running controversy over freedom and domination going into new forms, the lines drawn between hierarchs and radicals over sex the way they'd been drawn over nonviolence and anti-war actions in the sixties.

The Daniel Berrigan who accompanied men with AIDS was the opposite of a controvert. At St. Vincent's, he moved freely between two sides: a radical priest among compliant Catholics, a gay-rights sympathizer among scornful relatives. "Most of the ill at St. Vincent's are Catholic. Gay and Catholic. No news to anyone, the official church atmosphere toward their kind is a very whiff of brimstone . . ." he wrote. "Especially when the church, again and again, traces a blessing (powerful big medicine this) on the ingrained phobias of Irish or Italian or Polish or German (or anything) Catholicism.

"They gather about the bedsides of their stricken ones: parents, sons, daughters, brothers and sisters, lovers, wives. Sorrow, disorientation, anger, fear, dread of the unknown. The lovers have it hardest of all, making their unsteady way through the gauntlet of church, state, family, neighborhood, job, housing, life in sum; including the feral looks laid on them from the corner deli.

"And then, as if this weren't enough, in comes this priest—about whom, if one has ear to the ground, one has heard a few things. So what good can come of this?"

6

THE CITY IS BURNING

Those old souls with their dark imaginings were outsiders and doom-sayers in the culture at large.

In 1986 the United States was riding high—in the estimation of the people who ran things, at least. Ronald Reagan, campaigning for re-election in 1984, had made the Puritan forefather John Winthrop's image of "a city upon a hill" into an image of American superiority; and when he was elected to a second term, winning 58 percent of the popular vote, the margin of victory suggested that millions of people found the image attractive and persuasive. Reagan had originally evoked a city on the Potomac, but as he and his speechwriters firmed up their rhetorical opposition to the D.C.-based federal government, the "shining city" came rather to resemble Manhattan: "a tall, proud city built on rocks stronger than oceans, wind-swept, God-blessed, and teeming with people of all kinds living in harmony and peace; a city with free ports that hummed with commerce and creativity. And if there had to be city walls, the walls had doors and the doors were open to anyone with the will and the heart to get here."

A citadel of capitalism, immigration, the arts, and human striving: Tom Wolfe registered this sense of Manhattan in the novel he was writing. "Just think of the millions, from all over the globe, who yearned to be on that island, in those towers, in those narrow streets!"

his protagonist, Sherman McCoy, exulted; ". . . the city of ambition, the dense magnetic rock, the irresistible destination of all those who insist on being *where things are happening . . .*" Wolfe's Manhattan circa 1986 is indelible: investment bankers strutting like Masters of the Universe, squeegee men acting as shakedown artists, a stylish Black minister turning up the racial heat in Harlem and the South Bronx, while ordinary people traversed the city on subways scarred with graffiti.

In that moment, Christianity was also riding high. A Gallup poll found that Mother Teresa of Calcutta was the woman Americans most admired. The Catholic bishops, having drawn headlines with their pastoral letter on war and peace, were drafting one on economic justice. Big-city archbishops—James Hickey in Washington, Joseph Bernardin in Chicago, Rembert Weakland in Milwaukee—had credibility in the parishes and beyond. The Moral Majority—political arm of Rev. Jerry Falwell—was one of the most powerful lobbies in Washington. Pat Robertson, Robert H. Schuller, Jim Bakker, and Jimmy Swaggart—fundamentalists all—drew huge daily audiences on cable TV, making "televangelism" a cultural phenomenon.

Wolfe recognized the moment's religious charge. Cryptically, he drew the title of his novel he was writing from the annals of religious controversy. "The bonfire of the vanities" came from Savonarola, archpriest of the Inquisition in Italy, who heaped the playthings of the citizens of Florence in a piazza and set the tower of pleasure alight.

A shining city upon a hill . . . riding high . . . but in that moment, anno Domini 1986, the economy was about to peak . . . was riding for a *fall*! And Christianity was likewise about to be brought low by controversies . . . *of its own friggin' making!!!!*

The U.S. bishops were facing an internal controversy. The trial of Gilbert Gauthe, the priest charged with molesting, assaulting, and raping several dozen boys and young men, had gone forward in Lafayette. Jason Berry's reportage for *The Times of Acadiana* and the *National Catholic Reporter* made people angry—at him. As the *Times of Acadiana* stories ran, the Church in Lafayette urged readers and advertisers to boycott

the paper. Fr. Gauthe was found guilty and sentenced to twenty years in prison.

What had happened in Louisiana had happened in the Church throughout the world in the previous decades—wherever Catholicism was deeply rooted, and in places where it was not. Priests had molested, assaulted, and raped boys and young men, and bishops had concealed the priests' acts or dealt with them ineffectually, if at all. An editor at *The Times of Acadiana* asked, "How many tragedies, written in Latin, lie in musty vaults or have gone to the graves of bishops with scandals hidden in their heads? Four months ago I'd never have dreamed of asking such questions. Now I have no choice but to wonder."

Berry's stories were followed by stories in *The Washington Post*, on *60 Minutes*, and in *The New York Times*. ("We don't want to give the impression that it's a rampant problem for the church, because it is not," a spokesman for the U.S. bishops told the *Times*. "But even one case is too many.") Rev. Thomas Doyle, a Dominican friar trained as a canon lawyer and on staff at the nunciature, or embassy, in Washington, wrote a lengthy internal report insisting that priestly sexual abuse *was* a problem the bishops needed to address—but he framed it as a problem of financial liability and public relations rather than a matter of right and wrong. Through channels, Doyle made the report known to John Paul II and Cardinal O'Connor—the two figures with the greatest influence on the Church's approach to sexual morality in the United States.

Meanwhile, tens of thousands of young men who had been violated sexually by priests were coming of age—their experience of God and faith and Church disfigured by acts left unspoken out of shame that ought to have been felt by the perpetrators. Priestly sexual abuse made the young survivor a controvert, putting the spirit of devotion at war with the fact of violation. And it made the survivor's dealings with the Church fearful and tentative—made keeping one's faith to oneself a means of endurance and integrity.

In the phenomenon of clerical sexual abuse and cover-up, many of the suppressive aspects of Catholicism converged: Catholics' inability to speak frankly about sex, priests' unwillingness to speak ill of one

another, victims' shamed reluctance to tell others what had happened to them, bishops' insistence that the conduct of clerics was an internal matter, and the Church's application of pressure on law enforcement and the press to keep matters involving priests, sex, crime, and punishment out of the public eye—on the grounds that open discussion of priests' "peccadilloes" would be tawdry and vulgar.

In 1986 Fr. Gauthe's crimes were seen as an isolated case, but in retrospect it's clear that abuse and cover-up were already affecting American Catholic life profoundly. At a moment when the bishops had unprecedented power and influence in American public life, their wish to suppress, deny, explain away, and justify widespread criminal sexual misconduct in their ranks put them on the defensive. It prompted them to turn their energies away from matters of war and peace, of justice and inequality, and onto matters of sexual morality. And it led them to try to manage complex questions of human sexuality rather than ponder them. In effect, the bishops sought to defer and evade the inevitable controversy over sexual misconduct by priests, and the challenge to clerical authority it would bring, by shifting attention onto the sexual conduct of everybody else. And they transferred the fear and anger the controversy aroused in them onto a different controversy—the one involving the Church and people with AIDS.

AIDS was now recognized as a public health problem. *Time* and *Newsweek* had run cover stories the same week, the previous August: *Time*'s cover called attention to "AIDS: The Growing Threat" over a close-up of a blood cell, while *Newsweek*'s gave a summary alongside a photo of the actor Rock Hudson, the first celebrity to die of the disease: "New fears are growing that the epidemic may spread beyond gays and other high-risk groups to threaten the population at large."

The public health approach enabled the press at once to give the necessary attention to AIDS and to cast it as something other than a disease mainly affecting gay men. Statistics indicated that more than 14,000 people had AIDS, 70 percent of them gay or bisexual men, a

third of them in New York City, and that more than 6,000 had died of AIDS (more than a third in the city). But President Reagan had not mentioned the disease, and it was not recognized as an epidemic—only as the "gay plague."

A number of individual Catholics responded to the gravity of AIDS, as Michael O'Loughlin has established in a his book on the Church and AIDS. In San Francisco, the Church of the Most Holy Redeemer in the Castro district (where dwindling numbers of Italian Americans had made it a parish for "the grays and the gays") had set up a hospice of sorts in the parish hall, with the approval of the archbishop, John Quinn. A priest in "Boystown" on Chicago's North Side had organized the Pastoral Care Network with nearby Protestant churches. Two consecrated religious women—nuns—had set up hospice-style care for a few patients in Belleville, Illinois, near St. Louis; Good Samaritan House in Kansas City ran a six-bedroom hospice under the auspices of Catholic Charities. Dignity had chapters in dozens of cities; as members were overtaken by AIDS, other members sustained them informally and held Masses for them.

The Saturday-night Mass that Dignity's New York chapter held at St. Francis Xavier was drawing several hundred participants. Dignity members helped to establish the Gay Men's Health Crisis and supported the new group with a substantial donation. One of GMHC's town-hall-style meetings about HIV was scheduled for the parish hall at St. Joseph's, a Catholic church at Sixth Avenue and Waverly Place; when six hundred people showed up, the meeting was moved to the church itself, one of the oldest and loveliest in the city. Meanwhile, Fr. Bill McNichols, the Jesuit artist, had begun celebrating a monthly Mass for Persons with AIDS at Our Lady of Guadalupe, a chapel tucked mid-block on West Fourteenth Street—the oldest Spanish-language church in the city. Flyers featuring his calligraphy made clear that families and friends were welcome. Thus the devotion of Mexican Americans, outsiders for decades in Catholic New York, was joined to the suffering of the outsiders who were gay Catholics.

All that was in parishes in lower Manhattan. There were five

hundred parishes in the city, however, and Cardinal O'Connor's op-position to the gay rights bill in the City Council had set the tone for Catholic New York's dealings with gay people. O'Connor seemed not to grasp that to crow about providing care to gay people while declaring their "lifestyle" immoral struck many people as flagrantly uncaring, and seemed annoyed that the Church's efforts to work with patients weren't lauded and credited to him specifically.

The efforts themselves were clumsy. Shortly after *Time* and *Newsweek* ran their cover stories, the archdiocese announced that it would establish a "shelter" for patients at the Church of the Holy Name of Jesus on West Ninety-Sixth Street. The shelter would be staffed by members of the Missionary Sisters of Charity—Mother Teresa's order—who cared for indigent and dying people in India and elsewhere. Then parishioners objected, threatening to keep their children home from the parish school (where they might catch AIDS), and their protests were given wide play. The archdiocese halted the project right away—oddly, because Cardinal O'Connor usually didn't take the wishes of ordinary Catholics into account when making policy decisions. Two weeks later, parents in Queens kept their children home from a public school where a second-grader had contracted AIDS, prompting front-page stories in the *Post* (AIDS FUROR) and the *Daily News* (AIDS BOYCOTT) and another *Newsweek* cover (THE FEAR OF AIDS).

O'Connor turned the public scrutiny into an advantage. In late October he joined dozens of world leaders at the United Nations for a screening of a new film about Mother Teresa and a speech by Teresa herself. During the event, Teresa made reference to an AIDS hospice she was opening in the city. A few days later the *Times* reported that the lightly used rectory of St. Veronica's, a church on Christopher Street—the main street of the West Village—would soon be a hospice operated by the Missionaries of Charity. On Christmas Day O'Connor and Mayor Ed Koch opened the hospice with a press conference alongside Mother Teresa, who was wearing Ray-Ban sunglasses along with a veil after recent eye surgery. The hospice, called Gift of Love, would be owned by her order and funded through private donations. "Thank

you for publicizing this," O'Connor told the press. "We want people to know that we're trying to help, regardless of their religion or their moral beliefs or anything of that sort." He added: "We hope that what Mother Teresa and others are doing will help lead the way and show that it can be done," insisting that "it's a much bigger problem than we'll be able to deal with at the moment."

In effect, O'Connor had dealt with the "problem" of AIDS by outsourcing it to the figure the UN secretary general had called "the most powerful woman in the world."

Gift of Love had fourteen beds, and began with a single patient from St. Clare's who was joined by the three men furloughed from Sing Sing prison. Its effect was as much symbolic as practical: it made the Catholic Church's response to AIDS present in the heart of the gay community. And yet it shifted the focus away from gay men and toward "spiritual comfort" for dying people, away from the archdiocese and onto private charity, and so left the Church's commitment to AIDS relief open to question.

Meanwhile, the "supportive care program" at St. Vincent's Hospital, run by Patrice Murphy, a Sister of Charity, cared for several dozen AIDS patients at any one time. As the location of St. Vincent's made its emergency room the first stop for many men with AIDS, its policy of turning away no one (not even the uninsured) made it the hospital of last resort. "Once you came into the ward, it was like you stepped into another place," a nurse who trained there recalled. "There was warmth and love and compassion." And yet the encounter of men with AIDS with the staff of New York's flagship Catholic hospital was full of conflict. There were long, anguished waits for beds; there were men on gurneys parked in the hallways. There were diatribes against the Church; one patient took a crucifix off the wall and urinated on it. Men making bedside visits to their sick lovers were discouraged from touching or kissing them. Men discharged from the ward were given condoms on the sly, in defiance of Catholic teaching against the use of prophylactics—and against sex among gay people generally.

No amount of supportive care could undo the grim finality of the

disease. A long-awaited bed at St. Vincent's was often a deathbed. The West Village, and the gay community, was stalked by death—in apartments, in restaurants, on the street—and the imminence of death gave encounters with men who had AIDS the character of last rites.

AIDS was the shadow side of Manhattan in 1986. The economy was roaring; so was the art scene, as the stock market flooded the art market with new money seeking status and self-expression—and the new money settled on works of art as inscrutable as the financial derivatives that investment bankers had deployed to make it.

Andy Warhol was at the center of the scene, and his social life just then (recorded in his diary) reflected a level of celebrity unusual even for him. He spent time with younger artists—Keith Haring, Kenny Scharf, Julian Schnabel—who looked to him as a savvy elder. He went to the wedding of Madonna and Sean Penn, collaborating with Haring on a gift, a hand-decorated silk screen of the *New York Post*'s covers in the days after photographs of Madonna in her teens were published in *Penthouse*: MADONNA ON NUDE PIX: SO WHAT! and MADONNA: I'M NOT ASHAMED. He went to the wedding of Maria Shriver and Arnold Schwarzenegger ("There was the biggest crowd I've ever seen around a church"). He went to a dinner Yoko Ono gave for Bob Dylan, and one Nabisco gave for the seventy-fifth birthday of the Oreo cookie.

And he went to church, still keeping the vow he'd made after he pulled through on the operating table. Some Sundays he went to Mass at St. Vincent Ferrer on Lexington Avenue—where the congregation was flecked with gay men from the art and fashion worlds, such as the Chanel designer Adolfo ("Went to church and saw Adolfo and felt a little hurt because he walked right by and didn't say hello"). Others he ducked in for a few minutes. Sometimes he went straight from his town house to the Chelsea flea markets.

On Easter Sunday 1986 he joined three friends at the Church of the Heavenly Rest—an Episcopal church on upper Fifth Avenue, across from Central Park—to lend a hand distributing lunch to the poor, as

they'd done the previous Christmas. His account in the diary is a series of non sequiturs: ". . . a lady had her teeth in a napkin and the guy went to clear it away and she got excited. It was a lot of hard work. Wilfredo was good, he handed out the ham, he worked hard. They used six of those restaurant urns of coffee. And the four of us prayed and we saw a lady bring in a potted plant and trade it in for one of the better ones there."

And the four of us prayed: that remark comes as a surprise—a reminder that Warhol's religion wasn't an act. A different diary entry has the same effect: "I puttered around and then went to church, and while I was *praying*, this guy comes over to sell me a $100 raffle ticket. Can you believe that? For the church. He forces this ticket on me and it's this queeny decorator and then I hear him back there telling somebody that he just sold it to me, and I think he was actually getting rid of *his* ticket that he bought and didn't want . . . He said, 'I hate to disturb you while you're praying, but . . .'" Warhol's sense of religious observance was strong enough for him to be upset when it was violated.

Although the art market was booming, the art community was already fallen, as one artist after another was overtaken by AIDS. Warhol had made a collage incorporating a snippet of the *Post*'s AIDS FUROR headline, and his nightlife brought him into regular encounters with men who had the disease. Madonna, whose popularity on MTV made her the pride of downtown, headlined a benefit for AIDS relief at the Pyramid, the nightclub on Avenue A; Calvin Klein hosted one at the Javits Center on the West Side. Warhol went to a show of new couture from Perry Ellis, "and at the end there was a pause and they carried Perry out. And some people were crying; they said he had AIDS." A friend called to say that Mario Amaya, who'd been shot alongside him at the Factory in 1968, had died of AIDS. The dealer Alexander Iolas, who was in and out of New York, phoned from the airport to say he'd be at the Factory in twenty minutes—"and he *was!*" Warhol marveled, ". . . and he looked pretty bad." Iolas had AIDS.

The Milan show that Iolas had commissioned was due to open in November, and Warhol had been working intermittently toward it. Iolas's visit was a reminder that the deadline was looming; as the Warhol

curator Jessica Beck has proposed in a pathbreaking essay, "the commission . . . became a near-obsession for him."

One approach Warhol took to *The Last Supper* involved deriving a screen print from the etching (which had been mounted and cropped with masking tape) and applying it to canvas with black paint. The image, like Leonardo's, was broadly horizontal. Sometimes he screened colors onto it: pink, yellow, or variously colored vertical bands like a set of light filters for a camera. Sometimes he combined it with a camouflage pattern he'd been using in a series of self-portraits. Sometimes he multiplied it—as in the one called *Sixty Last Suppers*, akin to the multiplied images he'd done in the sixties. With Jean-Michel Basquiat, who had progressed from notoriety to renown, he made ten full-body Everlast punching bags with the visage of Leonardo's Christ screened in black onto each and offset with the word JUDGE in scabrous strokes from Basquiat's brush.

A constant in these silk-screen works is the flatness of the figures. The pictorial depth that is a crucial aspect of Leonardo's *Last Supper*—perspective going to a vanishing point at the back of the room—is gone. What remains in Warhol's *Last Supper*s is the tableau of Christ in the center and six apostles on each side. The flatness has the effect of giving equal emphasis to Christ and the apostles.

The focus on human faces is typical of Warhol, who put individual people into his work as often as any postwar American artist (along with Alex Katz and Chuck Close). In other ways, these works are a departure for him. For one thing, they make use of religious imagery rather than images from the mass media. For another, the central figure in them—Jesus Christ—has his eyes cast down and away. Liz, Marilyn, Elvis, Mao, Mick, Bianca, the Shah of Iran: all face the viewer directly, eyes wide open. But the Christ of *The Last Supper* withholds his gaze. He is an anti-icon, and the flattened, inked-up silk screens shift the attention away from him and onto the scene as a whole.

The change was profound. Leonardo's *Last Supper* is art in which religious art and popular art come together as never before or since. It is art in which a group of men come together and have a meal in the knowledge that one of them is going to die soon. In Warhol's handling,

it became a work of social commentary. At a moment when several thousand men in New York City had HIV; when the Manhattan art calendar was thick with events to benefit AIDS relief; when among gay men any meal with friends could be the last; when men in Warhol's circles, his age or younger, were dying of AIDS one by one: at that moment, Warhol was making *The Last Supper* contemporary and topical.

Like Warhol, Leonard Cohen was making new work that dealt with the AIDS epidemic.

The two men were outwardly so unlike each other that it was easy to forget Cohen had first come onto the American scene among the Warhol denizens at the Hotel Chelsea. In 1986 the one man was the very image of the Pop artist, the other struggling to find a fresh audience; one was gay, practically celibate, affectless, and flip, the other straight, passionate, sexually ardent, and self-serious about the "predicaments" his work dealt with. And yet Cohen, like Warhol raised in a tight-knit religious community with roots in Eastern Europe, was also a consecrant of cultish energies aswirl in society.

An article he'd read about the disease and its inevitable end gave him a title: "Ain't No Cure for Love." The finished song (which Cohen co-wrote with his friend Sharon Robinson) doesn't refer to AIDS or gay men, not even obliquely, but one verse captures the age-old drama of being in love in a way not sanctioned by the clergy. Sounding like Bob Dylan or Lou Reed, Cohen speak-sings: "I walked into this empty church, I had no place else to go / When the sweetest voice I ever heard whispered to my soul / I don't need to be forgiven for loving you so much . . ." Ain't no cure for love: There's no need for forgiveness because—as "scripture" and "blood" both make clear—authentic love is not freely chosen. It is contracted like a disease.

Cohen was out of the public eye in 1986, pursuing what he called "the voluptuousness of austerity": sometimes in Paris, sometimes in Montreal, and mainly in Los Angeles, sometimes living at the monastery and other times going there for morning zazen (three-thirty a.m.)

from his apartment nearby. He was busy writing: weeks spent working on a version of Federico García Lorca's poem "Little Viennese Waltz" for a tribute album called *Poets in New York* nearly overwhelmed him. And he was trusting in his sense that his words would represent him in the world. Jennifer Warnes's record (made with top session musicians) was done and due out, and he sent her a line drawing he'd made: JENNY SINGS LENNY, over two hands holding a lit torch as it is passed relay-style from one person to another. With the record, *Famous Blue Raincoat*, his songs would be in other people's hands more fully than at any time since Judy Collins and Joni Mitchell had hit records with his songs in the sixties.

Lately, too, he'd seized the opportunity to foreground his words through interviews. He'd always given interviews, but in the eighties they became occasions of brilliant, searching, wry self-exegesis. And the publication of the psalterish *Book of Mercy* had led him to speak in frankly religious terms. The book, he told one interviewer, was "a book of prayer and it is a kind of conversation." Six months later he told a different interviewer that the book was "the result of a certain kind of place that I found myself for three or four years when I felt the need to look into my own traditions and scriptures and roots." The poems themselves were prayers: ". . . in the midst of the writing, the prayer is answered and that's when the psalm ends—when the deliverance comes." The whole process is an effort to create words "designed to last forever," he said, "an attempt to speak from the deepest place."

In the latter interview he set out a view of human experience rooted both in Buddhism and in Western religion: ". . . we sense that there's a will that is behind all things, and we're also aware of our own will, and it's the distance between these two wills that creates the mystery that we call religion. It is the attempt to reconcile our will with another will that we can't quite put our finger on, but we feel is powerful and existent. It's the space between those two wills that creates our predicament."

Rising to the topic, he went further: "Somehow, in some way, we have to be a reflection of the will that is behind the whole mess. When

you describe the outer husk of that will which is your own tiny will—in all things mostly to succeed, to dominate, to influence, to be king—when that will under certain conditions destroys itself, we come into contact with another will which seems to be much more authentic. But to reach that authentic will, our little will has to undergo a lot of battering."

His sense of the term *various positions* (taken from yoga) applied to this process: "The various positions are the positions of the little will." And his sense of himself is as one of those "little wills" interacting with other wills from one moment to the next: ". . . I don't have any ambitions toward leading a religious life or a saintly life or a life of prayer. It's not my nature. I'm out on the street hustling with all the other wills."

That interview is the key to the work he was making: the poems in *Book of Mercy*, the songs on *Various Positions*, and the songs he had written since then. His aim as an artist was to be aware of the breakdowns and batterings in his interior life and to gain access to them through art—whether through a "Sunday school" effort like *Book of Mercy* or through songs that would speak from deep places of brokenness and despair.

He later explained his way of working—his vocation—in biblical terms: "You're just living your own life and where do you go when you want to speak? Where do you go when you want to sing? You have to find where the well is, or where the food is, and when I'm hungry or thirsty I try to find where to go so that I can eat and I can drink. And I often go to places where the landscape is burning, where the city is burning, where the sea is coming over the shore. That's where I go to eat and where I go to sing." Ordinary life is imprisoning: "Maybe I should stay there and not speak, and not sing. But when I want to sing I have to go where the sea is flooding, where the city is burning."

In 1986 the burning city was an everyday image: in Dublin (car bombs detonated by Ulster loyalists), on the Irish coast (an Air India jetliner blown up by Sikh terrorists en route to London), in Madrid (car bombs set by Basque separatists), in Rome (Islamic cultural center, destroyed by arson), in Paris (bombs in the Champs-Élysées, the Latin Quarter, a shopping center, a post office), in Berlin (a bomb in a disco),

in London (bombs in travel offices and news agencies), in Beirut (bombs at banks and embassies), in Jerusalem (bombs in restaurants and on buses), in Istanbul (a synagogue set afire during services), and in New York (firebombs at Lincoln Center and the Metropolitan Museum). In Chernobyl a nuclear reactor exploded, releasing plumes of toxic radiation. But the urban calamity that seized Cohen's imagination was AIDS, which was burning through the gay communities in New York, San Francisco, and Los Angeles, and he brought the dread and resignation prompted by the disease into a song.

The song is "Everybody Knows." Unlike most Cohen songs—in which music and lyrics arrived together, he explained, like "Siamese twins"—this one started as a set of written lyrics only. "Everybody knows that the dice are loaded": the song begins at the end and stays there, working through the various unfairnesses of things—"the poor stay poor, the rich get rich," for one—and then turns personal and sexual, as he recognizes that, sure, his lover's been faithful "give or take a night or two."

The song evokes the questions then in circulation in the gay community (and in the press about AIDS), as men were compelled to ask one another what they'd done and with whom and when and how. Then it becomes explicit, even controversial. "And everybody knows that the plague is coming / Everybody knows that it's moving fast / Everybody knows that the naked man and woman / Are just a shining artifact of the past . . ." So many endings are caught in those lines: the ends of lives due to AIDS, and the end of a way of life in which sex was social and the act itself uncomplicated, without "the meter on your bed" tallying partners and precautions taken.

To that point, the song registers the end of the worldly demimonde— but in the last verse Cohen stretches toward the religious. The lines "Everybody knows what you've been through / From the bloody cross on top of Calvary / To the beach at Malibu" are a compact autobiography, ranging from his Los Angeles present back to Montreal (where the mountain at the heart of the city is topped by a giant cross). And the last set of lines renders the plague as a global calamity—a "sacred heart" about to burst.

"Everybody Knows" is the latest of Cohen's various positions. Three decades after he'd made "Story of Isaac" a parable about the war in Vietnam, he speaks from "the deepest place" in a topical song, identifying the plague of AIDS with the human condition. The song is a tutorial in crypto-religiosity. Calamity calls forth a biblical sense of last things. Belief tamped down or left behind surges again—the sea coming over the shore—in response to sickness and death, war and plague and natural disaster, as if these ancient prompts to collective belief reassert themselves in us individually, or as if religion alone offers the means to respond to them: righteous anger, lamentation, a prayer for release—or, in "Everybody Knows," nothing-new-under-the-sun resignation.

In that moment Czesław Miłosz was focused on last things in the most literal and personal way. In April 1986 his wife, Janka, whom he'd known since 1937, died after a decade with Alzheimer's disease.

Her body was cremated, as per her wishes. In "On Parting with My Wife, Janina," Miłosz renders the rite, controvert style, as a conflict between the pagan and the Christian in him, the skeptic and the believer. In other poems, he had depicted the Nazi crematoria as the machinery of mass death; here, the fire of cremation is a force of existence prior to history and culture: "Elemental, pure, from the beginnings of the Earth." Magus-like, the pagan in him ends the poem by bidding the broken-down elements to reassemble themselves in some hereafter, while the Christian in him is just bereft: "Do I believe in the Resurrection of the Flesh?" he asks. "Not of this ash."

Janka's death was a loss but also a release. Spring came. *Unattainable Earth* was published in English translation (the *Times* gave its Sunday review the headline "Garden of Amazing Delights"); and after the term at Berkeley was finished Miłosz left California for Europe. He had been invited to meet John Paul II in a private audience at the Vatican.

His preoccupation with the future of Western civilization was now front and center, and he set it out in an interview in *The New York Review of Books*. He assessed Western society in terms akin to those of

the Catholics in the Reagan administration who were enthralled with John Paul. He saw Soviet communism as representing the takeover of Eastern European societies by the state, a process that was now being replicated in Latin America. He saw religion in the Soviet bloc as a form of civilized opposition. And he thought of the ravaging of Eastern Europe as a warning to the United States, where the stress on "freedom" and "creativity" had led to "an indifference to basic values," and where campus life was shaped by impiety verging on nihilism. "I have been witnessing in America the subversion of the ethic of the working class which was God, my country, my family," he said—reminding the reader that he was no liberal.

"As to the causes for all this, one can go back infinitely," he went on. "I link it with a very profound transformation as far as religious imagination is concerned." The prevailing image of human life had changed: it had been stripped of "the religious dimension." The loss of civic piety in the West was a consequence. So was "the mass participation of the Poles in religious rites today." He explained: "One can say . . . that religion is popular [in Poland] because it marks political opposition of the nation to the state. But there is more than this. Nonbelievers and believers alike take part in the pilgrimages because they share the same notion of good and evil . . . This affirmation of basic values of good and evil brings people together."

Where Miłosz stood apart from the Catholics in the administration was in his analysis of what was to be done. He didn't call for a restoration of traditional religion—which he suggested wasn't possible. Rather, he stressed the need to give sustained attention to the changing nature of the religious image: "I consider that both believers and nonbelievers are in the same boat as far as the difficulty of translating religion into tangible images," he said. "Or maybe we can say that the transformation that is going on in religion" was a sign that society was on the verge of fundamental change.

With all this in mind, he saw the crypto-religious artist as called to create patterns of reverence—and thus to transcend the simple opposition between subservience and rebellion. "I feel that everything depends on whether people are pious or not pious," he said. "Reverence toward

being, which can be formulated in strictly religious terms or more general terms, that is the basic value. Piety protects us against nihilism."

In a poem written a few months earlier (called "1945"), Miłosz had contrasted the café nihilism of the artistic avant-garde with his own instinctual piety. World war had exposed lofty modernist ideas as "illusions" and had left "a flat, unredeemed earth" where moderns feared to tread. It had left Miłosz "alone with my Jesus Mary against irrefutable power, / A descendant of ardent prayers, of gilded sculptures and miracles."

The passage is rooted in Miłosz's view of the crypto-religious artist as the true avant-gardist. The syntax is cryptic (the conjoining of "Jesus Mary," the pairing of "sculptures" and "miracles"). But the sense of such an artist's vocation is clear. This artist is solitary, fixed on imagery and ritual more than on ideas or social structures, appearing to others (and to himself) as at once "ridiculous and rebellious."

Miłosz's account of his position found sympathetic readers at the Vatican, where John Paul II and the Roman Curia saw the Church as the citadel of reverence and protectress of "the religious dimension" against state-sponsored barbarism.

In Rome, Miłosz went past the Swiss Guards and through the bronze doors to the Apostolic Palace, where the pope—unperturbed by Miłosz's doubts—welcomed him as a kinsman. After greeting Miłosz warmly, John Paul spoke extempore about his writing: the 1955 novel *The Issa Valley* and the recent "Six Lectures in Verse"—in which Miłosz, "an instructor in forgetting," surveys the twentieth century with a critical eye. (Lecture V ends: "We plod on with hope. And now everyone / Confess[es] to himself: 'Has he risen?' 'I don't know.'")

They spoke in Polish, the poet more formally than the pope.

Miłosz: "All my intellectual impulses are religious, and in that sense my poetry is religious. Also—and perhaps this is the same thing—it is pro Life and against Nothingness. Although, if we are speaking of Christianity, it is consistently couched in terms of yes and no."

John Paul: "You always make one step forward and one step back."

Miłosz: "Can one write religious poetry in any other way *today*?"

The audience concluded, Miłosz stayed on for several days in Rome, writing poems. It was a significant moment in his life. His wife had

died. His work, long disparaged by Party authorities, had gained rec-
ognition in Poland and in Rome, center of the historic Europe he had
made his subject. After resolutely committing to the Polish language,
he had been celebrated by a great living Pole who was also the pope.
Poland was not yet free, but he was in a position of exterior freedom
corresponding to the interior freedom he had found through poetry.

He was still exploring the tensions between devotion and desire,
between the carnal and the spiritual; and in Rome he looked to the
frankly worldly Catholic art of the city as the realm where seemingly
opposed desires were reconciled.

In "Caffè Greco"—named for a coffeehouse near the Spanish Steps
where poets from Leopardi to Ferlinghetti had gathered—he exults in
the saints and martyrs the city enshrined in stone: "From them we take
the measure, / Aesthetic, I should say, of works, expectations, designs. /
By what can literature redeem itself / If not by a melopoeia of praise, a
hymn / Even unintended?"

The poem "How It Should Be in Heaven" evokes the city as an
earthly paradise: "How it should be in Heaven I know, for I was there. /
By its river. Listening to its birds. / In its season: summer, shortly after
sunrise."

For Miłosz in that moment, the things of the world are evidence
of heaven, and his love of finite things reveals a desire for the infinite:
"For how could the mind / Stop its hunt, if from the Infinite / It takes
enchantment, avidity, promise?"

In Rome he has had a taste of heaven. The heaven of the theolo-
gians, he allows, has its purpose, and yet he prefers the earthly paradise of
art, "owned by imagination." And in Rome the crypto-religious Miłosz
had encountered the manifestly religious figure of John Paul. The pope,
known for certainty, had seemed to fault him for his lack of certainty.
And yet he hadn't yielded. In Poland he had insisted that he was "not a
Catholic poet." Now he maintained a double outlook: one step forward,
one step back; one step toward heaven, one toward the native realm of
the "flesh-enraptured" artist.

Miłosz's point of view now looks like foresight: the poet sitting in sunny Rome, pondering infinity over a coffee; the poet typecast as a political agitator in fact standing aside from current affairs in favor of the grand themes—love, sex, death, beauty, imagination—that would return to the center as the Cold War ebbed and the world changed.

And yet in 1986 the Cold War world was ongoing. Poland was unfree, and Solidarity was an illegal organization, its leaders jailed or murdered by the state—as in the case of the freedom fighter Jerzy Popieluszko, a Catholic priest. In South Africa, Nelson Mandela and several cohorts in the African National Congress were entering a third decade in prison; when the ANC called a general strike, the apartheid government imposed a state of emergency. In the Soviet Union, Andrei Sakharov, the Nobel laureate physicist and dissident, lived under surveillance in a one-room apartment in Gorky; he had gone on a hunger strike to secure medical care for his wife.

In Czechoslovakia Václav Havel, released from prison in 1983, was trailed, spied on, and forbidden to leave the country. A series of interviews with a Czech counterpart in West Germany was done on cassettes sent through the mail; Havel "shut himself in a borrowed flat and came out with eleven hours of recorded answers." The book—*Long-Distance Interrogation*—was published in samizdat in the summer of 1986.

While in prison, Havel had turned weekly letters to his wife, Olga, into reflections on freedom and constraint, being and nonbeing, resignation and fanaticism. After 144 letters over three years, he concluded the sequence by setting out his worldview. It was centered on imagery of the crucifixion. "I think that religious archetypes accurately mirror the dimensions of this ambiguous essence of humanity," he declared, and went on: "Yes: man is in fact nailed down—like Christ on the cross—to a grid of paradoxes: stretched between the horizontal of the world and the vertical of Being; dragged down between the hopelessness of existing-in-the-world on the one hand, and the unattainability of the absolute on the other, he balances the torment of not knowing his mission and the joy of carrying it out, between nothingness and meaningfulness . . ."

Havel's interlocutor in Germany asked him about religion: Had he

converted to Catholicism? No, Havel said. He believed in Christ "figuratively (as an archetype of man)" rather than in the binding way of the Christian. His faith was general: "I believe that all this—life and the universe—is not just 'in and of itself.' I believe that nothing disappears forever, and less so our deeds, which is why I believe it makes sense to try to do something in life, something more than that which will bring one obvious returns."

In 1986 (the 450th anniversary of the death of Desiderus Erasmus) Havel was awarded the Erasmus Prize. Forbidden to attend the ceremony in Rotterdam, he sent a lyrical acceptance speech. Alluding to Erasmus's *Praise of Folly*, he asked: "Are you not here today honoring a fool? And through him dozens and hundreds of others, who by demanding that the unchangeable be changed do not hesitate to risk years of imprisonment and—what absolute folly!—oppose the gigantic power of the state bureaucracy and police with their puny typewriters?"

Havel's exaltation of political prisoners caught the mood of the moment. They were saints of resistance, rock stars of human rights; and in that moment, actual rock stars were bringing attention to their cause through a tour on behalf of Amnesty International.

The Conspiracy of Hope tour was U2's idea, and with it they took the benefit-concert spirit of Live Aid into their own hands. No longer were they up-and-comers. The tour was a last surge of upstart attitude. From now on the responsibility for the next steps—in rock music and in social commitment—would rest squarely on them.

Amnesty, founded in London in 1961, campaigned for the freedom of "the forgotten prisoners"—dissidents locked up and tortured by oppressive governments. It had been awarded the Erasmus Prize in 1976 and the Nobel Peace Prize the next year. Its logo, designed for a Christmas card, was a lit candle wrapped in barbed wire.

U2 learned about Amnesty through their manager, Paul McGuinness, who knew its co-founder secondhand, and they played a benefit show for Amnesty at Radio City Music Hall in New York during the *Unforgettable Fire* tour. There, they met Jack Healey, Amnesty's American director—a

missionary for human rights. Healey had trained as a Franciscan friar, been ordained, and spent three years as a priest before leaving the ministry in 1968 to do humanitarian work: anti-hunger campaigns, the Peace Corps, and Amnesty. Healey paid a call on McGuinness in Dublin in 1985 and left with a commitment for U2 to organize a week of concerts for Amnesty's twenty-fifth anniversary.

Bono, now twenty-five himself, had plunged into activism as a form of self-education. On tour in New Zealand, he'd befriended a Maori stagehand, Greg Carroll; had added him to U2's crew; and had grown passionate about Indigenous people's rights. Just after Live Aid, he'd joined several dozen artists in making *Sun City*—a record and video organized by Steve Van Zandt from the E Street Band to protest against apartheid in South Africa, epitomized by the whites-only Sun City resort. (In the video, shot in Manhattan—Washington Square, Central Park, Harlem—Black artists and white ones are shoulder to shoulder, including Bono: hands upraised, fist pumping, bearded face locked in an embrace with Prince Markie Dee of the Fat Boys.) That fall Bono and Ali spent a week in Ethiopia with aid workers and a week in El Salvador and Nicaragua, encountering peasant farmers "caught in the crossfire" of civil war. "The ideas of the revolution" in Nicaragua, he recalled, grandiloquently, "were, from my point of view, a coming together of many of my interests: Christianity, social justice, artists in power."

Back in Dublin, Bono phoned other artists, recruiting them to join the Amnesty tour. Paul McCartney, Mick Jagger, and Prince said no. Sting, Lou Reed, Peter Gabriel, Joan Baez, and the Neville Brothers (Bill Graham had suggested them) said yes. Arenas were booked, T-shirts ordered featuring Amnesty's yellow candle.

The tour was spread across two weeks in June. Bono and Jack Healey met the press before each of the six shows, setting out the aims of Amnesty and the names of prisoners whose release they sought—and setting the tone, at once political and spiritual. "Every press conference started with Aaron Neville singing 'Amazing Grace' a cappella," Bono recalled. "Seeing Aaron, who is the sweetest gentleman, but who looks like he could rip your head off, singing that melody in his falsetto voice usually softened up even the most cynical journalist. Then Jack Healey

would hit them between the eyes with one of his sermons. When he spoke about the plight of the prisoners of conscience he summoned up an intensity of moral outrage that only a true believer could achieve."

The shows themselves followed a similar pattern. The Neville Brothers played early, and then were joined by Joan Baez. These, the two oldest acts on the tour, were also the least well known to fans of U2, and yet spirits were involved through the pairing. Baez was the angelic soprano of sixties protest music: raised a Quaker, a star from age eighteen—when she sang spirituals with Odetta and Bob Gibson at the Newport Folk Festival—and a fixture at protests ever since, leading musicians and audience in "We Shall Overcome." The Nevilles, in their fourth decade, made twentieth-century Black music present in their hands and horns and voices.

Now they brought their traditions together and into the arenas through a sequence that worked variations on the spiritual. The Nevilles played their New Orleans classic "Hey Pocky Way" and "Everybody Better Wake Up," a reggae protest anthem that Cyril introduced as "a prayer for peace." Baez gave an a cappella recitation of Dylan's "The Times They Are a-Changin'" and led audience sing-alongs (backed by the Nevilles) of "Let It Be" and "No Woman No Cry." Then Aaron and Joan came together for a duet. It's "[something] I think you'll recognize," she tells the audience, and then sings the familiar first line: "Amazing grace—how sweet the sound . . ."

It *is* recognizable, possibly the only spiritual that people of every race and religion know well. It was composed in the late eighteenth century by John Newton, an Anglican minister who had been a slave trader and who then worked for the abolition of slavery. In the recorded era, Mahalia Jackson, Judy Collins, Aretha Franklin, and Al Green made it a standard. Baez sang it in concert dozens of times before recording it in 1976. Aaron Neville had claimed it as an emblem of his own mid-career resurrection.

On video, their anthemic duet is one of the unlikeliest performances of the eighties—and one of the most striking. The "barefoot Madonna" of the counterculture is forty-five, wearing a bright striped blouse, her hair in a tight period trim with a touch of gray. Aaron Neville has been

off to the side, in a sleeveless T-shirt and tight jeans, gazing straight ahead as he bangs a cowbell and adds harmonies. Now he joins Baez center stage. Always distinctive-looking, here he is especially so. His upper body is cut by weight work. His afro is hennaed and trimmed close, making the scar and the tattoo on his face stand out. His eyes are outlined in kohl. He has the look of an avatar, a reconciler of opposites: male and female, Black and white, devotion and desire.

They alternate verses—Aaron's falsetto, Joan's soprano—and then come cheek to cheek and hum the known-to-all melody wordlessly, Joan breaking into a smile. It's a stadium-size act of piety. "Amazing Grace" is an account of conversion—from blindness to sight, from darkness to light—told from the convert's point of view. It says that it's grace—not activism, not regime change—that sets us free. All this makes it an odd fit for a concert for prisoners of conscience. And yet it works. Simple, beautiful, familiar, unsullied by history or popularity, it joins the causes and acts of conscience to what Czesław Miłosz had called devotion in the broadest sense, present and available to all.

U2, who closed the show most nights, used their set to make a straight shot for transcendence. They played "Pride," "New Year's Day," and "Sunday Bloody Sunday." Each was greeted rapturously. But the heart of the set—seen in videos from the shows in Los Angeles and Chicago—was a long, loose, high-spirited improvisation.

The videos are grainy VHS transfers, and they make the performances seem intimate, even stealthy. Bono seems a man in costume: wavy long hair, fringed suede jacket, tight pants, pointy black boots—a hippie Robin Hood. Over a repeated bass riff and droning, feedback-dipped guitar, he stitches together lyrics from Dylan's "Maggie's Farm" and John Lennon's "Cold Turkey." He takes a white cloth and folds it and then wraps it around his head as a kind of biblical blindfold— making himself akin to a prisoner of conscience. He falls to his knees. He takes the blindfold off. He sings a couple of lines . . . Aha, he's singing "Help!"—turning a Beatles song into a spiritual—and the audience joins in. It sounds like a reprise of "Amazing Grace," with Bono finding the through line from spirituals to the sixties to U2's anthems of need.

The tour was on a loose schedule, and Bono and Edge used the off

days between shows to deepen their American roots. Bono was "reading Flannery O'Connor and Truman Capote. I was reading Norman Mailer and Raymond Carver," Edge recalled. "We had all fallen under the spell of America—not the TV reality but the dream, the version of America that Martin Luther King spoke about." Bono recalled reading Baldwin, Ellison, Ginsberg, Tennessee Williams, Sam Shepard, and Charles Bukowski. "I had this love affair with American literature happening at the same time as I became aware of how dangerous American foreign policy could be in the countries around it . . . I started to see two Americas, the mythic America and the real America."

They were now clued in to Robert Johnson, John Lee Hooker, and other foundational blues musicians. And they were listening—again—to Bob Dylan. Dylan was on the road with Tom Petty and the Heartbreakers—the *True Confessions* tour—and the whole ensemble joined the Conspiracy of Hope show in Los Angeles. Edge met Dylan: ". . . he came up to me in the corridor at the Forum and said, 'Love your work, it's incredible. It's great to play with you, man.' I was walking about a foot off the ground for the rest of that week."

Edge had immersed himself in *Biograph*, the fifty-three-track box set, out the previous fall, that juxtaposed Dylan's many sides: folk, protest songs, rock and roll, country, and counterculture spirituals such as "I Shall Be Released." The box featured an image of Dylan as a stained-glass saint. It presented Dylan (who had put out *Desire* in 1976) pursuing carnal desire and spiritual desire without fretting over the distinction between them. It showed how naturally the songs from the gospel period sat alongside the rest—and how religious imagery figured into songs from every decade. *Biograph* at once closed the door on Dylan's gospel period and established that he'd been crypto-religious all along. And it pointed to ways forward for the next generation—U2 among them.

The finale of the Amnesty tour was a noon-to-midnight show at Giants Stadium in New Jersey, televised live on MTV, which flashed a donation phone number on-screen during the broadcast. Aaron and Joan sang "Amazing Grace" a cappella, joined by many of the fifty thousand people in the audience. Carlos Santana played with the Neville Brothers;

so did Fela Anikulapo Kuti—the pioneering Nigerian bandleader and political dissident, who'd been freed from prison through Amnesty's efforts. After sets by Peter Gabriel, U2, and the Police, everybody crowded onstage to sing "I Shall Be Released," with Bono altering the chorus—"*They* shall be released"—to speak to the plight of prisoners of conscience. It was sloppy, off-key, but symbolically effective. The torch of protest music was being passed from one generation to the next; U2 had replaced a white flag with a wire-wrapped yellow candle, swapping religious ardor for activism.

That's how it seemed at the time. It didn't turn out that way, though. Two weeks after the tour, Bono's Maori friend was killed in a motorcycle crash in Dublin; and the record that U2 made in the months that followed would take doubt and anguish into the archetypal territory of one-tree hills and cities where the streets have no name.

7

BE A SOMEBODY WITH A BODY

"Now why do you think that you would like to convert to Catholicism?" the lean cleric in trim black suit and J. Edgar Hoover glasses asks. ". . . Why did you make the decision to choose the Catholic faith?"

". . . well, first of all, because it's a very beautiful religion, it's a strong religion, it's very well structured," Woody Allen explains.

Twenty years after Vatican II de-emphasized Old World Catholic practices, images from the left-behind Catholic ghetto were still alive and well in American popular culture (as in Allen's film *Hannah and Her Sisters*, in theaters in the spring of 1986). There, Catholicism had hardly changed: cassocked clerics, habited and wimpled nuns, Gothic confessional boxes, and bathtub Madonnas (the Virgin Mary with open arms amid the crabgrass). Even as Catholic education atrophied, parochial school extremes of obedience and rebellion still animated the collective imagination—and were worked out in the arts, which the clergy could no longer regulate.

Madonna was both the evidence and the further expression of this phenomenon. In 1986 she was the bestselling female recording artist in the world and the most visible artist on MTV. Her second record, *Like a Virgin*, from 1984, had sold six and a half million copies in the United States and was still going; her third, *True Blue*, was the strongest-selling record of the year. Her efforts to break into acting and her marriage to

Sean Penn (of the Hollywood "Brat Pack") were chronicled relentlessly by the tabloids. Madonna had become famous so fast that it was easy to forget that her Catholic girlhood was only a few years back.

That the name was her given name gave her story the inexorability of opera. She was born in 1958 in Bay City, Michigan, near Detroit, the third of six children, and was baptized Madonna Louise, after her mother, who was of French-Canadian heritage. Her father, Silvio "Tony" Ciccone, was a son of immigrants from Abruzzo who had settled near Pittsburgh. Her mother died of breast cancer when she was five; the funeral, Mary Gabriel notes in her biography, "was held at Our Lady of the Visitation, the same Bay City church where she had been a young bride in white eight years earlier." Tony Ciccone remarried, and in her teens Madonna lived a double life in the suburb of Rochester Hills: devoted daughter at home, flamboyant rebel in public middle school and high school—doing an erotic dance to the Who's "Baba O'Riley" at an eighth-grade talent show with her family in the audience; railing against the need to wear a dress to Mass ("I would say to my dad, will Jesus love me less if I wear pants? Am I going to hell?"). When David Bowie came to Detroit on the *Diamond Dogs* tour, she was there: "Oh my God, he's everything . . . He's male and female and beautiful and elegant and pouty and funny and ironic and . . . otherworldly."

She graduated in 1975 and enrolled at the University of Michigan the next year on a dance scholarship, encouraged by a teacher—Christopher Flynn, Catholic and gay—who had made the step up from Rochester Hills to Ann Arbor. She spent a few weeks auditioning in New York City in the summer of 1977—the high-voltage summer of the blackout and of Son of Sam's killing spree. The next year she dropped out of college and moved to New York to dance professionally. She hit the city full-speed: living in Harlem and Hell's Kitchen, working as a nude artists' model to pay the rent, playing drums in a Blondie-like New Wave band, riding a bike around town. She was raped by a man who led her to a rooftop at knifepoint in daylight, a crime she scarcely spoke about. She paired off sexually with other young artists (Jean-Michel Basquiat among them) and got to know Basquiat's

friend Keith Haring. Combining music and dance, she found a base in the downtown club scene, where her Italian Catholic attitude took root in the Latino-Hispanic ghetto of Loisaida and produced a look: cutoffs, tights, lingerie, gloves, Ray-Bans, bangles, crucifixes. "What I was wearing at the time I was signed to my record contract became my look," she later said; she called it "pseudo–Puerto Rican punk rock freak out."

From the moment she dyed her hair blond, Madonna could have left her Franco-Italian-American Catholic upbringing behind—except that her name made it impossible for her to do so. As a stage name, it was absolutely apt. So she embraced it, made it her own—and then took it over until she was *the* Madonna and it belonged to her only. The name ensured that her struggle with traditional female ideals—of womanhood and motherhood, of virtue and erotic power—would be unmistakable. As an unanticipated side effect, it made old-school Catholicism suddenly, inexplicably sexy.

Andy Warhol was prominent on MTV, too, and *Andy Warhol's 15 Minutes* had opened another realm of his celebrity; to the openings, auctions, press events, and product launches was added a run of rock concerts. He went as a VIP to shows by Tina Turner, Miles Davis, and Bruce Springsteen (his cohorts, he told his diary, "couldn't believe how many autographs I had to sign for the New Jersey kids"). When Bob Dylan played Madison Square Garden with Tom Petty and the Heartbreakers in July, Warhol was there; and the account in his diary is a cryptic reflection on the life of the artist whose fame doesn't make him invulnerable to criticism.

He went backstage before the show, a guest of Ric Ocasek, from the Cars (he was directing a video for Ocasek's solo record), and planned to take pictures. "And they took us into the room and Dylan was there and Tom Petty and Ron Wood" from the Rolling Stones, he told the diary, but "Dylan said no. And then later Ric found out that Dylan was in a bad mood because he had just had a big fight with his girlfriend who's forty or fifty who I think works for the record company and at

the end of the fight she'd said something to him like, 'Oh go out and play your "Mr. Tambourine Man" or whatever.' And that would kill your mood—when your lover calls all your work you've done in your life (*laughs*) 'whatever.'"

Warhol just then faced the same challenge as Dylan: he was an artist of the sixties who needed to prove that his work was still relevant—that he was not the "commercial artist" he'd deemed himself to be after taking the *Last Supper* commission for the money.

He had just spent a week in London, where a show of his portraits, including self-portraits—the *Camouflage* series—had left him with a distaste for his own work. In New York, he resumed his nightly rounds. There were more concerts at the Garden: Prince ("we sat down just as Prince jumped out naked, or almost") and Elton John (". . . oh God, is he fat"). There were movie premieres: David Lynch's *Blue Velvet*, Madonna's *Shanghai Surprise*, Martin Scorsese's *The Color of Money* ("I slept through most of it," he said, but "everybody 'in' was there"). There were play openings: Madonna in David Rabe's *Goose and Tom-Tom*, Demi Moore in *The Early Girl*. Warhol went to shows of his recent work (portraits, "piss paintings") and to auctions where a Soup Can and a Mona Lisa were sold for sums that seemed stupendous. He wound up at Mr. Chow's or at Nell's, in Chelsea, a new after-hours place for the nightclub crowd.

The only irruption to the blaze and roar of the scene was AIDS. Martin Burgoyne, a Pratt graduate, thriving as a graphic designer, had been struck with AIDS at age twenty-three, and Warhol made a drawing of him to be used on the invitation to a benefit at the Pyramid, organized by Madonna: they'd lived next door to each other in the East Village. "[I]t's so sad, he has sores all over his face," Warhol told his diary; at the benefit, "Martin gave us big kisses and that threw me for a loop"—like so many people, he was phobic about getting AIDS through simple contact. "I read Cindy Adams' obituary of Roy Cohn"—who had died of AIDS without acknowledging that he was gay.

All that fall Warhol made new work, and duly registered his efforts in the diary: "Worked till 8:00." "Worked all afternoon." "Worked till 8:00." "Worked."

He was working on the *Last Supper* series. The works would have to be framed, crated, and shipped by November. The series had grown as he refashioned Leonardo's masterpiece in portraiture, collage, repetition, juxtaposition, and appropriation—the forms he'd mastered in his own career. Working with assistants, he produced details and line drawings of Christ's face and hands. A silk-screen close-up of Christ and John the apostle: a matched pair of handsome men, one bearded, the other fresh-faced. The face of Christ repeated 112 times, like a giant roll of stamps. The ten Everlast full-body punching bags emblazoned with the face of Christ and Jean-Michel Basquiat's rough brushstrokes. A pair of white Converse high-tops featuring a silk-screened image from an ad offering a Jesus night-light. He wanted his *Last Supper*s to be "transgressive"; he was trying to make Leonardo's familiar *Last Supper* "exciting again."

There came news about Jon Gould from Los Angeles. Warhol's manager, Fred Hughes, Bob Colacello reports in his biography, "took Andy aside at the Factory and told him that Jon was dying of AIDS. 'Andy was very, very upset,' said Sam [Bolton], who witnessed the scene." A friend had seen Gould at a screening, "clutching at seats to get up the aisle."

Gould died on September 18, 1986, age thirty-three. Warhol made no mention of the death in his diary. Pat Hackett, who compiled the diary for publication, added a laconic note about Gould: "He was down to seventy pounds and he was blind. He denied even to close friends that he had AIDS."

The next day's papers brought news of another death: Corita Kent, age sixty-seven, of cancer. Obituaries described the steady work she'd made during the years she spent in Boston after leaving religious life: a set of resplendent bands of color on a giant fuel tank outside the city, visible to all from the highway; the same bands of color on a U.S. postage stamp, above the hand-lettered word LOVE. The *Times* remarked on the popularity of her work, "which often combined Pop Art with religious imagery," and went on: "Ms. Kent was praised by art critics for her exceptional talent of recognizing the eternal in the ordinary and celebrating it with bursts of brilliant colors and bold shapes."

How keenly did Warhol feel Jon Gould's death? How fully did he register Corita Kent's death? To these questions, the *Last Supper* series may offer answers.

The curator Jessica Beck sees the *Last Supper* works as a response to Gould's death on several levels: a series of "radical responses to the extreme anxiety and fear about AIDS generated and sold by the press to an uninformed public"—fears that Warhol felt himself—as well as a deeply personal act of mourning through Christian motifs.

That fall Warhol turned to *The Last Supper* with religious intensity, creating works that are at once cryptic and explicit.

He made a batch of large *Last Supper* canvases festooned with logos of American brands: the owl's eye of Wise potato chips, the dove of Dove soap, the whorled initials of General Electric. These, as Blake Gopnik points out in his biography, bore the impress of Corita Kent's work in the use of "brand names and corporate logos to convey religious double entendres." The echo of Kent was especially strong in a mural juxtaposing the face of Christ with line-drawn motorcycles, a price tag ($6.99), the Wise owl-eye and other logos, and the phrase THE BIG C. In this mural (as Beck observes) several lines of influence converge. THE BIG C refers to Christ, pictured alongside. It echoes the Corita Kent serigraph in which "the big G" of General Mills referred to Goodness (and, obliquely, to God) and thus makes the whorled GE logo Warhol's version of "the big G."

Most directly, THE BIG C suggests cancer—and AIDS, known as "the gay cancer" and called that by Warhol in his diary. Warhol had juxtaposed a tabloid headline naming THE BIG C with one about AIDS FUROR in a throwback-style collage, linking the one with the other. Now he made the one expression stand in for the other, so that a slang term evoking Christ and cancer also represented the disease that so many people—his dead lover Jon Gould among them—were loath to identify.

That fall the Vatican's doctrinal office—the Congregation for the Doctrine of the Faith—was addressing questions involving homosexuality.

The CDF disciplined Fr. Charles Curran, a theologian who challenged Church teachings on masturbation, premarital sex, homosexuality, and the like. It prepared a fresh document on homosexuality with the Church in the United States in mind. And it moved against John McNeill, S.J. A decade after he'd been ordered not to discuss homosexuality, McNeill was speaking out again, and the Vatican sought to have him expelled from the Jesuits once and for all.

Daniel Berrigan was alarmed. He saw the controversy in terms of conscience, rather than sexuality—saw it as an effort to "unravel" Vatican II's affirmations of the rights of individual Catholics. He identified with McNeill as another voice crying out in the wilderness. And he was struck by "the familiar Torquemadan odor" of the effort—familiar because it was akin to the Jesuits' efforts to keep him from commenting on war and peace. "McNeill's predicament was my own. It was as simple as that." He drafted a letter, to be signed by the West Side Jesuits, in protest of McNeill's anticipated dismissal.

Berrigan was also dealing with last things. He had gone to Boston to spend a day with Corita Kent, in extremis. He was caring for Lewis Cox, a West Side Jesuit who was dying of cancer. "I'm his closest friend," he told Phil and Liz McAlister. "I think it's a little like a marriage—at least the closest I'm likely to get. For good health and ill."

In his role as listener of last resort, he accompanied an artist he knew through his last days with AIDS.

He'd first met the artist, named Douglas, at St. Vincent's Hospital the day Douglas was diagnosed. "He was of the true artificer tribe, a weaver of reeds and palm and hemp, into quasi-human shapes, some on stilt legs, impenetrable, dynastic, ancestral." When Berrigan returned from working on The Mission in South America, Douglas was the one man he knew with AIDS who was still alive. He was still making art, to give to his doctor as a way to pay down his medical bills. A work he'd made in the early eighties—a figure on a cot—prefigured his situation, and the new work he was making seemed to emerge from a drive at once to understand the disease and to defy it.

As Berrigan visited him regularly at his apartment on the Upper

West Side, he was awed by the dying man who continued to create. "Those stricken are under a mysterious summons. They are 'going on ahead.'"

Friends held a birthday party for Douglas—his last birthday, Berrigan grimly surmised. Several months passed. Douglas asked the priest to come over, and, once Berrigan was there, surprised him by reading aloud some prose pieces in which he'd woven together the themes of his short life, which had been diminished by AIDS, and also by "the peculiar Catholic horror—parents who came to know his delicts, his fault in nature; to fear it, and, for a long, desperate time to refuse credence or support.

"There we sat, young Lazarus and I, in a communion of grief . . . The end was near for Douglas [Lazarus], but not before one more thing: the visit, at his mother's behest, of their parish priest, who came and catechized him, on his deathbed.

"Seven sacraments!!! Channels of grace!!! Forgiveness!!! New start!!! YOU'RE INVITED TO REPENT AND START OVER!!!"

Start over, Douglas asked the priest, even though he was faulted as a homosexual by the Church? By no means, the priest responded: "Homo, hetero, whatever, whichever! . . . All bound by the same law: no sex premaritally, postmaritally only for purposes of procreation!"

Douglas died; his body was cremated; his friends, Berrigan among them, scattered his ashes in the East River—"and there came back on the wind such a cry of victory as our landlocked mortal ears had never heard."

Andy Warhol told his diary: "And I heard that Robert Mapplethorpe and Sam Wagstaff are *both* in the hospital." And he mused on Martin Burgoyne: young, gifted, handsome—like Jon Gould—and now gravely ill with AIDS. "I got the *Enquirer* with Sean [Penn] and Madonna on the cover, and it was about Martin, how he was once Madonna's roommate and now he has AIDS. And then Martin called me, and it must be so weird to read this article about yourself where it says you're dying."

The *Last Supper* deadline was upon him. He bore down on the series. At the studio, he made a work juxtaposing the bearded and robed Christ of Leonardo's *Last Supper* with an ad found in comic books of mid-century. The ad showed a thick-haired, shirtless, amply muscled young man, and the hand-lettered slogan *Be a Somebody with a BODY*. The man looks like Jon Gould as seen in Warhol's photographs—the thick-haired, shirtless, amply muscled man who struck bodybuilder poses for Warhol on the beach at Montauk. The resemblance is unmistakable: clearly Warhol made this work with Gould in mind—juxtaposing Christ and his lost lover, who is here restored to the proud and virile figure he'd been before AIDS ravaged his ideal body.

There's a metaphorical aspect to the work, too. The scholar Jane Dillenberger, in a masterstroke of art-historical sleuthing, turned up a photograph of Warhol in his twenties—round-faced, thick-haired, ordinary—and proposed that the amply muscled young man in *Be a Somebody with a BODY* is a stylized image of Warhol himself. That is, he is the man Warhol might have been but would never be, especially after the gunshot wound in 1968 left him with a long scar.

At the same time, he is the man Warhol became by other means. He became an artist with a body of work. He became a somebody—a man of fascination and controversy. And over time he—Andrew Warhola, sickly adolescent, slight and pasty grown-up—became somebody with a body, a figure known to all.

Supposing Warhol identified with the amply muscled man, and identified that man with Christ—a controvert who gathered others around him as disciples. Does it follow that Warhol saw himself as a Christ figure of a kind? It would be facile to regard the *Last Supper* series as simple autobiography, with Warhol as the master and the Factory denizens as disciples. Yet Warhol *did* attract disciples—from the Superstars and hangers-on at the Factory in the sixties to the downtown painters of the eighties. And it's sensible to suppose that Warhol, after three decades spent transfiguring the commonplace, would identify with Christ shown instituting the Eucharist, in which bread and wine are transubstantiated into the body and blood of Christ.

Be a Somebody with a BODY is the key to the *Last Supper* works. This mural unlocks the whole series—more than a hundred works in all—and makes its religious dimension emphatic and profound.

In the Catholic scheme of things, the Last Supper is the moment in the Gospels when the ordinary is identified as extraordinary once and for all. When Christ blesses bread and wine and tells the disciples, "This is my body" and "This is my blood," he affirms the goodness of ordinary things, as God had done in incarnating him as a carpenter's son at the edge of the Roman Empire—as an ordinary man. The Church made this affirmation central through the Eucharist: the ordinary is upheld as extraordinary whenever Mass is said. Vatican II made it a modus operandi for Catholics' engagement with the modern world. Warhol identified the new approach as akin to his own with Pop Art. He saw it celebrated in Pope Paul VI's visit to New York City in 1965. And with the *Last Supper* series twenty years later, he joined his own work to Catholicism's exaltation of the ordinary—and pointed both at the controversies of the moment.

Specifically, he brought Vatican II's affirmation of the ordinary-as-extraordinary to bear on the human body. *Be a Somebody with a BODY* spells out the theme of the *Last Supper* series: Jesus Christ is somebody with a body. At a meal with his disciples—with them for the last time—Christ turns the disciples' attention to his body: Take and eat; this is my body. At the Last Supper, then, he makes the human body central to the religion that will be taken to the ends of the earth in his name.

Warhol, never a subtle artist, grasped this affirmation and made it into a Pop Art credo: "Be a Somebody with a BODY."

With the *Last Supper* series Warhol—son of immigrants, Pope of Pop, furtive churchgoer—showed himself to be an old soul after all. Faith, fear, thwarted desire, and the peril of AIDS had stirred up themes that lurked beneath the bright surfaces of his work. Through *The Last Supper* he addressed them directly. He crowned his rejection of abstraction and his celebration of the ordinary, incorporating the human body in his work as never before. He stressed the connection between the human body and the body of Christ. As he did so, he pointed his work toward a church apprehensive about homosexuality. He brought

Leonardo's most famous work into the postsecular age, recharging its significance in terms of Christianity's dealings with the body. And he marked out the arts as the realm where the controversies of religion and the body can be dealt with frankly and figuratively, artists going where religious leaders are loath to go.

On October 30, 1986, the Vatican's fresh document about homosexuality was made public—a document known in Rome, per convention, by its opening words, in Latin: *Homosexualitatis problema*. It took the form of a letter to all the Church's bishops titled "On the Pastoral Care of Homosexual Persons." It was signed by Cardinal Joseph Ratzinger, the prefect of the Congregation for the Doctrine of the Faith, its main author, and was framed as the CDF's response to pressing needs—the need to offset scientific insights with the Church's teaching, which "does greater justice to the rich reality of the human person"; and the need to set things straight about what the Church taught.

Ten years earlier the Vatican had made a distinction between a homosexual inclination and homosexual acts. One result—the prefect lamented early in the document—was that in the years that followed, "an overly benign interpretation was given to the homosexual condition itself, some going so far as to call it neutral, or even good." Then he got right to the point: "Although the particular inclination of the homosexual person is not a sin, it is a more or less strong tendency ordered toward an intrinsic moral evil; and thus the inclination itself must be seen as an objective disorder." He went on: "Therefore special concern and pastoral attention should be directed toward those who have this condition, lest they be led to believe that the living out of this condition in homosexual activity is a morally acceptable option. It is not."

The prefect went on for another forty-four paragraphs. He granted that people with the condition could be generous and kind, and he deplored violence against them. But he dismissed the notion that opposition to homosexuality is a form of discrimination, and stressed that the Church should not support any organizations that downplayed the teaching that homosexuality is immoral. He castigated the "pro-homosexual

movement" and professed concern about "those who may have been tempted to believe its deceitful propaganda." And he cast the movement as dangerous, suggesting it scanted the fact that "homosexuality may seriously threaten the lives and well-being of a large number of people"—a cryptic reference to the AIDS epidemic.

"What, then, are homosexual persons to do who seek to follow the Lord?" the prefect asked. His answer was that they should take up "whatever sufferings and difficulties they experience in virtue of their condition" and join them to Christ's self-sacrifice on the cross; they should die to this aspect of themselves so as to bring about new life. "When they engage in homosexual activity," he declared, "they confirm within themselves a disordered sexual inclination which is essentially self-indulgent." So they should seek conversion from a homosexual way of life—a "conversion from evil."

Homosexualitatis problema was reported in the next day's papers. The *Times* article carried a response from a gay-rights activist: "A church that is supposed to be showing compassion and caring for those who suffer from this horrible disease instead is furthering bigotry and hatred." In New York, where a Halloween parade in Greenwich Village was an annual rite for gay people, the Vatican instruction was branded "the Halloween letter." Daniel Berrigan said, "Can you imagine being a Catholic dying of AIDS and hearing something like this?"

Berrigan was at the Jesuit compound on the Upper West Side, writing his autobiography. The *60 Minutes* segment "The Brothers Berrigan" had aired—the most prominent piece of reportage about the Catholic peace movement in fifteen years. Meanwhile, AIDS had reached the Jesuits. Joseph Roccosalvo was a Jesuit priest; his brother Michael had belonged to the order for ten years—"and then, as they say, took up with something different," as Berrigan tartly put it in a letter to Phil. Michael got HIV, and then AIDS, and then died of the disease. "I had had liturgy in his hospice room some weeks ago. He was blind and deaf and brain damaged at the end. His partner is also terminal." Word was that two other Jesuits had died of AIDS.

Berrigan would give the eulogy at Michael Roccosalvo's funeral.

And he would organize the conclusion of the autobiography around the theme of AIDS, at once joining his AIDS work to the work of nonviolence and making a dramatic counterstatement about homosexuality— opposing the Vatican's strong language with his own.

The opening of the *Last Supper* exhibit in Milan had been pushed to December. Warhol was doing as much work in 1986 as he'd ever done, and he was weary, but he kept up his run of nightlife—from openings of gallery shows of his portraits and photographs to a benefit at Barney's for the AIDS relief efforts at St. Vincent's.

On Thanksgiving Day he went again to the Church of the Heavenly Rest to lend a hand. After the woman in charge ("this big, dykey Irish woman") thought they'd come to eat, not to help, Warhol's friend Victor Hugo started cursing and yelling. To the diary: "This is in a *church*! And I finally told him, 'Victor, we're here because we *want* to be.'"

Martin Burgoyne died of AIDS that weekend. There was a wake for him a few days later, organized by Madonna. "Watching him die was the most frightening experience of my life," she later said.

Warhol didn't attend the wake. And he didn't travel to Europe for the first days of the *Last Supper* exhibit in early December, instead arranging to make the trip in the new year. He was fretting about his own health. He went to a chiropractor regularly; he frequented an herbalist who prescribed handfuls of vitamin pills and told him to surround himself with crystals (a New Age fad that Jon Gould had gone in for). He took a quarter of a Valium at bedtime and worried that he was addicted.

After Christmas—when he served the charity meal at the Church of the Heavenly Rest once more—he took a "rest day" at home, which was rare for him. He took another day in early January: "I decided not to go out and just rest up and be fresh for the opening of the show," he told the diary.

He went to a supper at Nell's in honor of Ian McKellen, the actor: ". . . and then Bob Dylan came over and sat down and he said he'd just seen my photography show at the Miller Gallery—that he'd literally just

come from there," he told his diary. He saw Robert Mapplethorpe at a supper at Mr. Chow's and was urged to take a seat next to him—"but I didn't want to. He's sick."

He told the diary: "I just can't face going to Europe. And the TV news said they're smearing themselves with bear grease in Russia this week, it's so cold over there." The next day: "Did a last Diary with PH before the European trip where it's still so cold."

And then he was on the Concorde, going to Europe. He would appear at a glitzy publicity event for the *Last Supper* exhibit shortly before it closed.

Alexander Iolas, gravely ill with AIDS, came out of the hospital in Milan to greet him in the VIP room at the airport: "He was like a little old lady wrapped up in fabric." Warhol was surprised to learn that the exhibit at the Palazzo delle Stelline was of his work and nobody else's. A press rep had arranged an interview with *La Repubblica* about the show, but he turned it down, saying he had a pain in his side.

He arrived in black jeans, sneakers, a turtleneck, a navy-blue hooded sweatshirt with the block letters of a school softball team, and a leather jacket. He was dressed for the cold, and for a run of events such as he generally thrived on: a press conference, lunch at Gianni Versace's palazzo, an autograph session, *Salome* at La Scala, a dinner in his honor. "They were expecting five or six hundred people," an associate recalled. "But there were five or six thousand. One paper said ten thousand. The police had to close off the street, and all the socialites arriving in their limousines couldn't get in."

Twenty-five of Warhol's *Last Supper*s had been shipped to Milan. He posed in front of the largest one, flanked by two white-robed Dominican friars. Then he sat signing autographs and fielding questions beneath two others: a *Last Supper* with panels in five colors, and a *Last Supper* with the GE and Dove soap logos and the $6.99 price tag. The hooded sweatshirt framed his white wig and round eyeglasses. The leather jacket gave him broad shoulders. The layers bulked him up. In the photographs taken that day he looks, more than usually, like somebody with a body.

The crowd surged toward him as he signed. They were there to see him, more than his work—there to spend a moment in the presence of the spectral artist, who was present in the flesh ("One Day Only!"), an ordinary man in a hoodie. This was a phenomenon that he'd spent his career apprehending, and that he understood as well as anybody. "[A]fter signing the posters, *Interview* magazines, invitations, and any other piece of paper still available," an associate recalled, he "started to sign glasses, ties, bags, bras, scarves. Everybody was giving him something to sign. They were craving for the guru's signature. Finally I said, 'Andy, you're tired, let's go.' 'No, no, I'll finish it,' he answered."

When it was finally over he was exhausted. A patron had coughed on him. He had a fever. He took a Valium and then another before going to bed, and he went straight to the airport the next morning after a sleepless night. "And on the plane a milestone happened—I was in the *International Herald Tribune* and I didn't even bother to clip the article," he told his diary. "I just—didn't—care. So I've gotten to that point . . ." In the cab home from JFK, he "really wasn't feeling well."

He wasn't well. In New York he went out night after night, including a long autograph session at the opening of a show of his photographs and a benefit for Covenant House, the Catholic shelter for runaway youth near Times Square. He spent a day in bed. He went to St. Patrick's Cathedral, and his associate Stuart Fremont met him there: "Stuart picked me up at church, and it was embarrassing to walk from the church steps into a big black limo." At a dinner party given by Francesco Clemente, he spent part of an hour in conversation with Robert Mapplethorpe (who looked healthy, he thought) about Mapplethorpe's "old girlfriend" Patti Smith from the Max's Kansas City days.

He felt a "pain" at the Factory, then "a sharp pain" during a supper at Nippon, ". . . and I got scared and said I couldn't go on," he told the diary. "I guess it was a gall-bladder attack." He had a sonogram, which showed stones in his gallbladder—for which surgery was the remedy.

He spent another day at home. He was feeling a little better. He took part in a fashion show organized by MTV at the Tunnel, in Chelsea, and kibitzed there with Miles Davis, admiring the elegance of the

trumpeter's long hands. "Get me out of here, Stuart," he told Fremont, "I feel like I'm going to die!" Then he went home and got into bed— the canopy bed worthy of a Renaissance potentate.

He saw a doctor, then a second, and a third. All said his gallbladder was severely inflamed and had to be removed right away.

On Friday, February 20, he went shopping, went to the Factory, and then went to "the place" to have "it" done—"dressed all in black, with a scarf around his neck," Bob Colacello recalled. At the hospital staff's suggestion, he checked in under an alias: Bob Roberts. The surgery was done on Saturday. He was moved to a private room. The next morning a nurse found him gray and with a weak pulse, and then no pulse. He had probably had a heart attack. A squad of doctors descended on his bed and tried to revive him, but couldn't.

ANDY WARHOL DEAD AT 58. The news was splashed across Monday's rush-hour tabloids. POP ART's KING DIES. In the days that followed, there were claims of negligence. Rumor had it that he'd died of AIDS.

The funeral, on February 26, arranged by Warhol's brother and sister-in-law, was at Holy Ghost Byzantine Catholic Church in Pittsburgh— the church of his boyhood—and he was buried alongside his parents at the church's cemetery outside the city. Many people who knew Warhol in New York City didn't know that he was from Pittsburgh or that he had grown up going to church in the Byzantine rite, or at all. But those who knew him well knew that he was a churchgoer in his way. Working together, the staff at the Factory and the staff at St. Patrick's Cathedral planned a memorial service.

Warhol's studio, as he left it, was in creative disarray. A photograph taken there shows several large *Last Supper*s against the far wall and one of the Campbell's soup cans leaning alongside. Arthur C. Danto regarded that photograph as capturing the beginning and the end of Warhol's career—the alpha and omega—and his insight captures the abrupt shift in significance effected by Warhol's death. Death drained the *Last Supper* series of social commentary, turning it away from the AIDS-haunted Manhattan art scene and facing it toward the artist. All at once *The Last*

Supper became a last work, rich in premonition about Warhol's own death, and a final statement of intent.

It *is* a premonitory last work: Warhol, intuitive and prone to dread, doubtless saw the deaths of people he knew and loved as auguries of his own death, which could come, thief-like, at any time. And yet the focus on Warhol's death (which no one else saw coming) scants the way those bold and unexpected images of Jesus and his disciples consecrated an artistic movement just as it reached a kind of fulfillment. Warhol the trendsetter and trendspotter saw art, religion, sex, and controversy converging; with the *Last Supper* series, he announced, in his way, that a crypto-religious moment was at hand.

It seemed otherwise. Emboldened by the Vatican directive about homosexuality, many U.S. clergy moved against gays in the Church. In New York City, some parish priests were still refusing to celebrate funeral rites for gay men who had died of AIDS, as if the men's worldly lives had placed them out of reach of eternity and beyond the succor of the sacraments. Some funeral directors declined to embalm the bodies of men who had died of AIDS, or insisted on placing a plastic bubble over the open casket during the wake.

Redden's Funeral Home, on West Fourteenth Street, was a crucial exception. For decades Redden's had "waked" dead parishioners from Catholic churches in Greenwich Village and Chelsea—St. Joseph's, St. Veronica's, St. Bernard's, St. Francis Xavier—prior to funeral Masses at the churches. As AIDS spread, the owners, a married couple, the Zaorskis, coordinated with Gay Men's Health Crisis to provide simple, dignified memorial services for men who had died of the disease. The *Times*, in a February 1987 article, offered a sketch of the Zaorskis, "who once ran a business with a largely Irish Catholic clientele and now find themselves dressing coffins with the flag of the Gay Liberation Movement."

Cardinal O'Connor had finally forbidden Dignity, the movement of gay Catholics, to organize Masses at churches in the archdiocese (shortly after the bishop of Brooklyn barred Dignity from churches in that dio-

cese). In March, Dignity's New York chapter held a final Saturday-night Mass at St. Francis Xavier, with John McNeill, on the verge of ouster from the Jesuit order, as a celebrant. The next morning several dozen gay Catholics went to Mass at St. Patrick's Cathedral, where Cardinal O'Connor was the celebrant. Each wore a lavender armband; as O'Connor began his homily from the pulpit, they rose in silent protest, some turning their backs to him.

O'Connor was all over the news just then, laying claim to the role of de facto leader of the Catholic Church in the United States. He was in Israel, meeting with Jewish leaders. He was at the Vatican, meeting with the pope. He was in Dallas, joining an off-record meeting in which a group of bishops authorized by Rome arranged for the removal of Archbishop Raymond Hunthausen of Seattle due, in part, to his support for gay Catholics. He was at the Vatican again, one of a squad of archbishops tasked with planning John Paul's American tour, envisioned as a papal journey without precedent.

And he was in *The New Yorker*, the subject of a two-part, twenty-thousand-word profile by Nat Hentoff from *The Village Voice*. The *Voice* had emerged as O'Connor's most aggressive antagonist in the New York press, excoriating Catholic churchmen as strange bedfellows of Republican politicians in Washington and accusing them of strangling the process of funding for AIDS research and treatment. Hentoff's opposition to legal abortion and gay rights had made him an outrider at the paper—and had made him and O'Connor men of common cause. In the *New Yorker* profile, Hentoff scarcely touched on O'Connor's dealings with foreign affairs, politics, Catholic-Jewish relations, abortion, or homosexuality. He depicted the cardinal in the cardinal's own terms—as a simple parish priest whose parish happened to be a city with three million Catholics. In such a "parish," he quoted O'Connor telling him, tensions over this or that issue were natural and inevitable. "I would be shocked if every priest, every nun, every lay person agreed with everything I do. In fact, I think they'd be crazy if they did. There'd be something wrong with them because I do some dumb things.

"So you're always going to have these tensions," O'Connor said,

"but I do not see them in the Church of the United States at this stage as nearly so volatile as some people think."

The Church set squarely against gay people; the archbishop in the corona of celebrity; the pope soon to visit: there things stood on Wednesday, April 1, 1987, when Andy Warhol was remembered in a memorial service at St. Patrick's Cathedral.

A third of a century later, that Warhol was memorialized at St. Patrick's seems even stranger than it did at the time. Natasha Fraser, a young Englishwoman (and a daughter of the writer Antonia Fraser) working at the Factory, recalled the service as the New York "equivalent of a royal event like the Queen's Jubilee or Charles and Diana's wedding." Others likened it to a night out in Manhattan—black limousines, celebrities, couture, paparazzi—transplanted to the cathedral on a weekday morning. It was a rite in which art, faith, death, fame, and the "tensions" of American Catholicism were on display.

The limousines arrived on Fifth Avenue; the paraparazzi were set up outside the cathedral to get pictures of the mourners going in. Christophe von Hohenberg, there for *Vanity Fair*, shot in black and white, and his photographs situate the celebrities of the day against the background of midtown: grim, gray, unironic Gotham, an earthly city of gilt and stone. Calvin Klein was in a double-breasted pinstripe suit, Raquel Welch in a mink coat, Robert Mapplethorpe in a bomber jacket, his hair swept back, still thick and dark. Bianca, Liza, Deborah Harry from Blondie: all were in black, dressed for mourning and clubbing alike. Tom Wolfe, he of the white suit, was in black that day.

The service was open to the public, and two thousand people came. Inside, each was handed a printed order of service backed with a Warhol drawing of the Holy Family (after Raphael) with a price over Joseph's head: $6.99. They took seats in the pews. The "March of the Priest" from *The Magic Flute* was played, then Messiaen's "Louange á l'Immortalité de Jésus," and the service began with a reading from the book of Wisdom.

From the pulpit, the rector of the cathedral, Fr. Anthony Dalla

Villa, eulogized Warhol as "the Christian gentle man, the Christian gentleman"—although he had hardly known Warhol apart from spotting him in church. Then some people who *had* known Warhol well offered recollections. Nicholas Love from the Factory quoted from *The Philosophy of Andy Warhol*: "'When I die,' Andy said, 'I don't want to leave any leftovers. I just want to disappear . . . although it would be very glamorous to be reincarnated as a great big diamond ring on Liz Taylor's finger.'" Yoko Ono recalled Warhol's tenderness toward her and Sean after John Lennon was murdered.

John Richardson took the pulpit—a biographer and society art writer who had been photographed by Warhol dressed in leather for rough trade. Richardson posed the question on the minds of so many people there: *Why on earth is Andy Warhol, our Andy, being remembered here, at St. Patrick's Cathedral?* By way of explanation, Richardson began: "Besides celebrating Warhol as the quintessential artist of his generation—the artist who held the most revealing mirror up to his generation—I'd like to recall a side of his character that he hid from all but his closest friends: his spiritual side.

"Those of you who knew him in circumstances that were the antithesis of spiritual may be surprised that such a side existed," Richardson said. He then sketched a portrait of the artist as a Catholic of a very particular kind: baptized Andrew Warhola, raised in the "fervently Catholic" Ruthenian immigrant neighborhood in Pittsburgh, "withdrawn and reclusive, devout and celibate" in his teens, faithful to his "adored mother, Julia," and a man who had the habit of going to church "more often than was obligatory."

The Andy Warhol whom Richardson had known, the one he now presented to other people who had known him, was not the amoral artist-celebrity of tabloid legend. On the contrary, he was a figure akin to "those saintly simpletons who haunt Russian fiction and Slavic villages" such as the ones his ancestors had come from. His passivity was the stance of "a recording angel" like those in the Bible. His detachment was "incorruptibility" in worldly guise. His indulgence of decadent behavior at the Factory was rooted in compassion for the lost souls who found their way there.

All this was at odds with the public Warhol. Why? The reason,

Richardson explained, was that Warhol had kept his religious faith "very, very secret." Only late in life had he brought religion to the surface of his art, with the *Last Supper* works. They were based on "a cheap mock-up of Leonardo's masterpiece," but Richardson saw them as works of complexity and depth. "Andy's use of a pop concept to energize sacred subjects," he said, "constitutes a major breakthrough in religious art."

Why were Warhol's friends remembering him *there*, at St. Patrick's? They were there because Warhol, whatever else he was, had been a crypto-religious artist. "The knowledge of this secret piety inevitably changes our perception of an artist who fooled the world into believing that his only obsessions were money, fame, glamour, and that he was cool to the point of callousness. Never take Andy at face value."

The service was a full Mass, including Communion. The Catholics in the congregration rose and processed toward the altar to receive the body and blood of Christ. As they returned to their seats, a twelve-year-old prodigy from the Apollo Theater's amateur music program sang "Amazing Grace." "Young men in Day-Glo Mohawk hairdos shared hymn-books with society dowagers," UPI's correspondent reported.

And then it was over; the cathedral doors were flung open, and the congregation spilled out onto Fifth Avenue—the cognoscenti becoming a crowd, as if in reminder that Warhol, whatever else he was, was a popular artist.

Four hundred invited guests went to the Paramount Hotel on West Forty-Sixth Street for a catered lunch. The waiters wore aprons silk-screened with the pattern from Warhol's *Camouflage* series. A large *Last Supper* hung across from the bar.

Everybody spoke of Andy—of Andy, and of themselves. Lou Reed had known Warhol since 1966, when Warhol had spotted him in the Velvet Underground. Probably not for the first time that day, he said: "It's hard to believe Andy's not going to be around. I was hoping he'd turn up and say, 'April Fool!'"

PART II

EXPLICIT

8

"BAD"

The New York City subway has hardly changed since the eighties. Now as then, you go a few strides beneath street level and pass through a steel gate and into a vast network of staircases, platforms, pillars, and tunnels—an underworld both literal and figurative. This crypt into which New Yorkers descend with ritual regularity is in many ways more real than the city above. Like many ritual sites, it conjoins seeming opposites. It's old but not historic. It's at once anonymous and distinctive, down to the smell—a devil's brew of concrete, sweat, steam, and urine. Although it was built a hundred or so years ago, the city prior to it is hard to imagine. For many of us, the map of the whole—colored lines snaking through shady landmasses and bodies of water—is *the* image of the city, and over time the correspondence between the subway and the NYC of the mind's eye has grown, until the subway is an image of the city's interior life.

Early in 1987 Martin Scorsese was down in the subway with a camera crew. Michael Jackson had finished recording a follow-up to *Thriller*, and the producer, Quincy Jones, had brought in Scorsese to make a short film based on the title track, "Bad."

The eighteen-minute film Scorsese made has two parts. In part one, shot in black and white, the Michael Jackson figure returns to Harlem from a suburban prep school where he is a student on scholarship and

gets a rough welcome from a gang leader, who presses him to prove he is "bad" by mugging an old man in the subway. The Michael figure just can't do it. But he will show them how "bad" he is by other means. In part two, shot in color, he leads an ensemble of archetypal city gangsters in a tableau of urban movement: dancing, vaulting turnstiles, slicing through crowds, and climbing the walls of the subway superhero-style, singing "Bad" all the while.

The Harlem sequences were set on a street of time-eroded brownstones, the subway sequences at the Hoyt-Schermerhorn station in downtown Brooklyn. The station had been built below the grand Abraham & Straus department store, but by the eighties (as Jonathan Lethem recalls in a searching essay) time and neglect had rendered it "a functional ruin." Meanwhile, it had become a prime location for film and TV production companies, because it had a "ghost platform"—a point of arrival from an abandoned station a few blocks away. Prop and lighting experts would load in and bring the platform to life. A graffiti-scarred train full of actors and extras would go to the abandoned station and return at top speed, brakes screeching as it rounded a bend. In this way, the station and its ghost platform became a site in the city of the imagination.

Scorsese shot the subway sequences for "Bad" over several weeks in December 1986 and did reshoots early in the new year. A second unit was brought in to produce a making-of-the-film video, and its footage is extraordinary. There's Michael Jackson, in chains-and-spurs regalia, radiantly out of place in the grimy station. One camera operator works from a boom up in the eaves; another rides backward on a dolly as Jackson and gang surge toward him. Between takes, Scorsese comes out from behind a camera to confer with Jackson and Wesley Snipes, who plays the gang leader. Taut, bearded, wearing a dress shirt and jeans, he blocks out the scene with his hands.

The "Bad" video is often characterized as a project Scorsese took on as a work for hire, but it was a fresh exploration of the themes he had made his own. The Harlem sequence echoed his childhood in Little Italy, where the street toughs left him alone only after he proved he could take punishment without flinching. The dance sequence connected his work to *West Side Story*'s choreographed clash of ethnic gangs

(set uptown in the years he was a teenager downtown) and to the "blax-ploitation" films of the sixties and seventies. And the conflict between Jackson and Snipes represented a conflict he was facing in his work just then—over *The Last Temptation of Christ*.

Late in 1986 Scorsese spoke about the *Last Temptation* controversy in a Q&A with David Ansen for *Interview*. He told the story of his recovery from addiction, and likened himself to Fast Eddie Felson in *The Color of Money*, a pool hustler trying to stay sharp and on top in midlife:

SCORSESE: Would I be able to bounce back like he does at the age of 53, which is not that far away from me now? . . . Or will I allow them to kill my spirit, like they tried to do three years ago?

INTERVIEW: When *The Last Temptation of Christ* was canceled?

SCORSESE: Right. Now *Temptation* is a picture I would like to make. I'm not saying it's going to be my greatest picture. It may not be a good movie at all. But I was supposed to make it, and I will make it. I will do it somehow. But what happened then was very strong, and since then I've been recuperating . . .

INTERVIEW: The Moral Majority put pressure on Paramount not to make *Last Temptation*. This mixture of religion and politics is getting scary.

SCORSESE: It's very dangerous. It's a tricky area. You can be born-again and believe in Jesus, believe in Jesus' ideas and try to live them out, without becoming totally intolerant of other people. That's what this country has got to understand.

Scorsese was determined to make *The Last Temptation of Christ*—and to make it his way. While he was "recuperating" from the controversy over the picture, he got new representation (Michael Ovitz of Creative Artists Agency) and fresh funding for the picture from Universal. He cast the principals (Willem Dafoe as Jesus, Barbara Hershey as Mary Magdalene, Harvey Keitel as Judas, David Bowie as Pontius Pilate) and revised the script, this time with Jay Cocks, an arts writer at *Time* whom he'd known since the sixties, and who had introduced him to Robert De Niro in the first place.

Down in the subway, he recast the controversy over the picture in visual terms. The Michael Jackson figure in the "Bad" film is a gifted, sensitive New Yorker who affirms his street cred—his badness—through artistry rather than rebellion. That is, he is a figure a lot like Martin Scorsese. Among other things, "Bad" was an allegory of the conflict Scorsese faced over *The Last Temptation of Christ*, with the "bad Catholic" director redeeming the strife and violence (and sex) of the gospel story through his art.

During the shooting, Scorsese made the "Bad" video's connection to religious controversy explicit. He had a poster printed and stuck up on a tiled wall of the Hoyt-Schermerhorn station: a black-and-white poster showing a mug shot of himself and the words WANTED: FOR SACRILEGE. Behind the camera, he zoomed in on the image of himself, so that it would be impossible for the viewer to miss. The message was clear. He was bad, but in the way of the artist, not in the way the fundamentalists said he was.

Round-the-clock televangelism had given Christian fundamentalists access to believers' homes—and a fresh source of worldly power. They'd figured out that such power was best exercised through controversy; they'd stirred up controversy over *The Last Temptation of Christ*, and it had worked, so far.

The forces that had massed against Scorsese were being felt in American society broadly. The alliance of Republican politicians, evangelical Christians, and conservative Catholics had swiftly hardened into the "religious right." The stalwarts of the religious right saw the present moment as opportune, indeed providential. During the first Reagan administration, they'd gained a foothold in Washington; with Reagan's landslide reelection, they'd laid claim to being an actual majority—even as they insisted that Christians, and Christianity itself, faced a mortal threat.

The alliance had been buttressed rhetorically by a pair of brilliant neoconservatives: Michael Novak and Richard John Neuhaus. Novak, a Catholic seminarian as a young man, had enthusiastically joined the post–Vatican II Catholic left and then swerved rightward in the seven-

ties, citing the federal affirmation of a woman's right to legal abortion in 1973 as a turning point. He became an evangelist of the free market, devising a synthesis of the gospel, economic patriotism, and deregulated corporate business practices. Neuhaus, a Lutheran from rural Canada, for some years a white pastor in a predominantly Black neighborhood in Brooklyn, took part in the latter days of the civil rights movement and then soured on progressive religion, instead seeking common cause with tradition-minded Lutherans and evangelicals—and with Michael Novak. In a 1984 book called *The Naked Public Square* Neuhaus made the case for the emerging religious right as a force needed to fight the left's supposed stripping of religion from civil society. He then presented the book's main ideas at the Reagan White House and at Bohemian Grove, the lush California retreat and men's club.

Novak and Neuhaus were men of complex, intense faith—true believers whose religious ardor was matched only by their contempt for people who took positions different from theirs, especially the progressive positions they themselves had held not so long ago. They had a strong sense of themselves as public figures whose positions mattered—as actors in the grand drama of sacred history. Turning rightward, calling themselves conservatives, and making common cause with buffoonish, lightly educated evangelicals—for them, all this was not just prudent; it was countercultural, a stage of ongoing personal conversion that had, as a goal, the conversion of society.

Neuhaus had come to know John J. O'Connor when O'Connor, then bishop of Scranton, served on the drafting committee for the U.S. bishops' pastoral letter on war and peace. After O'Connor was named archbishop of New York, as Randy Boyagoda recounts in his biography, Neuhaus arranged to introduce him to the city's religious leaders at invitation-only klatches in Manhattan. The next year, they both went to Rome for an "extraordinary synod" of Catholic hierarchs marking the twentieth anniversary of Vatican II, which Neuhaus wrote about for *National Review.*

Back in New York, the friendship at once begat and betokened an alliance of Catholics, disaffected liberal Protestants, conservative Jews, and evangelicals—a posse of well-placed, publicity-savvy religious men

united, paradoxically, around the claim that religion had been excluded from American civic life, leaving the public square "naked," especially in the coastal dens of iniquity, New York and California.

A distinctly different Catholic thinker had just brought out a book that spoke to the quandaries of religion in public life: René Girard, with *The Scapegoat*.

Girard was a French literary critic who had taught in the United States since the 1960s; after a secular upbringing, he had become a Catholic in 1959. In a series of books he had drawn on literature, history, and anthropology—and especially Mircea Eliade's ideas about the sacred—and developed an audacious interpretation of human culture across time. He had explored the relationship between the sacred and violence; he had pondered the cryptic character of the Gospels. In *Le Bouc émissaire*, published in French in 1982 and in English translation as *The Scapegoat* in 1986, he sought to spell out the crucial role of such a figure in controversies involving religion and society.

The term *scapegoat* comes down to us from the Hebrew Bible, and Girard rooted his account of the scapegoat in the idea that runs through all his mature work: the idea of "mimetic desire." Human culture, in his account, is derived from the ways people are born and raised to desire what other people desire. As a society develops, the convergence of many different people with similar desires leads to rivalry and then to conflict, which divides the society. At that point, people in leadership roles—oftentimes religious figures—draw on the rituals of violence and the sacred. They identify an outsider or outsiders and blame him—his uncommon origins, his singular views, or his way of life—for sundering the unity of the society. This outsider is the scapegoat. The leaders incite the masses to turn on the scapegoat and drive him out of the society, often through violence. The act of scapegoating—of collective ritual violence against an outsider—draws the society together in a common desire and restores its lost order and unity. So the leaders suppose; but it's only a matter of time before a fresh conflict arises and the pattern is set going all over again.

"It is expedient that one man should die for the people," the Gospels record the high priest Caiaphas saying in order to justify the crucifixion of Jesus. Girard proposed that Christianity "exposed" and transcended the pattern of scapegoating by presenting God himself as the scapegoat; and he went on to propose that the purpose of Christian revelation was to "reveal" the scapegoat pattern as false once and for all.

Girard's ideas were controversial, and remain so—in his stress on Christianity as a kind of master key that unlocks the workings of all cultures, and in his stress on the Jewish priesthood's role in rejecting Jesus's claim to be the Messiah and making him a scapegoat. The religious dimension of Girard's work also made him an underground man in literary-critical circles, a postsecular figure who saw Christianity as a mode of truth just when it had finally been deconstructed and relativized by scholarship.

Christianity as Girard wrote about it was an epoch-transcending dynamism. In actual late-twentieth-century American social practice, Christianity was a set of institutions whose leaders—many of them; too many—behaved the way most leaders in society generally did: marking out scapegoats, blaming them for violating society's norms, and seeking to drive them out of society so that a lost order might be restored.

So it is that Girard's idea of the scapegoat, applied to the 1980s, opens up a fresh understanding of the controversies of the moment. The "religious right" had emerged as a force in American public life: evangelicals, Catholics, and Republican moralizers in a powerful patchwork alliance. But its influence led to tensions on all sides, as evangelicals strove to convert people away from Catholicism in Latin America and U.S. Catholic bishops challenged Republican and evangelical fealty to a "gospel of wealth." An episode of scapegoating would serve to bind the movement together; and with the spread of HIV in the mid-eighties, an occasion emerged. Surely and predictably, Christian leaders made scapegoats of gay men, taking the spread of the virus among gays and the deaths of gay men from AIDS as evidence of the threat these outsiders posed to the dominant Christian way of life. A staunch position against gay people and a view of AIDS as a self-inflicted wound in the gay subculture restored the religious right to a kind of unity. It was

still a tenuous unity, however, so they'd stirred up a fresh controversy, joining together to oppose a common enemy: the supposedly godless, greedy power brokers of Hollywood. And they'd marked out a scapegoat: Martin Scorsese, a Catholic whose work was outside the bounds of the institutional church.

Those controvertings gained the religious right the relevance in public life that Neuhaus and Novak had made an ideal. The movement's leaders took the ensuing strife as a sign that sacred history was on their side. And yet in the same moment the most recognizable figures of the new right themselves became figures of controversy.

Rev. Jim Bakker and his wife, Tammy Faye Bakker, led Praise the Lord Ministries, which brought in tens of millions of dollars through a daily TV show and a Bible theme park. Then there came reports that Jim had had an affair with a comely church secretary, who'd been paid hush money by the church. Under pressure from the tabloid press, he claimed that the affair had been exposed by a malicious rival, Rev. Jimmy Swaggart, who'd subjected him to "spiritual blackmail." It was true: Swaggart *had* exposed him. Bakker ceded the supervision of his outfit to Rev. Jerry Falwell (who hosted *The Old Time Gospel Hour* on his own network); Tammy Faye Bakker confessed an addiction to prescription drugs and checked in to rehab. Meanwhile, Rev. Oral Roberts was telling his viewers that God would "call him home" unless they sent in $4.5 million. And Rev. Pat Robertson was trying to distance himself from the scandals ("I think the Lord is doing a little housecleaning"), because he was going to run for president.

The televangelists made the Catholic bishops seem figures of rectitude by comparison. After the Gauthe verdict in Louisiana, the bishops (eager to avoid liability) had tamped down discussion of priestly sexual abuse, in part by treating it as a local matter—a wayward priest here and there. The televangelists' misdeeds handily diverted public attention, especially in Louisiana, where Swaggart, a native son, was based. But Catholicism was involved in a pair of fresh scandals involving the abuse of power, as the hard turn to the right brought about by John Paul gave one sign after another that the Church had turned Vatican II inside out and was backing the bad guys after all.

One involved the Church's dealings in El Salvador. After a long trial, a court in El Salvador had convicted five national guardsmen in the 1980 rapes and murders of four American churchwomen—three nuns and a lay volunteer who had been left to die at the roadside. In the days after the murder, Reagan's foreign-policy adviser Jeane Kirkpatrick had insisted that the Salvadoran military was not involved and had cast aspersions on the women, suggesting they were tools of the Communist insurgency; Gen. Alexander Haig—a Catholic, and Reagan's eventual nominee for secretary of state—had insinuated that the women had brought the rapes and murders on themselves by running a military roadblock. Years later, the implication of the fresh guilty verdict was clear: a death squad deployed by the U.S.-funded Salvadoran military had murdered U.S. citizens and then covered up the crime, and the president's foreign policy team had made scapegoats of the slain nuns.

The other controversy involved the pope's dealings with the Jewish community. A couple of years earlier, some Carmelite nuns had chosen to situate a new convent at the place in Poland where four decades earlier the Nazis had chosen to situate a concentration camp for the torture and killing of Jews: Auschwitz. Some said the nuns had done so at the behest of the Polish pope. Jewish activists (led by an American rabbi) raised a protest: Auschwitz was a site of the Holocaust, and the convent sought to incorporate the horror of the Nazi campaign against Jews into the Christian narrative of suffering, death, and redemption. They called on the nuns to shutter the convent and leave. The nuns and their defenders in the Church pushed back: the convent was outside the camp walls, and the nuns were there to honor "all the martyrs of Auschwitz" and to offer prayers of repentance for the sins of all humanity.

The convent controversy put John Paul's Polish heritage in a harsh light. As archbishop of Kraków, he'd been the successor to Polish prelates who had presided over centuries of Catholic antisemitism—and who had looked on, outwardly neutral at best, as the Nazis put six million Jews to death with brutal efficiency, involving Catholic Poles in every stage of the process. So the controversy drew fresh attention to questions of the Church's complicity with the Nazis—questions that

had been largely postponed by Vatican II's opening to the Jewish people as Catholics' ancestors in faith.

Then John Paul agreed to receive Kurt Waldheim in audience. Waldheim, a Catholic, was the newly elected president of Austria. During the war he had served in the German army; and documents brought to light after his election showed that he had been directly involved in deporting Jews to concentration camps. The pope met the Austrian president anyway. The Israeli prime minister, Yitzak Shamir, called the meeting "outrageous," and the U.S. ambassador to the Holy See left Rome for the day in order "to convey a message without insulting the Vatican." A *Times* story about a protest in St. Peter's Square reported: "A man whose arm bore the tattooed number of a concentration camp inmate held up a small gallows with a sign that read, 'Waldheim offered the noose—the pope offers the cross.'"

As these controversies involving religious figures played out in the press, it was only natural for reasonable people to ask: Who was good and who was bad here?

The Last Temptation of Christ controversy would put that question front and center. The as-yet-unmade film had the power of augury; and the developing conflict over it showed that the terms of artists' engagement with religion were changing.

In the first part of the 1980s crypto-religious artists—Bob Dylan, Andy Warhol, U2, Leonard Cohen—made their work out of sight, working in studios and hotel rooms, and then dealt with whatever controversy it sparked once it reached the public. The work itself opened new space for the lived experience of belief and new forms for religious expression; but the controversy over Dylan's *Slow Train Coming* and the gospel-themed tours and records that followed (to take one set of examples) had less to do with the music itself than with Dylan's persona: Was he a believer, or wasn't he?

The "Bad" video signaled a different approach—via the WANTED: FOR SACRILEGE poster that Martin Scorsese stuck up on the wall of the subway station. The next run of crypto-religious works would have controversy wound into them from the outset, as the artists made their

conflicts with religious authority explicit and braced for condemna-
tion. Scorsese, fluent at once in Catholicism, in the big-screen biblical
epics, and in the history of cinema as a sound-and-light theater of the
forbidden, would incorporate the dynamism of controversy into the
film itself.

Go ahead and call us bad, Scorsese said, in effect. Call us bad Catho-
lics. Call our work sacrilegious. We're ready. We're making work we're
supposed to make.

Michael Jackson and Martin Scorsese weren't "bad" just yet. The *Bad*
album wouldn't be released till August, when the "Bad" video would be
given a grand premiere on CBS—the broadcast network's belated move
into territory colonized by MTV.

For the moment, two other artists owned the "bad" category.

One was Madonna. Six years after John Travolta's Tony Manero
danced his way through Italian-American Brooklyn in *Saturday Night
Fever*, five after Billy Joel complained that Catholic girls "start much too
late," four after Donna Summer made "Bad Girls" from near and far the
protagonists of New York disco, Madonna had brought the Catholic
girl and the bad girl together in a single figure: a young woman ethni-
cally rooted, highly sexed, ambitious, and wise to the ways of the street
and the bedroom. With the video for "Papa Don't Preach," she trans-
planted her Catholic upbringing from Detroit to the Italian-American
New York that Scorsese had made the site of latter-day Catholic drama.

In those first years following her breakthrough with "Holiday" in
1983, it was hard to tell whether Madonna was working out Catholic
issues or just flirting with controversy. The crucifixes she wore seemed
more decorative than devotional. When she sang "Like a Virgin" (and
cavorted on the footbridges of Venice in the video), the moment when
she was "touched for the very first time" seemed so far back that the
very idea of virginity was a tease. But when she showed up at the Video
Music Awards in 1984 in a wedding dress—one with garters, a bustier,
and a BOY TOY buckle—and wound up writhing orgasmically on the

lip of the Radio City stage, the sexiness of the song, and of Madonna's whole persona, was there for all to see, as if bursting out of that dress. This was wedding-night-passion-as-striptease.

Madonna's charisma early on involved the tension between how obviously worldly and sexually adroit she was and how young she appeared to be. At twenty-six, she still looked practically like a teenager, with round cheeks and shoulders not yet toned to perfection at the gym, and her wayward hair enhanced the effect, the dark roots showing through the dye job as if she had become a blonde only yesterday.

In the "Papa Don't Preach" video this effect became the heart of an Italian Catholic story, which imaginatively rerooted Madonna in the community she'd come from. The video is set in Italian-American Staten Island—a suspension bridge away from Brooklyn and a ferry ride from Manhattan. The Madonna character has her hair cut short, at once gamine and punky. In the narrative sequence, she is hanging out with her girlfriends, wearing a black T-shirt with the slogan ITALIANS DO IT BETTER. She goes to meet her boyfriend at the garage where he works, fetching in a white blouse and a leather jacket. On the ferry, they catch the eye of an old married couple, who bless them with their smiles. She climbs a hill to the frame house where she lives and cooks for her father. She has good news: she and her beau are in love, they're going to get married; she's pregnant, and she's going to keep the baby.

The next time we see her in the house, daughter and father are shown on opposite sides of a wall. She looks truly afraid, as if wondering whether he is going to beat her, or throw her out, or tell her she is on the express train to hell. "It's a sacrifice," she allows—the song's lyrics telling the story—but insists, "if you could only see / Just how good he's been treating me / You'd give us your blessing right now . . ." It's an affecting moment: Madonna, from the other side of the wall of fame, presents herself as an ordinary Italian-American Catholic girl chafing under her father's authority.

With the video due out, Madonna gave a candid interview to Stephen Holden of the *Times*. He drew a connection between "Papa Don't

Preach" and sixties girl-group vignettes like "Chapel of Love." She told him that her approach was rooted in her Catholic upbringing. Using the present tense—as if it were yesterday—she explained: "When you go to Catholic school, you have to wear uniforms, and everything is decided for you . . . Since you have no choice but to wear your uniform, you go out of your way to do things that are different in order to stand out." She went on: "I think people are named names for certain reasons, and I feel that I was given a special name for a reason. In a way, maybe I wanted to live up to my name."

The other exemplar of "bad" was Prince, His Royal Badness himself.

Prince put out *Sign o' the Times* in February 1987, an eighty-minute, sixteen-song double LP. The album had faced resistance from executives at Warner Bros. Records, and the resistance had led Prince to make it a statement record; he took out a full-page ad in *The Village Voice*'s annual Pazz & Jop music supplement, reproducing the title track's lyrics in outsize, spidery type.

"Some say a man ain't happy until a man truly dies," he sings on "Sign o' the Times"—setting a gospel truth over a pulsing beatbox rhythm and freestyle guitar. It's a familiar Prince move. Religious language figures prominently in plenty of songs he recorded in those years, but you can listen to them and hardly notice it. That it how it was with Prince. He stirred up images of sex and love and religion and booty-shaking, of ice cream castles and housequakes and everlasting adoration, and set them to music so catchy that you hardly realized what you were hearing. As with Bob Dylan, the more he said, the more perplexing he was. This most explicit of artists was an enigma.

On his early records, through *1999*, Prince presented himself as a sexual provocateur. His debut LP featured the track "Soft and Wet"; his third was called *Dirty Mind*; a poster folded inside *Controversy* showed him clad only in a crucifix. Sexually, he was confounding, at once androgynous and hypermasculine. Musically, he was equal parts funk and rock. Opening for the Rolling Stones in Los Angeles in 1981, he was

booed off the stage two nights in a row by the predominantly white crowd.

Then *Purple Rain* turned the enigma that was Prince into a hero in a cineplex coming-of-age story and made his outlook into a cosmology—a purple world of music, sex, clothes, and apocalyptic drama that had led him to urge us to "party like it's 1999." The record sold thirteen million units; the film grossed $70 million and was acclaimed as "the first long-form music video"—and suddenly Prince was up with Michael Jackson as an avatar of the pop-music future. Touré, in a pathbreaking book about Prince, *I Would Die 4 U*, points out that in 1984, the year when Black artists and performers broke through the walls of mass culture—Oprah Winfrey, Jackson, Spike Lee—Prince, as the album title *1999* made clear, was the most forward-looking of them all.

All the while, Prince's spirituality was hiding in plain sight. He'd been raised religious, going to a Baptist church in Minneapolis and then following his mother as a Seventh-Day Adventist and singing in the choir at a Methodist church. The first song on his first record features his voice singing "For You" in a churchy multitracked choir.

"Controversy," from 1981, was framed in reference to surging fundamentalism. The LP sleeve shows Prince against a cut-and-paste backdrop of headlines from a mock-newspaper called *The Controversy Daily* (Love Thy Neighbor; Do You Believe in God . . .). The video is set in a church of sorts—Prince and band stepping out from the altar and playing before a stained-glass window. The song is at once a spiritual, an erotic tease, and a topical song. It runs seven minutes, the groove funky and strident, driven by ticklish guitar and a squishy synth riff. The verses anticipate the conflicts of the decade with tabloid starkness: Black or white? Straight or gay? The chorus—"Do I believe in God? Do I believe in me?"—threads through the song, Prince posing the question of belief over and over in a falsetto. Partway through, a low and solemn voice comes in. It's Prince, reciting the Lord's Prayer from start to finish.

"Controversy"—Prince's first hit—was something like a rejoinder to the fiercest rejection of religion in pop music: John Lennon's "God," on *Plastic Ono Band*. There, Lennon, pure controvert that he was, opened

the seventies by foreclosing the question of belief, listing all the things he didn't believe in, the Bible and Jesus among them, and concluding that the reality he believes in is "me . . . Yoko and me." With "Controversy," Prince brought God back into the equation for the eighties. For him, belief in God and belief in oneself isn't an either-or decision; they're both possibilities.

Religion is a main topic of the vast exegetical literature devoted to Prince's music. Touré devotes a third of *I Would Die 4 U* to it. He points out that "1999" was more than a clever flash-forward: it's an expression of the end-times sensibility Prince got from Seventh-Day Adventists, beginning with the early line about Judgment Day. (The message: Judgment Day is real, so let's party fiercely.) And he identifies Christian motifs in dozens of other Prince tracks from the eighties, some obscure or unreleased.

The most striking of those is Prince's version of "Mary Don't You Weep," from the 1983 session released many years later as *Piano & a Microphone*. "Mary Don't You Weep" is a cherished Black spiritual best known on record from Aretha Franklin's version on *Amazing Grace*, from 1972. Performing solo, Prince sings mainly the chorus (leaving out Pharaoh, Moses, Martha, Lazarus, and Jesus). But he does so in an astonishing range of voices, thus joining his work at once to the song's roots in Black resistance to slavery and to Franklin's version. And he slides from it into a medley that includes a bit of the as-yet-unreleased "Purple Rain"—thus tying the history of Black sacred music to the new record he was making, and vice versa.

The *Purple Rain* LP begins in church, with Prince speaking solemnly over a pipe organ. *Dearly beloved, we are gathered here today . . .* : this, the opening of the Christian rite of marriage, is the opening of what Touré calls "the coolest sermon ever heard on top-forty radio"— Prince's exhortation to celebrate "this thing called life . . ." Touré sees the sermon as the key to the record, which will trace an arc of redemption, from the pulpit passion of "Let's Go Crazy" to the baptismal waters of "Purple Rain." For him the album "takes us through the structure of a religious event by opening with the preaching of the word and ending with the audience being forgiven and baptized." But that

structure is elusive; Prince, on *Purple Rain* and elsewhere, works in a way that's ingeniously defiant of conventional structures.

Take "I Would Die 4 U," from side two of *Purple Rain*. Here's a perfect pop song that's built around religious imagery of ingenious and disarming simplicity—lyrics so simple that you can sing them in the shower or wherever without noticing what they're about. In thrall to a lover, Prince begins in full androgyne mode, declaring that he is neither woman nor man but something "you'll never understand." Sure, that's akin to what the Christian tradition refers to as negative theology (in which the divine is sought through a "cloud of unknowing"), but first of all it's boudoir grandiosity—Prince shifting the game of sexual role-playing onto a higher plane. The rest of the verse is a promise, and a boast: he won't lie, or strike out in anger; faced with evil—a strong word—he'll "forgive you by and by . . ." The second verse begins, "I'm not your lover, I'm not your friend / I am something that you'll never comprehend . . ." and goes on: "No need to worry, no need to cry / I'm your Messiah and you're the reason why . . ."

Those lines could be chiseled in stone—that's how perfectly put they are. So could the ones that follow, where Prince likens himself to something other than human: a dove, conscience, love. But they're *not* chiseled in stone: they're delivered by Prince the musician over a pulsing electric riff; they're sung by Prince the lover as he reaches a peak of sexual ardor. This is ecstatic speech—unguarded, tossed off. Prince is vowing that his lover will never "comprehend" him (literally, hold him or grasp him fully) but he caresses, comforts, and celebrates that lover at the same time.

The verses of "I Would Die 4 U" are a self-portrait—one as vivid as Prince would ever give. Here he is: seductive, aloof, grandiose, independent, incomprehensible. But then, in the chorus, he is as selfless as could be—willing to die "4 U . . ."

What does he mean? Alan Light, in a book about *Purple Rain*, says Prince got the expression "I would die for you" from his absent father. Questlove says it's an expression of the sense of mission that runs through Prince's work: ". . . he was lending voice to what he perceived

as being the gospel message. I don't think he's literally saying he's the Messiah, but in his own way he's speaking for the Messiah." Touré says Prince frankly identifies himself as a savior figure.

It's all true—but the song is more straightforward than it might seem. I would die for you: this, on some level, is the natural way believers and lovers alike understand self-sacrifice. It's part of a whole lineage of darkly devotional lyrics, from Otis Redding's vow that he would do anything if he could just have one more day (in "Just One More Day," recorded in 1966) to Morrissey's yearning to die a "heavenly" death by his lover's side (in "There Is a Light That Never Goes Out," recorded a few months after "I Would Die 4 U"). It's what you feel when you're full of ardor for another.

By the time of the *Purple Rain* movie and the "I Would Die 4 U" video, Prince had changed the line to "He's your Messiah and you're the reason why"—a change that makes the lyric at once more surprising and more complex. Singing it that way, Prince cryptically alights on the most striking paradox of the whole Christian-salvation scheme: the notion that God became man and died on the cross for the sake of each of us personally, not for the human race as an abstract whole.

Outside of his songs, Prince was intensely but intermittently religious, the people who were with him say. "I pray every day," he said, and sometimes he would fall to his knees in prayer mid-rehearsal. Accepting a prize for *Purple Rain*, he thanked God. He understood his music as God-given—both his talent and individual songs (even hooks and riffs)—and God-talk runs through Duane Tudahl's day-by-day chronicle of his music-making. "God hands me a groove and I can't throw it away," Prince told Todd Herreman, an engineer on many recordings, after a marathon session at his home studio outside Minneapolis. "That's why I drag your ass out of bed at four o'clock in the morning." Herreman recalled: "And I'm just like, whoa, that's why we were up for sixty hours and he meant it, it's like this stuff comes *through* him, it doesn't come *from* him."

Plenty of musicians say that they feel they're vessels for the music. More than most, though, Prince presented himself as making his work

in a higher realm where music, sex, and the sacred were intertwined. As Alan Light (who is white) observes, Prince was perhaps the first Black American musician to wholly transcend the sacred/profane divide. For Prince sex is sacred, the spirit makes no claims apart from the body, and his cocksureness is offset by the vulnerability he feels before God and a lover. And it all takes place in a fantasy realm of color and pageantry. Costumes, motorcycles, color-coordinated imagery: Prince's cosmology is playful, and his theo-drama of sex-and-love-and-faith is acted out in imaginative space, closer to George Clinton than to Bob Marley.

For Prince, sex was religious: that is obvious. Less obvious is that in the paisley park of his imagination, religion is sexy. "I Would Die 4 U," for example, with its words of succor and sacrifice, its claims of mystery and ineffability, finally suggests that music and religion draw from the same deep sources of inspiration. More than it's proof of how religious Prince's music is, the song is a reminder of how much like music religion is. From the Song of Songs onward ("My beloved is mine and I am his"), a basic religious intuition is of the likeness between carnal and spiritual transcendence; and artists and mystics across the ages have drawn on the passions of sex and romance, courtship and surrender, to characterize the human encounter with the divine as a "lovesexy" experience.

"I wish people understood that I *always* thought I was *bad*," Prince told *Rolling Stone* in 1985. "I wouldn't have got into the business if I didn't think I was bad." And yet all this intermingled sex-and-love-and-faith was not especially controversial at the time. It's useful to compare him with Madonna—with whom he was linked romantically via rumors after they showed up together at the American Music Awards (paired by their publicists, Mary Gabriel suggests). Whereas Madonna rankled religious traditionalists from the beginning—picketers outside a show in Portland denounced her as a Daughter of Satan—the controversies involving Prince in the same years were about sex pure and simple.

Warner Bros. executives were trepidatious about the "When Doves Cry" video, which begins with Prince climbing out of a bathtub, naked except for a crucifix, and crawling toward a (female) lover who awaits him on the petal-strewn floor—but they financed it, put it out, and saw it go into heavy rotation on MTV. And the video for "Darling Nikki" stirred Tipper Gore, spouse of Sen. Al Gore, to join with three other Washington spouses to found the Parents Music Resource Center, known for the "Parental Advisory: Explicit Content" stickers put on LP and cassette packages.*

That video ends with Prince—the Kid—writhing on the stage floor as if pleasuring himself. In another scene in *Purple Rain* Apollonia strips off her leathers and jumps into Lake Minnetonka after the Kid tells her she must purify herself in its waters—and then the Kid rides off on his motorcycle, leaving her behind, cold and wet. The nod to baptismal purification is the least distinctive thing about the scene, which is a weirdly charming bit of regionalism—the rock star Prince's fantasy world converging with the lake-country lore that he'd heard growing up in Minnesota.

Prince was "bad," that's for sure—but the image didn't involve being an enemy of religion, or a exponent of "bad" religion. His one dust-up with religious authority came after the final date of the *Purple Rain* tour was scheduled for the Orange Bowl in Miami on the evening of Easter Sunday 1985. Some local pastors complained. Prince played anyway.† The crowd was large—more than 55,000—but not a sellout. Prince wished the fans Happy Easter. In an interview beforehand he declared that he was done with live shows for the near future. Off the road, he was going to "look for the ladder."

In the months that followed he put out two more albums and another movie, *Under the Cherry Moon*; disbanded the Revolution and

* Through a technique called "back-masking" (Matt Thorne reports), "Darling Nikki" had a subliminal message: "Prince announcing his happiness at Christ's future resurrection."

† A few nights earlier, at the Forum in Los Angeles, Prince had been joined onstage by Bruce Springsteen and Madonna for an encore of "Baby, I'm a Star"; Springsteen played a ripping guitar solo.

assembled a new band; toured the States and Europe; and played Madison Square Garden for the first time (the show Andy Warhol saw). He met with Michael Jackson, who played him a demo of "Bad" and broached the idea of him appearing on the track and in the video; he said no.

He also recorded nearly a hundred new ballads, funk workouts, slow jams, catchy pop. Two, recorded just days apart in July 1986, articulated his crypto-religious outlook and pointed it straight into the cultural moment.

One is "Sign o' the Times." The song was prompted by a run of news stories that Prince and a colleague read in the Minneapolis *Star Tribune* and the *Los Angeles Times*. Musically, it's minimal, akin to "Controversy" and "Kiss": beatbox, compressed bass, bell-like keyboard, stabbing guitar. Lyrically, it's a breakthrough. In 1986 Prince, master of stage and studio and bedroom, turned his full attention to the outside world.

Rockets exploding . . . A short hop from reefer to horse . . . A big disease with a little name . . . The images are nearly inscrutable (it wouldn't have been obvious to all that the "big disease" was AIDS). And yet the grave tone and documentary-sketch approach opened a vast new area in Prince's work. "Sign o' the Times" joined Prince to the grand run of rhythm-and-blues-as-social-protest: Marvin Gaye's "What's Goin' On," Stevie Wonder's "Living for the City," and other songs of the mean streets. But the vital point of comparison for "Sign o' the Times" is a song that wasn't out yet: Michael Jackson's "Bad." Having heard the demo, Prince, working by instinct—competitive instinct—caught the sound of the mid-eighties street through religious imagery. A street gang calls itself the Disciples; a hurricane tears the roof off a church and kills everyone inside. A man ain't happy unless a man truly dies: "Oh why, oh *why*?"

"The Cross" is a topical song of a different kind. It's doomy and ponderous, unfunky: strummed acoustic guitar, bass drum, snare, and a sitar-like lead guitar. But the refusal of rhythm opens space for the words, which are as direct and unadorned as the music. "Don't cry, he is coming / Don't die without knowing the cross." His biographer Matt Thorne observes: "Prince's use of religious imagery is almost

always cryptic . . . but 'The Cross' is unusually direct, a straightfor-
ward tale of the Second Coming that fits with the apocalyptic themes
elsewhere on the record." The images in the verses join up with those
of "Sign o' the Times": ghettos and flowers, a mother pregnant and
starving but sustained by the "sweet song of salvation" she sings.
Prince sings the verses twice each, making clear that for him—in this
song, at least—the sign of the times is the cross. When, at the song's
end, he delivers the words "the cross" one last time in a multitracked
heavenly choir of his voice, he's back where he began: making music
of adoration.

In that way, "The Cross" brings the great slow jam "Adore" to
mind. The last track on the *Sign o' the Times* double album, "Adore" is
often cited as one of the sexiest bedroom tracks of all time. It was re-
corded with a full band and a horn section, and yet it's intimate: Prince
is engaging in pillow talk and foreplay in a whispery falsetto. There's
nothing religious about the adoration here, until there is. Prince tells his
lover that if God struck him blind "your beauty I would still see"; and
the chorus, which opens the song and punctuates it all the way through,
is "Until the end of time." In "1999" he partied like the world was
about to end; now he is making love till kingdom come.

Just as "Sign o' the Times" and "The Cross" make a matched pair,
so "Adore" is one song of a pair, with "Forever in My Life," which
wraps disc one of the album the way "Adore" wraps disc two. On the
album, "Forever in My Life" is a plan-for-a-song, some lyrics set over a
chilly synth program. Onstage, it would come fully to life. In the *Sign
o' the Times* concert film it is an exuberant set-closer, a cross between
a second-line parade and a gospel celebration. A crew of percussionists
strut across the stage, drums slung round their necks. Backup singers
dip and sway. The song's main line tips toward call-and-response: "You
are my savior," he sings, and he wants "you" forever in his life. Prince,
wearing a black waistcoat and a drum major's cap, falls to his knees
like a preacher (and like James Brown), and then leads the proceedings
with an acoustic guitar—singer and musicians and audience rising to
a height of ecstatic devotion. It's inspiring, uplifting; there's nothing
"bad" about it.

The next time we see Prince on-screen with the guitar, he has come out for the final encore. For two years he had played "Purple Rain" in that spot—and in fact, he'd written the song with encores in mind, after the keyboardist in the Revolution pointed out that the way to hold an arena crowd was to do a power ballad. With "Purple Rain," Prince came up with a power-ballad-as-spiritual, a crossover song for the eighties.

Now, here—onstage, Paisley Park, Minnesota, spring 1987—he does likewise with "The Cross." In the crowd, the cigarette lighters go up and aflame as he strums the big open chords. The band joins part by part, elaborating what is basically a ringing two-chord drone, the volume rising slowly and familiarly. It sounds like—what? Yes, of course, that's it, absolutely: "The Cross" sounds like a U2 song.

It goes on for eight minutes; Prince sings the anthemic chorus and the lofty verses over and over, crossing over into the crypto-religious once and for all.

Prince and U2 had more in common just then than most of us noticed. Like Prince, U2 had been commercially successful from the beginning of their career and now were breaking through to a fame so extreme that it changed the terms of success. Their new record, released the same week as *Sign o' the Times*, initiated this new phase; and it did so the way Prince had done with *Purple Rain*: through the sound of a liturgically solemn pipe organ, lofting from a minor key to the major.

With *The Unforgettable Fire* U2 had turned toward the United States and adopted Brian Eno's concept of records as sonic landscapes. Now with *The Joshua Tree* they were taking on the States directly, through a sonic landscape that evoked the actual landscape of the American West: desert and continental divide, valley and sky.

That slow-burn organ prelude sets the mood. The world of this record is an open-air cathedral, a natural wonder that invites religious wonder.

The turn toward a country other than their own represented a

deepening of U2's approach. "The pilgrim's search outside the self rather than the guru's search within": that was the credo for Walker Percy, whose novel *The Thanatos Syndrome* was released that spring. After early work thick with self-scrutiny, U2 were searching outside themselves.

They'd opened up their sound through the use of traditional acoustic instruments: slide guitar and dobro, common-room piano and fireside harmonica (with the steely chime of a Stratocaster running through it all). Daniel Lanois had made a life's work of recording such instruments, and the record has a grand, airy ambience.

When Bono started writing songs for the record he had just returned from El Salvador and Nicaragua, and the America of his imagining was a cross between a Jehovan desert and Central America—"something biblical," he recalled. "My understanding of the scriptures were the psalms of David and the lyricism of the King James Bible and I tried to bring that in, to give it a religiosity. Then a picture of a face comes up to me, red like a rose on a thorn bush. It was Ronald Reagan . . ." To Edge, he described the sound he had in mind: "Put El Salvador through your amplifier."

That song was "Bullet the Blue Sky." The sound Edge made, running a glass slide up and down the neck of a thunderously amplified electric guitar, really does put a squadron of village-strafing jet fighters in mind—and puts in mind "The Star-Spangled Banner" as done by Jimi Hendrix at Woodstock, an anthem repurposed as an act of creative rebellion. "Outside it's America," Bono intones during the fade-out; but U2 wound up facing the record as a whole away from current events and toward mystery, as embodied in the biblically named Joshua tree— shown in the photograph on the sleeve, the mountains on the horizon at the end of the highway.

"I want to run, I want to hide / I want to tear down the walls that hold us inside": The record is a pilgrimage to the Joshua tree. The singer is a seeker. He will follow the voice of an angel into God's country, a place of locust winds and crooked crosses where the streets have no name and the day begs the night for mercy. He'll stand with the sons of

Cain as Jacob wrestles the angel. Here he sees seven towers and a one-tree hill; here he's searching for the figure he still hasn't found but can't live with or without.

The record is self-serious. But so is the work of the other crypto-religious artists of that moment: Warhol's *Last Supper* series and Leonard Cohen's anthems of self-examination; Madonna's parable of female independence and Prince's joyfully askew reading of the signs of the times.

What's different about U2 is that their self-seriousness isn't offset by gestures of rebellion. In the run of records culminating in *The Joshua Tree*, U2's music was a rebellion *against* rebellion and in the name of devotion. They took themselves seriously the way believers across the ages have taken themselves seriously: out of the conviction that how you live your life in the eyes of God is of ultimate significance. For such a believer self-seriousness involves an ongoing reckoning with forces larger than the self.

A third of a century on, *The Joshua Tree* sounds etched and permanent. There are Edge's guitars, which riff, pummel, slice, score, pulse, jangle, and percuss. There are Bono's vocals, which have come down to earth: the singer who climbed scaffoldings and flew white flags is now a lonesome voice at the bottom of a canyon of sound, and his cry to the heavens echoes the yodel of Hank Williams.

And there's the religious imagery, which does what religion ideally does: it offers patterns for experience that are larger and more durable than our individual experience and that deepen self-understanding by taking us out of ourselves. "Trip Through Your Wires," say—it's a rousing, loose-limbed song of sexual ardor, but the sexiest lines are the ones that echo the gospel: "I was cold and you clothed me, honey . . . Angel or devil / I was thirsty and you wet my lips . . ." Bono sings. Those words express what he feels better than any "original" words he could have come up with—and they open up the song's knotty image of love as a tripwire that catches the lover mid-stride.

Could U2 have struck the religious note without the self-seriousness? Their career since then has been a running attempt to do so. They've

tried to be less reverent and more street—tried, in their designer-leather-and-shades-clad ways, to be *bad*.

The change began as *The Joshua Tree* was released; and it was prompted by current events that would force U2 to reexamine their relationship to religion and how it figured into the music they were making.

9

WAR

The buses left Union Square at dawn and reached D.C. mid-morning. There was a festive air: hand-painted T-shirts, day packs festooned with buttons, *Graceland* and *The Joshua Tree* playing (but not *Raising Hell* or *Licensed to Ill*). The end of the Reagan presidency was in sight, and the sense of now-or-never was strong.

The Mobilization for Peace & Justice in Central America and Southern Africa was envisioned as the largest anti-war rally in Washington since the Vietnam era. A coalition of left, labor, radical, and religious groups had organized it, seeking to protest the Reagan administration's covert military operations in El Salvador and Nicaragua and its tacit support for the apartheid government in South Africa. The moment—the last Saturday in April 1987—seemed propitious. The administration was reeling. A stealthy, illegal scheme to support the Nicaraguan contras through sales of arms to the United States' sworn enemy Iran had been exposed and made the subject of congressional hearings. Articles of impeachment—the first step toward removal from office— had been filed against the president. The U.S. government's backing for repressive regimes in the Americas, a dirty secret of the Cold War, had become front-page news.

The predictions came to pass; the Mall was brimming with protestors, and the peace movement seemed to have regained the authority it

had claimed in the sixties. "The house full for the big rally in D.C.—some 200 thou[sand] there. And a good spirit," Philip Berrigan, back at Jonah House in Baltimore after the rally, wrote to Daniel, who was teaching in Kentucky. "Tomorrow, an Impeachment Coalition rally on the Capitol steps. And on Monday—the big c.d. at CIA headquarters in Langley. Hafta speak at the rally. Figger that impeaching Ronnie, Bush and Meese will save a lotta lives . . ."

In the sixties, the Berrigan brothers, priest-activists, had thrived on the discordancy of their position: they were organization men denouncing the organization. To be an anti-war Catholic was to stand apart from the institutional Church. This time, by contrast, the movement had Catholic clergy and lay leaders at its center. The new Catholics for peace represented a convergence of post–Vatican II progressivism in the United States and Catholic missionary efforts for economic justice in the Americas. Priests, nuns, and Church aid workers had joined with local churches and base communities in setting themselves against the regimes and their U.S. sponsors. Meanwhile, the U.S. bishops—whose predecessors had been stalwart boosters of the Pentagon—affirmed a "presumption against war." With opposition to apartheid added to the mix, a distinctively Catholic opposition had emerged: on the side of the poor, against the power elite, and determined not to bend the knee to the Caesars of the world.

Philip Berrigan wrote to Daniel a few days later to say that he had been one of six hundred protestors arrested outside CIA headquarters, exulting "as Reagangate unfolds in D.C. and the crooks go down in disgrace one by one." His voice was assured, and with reason. Civil disobedience ("c.d.") was having effects. Reagan's proposed "Star Wars" missile defense system had been stymied by opposition. The arms-for-hostages scheme had been condemned. Congress had opened another inquiry into the murders of the four churchwomen in El Salvador. And early in the year—the feast of the Epiphany—a group of Plowshares activists had broken into a Navy facility near Philadelphia and pounded warplanes with sledgehammers, stirring things up enough that Daniel asked Philip whether the movement's effort to "up the ante" had actually gone too far.

The Catholic peace movement circa 1987 was an explicit expression of Vatican II Catholicism. In a church devoted to the holiness of the ordinary, solidarity with terrorized Catholics in Central America was a portal to the extraordinary. And it offset the hierarchy's harsh approach to homosexuality: no matter what Cardinal O'Connor said about gays at St. Patrick's, here the Church was on the right side of history.

Or so it seemed. That high point was actually a turning point—an end point. The situation was changing. The U.S.-backed autocrats in El Salvador and Nicaragua would soon use state violence to suppress rebellion and retain power. Now that a door had been opened onto clerical sexual abuse, the U.S. bishops would keep pivoting to the "pelvic issues": abortion and in vitro fertilization as well as homosexuality. As they moved into the controversy space the televangelists had opened, actual wars would be displaced by culture wars, to be fought over the human body.

The controversy over the Martin Luther King Jr. holiday was an early skirmish. In New York City, it was possible to think that the religious right had coalesced around issues involving sex. But the movement had emerged in large part as a reaction to the civil rights movement. As public schools in the South were opened to Black students, many white parents opted to withdraw their children and educate them elsewhere. School desegregation was rooted in the principle that tax-supported public schools had to provide "equal accommodation" to Black and white students. Religious schools, not funded by the government, protected by constitutional precepts involving freedom of religion, were not required to provide equal accommodation. A "Christian academy" could contrive to admit white students only. All at once Christian academies sprang up across the South.

The televangelists were the beneficiaries of this strategy. By the mid-eighties, white evangelicals and fundamentalists had established a robust network of private schools, churches, and television and radio stations—a distinctly white society within the imperfectly integrated

society of the so-called heartland. In doing so (Stephen Prothero has observed) they recast their defense of "our way of life" as a defense of traditional religious and "family values" and used the media to spread the new message.

Meanwhile, the Black protagonists of the civil rights movement had gained recognition of their achievements through the marking of Martin Luther King's birthday as a national holiday. But white Christian conservatives resented the elevation of their old foe and scold into an American hero through a holiday akin to those honoring the founding fathers. In some states, they led opposition to the MLK day on the grounds of states' rights—the same grounds they and their forebears had used to resist integration.

A new book gave their opposition a fresh pretext, enabling them to shift public attention away from sexual scandals involving the leaders of their own churches and onto a long-ago sexual scandal involving Dr. King—and to revise King's public image from a justice-seeking saint and martyr to a stereotypically "bad" Black man.

Bearing the Cross, by David J. Garrow, was an appreciative biography of King, and it drew on recently declassified documents to reveal a covert and illegal blackmail campaign the FBI had conducted against him. In the early sixties, King, who was on the road most nights as the leader of the civil rights movement, carried on a number of consensual sexual affairs, while his wife, Coretta, was home in Atlanta raising their four young children. The FBI bugged King's hotel rooms and taped the sounds of his liaisons. In 1965 the agency sent an audio recording of King having sex with a woman to the Southern Christian Leadership Conference headquarters in Atlanta, along with a note to King, purportedly from a concerned Black citizen: ". . . you are a colossal fraud and an evil, vicious one at that. You could not believe in God . . . Clearly you don't believe in any personal moral principles." It went on, "Protestant, Catholic and Jews will know you for what you are—an evil, abnormal beast," and suggested that he should commit suicide "before your filthy, abnormal fraudulent self is bared to the nation."

King resisted the blackmail; he expressed contrition to Coretta

(who had opened the package), but he kept up his liaisons. This aspect of his life was little known to the public during his career and afterward. But early in 1987—nineteen years after he was shot dead in Memphis—Garrow's account of the FBI's blackmail campaign prompted a reappraisal of King's character. Howell Raines, in *The New York Times Book Review*, explained that Garrow gave equal stress to "what we might call the sacred and profane aspects of the Rev. Dr. Martin Luther King Jr.'s life"—both "the civil rights achievements" and "the inner torments King suffered because of his compulsive sexual adventuring and because of the Federal Bureau of Investigation's conscienceless campaign to use this weakness to destroy him." Republican politicians saw no such balance in the incident. Already they'd followed President Reagan in insisting that King had been a Communist. Now they called him an adulterer, a tomcat, a hypocrite—a man not worthy of a national holiday. And the governor of Arizona, Evan Meacham, a Republican and a Mormon, rescinded the observance of the holiday in that state.

As it happened, U2 had arranged for the *Joshua Tree* world tour to begin in Arizona, with a week of rehearsals followed by two shows in Tempe and a third in Tucson. They'd done so partly for symbolic reasons: having rooted the new record's biblical motifs in imagery of the desert, now they would set out "on the road" from the literal desert that was the American Southwest east of Joshua Tree National Park.

The Arizona governor's act was itself a piece of symbolism. It repurposed the old segregationists' claim of "states' rights" for the swiftly developing Southwest and for a different era; it suggested that in race matters the new right was the same as the old one.

U2 at that point were identified with the civil rights movement as much as with the Troubles in Northern Ireland. Through "Pride: In the Name of Love" Bono had invoked Dr. King's legacy onstage night after night, tutoring American fans on their own history. *The Joshua Tree*, by contrast, was emphatically not an issue-oriented record. And yet this tour wound up involving them in the U.S. culture wars.

While other groups canceled scheduled Arizona shows in protest of the state's canceling the MLK holiday, U2 decided to go ahead with

their shows—to play them as a form of protest. "A national tour by the Irish rock band U2 got off to a controversial start Thursday night at Arizona State University in Tempe," the *Times* reported. The band made a donation to a group calling for Governor Meacham to be recalled from office. Bono received a death threat. U2 were national news.

During a show in Los Angeles a few nights later, Bob Dylan joined them for an encore of his "Knockin' on Heaven's Door." Dylan rarely deigned to go onstage except as a headliner, so the effect was profound: in a stroke, he legitimized U2 for the sixties-rock audience. As the tour moved east, *The Joshua Tree* went to number one, and all at once the band was all things to all people: youthful and classic, challenging and popular, self-motivated and eager to please, white and male, and also the emergent voice of the global human rights movement.

They were tagged as religious, too. Evangelical Christian magazines depicted them as four disciples who were using rock music to spread the gospel. Irish Catholics claimed them as leaders of their tribe. U2 seemed to reflect Vatican II Catholicism at its loftiest, at once seeing transcendence everywhere and transfiguring the commonplace.

U2's religiosity was never in question. The question was what it meant to identify oneself as religious. Following the Arizona episode, then—when the Moral Majority and its allies came out against the legacy of Martin Luther King—U2 sought to complicate their relationship to Christianity and religion generally.

Time magazine had commissioned a cover story about U2 by Jay Cocks, its music writer (and Martin Scorsese's collaborator). The story came out in April; it was on newsstands and coffee tables the week of the Mobilization for Peace & Justice in D.C. It gave ample space to U2's religiosity. Were they Christians? What did they believe?

The Edge: I suppose I am a Christian, but I am not a religious person.

Mullen: I am a Christian and not ashamed of that. But trying to explain my beliefs, our beliefs, takes away from it. I have more in common with somebody who doesn't believe at all than I do with most Christians.

Bono: I feel unworthy of the name. It is a pretty high compliment. But I feel at home in the back of a Catholic cathedral, in a revival hall or walking down a mountainside.

What did U2 believe? It was hard to tell. They were not religious; they were crypto-religious. But they weren't done with old-time religion, or it with them, not yet.

U2's changing approach to Christianity was partly a response to a change in the role of religion in public life. To call themselves Christians meant something different in the mid-eighties than it had meant when they joined Shalom in the late seventies; a passion for faith-based social action meant one thing in Ireland and Europe (places heavy with church history and culture but light on individual passion) and another in the United States, thick with evangelicals and fundamentalists whose passionate, faith-based social action involved denouncing "Sodomites" and opposing the MLK holiday.

The sociologist James Davison Hunter was studying this shift, which he called the "culture wars." Strangely, the shift had come about as a result of the *waning* of religious conflict. Germany under Bismarck in the late nineteenth century had been racked by a *Kulturkampf*: a state-sponsored effort to limit the social and political influence of the Church that took shape as a culture war between Catholics and secular-minded Protestants, echoing the wars of religion of the sixteenth century. Through immigration, Protestant-Catholic conflicts were imported to the United States and reinvigorated on American soil. From the founding till World War II, the Protestant churches stressed their differences from one another; Protestants set themselves against Catholics (and vice versa); and Christians together distinguished themselves from Jews, socialists, and pagans.

By the 1980s those conflicts had eased, and there was "amity" among the churches. Yet strife involving religion was all around. Why? "Cultural conflict is taking shape along new and in many ways unfamiliar lines," Hunter explained. *"At the heart of the new cultural realignment are*



pragmatic alliances being formed across faith traditions." Instead of Protestant versus Catholic, it was conservative versus progressive. This could be seen in the alliance of conservative Catholics and Protestant evangelicals and fundamentalists that had elected Reagan president and reelected him with a "morning in America" mandate; their alliance, rhetorically retrograde, was historically new.

To make those pragmatic alliances the new religious right sought issues that would unite believers from different churches around a common cause. One was found in "the deep and long-standing hostility of the Judeo-Christian faiths towards homosexuality," as Hunter observed. Another was the idealizing of law and order and of war as a force of order. In El Salvador and Nicaragua, conservatives united behind Church-aligned military regimes, while progressives were divided between those who supported armed people's movements and those who opposed war as such. As conservatives shifted their sights to sexual morality, then, they united around the idea of a culture war—a conflict that progressives, leery of war, were loath to join.

The term *culture war* was not yet in common use, but the shift was recognizable in the pews and in news reports. In 1983 the U.S. bishops, influenced by the peace movement, declared: "The nuclear age is an era of moral as well as physical danger. We are the first generation since Genesis with the power to threaten the created order." Three years later they were upholding the CDF instruction that the "inclination" toward homosexuality "must be seen as an objective disorder." Through conflict, order would be restored. What had been implicit was now explicit: the culture wars were on.

Daniel Berrigan recognized the shift from actual war to culture war sooner than most.

The draft of his autobiography was thick with episodes about war and peace, action and protest—"the arrests, the courts, the jails and prisons, the hanging judges and voracious prosecutors," all sustained by "the search for ways and means, the tactics and planning, the discipline, the Eucharist, the life together, the Bible study." But a late chapter, climactic

in its way, was called "AIDS: The Dream, the Awakening," and depicted AIDS as a kind of final revelation of the emptiness of the "dream" of a society of "conspicuous consumption" maintained by nuclear-tipped state violence. There was a verbal sketch of Fr. Bill McNichols, who had come to live among the Jesuits on West Ninety-Eighth Street. "In his nervous, darting way, he knows what he's about . . ." Berrigan wrote of the younger priest. "He sheds light in dark corners—where, because of the present atmosphere of panic, many prefer to cower." He noted that McNichols was planning a day of public prayer for people with AIDS, the lepers of the present.

On gay issues Berrigan, no simple progressive, offered something to offend everybody. Like many a Catholic priest, left, center, and right, he assessed gay life, pre-AIDS, in old scholastic terms, as "an unimpeded appetitive life" of pleasure and gratification. He lamented that "many gays, among others, spent their days drifting through the Dream, enacting it, embodying it." And yet he made clear that he had been changed by the direct experience of AIDS. Now he called out the leftist populists of Latin America for despising homosexuality as one more expression of decadent capitalism—for letting "old hatreds jazz up in chic new fatigues." In fact, he proposed, the hard-left insurrectionists, the capitalists, and the Catholic hierarchy were in lockstep in their contempt for homosexuality. Big religion, big business, revolution, the war machine: all were society's efforts to gain "immunity from death." AIDS was a grim reminder that full immunity was impossible; and the encounter with it had recalled him to "the God who . . . eternally immune, rendered himself vulnerable to death."

With the autobiography complete—and called *To Dwell in Peace*—Berrigan celebrated Mass at a Dignity conference in Miami. The conference brought together 2,500 gay believers, Protestants as well as Catholics. "There was such grief and forgiveness and joy in Miami, I thought I was translated to a black church in the '60s," Dan wrote to Phil afterward, adding sardonically: "Something is happening to these achieving darlings of the kultcher; it's all the loss and dying and ghettoing."

The Gospel text was the story, from Mark, of the Syro-Phoenician

woman who asks Jesus to heal her daughter of an unclean spirit and is scorned, at first even by him. In his homily Berrigan pointed out that the woman, a gentile female, is "radically an outsider," but she makes Jesus hear her request. "What shall we name that quality of hers," he asked, ". . . that makes her an ideal and a model for the outsider? Courage? Persistence?" He went on to frame gay people's struggles in terms of the peace movement. The conflicts driving the religious right were war by other means. The Church's quickening opposition to the lives of gay people wasn't just hidebound traditionalism or raw bigotry. It was a form of violence—a force of evil.

He saw no sign that the Church would change its ways and heal "those it has wounded so grievously." But he urged the people of Dignity to practice a "persistent forgiveness" toward the Church. And he situated the AIDS epidemic—the virus, and the virulent response to it—in the "spirit of death" that peacemakers were called to oppose. It "haunts lives, institutions, churches" like an unclean spirit. It brought about "death to compassion, to a sense of the truth, to a sense of one another." And it led to "the 'putting to death,' with malign intent and sour will, of human variety, of sexual and racial and religious variety"— here he quoted Gerard Manley Hopkins—"all that 'wet and wildness' celebrated by the poet, to the honor of the Creator."

Gay Catholics in New York City took a distinctly different approach, blending persistence with righteous anger. The ouster of Dignity had left them with no obvious place to convene and organize. At the same time, the efforts of gay rights activists to get policymakers to address the AIDS epidemic were coalescing as a protest movement. And so it came to pass that in the spring of 1987 gay Catholics and anti-Church gay activists found themselves shoulder to shoulder in front of St. Patrick's Cathedral. The Lavender Hill Mob held protests outside Sunday Mass. So did the Cathedral Project, a group of Catholics that had emerged out of Dignity. The protests were boisterous and irreverent. As they grew from one week to the next, the Church turned to the law, securing a court injunction that required protestors to gather behind

police barricades on the Rockefeller Center side of Fifth Avenue rather than right outside the cathedral.

The AIDS-activism movement came to include several artists shaped by their firsthand conflicts with Christianity. The photographer Peter Hujar was one. He had grown up on a farm in New Jersey, raised by Ukrainian-speaking grandparents; from the age of sixteen, he lived on his own in New York, where he took up photography. A competition put him in a master class with Richard Avedon and introduced him briefly to Diane Arbus. Fulbright scholarships led him and his lover, the painter Paul Thek, to Italy, where Hujar took some arresting photographs in a Capuchin catacomb in Palermo: long-dead friars in coffins, their bodies decayed under robes so that their skulls had a jutting, leering intensity. A 1975 book paired his pictures of the dead Capuchins with portraits of his friends on the downtown art-and-performance scene: Divine, Charles Ludlam, and John Waters; William S. Burroughs, Robert Wilson, and Susan Sontag, many of them shown in bed. The effect was that of a memento mori, suggesting the cryptic, death-haunted quality of the downtown scene—an effect that would seem premonitory a decade later when Hujar, Thek, and many of their friends contracted HIV.

From the early eighties Hujar was involved with David Wojnarowicz, an artist of the next generation. Wojnarowicz, the son of an absent mother and a violently abusive father, had gone through Catholic grammar school in New Jersey (where the nuns "beat him and made him kneel on marbles," his biographer Cynthia Carr reports) and then the High School of Music & Art in Harlem. In his late teens he supported himself by working as a hustler on the far West Side, and he first gained notoriety as an artist for murals he made on the corral-like remains of the Hudson River piers. His *Arthur Rimbaud in New York* photo series, from 1979, depicted a figure masked with the poet's visage in various city sites, such as "making rude gestures at St. Patrick's during Mass." A later work flashed forward from his upbringing. Under a childhood photo, a caption read: "One day this kid will do something that causes men who wear the uniforms of priests and rabbis, men who inhabit certain stone buildings, to call for his death . . . All this will begin to

happen in one or two years when he discovers he desires to put his na-
ked body on the naked body of another boy."

Hujar and Wojnarowicz were outsiders, their work directed toward
the downtown scene. Keith Haring, by contrast, was an artist who
pointed his work toward the public. His early stencils on the unused
advertising quadrangles in New York subway stations were instantly
recognizable—at once childlike in the knobby, blockish human figures
and Warholish in the gushy exuberance of the motion lines around
them. They seemed sprung from the undergrowth of the city itself, not
from the hand of an artist. But they were rooted in Haring's upbringing
in Kutztown, Pennsylvania, among Mennonites and Anabaptists, in a
family who belonged to the United Church of Christ. "I was bom-
barded with Christian ideology . . . not Catholicism but Protestant-
ism," he recalled. "I was forced to go to Sunday school and church." He
read deeply in the Bible, at one point ranking the psalms as a personal
project; he grew more religious than his parents. As a teenager, he fell
in with Jesus Saves, a hippieish movement devoted to spreading the
Good News in public places. "I was considered a freak—a Jesus freak,"
he said. This pursuit subsided after he discovered pot, sex, the Grateful
Dead, and *The Art Spirit*, a 1923 book of wisdom for emerging painters
by Robert Henri, who saw works of art as "signposts towards greater
knowledge." ("There are some who have found the sign and through
their works we can to some degree follow . . .") After two years at the
Ivy School of Professional Art in Pittsburgh—where he recognized that
he was gay—he transferred to the School of Visual Arts and moved to
New York. That was August 1978, a few weeks after Madonna moved
to the city.

Haring's subway stencil series, and the "Radiant Child" stencil in
particular, was an extension of the popular impulse Haring had found
in the Jesus People and then in the Grateful Dead. "His radiant baby
was a trademark, a brand, yet also a warm compress of meaning that
established his key signature," Brad Gooch observes in his biography.
The stubby, thick-bodied humanoid figure echoes the Christ child in
a Nativity scene: as Haring put it, "lines radiate from the baby indi-
cating spiritual light glowing from within, as if the baby were a holy

figure from a religious painting, only the glow is rendered in the visual vocabulary of a cartoon." A critic called the lines "the first believable twentieth-century halo."

Another early work seemed to dramatize the controversies involving Christianity in America just then. It's done in stark black and white. On the left side, a humanoid figure set before a flag and the emblem *USA1981* holds a red cross at arm's length; on the right, a figure bound, mummy-like, with a red cross on its face swaddles a figure bound to a chair, the one covering the other's eyes with two hands. The latter image is either a challenge to the former (an image of Christian care for the suffering) or a gloss on it (Christianity binding a person and figuratively blinding it). Either way, the work is crypto-religious precisely because it is unstable in its significance.

None of these artists made essentially confrontational work, at least not initially. But as the downtown arts community was at once decimated by AIDS and demonized by the new religious right, they altered their approach. After Hujar tested seropositive in 1984, Wojnarowicz undertook a video, called *The Fire in My Belly*, that combined anticipatory grief over Hujar's likely death—and, very possibly, his own—with rage over AIDS and society's indifference to the death of gay people; one sequence features ants crawling over the bloody naked body of Jesus on a gift-shop crucifix. Haring designed a logo for the Gay Pride Parade down Fifth Avenue, so that an image of dancing figures literally hooking up—their heads the biology-class symbols for male and female—would be set against the fundamentalist Christians' placards outside St. Patrick's urging the powers that be to "Quarantine Manhattan Island . . . The A.I.D.S. Capital of the World."

In retrospect the merging of art and activism around AIDS and the Church's response to it seems so apt as to be inevitable. At the time, however, Keith Haring was still thought of as an emerging artist, protests outside churches as the work of a lunatic fringe, and the incipient culture war as an it's-about-time development—the Church finally asserting itself against the post-sixties slackening of orthodoxy.

John Paul's newly appointed cardinal archbishops saw things that way. So did Richard John Neuhaus. Pastor Neuhaus was running a foundation, editing a magazine, giving talks, advising the Reagan White House on religious matters, and living with a small group of like-minded believers in an East Side brownstone, called the Community of Christ in the City. Balding, just past fifty, he had swapped cigarettes for a pipe. His presence at the synod in Rome on the legacy of Vatican II had been transformative—strengthening his sense of Lutheranism as a reform movement (more than a tradition unto itself); deepening his reverence for John Paul; and quickening his sense of Roman Catholicism as a convergence of ancient faith, popular appeal, and present-day institutional power. A controversialist by temperament, Neuhaus saw controversy as the essence of religion—a site for disputation and conversion. He saw the controversies involving the Catholic Church as an opportunity and saw involving himself in them as a personal calling. He was, that is, what would be called a culture warrior.

Neuhaus scorned the religious left he had left behind for what he saw as its ceaseless Marxian striving to be "on the right side of history." But as both a journalist and as a controversialist, Neuhaus knew the value of seizing the moment and naming it—of reading "the signs of the times," as Jesus himself had called them. With a strong pope in Rome and powerful Catholics in office in Washington and New York, he proposed, in *National Review*, that the present was "the Catholic moment."

Not *a* Catholic moment: *the* Catholic moment, with Neuhaus's characteristic thumping rhetoric. This, he said, was "the moment in which the Roman Catholic Church in the United States assumes its rightful role in the culture-forming task of constructing a religiously informed public philosophy for the American experiment in ordered liberty." In outline, seizing the Catholic moment meant seeking points of concord between Catholic ideas of natural law and the moral order and the ideas of the American (Protestant) founders and framers. In practical terms, it meant striving to bring about change on cherished conservative issues: contraception, abortion, law and order, welfare and the family, the size and reach of government. And it meant hobnobbing with rich and powerful people: philanthropists, cabinet secretaries, presidential

speechwriters, federal judges—all in the name of the kingdom of God, which was not of this world.

Awkwardly, this herald of a Catholic moment was still a Lutheran. Through a twist of zoning, the grandest Lutheran church in New York City was St. Peter's, a geometric modern structure pocketed into the CitiCorp building, at Fifty-Fourth and Lexington. So it was that Neuhaus, pipe in mouth, began to seize "the Catholic moment" by leading events at a Lutheran church in the headquarters of a giant global bank.

He was writing a book on the topic, spelling out his position and how he had come to it. His attraction to Catholicism was sincere and deeply rooted in theology. But he also was keenly aware that the Church's stature in public life lent its leaders stature, too. Like Andy Warhol and Leonard Cohen, he had left a provincial religious upbringing behind to come to New York and make a name for himself in the big city. He was now loosening ties with his Protestant heritage in Canada and Missouri and moving toward the grand stage that was the Roman Catholic Church—the one everybody called *the* Church, as Lenny Bruce had put it in a once-outrageous monologue.

With a journalist's sense of timing, Neuhaus had the pope's imminent U.S. visit in mind. That April, John Paul traveled to Argentina for World Youth Day, celebrating an open-air Mass for a million people in Buenos Aires—a papa who preached, yes, but also a pop-cultural figure who smiled, sang, and praised young people for their ardor. That event stirred anticipation for his "apostolic journey" in September: ten days; eight cities in the South and West; Mass in the Superdome, the Silverdome, and the L.A. Coliseum. The tour would be an embrace of the ten million or so Catholic immigrants from Mexico and Central and South America, affirming Catholicism in places where evangelicalism was surging. It would be a papal showcase, using the mass media to counter "bad" influences with Catholic pageantry and vivid images of the holy man. And it would be a supervisory visit, enabling John Paul to see the controversy-ridden U.S. Church firsthand and to assert his authority directly—to take a role in the culture wars.

———

The papal tour would follow on from two worldwide tours that summer: U2's and Madonna's.

U2 played thirty shows in the United States in April and May, culminating in a five-night stand at the Brendan Byrne Arena in New Jersey, where the Irish Catholic diaspora joined up with Bruce Springsteen's following. Then U2 went on tour in Europe, beginning in Rome, where they played outdoors for forty-five thousand people. A camera crew tagged along. U2's rise in America had been spurred by the Red Rocks concert video on MTV; for this tour, they had arranged a movie: onstage, backstage, offstage, all filmed in evocative black and white by a young director, Phil Joanou.

Madonna was on the road with the *Who's That Girl* tour. She played in Japan and performed two dozen shows in North America—stadium shows, mostly—before going to Europe in August. She, too, was tailed by a camera crew for a concert movie.

In the months after its release, "Papa Don't Preach"—a topical song about teen pregnancy, after all—had been judged offensive by figures across the cultural-political spectrum: abortion rights groups . . . advocates for contraception and "safe sex" . . . feminists . . . evangelicals . . . and Catholic conservatives, who voiced support for the young woman's cry of "I'm keepin' my baby" (rather than seeking an abortion) but who distanced themselves from the song's tacit support for premarital sex and for the sort of marriage-of-circumstance prompted by an unexpected pregnancy.

Back when *Penthouse* ran nude photos taken in her late teens, Madonna's response had been SO WHAT! She had since sharpened her controversialist's edge, and she sought to take a definite position in the "Papa Don't Preach" furor. On tour that summer she performed the song in front of a giant video backdrop featuring images of Pope John Paul and President Reagan. She ended it with a chant of "Safe sex!" Typically, she told the crowds that she was dedicating the song to the pope.

The Church was opposed to condom use in any and all circumstances, whether among straight couples to reduce the likelihood of pregnancy or among gay men to prevent the spread of HIV. The Vatican had issued a document in March 1987 condemning a wide range

of emerging practices it characterized as "technologies of intervention in the human process of procreation"—in vitro fertilization, surrogate motherhood, amniocentesis—and in the months that followed, Church officials reiterated the Vatican's opposition to condoms as technology that stood in the way of procreation.

Now the Reagan administration, facing pressure over its inaction on AIDS, formed a National Commission on the Human Immunodeficiency Virus Epidemic. Its twelve members, announced in late July, included Cardinal O'Connor of New York. The next Sunday more than a hundred activists massed behind the barricades across Fifth Avenue from the cathedral, crying out, "Hey ho, hey ho, Cardinal O'Connor has got to go!" and "Shame, shame, shame!" When Mass began inside, fourteen people seated in pews up front rose and turned their backs to the altar to demonstrate their displeasure with the appointment of O'Connor—who wasn't there.

The "safe sex" encouraged by AIDS activists was immoral, no matter who practiced it or why. So the Church taught; so the clergy preached.

In response, Madonna made her show at Madison Square Garden a benefit for AIDS research, dedicated to Martin Burgoyne. And she made the sports arenas of Europe her pulpit. After her Catholic girlhood, she had developed her career among gay men on the Lower East Side. "Papa Don't Preach" was originally a daughter's appeal for compassion from her father. Now it became something else: an all-purpose rejoinder to male clerics who were telling people how to live their lives, and their sex lives in particular. Madonna—the Boy Toy, the Material Girl—was now a culture warrior.

In the way of hit songs, "Papa Don't Preach" applied, wierdly and aptly, to what Sinéad O'Connor was going through at the time.

She had just turned twenty and was making her first record in London. Shaven-headed, eight months pregnant, she put finishing touches on a song rooted in Psalm 91, which she'd made a morning prayer mantra after taking up with a Baptist-spiritualist medium. "I will walk in the garden / and feel religion within," she sang, plaintively. "I will

learn how to run with the big boys / I will learn how to sink and to swim . . ."

Outwardly, she was a cross between U2 and Madonna: radiantly young, Celtic down to her bootlaces, powerfully self-determined, rebellious, her image in perpetual motion. Inwardly, she was controverted—but how? Bravely, she was trying to figure that out—through music inflected with the harsh accents of old-country religion.

Her Irish upbringing, as chaotic as Madonna's Franco-Italian one, had happened only yesterday. She was the third of five children of parents who loathed each other. Her father was a hard-pressed patriarch, her mother a woman on the verge, her maternal grandparents grim figures living among "worn-out pictures of old popes on the wall and above the fireplace, along with Padre Pio and Mary and Jesus. Halfway up the narrow stairs there's a glowing Sacred Heart on the wall. It's really scary . . ." Her grandpa's imprecations were biblical: men who crossed him were Judases, women who wore makeup Jezebels.

Three generations of family members came and went at a cluster of houses in Dublin. An aunt with Down syndrome was an emissary of goodness. But O'Connor's mother was full of rage against her children. Brought along on a pilgrimage to Lourdes (her middle name was Bernadette), Sinéad prayed to God to give her mother some help.

When her father fell in love with another woman (a Protestant, sensible as could be) and moved out, her mother's mental illness overtook the household. She beat the children, told them they were worthless, didn't feed them or wash their clothes. Sinéad was nine. In the next years, jarred by the experience, she lived in her father's house (he had gained custody), at a boarding school, as a runaway, and in a Catholic home for wayward young women (like the one Louise Erdrich had rendered in "Saint Marie"). A nun sent her to stay overnight in the "laundry," a decrepit ward populated by shuffling, murmuring figures. It wasn't a punishment so much as a warning. "She was being a kind of nun I'd never seen before," O'Connor recalls in the autobiography. "She deliberately hadn't told me why I was to go to a part of the building I'd never known existed, climb a flight of stairs I would never have been allowed to ascend if I'd asked to, knock on a door I would previously

not have been permitted to touch, and enter such a scene with no staff present. She let me figure it out myself—if I didn't stop running away, I would someday be one of those old ladies."

Her mother's life was itself a warning about the inherited taint of mental illness and the harsh effects of enforced early marriage and motherhood. Her own rebellion was a rebellion against her mother first of all. And yet it was her mother, more than anyone, who had shaped her tastes, through the music played in the house: ". . . John Lennon, Johnny Cash's prison albums, Waylon Jennings, Ella Fitzgerald . . . Van Morrison's *Moondance*, the Velvet Underground, Lou Reed, lots of Beatles records, and *The Jungle Book* soundtrack . . . Nick Drake, Dusty Springfield, Joni Mitchell, Cat Stevens, Mike Oldfield . . ." Sinéad saw Elvis Presley as a father figure (and cried when he died). She fell in love with the rakish Dylan of the *Bringing It All Back Home* sleeve photo and grew "obsessed" with Dylan after *Slow Train Coming* came out.

She progressed from carrying an older brother's empty guitar case as a prop to singing, playing, and writing her own songs. A job as a coat-check girl opened a door to the Dublin music scene. Busking and open-mike nights led to a record deal with Chrysalis. One night she guested with the Waterboys, from Scotland, joining in their ecstatic blend of electric guitars and Celtic roots. In the video from that show she is wearing a jean jacket and a crucifix—the Madonna look.

Her mother died in a car crash in 1985. Sinéad left Ireland soon afterward, moving to London to make her record. There the behind-the-music controversy began. The label wanted a glossy pop production; she wanted harsh edges and resonant peaks. The label encouraged her to be more "girlie"; she responded by having her head shaved at a Greek barber's. She was involved romantically with the drummer in the band, and she found she was pregnant. Chrysalis urged her to have an abortion. ("Your record company has spent a hundred thousand pounds recording your album," the doctor said. "You owe it to them not to have this baby.") She refused. When the drummer was less than pleased, she stopped having sex with him. Her baby bump swelled in a counterpoint to her shaved head. "I got thrown out of an Italian café in Charing Cross by the old lady running the place," she recalled, ". . . because

I had on, cut so short that my bump was exposed, a white T shirt on which was printed ALWAYS USE A CONDOM."

She was living in a fleabag hotel in Camden Town, just out of her teens and already carrying a child, like so many Irishwomen in England before her. "How could I choose between my career and a child?" She chose career *and* child. She rejected the mixes made by the producer the label had assigned and took over the production of the record herself as an act of will. The approach she brought to the songs suggests the fierce personal discipline involved: the sound has been stripped down (strummed guitars, plangent vocals) and reenhanced with modal synth chords and overdubbed choruses.

She gave birth to a boy, Jake. And she made the astonishing video for "Troy." Seen today, it suggests that the song is the missing link in women's rock—her sky-scraping vocals etching a line from Patti Smith and Kate Bush to Courtney Love, PJ Harvey, and Alanis Morrissette. (For Robert Christgau they echoed the devil-convulsed young woman in *The Exorcist*.) The title suggested Greek mythology. The lyrics suggested both a broken romance and a lost past: "Tell me, when did the light die . . ." The Ireland the video evoked was a pagan place, where Sinéad, her head and shoulders sprayed gold, declaimed the lyrics before a curtain of flame. The shaved head made her look like a Buddhist monk or an emissary from the future. Five years after U2 had hit number one with *War*, a record saturated with Irish Christian imagery, Sinéad's music suggested that the isle's churchy, priest-ridden, saint-laden religion had been left behind.

It was there, though, just in jagged little pieces. One song's chorus was the word "Jerusalem" sung over and over, Sinéad swooping up through her register to hit a glass-shattering high note. Another featured Psalm 91. Her morning mantra was now the key to the record. "For He will command His angels concerning you to guard you in all your ways / They will lift you up in their hands so that you will not strike your foot against a stone / You will tread on the lion and the cobra; you will trample the great lion and the serpent." Those verses had kept her going during her first months out of Ireland—as sword and shield, as shelter from the storm. From them she took the record's title:

The Lion and the Cobra, which evoked nature red in tooth and claw. But she didn't sing them, not for the record. Enya, the mystical chanteuse, sang them—in Irish, a cappella. Enya's double-tracked voice blended with O'Connor's in a two-voice choir: *Satlóidh tú ar an leon is ar an nathair / Gheobhaidh tú de cosa sa leon óg is a dragan.*

Bob Dylan had been drawn into the culture wars long before they were so named; in his way, he had announced them: ". . . there's a slow train / Coming 'round the bend . . ." He had then felt the force of disapproval from fundamentalists *and* from their detractors. Mid-decade (he recalls in *Chronicles*) he was ground down, "freeze frozen in the secular temple of a museum." He felt that "my own songs had become strangers to me." A hand injury forced him to relearn how to play the guitar. The long tour with Tom Petty and the Heartbreakers left him thinking of retiring. Touring on his own, he "could hardly fill small theaters." He was forty-six years old.

He went to northern California to rehearse for a short tour with the Grateful Dead. The tour was booked, but he felt he couldn't do it: "I had written and recorded so many songs, but it wasn't like I was playing many of them. I think I was only up to the task of about twenty or so. The rest were too cryptic, too darkly driven, and I was no longer capable of doing anything radically creative with them . . ."

One night in San Francisco, out for a walk in the rain, he passed a bar on Front Street, down by the waterfront. A jazz combo was playing, led by an aging vocalist. He went in, ordered a gin and tonic, and listened. The singer "wasn't very forceful, but he didn't have to be: he was relaxed, but he sang with natural power." The approach struck Dylan as "revelatory," he recalled. "It was like the guy had an open window to my soul. It was like he was saying, 'Do it this way.'" Dylan went to the Dead's rehearsal space in San Rafael the next day, reassured and inspired: ". . . now I knew that I could perform these songs without them having to be restricted to the world of words."

With the Dead, and then again with Tom Petty and the Heartbreakers, he broke open his back catalog, working up eighty different

songs. He sang them without effort. But one night on a wind-whipped stage in Locarno, Switzerland, he opened his mouth and nothing came out. He panicked. He tried to conjure a sound from his throat: "I just did it automatically out of thin air, cast my own spell to drive out the devil." And in that moment—a "metamorphosis," he called it—a new, "multidimension" quality came into his famously narrow, nasal voice. "If I ever wanted a different purpose, I had one. It was like I'd become a new performer, an unknown one in the true sense of the word."

So it was that in midlife and mid-career Dylan the singer was born again.

In anticipation of John Paul's visit to California the *Los Angeles Times* arranged to publish a piece by the essayist Richard Rodriguez about the Catholic missions there. Rodriguez set the visit and the controversies surrounding it against the long-past cultural conflict that had shaped California, imprinting a sacred geography on the road map of the state. "Nuestra Senora la Reina de los Angeles de Porciuncula would become, in 200 years, L.A. Though the bells of the missions are now as muffled as the stuffed mouths of corpses," he observed, "living Californians— such was the genius of Spain—must yet compose a litany of words to get from one end of town to the other: 'Take the San Bernardino to the San Gabriel turnoff' . . ."

Rodriguez was known for his public engagement with two long-running controversies in California: over affirmative action in universities, and over bilingual education in primary schools. In a 1982 memoir, *Hunger of Memory,* he had rooted his positions in his own controverted character. Born in Sacramento, his parents immigrants from Mexico, he'd grown up speaking Spanish in a Catholic household of deep Latin piety: ". . . in our house on Good Friday we behaved as if a member of our family had died." But he'd been educated by Irish American nuns who insisted on English as the language of American public life; and he became a brilliant reader and writer in English, moving through Stanford, Columbia, London, and Berkeley, where he earned a PhD in Renaissance literature. His education in English, he found, formed

the public self one needed to live fully in the English-speaking United States; so he was opposed to bilingual education. Society was eager to recognize him as a "model minority" through an Ivy League teaching job when it ought to have been improving primary schools to benefit the truly disadvantaged; so he was opposed to affirmative action. Instead of the clarity of the Chicano-activist position, he chose the essayist's ambiguous calling.

On pilgrimage to the missions in 1987 he found the roots of those controversies—and his own—in the history of American settlement. The story of the United States was a conflict between "Catholic pessimism and Protestant optimism." California was at once the offspring of these points of view and the site of their ongoing conflict. "Two theologies vied for primacy in California; two theologies met here. The northward [from Mexico], the communal, the Catholic impulse dragged the gargantuan trap of European civilization in its wake, extending the great world. The Protestant, the westward, the individual impulse favored amnesia; left all behind."

Four and a half centuries after the Spanish missionaries, John Paul was coming to California as to missionary territory. The pope and his neoconservative American advance guard saw post-sixties California as a pagan place. "California is the Vatican's adversary in a competition for the imagination of the world," Rodriguez explained. "Hollywood manufactures 80 percent of the world's supernatural." And yet John Paul—something of a Catholic pessimist himself—saw it as improvident to try to convert California. He sought instead to scatter a few seeds and let them grow: "I think the Vatican intends to convey that in her book California is good soil—in the manner of the parable—and indeed, the fields of California seem especially plenteous of mustard this summer."

Rodriguez, living in San Francisco, homosexual (the term he favored) but not yet open about it in his writing, had nothing to say in that essay about the controversies around Catholicism and homosexuality. But a conversation with a priest, Michael Galvan, pointed up a different area of emerging conflict. Galvan was one of two priests in California who traced his heritage to the Indigenous peoples (the Ohlone, in his case) whom the missionaries had sought to convert. "He

is 36 years old. He could be my cousin. We are of the same height, same color," Rodriguez observed, and went on: "Father Galvan sees the European phase of the church coming to an end. 'For 2,000 years the church had moved from Jerusalem to Europe.' Now the church is finding a new heart in Latin America. 'By the end of this century more than half of the world's Catholics will be brown.'

"'You mean Spanish-speaking?'

"'Brown,' he replies. 'The world church will be brown. Indian.'"

Madonna's *Who's That Girl* tour reached Italy in September. The Vatican urged Italians to boycott the shows. The response revealed the diminished authority of the Church on cultural matters even in predominantly Catholic Italy. The show in Turin drew a crowd of sixty-three thousand people and was broadcast live on state television, where something like a quarter of the Italian population tuned in. Madonna did "Papa Don't Preach" in a flouncy dress and a leather jacket, strutting before a slide show (pope, president, Gothic cathedral) that ended with the words SAFE SEX in big block letters.

The next week two stories dominated the news in the United States: the confirmation hearings for Judge Robert Bork, a Catholic, opposed to legal abortion, whom President Reagan had nominated to the Supreme Court, and John Paul's imminent "apostolic journey." The papal visit was tagged as controversial. NBC aired a program about Catholic conflicts over homosexuality, abortion, and the ordination of women. The next day, there was a protest outside the Vatican nunciature, or embassy, in Washington: WOMEN'S RIGHTS ARE HUMAN RIGHTS, the unfurled banners declared. In response, the president of the U.S. bishops' conference, Archbishop John L. May of St. Louis, took a familiar line, insisting that "third parties" and "special interest groups have decided to use the visit to call attention to their particular grievances." This was a line that would harden as the culture wars deepened: in the eyes of the bishops the pope had appointed, Catholics who rejected or struggled with specific Church teachings were not Catholics at all, but outside agitators and special interests.

John Paul arrived in Miami on September 10, primed for a marathon: dawn flights, a daily motorcade in the Popemobile, half a dozen vast public Masses, forty-eight speeches prepared in Rome. He met Jewish leaders in Miami (some, angered over the Waldheim audience, refused to take part). He met Protestant leaders in South Carolina, Black Catholics in New Orleans, Hispanic Catholics in San Antonio, Polish American Catholics from a town in Texas founded by immigrants. In Phoenix, he entered the football stadium set up for an open-air Mass in a procession arranged by Native American Catholics wearing garments reflecting the traditions of their tribes.

The prepared speeches were thick with admonitions against abortion, divorce, sex before marriage, and individualism. "It has sometimes been reported that a number of Catholics do not adhere to the teaching of the Church on a number of questions, notably sexual and conjugal morality, divorce and remarriage," the pope declared, reading aloud to four hundred bishops. This could not stand. Catholics "selective in their adherence to the Church's moral teachings" should not be mistaken for good Catholics; they were at risk of excommunication.

The pope's statements were talking points for the bishops to use in the emerging culture wars. Against gay rights, for example: on the one hand, the bishops should preach that homosexuality was "against nature" and that Catholic teaching upheld a natural order recognized by all human cultures; on the other, they should preach that the Church's position was essentially countercultural, "by its nature" unpopular.

In California the controversies of the present were converging with those from the age of settlement, as the Church's plans to begin the canonization process for Junipero Serra, the Spanish Franciscan who had led the missionary efforts there, drew protests on the grounds that the tactics Serra used to "convert" Indigenous people to Catholicism amounted to cultural genocide. John Paul would address those controversies together in Masses—at Dodger Stadium in Los Angeles and Candlestick Park in San Francisco, each centered on a rite called the Triumph of the Cross.

But first he took his message to earthly powers. Fifteen hundred film and TV executives assembled at the Registry Hotel in Los Angeles

to hear him speak. They rose when he arrived—a standing ovation. He told them that their power as arbiters of culture gave them a special responsibility. "In a sense the world is at your mercy," he said. "Errors in judgment, mistakes in evaluating the propriety and justice of what is transmitted, and wrong criteria in art can offend and wound consciences and human dignity. They can encroach on sacred fundamental rights." It was another talking point: in place of the artist's right to free expression and the rights of competitors in an open marketplace, he put "sacred fundamental rights," which he left unnamed and undefined.

The next day he went by helicopter to a mission near Monterey and then to San Francisco. A motorcade up Geary Avenue brought him to the Mission Dolores, the church, built in 1791, that gave the Mission district its name. Nine hundred Catholics awaited him. Among them were sixty-two people with AIDS or HIV. Kenneth Briggs, who was there, described the scene: "John Paul moved slowly down the main aisle. Approaching the section where the AIDS patients stood, he began at once to reach out to them, marking some on the forehead with the sign of the cross, touching others on the head, cheek, shoulder, arm, or hand." He spoke on the Gospel story of the prodigal son, explaining that God loves his people, each of us, in our weakness, and the believer's knowledge of this "enables us to hope for the grace of conversion when we have sinned."

The sins implied were those that led to AIDS: intraveneous drug use and homosexual activity, whose practitioners were prodigals. The pope went on: "God loves you all, without distinction, without limit. He loves those of you who are elderly, who feel the burden of the years. He loves those of you who are sick, who are suffering from AIDS or AIDS-related complex. He loves the relatives and friends of the sick and those who care for them. He loves all with an unconditional and everlasting love."

His message, exquisitely mixed, was recognized as such. A couple of hours later a hundred and fifty people—gay men and their friends and relatives—processed by candlelight into the Palace of Fine Arts, a Greco-Roman edifice secured for the occasion. There, they—Dignity, unwelcome on Church property—celebrated Mass together.

The next day's papers featured a photograph of John Paul embracing Brendan O'Rourke, who had AIDS. O'Rourke was not a gay man or an addict in recovery. He was a four-year-old boy who had gotten the virus through a blood transfusion. God's love aside, the pope's embrace of people with AIDS was limited and conditional.

Czesław Miłosz watched the papal visit on television from his roost in the Berkeley hills and put down his impressions in the journal-of-a-year he was keeping.

He saw John Paul (not unlike himself) as one of Europe's spiritual aristocrats: "Among the statesmen, the monarchs, the leaders of the twentieth century, other than Karol Wojtyła there is not a single figure who could fit our image of kingly majesty." He saw his own life, in the pope's terms, as a "sign of refusal," an assertion of Old World pessimism against New World optimism. Like John Paul, he had been rendered landless by so-called revolution, and he was left with a suspicion of all revolutions (including the sexual revolution). With his great poem "Incantation" he rejected "beautiful and invincible" human reason, which presumes itself to be on the right side of history, serving truth and progress. For him the problem with human reason is that it does not recognize human limits. Through ironic refusal, he affirms a deeper, frailer human realism. The poem's title—with its echoes of Christian monastic chant and the cantor-led Jewish liturgy—suggests that its realism is at root religious.

The papal visit brought out Miłosz's controverted self in full. In Lublin he had taken the role of free-thinking independent against official Catholics; in Rome he had sung the song of his "flesh-enraptured" self; now, with Karol Wojtyła in California—Miłosz's "native realm" since the sixties—he took the side of the Polish pope against the American voices of personal fulfillment.

"The Pope in Hollywood: he has come to the lions' den, and unaware that they are ready to rip him to pieces, he recommends that they start eating vegetable cutlets instead of their bloody cuisine . . . The Pope in San Francisco: the same thing; the courage to proclaim the

Word in the city of the loosest mores, in the capital of homosexuality, in a city that would be expected to turn a deaf ear." Miłosz saw layers of meaning in the pope's speech: yes, the parable of the prodigal son suggested that gay men were prodigals, and yet a passage from St. Paul ("the enemy of homosexuals," Miłosz called him) gave emphasis not to the transgressions of gay people but to those of Paul himself, "the lowest of all sinners."

The coverage brought out Miłosz's suspicion of the American press and its "progressive glibness in defense of dissent." By way of rebuttal, he took up the metaphor of the papacy as a rock and developed it: "Sinful people press up against it from all sides . . . homosexuals, lesbians, women who have had one or more abortions, men who are responsible for those abortions one way or another; women and men whose means of livelihood are their genitalia; everyone who sleeps with someone outside a church-licensed matrimonial union; divorced men and divorced women. Isn't that enough?"

Such people he saw as products of a "universal licentiousness." The pope he saw as "a powerful, attractive image of man above the earth, above our monkey-like masses mired in lusts." He asked: "Don't we recognize ourselves in one of those enumerated categories? And don't we look upon the teachings of the Vatican with respect and humble envy as something that is too elevated for us ordinary mortals?"

As a history-obsessed Pole, Miłosz lived and moved in Berkeley as a walking, talking sign of refusal. And yet he was as skeptical of Truth with a capital T as he was of revolution. "My strictness, my defense of discipline, amuses me," he observed in the journal shortly after scorning San Francisco as the gay capital. "As if I conformed." He acknowledged his "great need for a higher order" and saw such an order embodied in the Church of John Paul, even if he could not submit to that order when it came to desire and the life of the body. "We have a right to behave swinishly, but there should be that higher authority over us. Rules exist in order to exist, not in order to be broken."

In Miłosz actual war and culture war were inextricably combined. He had created a vast body of work around the tension between the collective wisdom of the ages (embodied in religion) and the free person

living moment to moment—a tension that was at the root of the culture wars that were taking shape as the Cold War subsided. For all that, in many respects he was a traditional Catholic man of his generation: self-aware but also self-exculpatory. He recognized himself as a sinner of the commonest sort—a man prone to seek sex outside of marriage. And yet he didn't hate the sin, really, or want to move beyond it. He just wished that it be seen *as* a sin and not as a sign of progress or revolution. He wished that a man's right to sin with a woman be maintained, while sinning in other ways should be proscribed as inhuman.

10

DOWN IN THE HOLE

On Monday, October 19, 1987, the stock market crashed. A dramatic sell-off on Wall Street followed a week of sharp declines. The Dow Jones index fell by nearly 25 percent, the steepest drop since the Great Depression of 1929.

Many people in the decades since then have sought to undo the imagery of decline and fall, pointing out that the market soon stabilized and that the one-day drop was a cyclic expression of structural changes in the financial sector and not a sign of greed and recklessness. But for many of us the weeks after "Black Monday" were full of dread and righteous anger. The crash was described to us in quasi-religious terms: traders praying for a rally that never came, activists calling Black Monday a judgment day.

In New York City, the recession that followed the crash rendered the city a grim and medieval-seeming place. All the money made on Wall Street hadn't yet transformed Manhattan island, which was still more brick-and-mortar than steel-and-glass. The city, already under the "plague" of AIDS, saw tens of thousands of people pushed out onto the streets as "the homeless." A tent city arose amid the tenements of the Lower East Side. There were mendicants at every subway entrance and church step. Men in rags pushed carts through the streets, their worldly

goods stuffed in sacks knotted to the rails. A month ago they had been treated like beggars at the feast. Now they defined the place.

The Bonfire of the Vanities was just out, and suddenly the title seemed apt. It characterized New York City as a place where the spiritual energies of the country were concentrated and magnified. And it captured the sense of calamity that followed the stock market crash. The city disfigured by capitalism's successes was now crippled by its failures; alight all through the eighties, its furnaces fed with money and stoked by finance, it had burned itself out.

There was beauty in the semi-depressed city, and a kind of spirituality, too. Luc Sante, who had lived near Tompkins Square since the late seventies, was writing a book about the vestiges of "low life" still present on the Lower East Side. "In the early 1980s the economic mirage of the Reagan administration changed everything," Sante reported, "bringing in a pestilence of speculators, developers, profiteers of all sorts . . . rents shot up correspondingly." And yet gentrification and renovation had released long-locked-in spirits of ages past—ghosts who appeared with the exposed brick, testifying to the city's essential nature. New York was a city "where loneliness is a threat and a shield, where poverty forces an imaginative response from those caught in it, so that it can seem more alluring than bland security, where the most colorful elements are often the most poisonous, where ecstasy is purchased at the cost of death . . . The city was like this a century ago," Sante observed, "and it remains so in the present."

A film out in that moment inadvertently caught the mood, depicting an old city as a house of the spirits—spirits of which its inhabitants are unaware or half-aware. The film was *Wings of Desire*. The director was Wim Wenders, a German born after the war, raised a Catholic in Düsseldorf, bred on European art films and American road movies, and confirmed as an auteur during a long stay in New York in the seventies. The wings were those of a pair of angels—angels with the bearing of tall, pale, strong-jawed men wearing cloak-like overcoats and long scarves. The city was Berlin, divided by the Wall (blazoned with graffiti to rival New York's) and the former Potsdamerplatz nearby—bombed during World War II, left vacant after the war, overseen by guard towers

and overgrown with trash-strewn wild grass. The odd presence of an-
gels in this place was part of the effect: Berlin was a worldly city, and
a city of ruins—black and white, formerly religious, defiantly anti-
angelic, hung over with the excesses of the recent past.

The desire in *Wings of Desire* is one angel's yearning to shed his
angelic nature in order to be human: carnal, bounded by time, free
to follow his own desires. "I'm going to take the plunge," he tells the
other. "Let's climb down from this watch-tower of the never-born"—
and he does. At the moment he becomes human, he gets a black cof-
fee from a sidewalk stand; then he sells his angel's armor for a hideous
thrift-shop getup.

A third of a century later, the persuasive power of *Wings of Desire*
is hard identify precisely. The film now evokes the 1980s as much as it
does Berlin. Like Wenders's earlier *Paris, Texas*, it was an art film for
those of us who had grown up with *Close Encounters of the Third Kind*
rather than *Blow-Up*. For long stretches it was hard to tell what was hap-
pening on-screen. It was gravid and grasped for importance. And yet,
for many of us, it's as consequential a film as any we've seen.

Why is this? The source of its power, strange to say, is its high-
concept crypto-religiosity. *Wings of Desire* makes the notion of the su-
pernatural credible and vivid before our eyes. It invigorates the image
of the modern city as a fallen place, populated by walking wounded
whose limitations are marks of character and sources of life. Twenty
years after Vatican II, Wenders took the "presence" that Andy Warhol
had recognized in everyday American life and reinvested it with Old
World sacred grandeur.

For New Yorkers, Wenders's locked-down Berlin was a distant mir-
ror for our suddenly semi-depressed city. At a moment when some reli-
gious leaders were prone to speak of the AIDS virus as God's judgment
on gay men, Jessica Winter has observed, *Wings of Desire* "offered a solac-
ing picture of a divine order that was palliative, not punitive." Although
the dialogue is mostly in German, the film's black-and-white palette,
rooftop views, elevated trains, and vacant lots put New York in mind
(as does the sequence where Nick Cave and the Bad Seeds are playing
at a post-punk club). When the freshly human angel takes his first city

walk, the former angel who welcomes him to the world—played by Peter Falk, speaking English with a strong New York accent—recalls the place and time when he himself became human: Twenty-Third and Lex, thirty years earlier.

The method of *Wings of Desire* suggests a literary way for us to revisit New York in that moment. It depicts everyday life in the fallen city through a series of vivid tableaux; it invites us to take a spirit's-eye view of the city—to wing our way down into the city's dark corners and see the holy and the broken mixing it up together.

A Franciscan friar in brown cloak and sandals is paying a visit to a print shop near Penn Station. He is Mychal Judge, and there's a holy purpose to his visit. A gay man, he'd taken part in Dignity services at St. Francis Xavier; a recovering alcoholic, he joined AA meetings where gay men predominated. At the shop, a small black-and-white ad is composed for placement in the gay newspapers. A drawing shows a bearded young Franciscan tending sheep against the Manhattan skyline. A tag line reads "IN THE SPIRIT OF FRANCIS OF ASSISI . . . serving our brothers and sisters with AIDS." A New York address and phone number are given—the address and phone, you would find out if you called or stopped by, of the church of St. Francis of Assisi.

The church, tucked mid-block, was mainly a parish for commuters and office workers. Thomas Merton had gone there in the late thirties: "a grey unprepossessing place," he recalled in *The Seven Storey Mountain*, "crowded in among big buildings, and inhabited by very busy priests." Half a century on, the church, outwardly, had not changed: same gray stone exterior, same big buildings in the shadow of Macy's. But in spirit it was changing profoundly: it was becoming an outpost for gay Catholic life in the city. The archdiocese's ouster of Dignity from St. Francis Xavier had taken effect. Fr. Bernard Lynch had been sent to Rome on sabbatical. Judge, known as a moderate priest, had been asked to run a ministry for people with AIDS out of St. Francis.

He was in the middle of the road of his life—a road that had the truths of the Church and the Franciscan charism on one side and the

truth of his life as a gay man on the other. His boyhood on Dean Street in Brooklyn was marked by his father's long illness and death, when he was six; he shined shoes near Penn Station to help support the family. He joined the Franciscans at age fifteen and was ordained at age twenty-six in 1960. He was tall, thick-haired, charismatic, aware of his appeal (". . . so dashingly handsome," his friend Michael Daly recalled in a biography, that "he once arrived at a party in his habit and was mistaken for a male stripper in costume"). He served at a series of Franciscan churches in New Jersey and in the administration at Siena College, near Albany. After many nights rubbing elbows with politicians in the taverns around the Capitol, he acknowledged an addiction to alcohol and entered AA. In 1976 he had a chance encounter in a parking lot in Passaic with Karol Wojtyła, cardinal archbishop of Kraków, who was visiting Polish Catholics in the United States; when Wojtyła, shortly after his election as pope, celebrated Mass at St. Patrick's Cathedral, Judge was there.

As he turned fifty in 1984, Judge spent a sabbatical year in Canterbury, where he dressed in mufti: jeans, denim jacket, gold earring. The time out of the cloak confirmed his sense of himself as a gay man, and trips to Dublin, London, and Auschwitz rendered him a man on pilgrimage. When he returned to New York in September 1986 he took up a role at St. Francis of Assisi, living in the friary there and alternately hearing confessions (450 people came each day) and serving "parlor duty," which Michael Daly calls "a sort of spiritual emergency room for people who came in off the street in immediate need of a priest."

The stock market crash induced a state of emergency on the West Side, as shelters and soup kitchens were overcome by the newly down-and-out. The spread of AIDS had done so already, and in response the gay community had developed a robust culture of care—rooted, in many instances, in crypto-religious faith. To build on those efforts, Judge improvised an AIDS ministry not unlike that of Fr. Bill McNichols (whom he came to know over many cups of coffee at Aggie's Diner on Houston Street). After twenty-seven years as an ordained Franciscan, he had found "a new priesthood." He visited people with AIDS in hospitals or in their apartments—four people in a typical day. "How are you?" he

would ask. If they told him to go away, put off by his friar's cloak, he would resort to a tactic biblical in its strangeness. "He would go into their rooms and, despite the state of the patients' bodies, would pull back the blankets and massage their feet . . ." John McNeill recalled. "[Other] people were afraid to be in the room with them or even talk with them. But here was this very gentle and wonderful person coming in and massaging their feet. That would break down all their resistance!" He prayed with them. He anointed their foreheads with oil: the Sacrament of the Sick. He saw them weaken and lose weight; he watched them shudder, chill, dry, die. He organized their wakes, celebrated their funeral Masses, saw to the final disposition of their bodies.

He was not openly gay, and not an unstinting advocate for the rights of gay people in the Church. Where McNeill and Lynch thrived on controversy, Judge prized restraint. He declined to testify before the City Council in support of the gay rights legislation Cardinal O'Connor opposed. He later said he would rather "be burned at the stake on Fifth Avenue at the front doors of St. Patrick's" than embarrass the Church.

Judge's faith was wide open, but his self was semi-scrutable. To be a Franciscan was to be conspicuously Catholic, walking the streets of the city in cloak and sandals with a rope belted around his waist. But the twelfth-century outfit cloaked his sexuality, regarded as disordered by the Church in which he was called to serve. It may be that through his ministry to people with AIDS he embraced the person he knew himself to be, and it's tempting to assume that because he knew who he was, the Church's judgment was no great difficulty. But he insisted otherwise. "No one, absolutely no one," he wrote in his diary, "lives two fuller separate lives than I do."

Near Times Square, a wild evangelist in pointy shoes and shades is preaching a hellfire sermon to the down-and-out. "We'll all be safe from Satan / When the thunder rolls," he assured them: "Just gotta help me keep the devil / Way down in the hole."

This is Tom Waits, onstage with a band making a glorious racket behind him.

After a decade spent doing Beat stylings behind a piano in Los Angeles, Waits had moved to New York and doubled down on the down-and-out. It had worked brilliantly across a trilogy of records, which he now capped with a run of shows at the Eugene O'Neill Theatre on West Forty-Ninth Street, west of Broadway. The critic Robert Palmer would describe the shows in the *Times* in religious imagery: "The vivid, deftly realized characters in Mr. Waits' songs stumble down backstreets and alleys, pursued by demons, clutching a crumpled hat, an old accordion, a tattered dream. They're doomed, but indomitable; as long as they've got friends, and the bars are open, they can look forward to an eternity of torment and almost be cheerful about it."

Waits's songs from his first decade had depicted a stylized postwar L.A. underworld: nighthawks and grifters and loan sharks, cigarettes and cheap booze, and hookers who worked places like the Tropicana Motel, a bohemian haunt in West Hollywood where Waits lived for a while. The men in those songs knew their way around cocktail lounges and racecourses, hats on their heads, neckties loosely knotted. It was the California that the Beats in Jack Kerouac's novels had set out to find.

But Waits's L.A. underworld was not a fallen place. The life-circa-1949 that his lyrics evoked was life *before* the fall—before the suburbs, before the interstate highways, national TV, youth culture, and tie-dye. Like Kerouac, Waits took a romantic view of city life and California alike as having a gritty integrity that had gone missing elsewhere.

Like Kerouac's work, too, Waits's was wierdly, spasmodically religious. "I had church when I was a kid, oh yeah," he told a radio host in one of the colorful interviews the writer Paul Maher later pulled together. Waits spent his early years in Whittier, California—founded by Quakers—and his mother took him to Quaker meeting; after she split with his father, Frank, who taught high school Spanish in Los Angeles, she and Tom (and a sister) moved to San Diego. "I went to church when I was a kid, and one Sunday morning, I finally decided I wasn't gonna go anymore," he recalled in the same interview. And now? "I wouldn't say . . . No, I'm not religious."

The characters in his songs, however, were intermittently religious. The first song on his first record, *Closing Time*, has the singer getting

into his '55 Cadillac in the dead of night and hitting the road—feeling holy and (God knows) fully alive. An early profile described Waits, dressed in black and toting a battered suitcase, as "a Bible salesman on a cheap shot to nowhere." In interviews he told the family legend of a blind uncle, a church organist, who was fired because he played too many wrong notes but took the church organ home with him. And he told of seeing James Brown perform in Balboa Park in San Diego— "like a revival meeting with an insane preacher at the pulpit talking in tongues." He recalled, "It had all the pageantry of the Catholic Church. It was really like seeing mass at St. Patrick's Cathedral on Christmas and you couldn't ignore the impact of it in your life. You'd been changed, your life is changed now. And everybody wanted to step down, step forward, take communion, take the sacrament, they wanted to get close to the stage and be anointed with his sweat, his cold sweat."

That was in 1962, when Waits was thirteen. A few years later he hitchhiked to Arizona for New Year's Eve, slept in a ditch at the side of the road, and was taken in at daybreak, Good Samaritan–like, by a woman running a Pentecostal church. "So I sat at the back pew in this tiny little church," he recalled, "and this mutant rock 'n' roll band got up and started playing these old hymns in such a broken sort of way. They were preaching, and every time they said something about the devil or evil or going down the wrong path, she gestured in the back of the church to me, and everyone would turn around and look and shake their heads and then turn back to the preacher."

He wrote a song about it: "Well, he went down, down, down / And the devil said, 'Where you been?'" It's a pumped-up two-minute workout led by a "Pentecostal Revlon man." In it those two formative experiences of belief and commitment—the roadside encounter and the James Brown spectacle—are brought together.

A "mutant rock 'n' roll band" playing "old hymns in such a broken sort of way" is an apt description of the sound of Waits's records beginning with *Swordfishtrombones*. It's the sound of a glorious assemblage. There are odd percussion instruments ranging from marimbas to two-by-fours. There's spiky, atonal guitar (played by Fred Tackett, who had been the guitarist on Bob Dylan's gospel tours). There are horns, played

by Ralph Carney, a one-man Salvation Army band. And there's the influence of a screenwriter Waits had met in Hollywood while composing songs for Francis Ford Coppola's cocktail-lounge epic *One from the Heart*: Kathleen Brennan, with whom he fell in love. Brennan came from "a big wild loud Irish family . . . She grew up Catholic," Waits explained, "so all that, you know, blood and liquor and guilt" wound up in the lyrics he was writing.

"She saved my life," he said. They were married at a wedding chapel in Watts; they had a reception a week later ("a raucous gathering at Molly Malone's on Fairfax Avenue," Barney Hoskyns reports) and went on honeymoon to Ireland (where an eccentric slaughterhouse worker whose dwelling was "filled with religious items and crucifixes" inspired the song "Dave the Butcher"). They then settled in a house in a largely Mexican part of East L.A., which they chose "mainly for all the churches, dogs, and children." When their first child was born, they named him Casey Xavier. Waits started writing songs that were rooted in sounds-and-images rather than music-and-lyrics, trying, he said, "to arrive at some type of cathartic epiphany in terms of my bifocals."

Then he moved to New York City. With a second child on the way, he and Brennan came east for film work and to be near her parents in New Jersey, and they lived in a series of Manhattan apartments (eight, by Waits's count; one was on Fourteenth Street, across from a giant Salvation Army armory). Circa 1984 he joined the downtown scene in earnest. He went to a party given by Jean-Michel Basquiat for John Lurie, the Lounge Lizards saxophonist and avatar of thrift-shop style. There he met Jim Jarmusch, who had worked assisting Wim Wenders and was now making a film, *Stranger Than Paradise*, on black-and-white stock Wenders had given him, with Lurie in a key role, dressed, Waits-like, in a wifebeater and a fedora.

Waits wound up writing new songs in the Lounge Lizards' rehearsal space in Westbeth, the drafty artists' complex, and living in a loft at Washington and Horatio Streets, near the Hudson River piers and the meatpacking district—an area then still sketchy and unreconstructed, with warehouses and town houses side by side. And the sights and sounds of that edge city began to show up in his songs.

The change was revelatory. Written on guitar rather than piano, the new songs evoked street life rather than dimly lit interiors. The sound of the band—now clanking and jerky, now gutbucket grungy—was the sound of postwar electrified-and-amplified music broken down and put back together. And the people in the songs were not just down-and-out: they were poor, needy, broken.

The new record, *Rain Dogs*, was named for them. The earlier song "Underground" had been inspired by rumors of a ragtag community living in the tunnels beneath the city; *Rain Dogs* dealt with street people of all sorts. Asked what the title meant, Waits said slyly that a rain dog is a hot dog left in the rain until all that remains is a waterlogged bun ("You can get 'em in Coney Island . . . they're less expensive than a standard hot dog"). He then explained, more seriously, that the rain dogs on the record are "people who sleep in doorways, people who don't have credit cards, people who don't go to church . . ." He said, "All the people on the album are knit together by some corporeal way of sharing pain and discomfort."

For an LP-sleeve photograph of the artist, Island Records engaged Robert Frank, whose 1958 book *The Americans* had documented the seamy American ordinary. Frank took shots of Waits in an East Village bar and in Tompkins Square, with dogs and kids nipping at his pointed shoes. But the standout shot is one taken by the local photographer Ted Barron, which shows Frank photographing Waits in the square. It had just rained, and Waits is squatting in a puddle, wearing a black suit and clutching a fedora.

"Even Jesus wanted just a little more time," Waits observed in "Walking Spanish," and the songs he put together next extended the motif of people joined corporeally through the pain of living and dying. *Franks Wild Years* consolidated his recent work as a song cycle spread across three records. So did a "musical play" of the same title—"a cross between a love machine and the New Testament," he called it—staged by Steppenwolf in Chicago. And the collapse of the stock market and the thrusting of thousands of "rain dogs" onto the streets made Waits's work topical.

It was spiritual, too. From the beginning of his career, certain Waits

songs could be heard as spirituals of a kind, and one record he cited as a touchstone was the Stones' spontaneous-gospel outcry "I Just Want to See His Face," from *Exile on Main St.* ("You don't wanna walk and talk about Jesus / Just wanna see his face . . ."), with Mick Jagger singing falsetto over tribal drums and electric piano soaked in echo, the sound of the whole evoking a long-ago revival meeting.

Now Waits engaged with religious themes more emphatically. "Hang on St. Christopher" sets the tone, name-checking the patron saint of travelers. "Temptation" is what it says: over a hip-swaying rhythm kept up by a wobbly violin and chugging guitar, Waits sings a song of lust ("I can't resist") in a falsetto voice that he said he got from Jagger—and also from Prince, whose lean and pompadoured look was akin to his. The singer is lost and broke, and temptation is the wages of sin that he must pay.

"Way Down in the Hole" follows the cryptic spirit all the way back to Eden. "Checkerboard Lounge gospel," Waits called it: the skulking riff, the finger-snapping rhythm, and the heavens-piercing stab of guitar, sweetened by female voices that suggest a tabernacle choir in the off hours. The scene is the garden. The tempter is the devil. The savior is Jesus: the Lord is our only hope. The singer appeals to us directly and seeks our help. "Don't pay heed to temptation / For his hands are so cold / You gotta help me keep the devil / Way down in the hole." This fallen state isn't specific to night crawlers and street people. It is the state we all are in. We're down in the hole together.

This artist-out-of-time had anticipated the moment. The week in October 1987 that the stock market went down, Waits was playing every night near Times Square, and there he performed "Way Down in the Hole" as a drama of salvation and damnation akin to the ones enacted in Bowery missions and Salvation Army halls; he made the hole New York City, a hellhole populated by rain dogs and devils alike.

The concert video *Big Time* was shot in Los Angeles a few nights later—and the performance of "Way Down in the Hole" deepens the otherworldly mystery of the song. "I feel as though we should move right into the religious material," Waits tells the audience. He is dressed all in black, holding a red book that might be the Bible, and a steel-caged

miner's lamp is hooked on to the stand that holds the microphone, lighting him from below. He goes on: "We're in a beautiful area . . . Films with seven X's. Girls without skin. News and Erotica"—and all at once the conceit of the song becomes obvious. Aha: he is a preacher working a crowd of the down-and-out in a mission in a rough part of town, we the audience are his ragged congregation, and "Way Down in the Hole" is his fire-and-brimstone sermon. He sings it in a canker-ous voice, and he is at once a derelict in need of rescue and a man of the Lord warning others away from the dark side. He goes through the verses, twisting his skinny body this way and that, a cross between Dylan and Prince. The band takes the music down to a vamp. "Well, people, I got to *speak* about something," he says. "Can I get an 'Amen'? Can I get a 'Hallelujah'? Can I get a 'Praise the Lord'?" He tells us: "People, the Lord is a very, very busy man . . . I'll *do* what I *can*—but Jesus is always going for the big picture, but he's always there to help us out of the little jams, too." He contorts his body behind the mike stand. He breaks into a wordless falsetto. And then, as the band vamps on, he twists his body downward, shakes a scolding finger at the ground, and sets to driving out the devil through his own gravelly authority: "Down, down, down! Down beneath my boots! Go down, mighty devil! Find a place to live! Down, down, down!"

He's thrilling to see and hear, this singer, black-clad, bony, sweaty, hairy, sensual, issuing imprecations over a low-down riff, while the miner's lantern throws his shadow across the stage. He is way down in the hole, and he knows the territory. His message is to resist the devil and his seductions, but the seduction truly to be resisted is that of the singer himself, a postsecular preacher man, a figure darker, earthier, and wiser to the ways of the world than the vested suits of Reagan's America.

Body and soul, Jesus and Satan, temptation and redemption: this is real life, the performance says with gritty grandeur; here, down here, is where the action is.

An artist is bent low in a small apartment on East Tenth Street, arranging a piece in mixed media. The apartment, where he lives with his wife,

an artist herself, is also his studio. He sets up a black background, three lights, and a camera on a tripod and draws the window shades tight to block out the light from the outside world. In these pieces, which he has done intermittently over a few months, he is mingling religious objects and human substances and then photographing them.

He is Andres Serrano, a New Yorker in his thirties. He sees himself as an artist with a camera, not a photographer. After years of difficulty, he is getting the work out in the world, in group shows and in a solo exhibition at the Stux Gallery on Spring Street.

Like Jim Carroll, he had been shaped by the city's neighborhoods, where a person was marked by a Catholic upbringing as by race or ethnicity. He was born in Spanish Harlem—his mother of Cuban descent, his father Honduran—and grew up in Williamsburg, where Italian, Puerto Rican, and Polish Catholic communities and Hasidic Jews all rustled against one another. His grandmother owned a brick row house on Havemeyer Street, and he and his mother lived upstairs: he was an only child, and his father, a merchant seaman, had returned to Honduras. On Sundays they went to Mass. "[M]y mother was a Catholic, and so I was a Catholic," he told an interviewer decades later, and went on: "But she was the sort of Catholic who would go to church and arrive like ten minutes before the Mass ended . . . We never got to sit inside the church, you know, because it was so crowded we were standing in the back."

His mother, who spoke mainly Spanish, and who struggled with psychosis, as he told it, was protective of him, and in his teens he found that one way to break free of her was to take the subway into Manhattan and go to the Metropolitan Museum of Art. He attended Boys' High and Bushwick High, but dropped out, and fell in with two young men who were artists. At seventeen, he applied to the Brooklyn Museum's art school, was admitted, on a scholarship, and followed a two-year course in painting and sculpture.

His twenties—the drop-dead-New-York seventies—were hard years. He spent time on the streets. He used drugs; he sold drugs. He saw foreign films at the downtown art houses. He found work in advertising—art direction, copywriting—while struggling to break an addiction to

heroin, so as to be an artist before it was too late. He worked deliver-
ing takeout for a Chinese restaurant in Queens. He made works of
art, and photographed them, in case they went missing in moves and
breakups.

The religious dimension of his work took him by surprise. He had
stopped going to church after Confirmation, at age thirteen or so. The
sacrament, the nuns giving instruction told him, meant that "you were
becoming a soldier of God." The timing of it meant that he was be-
coming a young man, with a young man's desires. "There's a conflict
between what the church tells you about the body and what your body
tells you about it, the body," he recalled. "And you have to choose." He
chose the body. For years "I didn't think about God, and I didn't feel it,
although it was inside of me," he said—until "I was in my early thirties,
and I started to do my photographs. And realized that I was referring a
lot to Jesus and doing a lot of work on Christianity."

He had met Julie Ault, an artist and organizer, and had come to know
the artists involved with Group Material, a collective she had founded on
the Lower East Side. (They married in 1980.) And he had been granted
precious studio space at PS1, the artists' haunt in a repurposed school-
house in Long Island City. He generally worked alone, preparing tableaux
and photographing them, sometimes casting people he knew in iconic
roles—say, a pair of robed women beholding a cross devised from flesh
and bone.

He was influenced less by other artists than by his own experience:
childhood Catholicism together with the films of Fellini and Buñuel
he'd seen in his twenties, such as Buñuel's *Simon of the Desert*, about
St. Simon Stylites, who sat atop a high pillar for thirty-nine years in a
war of wills with Satan. "That inspiration, you know, prepares you for
what's to come later," he said. "But the initial impact, the things that
you respond to, things that make you feel something, that to me is the
most important influence."

The work he was making was vivid, bold, polished, confrontational.
He juxtaposed two figures—a naked young woman, wrists tied with a
rope and breasts splattered with blood, and a graying man in a cardinal's
red garb—and called it *Heaven and Hell*. He mounted a bloody carcass

on a cross, the bones showing through: *The Unknown Christ*. He photographed a woman in a robe holding a dead fish: *Pièta*. His advertising work had made him aware of the power of words. "You have to get people's attention. You have to be able to say everything you want to say in a few words," he recalled. "And so when it became clear to me that photography would be my art practice, I titled things in such a way that people would know what they were looking at."

A photograph called *Stigmata* aroused controversy in a small way. The printer Serrano usually worked with refused to print it, and after he found another printer, some patrons complained to the gallery where it went on view, a tiny space on Canal Street.

Work of his was exhibited in group shows at White Columns and the New Museum. He was there for the opening of a show featuring his work in the meatpacking district near West Fourteenth Street (seven people came). The Museum of Contemporary Hispanic Art included *The Unknown Christ* in a group show, *Thirteen Hispanic Photographers*, Sebastião Selgado among them.

He had to leave the space at PS1 and use the apartment on East Tenth Street as a studio. He was working with objects, raw meat, and bodily fluids. A work called *Bloodstream* involved milk and blood running together. One called *Blood Cross* consisted of cow's blood in a vitrine the shape of a plus sign, or a cross.

Stefan Stux offered to show his work. Stux was a Romanian Jew who had lived through the Holocaust as a child and then fled the Soviet state in Romania, winding up in Boston. He had earned a medical degree and worked at Harvard as an immunologist, meanwhile setting up an art gallery on Newbury Street with his wife, Linda Bayless. In 1986 they opened a gallery in SoHo, at 155 Spring Street, near West Broadway.

On East Tenth Street, Serrano drew the shades and fired up the lighting, focused on a vitrine set before a black backdrop. Working carefully, he filled the vitrine with urine—his own, collected over several weeks. An object was at the ready: a white plastic Christ affixed to a wooden cross. He set the camera and adjusted the lighting. He dunked the cross in the vitrine and photographed it, over and over, roll after roll.

He took the film to a printer he worked with, asking for forty-by-sixty-inch color prints.

The Stux show opened in September 1987 and was up into the next spring. There on one wall was a crucifixion. It was a large photograph, at once radiant and shadowy. The golden hue suffusing it had a touch of apocalypse; the tilt of the crucifix suggested windswept, earthshaking drama. The title was a reveal, a trick on the eye: *Piss Christ*.

"Photographs of objects shot through tanks of blood and urine" is how the show was described in the back pages of *New York* magazine. Serrano described the works he was making as "bodily fluids" work. A friend called them "immersions." He was making immersions with various motifs (God, the Madonna and Child, Rodin's *Thinker*—bent low, head in hand) and various fluids (milk, breast milk, semen). "When I started to do religious images, it's almost like I wasn't aware of how many of them I was doing until at some point I realized, oh, wow, you know, I'm using Christ a lot," he recalled. "And so I think that it was something inside of me that had to come out."

The work that came out of Serrano's Catholic experience was akin to the experience itself—that of a boy in Brooklyn taken by his mother to stand in the back of the church at the end of Mass. It stood on the threshold, in liminal space: inside and out, religious and not. And it found a public across the river in downtown Manhattan at a moment when the New York art scene was ravaged by a disease transmitted through bodily fluids and the city was riven by religious strife over the body and its claims.

Serrano would make more work of that kind in the months to follow—such as *Piss Discus* and *The Thinker*, each an immersion of small-scale classical statuary. He had come to see the pieces as a series, and himself as an installation artist whose medium was photography. And he had gotten a grant from the National Endowment for the Arts, in Washington, which had programs to support the work of visual artists.

Martin Scorsese is at Kennedy Airport, en route to Morocco. Fifteen years after reading *The Last Temptation of Christ*, ten after working up a

script and storyboards, five after the religious right began the pressure campaign against him, he is going to North Africa to make the picture.

The Passion, the contracts were calling it. The change was meant to avoid drawing controversy. So was the shift from Israel to Morocco. An advance team had scouted desert locations, and sets were being erected in a village with a biblical look.

Scorsese can see the picture already. He saw it when he first read Kazantzakis's novel. In effect, he has seen it since he was a teenager in Little Italy and drew storyboards for a biblical epic set in downtown Manhattan. He can see Jesus sitting in a circle drawn in the sand, tempted by the woman who appears as a cobra to offer him her breasts and her bed, and by the lion who offers him power in a New York accent, and by the pillar of fire that speaks the King's English and offers him dominion over all the things of this world. He can see Mary Magdalene, eyes rimmed in kohl, body lightly veiled—now stoned for being a prostitute, now asprawl in her bedroom, telling Jesus she has wanted him ever since they were growing up in Nazareth. He can see the crucifixion: the crowds, the torches, the blood and sweat on Jesus's body, the crown of thorns, and the intent gaze of Mary Magdalene, black-clad and distraught. He can see the picture in the dark room of his mind's eye.

U2 are in Harlem, musicians and gear and roadies crowded into the sanctuary of the Greater Calvary Baptist Church on West 124th Street, along with a camera crew. The church is bright, all white walls and clear windows, and seated up near the altar is Bono, vested and crucifixed, long hair tied up in a proto man bun. Edge is alongside, wearing an outsize suit jacket like a kid dressed up for church, a Stratocaster slung over his shoulder and plugged into an amp set on a chair. They're facing a congregation of several dozen young people, most of them Black, most of them women.

Bono and Edge begin a skeletal version of "I Still Haven't Found What I'm Looking For," like a couple of buskers working the crowd on a subway platform. Suddenly, on the but-I-still part, voices come in at

full strength. Aha: those young people aren't an audience; they're a gospel choir—thirty singers in their teens and twenties, led by a white man in his own outsize jacket and Ray-Bans, all answering the singer line for line, call-and-response style. Standing now, Bono sings and Edge wrings harmonics from the guitar and Larry Mullen slaps a conga and the choir sways from side to side, a pair of elders breaking into praise as the instruments drop out, the camera operators still shambling in the aisles. "I *still* . . . haven't *found* . . . what I'm looking *for* . . ." The song sounds as good, in this church, as it will ever sound.

"It doesn't sound much like a gospel song, the way we do it, but if you look at the lyric, that's pretty much what it is," Edge said a few months later. "We got a cassette from a friend of ours at Island Records of a gospel choir covering the song"—the New Voices of Freedom—"and it sounded totally different, really exciting and new, so we traveled down to Harlem . . ."

The Joshua Tree had sold ten million records. U2 had played open-air shows in Madrid (120,000 people) and at Wembley Stadium in London (two nights, 144,000). A show at the Flaminio in Rome left Brian Eno with tears in his eyes at the sound of the huge crowd singing melodies he'd first heard from behind a mixing board. After a month in Ireland the band returned to the United States, setting up in rented houses in the Hamptons and jetting to gigs in the northeast: Long Island, Philadelphia, New Jersey, Boston, Washington, New Haven, and two nights at Madison Square Garden.

"I Still Haven't Found What I'm Looking For" was written as a grand rejection of success as its own reward ("the idea Dylan expresses in 'Idiot Wind,' Edge said, "that 'You'll find out when you reach the top that you're on the bottom'"). Through *The Joshua Tree* U2 were clearly on top, and success was changing them ("and it *should* change you," Bono said). On one level, it made them even bolder; on another, it turned them toward musicians greater than themselves—toward elders and roots. In Ireland they had worked up some new songs rooted in country and western and rhythm and blues. Their concert film was turning into a road movie, shot in 16 mm black and white.

The Joshua Tree tour had changed U2 in another way. Making the

record, they had tapped roots of American religiosity, so that the Joshua tree found in California also suggested Joshua of the Hebrew Bible and the tree on which Christ had been crucified. Then the MLK controversy had pitted them against white evangelicals. They too were white evangelicals of a kind. There was a need to declare themselves: to make clear why and how they bent the knee and to what, and which kind of roots they sought.

The road movie gave them opportunities to pair white roots and Black roots. In Memphis, they had lunch with Johnny Cash (who said a "beautiful, meandering" grace before the meal, Bono recalled); they paid a visit to Rev. Al Green's church (Green, the soul singer turned Pentecostal minister, was out of town). They booked Sun Studio, where Sam Phillips had recorded Elvis Presley and Howlin' Wolf. A session there yielded "Angel of Harlem" (about Billie Holiday), featuring a Stax-style horn section. Another, with B.B. King, produced "When Love Comes to Town," its verses alternating between the spiritual (Bono: "I was there when they crucified my Lord . . .") and the carnal (B.B.: "When love comes to town, I'm gonna catch that train . . ."). Then, in New York, they went to the Harlem church to perform with New Voices of Freedom.

A few nights later the choir came to Madison Square Garden to perform with them. There's grainy black-and-white monitor footage online: Bono once again in vest and crucifix, the choir members in white shirts set ghostly-angelic against the darkness, the call-and-response structure enabling Bono to cut loose vocally and approximate a soul shouter, singing now to the choir and now to the crowd. It really works—because it's a one-off, and because it began with the choir's initiative, not the band's. U2 are having an encounter with American roots, musical and spiritual; in the moment, these most self-aware of rock musicians are finding what they've been looking for since the beginning—a sound, and a stance, and an outlook larger than themselves.

Willy DeVille is walking to a church near Tompkins Square, wondering if his new record is going to break through or is a stiff, already dead and buried.

On the Lower East Side he was somebody. The band he founded, Mink DeVille, were stalwarts of the original scene at CBGB and were featured on the *Live at CBGB's* record—people still thought his first name was Mink. *Rolling Stone* named him its Most Promising New Artist. The record he made in Paris—*Le Chat Bleu*—had been called one of the best of the year. He wrote songs with Doc Pomus, who had written "Little Sister" for Elvis and "Lonely Avenue" for Ray Charles. He got a double-barreled addiction to heroin and alcohol under control. Now he had made a record with Mark Knopfler producing—the guitarist who had worked with Bob Dylan and had had a run of hit records with Dire Straits. *Miracle* is simple, vivid, accessible. Knopfler has gotten one song, "Storybook Love," onto the soundtrack for a sticky commercial film, *The Princess Bride*. And yet here Willy is, ready to get down on his knees, asking a higher power for help, and he has made the mistake of telling the PR guy with A&M, who told Ty Burr from *SPIN* to come by his place early enough for him to get to church.

Devotion has haunted the music he's made all along. Growing up in Connecticut, he was Billy Borsey, an Irish Catholic hellion: "the kid who used to take the money out of the poor box," he told Burr, the kid who was transfixed by "the stuff the nuns told you about feeling every lash that Christ felt as he walked up the Mount of Skulls, and when they placed the crown of thorns on his head and blood ran down his face . . ." He called his high school band Billy the Kid & the Immaculate Conception. But devotion he found out of school, in the citified R&B of the early sixties. The Drifters, the Coasters, Ben E. King: the singers were Black, the songwriters were Jewish, but the roots they drew from were typed as "Spanish." "Latin-tinged tenement pop," his friend Glenn A. Baker later called the music he made. Willy himself described it as "urban folk music" and "pachuco rock—a pachuco is a sort of Latin type of character, almost like a Latino zoot suiter."

In the seventies, as Borsey moved to Greenwich Village, to London, to San Francisco, and back to New York, swapping Billy for Willy and taking his mother's maiden name for the band he called Mink DeVille, that urban folk music was put to fresh purposes. By Van Morrison, with his "street choir" sound. By Lou Reed on "Walk on the Wild Side."

By Bruce and the E Streeters and Southside Johnny and the Jukes and Aaron and the Nevilles. And by Ry Cooder, whose ensemble often included gospel-trained singers: on "Jesus on the Mainline," his slide guitar was joined (as the liner notes had it) to "the thumping treatment of a street corner salvation band." Morrison took it into the mystic with the song by that title, then with *St. Dominic's Preview* (its title taken from a church in San Francisco), all the way to Jesus with *Into the Music* ("like a full-force gale . . . I was lifted up by the Lord"), and with a run of albums registering the musings of a Celtic soul brother. But it fell to Willy DeVille to repatriate it to New York City and the latinate Old World broadly.

That is what he has done. "Spanish Stroll" gave a Lou Reed–style strut to the high-street style of the continent. A video shows Willy, lean, pompadoured, and pencil-mustached, fronting a band and a trio of rhythm-and-gospel singers (known as the Immortals) in sleek Italian suits. He firmed up his music's European connection in Paris, adding accordion to *Le Chat Bleu*; returning to the States, he'd spent time in New Orleans, whose Old World echoes and devotion to musical roots were akin to his own.

And he wrote the songs for *Miracle*: "Heart and Soul," "Spanish Jack," "Angel Eyes," "Nightfalls." The record is exceptional: up-to-date, more worldly-wise than down-and-out. But it is looking like a critic's favorite that won't sell. Mark Knopfler is on tour with Eric Clapton and Elton John; Willy is down-and-out again, without a band ready to take the songs on the road, and with the junk coming back at him.

So here he is, on the street rather than onstage, en route to *church*, of all places. "You gotta find faith in something," he told Burr, and this is what he'd found—a church like the one he'd sung about in "Heart and Soul," bells ringing and a choir singing "Ave Maria." What he has found here has helped him break the run of drink and drugs, because it led him to try to see his talent as not to be wasted, because it didn't belong to him only. "All I can figure is that I've got a gift I was born with. I have this talent that I'm supposed to share with people. It's a power, like having a gun and not knowing what you're supposed to do with it . . ." he told Burr.

Cathedral bells, they start to ring . . . The church bells are ringing. He is almost there. But a different song from the new record—which was getting old fast—is in his head: "I'm gonna need a miracle—need a miracle now . . ."

Peter Hujar is in the hospital: Cabrini Hospital, on East Nineteenth Street, named for Frances Xavier Cabrini, the Italian woman whose work with new arrivals from Italy to the United States made her the patron saint of immigrants. He is dying of AIDS. He is among friends and is surrounded by a cloud of witnesses: photos of the yogi Swami Muktananda, the Tibetan Buddist Karmala, the Tibetan Kalu Rimpoche, and the Italian healer Padre Pio. He asks for a Catholic burial and a plain box for a coffin. He declares that he doesn't want the body to be embalmed.

Hujar dies on November 26, 1987. David Wojnarowicz—to whom he was father, brother, friend, lover, and confessor, Cynthia Carr records in her biography—photographs him, gaunt and bearded, at the hour of his death.

The funeral is two days later at St. Joseph's Church in Greenwich Village. The pine box, obtained by Redden's from an Orthodox Jewish provider, bears the traces of a six-pointed star. The body is unembalmed.

A homeless man is holding forth at the Tower East Cinema on Third Avenue, all energy and grandiloquence. He is white, about fifty, a fedora on his head, his face all bloodshot eyes and whiskers; thus reduced, he looks the way Jack Nicholson would look if Nicholson wore a beat-up suit and boots without laces instead of tennis shirts and shades. He *is* Jack Nicholson, in the title role in *Ironweed*, co-starring Meryl Streep, adapted from William Kennedy's novel.

The movie opens beautifully, the scene shifting from the Catholic cemetery to a Protestant mission where the preacher in charge urges the drunks and bums who have come for soup to receive the Lord Jesus Christ and be born again. As in the novel, the Dantean pattern of purgatorial regeneration is thus joined to the Depression and the street life

of the prewar, pre-gentrification city, and to the promise of redemption found in spirituals and hymns. Nicholson's Francis Phelan seems actually down-and-out, broken but not holy, and his small acts of self-reform are giant steps in the direction of mercy. He's a counterpart to the overcoat-clad angels of *Wings of Desire*: where they yearn to enter the broken world, he, having hit bottom, has gained an intuition of his angelic nature there. He and they are crypto-religious kin. But then the movie stalls: the action moves to the lace-curtain interiors of Irish Albany, and the empyrean music of Francis's inner life, rendered, in the novel, with Joycean compound words, is crowded out by organ music and lachrymose ballads; his bad-Catholic hangover is done in Technicolor.

Ironweed has gotten a grand rollout, but with homeless people in the streets and subways representing a general lowering of the spirit, a big-budget romance about the down-and-out is received as an affront. In *The New Yorker*, Pauline Kael declares that "the running time—144 minutes—is like a death sentence." Bad reviews lead to worse box-office. The film about a voyage out from the flophouse world is a flop.

Down Third Avenue, near Bloomingdale's, Cinema 1 is showing John Huston's adaptation of James Joyce's story "The Dead." This, too, is a period drama dealing with "shades"—with Irish Catholics traversing the boundary between the living and the dead through patterns of regeneration lurking beneath their everyday lives. But it is getting raves. "*The Dead* is so fine, in unexpected ways," Vincent Canby observed in the *Times*, "that it almost demands a re-evaluation of Huston's entire body of work." Michiko Kakutani, in the same paper, presented Huston's adaptations of novels (*The Maltese Falcon*, *The Treasure of the Sierra Madre*, *Moby-Dick*) as a Joycean effort to match style to material so as to reveal the ways people fail to grasp the core truths about themselves.

Huston had died in August at age eighty-one, having lived in County Galway since 1951. *The Dead* was a family celebration of Irish ways: his son, Tony, wrote the screenplay, and his daughter, Anjelica, played the heroine, Gretta. Set at a Christmas party, the film is sumptuously furnished and radiantly lit, and it seemed all the more so in grim

New York City. It was a kind of pendant to the Danish film *Babette's Feast* (screened in the New York Film Festival two months earlier), which was about the transcendent's power to break through the ordinary. But where *Babette's Feast* takes up questions of transcendence in religious terms—setting a dour Protestant pastor's daughters against their French chef, a Catholic whose glorious cooking is a kind of liturgy, a transfiguration of the things of the senses—*The Dead* is this-worldly right down to the snow-capped toes of Gabriel Conroy's goloshes. The Christmas setting aside, religion is scarcely felt. Guests at the party laud the hospitality of the monks of Mount Melleray—who rise at two a.m. and sleep in their coffins. (Mr. Browne, a Protestant, asks: Why? "The coffin, said Mary Jane, is to remind them of their last end.")

In this, it is faithful to the story. Joyce wrote "The Dead"—a last addition to *Dubliners*—after leaving Ireland for Trieste and Rome, and the conventional view is that homesickness led him to depict Ireland as a nation of warmth and generosity rather than privation and pettiness. It is a place of hospitality, seen at the Misses Morkans' Christmas party: the guests welcomed, the goose carved and served, the conversation about music flowing easily. Hospitality is the trait that Gabriel in a toast celebrates as Ireland's special virtue, and a virtue threatened in the present, he says, for "we are living in a sceptical and, if I may use the phrase, a thought-tormented age . . ."

Huston, too ill to travel to Ireland, made the film in California, and like William Kennedy, he judged the American 1980s well. The film is a reproach to a decade of greed and callous indifference. Seen against the grotesque rise of investment banking, the stock market crash, and the surge of homelessness in Manhattan, it celebrates the virtue of hospitality just when hospitality is being ground out by the finance elite, the medical establishment, and the police.

Glasses are raised, "Hear hear" is heard. And then the holiday party ends and the dark spirits rush in. Gabriel sees his wife at the top of the stairs, listening intently to an old Irish air sung hoarsely in the next room. He sees her, in Huston's view, in the terms of Catholic iconography: Anjelica Huston set against a stained-glass window and wrapped in a headscarf like an early Renaissance madonna. But Gabriel's lofty

ideals and high sense of himself belong to death, not life; and life, it turns out, is to be found down among the shades, where the ghost of Michael Furey, the young man Gretta was "great with" as a young woman in County Galway, stands outside her house, lovelorn, chilled, skeletal, consumptive, begging to be let in—stands there now and forever, a lover whose passion Gabriel, he realizes ruefully, can only echo and approximate.

Huston's ending is faithful to Joyce's outlook. True hospitality, *The Dead* suggests, involves welcoming the spirits of the dead; real religion involves recognizing the claims of the dead on the living, so that the "crooked crosses and headstones" of the graveyard in the final shot are not images of affirmation but reminders of our last end.

And then it is Christmas, and the Pogues are on the radio and MTV, over and over again.

The song is "Fairytale of New York." The video tells the story. Shane MacGowan is in the city on Christmas Day, locked up in the "drunk tank" in a NYPD precinct house after a holiday bender, and there, as he hits bottom, he thinks fondly of his missus, their banter and quarreling playing over and over in his head:

She: "You're a bum, you're a punk . . ."

He: "You're an old slut on junk, lying there almost dead on a drip on that bed . . ."

She: "Happy Christmas, your arse—I hope it's our last!"

At the time, the Pogues are underground-familiar in New York: on the jukebox at the Dublin House on West Seventy-Ninth Street, opening for U2 at the Garden and headlining at the World in Alphabet City. *If I Should Fall from Grace with God* won't be out for a few months yet, but that MacGowan is some kind of believer is obvious. Even if you don't know that he is from a large family in Tipperary who prayed the rosary every night, or that going to Mass is something he was "beaten into doing" but found powerful and beautiful, or that he actually grew up mostly in London, where the Troubles defined him as an Irish Catholic whether he liked it or not, or that he went in for the Sex Pistols mainly

because Johnny Rotten was "so obviously bloody Irish"—even if you don't know any of this, it is obvious that he is afflicted with Irish Catholicism. When he sings, "At the sick bed of Cúchulainn, we'll kneel and say a prayer / And the ghosts are rattling at the door and the devil's in his chair," the sense of last things—dread of the worst, hope for the best—is as real as the drink he puked in church at midnight Mass.

Rum Sodomy & the Lash sounds like *Rain Dogs* with tin whistle and uilleann pipes, as if the down-in-the-hole outlook Tom Waits claimed by adoption is Shane MacGowan's birthright. The Waits echoes are intentional. The Pogues modeled their sonic concatenation on his, tried to land him as a producer (they got Elvis Costello instead), went to see *Franks Wild Years* when in Chicago and sought him out backstage— and he wound up coming to see them play the next night. "I love the Pogues," Waits said in the press, rhapsodically. "The songs are epic . . . whimsical and blasphemous, seasick and sacrilegious . . . These are the dead-end kids for real."

Shane MacGowan's faith is a black-and-tan of Irish Catholic pride and self-abasement. Its creed goes like this: I am fallen, and so are you, but at least I know it. I know that it's mostly my fault, that I'm responsible for what I do. And I know enough to ask for God's mercy. No matter how far I fall, how down-and-out I wind up, I know these things—and I know I'm better than you, holier than thou, because I do.

The Pogues' down-and-out folk-punk is popular music at heart. The "Fairytale of New York" video, shot over Thanksgiving in lush black and white, features the Irish American actor Matt Dillon as a police captain. The title is a nod to J. P. Donleavy's novel of an expatriated Irish American's return to New York City. It is an immediate hit and will become a holiday song for the ages, such that a third of a century later it comes around every December, tenement-mouthed Shane Mac-Gowan muttering its undislodgeable refrain: "And the bells are ringing out for Christmas Day . . ."

11

UNSPEAKABLE

Beloved was front and center at Logos Bookstore all that fall, a pair of rave reviews from the *Times* stapled to a tagboard propped up next to the cash register.

Logos was on Madison Avenue between Forty-Third and Forty-Fourth, next to the Condé Nast building. The front of the place was an ordinary card-and-book shop: boxed notes, a spinnable rack of Filofaxes, hardcover fiction. On a mezzanine (reached by a spiral staircase) was a selection of Christian books: A. N. Wilson's biographies of Tolstoy and C. S. Lewis; *The Dark Night of the Soul, The Interior Castle*, and other mystical texts; a chunky volume of Newman's *Parochial and Plain Sermons*, with ribbon marker. To tout a new book, the literary churchwomen who ran the place clipped and posted the *Times* review; typically the books they favored were crypto-religious.

That Night was set in suburban Long Island—where the author, Alice McDermott, had grown up—and was told in exaggerated retrospect, as if the early sixties were the Middle Ages. These were suburbs where the grottoed statues of the Virgin or St. Francis represented both Holy Mother Church and the old country that was New York City; where all the women stayed home to raise children while all the men worked nine to five; where a teenage girl who got pregnant was sent away to live with relatives or placed in a school for "troubled girls"; and

where these arrangements seemed permanent, even eternal, until "that night" when the boy who had gotten the girl pregnant "stood on the lawn before her house, his knees bent, his fists driven into his thighs," and issued a "love-sick boy's bitter cry"—a cry that broke the veil of that world and announced that the Church could no longer superintend the unruly forces of sexual desire.

The Counterlife was set mainly in Israel and aboard an El Al airliner. By 1987 Philip Roth was as emblematically Jewish as Albert Einstein; so was Nathan Zuckerman, protagonist of the "trilogy and epilogue" to which *The Counterlife* was a postlude. And yet Zuckerman's marriage to Maria Freshfield of Gloustershire has drawn him into "Christendom," as he puts it. So it is that, fresh from a trip to Israel ("your journey . . . to the Jewish heart of darkness," as *she* puts it), he winds up at a carol service in an Anglican church in London. He actually doesn't mind being in the company of these "gladdened" people as they kneel and pray and sing; it's a refreshing counterpoint to the zeal he has just seen at the Wailing Wall. But inevitably his reflections turn to what he thinks is missing in Christianity—the "orgasmic shudder" of sex and the everyday recognition of the body. "Holy shepherds and starry skies, blessed angels and a virgin's womb . . . Isn't the birth of a child wonderful enough, *more* mysterious, for *lacking* all this stuff?"

Louise Erdrich's *The Beet Queen* carried forward the saga of the Kashpaw clan from *Love Medicine*, mingling Catholic and Ojibwe motifs (as would a third novel, *Tracks*). Erdrich was also writing poems— "between the hours of two and four in the morning, a period of insomnia brought on by pregnancy." They were Catholic in pattern, many of them: an annunciation, a life of St. Clare, a meditation on "Orozco's *Christ*," an interior monologue from Mary Magdalene's point of view. The images are of fire and heat, coercion and violation. The Immaculate Conception is "a brand / that sank through me and left no mark." Magdalene washes Christ's feet with her hair and feels her own body "stiff as a new broom." The speaker of "Carmelites" compares her dark hours of lovemaking with those of a nun recalled from childhood—"rising every night, / scarred like the moon in her obser-

vance, / shaved and bound and bandaged / in rough blankets like a poor mare's carcass . . ." The poem "Forgetting God" suggests where an agon with Catholicism has left her: ". . . a doubter in a city of belief / that hails his signs . . ."

Vikram Seth's *Golden Gate* was a novel-in-verse that made the lives of young urban professionals in San Francisco the stuff of mock epic. Phil is divorced from his wife, and has half custody of their precocious young son. Ed, "gifted with . . . uncommon looks," is an urban Catholic ascetic: guitar, tennis racket, Bible, crucifix, on the wall a print of Holbein's portrait of St. Thomas More, and on the floor a volume of Aquinas's *Summa*. His manner is the "sullen melancholy" of a man, sexually unfulfilled, who believes he is obliged to remain so—because he is gay. A lovers' quarrel calls forth Ed's cogent self-defense: ". . . how can I explain it? / The point is that my body is / Not mine alone—I don't disdain it—/ But it's God's instrument . . ." Phil's rejoinder is just as poised: "But what was wrong or odd / With last night's loveliness between us? / Given a God, if he had seen us . . . / I'd say he blesses / The innocent bodies that express / So forthrightly such happiness." Their volleying has a playful spiritedness that isn't just owing to the hip-hugging strictures of the verse; it's owing to the fact that AIDS doesn't enter the picture until well into the story.

The Periodic Table was by Primo Levi, an Italian Jewish writer whose death by suicide that spring had caught the literary world by surprise, because it was as the survivor of the Nazi death camps that he had made his name—through the memoir published in English as *Survival in Auschwitz*. On its surface, *The Periodic Table* was a very different book: it was Levi's personal history of his life and work among chemists—"we transformers of matter"—through chapters named for elements common or rare. In substance, the book was partly a stealthy history of the Jewish community of northern Italy and the ways its members had survived and thrived for five hundred years. One way, set out in the book's first pages, was through the everyday use of a Hebrew-Piedmontese jargon—"a crafty language meant to be employed when speaking about goyim in the presence of goyim." This "underground"

language enabled northern Italian Jews to speak derisively about Catholics without risking the accusation of sacrilege. In it, Levi explained, the word *khaltrúm* describes the "intolerable" rituals of Catholics, and *khalto* Catholics' profane worship of images. "Completely cryptic and indecipherable . . . is the term *Odo*," he went on, "with which, when it was absolutely unavoidable, one alluded to Christ, lowering one's voice and looking around with circumspection; it is best to speak of Christ as little as possible because the myth of the God-killing people dies hard."

Good Woman traced the arc of a Black writer's life through poems and a coming-of-age story. The writer was Lucille Clifton, and the coming-of-age story was spare and strange. Born with twelve fingers, she felt herself touched from childhood, and was known as "Genius" among her family near Buffalo. The Baptist church where they worshipped threw a party to celebrate her going-away to Howard University—the first to go to college. She left after two years due to poor grades, but in adulthood her genius prevailed in poetry. Her poem "forgiving my father" alluded to sexual abuse she'd survived in childhood. The sequence "some jesus" distills scriptural episodes to a few taut lines each (Moses is "an old man / leaving slavery / home is burning in me / like a bush / God got his eye on"); a later sequence is akin to offertory poems "for the blind," "for the mad," "for the lame," "for the mute." The new poems in *Next* (also out in 1987) carried forward her vision of hard-won spiritual unities: "Things don't fall apart. Things hold. Lines connect in thin waves that last and last and lives become generations made out of pictures and words just kept."

Beloved was set in the middle of the nineteenth century in the middle of a country riven by slavery. The dramatic action of the novel involves a Black mother cutting her two-year-old daughter's throat with a handsaw rather than see her be enslaved; the imaginative life of the novel shows the spirit of the dead girl haunting the surviving members of the family two decades later. The novel—Toni Morrison's fifth—was recognized right away as a crowning achievement: a great Black novelist reckoning with the evil of slavery in incendiary terms and amplifying her style to do it justice. In the *Times*, Michiko Kakutani declared that "*Beloved* possesses the heightened power and resonance of myth." In the

Times Book Review Margaret Atwood wrote of Morrison that "if there were any doubts about her stature as a pre-eminent American novelist, of her own or any other generation, *Beloved* will put them to rest."

Beloved hit the bestseller lists and was nominated for the National Book Award in fiction, as were *That Night* and *The Counterlife*. The awards ceremony was held one night in November at the Pierre Hotel on Fifth Avenue. "Everybody and his brother thought *Beloved* was going to win," the publisher Gerald Howard later told the *Times*. But the prize went to *Paco's Story*, a Vietnam War novel by Larry Heinemann, and the passing over of a Black writer's breakthrough novel became a matter of controversy.

Morrison eulogized a friend at a funeral uptown a few weeks later. "Jimmy, there is too much to think about you," she said, "and too much to feel. The difficulty is your life refuses summation—it always did—and invites contemplation instead."

James Baldwin had died of cancer at sixty-three in St.-Paul-de-Vence, the French village that he had called home since 1971—and where he had written his last novel, *Just Above My Head*, about four childhood friends and their voyages-out from the churches of Harlem. The funeral was at the Cathedral of St. John the Divine, 112th and Amsterdam, in Morningside Heights, where four thousand people gathered to lay him to rest.

Morrison, a generation younger than Baldwin, had known him since the sixties. Now she celebrated his gifts: his language, his courage, his tenderness. With the cathedral decorated for Advent, she likened his death to the biblical season of mercy, when slaves were freed and debts forgiven.

It was hard to tell why Baldwin was being sent off from St. John the Divine. Sure, he was a native New Yorker and had kept an apartment on West Seventy-First Street. Sure, the giant Gothic cathedral looms over Harlem, where he had gained local fame as a "boy preacher" and which he had rendered unforgettably in fiction. But the cathedral—left unfinished during World War II—is the seat of the Episcopal Church,

and it was associated with choral evensong and New Age solstice rituals, not with the spirituals and pulpit oratory of the Black Church.

On a deeper level, however, the cathedral was apt, because its qualities—unfinished, ungainly, unorthodox—were those of the position Baldwin had taken since *The Fire Next Time*. There he'd called for Christianity, sponsor of slavery and Black resignation, to be done away with, but he couldn't do without it in his own writing. His essays were studded with scriptural allusions. The goal of his strivings was still religious. "The New Jerusalem" he called it, in an interview with *The Village Voice*'s Richard Goldstein about the situation of gay people. "Baldwin never relinquished the idea of a New or Heavenly Jerusalem found in the book of Ezekiel and the book of Revelation," Eddie S. Glaude Jr. explains, "where, for him, the idols of race and the shackles of obsolete categories that bound us to the ground were no more."

As the religious right sought to take over the civil rights narrative of a redemptive transformation of American public life, Baldwin had maintained his more complex position. Addressing the Carter administration in an open letter in 1979, he had characterized himself as an "ex-minister of the Gospel, and, therefore, as one of the born again"; in a rejoinder to liberals, he insisted that the solution to the race problem in America lay not in a structural reordering of society but in personal conversion. "If I were still in the pulpit which some people (and they may be right) claim I never left," he wrote, "I would counsel my countrymen to the self-confrontation of prayer, the cleansing breaking of the heart which precedes atonement."

In a fresh introduction to *Notes of a Native Son* in 1984, he had described the book's project of self-discovery in terms of the biblical rock of ages: "[T]here was, certainly, between that self and me, the accumulated rock of ages. This rock scarred the hand, and all tools broke against it. Yet . . . [t]he hope of salvation—identity—depended on whether or not one would be able to decipher and describe the rock." The rock is the church, the rock is racism, and the rock is the self, all at once. The inheritance of racism—Christian racism—is seen standing between Baldwin and his birthright, which is a true sense of himself; and the act of claiming himself is a calling and a kind of salvation.

Now he was dead, and his life was being celebrated at the Cathedral of St. John the Divine, as Andy Warhol's had been celebrated at St. Patrick's Cathedral back in April. Amiri Baraka called him "God's revolutionary mouth." Maya Angelou invoked him as a prophet gone to the promised land. Odetta sang "Motherless Child" and "The Battle Hymn of the Republic." And then the voice of Baldwin himself rang out in the cathedral—a recording of him singing "Precious Lord."

Beloved sold strongly in the run-up to Christmas, and in the new year Manhattan literary society was astir over the novel. The seeming snub of book and author at the National Book Awards had been compounded by a review, published shortly before the judging, from the Black literary critic Stanley Crouch, who challenged the premises of Morrison's body of work and derided the new book as a "blackface holocaust novel."

Those premises are better understood now than they were at the time. While writing *Beloved*, Morrison was also writing essays that have shaped the understanding of the novel ever since—the sense of it as a work that is thoroughly and purposefully cryptic. In her account, *Beloved* is a novelist's attempt to take "unspeakable things unspoken" and render them speakable through fiction. It's an effort to "rip that veil drawn over 'proceedings too terrible to relate.'" The "unspeakable" act at its center is based on a document in *The Black Book*, an anthology she had published at Random House, which described the Black woman Margaret Garner's decision to kill her daughter in the North rather than see her returned to slavery in the South. As she began to write, Morrison recalled, "I didn't know whether I thought what she did was right or wrong. I was sitting at my desk thinking, 'The only person who can say, who can answer this, is the person she killed.'" So she created a space for the dead child to answer. So the child begins to speak—and this ancestor's presence down the line of history makes clear that slavery is a kind of anti-ancestor, a progenitor of loss and grief. So the novel becomes a ghost story involving the spirits of enslaved people and the specter of slavery itself.

To tell the story, Morrison adapted her prose style to reflect the presence of the supernatural—of ghosts who speak. Back at Random House, she'd read *One Hundred Years of Solitude* with a sense of recognition. Her elders, who were raised religious, had spoken confidently of a world of "enchantments" and referred matter-of-factly to their everyday communications with spirits. So did García Márquez's ancestors, and his magic realism suggested a way to "blend the acceptance of the supernatural and a profound rootedness in the real world at the same time with neither taking precedence over the other." The goal was breadth or openness—"wide-spiritedness," she once called it.

She sought to make the "unspeakable" quality of the story an aspect of its form, too. She made the narrator go underground—so the reader would feel the "compelling confusion" the characters felt—finding themselves in a place, "suddenly, without comfort or succor from the 'author,' with only imagination, intelligence, and necessity available for the journey." This way, the reader would feel "yanked, thrown into an environment completely foreign . . . Snatched just as the slaves were from one place to another, from any place to another, without preparation and without defense."

Some readers did feel disoriented. One critic suggested that in dramatizing a mother's murder of her two-year-old daughter and making it out to be an act of mercy Morrison had gone too far; another said the use of magic realism had purpled her prose and made the story hard to follow. Then came Crouch's review. Headlined "Literary Conjure Woman," it found fault with James Baldwin as well as Morrison—or more precisely, with a "contrived, post-Baldwin vision of Afro-American experience" rooted in biblical notions of trial and tribulation. As Crouch told it, the preacher-turned-novelist Baldwin had depicted Black suffering as a source of integrity and redemption. Then feminism had come along and decried female suffering—and Black feminists had highlighted the ways Black women suffered at the hands of Black men, who were oppressed by racism but enjoyed the spoils of patriarchy anyhow. Morrison, Crouch alleged, had cannily combined the two positions, while also keeping *Roots* in mind, and had conjured up "a melodrama lashed to the structural conceits of the miniseries."

The National Book Awards ceremony was held a few days later. Baldwin's funeral was two weeks after that. Early in the new year, *The Village Voice* ran an interview with Baldwin by the poet Quincy Troupe—the last interview he had given. There was Baldwin recounting the circumstances that had led him to be denied a book prize a quarter of a century before: "When Ralph Ellison won the National Award in '52 for *Invisible Man*, I was up for it the next year, in 1953, for *Go Tell It on the Mountain* . . . I didn't win. Then, years later, someone who was on the jury told me that since Ralph won it the year before they couldn't give it to a Negro two years in a row. Now, isn't that something?"

The National Book Critics Circle Awards were presented in New York the next week. *Beloved* was on the shortlist. So was Tom Wolfe's *The Bonfire of the Vanities*. The prize went to Philip Roth for *The Counterlife*.

Several dozen Black writers had just seen one another at Baldwin's funeral. Now an act of protest was organized: an open letter to *The New York Times Book Review*, expressing the Black literary community's sense of injustice that Morrison had been passed over—twice over—and calling for recognition and redress.

A writer's friends calling for her book to get a big prize—and with the Pulitzer judging coming up: Wasn't that something? It was, and still is. But the real surprise is that they made their appeal—in the *Times*—in the biblical language of deliverance.

The open letter is really a pair of letters. The first one—signed by the poet June Jordan and the Penn literature professor Houston A. Baker—is addressed to the literary community. They begin with the lines from St. Paul's letter to the Romans that gave the novel its title—"I will call them my people / which were not my people / And her beloved / which was not beloved"—and then go on to make the scriptural text a figure for the plight of the Black artist in America, unrecognized and unbeloved. Sure, people were heaping praise on just-deceased James Baldwin, but "it is a fact that Baldwin never received these keystones to the canon of American literature: the National Book Award and the Pulitzer Prize: never." They want to ensure that the same thing doesn't

happen to Toni Morrison. So they make the case for her greatness—in Pauline terms. In her novels, they explain, Morrison has made beloved the very people whom racism has kept from being beloved even to themselves. "And, devoutly, she has conjured up alternatives to such a destiny: political and skin-close means to a transcendent self-respect."

In part two the letter turns to Morrison herself, through a "testament of thanks," signed by forty-eight writers. They address her intimately, the way she had eulogized Baldwin a few weeks earlier—in language flecked with religious accents: "You have never turned away the searching eye, the listening ear attuned to horror or to histories providing for our faith. And freely, you have given to us every word that you have found important to the forward movement of our literature, our life." Concluding, they celebrate her gift, as she had celebrated Baldwin's: they are writing "in grateful wonder at the advent of *Beloved*, your most recent gift to our community . . ."

The letter was published—a two-page spread in the *Times Book Review*—and the controversy deepened.

Beloved speaks in Morrison's clear, bold, stern voice, yet it is a purposefully cryptic book all the same. Its cryptic quality is due in part to the depths of its sourcing: it makes the unspeakable speakable by conversing with several narrative traditions at once.

It is a book that is in intertextual conversation with other Black works: fiction, slave narratives, spirituals, oral history. It is a book in dialogue with the literature of "wide-spiritedness" from *Moby-Dick* to *One Hundred Years of Solitude*. And it is a book engaged with the Christian past—a past characterized by violation of the precept set out by Paul that "there is neither slave nor free, but all are one in Christ Jesus." Its story is set against the sacred history of the Israelites: Sethe's killing of Beloved—a sharp blade to the throat—calls to mind Abraham's sacrifice of Isaac (which was stayed by God at the last moment) in the book of Genesis. It's a book, as John McClure observes in *Partial Faiths*, "in perpetual conversation with [St.] Paul: it takes its title, its epigraph, and the name of its male protagonist from his letters, and it

shares Paul's preoccupations with questions of love, the flesh, free will, and the relation of law to revelation." And it's a book attuned to the religious energies of African religion and their transformation by enslaved people in the United States. The scholarship on *Beloved* explores all this acutely. The novel's settings are "enchanted" places where the dead make themselves heard and felt; the sermon that Sethe's mother-in-law, Baby Suggs, gives partway through, at "a wide-open place cut deep in the woods nobody knew what for," is an image of the religious self-fashioning that Black people have undertaken out of creativity and necessity.

The graveyard scene at the front of the book is a marker for the "wide-spiritedness" of what follows. Religion matters here because it matters to the ancestors, who continue to speak in the manner of religion. The past is an open grave. History is half-written. Violation and expiation are inextricably mixed. The dramatic acts of our lives often involve dealing with history that precedes us and belongs to us whether we like it or not. Where Joyce had Stephen Dedalus declare that "History is a nightmare from which I am trying to awake " Morrison would have us awake *to* history—a past that, because it is half-written, is present to its descendants through spirits and hauntings.

In March 1988 *Beloved* was awarded the Pulitzer Prize in fiction. Asked about the campaign on its behalf, Morrison herself struck the crypto-religious note, calling the other writers' open letter "a kind of blessing . . . They redeemed me, but I am certain they played no significant role in the judgment." The Pulitzer judges, in their citation for *Beloved*, noted: "It captures new ground even while it is in dialogue with great American novels of the past"—with Hawthorne's *The Scarlet Letter*, with Faulkner's *Absalom! Absalom!* and *Go Down, Moses*. But the novel was also in dialogue with the work of Morrison's colleague William Kennedy, an exchange that was largely unspoken.

Morrison's devotion to religious inheritance joined her to peers she isn't generally associated with—to other crypto-religious figures, that is. The work they make is deeply personal. But their dealings with religion

are something other than personal. The "unspeakable" they strive to vocalize belongs not just to them, but to a people whose emissaries they are. Their own particular religious experiences hardly enter the picture. The supernatural is the territory they work in. Heaven and hell are the borderlands, angels and devils the superintending forces, salvation and the loss of the soul the stakes of the drama. Its presence—assumed, dealt with intermittently, but never dismissed—makes their work wide-spirited, even when creed and cult and dogma are left unspoken.

Patti Smith is such a figure. Like Morrison, she's now seen as a goddess or priestess. Those terms are so often used glibly or ironically, but not here: for Smith, as for Morrison, they're apt, because they arise from the frank spirit-seeking dynamism of her work. From the beginning Smith has approached belief and the supernatural with unflinching seriousness, even when she is being irreverent. Her credo "three-chord rock merged with the power of the word" shows that she sees prophecy as a personal duty. Her intensity is that of a person who believes that talent is a responsibility and our lives are themselves a kind of reckoning. And the lifetime-achievement energies that have flowed her way have completed the circle, so that this great devotee is at once the recipient and the channeler of devotion—a goddess or priestess after all.

That's not the way she was seen in the 1980s, though. She was thought of as a casualty—proof of Neil Young's adage that it's better to burn out than to fade away.

So it was a surprise when, in the spring of 1988, word came that a new Patti Smith record was due out later in the year. All signs were that it was a full-on comeback album. It featured Sonic Smith on guitar. It was produced by Jimmy Iovine, who had produced *Easter* and had gone on to produce era-defining records by Tom Petty and the Heart-breakers and Stevie Nicks. It had been made across a couple of years at state-of-the-art studios in New York and Los Angeles, suggesting that Smith's hibernation up in Michigan was over. She was emerging from the Great Lakes wilderness healthy, married, a mother, and as much an artist as ever.

Robert Mapplethorpe had come into view as an artist during Smith's withdrawal, their careers paired with a symmetry which suggests that

the rise in his reputation depended on the dimming of hers. After their split, he had taken to photographing the figures of the lower Manhattan S&M scene in action. The process was an act of artistic seduction, as Patricia Morrisroe spells out in her biography. Mapplethorpe would meet them at the bars in the old meatpacking district. He'd take them to his loft on Bond Street. They'd have sex. Then he'd photograph them, typically in full regalia: a pair hooded and chained to each other; a man with another's fist thrust up his anus; a penis protruding from an elaborately zippered crotch, and one laid out as if on a butcher's block. He photographed himself, from the rear, spread-eagled, with one end of a bullwhip lodged in his anus and the rest of it snaking out behind, awaiting the viewer's grasp—a pose capped by the demonic grin on his bearded visage. One admirer, an ex-seminarian, called him "the serpent in Eden." John Richardson (a habitué of the leather scene) called him "a cold-blooded angel figure."

Mapplethorpe also photographed men from the arts: Philip Glass, Robert Wilson, Thom Gunn, Bruce Chatwin, Andy Warhol. Chatwin, the English travel writer, sketched what he saw at Mapplethorpe's loft: ". . . there is a condition of perpetual night: the floor gray and grainy, mission-style furniture upholstered in black leather, the reflections of mirror or faceted glass, a black bedroom behind a white wire-netting cage, and, ranged around, the paraphernalia of an irreverent perversity (a scorpion in a case, a bronze of Mephistopheles, and a much smaller bronze of the Devil with his toasting-fork)." He went on: "Except for a few close friends, Robert rarely takes pictures of the same sitter twice—an hour or two of intimacy, an inimitable image, and that is all."

Mapplethorpe's own predilection was for cruelty and abasement expressed every which way. He was drawn to extremely fit Black men, whom he sought to dominate in the sexual act, capping the domination by calling them an unspeakable word over and over again. ("It made their cocks jump," he said.) He would cry out to his partners to "Do it for Satan." He wore a leather jacket with a swastika pin on it. He took photographs of preteen girls in compromising positions. He blackmailed men he had photographed, threatening to disseminate the

shots he'd taken of them. He ate shit. He saw himself as lazy, selfish, wholly devoted to self-satisfaction.

All the while, he was involved, as a romantic partner, with Sam Wagstaff, a connoisseur who had used the money from an inheritance to amass an exceptional collection of works from the history of photography. Their shared goal was to make that history include Mapplethorpe's work. They printed a small book, the *X Portfolio*, and it circulated on the leather scene and the fine arts scene. ("Here are the images of our modern martyrdom: our Scourgings, our Crownings with Thorns, our Crucifixions"—from the introduction, by a freelance critic.) Those photographs then shaped the perception of Mapplethorpe's other work. His dramatically lit black-and-white photographs of flowers made them seem like fetish objects. His book-length series of photographs of Lisa Lyon suggested soft-core S&M—the bodybuilder as dominatrix.

Arthur C. Danto interpreted the S&M photographs as Mapplethorpe's effort to register acts, and ways of life, that were still unspeakable in society at large. In his view, the photographs strive to initiate the viewer into a realm remote from ordinary experience. Although formally elegant, they are not formalist. Nor are they documentary work, "recording a form of life, though in fact and secondarily they provide such a record," he observed. "They are, rather, celebratory of their subjects, acts of artistic will driven by moral beliefs and attitudes. Mapplethorpe is not there like a disinterested, registering eye. He was a participant and a believer."

AIDS had sent waves of fear through the leather scene. As gay men died of the disease, Mapplethorpe's S&M photographs shifted, in perception, from transgressive to elegiac, and the shift smoothed the passage of his work into the fine-art canon. The Stedelijk in Amsterdam, the National Gallery in London, and the Whitney in New York planned full-scale exhibitions of his work. He moved into a loft at 35 West Twenty-Third Street, a short walk from the Hotel Chelsea, and decorated it with Catholic and Jewish *objets*: candelabras, a carved devil's-head, crucifixes small, medium, and large. He spent time with Andy Warhol, who made a portrait of him in 1983; returning the favor, he made, in 1986, an unforgettable portrait: a close-up of Warhol

in black turtleneck and white wig against a bright circle that can't be seen as anything other than a halo. The BBC came calling. "I captured something about a certain time and a certain place—something that can't be captured anymore," he told the interviewer. "You know, it was there, and that period's over now. Things have changed."

For the *Dream of Life* cover photograph Patti Smith had turned to Mapplethorpe once more. Sonic, early in 1987, had suggested that she reach out to him about the sleeve. "I hadn't seen or spoken with him for some time," she recalled.

> I sat to ready myself, contemplating the call I was about to make, when the phone rang. I was so focused on Robert that for an instant I felt that it could be him. But it was my friend and legal counselor Ina Meibach. She told me she had some bad news and I sensed immediately that it was about Robert. He had been hospitalized with AIDS-related pneumonia. I was stunned. I drew my hand instinctively to my belly [she was pregnant with a second child] and began to cry.

"I'm going to beat this thing," he told her in a phone call a little later, but the likely brevity of his time remaining stood in sharp contrast with the unhurried quality of her retreat in Michigan. Straightaway she drove east with Sonic and their son, Jackson, checked into the Mayflower Hotel on Central Park, and met Mapplethorpe, who was out of the hospital, fully ambulatory in a long black leather coat. She had her hair in braids. He called her Pocahontas. "The energy between us was so intense that it seemed to atomize the room, manifesting an incandescence that was our own." Then they went to St. Vincent's, where Sam Wagstaff was dying, and took turns holding his hand.

Back in the day, Mapplethorpe had photographed her undressed and disheveled in empty white rooms. For *Dream of Life*, he set her up in the

studio in his loft. She endured the ministrations of a makeup artist while a pair of assistants adjusted the backgrounds and calibrated the lighting. Then he went behind the camera.

They both were unhappy with most of the photographs. The one she liked best was taken with a Polaroid instant camera. She's wearing a blousy black dress, which concealed her pregnancy, and is holding a blue butterfly mounted on a dressmaker's pin; her hair is thick and flowing, robust with new life: "Everything read black and white offset by the iridescent blue butterfly, a symbol of immortality."

Sam Wagstaff died soon afterward. Mapplethorpe was distraught. So was Smith. She and Sonic composed and recorded the somber elegy "Paths That Cross"—"a sort of Sufi song in memory of Sam," she called it. "I knew that one day I might seek out those same words for myself. *Paths that will cross again.*"

After years apart, her path and Mapplethorpe's had crossed again—and kept crossing. She had been recording at the Hit Factory in midtown Manhattan in February 1987 when Mapplethorpe called her to say Andy Warhol was dead. She'd gone out of the studio to find the city dusted in snow—as if "in remembrance of Andy"—and wound up praying as she passed a churchyard. She had been recording in Los Angeles later that year when Mapplethorpe packed his cameras and joined her there. He took some shots of her "before a cluster of drying palms in the full sun."

She chose one of those for *Dream of Life*. "My hair is braided like Frida Kahlo's. The sun is in my eyes. I am looking at Robert and he is alive," she explains in *Just Kids*. To Patricia Morrisroe, she recalled: "Certainly it's not a glamorous picture, or the most flattering. But Robert knew it was the image I wanted. It was his gift to me."

It was a gift in more than a personal sense. All of a sudden Mapplethorpe was as famous in his way as Smith had been a decade earlier. "If style and its permutations, fashionability and taste, are major topics of late '80s art, then Robert Mapplethorpe is perhaps the most topical artist of the moment," Andy Grundberg observed in the *Times*. ". . . I am told that to see the exhibition of his work held recently at the National Portrait Gallery in London, one had to wait in line." Even as he

struggled with AIDS, then, Mapplethorpe was promoted to the role left vacant with Warhol's death—an avatar of the pop demimonde, a black-clad, all-seeing creature of the night.

In the fullness of time Mapplethorpe would gain fame such that his name would be cited allegorically on front pages, on talk shows, in protest marches, and in the halls of Congress—but not yet. In the spring of 1988 that role was being prepared for Martin Scorsese, perpetrator of *The Last Temptation of Christ*.

The location shoot in Morocco had been arduous, and Scorsese had returned exhausted. In New York, he joined Thelma Schoon-maker, the editor of his pictures, in a studio on the ninth floor of the Brill Building, at Broadway and Forty-Ninth Street. Once the roost of librettists for musicals, then the base for pop songwriters—Lieber & Stoller, King & Goffin—now the building nestled within it the dark-ened crypt-over-Broadway where Scorsese truly lived. There he watched the picture-in-the-making. "He didn't know whether he had it or not," Schoonmaker recalled, but "once he started looking at the footage, he was reassured and got excited." Peter Gabriel was compos-ing the soundtrack in a studio on a different floor. The goal was to finish the picture for a premiere at the New York Film Festival in September, followed by a release in the fall.

They put together a forty-minute synopsis of the picture and sent it to Los Angeles. There, Universal was preparing its rollout of the film, and the process (as Thomas Lindlof spells out) was becoming nearly as complicated as the making of the film itself. Two conservative Christian organizations had organized letter-writing campaigns and a petition with more than a hundred thousand signatures, and the studio hired outside publicists—a Christian marketing firm, an ex-Buddhist seminarian—to keep them apprised, and reached out to progressive religious figures, such as Daniel Berrigan and Paul Moore, Episcopal bishop of New York. One of the studio's partners for distribution, General Pictures, suggested it might decline to show the film in its more than a thousand theaters. A bootlegged script circulated among evangelical leaders. A convention of

religious broadcasters in Washington focused attention on the film, and the participants were primed to opine on the film on radio and TV and in newspaper opinion pages—which they did, railing against a movie that none of them had seen, or could have seen, because Scorsese and Schoonmaker were still editing it in the Brill Building.

Scorsese screened a rough cut for a small group of friends in May, then for the United Artists studio chiefs, and then for a larger group of executives from Universal and Cineplex Odeon. Reactions were mixed. Scorsese's friend, and Schoonmaker's husband, the director Michael Powell, teared up as it ended. UA's Sid Sheinberg anticipated outrage. Universal's Sally Van Slyke said, "This is trouble." After *The Philadelphia Inquirer* reported on "a series of secret New York screenings," evangelical leaders cried foul: Universal had promised to keep them apprised of the process, hadn't they? In response, the studio, by fax, invited the five most prominent of them to come to New York to see the rough cut with their own eyes. All five declined.

Universal made plans to move the release date up to August, funding round-the-clock postproduction and securing theaters in major cities.

In all this, Scorsese was equable. "I was supposed to make it, and I will make it," he had told *Interview*. He had made it. Now the challenge was to explain *why* he had made it. Months earlier, he had prepared a statement; and as the controversy swelled, it would serve as both ars poetica and credo. "*The Last Temptation of Christ* is a motion picture that I have wanted to make for over fifteen years," he explained. "Both as a filmmaker and a Christian, I believe with all my heart that the film I am making is a deeply religious one. Although Jesus is tempted by Satan, what the movie says and what I believe is that Jesus resisted temptation and was crucified as told in the Bible. I have made a film which is an affirmation of faith and I urge everyone not to judge my film until they see it."

Dream of Life came out in June. The cover showed a Patti Smith her fans likely didn't expect: serene, conventionally feminine, anti-iconic, shot in soft focus against a background of wild grass. Her lips are glossed;

her eyes are full of sleep, whether from parenting or midlife. Wherever she is, it's a long way from the Hotel Chelsea.

The record wasn't a breakthrough, a revelation, or a hit. Today the music sounds a little slick, but the lyrics strike a Patti-ish balance of defiance and surrender. Take "Going Under": the music is minor-key piano and liquid electric guitar. "Sun is rising on the water," Smith begins, and urges a companion to go under with her. "Is it heaven / Crack it open / And we'll slide down / its stream." The symbolic resonances are many: sex, drugs, mystical illumination, a death pact. But the strongest sense is the literal one: the singer and a friend are out swimming together, going under the surface of everyday life, and discovering hidden depths of themselves and each other along the way.

Reviewers struck the crypto-religious note. "Her prophetic rhetoric is biblical just like always," Robert Christgau observed in *The Village Voice*, "with a personal feel for the mother tongue I wish more metal Jeremiahs knew to envy." A "mini-resurrection," James Wolcott later called it. In *Rolling Stone*, Robert Palmer (who had praised her in the *Times* for years) went full gospel. "In New York in the mid-seventies, when Tom Verlaine and Patti Smith were friends trying to remake themselves as artists—Verlaine with his band Television, Smith as a poet—their shared tastes in reading, from Rimbaud to Paul Bowles, helped shape a unified aesthetic with definite spiritual aims," he observed, and then celebrated the record as a "visionary (and at the same time eminently practical) attempt to recharge the ideal of punk." The sound was "a soaring Gothic cathedral of electric-guitar harmonics." The strongest songs ("People Have the Power" and "Up There Down There") had an "alchemical intensity," with Sonic's guitar patterns a "cosmic metaphor" resounding in a "highly charged sonic space."

Patti Smith, he suggested, had grown up; and her intense spiritual yearning, a loose strand in her early work, had become an organizing principle.

She went to New York in July to promote the record. While she was there, she paid a visit to Mapplethorpe—at St. Vincent's Hospital. Eigh-

teen months after his partner's death from AIDS, he was fighting the disease, whose "wasting" process had reduced him to a hundred and ten pounds. He had made a formal portrait of himself holding a cane tipped with a white skull—a death's-head, aligned with his own head.

"Now she was sitting at the edge of Mapplethorpe's bed, as she had sat at Wagstaff's," Patricia Morrisroe reports. "Visitors to Mapplethorpe's room were touched to see her vigorously massaging his legs and feet one afternoon, perhaps hoping to spark some life into his nerve-deadened limbs."

She returned to Michigan; he was discharged from St. Vincent's, still ill. The Whitney show was imminent. In an interview for a *New York* magazine profile, he sought to dismiss any claim that he had HIV—on the grounds that he didn't want to be known as a gay artist—and he was angry when he didn't prevail.

That Mapplethorpe didn't identify himself as a homosexual, or gay, or queer, is now cause for amazement. But he had sound reasons. Gay sexuality was scarcely discussed in the press. He feared the category would narrow his audience and reduce his fees. Above all, he didn't want his parents in Queens to learn of it and be shocked, for he had never come out to them. (During his time with Patti Smith, he'd told them they were married.) And he had never come out to them because they were Catholics whose devotion to the Church was of a piece with their fealty to the neighbors and their obeisance to the *Daily News*.

What is the relationship of his S&M pictures to his Catholic boyhood? It's too simple to say they are a reaction to the strictures of the Church, though they were. They are the replacement of one set of rituals with another—those of religious submission with those of sexual submission—which he then made his own through the ritual act of making photographs of them. The acts of S&M were unspeakable, but they could be photographed. Each photograph was the flouting of a boundary: "It would be known in advance that such an image would challenge, assault, insult, provoke, dismay—with the hope that in some way consciousness would be transformed," Arthur C. Danto observed. The image would involve the viewers in the ritual, and make them see

things somewhat differently from before. "I want to see the Devil in us all," Mapplethorpe said. "That's my turn-on."

In his most recognizable self-portrait, Mapplethorpe is Satan himself, with a pair of horns nudging out from his thick, dark, curly hair, so strongly in contrast to his hairless body. "There's a sense of humor in what I'm doing," he insisted to the BBC. "More seriously, I thought, 'What would I look like if I had horns?' It's one aspect of myself, of everyone: the demon within." The image would be puckish, were it not for the grimace-inducing extremes of the photographs usually displayed around it.

Like Patti Smith, Mapplethorpe was drawn to the supernatural, fond of Catholic iconography, and committed to ritual as the royal road to the fulfillment of desire. Like her, he was a rebel, but his rebellion was an inverse of hers. She sought to be accepted as the rebel she was, and the anger in her work is righteous anger; she is one of a cloud of bohemian witnesses, the writers and artists and rockers who have fought the good fight and have been on the right side. He, too, was energized by rebellion as a vocation, but as a rule he didn't seek to justify the way he lived as good or right. On the contrary, he retained, from his Catholic upbringing, the sense of himself as *bad*—as fallen, one of Satan's rebel angels—and this sense of himself energized his art. It also depended on his maintaining an outer-borough narrowness. He wasn't interested in debating the merits of different ways of life: he was who he was. And he wasn't bent on remaking the world in his image: he'd rather remain a rebel in the world as he found it.

Patti Smith–and–Robert Mapplethorpe is now an archetypal pairing, a New York bohemian yin and yang. But another comparison, less obvious, is apt in its own way: that of Robert Mapplethorpe and Bruce Springsteen, who was on the road with the E Street Band all through 1988 on a tour called the Tunnel of Love Express.

The likenesses between these two bridge-and-tunnel boys are striking. The young man Mapplethorpe in a leather jacket and jeans,

slim-hipped, big-haired, strong of cheekbone, could be Bruce or one of his E Street bandmates. The "undercover" lover in Patti Smith's hit version of Springsteen's song "Because the Night" is said to be Sonic Smith, but he might as well be Mapplethorpe: the image of the pair sheltering-in from the world, sustained by love ("an angel disguised as lust"), fits their years together in Chelsea perfectly. And the Springsteen whom Annie Leibovitz photographed for the *Born in the U.S.A.* sleeve—seen from behind, in T-shirt and tight jeans, red ball cap dangling like a bandana—puts in mind the West Village as much as the heartland. "Looking back on those photos now, I look simply . . . gay," Springsteen recalls in his autobiography. "I probably would have fit right in down on Christopher Street in any one of the leather bars."

The resemblance runs deeper than appearances. Each had a surname that concealed his Catholic-ethnic ancestry. Mapplethorpe's Queens is akin to Springsteen's New Jersey: a place within the gravity field of New York and magnetically oriented toward the city and yet so far away culturally as to seem a different place. Catholicism in each place is so deeply bred into everyday life that it is indistinguishable from the general ethos. "Here we live in the shadow of the steeple," Springsteen writes in the autobiography, "where the holy rubber meets the road, all crookedly blessed in God's mercy, in the heart-stopping, pants-dropping, race-riot-creating, oddball-hating, soul-shaking, love-and-fear-making, heartbreaking town of Freehold, New Jersey."

For all their well-documented small-mindedness, those places somehow imparted a sense of the big picture—of what is at stake in a human life from a religious point of view. Outer-borough Catholicism stamped Mapplethorpe with categories of heaven and hell, salvation and damnation—categories whose power he drew on in the act of violating them. Down-the-shore Catholicism imbued Springsteen with a world-view so baroque and exultant that critics, from the beginning, chided him as grandiose.

In Springsteen's early work the spirits in the night are real, it's possible to be blinded by the light like an apostle out of Caravaggio, and a saint in the city is something you actually might want to be. By the late seventies Springsteen had earned the authority to sing "Adam

Raised a Cain" as if father and son in scripture were figures from the neighborhood, and to make going down to the river seem an act of desperation and baptismal renewal at once. When he sang that he believed in the promised land, so many of us born after the civil rights movement heard the biblical ideal made real and vivid for the first time. (Meanwhile, in the voice of a man in a murderous rage, he mocked the woman who would wind up shot point-blank: "Do you still kneel to say your prayers, little darling? / Do you still go to bed at night / Praying that tomorrow / Everything will be all right?")

Through the autobiography we now have a clearer sense of what Springsteen's Catholic upbringing meant to him. The Church provides a map of the world with the coordinates inked in, a cosmic Greasy Lake. "I live here! We all do. All of my tribe. We are stranded on this desert island of a corner, bound together in the same boat. A boat that I have been instructed by my catechism teachers is at sea eternally, death and Judgment Day being just a divvying up of passengers as our ship sails through one metaphysical lock to another, adrift in holy confusion." As with Mapplethorpe (and Jim Carroll, and Andres Serrano, and so many other postwar Catholic boys), that worldview was something to rebel against. For Springsteen it was a rebellion against Catholic-school gloom-and-doom: for him "it ain't no sin to be glad you've alive." As with Morrissey a little later, it was a rebellion against cruelty committed in the name of the holy. "Before my grammar school education was over I'd have my knuckles classically rapped, my tie pulled 'til I choked; be struck in the head, shut into a dark closet and stuffed into a trash can while being told this is where I belonged," Springsteen recalls. "All business as usual for Catholic school in the fifties." He saw the "face of Satan" in his father "tearing up the house in an alcohol-fueled rage in the dead of night."

Those experiences "estranged me from my religion for good," Springsteen reports; and yet he later came around to the familiar view that "once you're a Catholic, you're always a Catholic"—not a practicing one, but somehow "still on the team."

Tunnel of Love, released in the fall of 1987, was received as a breakup record, the songs steeped in the troubles in Springsteen's marriage to

the actress Julianne Phillips—troubles that would come out into the open on tour the next June after paparazzi photographed him sunbathing on a hotel balcony in Rome with Patti Scialfa, who had joined the E Street Band as a harmony singer. But *Rolling Stone*'s reviewer, Steve Pond, heard something else: ". . . it is an album in which you can hear Springsteen's Catholic upbringing: Again and again lovers pray for deliverance, romance is depicted as a manifestation of God's grace, and love brings with it doubt and guilt."

At the time, Springsteen's Catholicism was a matter of conjecture, which involved connecting the dots in his lyrics and seeing his three-hour concerts as a communal ritual with the Boss as celebrant (although the ritual they really resembled was the evangelical Protestant revival meeting). That's the approach Rev. Andrew Greeley took early in 1988 in a piece for the Jesuit magazine *America*. Greeley—priest, sociologist, columnist, author of sex-in-the-parish potboilers—saw the record as an expression of "the Catholic imagination of Bruce Springsteen." Overstating the case, he exclaimed that *Tunnel of Love* "may be a more important Catholic event than the visit of John Paul" the year before. He insisted he wasn't trying to "claim" Springsteen for the Church the way apologists had claimed athletes and movie stars back in the day. Then he claimed him through a professorial reading of *Tunnel of Love*'s lyrics (making no mention of the music). Springsteen, he declared, was a "Catholic meistersinger." He was a "liturgist," conducting a "minstrel ministry." And he was proof that "Catholics cannot leave the church" because they are shaped indelibly by "the Sacraments."

That piece opened up fresh territory in its recognition of the cryptic nature of Springsteen's dealings with religion (". . . he engages in this 'minstrel ministry' without ever being explicit about it, or even aware of it"). But it was special pleading of the clerical kind. It reduced art to a "ministry." And it assumed that religious images of light and water, sin and prayer, are specifically Catholic, accessed through a "sacramental" imagination.

They're not, and that is why they are so effective. They are images so broadly recognizable as to be archetypal. In Springsteen's work, biblical

imagery is one of the ties that bind him to his audience. Catholicism is not so much the source of such imagery as a point of access to it—for him, and for the fans who identify their lives with his. Through that imagery their yearnings for glory, community, and transcendence are made speakable. His Catholicism is roots; and his integrity lies in his recognition that Catholicism is a part of his life—nothing less, but nothing more, either.

The version of "I Ain't Got No Home" he recorded in 1988 shows how his sound in that period comes from the sheer abundance of roots—religious ones among them—that he claimed as his own and brought together with his guitar, his voice, and his band.

The song is Woody Guthrie's, best known from *Dust Bowl Ballads* of 1940. Springsteen recorded it for *A Vision Shared*, a tribute record to Guthrie and Leadbelly (Huddie Ledbetter) organized by the Smithsonian Institution. The man whose song it is sees himself as "just a wandrin' man, I go from town to town"—a migrant worker, at best. He's a poor man who is singing to the rich man who has kept him down. He has worked in the mines, harvested corn, sharecropped—but "always I was poor." Six children he has raised, but his wife is dead, and "my brothers and my sisters are stranded on this road." In a video interview, Springsteen explained the song in crypto-religious terms: "[I]t cries out for some sort of belief, and reckoning with, the idea of 'universal family,'" he said, "which is something that people long for: everybody longs for that . . . It reaches down and pulls out that part of you that thinks of the next guy."

He starts out solo, murmuring over a fingerpicked acoustic guitar, and the E Street Band gradually fills in the roots around him: two-step bass, old-world accordion, tent-revival taps on a tambourine, with Springsteen finally letting out a mournful yelp, like the whistle of the train that has left him behind as it did Elvis and Robert Johnson.

"I ain't got no home in this world anymore . . ." The refrain is a train of thought that carries the rest of the song as freight. Like the line "my brothers and my sisters stranded on this road," it's faintly but unmistakably biblical: with it Springsteen, like Guthrie, and like the

"wandrin' worker" whose story the song is, sees homelessness as the way of the world for so many, while intimating that there's another world more just than this one and that our true home is there, not here.

U2 also signed on for the Smithsonian project. On the record, their contribution came right after Springsteen's: a version of Guthrie's "Jesus Christ."

Lyrically, it's as simple as a children's song. Jesus the carpenter is "a hard working man," telling folks to give their wealth to the poor and attracting "followers true and brave"; Jesus is scorned, betrayed, arrested, and nailed to the cross by the bankers, cops, soldiers, and landlords. Jesus is killed: "And they laid Jesus Christ in his grave."

Guthrie's 1940 recording is sober and laconic, an etching in sound. A version Arlo Guthrie and friends did at a Woody tribute in Hollywood in 1970 is laid-back country and western (akin to Leonard Cohen's "Passing Through," from the same period). U2 revved it up and made it a ringing, clattering three-chord parable, folding in a hollered chorus of "Hallelujah!"—at once exultant and ironic—after each verse.

"'Jesus Christ' is a song that has to be sung—it's not a question of U2 *wanting* to sing it; we have to sing it. It's more relevant today than it even was when he wrote it," Bono says in the documentary, citing the line "The bankers and the preachers, they nailed him in the air" and applying it to the televangelists. But the band was obviously drawn, too, to Guthrie's sense of Jesus Christ as an ordinary man who sought a radical upending of the world as he found it. "There's a lie right now that's very popular: that you can't make a difference, that you can't change the world. The songs on the radio perpetuate that lie"—the words and music inducing "the big sleep," Bono says. "I think Woody Guthrie's music was much more awake than that."

U2's version could wake the dead; it's as close as they ever got to the raucous-roots sound of their original idols the Clash. "We were really a punk band trying to play Bach," Bono once said, cryptically, of their early days, and in this record it's absolutely clear what he meant.

"Jesus Christ" is also a marker of a real change for the band. In the seven years after "Gloria," U2 had reset their relationship to Christianity so as to set themselves apart from the fundamentalists in the heartland and on cable TV. Their religiosity is no longer about going into the mystic: it's about standing up for what is right in a world gone wrong. Christianity, for them, isn't an adolescent enthusiasm or an Irish hangover or a pledge to the brethren. It's a rock of ages, the root of the roots that music Irish and American, Black and white, somehow share. And it's a form of desire—one that will keep them strange as they make the shift from earnest strivers to standard-bearers.

U2 had figured out that it's a good idea to offset religious desire with carnal desire. "Desire"—the first single from *Rattle & Hum*—made that clear. Like "Jesus Christ," it's a three-chord basher: D, A, and E. The rhythm is the "Bo Diddley beat": guitar, bass, and tom-toms throbbing on a single note all together, New Orleans by way of Iggy and the Stooges. The lyrics are a series of riffs on what a woman is like to a man in the throes of desire. Then out of nowhere comes a crypto-religious line: "Oh sister, I can't let you go / like a preacher stealing hearts at a traveling show . . ."

"I wanted to own up to the religiosity of rock'n'roll concerts and the fact that you get paid for them," Bono explained. "On one level, I'm criticizing the lunatic fringe preachers, 'stealing hearts at a traveling show,' but I'm also starting to realize that there's a real parallel between what I am doing and what they do." Still controverted, he will have it both ways: where in "Jesus Christ" he joined Woody Guthrie in denouncing the preachers, here he self-incriminatingly identifies with them.

The band members were living the rock-star life in Los Angeles: big houses, fast cars, vintage motorcycles, late nights. The "Desire" video is set there. It puts black-and-white footage of the band in quasi-rockabilly regalia against images of downtown street life: neon signs, blazing marquees, liquor stores, phone booths, streetlights—and a black car pulling away with a biblical imprecation spray-painted on the back: IF YOU REJECT JESUS YOUR SOUL AND FLESH WILL BURN IN HELLFIRE FOREVER. It's

the one image that doesn't fit with the others; it's the sharp edge that sticks out. The gratuitous-seeming image is a sign. U2 were growing up—but they were keeping faith, as baggage they couldn't leave behind.

Bono went out to Malibu one night for a late supper at Bob Dylan's place. He brought a case of Guinness stout as a kind of offering. Dylan was restive. Coming off the tour of arenas and stadiums with the Grateful Dead, he had asked his manager to book a run of shows in small halls across America—shows "where I'd be entirely at once author, actor, prompter, stage manager, audience and critic combined." And after a time when he couldn't write songs, he had come unstuck—writing twenty verses of "Political World" one long night and then twenty more songs in the next month or so, on typed pages, which he then set aside: "I wrapped up and put them away to stay where they lay, kept them in a drawer, but I could sense their presence."

One showed that even if the so-called gospel period was ended, the gospel impulse hadn't been abandoned. "The song 'Disease of Conceit' definitely has gospel overtones," Dylan observes in *Chronicles*. He was prompted to write it by the controversy around Jimmy Swaggart, the televangelist—and first cousin to Jerry Lee Lewis, the pioneering rock-and-roll pianist. Swaggart had been linked with a prostitute, caught on video leaving her motel room, and the story was all over the tabloids and cable news shows. Dylan tells the story: "He wept in public, and asked forgiveness, but still was told to stop preaching for a while. He couldn't help himself, though, and quickly went back to preaching as if nothing had happened." And it was for his refusal to stop preaching, not for his philandering, that the church authorities stepped in. "The Bible is full of these things," Dylan goes on—stories of powerful people brought low by "the disease of conceit." The song doesn't speak directly about religion, but the disease of conceit is plainly the sin of pride. In concert, Dylan would play the piano part himself, and as he and band surged into the last chorus he would stand and shimmy at the keyboard, honky-tonk style, rollicking, exuberant—like Jerry Lee Lewis.

That night in Malibu, Dylan and Bono talked about Jack Kerouac; they talked about Andy Warhol. With the Guinness nearly gone, Bono

asked Dylan if he had any new songs. Dylan went to the drawer, took out the sheaf of lyrics, and handed them to Bono. "He looked them over, said I should record them," Dylan recalled. "I said that I wasn't so sure about that, that maybe I should pour lighter fluid over them. He said, 'No, no,' and he brought up the name of Daniel Lanois . . . said that U2 had worked with him and he had been a great partner—that he'd be perfect for me to work with . . .

"Bono picked up the phone and dialed the man, put him on the phone with me and we spoke for a moment. Basically, what Lanois said was that he was working out of New Orleans and told me that if I was ever there, I should look him up. I said I would do that." But not yet: there was a run of shows ahead of him, single nights in small halls for audiences with modest expectations. The Never-Ending Tour was about to begin.

That year's model for the grown-up musician was Leonard Cohen. An old soul from the beginning, he was gradually and elegantly aging into the role. Because he had never seemed especially young, he had no youthful self to update or leave behind; because had never been famous, a new generation could encounter his songs and persona as if discovering him for themselves.

I'm Your Man had been released by Columbia, his once and future label. The sleeve photograph showed him in pinstripe suit and shades, eating a half-peeled banana—an image that brought him close and lightened him up at the same time. The record got positive reviews (each record was said to be less bad than the previous one, he mordantly remarked) and sold strongly, topping the charts in Scandinavia. Sylvie Simmons, Cohen's biographer, observes: "It even sold well in America."

With the record came a round of press and a world tour. "Leonard had perfected 'the art of being Leonard Cohen,'" Simmons observes, and the interviews he gave—many with journalist friends—are as expansive and relaxed in a way the record was not. The one with Kristine McKenna in *LA Weekly*, for example:

"What three things never fail to bring you pleasure?"

"Good weather, a woman's body, and the moon."

"What's your idea of an important achievement?"

"There is only one achievement, and that's the acceptance of your lot."

He wasn't joking. If the former quip was a mini-compendium of poetic clichés, the latter one was a distillation of the themes of his work in these years: vocation and destiny on the one hand, loss and aging on the other, all considered from a point of view that blended Buddhist detachment, stoic resignation, and a biblical sense of chosenness. "This record broke down three or four times in the making of it," he said, "and the sense of struggle was more pronounced [than in the past] for a number of reasons. For one thing, I came to the end of a period I'd roughly describe as a religious inquiry, and many of the songs on this record began as purely religious songs."

So all those early mornings he'd spent on his knees at the *zendo* on Mount Baldy had ended with him accepting his lot, which was to be a singer and songwriter, a man who would work out his quandaries in public: standing at a microphone, plucking a guitar, delivering his songs in a manner akin to speech—"a true voice," he called it, "in the sense that it's not a lie."

The tour was nearly a hundred concerts spread across seven months and four continents. There's plenty of archival video: a full show from Spain, highlights from Oslo, an *Austin City Limits* episode taped in Texas. Cohen and band are dressed in black. The gear is black. The set is black. But the mood is bright, even ebullient. The songs are end-of-the-century standards, and the band is doing what it would do for the rest of Cohen's career, using a range of timbres—oud, pedal steel, mallets, backing vocals—to offset the wavery monochrome of his voice.

What's striking about these concerts is that Cohen, at fifty-three, is still coming into himself. He is neither old nor young, not yet an elder in a fedora but not ordinary, either. His songs are older and more reputable than he is. He wrote them; now he must accept them as his own and the singing of them as his lot, a calling he will take on, lest his inner life (and those of the people who recognize theirs in his) go unspoken.

Devotees tout a 1988 "Hallelujah" from Oslo as the best version ever. Two other songs from that moment stand out as affirmations of Cohen's sense of calling: "If It Be Your Will" (from *Various Positions*) and "Tower of Song." They're companion pieces: two songs about the vocation of speaking and naming whose wild disparities of tone and style suggest how hard the task of fitting words to experience can be.

With "Tower of Song," Cohen identifies himself as a songwriter working in a broad tradition. The image of a tower of song comes from Jewish lore (Harry Freedman indicates in a book about the ways religion figures into Cohen's work), and it evokes the towers of medieval fable. But the image also suggests the Brill Building and the songwriting co-ops of Nashville's Music Row.

"I was born like this, I had no choice / I was born with the gift of the golden voice, / and twenty-seven angels from the great beyond, / they tied me to this table right here in the tower of song." So much from that cultural moment is in that verse. The stress that he was born like this calls on the language gay people were using to affirm their sexuality as a given. The suggestion that he has the gift of the golden voice at once mocks his limits and joins him to singers from the David of "Hallelujah" onward. The twenty-seven angels tying him to a table put Wim Wenders's work in mind—and Robert Mapplethorpe's. "The hunger to speak is there but the capacity is seldom there," Cohen said in an interview, and the verse as a whole suggests that the process of naming is an ordeal—and a turn-on, too.

There in four perfect lines Cohen sets out his calling in crypto-religious terms.

In "If It Be Your Will," by contrast, the religiosity is explicit. Musically, this song is akin to Otis Redding's ballads ("I've Been Loving You Too Long"; "My Lover's Prayer"), which move unhurriedly through arpeggiated chords in a sequence as steady as a canon. Lyrically, it is a literal tower of song, the tight lines stacked like storeys:

If it be your will
that I speak no more . . .
I shall abide until

I am spoken for,
if it be your will.

The song has a simplicity found at the far side of striving. The archaic diction of the title makes clear that this is no double-entendre song in which God and a lover stand in for each other. No, here a singer is addressing a personal God, a source or creator. He offers up the gift of song, vowing to go silent if that is what is called for; then, the vow to abandon having brought him to a place of freedom, he offers to praise the divinity through his words; and then he petitions the Lord, so to speak, in the language of praise, evoking rivers that fill and hills that rejoice.

The last verse, and the half verse before it, are religious utterance as direct and sincere as any by any artist in that moment. The half-verse is enough to show it: "Let your mercy spill / On all those burning hearts in hell, / If it be your will / To make us well."

In this way, Cohen's songs of the mid-eighties go deep into the territory of the unspeakable. Adult sex, role-playing, the dread of AIDS, the flagging of virility ("I ache in the places where I used to play"): those are phases and stages in the life of love that most love songs leave out. Likewise the inner life of the artist: the ritual-devotional habits, the bent-knee submission to the process (songs taking shape "a note at a time and a word at a time"), the calling out to ancestors who will not reply, and the artist's sense that the act of making is a means of transcendence, self-expression greater than the self.

Cohen explained what he was trying to do in terms of clarity and mystery. "Clarity is one of the things I like to go for," he said. "I don't think we're ever free from this mysterious mechanism, though. Mystery can go all the way from not knowing what to do with yourself to standing in awe at the vast activity of the cosmos which no man can penetrate. I don't think we're ever free from any of that. On the other hand, you can't go around continually expressing your awe before these celestial mechanics. I think we're surrounded by, infused with, and operate on a mysterious landscape, every one of us. It's something to keep your mouth shut about if it really is a mystery."

In the tower of song, he was striving to make work that would last forever. The songs he wrote in that moment have lasted, gaining in aura over the years. Each is as chiseled as an epitaph, the product of an effort that he explained in theological terms: the act of finding words for the unspeakable, an act that ends in the end of religion, namely, the awed recognition of a mystery beyond words.

12

DREAM OF LIFE

In a long shot, the camera descends over the Empire State Building, the Flatiron Building, the L-shaped neon sign of the Hotel Chelsea, and the rooftops of the West Side, settling on the canvas awning and plate-glass window of a coffee shop. The next shot shows a man seated in a booth, compact, bearded, bright-eyed, in a sport jacket and an open-necked dress shirt, elbows to each side of the striped cup and saucer on the table.

Martin Scorsese is pondering his fate over coffee. Specifically, he's pondering the fate of *The Last Temptation of Christ*. It has turned out to be the most complex picture he's ever made: envisioned across fifteen years, shot for too many days in desert heat, and now being crashed through post-production at top speed as Universal, under pressure from controversy-seeking fundamentalists, struggles to control the story in the press by enabling the film itself to precede and thus to circumvent the outcry over it.

Rev. Donald Wildmon of the American Family Association is driving the controversy. The pressure is now taking several forms: denunciatory ads on Christian radio and in *The Hollywood Reporter*; a direct-mail "action packet" offering ways to oppose the film; an opinion piece in the *Los Angeles Times*; and the banding together of five other fundamentalist leaders as the "offended brethren"—who have turned down an invitation from Universal to come to New York and see the film.

On this day—Tuesday, July 12, 1988—Universal is screening the picture for several dozen other clergymen at Cineplex Odeon's theater on West Twenty-Third Street. They've kept the location secret so as to outfox any protestors, bringing the clergymen there in a plain white van from a midtown hotel. They've had the cinema inspected by men with walkie-talkies crawling down the aisles, looking for explosives under the seats. They've loaded the film into the projectors.

The picture is out of Scorsese's hands, and there's no telling whether that's an ending or a beginning. For the next forty days or so he will be in the wilderness, put to the test, made to stand in the crossfire of the culture wars as a spiritual exercise.

An aide arrives and tells him it's time. He pays the check and they walk the short distance to the theater. Some protestors are on the curb, placards held high.

Inside, standing in front of the blank screen, he tells the audience how the picture came about: his childhood outings to Times Square to see the big-screen biblical epics, his Pasolini epiphany, his long and intense encounter with the Kazantzakis novel. The film is "an act of faith and a labor of love," he says. It's an adaptation not of the Gospels, but of the novel; it's a work of the imagination.

He has dreamed of making a life of Christ since he was a boy on Elizabeth Street. For him the Church and the movies are the original sources of life, and a movie rooted in the Gospels has been a dream of life in its fullness, playing over and over in his mind's eye. Now it exists, not a dream but a motion picture, ready for screening in a cinema on the West Side of Manhattan on a Tuesday afternoon.

It opens simply, the camera descending over trees and dry ground and alighting on a man, bearded and brown-cloaked, asleep in a field.

"The feeling begins"—this is a voice-over—"very tender, very loving. Then the pain starts. Claws slip underneath the skin and tear their way up. Just before they reach my eyes, they dig in . . . and I remember."

The man (it takes no figuring out) is Jesus, and the voice-over is his voice.

He is a carpenter, hewing and hammering and mounting a rough piece of wood on a frame on the wall of a workshop. It's the horizontal beam of a cross, standard equipment for a Roman Empire execution. Shirtless, he spreads his arms the length of its span, as if trying it on for size. His back is scarred and bloody.

"First I fasted—whipped myself. At first it worked. Then the pain came back. And the voices. They call me by name: Jesus."

His voice is surprisingly ordinary: nasal, matter-of-fact, with no toughness, but no holiness, either. It's the voice of a vulnerable man.

This voice is the core of the picture, and it, more than anything else, is the basis for the objections that will arise against the picture in the coming weeks. It's the voice of Jesus's interior life. Fifteen minutes of screen time will elapse before sex enters the picture—Mary Magdalene at a brothel, sweatily submitting to a patron; Jesus going in to see her (she is half-clad, tattooed) and asking her to forgive him for some unspoken sin. But Scorsese has breached a boundary already by entering into Jesus's interiority. He has taken as his starting point the Christian doctrine (known to him since his days as an altar boy) that Christ is fully God *and* fully man, the human and divine natures subsisting together in the person of Jesus. With this picture he's exploring what that means. And that inner voice makes Jesus's humanity unmistakable. In Western civilization, to be human is to have an interior life: to live in the gaps between thought and expression, desire and fulfillment, anticipation and regret, and to be alive to echoes from the past and portents of times to come. This life—the interior life—is the space of the drama of human existence, as outward conflicts spark the conflicts within ourselves. Prompted by the Kazantzakis novel, the films he loves, the arc of his own work, and his crypto-Catholic faith, Scorsese has made the interior life of the Son of God the site of a human drama. He dares to depict Jesus Christ as a controvert, inwardly at odds like the rest of us.

There's a knock on the door. "Who are you," Jesus asks, "and why are you following me?"

Another man barges in, agitated. It's Harvey Keitel—Judas—and all at once this is a Martin Scorsese picture, the rugged sidekick berating the handsome leading man in a New York accent. All this cross-making

for the Romans is a betrayal, he says. "You're a Jew killing Jews! A disgrace, a coward! How will you ever pay for your sins?"

"With my life, Judas. I don't have anything else," Jesus says.

"With your life? What do you mean?"

"I don't know. I don't know," Jesus says.

It's a Martin Scorsese picture, all right—in its mix of violence and fraternal tenderness, of obsession and everydayness, all worked out in those New York voices. But Scorsese's effort to "get to know Jesus better" by making a film about him also coincided with a generation of scholars' efforts to see Jesus with fresh eyes. As the film came together, those developments were just beginning to reach a wide public, and the animus that the fundamentalists turned on *The Last Temptation of Christ* was their response to them as much as to the film itself.

One was an emphasis on the "historical Jesus." *The Atlantic* had run a cover story on the subject two Christmases earlier. "Who is he?" That question—posed by the controversial Swiss Catholic theologian Hans Küng—was *the* question of a generation of scholars who were drawing on recent archaeological finds, using technology to date texts precisely, and applying critical methods known as hermeneutics to the scriptural accounts of Jesus. Their goal was a firmer grasp of the man who had lived and died in Roman Empire Palestine. Their approach was to try to see Jesus "from below"—focusing more on the Jesus of history than on the Christ of faith, which was rooted in many centuries of doctrine and theology. Their work had uncovered an authentic-seeming Jesus—who was distinctly Jewish, who engaged with women as interlocutors and collaborators, who had only an obscure understanding of his role as Messiah. "The Christian message is He Himself," Küng said. "I hate to say it so simply—I've seen in America what television preachers can do with such remarks—but that is . . . the general idea."

A second development involved the recognition that the churches' ways of presenting Jesus were not perennial, but historical. This was the argument of *Jesus Through the Centuries*, on display at the Logos Bookstore that year. The white cover carried an icon of Christ from the

monastery of St. Catherine of Sinai—big-eyed, bearded, halo'd, clutching a jeweled gospel book, right hand gently making a sign of peace. The author was Jaroslav Pelikan, a professor at Yale. The argument was straightforward: Jesus has meant different things to different people at different times and places, and as times have changed, society's sense of who Jesus is has changed as well. To make the point, Pelikan offered a series of portraits of Jesus over time: the all-seeing Christ Pantocrator who presided over Byzantium from the tiled walls of the grand basilicas; the desert-dwelling ascetic who inspired St. Francis of Assisi; the Prince of Peace, the Enlightenment teacher, the liberator of the poor and oppressed masses. His account of St. Augustine's sense of Jesus was especially striking. In late antiquity, the neo-Platonists contended that history unfolded in cycles, which repeated ad infinitum. Augustine insisted otherwise, and his proof was "the life, death, and resurrection of Christ, as an event that was single and unrepeatable." He devised a Latin term for the decisive character of Christ's entry into history: *crucialis*, root of the English *crucial*.

Pelikan's argument had the force of an imperative. If every age had its Jesus, so did the present age—here and now in New York City—and it was crucial to know who the Jesus of our age was and what present-day conflicts came to a head in him.

But his grand survey left something out, as another current book made clear. This was *Adam, Eve, and the Serpent*, a historical investigation of the origins of Christian teachings on sex. The author, Elaine Pagels, who taught at Princeton, argued that the Christian view of sex was tragically time-bound. The apostle Paul and the other early Christians exalted celibacy as the highest form of holiness—but that was because they thought Christians should be free of any worldly attachments, believing the end of the world was nigh. As the expectation of an imminent end of the world receded, Christians became more flexible: prizing marriage, and sex within marriage, and seeing the struggle for sexual fidelity in terms of the Genesis narrative of Adam and Eve—as a consequence of human freedom. Then Augustine stepped in. He was haunted by the dozen years he'd spent in a sexually lively relationship

with a woman, acting on passions he turned against when he became a Christian and then a bishop. As Pagels told it, Augustine blended his loathing of (his own) unbridled sexual passion and sense of fallenness into the idea of original sin, and Christians had linked sex with sin ever since.

The book and clipped *Times* review also wound up on display at the Logos Bookstore. The very clarity of Pagels's argument aroused suspicion: Could fifteen hundred years of Church teaching be explained away so simply? But her development was persuasive and full of implications. The Church's teachings about sexuality are historically contingent, which means they are open to interpretation—demand interpretation. The life of belief is rooted in the interpretive act, which is at once an expression of our freedom and a consequence of our fallen state. And the believer's interpretation of the competing claims of celibacy and marriage, of sex as sinful and sex as fulfilling, runs through Christian history all the way back to the life of Jesus.

So Christianity belongs to history, and must be interpreted that way: The point seems obvious in retrospect. But just then, when the televangelists were noisily insisting that Christ's teachings are plain and simple and not in need of interpretation, and when the pope and the Vatican were putting out abstruse declarations saying essentially the same thing, those books were counterblasts of intelligence and daring. And they offered a kind of skeleton key to the controversy that was emerging around *The Last Temptation of Christ*. They made Martin Scorsese's effort to depict Christ as both divine and human seem not just licit but crucial, a crypto-religious leap of faith.

Daniel Berrigan was one of the clergymen in the audience for the *Last Temptation* screening in Chelsea. A Baptist minister (interviewed by a *Times* reporter) thought the movie "kind of hokey" and "on pretty shaky ground theologically," but powerful anyhow; the Episcopal bishop Paul Moore judged it a "theologically sound" working-out of the doctrine of the dual nature of Christ affirmed in A.D. 451. Berrigan

found it "a long, demanding film." He held off saying more, and his reticence is a reminder that there was no consensus about the film as yet and no embrace of it as a cause célèbre.

That made sense. Only a few people had seen the film; even Scorsese's associates knew it more by hearsay than through advance screenings. And it really was a demanding film. Not demanding in the way of the avant-garde: abstruse, convention-resistant, hard to crack. Demanding, rather, in the way of the "personal" filmmaking that Scorsese had made his own aesthetic standard. Just as *The Gospel According to Saint Matthew* was a product of Pasolini's cinematic vision, so *The Last Temptation of Christ* was a transmigration of Scorsese's own themes from the mean streets of Manhattan to those of Judea. This was made clear through the presence of Harvey Keitel as Judas (extending the brother-as-betrayer theme from Scorsese's New York films) and through those New York accents. A scene that comes just after the brothel scene had Judas dragging Jesus out of the shed where he's living and telling Jesus he's supposed to kill him—to which Jesus, after musing about destiny for a bit, suggests half-skeptically, half-sarcastically that this whole meant-to, destiny business is not as clear as it might seem.

And the picture was demanding because Scorsese approached Jesus "from below" in ways akin to the scholars of the historical Jesus. He used no special effects that would invite the viewer to recognize Jesus's divine nature, no clichés of the Son of God as a miracle-worker. His Jesus is a strange man—now pious, now seized by scruple, now derisive (along the lines of "Whaddaya want from me?"). For Catholics, especially, the idea of Jesus as an outward-facing force of holy authority is so deeply held that the anxious and testy Jesus of the film's first hour is disconcerting—as it was meant to be.

The fundamentalists found this Jesus off-putting for very different reasons. Although they hadn't seen the film, they'd seen a leaked early script. It didn't matter that the script had gone through many revisions since then. There was Jesus having sex with Mary Magdalene! For them, the film was obviously blasphemous—a deliberate affront to Christianity on the part of the movie industry and the people who ran it.

Their efforts against the film had converged in June. The American Family Assocation sent Xerox copies of the script to 250 like-minded ministers. The "offended brethren" held a press conference at the Registry Hotel in Los Angeles, denouncing the film. And Christians carrying Bibles and placards marched down Lankershim Boulevard to Universal Studios. The march evoked scenes from the biblical epics of old, and that was the point. If Hollywood was going to drag Jesus through the streets of Jerusalem, then the fundamentalists were going to drag Martin Scorsese through the streets of Hollywood.

The same week, they applied a fresh tactic. They offered to buy the film from Universal and then bury it. Their proposal, written by Bill Bright of the Campus Crusade for Christ and hand-delivered to the studio chief, cited John Paul II's remarks to movie executives at the Registry Hotel the year before about the rights of "consciences and human dignity." To protect those rights, the offended brethren would destroy every print of the film, so that it would never be seen by the public. The body of Christ would be kept clean.

On July 20, a cadre of fundamentalists protested outside the Beverly Hills home of Lew Wasserman, president of MCA, parent company of Universal. Some of them chanted, "Paid for with Jewish money!" The same day, Universal turned down the offended brethren's offer via a sternly worded letter stressing its commitment to free expression. The studio made its letter public via a full-page ad in the next morning's *Los Angeles Times*. In the days that followed, the media moved on the story en masse: assigning reporters, running think pieces, granting "equal time" to Rev. Wildmon and his associates. The Catholic archbishop of Los Angeles reached out to Lew Wasserman *sub secreto*, encouraging him to withdraw the film—and implying that the request came at the urging of the pope. *The Last Temptation of Christ* was front-page news; crypto-religious art was a matter of international controversy.

All this time, Andres Serrano's *Piss Christ* was on view in Los Angeles. Serrano's National Endowment for the Arts application had gone through and the committee had approved him for funding. The award

was fifteen thousand dollars and inclusion in a touring show of work by recent grant recipients. The show, organized by the Southeastern Center for Contemporary Art, in Winston-Salem, North Carolina, had opened at the Los Angeles County Museum of Art in May. For two months *Piss Christ* hung on a wall in the LACMA complex on Wilshire Boulevard, uncontroversially. Now it was taken down and packed for shipping to the next venues: Carnegie Mellon University in Pittsburgh, and then the Museum of Fine Arts in Richmond, Virginia.

The Whitney Museum of American Art's exhibit of Robert Mapplethorpe's photographs opened the last week in July. It brought together "fifteen years' worth of nudes, portraits, and still-lifes," in the tagline of *The New Yorker*'s Goings on About Town. An invitation-only opening reception—Wednesday, July 27, 1988—was the social event of the summer for the Manhattan art world (as Madonna's star turn in David Mamet's *Speed-the-Plow*, at the Royale, was for the Manhattan theater world). Sixteen hundred people showed up, plus squadrons of paparazzi.

Mapplethorpe had been discharged from St. Vincent's the week before, having spent ten days there with a bacterial infection associated with late-stage AIDS. Some people he knew thought he was too weak to take part in the opening. But he put on a monkey suit and went to meet his public. He had always dreamed of being a famous artist. Now he was one. "He was in a wheelchair, holding a gold-tipped cane like a scepter," Bob Colacello recalled. "He was wearing a tuxedo with a broken-collar formal shirt; his hair was slicked back, his temples and cheeks sunken, a living *memento mori*." From the wheelchair, and then from a tweed couch, he received people in audience, smiling wanly and gesturing with thinned hands as they bent low to hear him speak. He stayed to the very end; he left under his own power, leaning on a cane.

The show was reviewed widely and appreciatively. Arthur C. Danto, in *The Nation*, described the male nude, in Mapplethorpe's handling, as a reminder of death, and of the deaths of so many gay men from AIDS. "A Mapplethorpe show is always timely because of his rare gifts as an artist," he wrote. "But circumstances have made such a show timely in another

dimension of moral reality, and I am grateful the organizers did not stint on the gamy images of the 1970s, for they raise some of the hardest of questions, and comprise Mapplethorpe's most singular achievement": How does our sense of formal beauty interact with our feelings of apprehension and revulsion? What did it mean that photographs made as celebratory and defiant now registered as grimly premonitory?

The "gamy" nudes (the one with the cock ring, the one with the cutting board, the one with the bullwhip) made it "a pretty rough show" by museumgoing standards, Danto observed. "I was impressed by my fellow visitors. They were subdued and almost, I felt, stunned. There were no giggles, scarcely any whispers. It was as though everyone felt the moral weight of the issues. And one felt an almost palpable resistance to face the thoughts the show generated, which each visitor had to overcome."

Mapplethorpe was now canonical, his name known to people who would never go to an exhibit of his photographs. Prices for prints of his work had doubled. But he was dying, even as he insisted otherwise. And the run of publicity heightened his concern that some reviewer or journalist would state matter-of-factly that he was gay.

His sister Nancy had visited him at the loft in Chelsea in early July. To her blunt question—"Are you a homosexual?"—he had answered, "Yes." Back in Queens, with her sister and another brother, she told their parents, Bob and Joan, that Robert was sick with AIDS, but no more. Then Bob and Joan visited him in the loft. He primped the place beforehand, arranging photographs to suit their interests. He showed them his art, his objects, his furniture. They had tea and talked about the Whitney show. The conversation passed over homosexuality and AIDS.

Mapplethorpe's reluctance to scandalize his strict Catholic parents is a reminder that the view of homosexuality as an abomination and of AIDS as a reap-what-you-sow consequence was still prevalent in New York City; a generalized distaste for gay people was common among figures otherwise leery of fire-and-brimstone religion.

In this, Robert Hughes, the art critic for *Time*, was a voice of

consensus opinion. On the surface, Hughes was an erudite New Yorker. He filed thirty reviews a year for the magazine while traveling the world for book projects and public-television series about the arts. He kept a loft in SoHo and a house-and-studio in Shelter Island (he was an amateur painter). And yet in some ways he was still an embittered Catholic boy from Australia. Jesuit-educated, he had been awakened to art by a priest who gave him Jacques Maritain's *Creative Intuition in Art and Poetry* and took him to a museum show. A Miró was on display. "That can't be art . . . that isn't art," the teenage Hughes declared. "All right, Robert," said the priest, "if that isn't art, then why don't you tell me what art is." Before long Hughes pivoted to art and away from religion, put off by the Church's condemnation of "Vice" in general and masturbation specifically. As he moved to London and then to New York, he consecrated himself to the Western canon from antiquity to Abstract Expressionism. Adam Gopnik, in an appreciation, explained that Hughes saw "the monuments of Western civilization not as exhausted décor but as the well at the world's end, the great good thing at the close of a pilgrimage . . ."

In his PBS series *The Shock of the New*, Hughes called attention to art's transcendent qualities: "The work of art is layered and webbed with references to the inner and outer worlds that are not merely iconic. It can acquire (though it does not automatically have) a spiritual aspect, which rises from its power to evoke contemplation." A self-styled craftsman, he disliked conceptual art and art-as-commentary. He dismissed Andy Warhol as neither a fine artist nor a popular artist in the traditional sense—"a normal (and hence exemplary) person from whom extraordinary things emerge. Warhol's public character for the past twenty years has been the opposite: an abnormal figure (silent, homosexual, withdrawn, eminently visible but opaque, and a bit malevolent) who praises banality." And he disdained Robert Mapplethorpe, who had thrived without his blessing: "If that overrated photographer, instead of sticking a bullwhip up his ass and pretending to be the devil in front of his own Hasselblad, had done it on network television, the fuss would have been even greater. But if the image had been painted, who would have much cared?" This evangelist of "the shock of the new" in the history of art

was repulsed by the shock of the new in his own historical moment—
and he condemned it with the gusto of a priest deploring Vice.

Andrew Sullivan, a generation younger, was taking a distinctly
different approach in *The New Republic*. Like Hughes, he was an expa-
triate who wrote about Western Civ with a Catholic accent. But he had
come to America fully confident. Oxford-educated, a past president of
the Oxford Union, moving among the commentariat in Washington
and pursuing a doctorate in government at Harvard at the same time,
he was serene and dextrous in argument, without the class anxieties
common to the Irish Catholic tribe. An admirer of Margaret Thatcher
since his teens, he was the young conservative at *TNR*. He was a Cath-
olic who wrote about praying and going to Mass. And he was gay: he
thrived on the tensions among his sexuality, his conservatism, and his
Catholicism and tilted against the progressive gay subculture. He was a
down-to-the-roots controvert, and to read his writing was to grasp that
his views on civil society were the public expression of a long-running
inward controversy.

His piece in *TNR* that July was a long essay about a book just out
in English: *The Ratzinger Report*. Six years after taking up the leader-
ship of the Congregation for the Doctrine of the Faith, Cardinal Joseph
Ratzinger had become "the first prefect to give an extended, published
interview to the international press"—the Italian journalist Vito Mes-
sori. Sullivan depicted Ratzinger as a conservative not unlike himself—
but one whose cautious temperament had been loosened by his access
to power. In his own work Ratzinger had asserted personal experience
against systematics and had recognized individual Catholics' conscience
as sources of renewal. This ought to have made him a voice of subtlety
in Rome—but no. "The thinker who wrote above all about . . . the
core truths of Christianity, has begun to show signs of a creeping ob-
session with sex, and concern with the passing phenomena of a secular
agenda," Sullivan observed. Ratzinger was exercising the CDF's au-
thority to a degree that left other theologians no room to speculate. And
he was asserting the "objectively disordered" character of homosexual-
ity so strongly as to do away with the Church's distinction between the
homosexual person and the decisions about sex that such a person was

forced to make. For Sullivan, the "Halloween Statement" was so harsh that it seemed "a political rather than a theological exercise." And it left out something crucial, which he pointed up by reprising the Grand Inquisitor episode from Dostoevsky's *The Brothers Karamazov*—where Jesus, scolded by the aged Inquisitor, steps forward abruptly and kisses the other man on the lips. "That kiss," Sullivan concluded, "is a simple reminder that Christian truth may be painful, but without love it is also unbearable."

The "creeping obsession with sex" at the Vatican passed over one sexual issue: namely, the sexual abuse of minors and young adults by Catholic clergy. In retrospect, the contrast between the hierarchs' indifference to this problem and the intensity they brought to "culture war" issues involving sex suggests that the two responses are related—that their fierce attention to the one was a means of postponing scrutiny on the other.

Theodore McCarrick's doings in that moment make the point obvious. A priest from New York City and then the bishop of Metuchen (a smallish diocese in New Jersey), he was appointed archbishop of Newark by John Paul in 1986 and then was made a cardinal, and he swiftly sought to establish himself as a power broker akin to Cardinal O'Connor, who led the neighboring archdiocese of New York. The two men led a new Papal Foundation, soliciting donations from wealthy American Catholics. Meanwhile, McCarrick, who has since been accused of sexually coercing teenage boys and young men since the 1970s (accusations he has denied), used his new position for his own purposes. In Metuchen he had forced priests-in-training to spend weekends with him at a beach house in Sea Girt, on the Jersey shore; now he arranged for the house to be sold by the Metuchen diocese to the Newark archdiocese so he could keep up the practice. He hosted a summer cookout where young men he knew, as well as their parents, would come to New Jersey to catch up with the man they called (at his insistence) Uncle Ted. And he maintained influence over a young man he'd coerced since his teens by bringing him on trips where they met VIPs, introducing him as his "special boy." In 1988, the man, James Grein, decided

to do something about it. On a trip to Rome with McCarrick, he was brought to an audience with John Paul and other Vatican officials. Mc-Carrick introduced Grein to the pope as his "special nephew" and then stepped away—whereupon Grein, seeing an opening, told John Paul, "McCarrick has been abusing me since I was young." The pope did not respond directly. "He blessed me. He put his hands on my head. He dismissed me." And he told Grein that his sins were forgiven.

S&M in the museum, gay marriage on the newsstand, claims of clerical sexual abuse during a papal audience: In the circumstances, the dream of sexual and marital union Nikos Kazantzakis had come up with in *The Last Temptation of Christ* in 1955 was downright traditional by comparison. In the circumstances, you could have thought that traditionalist Christian leaders would actually welcome Martin Scorsese's film version for representing the marriage of a man and a woman and their settling down into child-raising as the ideal of ideals—a dream of life yearned for by the Son of God himself.

You would have been wrong. The Catholic hierarchy's discussion of sex often began and ended with the "spilling of the seed" in masturbation; to that, and to every other expression of sexual desire outside of intercourse between a man and a woman who had been joined in a sacramentally valid marriage and who had intercourse without contraceptives or birth control, the answer was No. The Protestant fundamentalists' discussion of sex focused on homosexuality as an abomination and a threat to the sanctity of marriage—even as the TV preachers Bakker and Swaggart profaned marriage through their extramarital affairs and sex with prostitutes. Those men championed the literal truth of the Bible, although marriage as they presented it—husband, (house)wife, children, home—could not be found in the New Testament. And while they thrived on public controversy, they avoided discussion of inward controversies the life of faith called forth—the ones Martin Scorsese had made *The Last Temptation of Christ* to dramatize.

"I go to the movies in the hope of nourishing both my eyes and my mind, only to walk out into the street afterward with a bad taste in my mouth, a feeling of shame, or simple rage. Such superb technique, such expertise at taking beautiful photographs, and such trash?" This was Czesław Miłosz, in the journal-of-a-year he was keeping—which would culminate in his account of an "imaginary movie" he'd yearned to make as a crypto-religious response to life during wartime.

The period he was calling "A Year of the Hunter" (beginning the previous August) had been one of turmoil in his native realm. The Soviet premier, Mikhail Gorbachev, initially cautious after his election in 1985, now had signaled a willingness to change. The Soviets had begun to withdraw troops from Afghanistan, acknowledging it as a lost war. In Poland, riot police surrounded the Gdansk shipyard after Solidarity went on strike. The union's leader, Lech Wałęsa, framed the situation starkly: unless the government recognized the need for fundamental change, there would be "a revolution, and a bloody one." The union wound down the srike, but the government did not commit to change. So the union planned fresh strikes at coal mines and steel plants.

Miłosz passed over all this in the journal, instead stressing the self-sufficiency of art and the freedom of the poet. A reading from the *Collected Poems* at Black Oak Books in Berkeley drew four hundred people, thrilling him. Travels to college towns left him confident that the poet in America was valued for his poetry more than for his politics. And yet there was Al Alvarez in *The New York Review of Books*, characterizing him (in an essay about the *Collected Poems*) as a "witness" to a lost world, an exiled survivor of "a country that has vanished utterly into the Soviet maw." He sent the *NYRB* a stern letter. "Am I really so exotic an animal that I deserve to be exposed in a separate cage labeled 'Far Away'?" he asked. As he saw it, the *Collected Poems* was evidence of his effort to resist the tyranny of recent history, not to bear witness to it: ". . . we, i.e., natives of hazy Eastern regions, perceive History as a curse and prefer to restore to literature its autonomy, dignity, and independence from social pressures."

Miłosz is so adept a controversialist that it is hard not to take his

side. And yet the journal-of-a-year suggests that he *was* preoccupied with history, just in other ways.

One involved the fate of religion. "It appears that we are probably witnesses and participants in an era of revolutionary change, which is the equivalent of the transition from paganism to Christianity under the Roman Empire," he declared. The present transition was *away* from religion. Science was secular; so was academia, Berkeley style. "My students display ignorance of even the simplest concepts deriving from biblical tradition, and indifference or even enmity toward religion," he observed. ". . . And yet the Christian churches, right next door to these temples of reason, are filled on Sunday, and no one knows to what laws this coexistence is subject."

This "coexistence" was a defining quality of the way of life that scholars would come to call postsecular. For Miłosz, it was not a matter of statistics, but a change in believers' way of thinking. And it was akin to the "coexistence" of devotion and skepticism that was the source of his own internal controversy. In an entry on the Polish Catholic philosopher Karol Ludwick Koniński, he recognized himself in Koniński's description of the "metaphysical not-quite-believer." The modern era had suffered "the erosion of the cosmic-religious imagination" and yet was animated by "the persistent strong presence of Old and New Testament images," which had power precisely because everyday religious structures had fallen away.

Miłosz's other preoccupation involved his personal history. As he traveled to Paris and Lisbon, he filled the journal with recollections of the war years, culminating in one involving the movies. "I am a contemporary of the cinema," he wrote, loftily. Its coming of age, like that of the novel, involved an effort to deepen beyond its commercial origins—a failed effort, on cinema's part. "A viewer such as I has the constant feeling of the almost limitless possibilities of film that have not as yet been realized," he explained, adding that he liked to create "imaginary films" in his mind. "There is one film in particular that I watch on my private screen," he confessed. And then he devoted several pages to setting out this film-of-his-imagination, which drew together history,

personal experience, New Testament imagery, and the transformative power of art.

It went like this: Over Christmas 1942, with Poland under Nazi control, Miłosz and his wife, Janka, and their friend Jerzy Andrzejewski had taken tram and train from Warsaw to a convent outside the city. The prioress there had established a home for women who had fallen into prostitution, consorting with German soldiers to support and protect their families. The prioress was herself a fallen woman of a kind. She was the former Stanislawa Umińska, a renowned actress in Paris in the twenties. After her fiancé was diagnosed with cancer, she acceded to his last request and shot him dead. She was tried for murder (a trial covered sensationally in the newspapers) and was acquitted. She then returned to Poland and took the veil, but she retained her habit of art. When the Jewish playwright Leon Schiller, sent to Auschwitz by the Nazis, was "ransomed out" by friends, she invited him to hide out in the convent, and he accepted. The Miłoszes and Andrzejewski, friends of Schiller's, went to the convent that Christmas to see a work of his staged as part of the underground theater that had emerged during the occupation.

"'She makes the entrance of a great actress,' said Jerzy when the prioress entered the hall with her nuns to occupy the first rows of benches," Miłosz recalls in the journal. The play was called *Pastoralka*—"a folk spectacle, a Manger scene, a Nativity play, performed by poor girls from the Warsaw streets who had never been in a theater." Joseph was dressed in "a sort of brown burnoose." And Mary: "The Mother of God was dressed in blue, of course: small, almost childlike, blond." When she spoke, and sang—in "a tiny, mouse-like voice"—Miłosz felt that he "was partaking of a mystery" that revealed theater's essence, namely, this person's ability to transform herself into another person. "The purity and holiness of the Mother of God were undoubtedly her own, this girl actress's," he mused, "although at the same time she was someone else and that someone else had recently sold herself to German soldiers for a couple of zlotys."

That Nativity play had left Miłosz with a vision of drama rooted in the controverted self: "a celebration of human multifacetedness and

plasticity which makes it possible for every man and every woman to bear within himself or herself an entire range of experiences and aptitudes, from the highest virtue to common evil, while being vaguely aware of this and therefore capable of resonating with the actors on the stage."

His journal-of-a-year ended there. On the last day of July he appended a cryptic remark by Maurice Maeterlinck, the Belgian Nobel laureate: "Lord, I did what I could. Is it my fault Thou didst not speak more clearly? I tried my best to understand."

Martin Scorsese spent the last part of July in the editing studio in the Brill Building, on Broadway. Universal had asked him to reduce the postproduction schedule from two months to *two weeks*. The goal was at once to preempt the film's antagonists and to make the film available when public interest was surging. Universal rented the Ziegfeld Theatre, on West Fifty-Fourth Street, the site of many a New York premiere. They settled on a release date of Friday, August 12. "I don't think any of us had ever experienced such a push to finish a film," Scorsese recalled. "None of us had. I remember being up almost day and night . . .": correcting color, syncing sound, trimming scenes—making changes, vital to his art, that would be indiscernible to his adversaries.

A few floors down, Peter Gabriel was finishing the score. Scorsese's own sense of what the film might sound like had been prompted by a Moroccan rock group called Nass El Ghiwane, featured in the 1981 documentary *Trances*. He liked Gabriel's post-Genesis solo records of the eighties and figured Gabriel's approach would fit the movie's theme: "For me, the rhythms he uses reflect the primitive, and his vocals reflect the sublime—it's as if the spirit and the flesh are together right there." And Gabriel had also dealt masterfully in the crypto-religious. He ended his live shows with "Biko," a droning tribute—part dirge, part hymn—to the slain South African freedom fighter (who had been an Anglican of a kind). With it he converted the audience ritual of calling for an encore through upraised cigarette lighters into a chorus of flame that expressed a liturgical collective feeling—a protest of fire against South Africa's apartheid regime.

For *The Last Temptation of Christ* Gabriel created a soundscape com-
bining intricate drumming, the massed electro-harmonies of the Fairlight
synthesizer, archive recordings, and the singing and playing of musicians
he had come to know through his World of Music, Arts and Dance
(WOMAD) festival: the Senegalese singer Youssou N'Dour, the Pakistani
qawwali singer Nusrat Fatah Ali Khan, the Indian violinist L. Shankar.
The score would be a sonic reminder that the life of Jesus—the basis for
the sexual ethic of "the West"—did not belong to Euro-American civili-
zation but arose in the desert societies of the ancient Near East.

Mid-picture, the soundtrack immerses the viewer in the action as
Jesus ventures into public life. After a scene in which Jesus and Ju-
das fall asleep side by side (underscored by Shankar's violin), Jesus wakes
abruptly in the middle of the night. He takes a bite from an apple and
then breaks it apart. The camera lingers on the fruit. It is an image of
Jesus's controverted inner life: it suggests a brain, and the spirit, but
suggests flesh, too—and when Jesus scatters its seeds, the act seems
confused and agitated.

There's a quick cut to daylight: the sound of drumbeats, the sight of
Black and brown faces, bodies gyrating. It looks like a bacchanalia, but
no: it's a baptism, men and women alike stripped and wading in a river
where a haggard man preaches. Jesus recognizes John the Baptist—from
a dream?—and gives him a command: "Baptize me."

Another quick cut takes us to nighttime at a campfire, musicians
clanging cymbals and playing a three-stringed lute called a gimbri.
Jesus, baptized but still conflicted, is pondering his next move. What
should he do? How should he know? John the Baptist tells him that if
he wants to speak to God he should go out into the desert—but should
be careful: "God is not alone out there." What follows is the archetypal
temptation scene: Jesus in darkness, seated before a mountain, confined
to a circle he has drawn in the sand, tempted in turn by a snake (sex),
a lion (worldly power), and fire (dominion over creation). Gabriel's icy
minor-key synths make the scene figurative—the temptation in the
desert as set on the dark side of the moon.

The Jesus of the next few scenes is out of sorts—quarreling with the
sisters Martha and Mary (who tells him God is to be found in the mak-

ing of children), calling his disciples to join him in a holy war, pushing away the demoniacs who rise naked from the mud to encounter him. But something is changing. When he uses mud and spit to restore the sight of a blind man, he, too, it seems, sees more clearly; as he changes water into wine at a wedding he is being changed, too. The wedding scene is plush with desert music, script and score working together to change our sense of Jesus. The music plunges us into the society where he lived and preached. The once-incongruous New York accents are now the voice of the everyday and the ordinary—the life out of which Jesus is being led, gradually and against his will. "The world of God is here now," he tells the disciples; but the life he is now leading is thoroughly out of the ordinary. We see him the way the world sees him, as a man knocked off-kilter by his sense of mission.

A close encounter at a tomb makes the change emphatic. The stone is rolled away. Jesus covers his nose, recoiling from the stench—a human response. A withered hand thrusts through the opening. Here—midway through the film—the Jesus who is Lord comes into view. As he calls forth the dead man Lazarus from the tomb, he is confirmed in his calling, and we are converted to sympathy with him.

But not without a challenge: "You're the son of Mary, right—who are you to tell us about God?" The question comes from a robed and bearded villager. Through him, Scorsese has incorporated the voice of his accusers—a turn-the-other-cheek thing to do, all the more so in that few viewers were likely to notice, his accusers least of all.

The roiling, fractious dream of life unfolding frame by frame in the editing studio above Broadway roughly corresponded to the life of the city below. New York was on edge. Nine months after the stock market crash, the depression had lifted on a populace charged up and touchy, under pressure from chaos on the one hand and law and order on the other. A stretch of 95-degree weather compounded the sense of the city as collectively stir-crazy, suspended between one moment and the next.

The mood was present in concentrated form in Tompkins Square. The clusters of homeless people camping there had grown to a tent

city—a place of mercy and menace, addiction and need. At nightfall the miked-up imprecations of the Lower East Side radicals mixed with the rhythms of the drumming circle and the flickerings of garbage fires, a homebrew stirred through the night. That the square was flanked by Ukrainian churches and restaurants (a Polish church was nearby) made it seem an outpost of the protests beginning in the Soviet bloc—a scrambling of the signals of social control.

On the last Saturday of July a rally organized to protest a newly instituted one a.m. curfew in the square turned into a bazaar of righteous grievances: against gentrification, funding for the Pentagon, restrictions on speech and assembly. Ousted from the square by police as the curfew was enacted, activists vowed to return en masse the next Saturday night.

That week was one of dueling tabloid-style stories: unrest in Hollywood over *The Last Temptation of Christ*, and unrest in Manhattan over Tompkins Square—where Martin Scorsese had gone as a boy to check out books from the public library there.

He delivered the final cut of the film to Universal on August 3. The next day the studio announced that the premiere would be Friday the twelfth. Caught by surprise, the fundamentalist leaders lashed out. "This is Hollywood's darkest hour," Rev. Jerry Falwell said in a chaotic briefing at the National Press Club in Washington. "If we don't speak out, anything goes . . . They'll do Mother Teresa next and then the Pope." He threatened pickets and boycotts. Rev. Wildmon of the American Family Association had vowed to bankrupt Universal's parent company, MCA, and to bring down the Democratic Party—all in response to "Christian bashing in Hollywood." The hyperbole worked: the owners of cinema chains in the South and in California declared that they wouldn't show the film on their screens, lest they court controversy. After the archbishop of Boston, Cardinal Bernard Law, spoke in support of boycotting the film, the large General Cinemas chain based there joined the refusal. Cardinal Law, who hadn't seen the film, called it "morally offensive and repugnant to Christian belief."

Early Saturday, August 6, protestors massed outside a Jewish temple on Wilshire Boulevard—a place they'd been told was where MCA's chief, Lew Wasserman, worshipped on Saturday mornings. A Rev. R. L.

Hymers set up a projector and a screen. An image on the screen showed a caricature of Wasserman nailing Jesus to the cross. Thomas Lindlof, in his book on the controversy, relates what happened next: "Hymers took a can of red spray paint and drew a large 'X' across the screen . . . with a box cutter. It was both a warning and . . . a 'show and tell' of how to vandalize theaters. 'If [MCA executives] are going to leave the sex scene during the dream sequence in,' Hymers said to print and television reporters, 'they can probably expect violence.'"

That night in Manhattan, the East Village, always thronged on weekends, had a carnival air: six kinds of music blasting, young people juiced up with beer or coffee and dressed in their bohemian best, sawhorses roped together and ready for use at the corner of Tompkins Square. As night fell, several dozen police officers stood in formation at the corner of Seventh and A, wearing helmets and holding plexiglass shields—a "praetorian guard" out of the Bible, or *Star Wars*. Protestors whooped it up, decrying the landlords and the gentrifiers, while the police looked on, at once stoic and bored.

After midnight a riot broke out, lasting till dawn. The images were on TV on Sunday and in the tabloids in the days following: crowds jeering, bottles thrown, the police advancing as one, officers cracking heads with nightsticks, protestors in flight. The word *riot* was used over and over like an incantation. *There was a riot in Tompkins Square last night . . . At the scene of last night's riot . . . Many are asking: What caused the riot? . . .* The question was: Who had started it—the protestors, or the police?

On Monday, Universal announced that *The Last Temptation of Christ* would open that Friday in nine cities: New York, Washington, Chicago, Minneapolis, Seattle, San Francisco, Los Angeles, Montreal, and Toronto. The film had been given an R rating, and the next day the United States Catholic Conference, which had appraised films for decades, succeeding the old Legion of Decency, issued its rating. *The Last Temptation of Christ* was "O": morally objectionable. A spokesman called it "a terrible movie, excruciating to sit through." The USCC's expert offered a thumbs-down: "Scorsese has given us an angry Christ, a bumbling Christ, a Christ more of this world than the next."

Scorsese went to ABC News near Lincoln Center that evening to

appear on *Nightline*. The producers, in a surprise, had arranged to pair him and Rev. Wildmon, leader of the protest, on camera from Memphis, with wire-rim glasses and a thick southern accent. Scorsese was in a dark suit, a white shirt, and a dark tie, tightly knotted, his Vandyke beard flecked with gray. Ted Koppel was the moderator.

"I sincerely understand their taking offense to it," Scorsese told Koppel, and went on: "My feeling is that I think there are people out there who want to see it, and want to have this spiritual experience, I believe a moving experience. And by having it, by seeing this film and having that experience, they'll get to know God or Jesus better, get to know his ideas better—and maybe even begin to live them." Koppel followed with questions, moving in on Scorsese by degrees. Was he surprised by the reaction to the picture he'd made? Not by the reaction per se, the director said, but by the antisemitism of it. The New York accents: What was going on there? They were the equivalent of demotic Greek—used so as to make the viewer hear the Sermon on the Mount as if for the first time. How about the sex scene in the dream sequence— was it really necessary to show that? Yes, it really was necessary, so that the viewer would see all the stages of temptation Jesus faced. Likewise the depiction of Jesus as racked by inner division: "It's not an image of a weak person, certainly not a deranged man, but one who is struggling, just the way we struggle." The film's subject was Jesus, fully human and fully divine; the approach was to depict Jesus from his human side—"the human side becoming fully aware of his divinity. This way we really begin to appreciate more the sacrifice at the end."

Scorsese's composure was remarkable, given that ABC had unexpectedly set him up against his main accuser. In retrospect, his composure makes sense. About the Church and his relation to it, he was divided ("I'm a Catholic—*raised* Catholic," he said). About the film itself, he was assured. And yet he despaired for its prospects in public. "Shelve it," he told Universal executives after the *Nightline* taping. "Just shelve it."

It was the rejection by the Catholic bishops—men who hadn't seen the film themselves, just taken things on trust from their subordinates— that pushed things over the line. An interview in *Newsday* carried Scorsese's response. "As a Catholic, I am, obviously, even more saddened by

their reaction than I am by the response of the fundamentalists," he said. ". . . I am disturbed by it, upset by it, saddened by it. But I understand their political motives. They had to do it," he said.

The Catholic bishops didn't have to do it. They could have watched the film before dismissing it. They could have gone with their people to the theaters and watched it with them, the way Father Principe had done with the altar boys of Little Italy in the fifties. They could have taken the controversy as an occasion to affirm the doctrine of the two natures of Christ and urged Catholics to watch the film with that in mind. They could have recognized Scorsese as a Catholic of a kind, one whose search was aligned both with current Catholic biblical scholarship and with the struggles of ordinary Catholics in the pews on Sundays. But they didn't— and that they didn't was no surprise. The film had been made so as to present the climax of the Gospels—the crucifixion—as a free act of self-surrender, the culmination of a mighty inward controversy on Jesus's part; but the Church's response to it was so fixed as to seem foreordained.

"Last night, more than 600 protestors, angrily chanting slogans, marched from St. Brigid's Church at Seventh Street and Avenue B to the 9th Precinct at Fifth Street between First and Second avenues," the *Times* reported in a story on Thursday's front page. St. Brigid's, on the east side of the square, had opened its doors to the protestors, joining their struggle against gentrification to the struggle of rich versus poor that Catholic radicals had made their own at the two Catholic Worker houses of hospitality nearby.

The *Times* story focused on the role of law enforcement in the riot. Police had clubbed protestors without provocation. Some officers had removed or covered their badges to evade scrutiny. At the peak of unrest, the NYPD commander in charge had left the area to use the bathroom at a precinct house on East Twentieth Street—ten blocks and a world away from the square—and his absence enabled officers to use force unsupervised.

Later the same day, protestors arriving in Hollywood by bus from local churches assembled near Universal Studios (7,500 people, by the *Times'* estimate). They chanted the letters J-E-S-U-S as an assemblage of helium balloons formed the name overhead. Some carried crosses. Traffic was jammed, as the protestors intended. The object of their protest had shifted from *The Last Temptation of Christ* to the Hollywood establishment. In a letter to MCA's chief executive, Sidney Sheinberg, Rev. Wildmon had asked: "How many Christians are in the top positions of MCA/Universal? How many Christians sit on the board of directors of MCA?"—striking the insinuatory note about "Jewish control" that antisemites had struck for decades.

On *Nightline* Scorsese had said that he was surprised by the antisemitism running through the protests; but Christian antisemitism had a basis in the Gospels, and to read the Bible "literally," as fundamentalists did, was to accept and even embrace the Gospels' assertion that Pilate put Jesus to death at the behest of "the Jews."

The Cleansing of the Temple is another episode that has underwritten antisemitism. It appears in all four Gospels, and it's striking as a moment when Jesus uses physical force—violence—against the Jewish religious order. He arrives in Jerusalem on the back of an ass, passing crowds of people who wave palm branches, in a mock hero's welcome. He goes to the temple and is affronted by what he sees. He turns over the money changers' tables, brandishing a whip; he declares that his father's house is supposed to be a house of prayer for all peoples but they've turned it into a den of thieves.

Over the centuries the passage has been taken to mean that Jews more concerned with money than piety have despoiled a sacred place. Circa 1988, that stereotype was living and active. *The Wall Street Journal* had won a Pulitzer Prize for reports about the insider trading that prompted the stock market crash the previous fall, and a subsequent book, *Den of Thieves*, took a passage from Matthew's Gospel as its epigraph: Wall Street was a temple and the masters of insider trading—notably Ivan Boesky and Michael Milken, both Jewish—were the thieves.

The fundamentalists' protests against *The Last Temptation of Christ* were a latter-day expression of the episode. Hollywood was no temple,

as the fundamentalists reckoned it, but the local cinema was—and now (so it was said) Jews mindful of money were despoiling it. So these biblically strict Christians would cleanse the temple through protests and boycotts—and perhaps, as Jerry Falwell had threatened, through violence.

From early on, Scorsese had been determined to give emphasis to the Jewishness of Jesus. He'd read *Jesus the Jew*, by Geza Vermes, a Jewish scholar who interpreted Jesus as a Galilean *hasid*, or holy man. But even in a film attentive to Jesus's Jewishness by a director keenly aware of antisemitism, the temple-cleansing episode remains disturbing. Scorsese's rendering of it shows his fidelity to the Jesus of history; and it would enable the fundamentalists to turn it against him, claiming their own campaign against the film as an act of cleansing.

We see Jesus and some disciples striding through the temple precincts—pillared and arched, overseen by the bust of a Roman deity; the Jewish temple is also a Roman temple. One man weighs coins on a scale; one is selling doves; aother sidles up to a woman who shows a bare leg—even sex is for sale here. "We came here to pray," Jesus says, "and look at this." He goes up to a money changer seated behind a table—there so Jews can exchange shekels for Roman coins in order to pay the imperial tax. "How's business?" "Fair." "Making a good profit?" "Fair." At this, Jesus goes into a rage. He overturns the table, and some others; he snatches a dove from the seller's hands; he throws a heap of coins into the air, and the camera follows them—bright gold Roman coins, they are. The temple precincts are roiled with the commotion. "This is my father's house—it's a place of worship, not a market!"

Now a rabbi confronts Jesus: What is he doing? The empire expects them to pay tax with Roman coins—they're blazoned with the image of a false god, but that's the law.

"I'm throwing away the law: I have a new law, a new hope," Jesus says. The rabbi presses him: Has God changed his mind about the law? How can he presume?

". . . Because I'm the end of the old law and the beginning of the new one . . . When I say 'I,' I'm saying 'God' . . ."

"That's blasphemy," the rabbi says.

"Didn't they tell you?" Jesus says. "I'm the saint of blasphemy . . . I didn't come here to bring peace: I came to bring the sword . . ."

An aide at the rabbi's side interjects: "Talking like that will get you killed," he tells Jesus.

Jesus goes into full-on prophecy. The temple will be destroyed—"down to the ground." God is an immortal spirit who belongs to everybody—"God is not an Israelite."

The market is in chaos. One man tells Jesus he won't leave this city alive. Another—this is Saul—insists that there's no conflict with the Romans here, just Jews quarreling among themselves. Judas insists that there's more going on. "He's going to destroy the temple so as to build it up again in three days," he says.

When we see Jesus next he is on the back of an ass—a comically small one. In Scorsese's treatment, the Jesus of the episode known as the Procession into Jerusalem is not a misunderstood holy man but a figure of public ridicule. Again he goes into the temple precincts with the disciples, who are carrying torches. Again he strikes out, hurling goods and upending tables. Again he cries out to the crowd. He is enraged and semi-coherent: it's God's time and he is God and he is here to baptize with fire.

He is semi-coherent because he is divided—controverted. The voices he hears have overwhelmed him. He is staggered, reeling. Cryptically, he asks God to take him now.

Alone with Judas a little later, he strikes the same note. He wants to die right now, he says—to be struck by an axe. He begs Judas to kill him. But Judas says he can't without a command from God. There's blood streaming from Jesus's hands. All right, then, Jesus says, and he confides his secret to Judas; he is going going to die on the cross, and then three days later . . .

So now Judas knows. And Judas asks him: What about the others? "I'll tell them tonight," Jesus says.

Universal laid plans to overtake the protests through the Ziegfeld premiere, a strong first weekend in the big cities, and a gale of publicity, driven by reviews, controversy, and what's-the-fuss-all-about curiosity.

At the Simon & Schuster offices at Forty-Ninth and Sixth, the publisher committed to two hundred thousand copies of a tie-in edition of the Kazantzakis novel, with a cover based on the movie poster: a crown of thorns, stressing the crucifixion, not the temptation inter alia. Across the avenue, the editors of *Time* put finishing touches on a WHO WAS JESUS? cover story, which placed the controversy in the context of recent scholarship. "One major lesson in the ruckus," it concluded, ". . . is that believers do care about the historical Jesus and urgently want him to square with the figure they know through faith."

"Who was Jesus?" will be the question of the disciples in the climactic scenes of Scorsese's film, too. They're having supper together on a pro-verbial Thursday evening—a dozen or so people, men and a few women, robed and seated informally. Jesus holds up a piece of bread, flat and round. This is my body, he says, and the bread is passed from hand to hand. He raises a bowl of red wine. This is my blood, he says, and the bowl is passed from mouth to mouth. Judas spills some. He gets up and makes to go. "Hey, we're not finished," another man says. Jesus says let him go, it's all right. He turns to the others and says that he wants to tell them something.

And then Jesus goes where he and we know he must go. Night has fallen on Jerusalem, and the film's visual palette changes from earth tones to grays and greens. The disciples, three of them, huddle together at the edge of the glade while Jesus goes on alone. But he is not alone. This is the Agony in the Garden, and we are there with him. He's in a close-up, wearing a rough cloak, head bent diagonally across the frame, hands folded in foreground, praying for his life. "The world you've made that we can see is beautiful," he tells his father, "but the world you've made that we can't see is beautiful, too"—and he doesn't know which one is better. He begs his father to spare him from having to go through what is coming. This is a temptation—the temptation of the ordinary, a human life, un-inevitable, ending when it does for reasons we never fully know. The long close-up brings us close. We are close to Jesus physically, his face pressed up against ours. We are close to him

in the way of a confidant, right there with him in his dark night of the soul. He and we are identified: we are like him and he is like us—each of us vulnerable, all half-hidden depths, controverted to the core.

The close-up holds. He is bent low, almost out of the frame, so that our eyes go to his cloak—two pieces of fabric stitched together with coarse thread, the seam like a seam between the seen and the unseen, between this world and the next one.

On Friday morning sawhorses were ready for use at Fifty-Fourth and Sixth. The theater was mid-block, the name Ziegfeld in big script. Six hours before the premiere, a few knots of protestors were there: young men, white shirts, dark ties, dark slacks, short hair, close shaves. They wore slogans on sandwich boards like vendors in a silent movie.

The *Times* review was in that day's paper: exquisitely mixed all the way through, before concluding with a paean to the "absolute conviction" that had gone into the making of the film: "Anyone who questions the sincerity or seriousness of what Mr. Scorsese has attempted need only see the film to lay those doubts to rest." Other papers were less equivocal. *The Washington Post*'s critic pronounced the film a "failure . . . at the most basic level"—it didn't bring him any closer to Jesus. The wire services were dismissive. And a news story from the Republican National Convention in New Orleans reported a threat to film and director alike. "I think we can drive it out of existence in the next few weeks . . . We're going to bruise him so badly that the others are going to pull back and let him die alone." The speaker was Jerry Falwell of the Moral Majority.

Outside the Ziegfeld, people waited for tickets—waited three hours, upbraided by protestors the whole time. The police had set up sawhorses at both ends of the block, penning patrons and protestors together on West Fifty-Fourth Street. Fifteen months after a quarter of a million people, many of them Christians, massed on the Mall to protest U.S. militarism, Christians were massing outside a theater to decry a film they refused to see.

The Directors Guild of America held a news conference at its headquarters on Sunset Boulevard. One speaker was Sydney Pollack, who had won a pair of Oscars for *Out of Africa* a couple of years earlier. "What's at stake here," he said, "is the very essence of what we think of when we talk of a free society." Now that the film was out (and was getting mixed reviews), this was the form the defense of it would take—a defense not of the film itself but of the director's right to make it.

The patrons were shown into the Ziegfeld. They emerged three hours later as an audience. Together, they had seen *The Last Temptation of Christ* for themselves. They saw Judas enter the glade at the head of a squadron of Roman soldiers and mark Jesus with a kiss. They saw Pontius Pilate (David Bowie, that's right) interrogate Jesus in a torchlit imperial outpost. They saw the faces of the crowd, grizzled and toothless, as Jesus bore the heavy beam that he would die on. They saw the centurions nail him to the cross and heard him scream in pain. They saw the crowd jeering, stabbing the air with imprecation. They saw Jesus cry out: "Father, why have you forsaken me?" They saw what happened next: the nails withdrawn, the crown of thorns removed by a sweet-natured guardian angel, and Jesus led out into a wide spread of green hills and to a wedding—his own—and then to a stone-and-thatch house in a glade, the garden transfigured from a place of agony to a place of communion. And they saw the sequence, about a minute from start to finish, that begins with Mary Magdalene swabbing and stroking the blood from Jesus's wounds and then cuts to Jesus rising into her embrace, meeting her kiss with a kiss, turning to her and onto her and making love to her in the cool darkness of the house as she murmurs that they could have a child, a child, the angel attending all the while. Finally, they'd seen it: the dream of life that took shape in the depths of the Son of God, probably not for the first time, as his earthly life expired.

That Friday, Jean-Michel Basquiat was expiring. He was at 24 Bond Street, in a duplex apartment, formerly a stable, that he had rented from

Andy Warhol. The place was a combination artist's loft, crash pad, addict's shooting gallery, and storage space for the profusion of work that Basquiat had made in 1987 and 1988: paintings, drawings, mixed-media assemblages, and the like. That day, he was shooting up, and crashing: he'd taken heroin and cocaine, and was sleeping it off upstairs. Some friends called, following up on plans to go see Run-DMC that night at the Nassau Coliseum on Long Island. A girlfriend found him in bed, semi-conscious, foaming at the mouth. She called 911; she called his gallerist. Paramedics arrived; they propped him upright and spread his arms so that his veins could receive the IV drips they administered. They brought him downstairs, where curious locals had gathered on the sidewalk. They loaded him into an ambulance idling at the curb. Probably he was dead already; he was pronounced dead on arrival at Cabrini Hospital on East Nineteenth Street.

The Basquiat story was just beginning, as his life, always at the center of his art, acquired the stature of myth, and his death gained the tincture of martyrdom—that of a savant sacrificed to the voracious art market. The work itself continued to speak. On Warhol's advice, Basquiat had put hundreds of drawings and dozens of canvases in storage, out of reach of his dealer, and these would be the basis for a posthumous canonicity: the artist ever more vivid, the work perpetually cryptic.

The Ziegfeld was full all weekend; so were the theaters in Washington, Chicago, Minneapolis, Seattle, San Francisco, Los Angeles, Montreal, and Toronto. The personal film about Jesus that Scorsese had dreamed of making for so long was a worldly success.

The protests subsided—the Christians who'd been summoned to Hollywood by Rev. Wildmon returning to the places where their God was not blasphemed and their faith not dishonored. And so they yielded Los Angeles to the "bad" believers.

Madonna arrived from New York and settled in at a studio in Burbank to make a new record. Her performance in *Speed-the-Plow* had been drubbed. Her marriage to Penn was falling apart, under pressure from her fame, his anger, and the long separations their careers required. A

summer of nights out with the comedienne Sandra Bernhard—openly bisexual, stylishly butch—had reaffirmed her roots on the downtown gay scene and stirred rumors that she was a lesbian, leaving Penn jealous and humiliated. After showing up with Bernhard at the Pyramid, she and Penn argued volcanically in open view of paparazzi.

It was a lot to process, and she'd done so by writing some lyrics in her journal. Now she shaped them into a song. Madonna Ciccone, age thirty, far from family and Michigan, rich and famous beyond measure, turned again to Catholic imagery as if by instinct. Heaven, and a mystery choir; fallen angels, midnight prayers: she was down on her knees, hearing a voice, feeling his power, and wanting to submit.

The song owed something to the circumstances of her life, and something to the music of Prince. In Los Angeles, she decided that it would be the first song she'd do for the new record: "Like a Prayer." Through management, she reached out to Prince and asked him to contribute a guitar part, and she ordered up a gospel choir.

U2 were still living in rented houses in Beverly Hills. *The Joshua Tree* had gotten a Grammy Award as album of the year (over *Bad*) and was selling well. *Rattle & Hum* was in postproduction. They were moving on from American roots, resituating themselves as the successors to the conscience-of-a-generation musicians of the sixties.

A track for the *Rattle & Hum* soundtrack made that clear: "God Part II." It's a litany of unbelief and disbelief. The lyrics echo late-seventies tracks by Talking Heads ("I believe that we don't need love") and the Buzzcocks ("I believe in original sin / I believe what I believe in . . ."). Bono sings: "Don't believe the devil I don't believe his book / But the truth is not the same without the lies he made up . . . / Don't believe them when they tell me there ain't no cure / The rich stay healthy the sick stay poor . . ."

The title was a tip of the hat to John Lennon's "God," from *Plastic Ono Band*. But the long lines, the tight rhymes, the echoes of "Ain't No Cure for Love" and "Everybody Knows" suggest that the song's true precursors were the songs of Leonard Cohen.

Cohen was in Los Angeles, too, between stretches of a world tour in support of *I'm Your Man*. Sylvie Simmons sketches the moment: "Leon-

ard was upstairs in his duplex, in the corner of the living room, playing his Technics synthesizer—something he spent much of his time doing when he was not needed elsewhere. He was happy enough in his cell with its bare floorboards and its plain white walls, no pictures or distractions. The windows were open, letting in the sweltering heat. He had thought about installing air-conditioning but would not get around to it until the next decade."

He did a pair of interviews on KCRW, the FM station in Santa Monica. Not for the first time, he traced his outlook to his coming-of-age in the bohemian quarter of a city saturated with old-school religious belief. "I grew up before television so it was easier to create one's own mythology, but we truly believed that Montreal was a holy city, all of us were sainted, gifted beings, our love affairs were important, our songs immortal, our poems deathless, and we would lead lives of delicious self-sacrifice to art or to God."

To the interviewer (his friend Kristine McKenna) he then set out, as cogently as he ever would, an account of the mix of biblical religion and Buddhism found in his work. His songs dealt with love, and with the "surrender" of the self that love involved ("you have to take a wound," he explained). His theme was defeat—the "fall" or "wipeout" that any real relationship brought about. "And the wipeout specific to our particular culture is of the self. We exist in a continual process of establishing a personality that works for a while, then finally disintegrates under the abrasive activity of maintaining it.

"When it falls," he went on, "we're resurrected through the creation of a new self. Don't forget that the central myth of our culture, the crucifixion, also involves a resurrection, and that is what we're continually doing; the personality gets crucified because it isn't any good. It doesn't work, it's inappropriate, fictitious, so it gets crucified and hung up there for everybody to see."

And he offered something like an analysis of civilization as found in his songs. "I've always regarded the Bible as a collection of stories we all know," he said, "and it's important to tap into a common reservoir." But that reservoir was being "evaporated." In consequence, "we seem . . . to be in one of those periods where there's a great gap between

public expression and private experience, and where almost anything that manifests itself on the public level has an air of artificiality and irrelevance."

The evaporation of culture had consequences for private experience, too: ". . . people find themselves in predicaments that have the potential of being addressed from a religious point of view, but they lack the religious vocabulary to address it," Cohen said. "This is unfortunate because although the secular approach to personality and the destruction of the self is valuable, it's one-sided. The fact is we do feel a connection with the divine and sense the presence of a deep meaning that the mind cannot penetrate."

What he was describing, McKenna suggested, was a society in spiritual crisis; and while he agreed, he used more robust terms. "The notion that we're divine beings is one that's been largely discarded by society, yet there's a crucial kind of nourishment that belief can supply," he said. "So yes, in that sense the crisis we're discussing is a religious one."

13

SEEN AND UNSEEN

Everybody knows what comes next: a full-dress pageant involving artists, religious leaders, politicians, and the press, focused on crypto-religious work judged offensive to the public—all while the folks doing the judging take steps to keep the public from seeing the work for themselves. Crypto-religious art will be decried as not cryptic enough—as too explicit. Because there is no saying for sure what the work conveys about what the artist believes or belief in general, what is said is that the work is sacrilegious. Through controversy it will become contraband.

All that shall come to pass, and it will coincide with great changes becoming visible in the United States and its dealings with the world. The settling-in of large numbers of new Americans from China, Korea, Taiwan, Hong Kong, Vietnam, and South Asia will reveal the U.S. as a multireligious society. The breakup of the Soviet empire will at once symbolize the failure of "godless" communism and expose the internal conflicts of the Euro-American culture called the West. The anti-government protests in Beijing and the government's response will shift the sights of freedom and control, protest and suppression eastward.

All that shall come to pass—beginning with a controversy over a

crypto-religious work whose publication will change the terms of the conflicts involving religion and the arts.

"'To be born again,' sang Gibreel Farishta tumbling from the heavens, 'first you have to die. Ho ji! Ho ji! To land upon the bosomy earth, first one needs to fly.'"

So begins one of the great openings in contemporary fiction: two actual living men tumbling earthward from a jet plane blown to bits by terrorists at thirty thousand feet—two men falling upside-down but miraculously held at arm's length, quarreling, singing, and telling life stories along the way.

So begins a novel about a pair of gone-away, observance-be-damned South Asian Muslims, on terms familiar and pertinent to the Anglo-American Christian West—as a story of fall-and-rebirth in which the protagonists are born again. It presents migration as an experience in which one self is cast off and another claimed, again and again, in terms that draw both on Hindu concepts of reincarnation and on Western Civ notions of new worlds and promised lands.

Salman Rushdie had finished writing *The Satanic Verses* in February 1988. With it he completed what he thought of as a fictional trilogy on origins—the "'first business' . . . of naming the parts of myself." *Midnight's Children* (1981) was about India, where he'd been born in August 1947—the month the nation claimed its independence from Great Britain. *Shame* (1983) dealt with the "other-made" country of Pakistan, where his parents, Indian-born Muslims, had settled in the 1970s. *The Satanic Verses* was about Britain and the "imaginary homelands" of people geographically distant from their cultures of origin—such as the South Asian Muslims of eighties London.

The novel was set for publication in September in the U.K. and the next February in the U.S. Proofs were printed and bound; Rushdie, who lived in St Peter Street, Islington, gave a set to a writer friend visiting from India, Madha Jain, and in late August the novel was in transit from London to Delhi, reverse-migration-like, in her carry-on bag.

Rushdie had come to England himself from Bombay at age twelve in 1959 to attend Rugby, following the path of his father, a prosperous but dissolute businessman. At Rugby and then at Cambridge he developed a sense of "double consciousness." He felt himself an outsider in India (as a Muslim), in England (as a "wog"), and in Islam (as an unbeliever). In his last year at Cambridge he made this predicament an object of study, arranging a tutorial—he was the only student—on early Islam; in the years after, working as an advertising copywriter, he sharpened his perceptions of the English populace and its desires. At nights he wrote a novel, which was published to so little attention that a second novel, *Midnight's Children*, was reviewed as if it were his first—an author's coming-of-age story doubled with the story of his country's independence.

Midnight's Children won the Booker Prize for 1981, and Rushdie was chosen for *Granta*'s first "Best Young British Writers" issue in 1983, with Ian McEwan, Martin Amis, Kazuo Ishiguro, and Graham Swift, who became his friends. *Shame* got equally strong reviews. The acclaim emboldened him; during a trip to Australia, a trek on the aboriginal "songlines" with Bruce Chatwin led him to conceive a giant "novel of discontinuities" on themes of migration and mongrelization. "I didn't know if it was one book or three," he recalled. "It took me quite a while to be brave enough to decide it was a single work."

The Satanic Verses was one book, shaped around the idea of doubleness. There were two protagonists: Saladin Chamcha, a businessman "torn, to put it plainly, between East and West," and Gibreel Farishta, a Bollywood film star "who has lost his faith and is strung out between his immense need to believe and his new inability to do so." There were two narrative lines—one set in contemporary "Babylondon," the other braided from extraordinary episodes in the history of Islam. There were two modes of storytelling—the realist-cosmopolitan and the fantastical, which blended together.

The historical strand of the novel began with the "incident of the satanic verses," which Rushdie had studied in the tutorial at Cambridge. It was a focus of recent scholarship: verses describing a trio of goddesses were delivered to Muhammad—God's messenger; then they were re-

placed with similar verses affirming monotheism, and were deemed the work of Satan—the devil. The incident complicated Islam's central belief that there is no God but God and Muhammad is his prophet; it suggested, as Rushdie later put it, that Muhammad early on had been "flirting with polytheism."

The contemporary strand of the novel followed the doings of the paired protagonists and a vast and varied cast of Muslims in London—a family running a guesthouse for migrants, a bearded mullah-in-exile who had turned a suite of apartments in Kensington into a theocracy behind closed doors. These sections drew on Rushdie's involvement in anti-racism efforts, which sought to build solidarity among Muslims, West Indians, and other immigrants whom he thought of as a "new Empire within Britain," and whose lives, seldom seen in English fiction, he sought to make visible.

The novel's central challenge was a crypto-religious one: How should the novelist deal with, do justice to, derive art from . . . Islam?

For Rushdie, Islam was roots, an aspect of his formation, not an object of devotion; now he was drawing on it in a work of fiction in which personal experience, scripture, fairy tale, archetype, urban realism, and social commentary were exuberantly mixed. In the story of Gibreel Farishta, for example. Named Ishmail Najruddin at birth, a Muslim, he is reborn when, orphaned as a young man, he is taken in by a childless Hindu couple and steeped in the spirit of reincarnation, and then is born again as a Bollywood actor (named for the guardian angel in Christianity and Islam) who thrives in the genre called the "theologicals," playing divinities: Krishna, Gautama, the Grand Mughal. As he gains fame, he pursues a feverish course of study in the world religions. Then he is reborn once more through a mortal illness that leaves him sound of body but spiritually askew—racked by the loss of faith. His begins his new life as a secular man by feasting on pork (forbidden in Islam), which leads to a "nocturnal retribution, a punishment of dreams." And that is just Gibreel's story; his counterpart Saladin Chamcha's story is likewise full of riffs on themes of metamorphosis and rebirth.

The Satanic Verses, as Rushdie conceived it, was at once a novel about religion and a novelist's exploration of religion through fiction.

It depicted a city burning with the ardor stoked by the unhitching of devotion-prone souls from formal religion and overtaken by carnal desire. It featured a figure "not quite" Muhammad and told (sexually) explicit stories about him. It extended Rushdie's efforts to tilt against public figures (the despots Indira Gandhi in *Midnight's Children* and Gen. Zia-ul-Haq in *Shame*), taking on Margaret Thatcher (called "Mrs Torture") and the Ayatollah Khomeini (a model for the mullah-in-exile). It was brimming with his polyglot style, and yet the title and a framing device suggested that Satan was the actual author.

The novel was "a huge monster I was wrestling with," Rushdie recalled. The struggle lasted five years. When it was done he felt "lobotomized."

The literary agent Andrew Wylie sold the English-language rights to *The Satanic Verses* at auction, confident that the need to earn back a large advance would compel a publisher to market the novel aggressively. Nine publishers bid by phone and fax. Viking Penguin's publisher, Peter Mayer, prevailed, offering $850,000, a huge sum. He made each of the firm's English-language subsidiaries responsible for recouping a share. Viking in London ordered a first printing of 25,000 copies—sizable for Britain, modest given the large advance. Viking in New York planned 75,000 copies for starters. Penguin India asked to stand aside from the novel due to religious strife there, and Mayer, seeing India as a small market for a novel set mainly in England, said all right.

In the summer of 1988, then, publication of *The Satanic Verses* as a big commercial novel took shape—despite the fact that the double plot, the magic-realist style, the encrypted early history of Islam, and the Joycean puns in English and Urdu made the novel hard even for the people who were publishing it to understand.

After a helicopter carrying General Zia crashed in August, killing all aboard, Rushdie wrote an opinion piece called "An End to the Nightmare." The nightmare was Zia's rule of Pakistan, where he had imposed martial law and an "Islamicization" of society. Magical-

realistically, Rushdie told the tale: "Eleven years ago he burst out of his bottle like an *Arabian Nights* goblin, and although he seemed, at first, a small, puny sort of demon, he instantly commenced to grow, until he was gigantic enough to be able to grab the whole of Pakistan by the throat." Now Zia was dead, and "the sad, strangulated nation" of Pakistan, Rushdie wrote, "may breathe a little more freely." Concluding, he expressed a hope that the coalfire-and-brickbat form of Islam that Zia had stoked in Pakistan would ease. "It needs to be said repeatedly in the West that Islam is no more monolithically cruel, no more an 'evil empire,' than Christianity, capitalism or communism," he observed, and went on: "To be a believer is not by any means to be a zealot."

Viking's big literary novel in the United States in that moment was *Libra*, by Don DeLillo. The novel, which followed on *White Noise*, was an intricately fictionalized account of "the seven seconds that broke the back of the American century": the assassination of John F. Kennedy in 1963. Publication in July was pointed toward the twenty-fifth anniversary of the assassination in November, and reviews focused as much on the novel's treatment of history as on its literary qualities. The novel's suggestion that the assassination was a coordinated strike and not just the work of a lone gunman was thought so provocative that Viking asked DeLillo to append an author's note so as to forestall controversy. He did so in his own steely terms. "This is a work of imagination . . ." he began. "Any novel about a major unresolved event would aspire to fill in some of the blank spaces in the known record. To do this, I've altered and embellished reality, extended real people into imagined space and time, invented incidents, dialogues, and characters." He affirmed the power of the imagination in terms that evoked past disputes over scripture: "Because this book makes no claim to literal truth, because it is only itself, apart and complete, readers may find refuge here—a way of thinking about the assassination without being constrained by half-facts or overwhelmed by possibilities, by the tide of speculation that widens with the years."

There was no real controversy over *Libra*; but that author's note would apply inadvertently to Viking's next big literary novel.

The Satanic Verses was published in London on September 26, 1988. Viking took out splashy ads ("Wonderful stories and flights of the imagination surround the conflict between good and evil") and held a launch party; Rushdie relished a long-awaited, hard-worked-for success.

The novel would soon be banned in India. After reading the proofs, Rushdie's friend Madhu Jain had filed a review, detailed and appreciative, to *India Today*. It ran under the headline AN UNEQUIVOCAL ATTACK ON RELIGIOUS FUNDAMENTALISM. "The root idea of the novel is that there are no absolutes. Heaven and Hell have no boundaries. It's almost impossible to tell angel and devil apart: Mahound the prophet has a tough time telling the difference between the voice of the angel and the *shaitan* (devil) up there on Mount Coney," Jain explained. "In the process, Rushdie takes a very irreverent look at Islamic folklore and fact"—by inventing a brothel whose courtesans are named for the Prophet's wives, by suggesting that the pilgrimage to Mecca is a money-making enterprise, and so on. Jain concluded that readers might find the novel confusing, but she was sure "the sentinels of Islam" would see its point clearly: "*The Satanic Verses* is bound to trigger an avalanche of protests from the ramparts."

India and then Pakistan soon forbade publication or distribution of the novel. News of the ban in South Asia soon became news for Britain's immigrants from the region—the talk of guesthouses like the one Rushdie had depicted in its pages.

The novel of doubleness led a double life that fall. In one life, it was reviewed, bought, read, and discussed by London literary people. Was *The Satanic Verses* "several of the best novels that Rushdie has ever written" (*TLS*)—or was it an adventure in "unreadability" (*Observer*), a work without the broad appeal of *Midnight's Children*?

In its other life it was condemned by people who hadn't read it, but had only seen smudgy faxes of xeroxed pages. A detractor's claim that "I don't have to wade through a filthy drain to know what filth is"

set the tone, and there was no groundswell of immigrants emerging to say the novel spoke for them. Instead, there was a coordinated outcry: open letters, petitions, entreaties to public officials to ban the novel and censure its author by applying anti-blasphemy laws from the era of religious civil wars.

Rushdie had anticipated such developments, and had incorporated them into the novel. One aspect of its doubleness is the tension between Gibreel Farishta's inward agonies of un- and disbelieving and the slick, superficial approach to religion taken by the Bollywood film industry whose most famous figure he is. The early Islam sections feature "blood-praising versifiers" and a sinister "lampoonist." But these reflexive devices wound up giving credence to the claim that the novel was calculated to offend.

When the novel was shortlisted for the Booker Prize in late September there was hope that the nomination might quell the controversy. It didn't. The next month, the Nobel Prize committee in Stockholm awarded the literature prize to Naguib Mahfouz, an Egyptian whose novels of mid-century Cairo treated Islam and the conservative culture of the old city (shaped by Islam) with deferential respect. Mahfouz was the first Arabic writer the Nobel committee had recognized. The timing seemed significant.

The Booker Prize ceremony was held on October 28 at the London Guildhall, an edifice dating to the Middle Ages. The organizers had prepared video profiles of the authors and their books. There on-screen was Bruce Chatwin, severely emaciated, talking about *Utz* ("art always lets us down"); he was ill and unable to attend. There was Peter Carey expounding on *Oscar and Lucinda*, a novel about an English seminarian in Australia, whose generative image was of a glass church floating down a river in New South Wales—an image for "the moment when all the Christian stories entered the landscape that had previously been peopled with aboriginal stories." And there was Rushdie, relaxed in an open-necked shirt and wire-rim glasses. "I ceased to be formally religious at quite an early age—as a teenager, I suppose—and I've never

changed; I've never been born again, so to speak," he said. "But I've always remained—there's always been some sort of nagging space where the religion used to be . . . a book doesn't come from one place, it comes from a number of places, but one of the places it came from was a desire to make some kind of reckoning with that."

The controversy over *The Satanic Verses* hovered over the ceremony. Security officers at the entrance detained a stranger who claimed he was a reporter named Salaman. Chatwin had told Rushdie that if either won the prize he should share it with the other. Rushdie and Peter Carey joked about it. "I hope you win," Rushdie said, adding: "I couldn't win if I wrote *Ulysses*." As the shortlist was read out, a literary critic in the audience pantomined an explosion. The Booker went to *Oscar and Lucinda*.

That Chatwin was dying was apparent from the video. Other aspects of his situation were less well known. One was that the disease ravaging him was AIDS. Another was that he had become a Christian, converting to the Greek Orthodox Church, inspired by a fever dream involving his 1985 trip to Mount Athos, where a visit to the Stavronikita monastery led him to write in his journal: "There must be a God." He was dying; but in his diminished state, he made plans to go to the Holy Mountain again.

Robert Mapplethorpe was dying, too; and he, too, was still convinced that he could beat the disease while keeping the public from knowing that the disease was AIDS.

Patti Smith, in *Just Kids*, recalls traveling between Detroit and New York again and again to visit him. In November he'd invited 250 people to the loft in Chelsea for his birthday: he was forty-two. But the loft had since become "his sick bay"—Mapplethorpe in bed, a nurse attending, the wheelchair he'd acquired parked in a room of art and sculpture. Smith presents his suffering as a sort of pagan crucifixion, with herself as akin to the devoted women at the foot of the cross. "Robert had fought as if he could be cured by his will alone. He had tried everything from science to voodoo, everything but prayer," she observes. "That, at least, I could give him in abundance. I prayed ceaselessly for him, a

desperate human prayer. Not for his life, no one could take that cup from him, but for the strength to endure the unendurable."

One day, he asked her, cryptically: "Patti, did art get us?" She looked away and told him she didn't know. In the memoir, she goes on: "Perhaps it did, but no one could regret that. Only a fool would regret being had by art; or a saint."

A Catholic priest, George Stack, visited him. Joan Mapplethorpe had asked the priest to go. Twenty-five years later Stack would be removed from ministry after credible accusations that he had sexually abused teenage boys, including two at Our Lady of the Snows in the years when Mapplethorpe was there (one later committed suicide). For now, Fr. Stack was the priest from Mapplethorpe's boyhood parish, paying a pastoral call. Patricia Morrisroe in her biography presents the visit from his point of view—Stack registering shock at the mix of art, fetishism, and pornography in the loft. "The priest was mesmerized by the objects in that room, for, outside of religious art, he had never seen the battle of good versus evil depicted in such a decorative way. He couldn't imagine the life the photographer had led . . ." He and Mapplethorpe talked about other boys from the parish. The priest asked the artist whether he believed in God. "I don't know," Mapplethorpe said. "I don't believe in dogmas and theologies." Piously, he went on: "I just believe in being a good person. I've always been honest with people. I've never lied. I think I've lived a moral life." He asked the priest to come again.

An exhibit of his photographs—*The Perfect Moment*—opened in Philadelphia in December, and *Vanity Fair* prepared a valedictory piece with the cover line "Robert Mapplethorpe's Long Good-bye."

He was not dead yet, and as if to demonstrate this, he took an assignment: a cover portrait photograph for *Time*. The subject was C. Everett Koop, the surgeon general, who was credited with spurring the federal government to address AIDS more directly. And so it came to pass that President Reagan's handpicked top health official, an evangelically inclined Presbyterian, of Lincolnesque beard and general-befitting dress blues, made a house call of sorts to the loft consecrated chapel-like to the gay "lifestyle" the Reaganites had demonized. The hour of the shoot

was full of "powerful, unspoken emotions," *Time* reported. "Koop, a strapping man in uniform, seemed the epitome of physical strength. Mapplethorpe, pale, coughing and looking emaciated, moved about in obvious pain as he worked . . . Out of respect for the Surgeon General's well-known views on smoking, Mapplethorpe hid his cigarettes before Koop arrived."

The Whitbread Prize committee named *The Satanic Verses* its book of the year for 1988. The controversy over the novel deepened. "India, Pakistan, Iran, Bangladesh, Sudan, Sri Lanka, Egypt, and Saudi Arabia had banned the book," John Walsh recalls in his memoir of eighties literary London. A critic in Tehran summed up the grievances, declaring that it presented "false interpretations about Islam and wrong portrayals of the Koran and the prophet Muhammad. It also draws a caricature-like and distorted image of Islamic principles which lacks even the slightest artistic credentials."

The open letters and petitions-to-ambassadors gave way to more direct forms of protest. Bomb threats were called in to Penguin's offices in London and Viking's in New York; in London, the Metropolitan Police stationed bobbies at the Penguin entrance and installed a metal detector, rare at the time. Mullahs made incendiary speeches; in northern England, their followers organized mass marches and burned the author in effigy. "A photograph showing a furious Muslim nailing a copy of the book to a wooden stake before burning it, went around the world," Walsh recalls. The Fleet Street tabloids played up the "Rushdie Affair," depicting the aggrieved Muslims as victims of a self-important writer with a posh education.

This, too, was a critique Rushdie had addressed in his fiction. Early in *Shame*, about Pakistan, his parents' homeland, largely unknown to him, he took up the question of a writer's claim to material not literally his own: "*Outsider! Trespasser! You have no right to this subject! . . . We know you, with your foreign language wrapped around you like a flag: speaking*

about us in your forked tongue, what can you tell but lies?" Now Muslim leaders in Britain, making no provision for magic-realist "not-quite" belief, were basing their rage against him in their certainty that he was not a Muslim. Brown-skinned, Bombay-born, early-Islam-tutored-at-Cambridge, anti-racist in London—all these were for naught; lacking belief, he was nothing but a forked-tongued foreigner.

"This is, for me, the saddest irony of all," Rushdie responded, "that after working for five years to give voice and fictional flesh to the immigrant community of which I am myself a member, I should see my book burned, largely unread, by the people it's about, people who might find some pleasure and recognition in its pages . . . I tried to write against stereotypes; the zealot protests serve to confirm, in the western mind, all the worst stereotypes of the Muslim world."

He went to lunch at the Reform Club, on Pall Mall, which had a history of illustrious authors as members: Henry James, Arthur Conan Doyle, H. G. Wells, E. M. Forster—and Graham Greene, his host, who that day had invited a few U.K. writers "of color" to the club. "'Rushdie!' he called out. 'Come and sit here and tell me how you managed to make so much trouble! I never made nearly as much trouble as that!'" Forty years earlier Greene had drawn controversy for having a series of extramarital affairs while enjoying a reputation as a Catholic novelist. Now he was an English eminence. Both the nature and the scale of controversy involving art-and-religion were changing.

In early February 1989 the Museum of Modern Art opened its doors to patrons for *Andy Warhol: A Retrospective*. "Be a Somebody with a BODY!" was the message of Warhol's *Last Supper* juxtapositions; now his body of work was all together for the first time: the *Brillo Boxes*, the *Jackie*s and *Marilyn*s, the celebrity portraits, the skulls, and a set of large canvases from the *Last Supper* series. The *Times*' critic, Michael Brenson, likened the artist to cleric, saint, and messiah all at once: "His pale priestly face frets or blesses from newsstands. Images he appropriated from popular sources are studied like sacred scrolls. Just about every scrap he breathed upon is coveted like a religious relic. Moving through

the spectacle of the Warhol retrospective . . . it is clear just how many artistic disciples he now has."

Robert Mapplethorpe went to the show, rolling past the images in his wheelchair. He stayed two hours; people who knew him were amazed that he got there at all.

Don DeLillo went to the show. He was gathering material for a new novel, going deep into the power of words and images. The sentences were forming, coiling in his mind: "Scott had never seen work that seemed so indifferent to the effect it had on those who came to see it. The walls looked off to heaven in a marvelous flat-eyed gaze."

In the context of Warhol's body of work, the large *Last Supper* paintings had a fresh effect. The most present-minded of artists, Warhol had kept his eyes on the prize of posterity, grasping that the figure of Christ and the art of Leonardo had staying power that would accrue to his treatment of the Gospel episode as the shock effect of his methods subsided. It worked: while his *Marilyn*s and *Mao*s seemed to belong to another time, the *Last Supper*s seemed to belong to ours.

Bruce Chatwin died, in Nice, of unspoken causes. The *Times* obituary put it this way: "In a 1987 interview Mr. Chatwin said that during a trip to western China in the early 1980s he had contracted a rare and debilitating bone-marrow disease, an ailment he dismissed with the comment, 'Hazards of travel—rather an alarming one.'"

His friends were invited to a memorial service at the Greek Orthodox cathedral in Bayswater, West London. Salman Rushdie and his wife, the novelist Marianne Wiggins, were among them. The controversy over his novel was surging again. A protest against the book in Islamabad, Pakistan, had turned violent (five people dead, several dozen injured); one in Kashmir led to a riot (one dead, a hundred injured). A protestor in the crowd of two thousand in Islamabad chanted, "Hang Salman Rushdie."

The morning of the service a BBC reporter cold-called Rushdie in London and told him that the Ayatollah Khomeini, in Tehran, had issued a fatwa, urging Muslims worldwide to kill the author of *The*

Satanic Verses. How did it feel, she asked him, to be sentenced to death? "It doesn't feel good," he said. But for the moment he was determined to go on living his life. He went to Knightsbridge and did an interview with *CBS This Morning,* telling the host, "Frankly, I wish I'd written a more critical book. A religion that claims it is able to behave like this, religious leaders who are able to behave like this, and then say this is a religion that must be above any whisper of criticism—that doesn't add up." He went to Chelsea to talk things over with the literary agent Gillon Aitken, Andrew Wylie's London counterpart. Should he lie low? It was after traveling the songlines with Bruce Chatwin that he had struck on the idea for the "novel of discontinuities." It wouldn't be right to miss the memorial. "Fuck it, let's go," he said.

The service was a traditional Orthodox one, the priest intoning the prayers in Greek with his back largely turned to the congregation: art dealers, curators, socialities, literati, journalists. Rushdie was seated next to the American writer Paul Theroux. "I suppose we'll be here for you next week, Salman," Theroux said.

Outside afterward, a mob was waiting—a mob of reporters and photographers.

"Are you Salman Rushdie?" one called out to Harold Pinter, the playwright. "No, he is," Pinter said, pointing at the publisher Tom Maschler, a step behind.

Rushdie was another step behind. A photographer took a point-blank picture of him, and it shows the thick eyebrows, darting eyes, sharp ears, comb-over, and boxy eyeglasses that tabloid illustrators were turning into caricature: Satan Rushdy, enemy of Islam.

Strictly speaking, a fatwa is an Islamic leader's pronouncement rooted in Islamic law. The fatwa from the Ayatollah Khomeini pronounced a sentence of death on the author of *The Satanic Verses,* and on the book's publishers and translators, too. "I call on all valiant Muslims wherever they may be in the world to kill them without delay, so that no one will dare insult the sacred beliefs of Muslims henceforth," it read. Shortly after it was issued, a bounty was attached: "£1,500,000 TO KILL

HIM—by order of that Mad Mullah," the front page of the *Daily Mirror*
announced. Within a few days the bounty had been upped to more than
$5 million, and the term *fatwa* was in common use among those in the
West who knew next to nothing about Islam.

The fatwa was the opposite of cryptic: it said that this man is an
an enemy of Islam and so you must kill him—kill him for depicting
the Prophet, who must remain unseen. But the fatwa's grim clarity of
purpose served to obscure the motives of the man who issued it. Soon
after it was announced by Radio Tehran, Amer Taheri, an Iranian au-
thor of a biography of Khomeini, set out the background in the *Times*
of London. "Khomeini's motives for giving his order," he explained,
"are not entirely religious." Iran had just lost an eight-year war with
Iraq; Pakistan had just elected a woman, Benazir Bhutto, as president;
the Soviet withdrawal from Afghanistan had left the Iranian presence
diminished there. So Khomeini "has therefore been looking for an issue
to stir the poor and illiterate masses . . . the Ayatollah hopes to tell his
supporters that plots against Allah have not ceased, and that if one war
has ended another is about to begin." The piece ran under the headline
KHOMEINI'S SCAPEGOAT.

The novel was selling strongly in London. The cryptic quality of
the text was suddenly not an obstacle; the bold title and jacket made *The
Satanic Verses* a talismanic object, to be bought in solidarity, perused and
put on display, and not-quite read.

The novelist had gone into hiding. He was put under round-the-
clock protection by the Special Branch police. He was moved from
location to location: a friend's cottage in the Cotswolds, a safe house
in Camden Town, each swept for explosives by the police before he
arrived. Asked to supply an alias, he came up with Joseph Anton, a
compound of the first names of Conrad and Chekhov.

In his absence, London literary society took sides. His friends stumped
for him in the opinion pages. Others writers lent their voices to a call for
Rushdie and Penguin to withdraw the novel. "Nobody has a God-given
right to insult a great religion," John le Carré declared in *The Guard-
ian*, "and be published with impunity." V. S. Naipaul, who felt he had
been taken to task by the left for his own acid portrait of Khomeini

in *Among the Believers*, saw the left's support for Rushdie as an "odd-ity" akin to hypocrisy. Roald Dahl, author of *Charlie and the Chocolate Factory*, claimed Rushdie had provoked trouble to get "an indifferent book onto the top of the bestseller list." Dahl wrote, ". . . he must have been totally aware of the deep and violent feelings his book would stir up among devout Muslims. In other words, he knew exactly what he was doing and he cannot plead otherwise." He added: "To my mind, he is a dangerous opportunist."

The European political establishment split the difference, on the one hand decrying a violent challenge to freedom of expression and on the other decrying an "insult" or offense to Islam and Muslims. The Netherlands canceled its foreign minister's planned visit to Tehran, and West Germany called back its chargé d'affaires. The Vatican stood aside. Asked on behalf of Iranian diplomats whether Pope John Paul would make a statement, an official of the Secretariat of State said: "It's their problem, not ours, we have enough of our own, especially with all the books and films that cast doubts on Jesus Christ himself. We have never asked for Moslem help in curbing their sale."

On Saturday, February 18—five days after the fatwa—Rushdie put out a statement, sounding not quite like himself: "I profoundly regret the distress that publication has occasioned to sincere followers of Islam. Living as we do in a world of many faiths this experience has served to remind us that we must all be conscious of the sensibilities of others."

He was suddenly Britain's most famous author; but he had "vanished into the front page," as the novelist Martin Amis put it. Going under-ground, he returned to the migrant's original condition, which he'd rep-resented in fiction. That the migrant's true migration is internal, less about geography than identity, that compound of self, ancestry, belief, and imagination, was his great theme; now the novelist of migration was at once seen and unseen, walled into a crypt whose location kept shifting.

"The phone has been ringing off the hook," a clerk at St. Mark's Book-shop in the East Village told the *Times*. "Almost everyone coming in the door wants a copy."

The Viking edition of *The Satanic Verses*, just off press, had sold out in shops in the United States. But the pressure on Penguin to withdraw the book in other territories had created a pressure for Viking to soft-pedal its U.S. publication. In response, PEN, the writers' group, made plans for a New York event in support of Rushdie and the novel.

That Sunday, Cardinal O'Connor weighed in. He had kept a low profile during the controversy over *The Last Temptation of Christ*, perhaps because he, more than most Catholic bishops, was sensitive to antisemitism.* But not this time. From the pulpit of St. Patrick's Cathedral, O'Connor called *The Satanic Verses* "insulting and insensitive to the Moslem faith," while deploring "any and all acts of terrorism" committed against the novelist in the name of Islam, and urging Catholics to exercise their "mature" judgment and recognize for themselves that the novel was an offense to Islam. That's how a spokesman summarized his homily. Asked by a reporter whether the cardinal had read the novel, the spokesman said he had not and had "no intention" of doing so. Like the book-burners in Britain and the Ayatollah in Tehran, O'Connor had judged the novel sight unseen.

Khomeini, a few hours later, affirmed the fatwa: "Even if Salman Rushdie repents and becomes the most pious man of all time, it is incumbent on every Muslim to employ everything he has got, his life and his wealth, to send him to hell."

The two developments were reported in the next day's papers. Responding to Khomeini, the European Community member nations pledged to suspend diplomatic relations with Iran, a position with which the United States, Canada, Australia, Brazil, and others aligned themselves soon afterward. Responding to Cardinal O'Connor, some Catholic writers drafted a letter.

They were a varied group: the novelists Don DeLillo, William Kennedy, Mary Gordon, and Maureen Howard (who coordinated the effort); the *New York Review* stalwarts Garry Wills and John Gregory

* A quarter century later it would emerge that his mother had been a Jewish convert to Catholicism and his grandfather had been a rabbi, truths that O'Connor had likely known or suspected.

Dunne; the playwright John Guare; Rev. Andrew Greeley; and eight others. Apart from Greeley, their public relationship to religion was mainly intellectual and imaginative; yet they addressed the threat posed to writers and artists by religious figures, whether an ayatollah in Tehran or an archbishop of New York, who would pronounce on works of art without encountering them firsthand.

"John Cardinal O'Connor has not read, does not intend to read, but criticized Salman Rushdie's *Satanic Verses*," the letter began, to-the-editor style, and continued: ". . . The undersigned writers, of widely varying Roman Catholic backgrounds, deplore the moral insensitivity to the plight of Mr. Rushdie and an ecumenical zeal that would appear to support repression. We cannot see how the Cardinal's call on Catholics to work with Muslims to achieve mutual understanding and promote peace, freedom and social justice can be implemented by a position that censors the basic freedoms to write, to publish and to read that give life and possibility to such understanding."

That these were writers "of widely varying Catholic backgrounds" was crucial. It acknowledged that Catholicism, for them, was a shared point of origin, about roots as much as firm belief or devotion. But it made no apology; on the contrary, it affirmed that "widely varying" was appropriate—pushing against the position maintained by the Church under John Paul II, which made variety akin to apostasy.

It went on: "A spokesman for the Cardinal reports that Cardinal O'Connor said of the novel that 'he trusted the judgment of Catholics as being mature and recognizing the affront it poses to believers in Islam.' Mature Catholics do not believe that any dialogue with the non-Christian world can be conducted within a system that prejudges books. Mature Catholics do not believe that a death threat can be met with ambiguity."

The letter was the closest thing to a unifying act for American Catholic writers in that moment, drawn together by the controversy over a novel and Islam.

Wednesday, February 22, was the publication date of the U.S. edition. Late that morning two dozen writers met at Jerry's on Prince Street, a

boîte favored by the SoHo art crowd. In the rain, they trudged to the Columns, a performance space in a neoclassical building near Houston Street. Metal detectors were set up at the entrance. A crowd of several hundred people were outside, hoping to get in; several dozen protestors were across the street, yelling, "Death to Rushdie!"

Inside, the hall was full: five hundred people. The writers took seats. Abbie Hoffman was there; so was Tom Wolfe. Joan Didion and her husband, John Gregory Dunne, were there. Leon Wieseltier, staunch supporter of Israel, was there; so was Edward Said, the Columbia professor, raised a Christian, who was an adviser to the Palestine Liberation Authority. If news reports were any indication, no writer of Muslim heritage was there.

The strangeness of the event is more apparent now than it was at the time. Here were American writers affirming kinship with an Indian-born British writer of Muslim heritage in a controversy involving a religion whose texts, precepts, hierarchies, and taboos were outside the ambit of their work. What united them was the resistance to the Ayatollah Khomeini and a commitment to free expression—PEN's support of writers under seige now powered with a media savvy akin to Amnesty International's.

Windows were open, and the sound of the protestors came up from the street: "Death to Rushdie! . . . Death to Rushdie!"

The first writer rose to read—the Catholic-schooled writer whose novel *A Flag for Sunrise* depicted a conflict between justice and ill-used Church authority in Central America. "My name is Robert Stone," he said, "but today we are all Salman Rushdie."

What followed was a blend of public reading, rite, and performance. A photograph in the next day's *Times* caught the moment: Susan Sontag in jut-jawed reverie; Gay Talese and E. L. Doctorow in dark suits and ties; Norman Mailer loose of coat and collar; Don DeLillo staring at the camera from the background. It suggested a gathering akin to the one held at the Orthodox cathedral in London a few weeks earlier: writers and friends coming together to celebrate an author and his work.

They read and spoke into the evening. Mailer said of the fatwa, "This must be the largest hit contract in history." Talese recited the

Lord's Prayer "for the safety of Rushdie and his family." Wieseltier declared, "One day the Muslim world may recall with admiration its late-twentieth-century Anglo-Indian Voltaire." Christopher Hitchens cited a single sentence from the novel as a brilliant defense of the whole: "To turn insults into strengths, whigs, tories, Blacks all chose to wear with pride the names they were given in scorn; likewise our mountain-climbing, prophet-motivated solitary is to be—Mahound."

That night the Grammy Awards were held in Los Angeles and broadcast on CBS. "This is no ordinary talent," the host, Billy Crystal, said, introducing an artist still unknown to most people watching. She was Sinéad O'Connor: shaved head, black halter top, bare midriff, faded jeans, black boots, and an infant's onesie dangling like a loincloth over the rear pockets of the jeans. On the left side of her head, a bull's-eye was etched into the stubble: the logo of Public Enemy, the rap group who had denounced the organizers' refusal to acknowledge rap as a form of music warranting a Grammy. As she sang "Mandinka"—about knowing no shame and feeling no pain—her image suggested an urban Irish punk Madonna.

Madonna was absent from the show, but she had arranged to dominate the night. Mid-broadcast, CBS ran a cryptic thirty-second spot: a commercial for a commercial. The camera panned over a desert, showing a scantily dressed man striding toward a shebeen outfitted with a satellite dish. "No matter where you are in the world on March second, get to a TV and watch as Pepsi-Cola presents Madonna, singing her latest release, 'Like a Prayer'"—and on TV in the shebeen was Madonna, the voices of a gospel choir behind her—"for the very first time on planet Earth."

The full commercial aired the next Thursday during *The Cosby Show* in the United States and in forty other countries. Shot in black and white, with a red-and-blue Pepsi logo poking through, it's high-toned and celebratory. As a stand-in for the eight-year-old Madonna Louise Ciccone dreams of being a star, Madonna the global pop star herself takes a giant step back into her childhood: shiny cars, schoolgirls

in uniform, folks dancing in the streets, believers swaying in the pews of a church as she sashays up the aisle toward that gospel choir. It's as if Madonna and the director (Joe Pytka, who had made a Pepsi commercial featuring Michael Jackson) set out to combine Martin Scorsese's video for Jackson's "Bad" and U2's gone-to-Harlem video for "I Still Haven't Found What I'm Looking For." Now a brunette, in black bustier and capri pants, Madonna is dressed up and classy—fully grown-up for the first time.

The actual video aired on MTV beginning the next morning—and the controversy began. A third of a century later, it's hard to say what the controversy was about, because the video is cryptic in the extreme. Summaries put out later offer a framing narrative involving a Black man falsely accused of raping a white woman, but the video is mainly a sequence of distinctly Christian images: a cross of flame . . . a clapboard church lit from within . . . a black-skinned plaster saint behind an iron gate in a crypt-like chapel . . . Madonna approaching in a brown slip, a cross prominent on her clavicle . . . a tear dropping from the saint's eye . . . Madonna stretched out in a pew, possibly dreaming . . . Madonna kissing the saint's feet . . . the saint coming to life as a Black man and stepping out from behind the gate to the kiss her on the forehead before he goes out of the church . . . Madonna picking up a dagger and seeing her palms stigmatized . . . Madonna writhing before a field of burning crosses . . . Madonna dancing with the robed female leader of a gospel choir and then falling to her knees . . . a hint of saint-on-singer lovemaking . . . the Black man returning to his role as a plaster saint behind the iron gate . . . Devotion and desire are mysteriously and seductively combined.

Opposition to the video was swift. Rev. Donald Wildmon, emboldened by the controversy over *The Last Temptation of Christ*, urged Pepsi to withdraw its planned sponsorship of Madonna's summer tour and called on traditionalist Christians to boycott Pepsi products. A Catholic bishop in Texas joined in, followed once again by Italian Catholic groups and then by the Vatican. The opposition worked—for all involved. Pepsi withdrew its sponsorship, and Madonna canceled her

tour (retaining Pepsi's $5 million fee). But MTV kept playing the video, boosting the sales of the song and LP, and the images of a saint's arousal and a sexy singer's carnal devotion became as indelible as any MTV had aired. Madonna's position was as blunt as her SO WHAT? of 1985: "Art should be controversial, and that's all there is to it."

In a *Rolling Stone* interview she returned, again, to her Catholic girlhood: "Once you're a Catholic, you're always a Catholic—in terms of your feelings of guilt and remorse and whether you've sinned or not. Sometimes I'm wracked with guilt when I needn't be, and that, to me, is left over from my Catholic upbringing. Because in Catholicism you are born a sinner and you are a sinner all of your life. No matter how you try to get away from it, the sin is within you all the time." But "Like a Prayer" suggested that her Catholic guilt was long gone, and that what was left over from her upbringing wasn't the Catholic guilt: it was the sense of devotion as a form of desire.

Robert Mapplethorpe died on Thursday, March 9, 1989, at Deaconess Hospital in Boston. He'd gone there the week before, conveyed from New York by rented rock-star tour bus, to take part in a trial of an experimental treatment for AIDS, but after admitting him the doctors judged him too unwell to participate. His sister Nancy arrived and found him in extremis: "I can't explain it, but it was like a veil had come over his eyes," she told Patricia Morrisroe. A chaplain making the rounds gave him the last rites.

Patti Smith was with her family in Michigan when the news came. The television was on—a broadcast of Puccini's *Tosca*, of all things. "I was drawn to the screen as Tosca declared, with power and sorrow, her passion for the painter Cavaradossi," she recalls in *Just Kids*. The phone rang: Robert's brother. She knew what he was telling her. She shuddered—"overwhelmed by a sense of excitement, acceleration, as if, because of the closeness I experienced with Robert, I was to be privy to his new adventure, the miracle of his death." She was sitting in front of the TV, a book open in her lap. ". . . Tosca began the great aria 'Vissi

d'arte.' I have lived for love, I have lived for Art. I closed my eyes and folded my hands. Providence determined how I would say goodbye." They had lived for art of a certain cryptic kind.

She left home with Sonic and the children and drove for hours, set-tling at a hotel on the Atlantic coast. She took a long walk on the beach, wrapped widow-like in a long black coat. "Finally, by the sea, where God is everywhere, I gradually calmed . . ." There, she felt Mapple-thorpe's presence: "You will see him. You will know him. These words came to me and I knew I would one day see a sky drawn by Robert's hand." She improvised a ritual of parting: she took off the moccasins she was wearing and waded into the water, singing those words to a melody that had just come to her.

Fame was a motive for Mapplethorpe's life as an artist, and in 1987 and 1988 he had gained art-world fame of a kind. In his final months, death-racked, he was determined to be remembered: he planned for his estate to fund a Mapplethorpe Award in photography (akin to an Oscar or a Grammy), but then shifted his sights and donated $1 million to Beth Israel Hospital for a residential AIDS treatment center bearing his name. Now fame was conferred on him in a Warhol-like moment of ubiquity—not by some critic or curator but by politicians who had never heard of him during his lifetime.

One was Jesse Helms, Republican of North Carolina. A Baptist, elected to the Senate in 1972, Helms was a founding member of the Moral Majority, and his rock-ribbed traditionalism and taste for con-frontation would help shape it. He led a sixteen-day filibuster against the Martin Luther King Jr. holiday. He derided the University of North Carolina as the "University of Negroes and Communists." He was against homosexuality in any form, and he opposed federal funding for research into an AIDS treatment or cure, claiming in 1988, in defiance of medical fact, that "there is not one single case of AIDS in this coun-try that cannot be traced in origin to sodomy."

Helms's positions aligned generally with those of Rev. Wildmon, and then specifically in April 1989. A member of the American Family

Association in Richmond, Virginia, wrote to Wildmon, calling his attention to Andres Serrano's *Piss Christ*, which had been part of a touring show at the Virginia Museum of Fine Arts in Richmond, featuring artists who had received grants from the National Endowment for the Arts. Serrano had given a talk at the museum, and a patron asked about the use of bodily fluids in his work.

By this time, as Stephen Prothero points out in his book on the culture wars, "'Piss Christ' had been shown without fuss or fury in Manhattan, Los Angeles, Pittsburgh," Richmond, and Winston-Salem. That made no difference to Rev. Wildmon. He initiated a direct-mail campaign against the arts agency. As with his campaigns against *The Last Temptation of Christ* and "Like a Prayer," it began with a letter sent to his supporters declaring that this "desecration of Christ" was evidence of the spread of "bias and bigotry against Christians." He urged his supporters to sign and mail preprinted letters in protest. The letters were sent en masse to the two private funders of the show—Equitable Life Assurance and the Rockefeller Foundation—whose leaders, doubtless with the two recent controversies in mind, sent apologies. Then a reproduction of *Piss Christ* with a denunciatory letter was mailed to every member of Congress.

It was a familiar strategy, but with a key difference. Instead of lamenting the lack of Christian studio chiefs in Hollywood, Wildmon took the fight to Washington, where Christian politicians were thriving. A number of North Carolinians sent Wildmon's preprinted complaint to Senator Helms's office. As if he needed a reason to join the campaign, the "desecration" in question had been exhibited in a federally funded show that originated in his state—at the Southeastern Center for Contemporary Art (SECCA) in Winston-Salem.

Helms was not the grand inquisitor yet; other politicians did the spadework, spurred by the televangelist Pat Robertson and the pundit Patrick Buchanan.

The first was Senator Alfonse D'Amato, a Republican and a Catholic from Long Island. He brought the catalog from the touring show to the Senate chamber, and he used his floor time to decry *Piss Christ*. It was "so-called artwork." It was meant "to dishonor Our Lord." It

was a desecration. There in the chamber, he undertook a "counter-desecration"—by tearing up the catalog pages that featured the photograph. He had prepared an open letter denouncing the process whereby the NEA funded work that was "shocking, abhorrent, and completely undeserving of any recognition whatsoever"; echoing the British Muslim imams who had decried *The Satanic Verses*, he called it "filth." Helms joined in, calling Serrano "not an artist" but "a jerk" who was "taunting the American people." Several dozen senators signed the letter.

Serrano learned about the controversy via Page Six, the *New York Post*'s gossip page. "You know, 'Furor Over Piss Christ Photograph,'" he recalled. "And shortly after that Ted Potter contacted me and said yes, that things had been brewing up in Congress and in the Senate." For the next few weeks Serrano kept to himself in the East Village. He got death threats anyhow. "I felt like I was taking it all alone," he recalled, "and no one was defending me except Ted Potter and SECCA, the people who gave me the award. No one was coming to my defense, you know." When Potter came up with a way to explain *Piss Christ*—the work was a critique of the commercialization of religious imagery—Serrano went along with it. Unplacated, Sen. Slade Gordon, Republican of Washington, proposed legislation forbidding future grants to SECCA or museums like it.

Then Dick Armey, Republican of Texas, dragged Robert Mapplethorpe into the controversy. From Philadelphia, the show of Mapplethorpe's photographs had traveled to Chicago; the next stop was the Corcoran Gallery of Art in Washington, where it was due to open on July 1. The show included photographs from Mapplethorpe's *X Portfolio* and photographs of a boy and a girl with their genitals visible. The Philadelphia leg of the show had received $30,000 in funding from the NEA, and the Corcoran had received $300,000 in federal funds to support yearly operating costs. Armey, who had long sought for the NEA to be done away with, drew up a letter threatening to withdraw congressional support for the agency and asking meanwhile "what steps the agency is taking" to ensure that its funds were not used to support "morally reprehensible trash." He circulated the letter to his House colleagues.

All summer, official Washington, the art world, and the tabloids

would be consumed by the letter's effects. More than a hundred congressmen would sign it. The Corcoran, on Seventeenth Street, a block away from the White House, would cancel *The Perfect Moment*, so as not to provoke the conservatives to eliminate the NEA. Helms would denounce Mapplethorpe over and over in the Senate and in the press. In his mouth the artist's name would become a byword for evil. Robert Mapplethorpe was a purveyor of "filth and the forbidden." Robert Mapplethorpe was an "acknowledged homosexual," a figure greedy and depraved, who produced "explicit homoerotic photography and child obscenity." Homosexuals were "a repugnant organized political movement" determined to "proclaim the virtues of their perverse practices" even as thousands of them (who ought to have been quarantined) died of AIDS, the way Robert Mapplethorpe did.

Meanwhile, Helms would identify his own name with the cause of uprightness. A proposed Helms Amendent would forbid the National Endowment for the Arts to fund art that was "obscene or indecent" or was seen to denigrate people based on religion, gender, handicap, or national origin; it didn't pass in Congress, but a compromise amendment referring only to obscenity did. On the Senate floor, Helms would deride "self-proclaimed experts [who] under the banner of art would have us view pornography and obscenity on aesthetic but never moral grounds." *The Perfect Moment* would open at the Contemporary Arts Center in Cincinnati, face a police raid, and then close abruptly, as the museum's director was charged with promoting obscenity.

Andres Serrano and Robert Mapplethorpe never met, but they are forever joined; the controversy involving their work, the NEA, and Congress is a crucial episode in the narratives of the culture wars, with implications for censorship, arts funding, the role of government in the arts, the influence of religion, and the place of gay people in society.

It was also a culminating episode in the story of crypto-religious art in that moment. In retrospect several aspects of the controversy stand out.

One is the way public anger was turned on individual artists. The outcry over *The Last Temptation of Christ* had been directed at the

Hollywood studio chiefs as much as at Martin Scorsese; the one over "Like a Prayer" had been aimed at PepsiCo more than Madonna. But this time Rev. Wildmon and Senator Helms—full-throated evangelists for the American Christian way of life—took their oppositional cue from the supreme leader of the Islamic Republic of Iran. The Ayatollah Khomeini had focused fanatical Islam's hatred of the West onto Salman Rushdie of north London; they focused their hatred of "Sodom-on-the-Hudson" on Andres Serrano of the East Village and Robert Mapplethorpe of Chelsea. They tapped an impulse, as hallowed as the Bible they swore oaths on, that sought to unify a community in angry opposition by marking out an individual as a sacrificial victim—a scapegoat. Rushdie, Serrano, Mapplethorpe: the artist working on his own was easily demonized, the singular imagination no match for the madding crowd.

Another is how swiftly a controversy framed as Christian anger over supposed blasphemy turned into (or revealed itself as) one focused on contempt for homosexuality. In the span of a few months, forces self-aligned with Christian fundamentalism went from decrying the suggestion that Jesus had (hetero)sexual desires (in *The Last Temptation of Christ*), to bemoaning the mere linking of Jesus with "bodily fluids" of any kind (in *Piss Christ*), to demonizing Robert Mapplethorpe's photographs in large part because he had been an "acknowledged homosexual." A controversy about the stature and power of religious images in American society was turned into one about the "perverse" gay movement, even as that movement, ravaged by HIV, underwent a moment of collective agony. "Again and again Helms hammered away at the essential equivalency of art, homosexuality, and AIDS," the queer art historian Jonathan D. Katz observes, "reanimating, zombie-like, the corpse of Robert Mapplethorpe to bear his message." The religious right, finding that it couldn't keep gay people down, found an individual gay person to scapegoat—one who was dead and couldn't defend himself.

The religious right's broader message in the controversy was that sex and religion shouldn't go together. Camille Paglia saw this, and she spelled out the nature of their opposition more boldly and syn-

optically than anybody else. Raised a Catholic in upstate New York among grandparents born in Italy, she had earned a PhD from Yale, and she'd spent years expanding her doctoral thesis into a book called *Sexual Personae* and then several years more struggling in vain to get it published. ("I felt like Cervantes, Genet"—who wrote great books in prison—she later said. "It took all the resources of being Catholic to cut myself off and sit in my cell.") In the book she argued that Western culture has been animated by an ongoing struggle between Puritanism and paganism. *Puritanism* is her term for a restrictive impulse expressed at different points by Protestantism and feminism; *paganism* is a broad term for a carnally exuberant culture borne first by Greek and Roman classical culture and then by Italian Catholicism, which celebrates the body and the life of the senses and thrives on the sexual allure of the forbidden. Paglia identified with Madonna as an Italian-American Catholic "who found Catholic dogma too restrictive"; a few years later, she would call Madonna's early work an "exhilarating burst of defiance and profanation" that tilted against "the resurgence of puritanism among evangelical Christians, right-wing Republicans, and censorship-minded feminists." Had it been available, *Sexual Personae* would have spoken directly to the controversies of the moment; in its terms, Madonna, Scorsese, Serrano, and Mapplethorpe were not "bad" Catholics so much as Catholics in touch with their religion's sources in paganism.

Paglia's insights point up the most striking way that puritanism and Catholicism as she understood them—the fear of the image, and the spellbinding power of the image—intersected in the NEA controversy. Which is this: As the controversy about the nature of images funded by the agency played out in Congress and in the press, the images themselves remained all but unseen. Puritanically, they were withheld from the public whose presumed indignation powered the efforts against them.

This, although the images were photographs. Then as now, photography was the medium par excellence of the middle-class public: photos were easy to make, reproduce, and share. And photography was the medium of the media. *Time* had commissioned Robert Mapplethorpe to shoot Dr. Koop for its cover; if its title were left off, *Piss Christ* could

have been a *Time* cover shot for a feature about Christianity adrift. And yet the media largely refused to print or show the images that official Washington was convulsed over, and held back from printing Mapplethorpe's other photographs, too.

The efforts of suppression, however, had the effect of furthering the controversy. Scorsese, Madonna, Serrano, and Mapplethorpe had made the unspeakable speakable. *Be a Somebody with a BODY*: in their work the carnal aspects of Christianity were frankly and vividly embodied: the fully-man humanity of Christ; the twisty currents of devotion and desire; the immersion in the life of the body that the incarnation had brought about; the thin line between Catholic self-subjugation and devilish self-abasement. Working cryptically, they had shown the supposed clarity of traditional Christian teachings about the body to be as clouded by human frailty as was the crucifix in Serrano's photograph. Through their work, questions of religion and sex were posed as never before.

Once spoken, the unspeakable couldn't be unspoken; the seen couldn't be made unseen. Opposing suppression—defying it—artists and the arts community reasserted the power of images in their own ways. Serrano sat for a *Times* profile but forbade the paper to take a photograph of him. The profile showed his studio instead: ARTIST WHO OUTRAGED CONGRESS LIVES AMID CHRISTIAN SYMBOLS, the headline reported.

In response to the Corcoran's cancellation, a group of artists in Washington arranged for Mapplethorpe's work to be shown at an arts center in the capital, and then, cunningly, at the Corcoran itself. For the night *The Perfect Moment* had been set to premiere they arranged an open-air exhibition that was manifestly free and open to the public. As seven hundred people demonstrated against the cancellation outside the gallery's entrance ("Shame, shame, shame!"), the artists projected reproductions of Mapplethorpe photographs onto the building's pillared granite exterior—giant-size, bright and vivid in the night. The show would go on, the suppressed images exhibited. There was an encircled male nude, as diagrammatic as a Leonardo; and there was a portrait of

the artist himself in a leather bomber jacket and a rebel-without-a-cause hairdo—an unlikely martyr, but a recognizable one.

Keith Haring, too, was emblazoning exterior walls with giant-size images. His bold, kinetic work and the fame that followed on it had made him an international figure, and he traveled regularly to Paris, Milan, and Tokyo, spending time at offshoots of his Pop Shop, first established in New York in 1986 on Jersey Street, behind St. Patrick's Old Cathedral (where Martin Scorsese had been an altar boy). It was in Tokyo in July 1988 that he first noticed a purple "splotch" on one leg: a Kaposi's sarcoma lesion. Back in New York, he was diagnosed with AIDS.

Still strong, he kept working and traveling. For a solo retrospective at the CAPC Musée d'Art Contemporain de Bordeaux in 1986 he had fitted ten of the museum's Romanesque arches with cheeky renderings of the Ten Commandments. Now he took a commission to make a mural for an exterior wall of the church and convent of Sant'Antonio in the historic center of Pisa, and he arranged to spend a week in June there: working, seeing the city, partying with friends, and reflecting in the empty church. As Brad Gooch explains, the mural, *TuttoMondo*, is thick with Christian symbolism: ". . . winged angels, the Madonna and Child, the evil serpent, and the figure bowed in a crucifixion pose," as well as a four-headed figure recalling the knob-tipped cross that is a symbol of Pisa. A photograph shows Haring at the base of the mural, dwarfed by the figures of his imagination. "It will be here for a very, very long time . . ." he wrote in his journal. About Pisa he observed: "It's really beautiful here. If there is a heaven, I hope this is what it's like."

Ayatollah Khomeini died in Tehran on June 3, age eighty-nine. In a final speech, broadcast on state radio, he urged militant Islam's true believers to keep waging war against Western capitalist-imperialists and their lapdogs in the Middle East. Iran's president would succeed him. The fatwa against Salman Rushdie would remain in place.

The same day, a Saturday, China's Communist government declared martial law in Beijing, deploying troops and tanks to disperse a huge crowd gathered in the space outside party headquarters: Tiananmen Square. The conflict had been escalating for months. A proposal for greater economic openness had led to hope for greater political openness, and then to student rallies and protests demanding such openness. The presence of tens of thousands of young people in Tiananmen Square made the yearnings of the populace, unseen due to restrictions on public assembly, visible as never before. The situation in China seemed akin to the one in Poland at the front end of the decade: an authoritarian Communist state long thought invincible was breaking open.

That this wasn't the case was made clear on Monday by a different image. There was a column of tanks rolling through the square, and a man dressed in white was standing in front of them, a shopping bag in each hand, like a pedestrian in a crosswalk insisting on his right of way. For those of us who had come of age after the Vietnam War, the Tank Man footage was as clear an image as we'd seen of individual opposition to state violence, and of its consequences (surely the man was arrested and killed or jailed). And in that moment—when the U.S. news was overloaded with religion—it was a reminder of all the global goings-on that had nothing to do with religion.

The funeral for Khomeini was held in Tehran that day. As the temperature rose to a hundred degrees, a million "weeping, chanting mourners" (as the *Times* called them) massed at the foot of the snow-capped mountains on the city's outskirts, streets and crowds alike clad in black. Khomeini's body, shrouded in white cloth, turban set on the chest, was in a refrigerated glass coffin; as it was borne toward a bier made of shipping containers, the crowd surged and the coffin broke open. The stampede (eight people killed, five hundred injured) was shown on television worldwide—the camera zooming in on the ravaged face of the dead zealot, the crowd chanting like supporters at a soccer match: "Sorrow, sorrow is this day; Khomeini the idol-smasher is with God today."

Salman Rushdie was watching on TV at a cottage in Wales: ". . . the

uncontainable surge and lurch of that many-headed monster, then the bier tilting, the torn shroud, and all at once the dead man's frail, white leg exposed for all to see." The spectacle surpassed his understanding; try as he might, he couldn't dismiss it as the behavior of people in thrall to a tyrant. "The imam had been, for these people, a direct link to their God. The link had snapped. Who would intercede for them now?"

Don DeLillo was watching. He was struck by the aerial shots of massed humanity extending beyond the reach of the camera ". . . like pictures of a thousand years ago, some great city falling clamorously to siege." The images took shape in his imagination as an internal mono- logue for a character in his new novel: Karen, ex–Unification Church, prone to true-believing. "People beat themselves unconscious and were passed limply from hand to hand over the heads of the crowd to re- covery areas nearby . . . [W]omen wrapped in chadors came forth and moved in close and there were many hands pressed to the container, there were hands pressed to the photographs and touching the metal."

The future belongs to crowds: this would be the chant-like refrain at the heart of the novel, an idea at once called forth and borne out by the events of the months to follow. Solidarity in Poland would win ninety- nine of a hundred seats in parliament in the first free elections in four decades. After the release of Václav Havel from prison, dissidents in Prague would frame a new government, with great popular support, even as tens of thousands of people fled to the now-porous border with West Germany. Citizens of the German Democratic Republic (East Germany) would draw together in civil opposition to the communist state there, holding rallies in streets and squares and churches. In the Soviet Union the ruling cadre would agree to hold open elections and allow the Soviet republics to take steps to independence. Finally, on November 9, the Berlin Wall would fall, brought down by crowds of people who joined together to assert their right to live as individuals, not hidden behind the Iron Curtain but visible to all.

The images of peoples united in support of freedom and self- determination were here, there, and everywhere that autumn. It was a moment of geopolitical clarity after half a century of allusive coexis- tence. Americans could have drawn together in support of the assertion

of democratic ideals in the once-solid Soviet bloc—but it was not to be. Earlier in the year, as Jonathan Katz observes, Sen. Daniel Patrick Moynihan of New York, seeing the Soviet empire unraveling, had posed the question of "what would supplant the Communist East as the embodiment of evil in America's eyes." The religious right's demonizing of Mapplethorpe and Serrano offered an answer. The NEA controversy showed that "the absence of a foreign conflict tended to lead the right" to seek out a domestic one, "for the right's central discourse of defensive containment has long required 'others' to define itself against." The religious right was dividing the American people at the very moment when the peoples of Europe were reuniting.

The end of communism was claimed as a victory for traditional, institutional religion. With the fall of the Iron Curtain, believers who had kept faith furtively under the Soviets could believe openly. Religion after state communism would take various forms: muscular, triumphal Catholicism in Poland; dissident priests in Prague helping to rebuild Czech civil society; newly elected officials in Moscow restoring ties between the Russian state and Russian Orthodoxy. The Catholic Church's century-long campaign against institutional atheism had prevailed, brought to fulfillment by Pope John Paul II, who was now seen as both prophet and architect of a new world order.

But there was no new world order, really; beneath the rhetoric of endings and beginnings, the conflicts of the moment ground on.

News from El Salvador in mid-November made that clear. After ten years of civil war, the country was convulsed by street fighting between the FMLN "rebels" and the Duarte military regime, whose killing of civilians had the tacit support of the Bush White House. The Catholic Church was not under the thumb of the regime. Jesuits at Central American University decried the regime's violence and called for a "negotiated settlement" to end the war; the rector, Ignacio Ellacuría, a Spanish theologian, likened Salvadorans to the "crucified peoples" of history. The night of Thursday, November 16, a state-sponsored death squad—men trained by U.S. special forces—broke into the Jesuit

residence at the university. Six priests were asleep; so was the caretaker (a laywoman) and her daughter. The intruder-executioners woke the priests, dragged them to the grass outside, and shot them in the head one by one; caretaker and daughter were shot dead in their beds.

The eight are now recognized as martyrs—Catholics killed for their faith, as Archbishop Romero had been killed by a death squad early in the decade. That is apt, for their deaths fit the pattern of Christian martyrdom: they were believers whose manner of death makes them images of the life of faith. But their deaths also belong to the pattern of religious violence circa 1989, when authoritarian rulers—in El Salvador as in Iran—ordered the deaths of people whose beliefs differed from theirs.

HIV was likewise resistant to the spirit of new beginnings. Nearly a decade into the AIDS epidemic, and five years after the presence of HIV became a pervasive experience for the gay community in the United States, the deaths came without ceasing. Seventy thousand Americans had died of AIDS; another 31,000 would die in the next year. For young men in San Francisco, Los Angeles, and New York City, AIDS was the leading cause of death. A fifth of people who died of AIDS were women or heterosexual men who used drugs intravenously, and the disease was spreading, especially among Black women. The antiretroviral drug AZT was proving useful in the treatment of AIDS and its symptoms; and yet there was no prospect of a cure, or even of a public health effort that would address the disease at the scale it demanded.

Across the decade, the gay community's acts of mourning its own—memorial services and ash-scatterings, posthumous art shows and performances, scrapbooks and mixtapes—had become progressively more communal. The most visible of these collective expressions of loss, grief, and rage had a religious dimension.

The AIDS Memorial Quilt was a giant-size example. It was both do-it-yourself and communal; it was a one-of-a-kind work of public art that drew on the craft traditions of Christians who thrived on apartness from conventional society. The Amish were known (as gay communities

now were) for their mutual aid; the Shakers had kept up their community (as gays were now doing) without replenishing their numbers via procreation.

By the fall of 1989 there were 12,000 panels: 12,000 craft-works conjoined in a memorial to people who had died of AIDS. Each panel was three feet by six feet—"the approximate size of a grave." And three feet by six feet was akin to the size and shape of a canvas at MoMA or a Cibachrome photographic print in a downtown gallery (*Piss Christ*, say). Through the AIDS quilt, the same-sex love historically scorned as out of the ordinary was now registered through American history's most ordinary of domestic objects—the patchwork quilt; the gay community, typed as driven by lust and promiscuity, was now stitched together through acts of devotion.

The ACT UP protest and direct action at St. Patrick's Cathedral would be different.

ACT UP, founded out of the Lesbian and Gay Community Center in 1987, sought to use direct action to force the government to undertake and fund AIDS research and to bring broader recognition of the disease and of the gay community it affected. ACT UP's SILENCE=DEATH sticker—the equation set in white type under a pink triangle on a black background—was stuck on lampposts and phone booths all over Manhattan. Keith Haring, who had been diagosed with AIDS in August 1988, designed a SILENCE=DEATH poster, offered works for auction, and gave generously to the movement (a third of its funding in 1989, Brad Gooch reports). Members chained themselves to the New York Stock Exchange to protest the market's control over AIDS-treatment medicines; members bearing foam tombstones held a "die-in" at the Food and Drug Administration offices near Washington, D.C., prompting the agency to close for a day. (David Wojnarowicz was there, wearing a jean jacket with a message stenciled on it: *If I Die of AIDS, Forget Burial—Just Drop My Body on the Steps of the FDA.*) Five thousand activists joined an ACT UP protest outside City Hall in Manhattan and crossed the Brooklyn Bridge.

As an action at St. Patrick's took shape, Haring took part in Monday meetings at the Gay and Lesbian Community Center in the West

Village. So did Wojnarowicz. His work had been chosen for a group show of art dealing with AIDS called *Witnesses: Against Our Vanishing*, organized by Nan Goldin at Artists Space on Wooster Street, and he had been asked to write an essay for the exhibition catalog.

The cathedral action (as Sarah Schulman spells out in a comprehensive oral history of ACT UP) would extend the movement's previous efforts intentionally and deliberately. It would be a real-time response to the strong language of the Catholic hierarchy's latest efforts to deal with AIDS, gay people, and public health. It would link AIDS policy to issues beyond the ambit of the gay community. And it would draw on the symbolic expressions that crypto-religious artists had developed through the decade, at once extending them and turning them into something else.

The hierarchy's efforts were in the news that fall. Cardinal O'Connor addressed a White House commission on AIDS. (So did the playwright Larry Kramer, founder of ACT UP; speaking straight to the cardinal, he offered a list of great Catholics who he said were gay, Leonardo da Vinci among them.) In interviews after Sunday Mass in late September, O'Connor praised Operation Rescue, a movement whose members expressed their objection to legal abortion by handcuffing themselves to the doors of clinics where abortions were performed; he suggested that he'd like to take part, even to get arrested.

In early November the U.S. Catholic bishops withdrew their strictly limited support for condom instruction in public education. They ratified a new measure rejecting support for use of prophylactics in any circumstances; the archbishop of Los Angeles derided AIDS education via condom instruction as "the safe-sex myth . . . both a lie and a fraud." They also denounced needle exchanges for promoting the immoral behavior that was drug use.

The Church's directives then became entangled in a fresh controversy involving the National Endowment for the Arts. The *Witnesses* show was funded in part by an NEA grant. Prior to its opening, word spread of David Wojnarowicz's catalog essay. In it he imagined killing Jesse Helms, Cardinal O'Connor, and William Dannemeyer, a Republican congressman who had published a book denouncing homosexuality

with Ignatius, a Catholic press. Of O'Connor, Wojnarowicz wrote: "This fat cannibal from the house of walking swastikas up on fifth avenue should lose his church-exempt status and pay taxes retroactively for the last couple of centuries . . . This creep in black skirts has kept safe-sex information off the local television stations and mass transit spaces for the last eight years of the AIDS epidemic thereby helping thousands and thousands to their unnecessary deaths." Conservatives called for the grant to Artists Space—ten thousand dollars, as yet unpaid—to be rescinded. Artists rallied in support of the as-yet-unseen exhibit. The grant money was withheld. O'Connor said, "Had I been consulted, I would have urged very strongly that the National Endowment not withdraw its sponsorship on the basis of criticism against me personally. I do not consider myself exempt from or above criticism by anyone." The NEA's chairman was given a preview of the show; after seeing it, he reversed the agency's position and authorized the grant, as long as it would not be used to fund the catalog (which the gallery funded with a grant from the new Robert Mapplethorpe Foundation). Unmoved, Wojnarowicz put together a dossier of church leaders' and public officials' "Seven Deadly Sins" against gay people and people with AIDS.

A thousand Catholic clerics and health experts met in Rome in mid-November. "John Cardinal O'Connor of New York opened the first Vatican conference on AIDS today by assailing the use of condoms and the distribution of syringes to addicts as means of stopping the spread of the disease," the Times report began, bluntly. "He also urged that people with AIDS not be treated as outcasts, perceived as public health hazards and left to die. 'The truth is not in condoms or clean needles . . . These are lies, lies perpetrated often for political reasons on the part of public officials.'" Further in, there was this: "'Sometimes I believe the greatest damage done to persons with AIDS is done by the dishonesty of those health care professionals who refuse to confront the moral dimensions of sexual aberrations or drug abuse . . . Good morality is good medicine.'"

The U.S. bishops' letter was released November 28. Their observations were offered as certainties, grounded in the authority of the Church, which was "expert in humanity" (as the pope had said). "Sexual

intercourse is appropriate and morally good only when, in the context of heterosexual marriage, it is a celebration of faithful love and is open to new life. The use of prophylactics to prevent the spread of HIV is technically unreliable. Moreover, advocating this approach means, in effect, promoting behavior that is morally unacceptable."

Myths, lies, fraud, dishonesty, damage, unacceptable: it was partly in response to such lofty observations from men "expert in humanity" that ACT UP's "Stop the Church" action took shape. It would be a "Massive Protest" that would address AIDS policy, abortion rights, gay rights, and sex education all together. Women's Health Action and Mobilization (WHAM!) was a co-organizer; at meetings held across several weeks, members of the two movements planned a protest, designed posters, crafted slogans, and devised a media strategy. An ACT UP member, Robert Hilferty, took video of one of the meetings—a raucous session full of anger and contempt for the Church.

ACT UP members weighed the pro and cons of disrupting Mass, as Anthony M. Petro makes clear in a comprehensive account of the protest. Hilferty's footage records their deliberations. Some were all for "getting into that church to offend parishioners." Some were against on the grounds that it would violate the worshippers' free speech ("We wouldn't want them busting into an ACT UP meeting"). And some were against because O'Connor, not the Church as such, was the target ("For God's sake, three [sic] priests were killed this week in El Salvador!"). The members made an arrangement whereby ACT UP would organize the protest outside the cathedral and "affinity groups" would protest inside. They drafted a media advisory clarifying their aims: "We are marching on the Church to show the Cardinal and his fanatic followers that their religious bullying infringes on the personal rights of all Americans." Flyers for distribution at the cathedral observed that St. Patrick's "is, after all, your place of worship . . . We are aware of this, and we ask for your understanding and participation."

The posters ACT UP produced, by contrast, were confrontational. PUBLIC HEALTH MENACE featured a photograph of Cardinal O'Connor with pinwheels over his eyes; STOP THIS MAN showed robed jihadists with guns drawn—supposedly representing O'Connor's wish to "get

more aggressive" against abortion. AYATOLLAH O'CONNOR equated the one religious leader and the other. A pair of posters drew on Andy Warhol's *Last Supper* series, juxtaposing a black-and-white outline of Jesus with dialogue bubbles from comic strips. In one, Jesus (wearing a SILENCE=DEATH button) holds a condom in his hands: "Let me demonstrate!" he says. In the other, he says "Let me demonstrate" again; but this time he swings a hammer at a spike, driving it into the neck of O'Connor, who has devil's horns protruding from his head.

As word of the protest circulated, the archdiocese and the city made plans. Sawhorses were set up on Fifth Avenue, police officers assigned Sunday duty; Cardinal O'Connor had the text of his homily printed, in case he was unable to deliver it from the pulpit.

December 10 was the second Sunday of Advent, the "season of waiting" prior to Christmas—and prime time for holiday tourism in midtown, centered on the gigantic outdoor Christmas tree at Rockefeller Center. Activists and authorities alike made ready for a crowd of five thousand activists to converge on the cathedral.

Something like that many came. Together the two movements and their supporters constituted a crowd. They marched down Fifth Avenue to Fiftieth Street—Rockefeller Center opposite, Saks just ahead, and the cathedral barricaded by sawhorses, as it had been the day in 1987 when a crowd came to remember Andy Warhol.

The crowd surged against the barricades, yelling "Stop the Church! Stop the Church!"—an image that would be repeated over and over on the local news and then in the world news. "Keep your church out of my crotch!" And: "Keep your rosaries off my ovaries!" Counterprotestors were in the mix, taunting: "We hate fags!" David Wojnarowicz was there, a ski mask over his face. Keith Haring, shivering in a light jacket, happened on a friend from the School of Visual Arts, Frank Holiday, who gave him a scarf to wear. "A guy lit a Bible on fire . . ." Holiday recalled. "Someone dressed as the Flying Nun was being held above our heads, shouting, 'I'm flying!' I looked back, and Keith was gone."

The protest outside St. Patrick's was the largest ACT UP had organized, and one whose scale and collective energy would not be surpassed. But what happened inside the cathedral drew more intense

scrutiny. Because the tabloid coverage was unreliable, what happened is still open to interpretation. Hilferty's footage shows that many dozens of activists entered the church peacefully, eyed by parishioners, ushers, and police. They distributed the flyers spelling out the aims of the protest. Mass began, as usual: organ prelude, hymn, opening prayers, scripture readings, homily. Cardinal O'Connor climbed the steps to the pulpit, a marble crow's nest mounted alongside a pillar in the nave, and began to speak. A couple of minutes into his homily, a referee's whistle blew. The activists fell to the ground and let their bodies go limp. This was a die-in. But it wasn't just that. As worshippers and protestors alike fell silent, a man's voice cried out, wildly: "Stop killing us! We're not gonna take it anymore!"

"O'Connor, you're a bigot!"

"You're murdering us!"

"We're fighting for your lives, too!"

O'Connor began to say the Our Father, and the congregation joined him. Activists lay unmoving in the aisles; and as he said the Hail Mary, and then the Doxology ("Glory Be . . ."), ambulance men and police approached them, stretchers in hand. The activists did not move. The officers bent low and strapped them to stretchers and bore them out of the cathedral, where they were arrested for disturbing the peace.

O'Connor spoke to the congregation: "We must never respond to hate with hate, only with love, compassion, and understanding." The Mass resumed. A little later, the worshippers formed lines to receive Communion. An activist was among them: a man in his twenties, conservatively dressed. A Franciscan priest, vested in purple and white over his hooded brown cloak, presented the Eucharist to him. The man took the host in his hands, as Catholics have done since the reforms of the Second Vatican Council. "This is what I think of your God," he said; he broke the host into many pieces (as the priest does during the Consecration); then he opened his hand, letting the pieces scatter onto the floor of the cathedral, where activists had lain in mock rigor mortis a few minutes earlier.

This was the act that made ACT UP notorious and got the "massive protest" splashed across the front pages of the next day's papers. The

Daily News front page showed a photo of O'Connor and the words OVER MY DEAD BODY. The *Times* headlined an editorial "The Storming of St. Pat's." The *Post* called it an "invasion." All this for a demonstration that was largely peaceful—one that, like O'Connor's prayerful response, drew on the tactics of nonviolence pioneered by the civil rights movement.

Why did the press so bluntly characterize the episode in terms of violence? One reason is that the protestors themselves had framed their efforts in terms of violence—on their placards and in their chants. Another is that the site of the protest was not a lunch counter, or an abortion clinic, or the sidewalk outside the cathedral, but the cathedral itself; beyond the right of free exercise of religion, a respect for sacred space—a respect ancient and rooted in forces beyond law—had been violated.

The desecration of the Eucharist (supposedly as many as seven activists had done it, not just one, as the story metastasized in the press) was an affront to the Catholic belief that the consecrated host is the actual body of Christ, made present in the Mass. A less obvious affront was that gay people, so long seen as marginal and vulnerable, had presented themselves in numbers: vocal, aggressive, allied to other progressive causes.

True enough—and yet the uproarious headlines also fit the established pattern whereby gay people were made into scapegoats.

The long-term effects of the cathedral action were pronounced. ACT UP and its equating of silence about AIDS with death came to be known all over the world, not just in Manhattan, and its pink-and-black graphics made the pandemic visible to people who would never see a Kaposi's lesion. The movement's demands for swift action on treatment for HIV were recognized as common sense. The AIDS crisis was recast as a failure of public policy—the action underscoring the conclusions of a government report released the week before. Gay rights and AIDS relief were joined to women's rights and abortion rights—activists forming a united front around sexual behavior as the core of individual freedom.

Those effects were felt by many of us in the city who identified ourselves as Catholics first of all. Through the cathedral action, the

size, anger, determination, cleverness, and essential middle-class-ness
of the gay community and those in solidarity with it were apparent as
never before. AIDS activists were people in down jackets, stonewashed
jeans, Reeboks. No longer other, they were ordinary New Yorkers who
would protest in midtown on Sunday and go to work in midtown on
Monday.

But the action itself, at the time, was still other. "Rend your hearts
and not your garments"—the biblical injunction came to mind. The
cause was just, but so was the rending feeling it left, as if a cathedral-
shaped space of interiority had been violated.

Out of the public eye, the action divided ACT UP, too, in the days
that followed, with some members concerned that the new united front
was a distraction from AIDS-specific agitation, and others feeling that
the die-in and the desecration had unwittingly turned public attention
away from sexual freedom and onto freedom of religion.

Such issues would animate public discourse into the next century.
Truly, they would dominate the discourse to such a degree that it
now takes close attention to see the cathedral action as one having do
to with the power of religious patterns and images—a power unleashed
when the images were stretched and pushed to the point of violation.

The action followed on the crypto-religious work of the moment—
the aggressive Cleansing of the Temple in Scorsese's *The Last Tempta-
tion of Christ*, Madonna's sexy self-prostration before a Black saint in a
church in the "Like a Prayer" video. But it followed more specifically
on the religious right's massive protests against art of this kind, protests
that had moved the controversy over art, sex, and religion into the
streets and into the chambers of Congress, where Senator D'Amato (a
Catholic New Yorker) had torn up a work of art—an image of Christ
on the cross—to get some publicity and make a point.

In its coverage of the cathedral action the press treated respect for
sacred space as a kind of prophylactic: hardly visible, intermittently felt,
and vital to the health of the body politic. But the action itself engaged
sacred space on a deeper level. As ACT UP reckoned it, the Church's
involvement in public health policy on sex education (in public schools,
no less) had eroded the distinction between sacred space and public

space. Emboldened by the Church's opposition to condom use, the pro-
testors did away with the prophylactic that would keep the Church itself
untouched.

This was apt, for the Church had failed to grasp the full significance
of sacred space. It was a big fail. With its pastoral letters and policy pre-
scriptions ("good morality is good medicine"), the hierarchy had treated
AIDS mainly as a problem to be addressed, rather than as an experience
to be undergone—to be apprehended through faith, centered on the
suffering and death of Jesus ("This is my body, which I have given up
for you") as made present at Mass. When Catholic New Yorkers who
were gay—Dignity—found community by bringing the suffering of
AIDS to Mass, the archdiocese ousted them from its houses of worship.
In this sense, the ACT UP cathedral action was not a violation of sacred
space but a reclamation; it brought AIDS out of the documents of the
bishops' conference and into the church, where it ought to have been
all along.

The action was uncivil and irreverent, but it worked. In a sense, it
worked for all involved. It made ACT UP a force in AIDS policy. At
the same time, the public response to it made clear that the cathedral—
the city's most visible symbol of institutional Christianity—still had the
aura of the extraordinary that Catholic leaders had sought when they
erected it on Fifth Avenue. Sacred space was still sacred; the Gothic
Revival tourist attraction near Saks and Radio City was a house of
worship first of all.

The response to the desecration of the Eucharist had a like effect.
A quarter century after Vatican II shifted the Mass's emphasis from the
Real Presence of Christ to the presence of the community of faith, it
turned out that the presence of Christ in the Eucharist was still "real"
for the Catholic populace and still credible in society. But just as the
Church taught that the consecrated host "is" the Body of Christ, so the
Church taught that the human body "is" the Body of Christ, made in
God's image. The Church taught that gay sex was a violation of that
body. The gay community insisted otherwise. *Be a Somebody with a
BODY*: the injunction from Warhol's *Last Supper* series—a work that
had been praised at St. Patrick's as "a major breakthrough in religious

art"—was made real through the cathedral action, as the bodies of activists went still as at the hour of death and were borne out of the place on stretchers as if for burial.

As archbishop of New York, Cardinal O'Connor was bound to decry the action. Sacred space had been violated; the Eucharist had been desecrated; he had been made a scapegoat by the protestors. But his insistence that the action infringed on the Church's civil rights was a step too far. Ten months earlier O'Connor, at St. Patrick's, had denounced a novel that he hadn't read in the name of protecting the civil rights of a religion that wasn't his. The archbishop with a poli-sci PhD had gone in for a higher ignorance, yoking his efforts to be "expert" in public morality to the ravings of a fanatical tyrant who urged Muslims worldwide to kill a writer for the sake of religious rights.

In that moment, artists had been working the territory where sacred met profane in complex and profound ways, making art that was not religious or irreligious but crypto-religious. The Christian right, maintaining that there must be no contact between the sacred and the profane, found their view afirmed by the Ayatollah Khomeini, who urged murder as a preventive measure. O'Connor, prone to take sides, took a side—not in an interview or a newspaper column or a forum on interreligious dialogue but from the pulpit of the cathedral during Mass on Sunday. His denunciation of violence aside, he used the sacred space he supervised to stand with the fanatic.

The ACT UP protestors, entering the cathedral on another Sunday, walked through a door the archbishop had opened.

"From the wars against disorder, from the sirens night and day / from the fires of the homeless, from the ashes of the gay . . ." / With those images, Leonard Cohen, singing over a synthesizer and a snare drum, envisioned (on *The Future*) a near future that was akin to the present but distinctly different from it.

Along with the doctors, the lawyers, the politicians, the scholars, the activists, the clerics, and the talking heads, artists in the near future would ponder the breaking-through of AIDS into American public

life that was manifested that Sunday at St. Patrick's. One was doing so already.

Richard Rodriguez, in San Francisco, went to Sunday Mass in those days at the Church of the Most Holy Redeemer, corner of Eighteenth and Diamond streets.

San Francisco, not New York, was the place in the United States most gravely affected by the AIDS epidemic (109 deaths per hundred thousand people, as compared with 58 per hundred thousand), and the smaller, more neighborly character of the city compounded the effect. The Catholic Church there was led by Archbishop John Quinn, who had been appointed shortly before John Paul II was elected and made an admonitory approach to sexuality a main qualification for archbishops. Quinn was the first big-city archbishop to engage with the AIDS crisis—by authorizing an AIDS ministry at Most Holy Redeemer—and the first to urge the Vatican to do so.

Most Holy Redeemer was built in 1900 as a parish church in the Eureka Valley; in the 1970s, as the district drew gay men, who referred to it by the name on a prominent movie-house marquee—the Castro—Most Holy Redeemer became the parish church for gay Catholics, many coming from other neighborhoods, as Rodriguez did.

The gay Catholic early-eighties San Francisco yuppie in *The Golden Gate* had been a solitary figure, alone with his *Summa* and his scruples. AIDS and the Church's response to it had made such a figure incredible. Being homosexual—like being Catholic—now had an inescapably public dimension, and the homosexual who was Catholic had to sort out his orientations. That is what Rodriguez was doing, in an essay whose style and mood were so far from the action at St. Patrick's as to be a counterargument. In it he developed his own outlook, shaped by the qualities that had shaped his city—"the Mediterranean, the Latin, the Catholic, the Castro, the gay"—qualities that seemed to fit together and to touch the depths of the calamity that was AIDS. And the singularity of his outlook would serve as a reminder of all the essays that went unwritten, the art and music never made, the reckonings with religion left unfinished because the men who could have undertaken them died of AIDS.

The essay is a compact epic with Rodriguez as a reluctant pro-
tagonist. We meet him in the late seventies, emerging from a Latin
Mass (the subject of an earlier essay) to see for the first time a gay pride
parade, the affinity groups on the march behind banners putting in
mind "the consortiums of the blessed in Renaissance paintings"—GAY
DENTISTS . . . LATINA LESBIANS . . . et al. The tone turns detached: "Five
years later, another parade. Politicians waved from white convertibles.
Dykes on Bikes revved up, thumbs upped. But now banners bore the
acronyms of death. AIDS. ARC. Drums were muffled as passing, plum-
spotted men slid by on motorized cable cars."

There follows a chronicle of the flowering of gay life that had rein-
vigorated the city in the seventies. San Francisco was already a demi-
paradise, "famed as a playful place, more Catholic than Protestant in its
eschatological intuition"—like Rome, an open city in a world at once
fallen and redeemed. Homosexuals came to the city for its reputation
for openness, explored their desires in the rough-and-tumble bars of the
Tenderloin and Folsom Street, and then roosted in the Castro. There,
Rodriguez mordantly observes, wood-framed Victorian houses (the ar-
chitectural image of upright Protestant family life) became "dollhouses
for libertines." There, the acting-out of a pageant of domesticity (inte-
rior decoration) and the promiscuous acquisition of real estate ("buying,
fixing up, then selling and moving on") brought about a way of life that
he saw as a reproach to the modernizing energies of downtown, and
of New York and Washington, too. There, the extraordinary became
ordinary; while the leather bars still propped their doors open to rough
trade, "the Castro District, with its ice-cream parlors and hardware
stores, was the more revolutionary place." And the Castro was a place
whose dedication to lives lived "against nature" (against bourgeois no-
tions of sex, marriage, and child-raising) made it faintly but distinctly
Catholic. Against the skyscraping profit center of downtown, the Cas-
tro and the neighboring Fillmore "asserted idiosyncrasy, human scale,
light." The men there were a confraternity pledged to a communal
existence. On the streets, in Victorian houses, clinking wineglasses in
restaurants, they made a vocation of "the perfected life-style, the little
way of the City of St. Francis."

If Rodriguez had stopped there, his sketch would have been original and arresting—a gay Catholic's re-envisioning of the supposedly secular city. But of course he couldn't stop there. The optimism that spurred homosexuals to make gay lives in San Francisco had been arrested by AIDS. And as AIDS took gay men, individually and then in legions, the city's "eschatological intuition," deeply rooted in the Catholic suspicion of all things new and improved, reasserted itself. Death came to the demi-paradise. San Francisco, blessed with location, natural beauty, and charm, was, first and finally—right here, right now—a fallen place.

It was a place where biblical calamity was near at hand. Now the gay newspapers were running ads for caskets and funeral parlors, publishing obituaries. Now men like Rodriguez's dear friend César (who "had no religion other than aesthetic bravery") were fashioning memorial services. Rodriguez, an old soul, became a recording angel, called to find words for the unspeakable that was death from AIDS as Death itself came to roost in the Castro. "I have seen people caressing it, staring Death down," he wrote. "I have seen people wipe its tears, wipe its ass; I have seen people kiss Death on his lips, where once there were lips."

What he was witnessing, in the face of Death, was something other than deathly: "AIDS was a disease of the entire city; its victims were as often black, Hispanic, straight. Neither were Charity and Mercy only white, only male, only gay. Others came. There were nurses and nuns and the couple from next door, co-workers, strangers, teenagers, corporations, pensioners. A community was forming over the city."

The people who gave succor to people with AIDS were the saints of the city—an insight Rodriguez felt in its full significance when he went to Mass in the Castro. "And the saints of this city have names that are listed in the phone book, names I heard called through a microphone one cold Sunday in Advent as I sat in Most Holy Redeemer church"—where people involved in the parish AIDS ministry were recognized and applauded. "It might have been any of the churches or community centers in the Castro district, but it happened at Most Holy Redeemer

at a time in the history of the world when the Roman Catholic Church still pronounced the homosexual a sinner."

The Richard Rodriguez we encounter in "Late Victorians" (as the essay is called) is not an activist, not a volunteer in the AIDS ministry. He is not on the right side of history; he is a writer, a Catholic, and a homosexual, a man in the middle of his life in San Francisco. But he recognizes the significance of what he saw at Mass that Sunday. In the essay, he looks forward (with a certainty which matches that of the bishops) to a time when the Church will no longer pronounce the homosexual a sinner. In that time the Church will embrace the homosexual as ordinary, an embrace prefigured by this assembly of the blessed at Most Holy Redeemer—"this, what looks like a Christmas party in an insurance office and not as in Renaissance paintings, and not as we had always thought, not some flower-strewn, some sequined curtain call of grease-painted heroes gesturing to the stalls." It is a time shown (through a glass, darkly) in the specifics of one Sunday in San Francisco. No activist, this writer whose closely held Catholicism left him leery of revolution has seen the future and is making it present through an act of the imagination.

This is the way of the crypto-religious artists who are his next of kin—the artists whose tales this book has sought to tell. These are figures who have seen deep into the moment in time they find themselves in. Across a decade, they have made work that pushes past boundaries upheld by formal religion, and have been called out for doing so. It is work that points to the future, but is rooted in the present—a more complex present than the keepers of the keys to the churches can recognize. It makes vivid habits of belief that might be left unseen and unspoken otherwise. It seems prescriptive, but it is descriptive first of all—devoted, in the way of art, to rendering things as they are.

Bob Dylan was the forerunner; the music he made in the sixties, rooted unmistakably in the past, gestured surreally and prophetically toward the future, but the effect was to define the present unforgettably for a generation, such that the next generation had to struggle to find some way out and past it. Then on the threshold of the eighties he

saw a slow train coming around the bend and prophesied the present again.

Now Dylan followed up on the introduction Bono had made and sought out Daniel Lanois in New Orleans. There, Lanois was finishing a record with the Neville Brothers. Things were looking up for them. Charles, Aaron, and Cyril had kicked drugs, even as Art got hooked after years of resistance. They'd been embraced by the Deadheads as masters of hip-shaking transcendence. Aaron had done four duets with Linda Ronstadt (at peak Sinatra-songbook acclaim); the brothers had gotten a record deal with A&M. And they were finding their way toward interior peace: Aaron in Catholicism, Charles in the Higher Power of the recovery movement, Cyril in Rasta-inspired political activism. Charles: "I made a decision to accept God's will, not my own. No one dictated my definition of God. I wasn't pressured to accept any specific theology or moral code. It was the God of my own understanding." Lanois had rented a place on St. Charles Avenue (the streetcar ran right past) and outfitted it as a studio. "Artie brought in a stuffed bobcat, some big ol' rubber snakes, and thickets of moss to hang from the ceiling," Cyril recalled. "Lanois had the voodoo vibe going strong; he had psychics dropping by . . ." Lanois himself said, "The vibe was thick and significant."

The record they made in the Uptown place, *Yellow Moon*, was more somber than anything they'd done. The sound was at once past-casked and topical. The songs were a mix of originals and well-worn songs by others. They did languid versions of "Will the Circle Be Unbroken" and "A Change Is Gonna Come"—anthems of the civil rights movement. And they did a couple of songs from Dylan's early folk-protest records: "The Ballad of Hollis Brown" and "With God on Our Side," sung by Aaron, recital-style.

Yellow Moon was almost finished when Dylan dropped by. Lanois played him some mixes. Hearing his own songs, Dylan was caught by surprise. "Aaron is . . . a figure of rugged power, built like a tank but has the most angelic singing voice, a voice that could almost redeem a lost soul," he recounts in *Chronicles*. ". . . There's so much spirituality in his singing that it could even bring sanity back in a world of madness."

"With God on Our Side," specifically, was a kind of opening: a song the Nevilles made their own by inverting the original—throwing it forward, giving it new life.

The song is a history lesson in nine verses. "I was taught and brought up / To the laws to abide / That the land that I live in / Has God on its side": from there, the lyrics work through American strife—frontier wars, Spanish-American War, Civil War, First World War, Cold War. Dylan's version on *The Times They Are a-Changin'* is primitive-plaintive. A duet version with Joan Baez at Newport in 1964 is all harsh edges and split ends: their voices, stretching out of range, convey young whites' rising anger over the thwarting of Black civil rights and the deepening of the war in Vietnam. It is protest music at its most strident—a song against religious righteousness that is itself righteous.

In New Orleans, the Nevilles and Lanois had brought the old song back home. A somber, muted synth sets the mood, a pedal point that will be sustained throughout. But this version is basically all Aaron. In his falsetto he works slowly and gently through the verses, adding a new one about Vietnam before returning, as Dylan did, to the biblical: "But I can't think for you / You'll have to decide / Whether Judas Iscariot / Had God on his side . . ."

He ends with a personal grace note: "Jesus loves me, this I know," he mumbles, with a sincerity beyond irony. It's an extraordinary moment. With the culture wars thickening, a great anti-war song has been refashioned as a hymn against true-believing.

"Over the years, songs might get away from you, but a version like this always brings it closer again," Dylan recalls in *Chronicles*. "After hearing Aaron's renditions of my songs, I faintly remembered the reason we were there."

Dylan returned to New Orleans a few months later to make a new record of his own. Lanois had rented a rambling Victorian house near Lafayette Cemetery No. 1 and outfitted it with vintage gear. Dylan decreed that they would record only at night. By day he roamed New Orleans and southern Louisiana. He explored the cemeteries, sometimes stopping to pray beside a tomb. He rode a Harley-Davidson out into the bayou. He listened to WWOZ, the local roots-music station,

which reminded him of the radio stations he'd grown up with. He took in the mysteries of the city. "Even with all the churches and temples and cemeteries, New Orleans doesn't have the psychic current of holy places," he observed. As an oft-told anecdote had it, ". . . here the devil is damned, just like everybody else, only worse. The devil comes here and sighs."

By night he recorded dozens of songs, working with roots musicians drawn from near and far. They didn't know what they were looking for or if they were finding it.

The record, *Oh Mercy*, came out in the fall and jostled with *Yellow Moon* for attention on year-end lists. Critics and followers were divided about it. So was Dylan himself. But more or less uncontested was the view that he and Lanois had found a fresh *sound* for his music. This would be the sound of the stronger and subtler records he would make a decade later: *Time out of Mind* and *"Love and Theft."* Murky, swampy, rootsy, ambient, reverberative, mysterious: the critical argot was tapped for terms to describe a recorded sound that made the music as cryptic as the words.

One song on *Oh Mercy* was left all but untouched by the sonic appliqué: "Ring Them Bells." Dylan sang over a chiming piano, the way Aaron Neville had sung "With God on Our Side" over a sustained synth note. Like that song, this one was a stately recitation with religious overtones. "Ring them bells ye heathens from the city that dreams," he began, and the verses that followed tolled the hours, first to last. Ring them bells, St. Peter, over the sun going down; ring them bells, sweet Martha, over the shepherds in the fields—and so on . . . "Ring them bells for the blind and the deaf / Ring them bells for all of us who are left / Ring them bells for the chosen few / Who will judge the many when the game is through . . ."

This song was neither old nor new; it evoked Dylan's folk-protest era and his gospel period. It used biblical imagery to set history in a space of transcendence above and beyond belief; it rang them bells over and over as if in mourning for a moment that was ending, for a state of mind he was abandoning, for religion itself.

EPILOGUE: HARD LINES

Religion is cryptic. Its cryptic quality is its animating spirit—its style, its power, its wisdom, its original sin. At the level of lived experience, era-spanning collective undertakings that are the religions are efforts to unencrypt the spirit—to make its paths straight. Happy are those who feel the divine presence in those efforts: the rituals and precepts, the here-I-ams and thou-shalt-nots, the joyful noise, the joinings of hands and hearts to God. Happy are those whose beliefs make things clear and distinct. But no matter how hard we try to master it, the spirit won't submit. It will defy the explicit, withdrawing to cave or desert or pillar (those original liminal spaces) to recover the power we call mystery.

Crypto-religious art is sourced there. In an explicit age, rich in how-to-do-that and why-this-matters, it reconciles the cryptic quality of religion with the cryptic quality of lived experience. It writes straight with crooked lines; it puts stress on the cracks and breaks in created things, so that we can see ourselves in the light that gets in. It reminds us that the questions at the core of the human situation can't be settled through fact or doctrine, which means they must be approached imaginatively.

With time, crypto-religious work judged as confounding or appalling in the era of its making comes to seem familiar, straightforward,

tradition-evocative, rootsy. But its cryptic aspect still lurks within. A stadium encore improvised out of a psalm; a pair of angels walled off from mortality in black-and-white Berlin; a crucifix aglint in golden light: even when the context is filled in, this work has the qualities the literary critic Harold Bloom celebrated in scripture, Shakespeare, and modernism—it has strength and strangeness.

The circumstances of the work's life in the world remain strange, too. It's strange that Andy Warhol went deep into *The Last Supper*, not knowing that he would die when he finished. Strange that Martin Scorsese would devote parts of fifteen years to making a personal picture about Jesus Christ.

Strange that Keith Haring, weakened by AIDS, would use a knife to etch clay tablets with lines and figures suggesting episodes from the Gospels; strange that the designs would be cast in bronze and covered in white gold and put on display at Grace Cathedral in San Francisco and the Cathedral of St. John the Divine in New York, Episcopal congregations whose members had cared for people with AIDS.

Strange that *Beloved*, cryptic to its core, would become a standard text for twelfth-graders (and would be scratched from some syllabi as explicit); strange that Leonard Cohen's "Hallelujah" would join "Amazing Grace" as the one spiritual everybody knows; strange that Nick Cave and PJ Harvey would work through scriptural-theological obsessions in songs beyond number, becoming Cohen's brooding God-haunted successors. Strange that the moment when Sinéad O'Connor tore up a picture of a pope on live TV would define her career.

That incident is the beginning of the end of these tales of the crypto-religious, for it's at once a kind of postlude to the controversy-heavy 1980s and a pivot point which connects that decade to the present.

On YouTube the video clip comes and goes—put up, taken down for copyright reasons, and then put up again. Ah, there it is—there she is. At twenty-four, a star for five years already, she is youth-and-beauty itself, railing against authority as she speak-sings "War" and rips the clipping of John Paul. But the clarity of her stance, her visage, her voice, and the emotions she summons conceal how cryptic the gesture is.

In her 2021 autobiography she filled in the backstory. She was thirteen when John Paul visited Ireland in 1979. Her mother clipped a news story about the visit and stuck it on a wall of their home in Dublin: "Young people of Ireland, I love you," the pope had said. Sinéad took the clipping off the wall after her mother's death and carried it on her person, amulet-like, as if to remind her where she had come from.

SNL began its eighteenth season in the fall of 1992. Sinéad arrived in New York in late September to perform on the October 2 episode and at a Bob Dylan tribute concert two weeks later. She'd been following news reports out of Ireland about children who said they were abused by priests but weren't believed; she'd been reading *The Holy Blood and the Holy Grail* ("a contrarian, blasphemous history of the early church"). She was staying at the Hotel Chelsea, but her base in the city was a bar near Tompkins Square owned by Irish and named for the patron saint of the mentally ill, St. Dymphna. Hating bars, hating alcohol, she would sit on a bench outside with a coffee and a smoke. Before long she gravitated to a juice bar across the street—a place run by Rastafarians, the weed smoke semi-concealing an altar at the rear. The dreads there quoted bits of scripture and muttered imprecations against homosexuals. One, named Terry, lent her his long leather coat and spelled out the Rasta worldview. The book of Revelation is about "the end of religion." England is the eternal enemy of Ireland. "'An deh pope is deh devil. So deh devil is deh reeel h-enemee,'" Terry said.

That Friday, Terry, out of nowhere, told her that some men were going to kill him because he had crossed them up in a drug deal; strangely, he asked her to forgive him. She was alarmed. Her dread-guide was a gangster, and in danger! She took a taxi to the hotel (the cabbie making a move on her en route) and paced the floor through the night.

On Saturday, tired and addled, she went from the hotel to the *SNL* studio in Rockefeller Center. She brought an article she'd read about a young person in Brazil—a street kid—who'd been killed pointlessly by police. During a rehearsal she brandished the article about Brazil; on the live broadcast a few hours later she swapped in the clipping from her childhood. She held it up and tore it up. That the figure on it was

the pope was plain to see. But when she urged the audience to "Fight the real enemy!" the gangsters stalking her Rasta friend were the enemy she had in mind.

Terry was killed; Sinéad was "banned for life" from NBC; the press rounded on her like the hoodlums who'd thrown eggs at her and her assistant as she left 30 Rock after the show (Sinéad and aide gave chase, and the guys fled). And then Madonna weighed in. Since the "Like a Prayer" fracas, she had pushed her use of religious imagery past provocation to confrontation. Her *Blond Ambition* tour featured a sequence in which she mock-masturbated to orgasm, was condemned by dancers dressed in clerical garb, then donned a friar's cloak and bent low in sexy reverie, a heavy crucifix dangling over her breasts—and then shucked off the crucifix to sing "Papa Don't Preach." Her "Justify My Love" video showed her fellating a man who wore a clutch of crosses. Her *Sex* book was graphic. But in this controversy she took the role of scold: "I think you need to do more than denigrate a symbol," she said.

In the days that followed, Sinéad had to fend for herself. She went to Madison Square Garden for the Dylan tribute: she was going to sing "I Believe in You," from *Slow Train Coming*, a favorite since childhood. As she took the stage, in a pale-blue dress, many in the crowd of twenty thousand booed. Alone in the spotlight, she prayed silently, asking God what to do. She spotted Kris Kristofferson, who had sung earlier, approaching center stage. "As he's making his way there, I get my answer from God: I'm to do what Jesus would do. So I literally scream the biggest rage I can muster, the Bob Marley song 'War' to which I tore up the pope's picture [on *SNL*]. And then I almost get sick."

It was a strange moment. Strange that she'd been initiated to Dylan by *Slow Train Coming*. Strange that as a rising star she struggled to make sense of the religion she was raised in; strange that she kept that struggle at the center of her work as she gained fame, seeing the work as a way to find clarity for herself and her audience. Strange that she was still going to sing "I Believe in You" after the *SNL* debacle; and strange that she responded in a spirit of devotion as the crowd booed her. Strange that she still believed—still petitioned the Lord with prayer in an hour of

need. Strange that she sang a Bob Marley song—but prescient, too; she grasped that in the ten years following his death Marley had become *the* global voice of prophetic utterance, and that she and Dylan belonged to a tradition of crypto-religious protest that was bigger than both of them.

The incident has been simplified in the decades since. The tearing-up of a clipping on *SNL* is recalled as a protest against the sexual abuse of children in the Catholic Church; as a desecration of the pope, not of a picture of him. The simplifications are telling, for they reveal the way the religious situation of our time has been simplified.

That incident comes after a decade in which crypto-religious figures have worked the liminal space between belief and disbelief to powerful effect. In the 1990s, as actual war yields to culture war, the liminal space becomes a border and then a hard line between religion and anti-religion. When Sinéad tears up a picture of the pope on live TV she is an agent of that hardening; in the aftermath, she winds up a casualty of it.

In the moment, she is acting on precedents largely overlooked then and since. Cardinal O'Connor used the pulpit of St. Patrick's Cathedral to give credence to a campaign of deadly violence against the author of a book he hadn't read about a religion that was not his. Alfonse D'Amato, in the Senate chamber, tore up pictures of work funded by the National Endowment for the Arts and called the artist "a jerk." The activists of ACT UP desecrated the Eucharist during Sunday Mass at St. Patrick's.

She is also on topic, aligned with the news currents of 1992. Her tearing-up of a photo of the pope—whose travels have made him the very image of Catholicism, at once powerful and visible—coincides with reports through which the American press finally bring the sexual abuse of young people in the Catholic Church fully into the public eye. A few weeks before, ABC airs an episode of *Primetime Live* about the crimes of Fr. James Porter, a serial sexual abuser of children in Massachusetts. The week after, Doubleday publishes *Lead Us Not into Temptation*, Jason Berry's unstinting account of priestly sexual abuse and clerical cover-up.

In December several hundred survivors of clerical sexual abuse meet in Chicago at a conference called Breaking the Silence—the culmination of efforts that Frank Bruni and Elinor Burkett will chronicle in a book called *A Gospel of Shame*. The same month, the CBC broadcasts *The Boys of St. Vincent*, a documentary about the sexual abuse of youth at Catholic-run orphanages in Canada—places like the "laundry" in Ireland where Sinéad had been sent for a time.

And she is made a scapegoat by the same powers of Church and commentariat that stifle the reports of clerical sexual abuse. Those reports made the unspeakable speakable. But the Catholic bishops seek to make clerical abuse unspeakable again. Instead of confronting clerical sexual abuse directly and specifically, they address the implications of it for the Church generally—and for the Church's public image. They hire pathologists to study the problem while directing attorneys to keep it out of view of law enforcement and the public. They frame it as a problem of individual dioceses rather than the Church as a body, in part to deflect criticism away from the Vatican—and away from John Paul. Through their efforts, many distinct acts of coercing, accosting, molesting, sexual subjugation, and rape of young people by priests are re-encrypted in the language of law and social science, obscuring the questions of who did what to whom and how they got away with it. In those ways, the Catholic inability to speak frankly about sex that sparked a crypto-religious response in the eighties is given fresh sanction for a new decade. So Sinéad O'Connor's protest, inchoate as it is, points toward a Church-led campaign of suppression that is taking shape just then—and that will suppress her voice as a show of force.

In retrospect, the act and the controversy over it reveal that something has changed. So many of the religious controversies of the eighties involve traditional Christian sexual morality challenged, traduced, or contradicted: over Dr. King's trysts, and those of the televangelists; over the Vatican's "Halloween statement"; over Madonna's and Prince's records, and Mapplethorpe's and Serrano's photos, and Scorsese's life of Christ. But the Ayatollah Khomeini's call for faithful Muslims to kill Salman Rushdie in 1989 shifts the focus from sex to violence as the defining aspect of religious controversy. So will the gradual uncovering

of clerical sexual abuse—which, properly understood, involves violent crimes committed by clergymen against young people. Sure, one reason given for the fatwa was that *The Satanic Verses* included a dream sequence involving Muhammad in a brothel; sure, the abuse of children by priests involves sex as well as violation. The shift in emphasis from sex to violence is real, though, and Sinéad is caught up in it. Her music and her looks are decorous, compared with Madonna's; the white dress she wears on *SNL* is the very image of mid-century elegance. But John Paul had been shot by a gunman in St. Peter's Square in 1981; for tearing up a picture of him on TV in 1992, Sinéad O'Connor is treated as an assassin.

Lo and behold, the next spring an angel appears at sites across Manhattan: at bus kiosks, pasted to plywood at construction sites, and aglow on the marquee of the Walter Kerr Theatre on West Forty-Eighth Street. The angel is the graphic signature of *Angels in America*, by Tony Kushner, which will run on Broadway through 1993 in two parts, four hours in all. This angel is a Milton Glaser creation; its wings, a multi-colored plumage, echo Glaser's polychrome-halo'd Bob Dylan of 1966, but its body evokes the recent past—it is the body of a man naked and bent in grief or prayer or the two together.

The angel on Broadway, no less than Sinéad on *SNL*, at once announces a change and enacts it—foregrounding crypto-religion, albeit as a thing of the recent past.

Part one of *Angels in America* is titled "Millennium Approaches," but it is a foreshortened look back at the New York of the eighties. It opens in 1985. "Fifteen years till the third millennium. Maybe Christ will come again," one character, a Mormon housewife, announces. Hooked on Valium, married to a man who is beginning to acknowledge that he is gay, she watches nature documentaries on TV: ". . . holes in the ozone layer. Skin burns, birds go blind, icebergs melt. The world's coming to an end." All good things are coming to an end: the gay community is decimated, the city is going to hell, and Republicans (the devilish lawyer Roy Cohn among them) are running the country. But the gravest

sign of end-times is the young gay man Prior Walter's discovery of a Kaposi's lesion on his skin—"the wine-dark kiss of the angel of death."

Prior is descended from a namesake Prior Walter who was depicted in the Bayeux Tapestry. During a sleepless night, an angel appears to him—a turn of events that is perfectly, plausibly apt. As his body becomes skeletal, the ghost of his namesake shows up at his bedside. "The pestilence in my time was much worse than now," this Prior says. "Whole villages of empty houses. You could look outdoors and see Death walking in the morning, dew dampening the ragged hem of his black robe. Plain as I see you now." This Prior died of the plague: ". . . the spotty monster. Like you, alone."

The Bayeux Tapestry is an analogue for the sprawling, arms-spread-in-embrace quality of the play, which takes in the downtown courthouses, Central Park (a plaza presided over by a stone angel), the "Alphabetland" of the Lower East Side ("home to immigrant Jews and now their fucked-up grandchildren"), and the "heaven" of Salt Lake City. Frank Rich of the *Times* observed that the settings are occasions for the play's "unifying historical analogy, in which the modern march of gay people out of the closet is likened to the courageous migrations of turn-of-the-century Jews to America and of 19th-century Mormons across the plains." The angel is likewise a figure for the angel for the play's mise-en-scène—a fallen city where institutional religion is absent but crypto-religion is superabundant.

Strange as it is, *Angels in America* is the leading edge of a trend: the retrospective enshrining of religion as a feature of the American century—a metaphysical set of tail fins. As the millennium's end approaches, publishers are bringing out giant-size novels whose length and rhetorical amplitude and rickety structures suggest a summation of a hundred years of experience. Like Tony Kushner, their authors use lofty religious imagery (starting with a title) to gain a surveyor's altitude on the recent past. Leslie Marmon Silko in *Almanac of the Dead* relates the century as a Native American epic. Leon Forrest catches the outsize human comedy of Black Chicago in *Divine Days*; in *So Far from God* Ana Castillo makes an adage about Mexico (". . . and so close to the United States") a metaphor for the tribulations of characters on

the border. Don DeLillo renders Manhattan as *Underworld*, its financial district erected on landfill that embeds a secret history, its streets piled with trash due to a sanitation workers' strike. Louise Erdrich's *The Last Report on the Miracles at Little No Horse* follows a priest in reservation territory through its changes, and his own. The doorstopping bulk of these books is a pre-internet late expression of the novel's claim to capture the fullness and variety of life itself. The religion in them is structural more than personal; it is a surging, shaping force of history—and one that, like the century, is swiftly receding into the past.

The strongest of those novels is the one that strives the least to represent an age: *The Poisonwood Bible*, by Barbara Kingsolver. It's a fictional counterpart to an extraordinary run of memoirs by women who deal forthrightly with religious belief and its implications, among them Kathleen Norris, Helen Prejean, Annie Dillard, and Mary Karr. It's a deeply personal retrospect about Christianity and the misadventures it has sponsored over the decades; although most of the action takes place in the 1960s, the novel feels contemporary rather than historical, made so by its stress on the co-dependent relationship of religion and violence.

In outline it is a family saga involving a missionary, Nathan Price, his wife, Orleanna, and their four daughters, who leave Georgia for the Congo in 1959 bearing the Gospel (and the cake mixes and cosmetics of postwar America), and who are drawn into the struggle between colonial Belgians and Congolese over the future of the country, and then into a civil war stirred up by the CIA. In spirit (as the title suggests) the novel is a counter-gospel, as Orleanna and the four daughters tell the story, each drawing on the Bible and the lived experience of religion, which they gain as they go. Alternating across 500 pages, the first-person narratives have the amplitude of a nineteenth-century novel and the sly play of language of modernist fiction. They're so idiomatic that they lead you to forget the audacious claim made by the title—namely, that each Price woman's narrative is a reckoning with the worldview impressed on her by the Bible and her religious upbringing and that the five together are a testament, set against that of Nathan Price, whose point of view we see only through theirs.

In the novel's final pages the four surviving Price women, and we the readers of this testament, are addressed by the Price girl who was disastrously left behind in the Congo. She is the Eyes in the Trees, an animist spirit, who has moved past the hard line Christianity puts between creation and creator. "I am *muntu* Africa, *muntu* one child and a million all lost on the same day . . . Yes, you are all accomplices to the fall, and yes, we are gone forever. Gone to a ruin so strange it must be called by another name. Call it *muntu*: all that is here." Her meaning is obscure, but her authority is complete: she has found words and images for the life she lived that are more true than the ones she was given. Out of received religion—instilled in Georgia no less subtly than in the missionary territories of colonial Africa—she has fashioned a personal religion.

In 1993 Octavia Butler is looking ahead rather than back, envisioning the future that is our present in a work of speculative fiction with a scriptural accent.

She is well known in the realm of science fiction and little known outside it. She lives in southern California, where she was raised a Baptist, and has written steadily since her teens. In conversation with Randall Kenan for *Callaloo* she describes her eleventh novel, *Parable of the Sower*, which is in progress: "It's not a postapocalyptic book, it's a book in which society undergoes severe changes, but continues."

The setting is California in the third decade of the new millennium. The American West is ravaged by drought, fire, and addiction, and, partly as a result, is in the grip of end-times consternation—from fervid believers whose verses have gained a gnarly authority, from anarcho-capitalists selling water at a markup, from survivalists who make the prepping of a ready-to-go backpack a spiritual practice. A culture war has become an actual war, with guns and ammunition. But the real drama is taking place on the page, where Lauren Oya Olamina—a teenage girl, Black, disabled, touched with "hyperempathy"—is keeping a journal as a form of witness.

"Sometimes naming a thing—giving it a name or discovering its name—helps one to begin to understand it. Knowing the name of a thing *and* knowing what the thing is for gives me even more of a handle on it," Lauren explains. "The particular God-is-Change belief system that seems right to me will be called Earthseed." Her journal will be the scripture of a new religion, and she will be Earthseed's foundress and prophet.

Parable of the Sower is speculative fiction designed to speak forward from the time of its making. The calamity in it is conventionally dystopian: squatters, scavengers, and cannibals; gunfights, exploding trucks, ad hoc militias controlling the water supply, and swarms of displaced people "walking north from L.A. to who-knows-where." What makes the book strange is its crypto-religiosity. A "preacher's kid," Lauren grew up striving to please her father; and after learning that he and her half brother are dead, she resolves to seek God: "I wasn't looking for mythology or mysticism or magic. I didn't know whether there was a god to find, but I wanted to know. God would have to be a power that could not be defied by anyone or anything."

The God she finds is Change: a God that cannot be defied, only "shaped" through prayer and deliberate action. "'God is Trickster, Teacher, Chaos, Clay,'" she explains. "We decide which aspect we embrace—and how to deal with the others." Her traveling companion Bankole skeptically asks: "'You believe in all this Earthseed stuff, don't you?' 'Every word,' I answered." She goes on: "Earthseed is being born right here on Highway 101—on that portion of 101 that was once El Camino Real, the royal highway of California's Spanish past. Now it's a highway, a river of the poor." She will fish that river for souls, hoping to find "those few . . . who would join us and be welcome." Her response to loss of family and collapse of society will be to foster a faith community.

Parable of the Sower has since gained force as the first book of a trilogy, and as the basis for an opera and a TV series. It has also become clearer with time, because it gestures cryptically toward phenomena that have since come fully into view.

There's the violence of American life and the weird intersection of God, guns, and the government. As Earthseed takes shape, the counterpart to the journal Lauren keeps is the .45 pistol she carries: although Earthseed's credo is progressive in some aspects, she vows that the new community will not hesitate to use violence to protect itself from hostile outsiders. And there's the way religions lose sight of their origins, until believers in the present organize their lives around precepts from idiosyncratic texts written in response to events of ages long past. Here the quasi-scriptural title forces us to compare Earthseed with religion as it actually exists; and the result is that the precepts Lauren Oya Olamina writes in her journal seem as credible as those of the faiths we know firsthand.

Late in the last century, the question that has become so urgent in this one—why do religion and violence go together?—was already urgent for Butler and her seed-sower, as it would be for Barbara Kingsolver and the Price women in *The Poisonwood Bible*. Why *do* so many acts of violence in our society have a religious dimension? Why is so much religion characterized by anger, aggression, control, and resentment? Why is it that the burning city so often has a chapter-and-verse zealot at its center, who is stirring the flames to inferno instead of trying to get them to subside? Kingsolver suggests that it was ever thus, Butler that violence is a consequence of change—of becoming.

In 1993 that shelf of century-capping novels doesn't feature one about Muslims making their way in Western society. Islam in American public life is still typed as peripheral and cryptic, as gay life was a decade earlier; Islam is from elsewhere—say, as an element of the marriage plot of Vikram Seth's *A Suitable Boy*, set in India circa 1952.

One reason for the lack is that an epochal such novel has already been written and published: Salman Rushdie's *The Satanic Verses*. Another is the indifference of U.S. publishers to fiction dealing with Muslims and Islam. And another, it seems clear, is the fatwa. An Islamist potentate's call for the murder of a writer with roots in Islam doubtless affects writers generally; "the assassin's veto," as Timothy Garton Ash

will call it, works effectively, so that others fear to venture into the territory Rushdie opened.

In that moment Rushdie himself remains a man underground. His daily life is a regimen of secret locations, round-the-clock security (treated as pricey cossetting by the British tabloids), and stealthy meetings with politicians who might help him regain his freedom. He emerges into public life for half a day now and then. He visits the tower near Dublin where Joyce set the opening scene of *Ulysses* (pronouncing the *Introibo ad altare Dei* from the Latin Mass sotto voce); he joins U2 onstage at Wembley Stadium (his handlers figuring that there are no Islamist gunmen among the band's devotees). A weekend trip to the Finger Lakes in upstate New York is a "pure gift" of ordinary life: he "ate in a fish bar, walked out to the end of the pier, *behaved normally*, felt abnormally light-headed with joy." He is not out of danger, though: the Norwegian publisher of *The Satanic Verses* is shot three times at point-blank range at home in Oslo (as several other publishers and translators have been since the fatwa was issued). He is piqued to learn that Gabriel García Márquez is keen to write a magic-realist novel about his ordeal.

The lack of a fresh artistic reckoning with Islam means that the terrorist attack in Manhattan on February 26, 1993, comes like a blast of pure fact. A bomb in the parking garage of the North Tower of the World Trade Center; six people dead, a thousand injured; TV and radio signals knocked out: these are the specifics of the attack, recited over and over again in the hours that follow. The arrest of two suspects a week later and the tracing of a third to Egypt—he is extradited to New York in shackles—make the public narrative of the attack seem over almost before it begins, relegated to courtroom reportage about the trials of a blind Egyptian sheik and his associates.

This is partly because the attack was, in essence, a screw-up. As plotted, it was to have brought down the North Tower and killed tens of thousands of people, followed by a coordinated strike on New York's bridges and tunnels, the FBI's regional headquarters, the Diamond District, and the Statue of Liberty. The plot involved the sheik, a cabdriver trained in jihad in Afghanistan, a Kuwaiti American with a chemical-engineering degree from Rutgers, and an Egyptian imprisoned at Attica

on weapons charges; it was developed in apartments, a storage facility, and mosques in Jersey City and on Atlantic Avenue in Brooklyn. That is, the plot took shape within the Muslim community of the New York metro area—akin to the London Muslim community that Rushdie had depicted in *The Satanic Verses*—and a full account of how it did so couldn't fail to reveal the variety and complexity of immigrant Muslim life in the city. (That will come a year later, in *Two Seconds Under the World*, a vivid, detailed book about the attacks.)

Of course, the fatwa and the attack *are* related, in ways that the attack of September 11, 2001, will make clear. In each, religious fanatics use deadly violence to pursue the goal of a strict-and-straight purification of a free society.

In the years after *The Satanic Verses* is published, Salman Rushdie gets an annual "anniversary" message from an unnamed foe, reminding him that the fatwa is still in place. February 14, 1994, will be the fifth anniversary, and Don DeLillo and his friend the novelist Paul Auster come up with a plan to keep Rushdie and his predicament in the public eye. A pamphlet will be inserted by booksellers into every book sold in North America and Britain that day. Money is raised for the printing of half a million pamphlets. DeLillo writes a short, pointed text.

"On February 14, 1989, the religious leader of one country called for the death of a citizen of another country," it begins. "Five years later, Salman Rushdie is still a man with no fixed address . . . still in hiding, still writing nearly every day, making public appearances on occasion— but effectively under threat, marked as with an incandescent X on his chest and back." The text notes that the death sentence is a violation of the compact between reader and writer, explores the ties between freedom from fear and imaginative freedom, and urges the reader to keep Rushdie in mind. And it makes the connection that eludes readers, politicians, and religious figures—between *The Satanic Verses* "and the continuing impact of world Islam on the consciousness of the West."

The continuing impact of world Islam has forced Rushdie to go underground, as into a crypt: "Now the world is smaller around this man. He is distanced from the people who have nourished his work and severed from the very texture of spontaneous life, the tumult of voices and

noises, the random scenes . . . He is alive, yes, but the principle of free expression, the democratic shout, is far less audible than it was five years ago—before the death-edict tightened the binds between language and religious dogma." The conclusion is grim: "A shadow stretches where a man used to stand."

A hard line now joins religion and violence, and a hard line walls off the novelist from the society that is his work's source and its destination. For exploring the borderland of religion and art, this crypto-religious artist lives in the valley of the shadow of death.

Threescore and ten—seventy years—is the scriptural span of a human life. And it's often the span of a cultural epoch: from *Plessy v. Ferguson* to the Voting Rights Act; from the Baltimore Catechism to Vatican II; from the Great War to the fall of the Berlin Wall—the span Eric Hobsbawm called the Age of Extremes.

By such a measure, the span of time we call the 1980s is now a half-life ago—back there with subway tokens and pay phones and smoky cash-only bars; back before Y2K and 9/11 and Hurricane Sandy and the pandemic; before gay marriage, a Jesuit pope, and a Supreme Court stocked with Catholics of a certain kind.

In the half-life between that moment and the present, as the liminal space between belief and disbelief has hardened, the connection between religion and violence has been made straight and narrow as a gun barrel through acts of violence committed in God's name. The American population has become less religious, and religiously more diverse; while our civic life is now ill at ease with religion, our political life is burdened with it. All these changes have taken place before our eyes, in the supposedly naked public square, with cameras running and a news crawl below.

Their cumulative effect has been to blunt the direct experience, familiar to many of us, that informed the crypto-religious work of the eighties—the experience of matters of belief as complex, agonized, uneasily resolved, but crucial to our sense of life's significance—and to push it underground all over again.

422 THE LAST SUPPER

That is understandable, even apt. The crypto-religious outlook thrives on the periphery; it is diminished by wide recognition and dissipates when taken to scale. At the same time, it depends on an encounter with public, institutional religion—as roots, as adversary, as a community whose aspirations it challenges and deepens. If public religion atrophies, personal, speculative, improvisatory religion will thin out too.

In our moment, the arguments against religion are omnipresent and often elegant. Neuroscientists propose that our desires are the expression of electrical impulses in the brain. Critical theory unmasks the world religions as manifestations of the will to power. Freud's proposition that God is a projection of human traits and yearnings is now a baseline assumption even in the churches. A generation of digital natives assumes that the species is "wired" for this, that, and the other behavior—but the seeking of transcendence through devotion to a personal God and service to others isn't one of them.

A consequence of all this is that religious desire, when it makes itself felt, feels either threatening or gratuitous—a toxic event, or a trivial pursuit. Such an outcome is only fair: the malfeasant religions have brought it upon themselves. But in the arts this state of things winds up having a surprising effect. In a society in which religion is socially unnecessary, the artist who credibly engages with religious material will stand out—drawing admiration tinged with gratitude as a song or poem or picture or novel makes the supernatural imaginable and belief believable. Strange at first, the crypto-religious will grow familiar; it will be seen as crucial, and then recognized as canonical—as work we cannot do without. Finally, it will be seen as religious. We'll turn to it on our search, out of curiosity or reverie or in an hour of need, as if it has been there since the beginning.

NOTES

ACKNOWLEDGMENTS

INDEX

NOTES

PROLOGUE

4 Bob Dylan was the musical guest on *Saturday Night Live* on October 20, 1979. The "Gospel Period" is treated by Clinton Heylin in *Bob Dylan: Behind the Shades Revisited* (Morrow, 2001) and *Trouble in Mind: Bob Dylan's Gospel Years—What Really Happened* (Lesser Gods, 2017), and by Amanda Petrusich in her liner notes to *Trouble No More: The Bootleg Series Vol. 13 / 1979–81* (Columbia, 2017). Petrusich quotes Bob Marley speaking about *Slow Train Coming*; the CD booklet reproduces the headline "Rolling Brimstone," without saying what publication it is from.

4 Sinéad O'Connor recounts her early encounters with Dylan's music and image in *Rememberings* (Houghton Mifflin Harcourt, 2021). A column in *Newsday* was headlined "No Hair, No Taste," and articles in *Time* and *The Washington Post* after her death in July 2023 synopsized the *SNL* controversy.

6 Czesław Miłosz characterized himself as "crypto-religious" in his first letter to Thomas Merton (who initiated the correspondence), January 19, 1959, published in *Striving Towards Being: The Letters of Thomas Merton and Czesław Miłosz*, ed. Robert Faggen (Farrar, Straus and Giroux, 1997); his years in exile are treated in *Miłosz: A Biography*, by Andrzej Franaszek, edited and translated by Aleksandra and Michael Parker (Belknap, 2017); by Stephanie Burt in a review essay in *The Nation*, June 1, 2017; and by Cynthia L. Haven in *Czesław Miłosz: A California Life* (Heyday, 20210).

7 Mary McCarthy, reviewing *The Handmaid's Tale* for *The New York Times Book Review* (February 9, 1986), noted that the novel was "offered by the publisher as a 'forecast' of what we may have in store for us in the quite near future"; the novel was published by Houghton Mifflin on February 17, 1985. *White Noise* was published by Viking on January 21, 1985; Scott Moringiello, chair of the Department of Catholic Studies at DePaul University, urged me to treat the novel early in this book's story. Vince Passaro's profile "Dangerous Don DeLillo" (*The New York Times Magazine*, May 19, 1991) goes into DeLillo's Catholic upbringing in depth. DeLillo described the effects of his Roman Catholic upbringing in an interview

with Thomas LeClair, published in *In the Loop: Don DeLillo and the Systems Novel* (University of Illinois, 1988); I first read the interview, condensed by Thomas Ranieri, in Fordham University's alumni magazine. DeLillo said, "I'm interested in religion as a discipline and a spectacle, a something that drives people to extreme behavior. Noble, violent, depressing, beautiful. Being raised as a Catholic was interesting because the ritual had elements of art to it and it prompted feelings that art sometimes draws out of us. I think I reacted to it the way I react today to theater. Sometimes it was awesome, sometimes it was funny. High funeral masses were a little bit of both and they're among my warmest childhood memories."

9 Greil Marcus's insight about "unities that already exist" is in the Author's Note to *Mystery Train* (revised edition, Dutton, 1982). The Author's Note has the colophon "Berkeley, August 9, 1974," and the text indicates that the book as a whole was written between "the fall of 1972" and "the summer of 1974"—the period of the Watergate hearings and the resignation of President Nixon. Here is the whole passage: "What I bring to this book, at any rate, is no attempt at synthesis, but a recognition of unities in the American imagination that already exist. They are natural unities, I think, but elusive; I learned, in the last two years, that simply because of those unities, the resonance of the best American images is profoundly deep and impossibly broad. I wrote this book in an attempt to find some of those images, but I know now that to put oneself in touch with them is a life's work." Marcus's *Lipstick Traces* (Belknap, 1989) is subtitled "A Secret History of the Twentieth Century"; in a prologue, he asks: "Is history simply a matter of events that leave behind those things that can be weighed and measured—new institutions, new maps, new rulers, new winners and losers—or is it also the result of moments that seem to leave nothing behind, nothing but the mystery of spectral connections between people long separated by place and time, but somehow speaking the same language?"

9 Fredric Jameson introduced the idea of "the long sixties" in "Periodizing the 60s," in *Social Text* (Duke University, 1984). Eric Hobsbawm introduced the idea of a "Short Twentieth Century" in *The Age of Extremes: A History of the World, 1914–1991* (Pantheon, 1995), where he observes: ". . . I have drawn on the accumulated knowledge, memories, and opinions of one who has lived through the Short Twentieth Century, as what the social anthropologists call a 'participant observer,' or simply as an open-eyed traveller, or what my ancestors would have called a *kibbitzer* . . ." In a footnote, he remarks that he has sought to relate the history of "the long nineteenth century (from the 1780s to 1914)" in three volumes: *The Age of Revolution, 1789–1848*, *The Age of Capital, 1848–1875*, and *The Age of Empire, 1875–1914*. James Meyer's *The Art of Return: The Sixties and Contemporary Culture* (University of Chicago, 2019) has pertinent insights about "the long sixties" and the era's presence in the arts (and vice versa).

10 Of the many books dealing with the history of religion in contemporary America, Frances FitzGerald's *The Evangelicals* (Simon & Schuster, 2019) and John T. McGreevy's *Catholicism: A Global History from the French Revolution to Pope Francis* (Norton, 2022) have been recurringly useful, as is Stephen Prothero's *Why Liberals Win the Culture Wars* (Harper, 2017). James Baldwin chided the "born again" President Carter and his administration in "Open Letter to the Born Again," in *The Nation* (September 29, 1979), in *Baldwin: Collected Essays*, ed. Toni Morrison (Library of America, 1998). Ronald Reagan's religiosity is treated at length in Gary Scott Smith's *Faith and the Presidency* (Oxford University, 2006).

11 My introduction to the "postsecular" was through my Georgetown colleague José Casanova, who develops the term in "Exploring the Postsecular: Three Meanings

of 'the Secular' and Their Possible Transcendence," in *Habermas and Religion*, ed. Craig Calhoun, Eduardo Mendieta, and Jonathan VanAntwerpen (Polity, 2013). Jürgen Habermas uses the term in "Notes on a Post-Secular Society," in *New Perspectives Quarterly*, October 2008. James Wood gives the title "Secular Homelessness" to the concluding essay in *The Nearest Thing to Life* (Brandeis University, 2015). John McClure's *Partial Faiths: Postsecular Fiction in the Age of Pynchon and Morrison* (Georgia, 2007) applies the term to literature. Robert Anthony Orsi, drawing on his groundbreaking 1985 book *The Madonna of 115th Street*, sets out his sense of the importance of "lived religion" in "Everyday Miracles," an essay in *Lived Religion in America: Toward a History of Practice*, ed. David D. Hall (Princeton University, 1997). Amy Hungerford explores the ways "the enactment and the discussion of belief" come together in *Postmodern Belief: American Literature and Religion Since 1960* (Princeton University, 2010). Nick Ripatrazone's *Longing for an Absent God* (Fortress, 2020) is a vital critical survey of the work of contemporary writers shaped by Catholicism. Katy Carl, in a 2024 essay-booklet (Wiseblood Books), identified Christopher Beha, author of *The Index of Self-Destructive Acts* and other works, as a "novelist in a postsecular world," and defined the "postsecular novel" as one that "once again holds open the possibility of characters' making a serious commitment to faith that is treated in an unironic manner" and reflects an "organizing consciousness," associated with premodern work, "that proceeds as if the claims of faith were true." Beha himself has discussed the situation of such a novelist on many occasions, notably in a conversation with the novelist William Giraldi in the *Los Angeles Review of Books* (June 12, 2012). I explored the place of religious belief in contemporary literary fiction in an essay for *The New York Times Book Review* (December 19, 2012); the novelist Ayana Mathis then did so in a series of essays for the *Times Book Review* in 2023.

12 Two essential books recount the history of the AIDS pandemic in the United States, and in New York City in particular: David France's *How to Survive a Plague* (Knopf, 2016) and Sarah Schulman's *Let the Record Show: A Political History of ACT UP New York, 1987–1993* (Farrar, Straus and Giroux, 2021). Anthony Petro sets artistic controversies in the context of the pandemic in *After the Wrath of God: AIDS, Sexuality, and American Religion* (Oxford University, 2015); Jonathan D. Katz, in "'The Senators Were Revolted': Homophobia and the Culture Wars" (2006), in *A Companion to Contemporary Art Since 1945*, ed. Amelia Jones (Wylie, 2009) sets the AIDS pandemic and the controversies over government-funded art in the context of a broader pivot from anti-communism to culture wars. Arthur C. Danto characterizes "disturbatory" art in *The Philosophical Disenfranchisement of Art* (Columbia, 1985) and in *Encounters and Reflections* (Farrar, Straus and Giroux, 1990). "Controversy" is the title track of Prince's 1981 LP (Warner Bros.); "Sunday Bloody Sunday" is on U2's 1983 LP *War* (Island). Richard John Neuhaus's *The Naked Public Square* was published by Eerdmans in 1984. Leonard Cohen described the tension between a "religious point of view" and "the lack of a religious vocabulary" in a 1988 KCRW-FM interview with Kristine McKenna, in *Leonard Cohen on Leonard Cohen: Interviews and Encounters*, ed. Jeff Burger (Chicago Review, 2014), which is full of extraordinary material.

16 The phrase "a secret chord" is drawn from Cohen's song "Hallelujah," on *Various Positions* (Passport, 1984).

16 Writing this prologue, I have had an eye on Simon Reynolds's introduction to *Rip It Up and Start Again* (Faber, 2005), where Reynolds explains that, in addition to his desire to represent a moment passed over by many critics and historians, he

has written the book out of the "subjective" crisis of a critic in mid-career, which "prompted me to wonder when exactly it was that I made the decision to embark upon a life of taking music seriously. What made me believe music could matter this much?"

1. PRESENCE IS EVERYWHERE

19 Andy Warhol's visit to Rome is recounted in *The Andy Warhol Diaries* (Warner, 1990) and in Bob Colacello's personal biography *Holy Terror: Andy Warhol Close Up* (Vintage, 2014), where Colacello recalls: "The only person Andy really wanted to paint in 1980 was the Pope. He had been wanting to paint the Pope, any pope, since at least the early sixties." Blake Gopnik's *Warhol* (Ecco, 2020) is a fount of detail, insight, local color, and source material. Stephen Metcalf reviewed the book perceptively (and enthusiastically) for the *Los Angeles Times* (April 22, 2020); Metcalf also wrote about Warhol for *The Atlantic* (January/February 2019).

19 Jane Daggett Dillenberger's *The Religious Art of Andy Warhol* (Continuum, 1998) is the basis, formal and informal, for much of the further scholarship and reflection on the religious dimension of Warhol's life and work.

20 The catalog for the Brooklyn Museum's 2021 show *Andy Warhol: Revelation*, by José Carlos Diaz and Amanda Lash (Andy Warhol Museum, 2019) relates specifics of Warhol's religious upbringing and preoccupations. A Vatican photograph of Warhol receiving a handshake blessing from Pope John Paul II accompanied my article "Andy Warhol's Religious Journey" (newyorker.com, December 7, 2021); others are online. The black-and-white snapshot Warhol took of John Paul was on view in *Andy Warhol: Revelation*. Bob Colacello discussed Warhol's relationship to religion with me over lunch in Manhattan in 2018. Jessica Beck, a curator at the Andy Warhol Museum, goes into Warhol's dealings with religion in depth in "Sixty Last Suppers," in *Gagosian Quarterly* (summer 2017), and in "Warhol's Confession: Love, Faith, and AIDS," a catalog essay in *Andy Warhol: From A to B and Back Again* (Whitney Museum of American Art, 2018); she spoke with me at length in 2019. Natasha Fraser-Cavassoni, who worked at the Factory in 1986 and 1987, touches on Warhol and Catholicism in *After Andy* (Blue Rider, 2017); Nick Ripatrazone wrote about Warhol and religion for *Rolling Stone* (August 2, 2017) and the *Catholic Herald* (May 30, 2022); Angela Alaimo O'Donnell did so for *America* (June 30, 2022). Antonio Spadaro's *Oltrecolore* (Vita e pensiero, 2023) has a wise and perceptive chapter on Warhol's work and spirituality.

22 Warhol's foray into portraiture, and his weariness with it, is related in Colacello's biography. His method of portraiture is set out in detail in Wayne Koestenbaum's *Andy Warhol* (Viking, 2001); Koestenbaum observes that "the portraits celebrate Warhol's happy marriage of photography and painting, the two media he could never choose between." The *Modern Madonna* series is presented in a 1999 book by that title (Jablonka Galerie). Warhol relates looking for a terra-cotta *Last Supper* near Times Square in the *Diaries*, April 25, 1985, after seeing one he thought too costly ($2,500) at a shop on Madison Avenue. Evelyn Hofer's photograph of Warhol's studio, taken after his death, is in Beck's "Sixty Last Suppers"; it shows a three-dimensional model fashioned after Leonardo's painting.

22 Among the vividest accounts of New York City in the early 1980s are those of Luc Sante (now Lucy Sante): in *Low Life: Lures and Snares of Old New York* (Noonday,

1992) and *Maybe the People Would Be the Times* (Verse Chorus, 2020). I have lived in New York City since August 1983, and I felt the life of the 1980s city firsthand.

25 Warhol's identity as a New Yorker is developed thoroughly in Colacello's and Gopnik's biographies. Gopnik goes into Warhol's relationship with Julia in detail, and presents his time living on St. Mark's Place. Colacello quotes "one of Andy's relations" about the family's poverty. Warhol's painting of the living room of the family home is in *The Religious Art of Andy Warhol* and *Andy Warhol: Revelation*, as is Julia Warhola's visual art.

25 Blake Gopnik describes Warhol's early years in New York in vivid detail, and reports that Warhol lived in a fourth-floor walk-up at 242 Lexington Avenue through the 1950s before buying a row house at 1342 Lexington Avenue. Bernard Weinraub's interview with Julia Warhola, in *Esquire* (November 1966), is quoted by Gopnik. Warhol's sense of Pop Art as making use of images that anyone could recognize is in his book *POPism: The Warhol Sixties*, with Pat Hackett (Harcourt Brace Jovanovich, 1980); his comments on "presence," made to *ARTnews* in 1963, are quoted in Peter Plagens's review of *The Philosophy of Andy Warhol* in *Artforum* (February 1976). Jaroslav Pelikan explains the iconoclastic crisis in *Jesus Through the Centuries* (Yale University, 1985). The notion of Warhol as an iconographer informs *Andy Warhol: Revelation*, as it did the show by that title at the Brooklyn Museum in 2021, which I wrote about in "Andy Warhol's Religious Journey," on newyorker.com (December 7, 2021). *A Boy for Meg* is in the National Gallery of Art in Washington, D.C.

29 The Catholic Church's dealings with modernity and so-called Modernism are recounted in John T. McGreevy's *Catholicism: A Global History*. James Joyce's dealings with Catholicism are recounted in Richard Ellmann's biography (new and rev. ed., Oxford University, 1983), in Ripatrazone's *Longing for an Absent God*, and in many other works.

30 James Baldwin's story is told in the *Norton Anthology of African American Literature*, volume 2 (3rd edition, 2014); in Eddie S. Glaude Jr.'s *Begin Again* (Crown, 2020); and in Morris Dickstein's *Leopards in the Temple* (Harvard University, 2002); the chronology of the Library of America's *Collected Essays* gives precise dates and particulars. Baldwin described himself as a "black creation of the Christian Church" in a 1968 address to the World Council of Churches—"White Racism or World Community?"—in the *Collected Essays*. Edwidge Danticat, in *The New Yorker* (September 25, 2016), noted that *Go Tell It on the Mountain* is set in a twenty-four-hour period and had the working title *Cry Holy*. Colm Tóibín explored Baldwin's debt to Joyce in the *London Review of Books* (September 14, 2001), as did Claudia Roth Pierpont in *The New Yorker* (February 1, 2009). Baldwin's "Letter from a Region in My Mind" was published in *The New Yorker* (November 9, 1962); *The Fire Next Time* (Dial) was published in January 1963; *Time* depicted Baldwin on the cover (May 17, 1963). "I find myself, not for the first time, in the position of a kind of Jeremiah" is the first line of an essay in *The New York Times* (March 7, 1965), in the Library of America's *Collected Essays*.

33 Jack Kerouac's story is told in *Leopards in the Temple* (where Morris Dickstein identifies "the new kind of American saint of Jack Kerouac" as a postwar literary type); in Joyce Johnson's *Minor Characters* (Houghton Mifflin, 1983); and in *The Beats: A Literary Reference*, ed. Matt Theado (Carroll & Graf, 2003)—where the Kerouac entry quotes his ambitions to write an explanatory "lyric epic." Robert Giroux edited *The Town and the City* (Harcourt Brace, 1950). Kerouac wrote of "the great raw bulk and bulge of my American continent" in *On the Road* (Viking, 1957). James T. Keane's article about Kerouac's Catholicism for *America* (January 9, 2013) quotes his declaration that *On the Road* is "really a story of two Catholic buddies

roaming the country in search of God." John Clellon Holmes's observation that for the characters in *On the Road* the "real journey was inward" is in "The Philosophy of the Beat Generation," in *Esquire* (February 1958), excerpted at several points in *The Beats: A Literary Reference*.

35 Blake Gopnik describes the first Stable Gallery show of Warhol's work and quotes Michael Fried's review in *Art International* (December 1962); he then describes the 1963 Met show, recounts Warhol's trip west as one of a cohort of "nellie queens," sketches the first Factory, and evokes the second Stable show. Arthur C. Danto writes incisively on Warhol's work in *Encounters and Reflections* (Farrar, Straus and Giroux, 1990) and *Beyond the Brillo Box* (Farrar, Straus and Giroux, 1993), and sets out one of his master theories of art-as-philosophy in *The Transfiguration of the Commonplace* (Harvard University, 1981). James Wood celebrated Muriel Spark and *The Prime of Miss Jean Brodie* in *The Guardian* (September 12, 2006).

37 Corita Kent's story is told in her *Times* obituary (September 19, 1986); at the website corita.org; in Rose Pacatte's review of April Dammann's *Corita Kent. Art and Soul. The Biography* in the *National Catholic Reporter* (August 3, 2016); and in Pedro Kos's documentary *Rebel Hearts* (2021); I wrote about the Sisters of the Immaculate Heart of Mary's struggles with the Church hierarchy for newyorker.com (March 3, 2021). The story of Pope Paul VI's 1965 New York visit is told in *Catholicism: A Global History*; Warhol's and the Factory denizens' reactions are in *Popism*. I went to a show of Kent's work, *To the Everyday Miracle*, at the Andrew Kreps Gallery in New York in spring 2021.

2. OUT OF THE ORDINARY

41 Jim Carroll's story, told in the *Times* (September 25, 2009) shortly after his death at age sixty, and then by Thomas Mallon in *The New Yorker* (November 28, 2010), is related in fan's-notes detail at catholicboy.com. *The Basketball Diaries* was published by Toumboktou (1978), then by Bantam (1980), and then by Penguin (1987). In a photograph of Carroll and Keith Richards onstage at Tramps in 1980, at rolling stonesdata.com, Carroll wears a black T-shirt and a crucifix around his neck. John Rockwell reviewed the show for the *Times* (December 31, 1980). Fifty-four boxes of Carroll's papers are in the New York Public Library (archives.nypl.org).

42 Martin Scorsese's story is told in a wide array of books and articles: Mary Pat Kelly's *Martin Scorsese: A Journey* (Thunder's Mouth, 2004); Peter Biskind's *Easy Riders, Raging Bulls* (Simon & Schuster, 1998); *Scorsese on Scorsese*, ed. Ian Christie and David Thompson (Faber & Faber, 2003); Richard Schickel's *Conversations with Scorsese* (Knopf, 2011); *Martin Scorsese Interviews*, ed. Peter Brunette (Mississippi, 1999); Mark Singer's *New Yorker* profile (March 19, 2000); and in interviews with the writer and director Rebecca Miller for a forthcoming documentary. I wrote about Scorsese for *The New York Times Magazine* (November 21, 2016) and then for new yorker.com (June 27, 2022), interviewing him several times for each article, and took part in public conversations with him in Washington, D.C.; in Quebec City; and for the American Academy of Religion.

43 Scorsese's comments about his boyhood are from my *Times Magazine* article, those about the Bowery from Rand Richards Cooper's three-part interview with Scorsese for *Commonweal* (November 2016). Pier Paolo Pasolini's story is told in Shawn Levy's *Dolce Vita Confidential* (Norton, 2017) and in many other sources. Scorsese's insights about *The Gospel According to St. Matthew* (1964) are in *Scorsese on Scorsese*.

The religious aspects of film are masterfully explored in *The Hidden God: Film and Faith*, ed. Mary Lea Bandy and Antonio Monda (Museum of Modern Art, 2003).

44 Warhol's career in the sixties is chronicled in *Popism*, in Colacello's and Gopnik's biographies, and in Wayne Koestenbaum's *Andy Warhol*. The mid-decade Factory was at 33 Union Square West. De Antonio's ramblings about the pope in *Chelsea Girls* are quoted by Gopnik. Colacello observes, "There was something Catholic, something cabalistic and cultish, about the Factory and its Pope"; he discussed the Catholic aspects of Warhol's work in the 2017 interview with me. Koestenbaum depicts Warhol as an artist who was emphatically queer and one for whom "everything is sexual." Joan Acocella's review of Gopnik's biography in *The New Yorker* (June 1, 2020) notes, "Warhol claimed that he was a virgin until he was twenty-five," and then presents details from the biography that suggest an active sex life. Colm Tóibín's review in the *London Review of Books* (September 10, 2020) was headlined "Life Among the Sissies."

46 The biographies of Martin Luther King Jr. by David J. Garrow, Taylor Branch, and Jonathan Eig set the civil rights movement in the context of other events of the era.

46 Daniel Berrigan's life and work are treated in Jim Forest's outstanding biography-memoir *At Play in the Lion's Den* (Orbis, 2017); in Berrigan's autobiography, *To Dwell in Peace* (Harper & Row, 1987); and in *Disarmed and Dangerous*, by Murray Polner and Jim O'Grady (Basic, 1997). Berrigan's story is told in brief in my book *The Life You Save May Be Your Own* (Farrar, Straus and Giroux, 2003); an article of mine about Berrigan upon his death in 2016 was posted on newyorker.com (May 2, 2016), and one of mine on his centenary on americamagazine.org (May 5, 2021). Amy Hungerford's insight about Allen Ginsberg is in *Postmodern Belief*.

48 Valerie Solanas's attempt to kill Warhol is treated in the two biographies. Richard Avedon's 1969 portrait of Warhol is in the collection of the National Galleries of Scotland (nationalgalleries.org). About Warhol's post-convalescence response to being shot, Blake Gopnik observes: "In the early 1970s, after the religious 'awakening' that Warhol was supposed to have experienced on recovering from being shot, he answered point-blank questions about whether he was a Catholic, or in any way religious, with a clear-cut 'no.' (Although a few years later, when asked 'Do you believe in God?' his answer was 'I guess I do.')"

48 Bob Colacello describes his upbringing and tells how he wound up working for Warhol in *Holy Terror*, and did so in greater detail in an interview with Olivier Zahm and Aleph Molinari in *Purple* (spring/summer 2023), at purple.fr.

49 Jim Carroll recounts his time working for Warhol in *Forced Entries* (Viking, 1987); Pat Hackett notes Warhol's deepening commitment to society portraiture in the introduction to *The Andy Warhol Diaries*.

50 Colacello recounted his relationship with Robert Mapplethorpe and Patti Smith in *Vanity Fair* (March 2016). Mapplethorpe's story is told in Patricia Morrisroe's *Mapplethorpe: A Biography* (Random House, 1995), a very strong book that has withstood early criticism from people who knew Mapplethorpe and who figured into the story, and in Patti Smith's extraordinary *Just Kids* (Knopf, 2010). Mapplethorpe's Pratt classmate Kenny Tisa is quoted in Morrisroe's biography. Patti Smith's early performances are vividly recalled by Luc Sante (now Lucy Sante) in *Maybe the People Would Be the Times*, and in James Wolcott's's *Lucking Out: My Time Getting Down and Semi-Dirty in the Seventies* (Doubleday, 2011); Wolcott's articles about Smith for *The Village Voice* in 1975 are in *Critical Mass* (Doubleday, 2013), as are his foundational *Voice* cover story about CBGB (August 18, 1975)—headlined "A Conservative Pulse in the New Rock Underground"—and a review essay of Legs McNeil and Gillian

McCain's *Please Kill Me* (1996), in which he recalls, "Patti shone with messianic purpose back then. Her bare-bulb intensity was like a halation."

52 David Lodge's novel *How Far Can You Go?* (Secker & Warburg, 1980; William Morrow, 1982, as *Souls and Bodies*) captures the ways Vatican II registered domestically, Robert Stone's *A Flag for Sunrise* (Knopf, 1981) its effects for American Catholics abroad. The image of the Church as the "people of God" on pilgrimage in time is from the Vatican II document *Gaudium et spes* (December 7, 1965). The notion of Christian "base communities" as a "new way of being Church" was a key point of the Brazilian theologian Leonardo Boff's thought and that of liberation theology broadly.

54 Paul Schrader's story was told by Alex Abramovich in *The New Yorker* (May 1, 2023). *Transcendental Style in Film*, first published in 1972 (University of California), was republished with a new introduction in 2018. Scorsese spoke of "my brother's keeper" as the theme of *Mean Streets* in my *Times Magazine* article, Travis as an "avenging angel" in *Scorsese on Scorsese*, the "six years" he spent reading Kazantzakis's novel in an interview with Harlan Jacobson in *Film Comment* (September-October 1988).

55 Bob Colacello describes going with Andy Warhol to the Basilica of the Virgin of Guadalupe in Mexico City in *Holy Terror*. Photographs of Warhol's bedroom are in Dillenberger's *The Religious Art of Andy Warhol*.

56 Robert Christgau's 1975 review of Patti Smith's *Horses* is at robertchristgau.com (as are all his reviews). Luc Sante's observations about Smith are in *Maybe the People Would Be the Times*. Smith's *Radio Ethiopia* was released in 1976; John Rockwell reviewed a Patti Smith Group show for the *Times* (January 2, 1976); his pioneering book *All American Music* (Knopf, 1983) gives the context for her work, and for much of the crypto-religious work being made in New York at that moment. Lynn Goldsmith recalled photographing Patti Smith for *Easter* in an interview with Dale Berning Sawa for *The Guardian* (December 12, 2019). Pope John Paul II's story is told in George F. Weigel's biography *Witness to Hope* (Cliff Street, 1999). Smith recalls the making of *Wave* in *Just Kids*. Her March 1979 interview with William S. Burroughs, long unpublished, was published in *SPIN* (April 1988).

60 Scorsese's out-of-control life in Los Angeles is related in *Easy Riders, Raging Bulls*; Scorsese recalled "harboring a lot of anger and rage" to Richard Schickel, described *Raging Bull* as a "rehabilitation" to Mary Pat Kelly, recalled spending "six or seven weeks in bed" in *Scorsese on Scorsese*, declared that "sometimes God picks you up" in an interview with David Ansen for *Interview* (January 1987), and described Hell's Kitchen in *Scorsese on Scorsese*.

61 In a lavish feature package about Pope John Paul II's 1979 visit, the *Times* (October 3, 1979) reported: ". . . with cheers and placards in a multitude of languages . . . throngs of New Yorkers of all beliefs and ethnic origins gathered jubilantly along streets and in appointed places yesterday to welcome Pope John Paul II and to celebrate the first papal visit to New York City since 1965." Garry Wills, especially, registered John Paul's "heavy-handed traditionalism in Church affairs." I wrote about the assassination of Óscar Romero in *The Atlantic* (November 2018), and about John Paul's working relationship with Joseph Ratzinger in *The Atlantic* (January/February 2006). John Paul's "theology of the body" is set out in *Love and Responsibility* (Farrar, Straus and Giroux, 1981), written in Polish in 1960, when he was Karol Wojtyła. The tension between the Vatican's position and that of the U.S. bishops is set out in Penny Lernoux's *People of God* (Viking, 1989) and elsewhere. The U.S. Catholic bishops' pastoral letter *The Challenge of Peace* was issued in 1983, the pastoral letter *Economic Justice for All* in 1986. Archbishop James Hickey's testimony to Congress, March 7, 1983, is at usccb.org.

63 The planning, canceling, restarting, filming, editing, and release of *The Last Temptation of Christ*, and the controversy surrounding it, are treated in precise detail in Thomas R. Lindlof's *Hollywood Under Siege* (University of Kentucky, 2008). Martin Scorsese related his frustration to David Ansen in *Interview*; he recalled telling a studio executive he was making the picture "to get to know Jesus better" in our public conversation in Quebec City, quoted in *America* (June 22, 2017).

64 The Vatican's "Declaration on Certain Questions Concerning Sexual Ethics" (December 29, 1975) is at vatican.va. John J. McNeill's story is told in Kenneth A. Briggs's *Holy Siege* (HarperSanFrancisco, 1992), which I reviewed for *Newsday*, and in the *Times* obituary for him (September 25, 2015), which notes his *Today* appearance. *The Church and the Homosexual* (Sheed Andrews and McMeel) was published in 1976. Jeffrey Cisneros's 2013 paper "John Boswell: Posting Historical Landmarks at the Leading Edge of the Culture Wars," in the *Journal of the National Collegiate Honors Council*, at digitalcommons.unl.edu, tells Boswell's story and that of *Christianity, Social Tolerance, and Homosexualiy* (University of Chicago, 1980).

66 The conflicts between the Archdiocese of New York and the New York City government over policies regarding homosexuals are addressed in *Father Mychal Judge*, by Michael Ford (Paulist, 2002), which has several passages about the controversy involving Bernard Lynch; in David France's *How to Survive a Plague*; and in Joseph Berger's *Times* profile of Cardinal John J. O'Connor (February 17, 1986), one of many pieces dealing with O'Connor that Berger wrote while the paper's religion correspondent. Michael J. O'Loughlin's *A Hidden Mercy* (Broadleaf, 2021) sets out efforts by clergy, sisters, parishes, and individual Catholics that offset the often harsh efforts of the Church hierarchy.

67 Warhol's relationship with Jon Gould is explored by Colacello, by Gopnik, and especially by Jessica Beck in "Love on the Margins," in *Contact Warhol: Photography Without End*, ed. Peggy Phelan and Richard Meyer (MIT, 2018). The effects of AIDS on the Manhattan art scene are registered in *The Andy Warhol Diaries*. David France vividly evokes the early days of the pandemic in *How to Survive a Plague*; the scene at the St. Vincent's emergency room is one I witnessed firsthand, emerging from the subway at Seventh Avenue and Twelfth Street.

69 John J. O'Connor's story is told in Joseph Berger's *Times* profile and in Nat Hentoff's two-part profile in *The New Yorker* (March 23, 1987; March 30, 1987), then published as *John Cardinal O'Connor: At the Storm Center of a Changing Church* (Scribner, 1988). In a profile, also by Joseph Berger, in *The New York Times Magazine* (March 26, 1989), O'Connor asserted, "I'm involved in a hands-on situation with AIDS, more than any other bishop in the United States. I have visited, washed the wounds or emptied the bedpans of more than 1,000 persons with AIDS."

71 Warhol's interest in the Reagans is recorded in dozens of entries in the *Diaries*; he mused that an interview with the president would put *Interview* "on the map" (September 26, 1983). His relationship with Jean-Michel Basquiat is set out in the *Diaries*, in Colacello's and Gopnik's biographies, and in Phoebe Hoban's *Basquiat: A Quick Killing in Art* (Viking, 1998). The passage Gopnik cites in which Warhol goes to sleep "facing life alone" is from the *Diaries* (May 26, 1985).

72 William Hart McNichols's story is related in James Forest's *At Play in the Lion's Den* (Orbis, 2017), an expansive biography of Daniel Berrigan and his circle, which includes a photo of McNichols as a youngish Jesuit. McNichols spoke about his life, including the childhood incidence of sexual abuse, in conversation with me in Washington, D.C., in November 2022. He gave me a flyer for the Dignity

AIDS liturgy and other materials. Dignity's story also figures into France's, Ford's, Briggs's, and O'Loughlin's books.

73 Colacello, Dillenberger, Beck, and Gopnik all relate the circumstances of the *Last Supper* commission. In the *Diaries* Warhol likened the Broadway studio to a loft (March 23, 1983) and himself to a commercial artist (April 25, 1985). In his biography, Gopnik observes: "When it came time to make his new suite of sacred pictures, Warhol found easy inspiration in the works of Sister Corita Kent, the rebel nun whose sacred Pop Art had itself borrowed heavily from Warhol, in the first place." And he reports that "a much younger artist had sent him a fourteen-page package about her ambitious (but quite terrible) project based on the Last Supper." The artist was Kathleen Louise Mendry, and the package she sent was dated March 17, 1984.

3. DEVOTION VS. DESIRE

75 U2 played an outdoor show at the State University of New York at Albany on Saturday, May 7, 1983; I was in the crowd.

76 Bono tells his and the band's story in *Surrender* (Knopf, 2022). Among the many other books about U2 are *U2 by U2* (ItBooks, 2005) and *Unforgettable Fire*, by Eamon Dunphy (Warner, 1987); *We Get to Carry Each Other: The Gospel According to U2*, by Greg Garrett (Westminster John Knox, 2009), and *One Step Closer: Why U2 Matters to Those Seeking God*, by Christian Scharen (Brazos, 2006), go into the religious aspects of their work, as did Joshua Rothman in "The Church of U2," in *The New Yorker* (September 16, 2014). Tour dates are given on u2tours.com, set lists there and at u2gigs.com and u2setlists.com. Video of U2 at the US Festival (May 30, 1983) and Red Rocks (June 5, 1983) is on YouTube. The *Under a Blood Red Sky* LP was released in November 1983 (Island), the concert video in April 1984 (MCA). Bono described the white flag in *U2 by U2*: "Those were very dangerous times in Ireland—Nationalism was turning ugly. So we rather turned against the tricolour (the Irish flag), and when they would be thrown on stage, I would dismantle them. I'd take off the green and the orange and be left with the white bit in the middle, and that became the white flag." In *Surrender*, he recalls that he began to tear off the green and orange parts of the flags after the death of the Irish revolutionary Bobby Sands due to a hunger strike in 1981, and adds: "Later, I began to emphasize the white flag as an image of spiritual surrender, but for now we allowed ourselves a kind of militant pacifism."

76 The history of early rock is related in dozens of books, among them *The Rolling Stone Illustrated History of Rock & Roll*, ed. Jim Miller (Random House, 1980); the history of punk is related there and in Jon Savage's *England's Dreaming* (Faber, 1991), of postpunk in Simon Reynolds's *Rip It Up and Start Again*. Kelefa Sanneh's *Major Labels* (Penguin Press, 2021) spells out both the power and the limitations of music history interpreted through genre.

77 Bono spells out U2's devotion to the Clash and calls his own band "four guys with funny haircuts" in *U2 by U2*. The band's emergence in the United States coincident with MTV's is set out in *I Want My MTV*, an oral history by Rob Tannenbaun and Craig Marks (Dutton, 2011).

78 Patti Smith's "Gloria" is on *Horses* (Arista, 1975); Them's "Gloria" was released in 1964; Jim Morrison sang an explicit version of Them's with the Doors in a rehearsal at the Aquarius Theatre in Hollywood in 1969 and in concert at Madison Square

Garden in 1970. U2's "Gloria" is on *October* (Island, 1981); the video—U2's first—
was released in October 1981. U2's coming together and their eventual crisis figure
prominently in all the books, as does the significance of "40." Bono's mordant
recollection that "we didn't want to be the band that talks about God" is in *U2 by
U2*, as is the notion that U2 is the "little combo" signed up to play at Christendom's
funeral.

82 The Smiths were Steven Morrissey, Johnny Marr (né Maher), Andy Rourke, and
Mike Joyce. The sleeve of *The Smiths* (Sire, 1984) features a detail of a still pho-
tograph of Joe Dallesandro in *Flesh* (1968), directed by Andy Warhol's Factory
associate Paul Morrissey. *Hatful of Hollow* was released on Rough Trade the same
year. "Still Ill" and "Accept Yourself" are on both records, "Please, Please, Please
Let Me Get What I Want" only on the latter. Morrissey tells his story in *Auto-
biography* (Putnam, 2013), Johnny Marr in *Set the Boy Free* (Dey Street, 2016);
Tony Fletcher tells the stories of the Smiths in *A Light That Never Goes Out*
(Crown Archetype, 2012). Mike Scott of the Waterboys described his goal of
making music that would serve as "a metaphor for God's seeing signature in the
world" early in their career; the insight has since been quoted in many articles,
such as one on the Live Sessions page of npr.org.

87 Eamon Dunphy's *Unforgettable Fire* has a detailed section about U2's first months
as full adults; Edge's concession to "the bride's church" for their wedding is in *U2
by U2*.

87 Brian Eno's life and career are spelled out in his *A Year with Swollen Appendices* (Fa-
ber, 1996) and in *On Some Faraway Beach: The Life and Times of Brian Eno*, by David
Sheppard (Chicago Review, 2009), where Bono is quoted saying, "We didn't go
to art school . . . we went to Brian." Eno's work with Talking Heads figures into
John Rockwell's *All American Music* (1983; rev. ed., Da Capo, 1997), David Gans's
Talking Heads: The Band and Their Music (Avon, 1985), David Bowman's *This Must
Be the Place* (Harper, 2001)—the source of Tina Weymouth's remark about Eno's
aversion to popularity—and the drummer Chris Frantz's *Remain in Love* (St. Mar-
tin's, 2020). *Musician* and *Music and Sound Output* published detailed accounts of the
making of *Remain in Light* in 1980. *My Life in the Bush of Ghosts*, made in 1980, was
released by Sire on February 1, four months after *Remain in Light*. Sasha Frere-Jones
called attention to Eno's long attraction to hymns in *The New Yorker* (July 7, 2014).
In a piece about Eno's New York years on redbullmusicacademy.com (April 2013),
Simon Reynolds cited Eno's recollection, "The idea of New York as a 'strange,
medieval, huge complex town in the middle of nowhere . . . suddenly made the
place tolerable for me. You can easily live in New York and just see the mess of it.
I wanted to make it mysterious again.'"

90 Eno's pioneering work with the Yamaha DX7 was set out in *Keyboard* magazine
(February 1987). Paul Hillier's *Arvo Pärt* (Oxford University, 1991) is an account
of the composer's life and work, as is Paul Hegman's 2019 documentary *That Pärt
Feeling—The Universe of Arvo Pärt*. The 1984 *Daily News* review is cited in *Arvo Pärt's
Tabula Rasa*, by Kevin C. Karnes (Oxford University, 2017). Philip Glass recounts
his life as an artist in *Words Without Music* (Liveright, 2015). Steve Reich's *Tehillim*
was composed in 1981; a profile by Richard Taruskin, in the *Times* (August 24,
1997), is a superb explanation of Reich's approach.

92 Daniel Lanois recalls his and Eno's work with U2 in *Soul Mining: A Musical Life*,
with Keisha Kalin (Farrar, Straus and Giroux, 2010). EG released *Ambient 2: The
Plateaux of Mirror* in 1980. Mullen describes Lanois's "bottom up" production ap-
proach, Bono the "improv piece" of "Bad," and Edge Bono's Peace Museum visit

in *U2 by U2*. Bono has spoken of "hymns for the future" often, such as in a *Rolling Stone* profile by Brian Hiatt (March 19, 2009). Island released *The Unforgettable Fire* in October 1984.

96 Chuck Klosterman describes the Smiths' audience (unforgettably) as the "fey underground" in *Chuck Klosterman IV* (Scribner, 2007). Footage of Morrissey's 1984 return to Sacred Heart Grammar School in Manchester is on YouTube. "The Headmaster Ritual" is on *Meat Is Murder* (Sire, 1985); "There Is a Light That Never Goes Out" is on *The Queen Is Dead* (1986).

4. WHAT ARE ROOTS?

100 Louise Erdrich's "Saint Marie" was published in *The Atlantic* (March 1984) and then in *Love Medicine: A Novel* (Holt, Rinehart and Winston, 1984), which was reviewed in *The Washington Post* (November 14, 1984). Nick Ripatrazone's *Longing for an Absent God* treats Erdrich's, William Kennedy's, and Toni Morrison's work from a Catholic perspective.

101 Maureen Dowd's report on the 1984 Pulitzer Prizes in the *Times* (April 17, 1984) noted that *Ironweed* had been turned down by thirteen publishers and that William Kennedy learned of the prize "as he was on his way to the hospital where his daughter, Dana, was in labor. She gave birth to a boy . . ." Kennedy's long struggle to find a publisher and an audience for his fiction was then related in dozens of articles, a number of them in the Albany *Times Union*. He spelled out the particulars to Mona Simpson in a July 1984 interview for *The Paris Review* (winter 1989), saying of *Ironweed*, "It's a book about family, about redemption and perseverance, it's a book about love, faded violence, and any number of things. It's about the Irish, it's about the church . . ." Sam Jordison's celebration of the novel in *The Guardian* (April 10, 2018) is full of vivid details, as is Emma Brockes's *Guardian* profile of Kennedy (February 24, 2012). Kennedy and I corresponded about his friendship with Gabriel García Márquez during my reporting for a *Vanity Fair* article (January 2016) about *One Hundred Years of Solitude*. Kennedy recounted the history of the New York State Writers Institute in a fortieth-anniversary address published in the *Times Union* (January 29, 2023).

105 Toni Morrison's story is told in *The Norton Anthology of African American Literature*, in Danille Kathleen Taylor-Guthrie's introduction to *Conversations with Toni Morrison* (University of Mississippi, 1994), in three articles by Hilton Als in *The New Yorker* (October 19, 2003; August 8, 2019; January 27, 2020), and elsewhere. Morrison recalled her mother's dislike of the name Ramah in a 1980 interview with Anne Koenen, published in *History & Tradition in African American Culture*, ed. Gunther Lenz (Campus, 1984), and republished in the Mississippi volume. She declared, "I had a Catholic education, even though my mother, who was very religious, was Protestant," in Antonio Monda's *Do You Believe: Conversations on God and Religion* (Vintage, 2007), a book of interviews with contemporary writers, adding: "As a child I was fascinated by the rituals of Catholicism, and I was strongly influenced by a cousin who was a fervent Catholic." *Goodness and the Literary Imagination*, ed. David Carrasco, Stephanie Paulsell, and Mara Willard (University of Virginia, 2019), includes Morrison's 2012 Ingersoll Lecture at Harvard Divinity School. Nick Ripatrazone traces the variegations of her Catholic adherence in *Longing for an Absent God*, as did Kaya Oakes in *U.S. Catholic* (August 6, 2019). The Georgetown literature professor Angelyn Mitchell, an authority on Morrison and the author of *The Freedom to Remember: Narrative, Slavery, and Gender in Contemporary Black Women's Fiction*

(Rutgers University, 2002), which has a robust chapter on *Beloved*, shared many insights (and responded nimbly to some of mine) in a long conversation via Zoom.

106 An Albany *Times Union* oral history compiled by Paul Grondahl after Morrison was awarded the Nobel Prize (October 8, 1993) notes that she taught at SUNY Albany from 1984 to 1988, often hosting students and colleagues at an apartment near Washington Park; that *Dreaming Emmett* was produced at Capital Rep in 1986; and that she bought a computer while there (the novelist Maureen McCoy, who shopped with her, recalls the salesperson asking, "Are you planning to write a book on this?" William Kennedy remarked on his collegial relationship with Morrison in an email to me, July 9, 2024.

107 Seamus Heaney's *Station Island* was published by Faber & Faber in 1984 and by Farrar, Straus and Giroux in January 1985; it was reviewed by Paul Muldoon in the *London Review of Books*, Richard Ellmann in *The New York Review of Books*, and Helen Vendler in *The New Yorker*. The story of Heaney's life as a poet, told in many feature articles, is also set out in Michael Schmidt's *Lives of the Poets* (Knopf, 1998). Heaney described the composition of the long poem, and the return to Catholicism it involved, in a 1985 interview with the Cambridge journal *Isis* and in a 1999 interview with Karl Miller, editor of the *London Review of Books*, published as *Seamus Heaney in Conversation with Karl Miller* (Waywiser, 2000). A 1997 *Paris Review* interview by Henri Cole foregrounds the details of Heaney's life at Harvard. Heaney recalled being in Madrid during the Troubles in "Summer 1989," a poem in *North* (1975) and in *Selected Poems 1966–1987* (1990).

110 Bruce Springsteen's autobiography, *Born to Run*, was published by Simon & Schuster in 2016; the road trip taken in a 1969 Ford XL convertible is recounted in chapter 44, "Deliver Me from Nowhere." *Nebraska* was released in September 1982. The interview published in *Rolling Stone* (December 6, 1984) was with Kurt Loder.

112 Bob Dylan played Slane Castle with Mick Taylor on July 8, 1984; audio of "Blowin' in the Wind" is on YouTube, accompanied by photographs of Bono wearing a jean vest and top hat. Bono's interview with Dylan was published in 1984 in *Hot Press*, which posted it online in 2016 with commentary on how it had come about. In *U2 by U2*, Bono looks back on the early eighties: "The muse got drunk, the clothes got bad and the hair got very, very long. But we were affected by this, it pushed us down the road of looking for roots. My conversations with Bob Dylan and Van Morrison and Keith Richards were all pointing me to look back."

113 U2 played Nassau Coliseum on Long Island on April 3, 1985; I was in the audience. Bono and the Edge describe playing Madison Square Garden for the first time, with their families present, in *U2 by U2*. *Rolling Stone* covered U2 steadily in the period after *War* (March 31, 1983; June 9, 1983; October 11, 1984; March 14, 1985, among others); the last piece was headlined "Keeping the Faith."

114 The Clash's "The Sound of Sinners" is on *Sandinista!* (1980). I saw and heard Peter Gabriel perform "Lay Your Hands on Me" at the Saratoga Performing Arts Center, July 24, 1983. Kate Bush's "Running Up That Hill" is on *Hounds of Love* (1985); the video is on YouTube. R.E.M.'s *Fables of the Reconstruction* (aka *Reconstruction of the Fables*) was released in June 1985. Paul Simon recorded much of *Graceland* in Johannesburg, South Africa; Robin Denselow recounted the controversy over Simon's decision to travel to the apartheid state in *The Guardian* (April 19, 2012). "Do They Know It's Christmas?" was released in December 1984, as a single and as a thirty-minute documentary video. Bono recalls watching the Philadelphia segment of Live Aid in a London hotel room (and falling to his knees) in *U2 by U2*.

115 Kelefa Sanneh's *Major Labels* explores the relation of genre and notions of "authen-

ticity" in depth. Jeff Chang's *Can't Stop Won't Stop* (Picador, 2005) tells the story of hip-hop; Questlove's *Music Is History* (Abrams Image, 2021) situates hip-hop within the broader musical culture of Questlove's lifetime.

118 The Neville Brothers' story is told by Art, Aaron, Charles, and Cyril Neville in *The Brothers Neville*, with David Ritz (Da Capo, 2001) and in Jason Berry's *Up from the Cradle of Jazz: New Orleans Music Since World War II*, 2nd edition (University of Georgia 2009), which also relates the life stories of James Booker and Allen Toussaint. Berry's history of New Orleans, *City of a Million Dreams* (North Carolina, 2018), is rich with insights about the city's music, its religious mix, and the ways these fit together; there, Berry mentions Pope Pius X's 1903 *moto proprio* "On Sacred Music" (written "by his own hand," Berry notes) and spells out its consequences for music in New Orleans. George Landry's krewe name is given as Big Chief Jolly in some places, Big Chief Jolley in others. Jon Pareles's review of a Neville Brothers show at a "hugely overcrowded Lone Star Café" was published in the *Times* (May 31, 1984). *The Wild Tchoupitoulas* was released in 1976, *Fiyo on the Bayou* in 1981; here, the songs are discussed in an order I've chosen myself—a personal shuffle. The website deaddisc.com indicates that "'Sitting in Limbo' was performed more than one hundred times by various Jerry Garcia groups between 1974 and 1994."

126 The Persuasions joined with Joni Mitchell for "Shadows and Light" (and much else) on the 1979 tour captured on the *Shadows and Light* album and full-length concert video released the next year; on *The Hissing of Summer Lawns* (1975), Mitchell had created a choir by combining multiple tracks of her own voice.

128 Flannery O'Connor filled a letter to John Hawkes (November 24, 1962) with observations about New Orleans, where she'd just spent time; it is in *The Habit of Being*, ed. Sally Fitzgerald (Farrar, Straus and Giroux, 1979).

129 Jason Berry's reporting for *The Times of Acadiana* (beginning May 1985) and the *National Catholic Reporter* (beginning June 7, 1985) was the basis for his book *Lead Us Not into Temptation* (Doubleday, 1992), which goes into the Gauthe trial in detail.

131 The Neville Brothers' history with Bill Graham and the Grateful Dead is spelled out in *The Brothers Neville*. Samuel G. Freedman reported on Aaron Neville's turn to spirituals in the *Times* (May 8, 1987), noting that Neville would play "in a rare solo setting" (joined only by a pianist) at the Church of St. Ann and the Holy Trinity in Brooklyn Heights. A fifty-minute video of the Neville Brothers' set at Oakland Coliseum Arena on December 31, 1985 (not the Oakland-Alameda County Coliseum, as the video indicates), is on YouTube, as are assorted audio and video recordings of the Grateful Dead's two sets from the same show. Rob Tannenbaum chronicled the tension between the Neville Brothers' reputation as New Orleans legends and their emergence as a national act in *Rolling Stone* (July 2, 1987), which includes vivid accounts of shows they gave on the Mississippi riverfront and at the Jazz & Heritage Festival. *The Neville Brothers Live in New Orleans* (Flashback, 2001), recorded September 24–25, 1982, captures the place of spirituals in their set in that period, as does a recording from their set opening for the Rolling Stones at the Superdome in New Orleans (December 3, 1981), on wolfgangs.com, and many audio and video recordings on YouTube.

5. OLD SOULS

133 Leonard Cohen's story is told in Sylvie Simmons's *I'm Your Man: The Life of Leonard Cohen* (Harper, 2012), in his own words in *Leonard Cohen on Leonard Cohen*, ed.

Jeff Burger (Chicago Review, 2014), and in David Remnick's *New Yorker* profile (October 17, 2016), among many books and articles; and in the documentaries *Bird on a Wire* (1974), *I'm Your Man* (2005)—in which U2 comment on Cohen's life and work and serve as his backing band—and *Marianne and Leonard: Words of Love* (2019), about Cohen's relationship with Marianne Islin. Harry Freedman's *Leonard Cohen: The Mystical Roots of Genius* (Bloomsbury Continuum, 2021) and Marcia Pally's *From This Broken Hill I Sing to You* (T&T Clark, 2021) consider the place of religion in his life and work. Simmons notes that he was billed as "Poète, chansonnier, écrivain" at Expo 67 in Montreal, and that he began sitting zazen in the time prior to *Book of Mercy* (1984).

133 *Various Positions* was released in Canada in December 1984 and in Europe and the United States in February 1985. Stephen Holden's profile was published in the *Times* Weekend Arts & Leisure section (May 3, 1985). Cohen spoke about the Beats to Robert Sward in an interview in *Malahat Review* (December 1984), in Burger's *Leonard Cohen on Leonard Cohen*. Nathan Zuckerman likens himself to "an unchaste monk" in the early pages of Philip Roth's *The Ghost Writer* (Farrar, Straus and Giroux, 1979). Cohen mentioned religious insight as the goal of worldly experience in Don Owen and Donald Brittain's 1966 documentary *Ladies and Gentlemen . . . Mr. Leonard Cohen,* and likened himself to a "cantor" and insisted that the ordinary man has "never soared" in Sandra Djiba's interview in *Ubyssey* (February 3, 1967), both in *Leonard Cohen on Leonard Cohen.*

136 Simmons recounts Cohen's relationship with Joni Mitchell in the chapter called "How to Court a Lady," noting, "She would go on to describe him as 'in many ways a boudoir poet'" but that "over the decades, Leonard and Joni have remained friends."

136 *Stranger Music* (Cape, 1993) is subtitled *Selected Poems and Songs.* "Story of Isaac" is on *Songs from a Room* (1969), "Last Year's Man" on *Songs of Love & Hate* (1969). Freedman and Parry go into Cohen's Judaism in depth. *The Boston Globe*'s review of the novel *Beautiful Losers* (Viking, 1966) likened Cohen to James Joyce. Simmons quotes Judy Collins praising Cohen's ability to "take the Bible to pieces." Lou Reed's song "Jesus" is on *The Velvet Underground* (1969).

139 Jennifer Warnes's account of the writing of "Song of Bernadette" is in an item by Paul Keggington on fscc-calledtobe.org (February 1, 2012); a photo of Cohen and Warnes on a bus, smoking (and writing the song together, the caption indicates), is in Simmons's biography, which recounts their relationship; the booklet for a twentieth-anniversary CD reissue of Warnes's *Famous Blue Raincoat* (1986) features her handwritten parochial school essay about St. Bernadette, from 1956 (it was given a B+). Warnes's "Up Where We Belong" debuted on *Billboard*'s Hot 100 on August 21, 1982.

139 Cohen's eighties songwriting agon, first at the Algonquin Hotel (Simmons indicates) and then at the Royalton, is a set piece in most of the biographical writing about him. Liel Leibovitz likens his Casio keyboard to a "portal" in *A Broken Hallelujah* (Norton, 2014). His remark "I had to resurrect not just my career" is quoted in Simmons's chapter 17, "The Hallelujah of the Orgasm." Marianne Faithfull's "Broken English" is from 1979, Lou Reed's "Teach the Gifted Children" from 1980, Roxy Music's "More Than This" from 1982, the Police's "Every Breath You Take" from 1983. Simmons's account suggests that "If It Be Your Will" was written at the Algonquin Hotel in December 1980 and that "Hallelujah" (which "took Leonard five years to write") was partially written there. The history of Covenant House figures into a *Times* story about Bruce Ritter published after his death (October 22, 1999).

142 Jennifer Warnes's recollection of what Cohen made of Bob Dylan's conversion to Christianity is in Simmons's chapter 16, "A Sacred Kind of Conversation."

143 Dylan's work in the years after *Slow Train Coming* is treated in the liner notes to *Bob Dylan: Trouble No More*, by Rob Bowman and Penn Jillette, as well as Amanda Petrusich; and by Clinton Heylin in *Bob Dylan: Behind the Shades Revisited* and *Trouble in Mind*. In *Behind the Shades Revisited*, Heylin sets out the tensions between Bob Dylan and the producer Jerry Wexler that vexed the "labored" *Saved* sessions, and the extended process of recording, mixing, and sequencing for *Shot of Love* that occluded the broken-in feel of the songs. There, too, he remarks that *Infidels* seemed to be Dylan's "passage out of Christian orthodoxy"; and he gives particular emphasis to "Blind Willie McTell," calling it "the world's eulogy, sung by an old bluesman recast as St. John the Divine, forming those oh-so-familiar chords as he gazes out of the St. James Infirmary."

144 Cohen recalled meeting Dylan at a café in Paris in a January 1987 interview with Robert O'Brian for *RockBill* (September 1987), in *Leonard Cohen on Leonard Cohen*. David Remnick's *New Yorker* profile of Cohen quotes a different account: "'Two years,' Cohen lied. Actually, 'Hallelujah' had taken him five years." Remnick cites "Dylan's comment that Cohen's songs at the time were 'like prayers.'" A printed program sold during Dylan's 1984 European tour (shown on the fan website bobdylan-comewritersandcritics.com) indicates that Dylan played Paris on July 1, 1984; the show at Slane Castle in Ireland on July 8 was recalled years later in the *Irish Examiner* (November 2, 2022).

145 *Biograph* was released in November 1985. Stephen Holden's brief review of Cohen's 1985 Carnegie Hall concert was in the *Times* (May 7, 1985).

145 Czesław Miłosz was born in 1911; his story is told in Andrzej Franascek's *Miłosz: A Biography*, trans. Aleksandra Parker and Michael Parker (Belknap, 2017); in Cynthia L. Haven's *Czesław Miłosz: A California Life* (Heyday, 2021); and in his own *Beginning with My Streets: Essays and Recollections*, trans. Madeline G. Levine (Farrar, Straus and Giroux, 1985), *To Begin Where I Am: Selected Essays*, ed. Bogdana Carpenter and Madeline G. Levine (Farrar, Straus and Giroux, 2001), and *Native Realm*, trans. Catherine S. Leach (Farrar, Straus and Giroux, 2002)—and in his poetry. Robert Pinsky's *Jersey Breaks* (Norton, 2022) has a sharp, fond memoir of Pinsky's time as Miłosz's colleague, translator, and friend. Stephanie Burt's review of *Miłosz: A Biography* in *The Nation* (June 1, 2017) is very perceptive about the poet's reputation in the United States before and after the Nobel Prize. Jeremy Driscoll, O.S.B., who befriended Miłosz late in the poet's life, shared insights about him with me in conversation, as did Robert Faggen, another late-life friend of Miłosz's; Driscoll considered his achievement in "The Witness of Czesław Miłosz," in *First Things* (November 2004). I first wrote about Miłosz's crypto-religiosity in "A Fugitive Catholicism: The Work of Dave Eggers, Richard Rodriguez, and Czesław Miłosz," in *Commonweal* (November 5, 2004).

145 "A Confession" is in the New Poems section of *The Collected Poems, 1931–1987* (Ecco, 1988), with the colophon "Berkeley, 1985." "My Faithful Mother Tongue" is in the *Collected Poems*. Miłosz deplored the "impotent negation" of American intellectuals in an undated letter to Thomas Merton (late 1960 or early 1961), in *Striving Towards Being*; derided progressives' "unlimited love for humankind" and support for "all the good causes" to Merton (March 14, 1962); and expressed his dislike for Mass at Berkeley's Newman Center to Merton (May 30, 1961): "The Mass here in Newman Hall is a sort of gymnastics: get up, kneel, get up, sit down—

like a military discipline." Writing to Merton that fall (October 5, 1961), he asked: "How many people in the world today are crypto-religious? How many stand in various Newman Halls like here with a 'bouche bee'? At the sight of gymnastics called a Holy Mass?" To Merton during Vatican II (December 31, 1964), he observed: "The liturgical reform. Yes. But the mass in English is a mistake . . . Why to 'protestantise' the Church in those aspects which are the least valid?" "If Only This Could Be Said" is a 1991 essay (trans. Madeline G. Levine) in *To Begin Where I Am*. Donald Davie muses on Miłosz's aversion to strict religious affiliation in *Czesław Miłosz and the Insufficiency of the Lyric* (Cambridge, 1986). Miłosz's return to Poland in 1981 is treated in detail in Franascek's biography. *Unattainable Earth* was published in Poland in 1984 and in 1986 in English translation by Miłosz and Robert Hass (Ecco). *A Year of the Hunter*, trans. Madeline G. Levine (Farrar, Straus and Giroux, 1994) is, Miłosz notes in a preface, "the diary of one year of my life from August 1987 to August 1988." His relationship with Renata Gorczyńska is recorded in *A California Life*. He averred that he was "bound by an oath" to Janka in "On Parting with My Wife, Janina" (colophon: Berkeley, 1986) and wrote of going to Mass at St. Mary Magdalen in Berkeley (on his seventy-fourth birthday) in "With Her" (Berkeley, 1985), both in the New Poems section of *The Collected Poems*; he wrote of a night of carnal pleasure in "Annalena," and of himself as "flesh-enraptured" in "Father Ch., After Many Years," both in *Unattainable Earth*.

Daniel Berrigan's activities in the eighties are treated in *At Play in the Lion's Den*, *To Dwell in Peace*, and *Disarmed and Dangerous*; in *Sorrow Built a Bridge*, foreword by Walter F. Sullivan, introduction by Sister Patrice Murphy, C.S.C. (Wipf and Stock, 2009), a stylized journal of the 1980s originally published by Catholic Worker Books/Fortkamp (1989); and in *The Berrigan Letters*, ed. Daniel Cosacchi and Eric Martin (Orbis, 2016), which brings together letters written by Berrigan and his brother, Philip, some addressed to Philip's wife, Elizabeth McAlister. I met Daniel Berrigan briefly at the West Side Jesuit residence in the mid-1980s and attended a Mass he celebrated at the NYU Catholic Center late in the decade.

The early history of the Plowshares movement is set out in *At Play in the Lion's Den*, as is Berrigan's participation in a weekly protest outside Riverside Research in Manhattan, also treated often in *The Berrigan Letters*. The reflection on the need to trust in outcomes as in "other hands than ours" is in the chapter of *To Dwell in Peace* titled "Another Day: Towards Life." Emile de Antonio's documentary *In the King of Prussia* (1983) is discussed in a number of letters. Phil related the expectations of the *60 Minutes* producers in a letter of February 25, 1986; Dan raised objections, using bullet points, on March 4. Dan set out his initiation into hospice work, and his defense of John McNeill, in the chapter of *To Dwell in Peace* called "AIDS: The Dream, the Awakening."

156 William Hart McNichols's account of meeting Daniel Berrigan on a subway platform while en route to St. Vincent's Hospital is in *At Play in the Lion's Den*. Berrigan's account of how he got involved, in *To Dwell in Peace*, corresponds with the one given by Sister Patrice Murphy in her introduction to *Sorrow Built a Bridge*. His account of his efforts to accompany the "artificer" Luke in the struggle with AIDS is in the autobiography. Carl Siciliano synopsized Berrigan's efforts with men with AIDS in "Remembering Dan Berrigan, a Forgotten AIDS Hero," on huffpost.com (May 20, 2016). Berrigan characterized himself as a "listener of last resort" in *Sorrow Built a Bridge*. Roland Joffe's film *The Mission* was released in 1986.

158 John J. O'Connor's approach to gay people and people with AIDS as archbishop of

New York is treated in Michael Ford's book on Mychal Judge, David France's *How to Survive a Plague*, and Joseph Berger's 1986 *Times* profile of O'Connor. Berrigan called the Church's approach to gay people "a very whiff of brimstone" in *To Dwell in Peace*.

6. THE CITY IS BURNING

160 Bradford D. Martin's *The Other Eighties* (Hill & Wang, 2011) is a pointed and valuable reconsideration of the decade. The image of the "shining city on a hill" is from Ronald Reagan's "farewell address" from the White House, January 11, 1989, quoted in Smith's *Faith and the Presidency*; elaborating on the passage, Reagan remarked, "I've spoken of the shining city all my political life." Tom Wolfe's *The Bonfire of the Vanities* was serialized in *Rolling Stone* beginning July 19, 1984. An article on gallup.com (January 1, 1998) notes that Mother Teresa was the woman Americans polled most admired in 1986, 1995, and 1996.

161 Jason Berry's reporting efforts, and the resistance to them, are set out in *Lead Us Not into Temptation* (where the lament of the *Times of Acadiana* editor Linda Matys is quoted); in Manuel Roig-Franzia's *Washington Post* profile (September 20, 2011); and in a *Times* video documentary, "The First Report," by Ben Proudfoot (August 14, 2021). *The Washington Post* published a report about the imminent trial of Gilbert Gauthe on June 8, 1985, the *Times* on June 20, quoting Rev. Kenneth Doyle, "a spokesman for the United States Catholic Conference in Washington." The "Doyle-Mouton-Peterson Report," ninety-plus pages, was compiled in June 1985. The *Time* and *Newsweek* reports on AIDS, and President Reagan's refusal to mention the disease, are treated in France's *How to Survive a Plague*. Briggs's *Holy Siege* reports the presence of Dignity chapters in dozens of dioceses, as does Michael O'Loughlin's *Hidden Mercy*, which has many episodes involving the Church, Catholics, gay people, and AIDS activism. William Hart McNichols, no longer a Jesuit, shared flyers and other documents with me.

165 The *Times* reported on the Archdiocese of New York's efforts to establish a shelter for people with AIDS on August 19, 21, and 31, 1985; on the showing of a film about Mother Teresa at the United Nations, October 27, 1985 (Secretary General Javier Pérez de Cuéllar is quoted calling Teresa "the most powerful woman in the world"); on the planned hospice at St. Veronica's on Christopher Street, November 6, 1985; and on the news conference outside the hospice (with Teresa wearing sunglasses), December 25, 1985. The "supportive-care program" at St. Vincent's is described in Sister Patrice Murphy's introduction to *Sorrow Built a Bridge*, in France's *How to Survive a Plague*, and in O'Loughlin's *Hidden Mercy*. A stock photograph on sciencephoto.com ("AIDS Crisis in the News," 1985) shows covers of a number of newspapers and magazines.

167 Andy Warhol's social friendships with Kenny Scharf, Julian Schnabel, and Keith Haring are presented in Colacello's and Gopnik's biographies (each drawing from the *Diaries*), the friendship with Haring in Brad Gooch's superb biography *Radiant: The Life and Line of Keith Haring* (Harper, 2024). In the *Diaries*, Warhol records collaborating on a gift for Madonna and Sean Penn, August 5, 1985; anticipates attending the wedding of Maria Shriver and Arnold Schwarzenegger, April 21, 22, and 23, 1986; comments on Yoko Ono's party for Bob Dylan, November 14, 1985; and records his presence at a party for the Oreo cookie, at the Waldorf-Astoria, June 6, 1986. Of his many references to going to church, the one about running into Adolfo

(March 2, 1986) is among the most detailed. In an entry of March 9, 1984, Warhol notes, "Adolfo says that he sees me in church every Sunday, that he sits right next to me, so I'm embarrassed that I've never recognized him." He reports on outings to the Church of the Heavenly Rest, December 25, 1985, and March 30, 1986, to the AIDS benefit at the Javits Center, April 29, 1986, and to the Perry Ellis show ("they had to carry Perry out"), July 8, 1986. He recalls Alexander Iolas's visit to the studio, June 23, 1986.

169 Jessica Beck observes that the *Last Supper* commission "became a near-obsession" for Warhol in "Andy Warhol: Sixty Last Suppers," in *Gagosian Quarterly* (summer 2017), which reproduces a Warhol collage showing a snippet of the *Post*'s AIDS FUROR headline. After considering the *Last Supper* works, the *Diaries*, and the gravity of the AIDS pandemic, in New York's arts community, especially, Beck concludes: "More than a demonstration of reverence for Leonardo's masterwork, or even an unveiling of his Catholic faith, Warhol's Last Supper paintings are a confession of the conflict he felt between his faith and his sexuality, and ultimately a plea for salvation during the mass suffering of the homosexual community during the AIDS crisis."

170 For all their differences, Leonard Cohen and Andy Warhol moved in the same circles often: that of the Exploding Plastic Inevitable, which, Sylvie Simmons proposes in her biography, led Cohen to become a songwriter of a certain kind; and that of the Hotel Chelsea, where he lived in 1966 and 1967—the months after Warhol's film *Chelsea Girls* had made the life of the hotel synonymous with an enervated bohemia. Will Hermes's *Lou Reed: The King of New York* (Farrar, Straus and Giroux, 2023) notes that Cohen went to the Dom—the Polish community hall on St. Mark's Place where the Exploding Plastic Inevitable was held—and met Nico, with whom he had an affair, and who introduced him to Lou Reed. Alan Light's *The Holy or the Broken* (Atria, 2012) explains that the emergence of Cohen's "Hallelujah" as a spiritual for the ages began with a 1991 version by John Cale (who had played with Reed in the Velvet Underground, the band featured during the Exploding Plastic Inevitable), which Jeff Buckley (not knowing Cohen's version on *Various Positions*) made the basis for his version.

171 Cohen spoke deeply of the "traditions and scriptures and roots" he drew from in *Book of Mercy* in an interview with Vicki Gaboreau for CBC radio in May 1984, and went on to describe his outlook with depth, precision, and feeling in a December 1984 interview with Robert Sward, for *Malahat Review* (December 1986). Both are in *Leonard Cohen on Leonard Cohen*.

174 Stanislaw Baranczak's review of Miłosz's *Unattainable Earth* was published in the *Times Book Review* (July 6, 1986), under the headline "Garden of Amazing Delights." Miłosz's travels to Rome are chronicled in *A Year of the Hunter*; I'm grateful to John Glusman, who edited the book at Farrar, Straus and Giroux, for urging me to read it. Nathan Gardel interviewed Miłosz in August 1985 for *The New York Review of Books* (February 27, 1986). In *The Collected Poems*, the New Poems are dated by colophon: "1945" (Berkeley, 1945); "Six Lectures in Verse" (Berkeley, 1985); "Caffé Greco" (Rome, 1986); "How Should It Be in Heaven" (Rome, 1986).

178 Václav Havel's tape-recorded conversations with Karel Hvížd'ala, published in samizdat as *Long Distance Interrogation* in 1986, were published in English in 1990 as *Disturbing the Peace*, trans. and with an introduction by Paul Wilson (Knopf). *Letters to Olga*, trans. and with an introduction by Paul Wilson, was published in 1989 (Holt). Havel's speech accepting the 1986 Erasmus Prize is at erasmusprijs.org.

179 U2's role in organizing the *Conspiracy of Hope* tour is set out in *U2 by U2*, *Surrender*, and especially Eamon Dunphy's *Unforgettable Fire*, which relates how the band

members met Jack Healey through their manager, Paul McGuinness, who was "a long-time friend of Tiernan McBride, son of Sean McBride, one of Amnesty's founding members." The history of the organization and its logo are on amnesty.org. Little Steven's "Sun City" video (1985) is on YouTube. Bono describes his and Ali's trip to El Salvador and Nicaragua in *U2 by U2*—where he mentions "Christianity, social justice, artists in power"—and at length in *Surrender*. The Neville Brothers' role in the tour is set out in *The Brothers Neville*; Bono recalls Aaron's way of opening the press conference in *U2 by U2*. Joan Baez's early story is told in David Hajdu's *Positively 4th Street* (Farrar, Straus and Giroux, 2001), where Hajdu summarizes her public image as "the Peace Queen folk goddess madonna." The history of "Amazing Grace" is set out in an overview of the Library of Congress's collection of items related to the hymn on loc.gov. Bono and Edge recall their "love affair with American literature"—and with some of the authors whose books they read—in *U2 by U2*; there, too, Edge recalls his immersion in Dylan's *Biograph* and his thrill on meeting Dylan at the Forum in Los Angeles. In her liner notes for *Trouble No More*, Amanda Petrusich points out that "in a sense, Dylan has always performed devotional material—work that suggests an unyielding allegiance to a certain worldview, a giving over of the self to unseen forces." Dylan's tour with Tom Petty and the Heartbreakers is described in detail in Clinton Heylin's *Bob Dylan: Behind the Shades Revisited*. Video of the Conspiracy of Hope show at Giants Stadium in New Jersey (June 15, 1986) is on YouTube, as are videos of U2's sets at the Los Angeles Sports Arena (June 6) and the Rosemont Horizon in Chicago (June 13). Bono recalls the death of his friend Greg Carroll in *U2 by U2*.

7. BE A SOMEBODY WITH A BODY

185 Woody Allen's *Hannah and Her Sisters* was released on February 7, 1986. Madonna's upbringing, emergence, and early fame are recounted in Mary Gabriel's *Madonna: A Rebel Life* (Hachette, 2023) and in Christopher Andersen's *Madonna Unauthorized* (Simon & Schuster, 1991); Gabriel presents Madonna's quarrels with her father over God and Jesus, and notes the rape Madonna survived. Her time as a drummer in a New York post-punk band is dramatized in the biopic *Madonna and the Breakfast Club* (2019). Her relationship with Keith Haring is described in Brad Gooch's *Radiant: Keith Haring's Life and Line* (Harper, 2024), as well as in Andersen's and Gabriel's biographies. She characterized what became her "look" to Stephen Holden of the *Times* (June 29, 1986); she called her style "pseudo–Puerto Rican punk rock freak out" in her first published interview, for *Island* magazine (October 1, 1983), later posted on todayinmadonnahistory.com. Joanna Biggs's review of Gabriel's biography in *The New York Review of Books* (May 23, 2024) has much to say about Madonna's style.

187 *Andy Warhol's 15 Minutes* was first shown on MTV in October 1985.

187 On publication in 1989, *The Andy Warhol Diaries* was notorious as a book-without-an-index. Warhol mentioned seeing Tina Turner in the diary on August 2, 1985; Miles Davis, April 6, 1986; Bruce Springsteen, September 1, 1985; and Bob Dylan, July 17, 1986, as Ric Ocasek's guest. He was in London July 6–13, 1986. He noted seeing Prince in the diary, August 2, 1986; Elton John, September 13, 1986; *Blue Velvet*, September 29, 1986; *Shanghai Surprise*, September 25, 1986; *The Color of Money*, October 8, 1986; *Goose and TomTom*, August 28, 1986; *The Early Girl* ("the Demi Moore play"), November 8, 1986. He mentioned attending the Pyramid benefit

for Martin Burgoyne in the diary, September 4, 1986; seeing the "sores all over his face," August 30, 1986; and reading the obituary for Roy Cohn, August 4, 1986. He noted, "Worked all afternoon," September 5, 1986; "Worked till 8:00," September 24, 1986; "Worked," October 21, 1986. His remarks that he hoped to make *The Last Supper* "transgressive" and "exciting again" are quoted in Gopnik's biography.

189 Bob Colacello recalls Warhol's reaction to Jon Gould's decline and death in *Holy Terror*. Gopnik quotes from the diary entry of September 21, 1986: "And the Diary can write itself on the other news from L.A., which I don't want to talk about." In the 1989 edition of the *Diaries*, Pat Hackett's note appears in italics following the entry for September 21, 1986; it does not appear in the 2014 edition.

189 The *Times* published an obituary for Corita Kent on September 19, 1986. The *Diaries* make no reference to her.

190 Colacello recalls, "Within days of Jon's death, Andy started what would turn out to be his final big series of paintings: The Last Supper." Jessica Beck reflects on the *Last Supper* series as a response to AIDS and to Jon Gould's death in "Love on the Margins" and in "Andy Warhol: Sixty Last Suppers," where she notes that Jane Dillenberger "makes no reference to the epidemic in her book"; and in "Warhol's Confession: Love, Faith, and AIDS," where he develops the connections among cancer ("the Big C") and Christ. With regard to Corita Kent, Gopnik notes that the influence flowed in both directions: Warhol influenced Kent, and Kent influenced Warhol.

191 The Vatican's disciplinary actions against Charles Curran are set out in *Holy Siege*, those against McNeill in that book and in *To Dwell in Peace*, where Daniel Berrigan observes, "McNeill's predicament was my own." Berrigan describes drafting a letter in support of McNeill in a letter to Philip Berrigan and Elizabeth McAlister, October 30 and November 7, 1986, in *The Berrigan Letters*. He relates his concern for Lewis Cox on June 13, 1986, calls their relationship "a little like a marriage" on September 29, and reports having visited Corita Kent in a letter of August 5. Her role in designing the cover for his play *The Trial of the Catonsville Nine* was described in an article about an exhibit of her work at Harvard's Schlesinger Library on radcliffe.harvard.edu; evidently a different exhibit, *Corita Kent and the Language of Pop*, on view in 2015 and 2016, is described on harvardartmuseums.org. Berrigan's account of his time spent accompanying Douglas is in *To Dwell in Peace*.

192 Warhol remarked on Robert Mapplethorpe and Sam Wagstaff in the diary, October 7, 1986, and on the *National Enquirer* piece about Martin Burgoyne, October 13, 1986. Jane Daggett Dillenberger's account of *Be a Somebody with a BODY* is in *The Religious Art of Andy Warhol*; a black-and-white photograph of Warhol circa 1950 is juxtaposed with the work, making the resemblance of artist and bodybuilder clear. Wayne Koestenbaum, in *Andy Warhol*, notes that "in 1954 he went with with a friend to a gym" and that three decades later "he worked with trainer; he tried, as his weight-lifter painting advertised, to be somebody with a body."

195 The Congregation of the Doctrine of the Faith's letter *Homosexualitatis problema* was "given at Rome, 1 October 1986," in Vatican parlance, and was signed by Joseph Ratzinger, the prefect, and Alberto Bovone, the secretary of the CDF. It carried the pro forma note: "During an audience granted to the undersigned Prefect, His Holiness, Pope John Paul II, approved this Letter, adopted in an ordinary session of the Congregation for the Doctrine of the Faith, and ordered it to be published." The *Times*' Roberto Suro reported on its release on October 29, 1986, and then on October 31; the latter article bore the headline "Vatican Reproaches Homosexuals with a Pointed Allusion to AIDS." Daniel Berrigan's response is cited in the account of the episode in Briggs's *Holy Siege*.

196 CBS News's *60 Minutes* segment "The Brothers Berrigan" aired November 16, 1986. Daniel Berrigan remarked on the life and death of Michael Roccosalvo in two letters to Philip Berrigan and Elizabeth McAlister, October 16 and 30, 1986, and the "grapevine" news that two Jesuits had died of AIDS in a letter of November 7, 1986. The penultimate chapter of *To Dwell in Peace* is called "AIDS: The Dream, the Awakening."

197 Andy Warhol mentioned the postponement of the *Last Supper* exhibition to December 15 in his diary, November 10, 1986, and the AIDS benefit in the same entry ("And then as we were leaving Chris Makos shoved some nuns at me for a picture . . . They were from St. Vincent's, the benefit was for them"). Colacello mentions openings of gallery shows of Warhol's *Hand-Painted Images 1960–62* at Dia and *Oxidation Paintings 1978, 1986* at Gagosian, and recounts that Warhol went to the the Church of the Heavenly Rest on Thanksgiving to "ladle soup to the homeless." A photo of him there, carrying a tray of paper cups, is in *The Religious Art of Andy Warhol*. He recalled the outing in his diary, November 27, 1986, remarked on hearing of Martin Burgoyne's death on November 30, and described skipping the wake on December 2. Madonna's fright over Burgoyne's death is related in Mary Gabriel's biography. Colacello spells out Warhol's health frettings, documented repeatedly in the fall 1986 entries in the diary; he worried about a Valium addiction in entries of October 2 and December 29. Warhol mentioned an outing to the Church of the Heavenly Rest, December 25, a "rest day" on January 1, and another on January 5, the party for Ian McKellen at Nell's on January 14, seeing Robert Mapplethorpe at Mr. Chow's on January 16, his reluctance to go to Europe in the same entry, and a "last Diary" on January 17. Colacello, who was present at Nell's, recounts the evening firsthand. Warhol recalled the trip to Europe and the *Last Supper* show in entries of January 18–24. Photographs of Warhol with two Dominican friars at the show are in Dillenberger, and photos of Warhol by himself and Warhol signing posters amid a crush of fans in Beck's "Andy Warhol: Sixty Last Suppers." Colacello quotes Warhol's associate Daniela Morera, *Interview*'s Italian editor, on the size of the crowd; Gopnik quotes her on the frenzy of the signing. Warhol related the "milestone" on the plane and "not feeling well" in the diary, January 24.

199 Warhol's final days are registered in the diary and in Colacello's and Gopnik's biographies; Gopnik observes, "It seems Warhol was hiding how sick he really was from Pat Hackett, and thus from his diary. Days where he said 'nothing much happened' were actually spent in bed." Dillenberger's book includes photographs of his bedroom and canopy bed. Colacello reports that Warhol said, "I feel like I'm going to die!" and that he checked into the hospital as "Bob Roberts." Gopnik describes the outfit Warhol wore to New York Hospital in fashion-fluent detail. Colacello records that "one West German newspaper, *Bild Zeitung*, quoted unnamed New York Hospital sources who said that Andy had had AIDS." The photograph of Warhol's studio, by Evelyn Hofer, is reproduced in a number of the books and articles dealing with the *Last Supper* series; Arthur C. Danto remarks on the photo in *Andy Warhol* (Yale, 2009).

201 Kenneth Briggs, David France, and Michael O'Loughlin record the standoffishness of Catholic clergy toward openly gay people and people with AIDS in the Church. The *Times* profiled the proprietors of Redden's Funeral Home (February 13, 1987). The ouster of Dignity figures into *Holy Siege*, Michael Daly's and Michael Ford's biographies of Mychal Judge, James Forest's *At Play in the Lion's Den*, and *The Berrigan Letters*, where Daniel Berrigan remarks on it a letter of August 17, 1987. The *Times* reported on a protest at St. Patrick's over the cessation of Dignity's Mass (March 16,

1987). Matt Foreman and Richard Ferrara spoke with me about Dignity and the Cathedral Project.

202 Cardinal O'Connor's activities figure prominently in *Holy Siege* and in Nat Hentoff's 1987 *New Yorker* profile. The memorial Mass at St. Patrick's is featured in all the Warhol biographies and in Dillenberger's *The Religious Art of Andy Warhol*; Natasha Fraser-Cavassoni, who was there in her role as an assistant at the Factory, recalls it in *After Andy*. Dillenberger's book reproduces a photograph taken outside St. Patrick's, alongside John Richardson's eulogy; a much longer recollection of Richardson's was published in *Vanity Fair* (June 1987), with photographs by Evelyn Hofer. *Andy Warhol: The Day the Factory Died*, by Christophe von Hohenberg and Charlie Scheips (Empire, 2006), includes several dozen photographs by Hohenberg and others before, during and after the Mass, as well as the printed program and Richardson's eulogy. UPI's report (April 1, 1987) indicates that 3,000 people attended, the *Times*' (April 2) that 2,000 attended; Lou Reed's quip about April Fool's Day is in the latter. A few weeks later (May 5, 1987), *The Village Voice* published a twelve-page appraisal of Warhol and his work, leading with Gary Indiana's piece—featured on the cover—"Is God Dead? A Skeptic Looks at Warhol Worship."

8. "BAD"

210 Jonathan Lethem's essay "Speak, Hoyt-Schermerhorn" was published in *Harper's* (December 2004) and in *The Disappointment Artist* (Doubleday, 2005). The "Bad" video is on YouTube; Spike Lee's documentary *Bad 25* (2012) fills in the story. A "Behind the Music" segment on YouTube details the efforts that Scorsese undertook to shoot the "Bad" video. The challenges Scorsese faced in getting *The Last Temptation of Christ* produced are set out in Lindlof's *Hollywood Under Siege*, in *Scorsese on Scorsese*, in *Martin Scorsese: A Journey*, in the 1988 *Film Comment* interview, in Cooper's 2016 *Commonweal* interview, and elsewhere. The "Wanted: For Sacrilege" poster is shown at 13:30 of the "Bad" video.

212 Michael Novak's formation and his conversion to neoconservativsim are related in Peter Steinfels's *The Neoconservatives* (Simon & Schuster, 1980). Richard John Neuhaus's life and work are expertly surveyed in Randy Boyagoda's biography (Image, 2015). I came to know Neuhaus and his writing in 1992 through reporting for a *New Republic* profile (unpublished). Garry Wills—a contemporary of Novak's and Neuhaus's, and their strongest adversary on many of the issues involving religion and society—sketched their ascent to prominence retrospectively in *The New York Review of Books* (October 6, 2005). Neuhaus set out his sense of the significance of the extraordinary synod of 1985 in *The Catholic Moment* (Harper & Row, 1987); Boyagoda develops the working friendship of Neuhaus and John J. O'Connor.

214 René Girard's life and the main lines of his thought are set out in *The Girard Reader*, ed. James G. Williams (Crossroad, 2000), and in Cynthia L. Haven's biography, *Evolution of Desire* (Michigan State, 2018). The *Reader* includes a biographical sketch, and, as an epilogue, a conversation with Girard, in which he indicates that he became a Catholic in 1959. Leo D. Lefebure initiated and deepened my understanding of Girard, in conversation and through the section on Girard in his *Revelation, the Religions, and Violence* (Orbis, 2000). George Packer's profile in *The New Yorker* (November 20, 2011) of the venture capitalist Peter Thiel, a Girard devotee, called attention to the extra-religious implications of Girard's work. *The Scapegoat*, Yvonne

Freccero's English translation of *Le Bouc émissaire*, was published by Johns Hopkins University Press in 1986; a review by John Howard Yoder in *Religion and Literature* (Autumn 1987) set out its argument. Caiaphas is recorded saying, "It is expedient that one man should die for the people" in the Gospel of John, 11:50.

215 Penny Lernoux's books *Cry of the People* (Penguin, 1982) and *People of God* dramatized the conflict between Catholic and Protestant churches in Latin America and the concurrent conflict between U.S. bishops' opposition to a "gospel of wealth" and the Vatican's opposition to communism there. More recently, the subject has been treated by John T. McGreevy in *Catholicism: A Global History* and Leslie Woodcock Tentler in *American Catholics*. *The Gospel of Wealth* is an 1889 book by Andrew Carnegie.

216 The scandals involving the televangelists Bakker, Swaggart, and Robertson are treated in Prothero's *Why Liberals Win the Culture Wars*; the conflict involving the rape and murder of four American churchwomen in Briggs's *Holy Siege*, as are the controversies over the establishing of a Carmelite convent at Auschwitz and Pope John Paul's meeting with Kurt Waldheim; the explanation of the U.S. ambassador's absence and the Holocaust survivor's protest were reported in the *Times* (June 26, 1987).

219 Madonna's "Papa Don't Preach" video, directed by James Foley, a native of Bay Ridge, Brooklyn, was shot on Staten Island on May 29, 1986 (the Facebook page Classic Staten Island indicates) and was released on June 30. Stephen Holden's *Times* article about Madonna was published the day before. Mary Gabriel's biography relates that period of Madonna's career in vivid detail.

221 Prince's *Controversy* was released in 1981, *1999* in 1982, *Purple Rain* in 1984, *Sign o' the Times* in 1987, and *Piano & a Microphone* in 2018. The full-page ad for *Sign o' the Times* ran in *The Village Voice*, March 3, 1987; in his Consumer Guide, the *Voice* music critic Robert Christgau gave the record an A+.

221 Prince's life and work are explored in Matt Thorne's biography (Faber, 2013); in Touré's *I Would Die 4 U* (Atria, 2013); in Questlove's *Music Is History*; and in Alan Light's *Let's Go Crazy* (Atria, 2014), as well as in *The Beautiful Ones*, a collaboration by Prince and Dan Piepenbring (One World, 2019). Duane Tudahl's *Prince and the Parade and Sign o' the Times Era Studio Sessions: 1985 and 1986* (Rowman and Littlefield, 2021), one in a series, chronicles Prince's activities in the studio and elsewhere with chronological precision. Light notes that Prince, when he performed "I Would Die 4 U" after becoming a Jehovah's Witness, sang "He's your Messiah" rather than "I'm your Messiah," and sets out the conflict involving Prince's performing at the Orange Bowl in Miami on Easter Sunday. Tudahl quotes Todd Herreman's recollection that Prince told him "God gave me a groove." The Smiths' "There Is a Light That Never Goes Out" is on *The Queen Is Dead* (Rough Trade, 1986).

226 Prince said he always wanted to be thought of as bad in *Rolling Stone* in 1985, quoted in a piece about the Prince-MJ rivalry on popmatters.com (April 29, 2016). The *Rolling Stone* piece is Neal Karlen's "Prince Talks: The Silence Is Broken" (September 12, 1985). Mary Gabriel goes into the Prince-Madonna pairing in detail in her biography; Thorne notes that Prince, Madonna, and Bruce Springsteen performed Prince's "Baby I'm a Star" together at the Forum in Los Angeles. Alan Light reports that Prince resisted Michael "Jackson's overtures to record the song 'Bad' as a duet." Duane Tudahl reports that Prince recorded nearly a hundred new songs from mid-1985 to mid-1986, recording "The Cross" on Sunday, July 13, 1986, and "Sign o' the Times" on Tuesday, July 15. He relates that Prince and Susannah Melvoin, vocalist in the Revolution, read articles in the *Los Angeles Times* (about "President

Reagan's 'Star Wars' anti-missile program, the growing AIDS crisis, the investigation of January's space-shuttle explosion, and stories of drug abuse in the inner cities") and in the Minneapolis *Star Tribune* ("about a street gang called 'The Disciples'") and that these inspired the lyrics to "Sign o' the Times." He compares the song to "What's Goin' On."

230 Touré tells the story of how "Purple Rain" was inspired by Bob Seger and the Silver Bullet Band's power ballad "We've Got Tonight." A live version of "Forever in My Life" filmed at Paisley Park on March 21, 1987, is on YouTube; the version in the *Sign o' the Times* concert movie (released November 20, 1987) was filmed in Antwerp and Rotterdam in June 1987, according to princevault.com; an item by Jem Aswad in *Variety* (August 27, 2020) examines several versions of the song.

230 U2 evidently recognized "The Cross" as a song along their lines: at a party following a show in Dublin in 1995, Bono sang it to the crowd of insiders—and Prince joined him partway through. On *Sign o' the Times*, the song is in the key of E flat—an unusual key for most guitarists but a common one for Edge in the 1980s.

231 Walker Percy spoke of "the pilgrim's search outside the self rather than the guru's search within" in his remarks at the National Book Awards in 1962, where his first novel, *The Moviegoer*, was awarded the fiction prize. Bono describes his wish for "something biblical" and his vision of a Reaganish face "red like a rose" in *U2 by U2*.

9. WAR

234 The Mobilization for Peace & Justice was reported in the *Times*, April 26, 1987. Philip Berrigan described the mood to Daniel Berrigan in a letter, April 25, 1987, in *The Berrigan Letters*, and the protest at CIA headquarters in one of May 3; Daniel had expressed concern about the drive to "up the ante" on January 20. The U.S. bishops affirmed a Catholic "presumption against war" in *The Challenge of Peace* (1983). The English Catholic commentator Austen Ivereigh introduced me to the term "pelvic issues"; in focusing on them, the U.S. bishops followed the lead of the Vatican, which issued an Instruction against legal abortion in February 1987 and one against artificial insemination and in vitro fertilization in March 1987.

236 The conflict over the Martin Luther King Jr. holiday is described in Prothero's *Why Liberals Win the Culture Wars* and elsewhere. Howell Raines reviewed David J. Garrow's *Bearing the Cross* in the *Times*, December 28, 1986. The conflict was reported in the *Times*, April 4, 1987; Bono recalls it, and the show with Bob Dylan in Los Angeles (as does Edge), in *U2 by U2*. *Time* published Jay Cocks's cover story about U2 in the issue dated April 27, 1987 (and in readers' hands the week before). Basic Books published James Davison Hunter's *Culture Wars: The Struggle to Define America* in 1991. The U.S. bishops warned of a human threat to "the created order" in *The Challenge of Peace*.

243 Daniel Berrigan's homily at Dignity's conference in Miami (July 26, 1987) is the epilogue to *Sorrow Built a Bridge*. The protests of gay Catholics and AIDS activists were reported by UPI (March 16, 1987), and the New York Archdiocese's court injunction—meant to apply during the Gay Pride Parade—in a *Times* article (March 10, 1987); the activities of the Lavender Hill Mob are recorded in Sarah Schulman's *Let the Record Show*. Peter Hujar's story is told in Maisie Skidmore's survey of his lesser-known works in *AnOther Magazine* (February 2, 2018) and in Cynthia Carr's capacious *Fire in the Belly: The Life and Times of David Wojnarowicz* (Bloomsbury, 2012); Jeff Seroy urged me to look into Hujar's story. Brad Gooch's *Radiant* emphasizes

the influence of Robert Henri's *The Art Spirit*. A 2021 post on artandtheology.org by Victoria Emily Jones includes Michael Wright's piece (from his e-newsletter *Still Life*) about Keith Haring's time among the "Jesus freaks," which itself draws from Natalie E. Phillips's "The Radiant (Christ) Child: Keith Haring and the Jesus Movement," in *American Art* (fall 2007). Gooch's prologue quotes the critic Barry Blinderman on the Radiant Child's halo. David France, in *How to Survive a Plague*, notes that Haring designed a logo for the 1986 Gay Pride Parade in Manhattan (and that Haring's cheerful work was in contrast to the stark iconography of ACT UP), and quotes the ugly imprecations of Rev. Jerry Falwell's supporters.

247 Richard John Neuhaus proposed "the Catholic moment" in *National Review* (November 7, 1986) and in *The Catholic Moment*. The *Times* reported on planning for John Paul's U.S. visit on September 19, 1985; November 8, 1986; February 18, 1987; and March 19, 1987.

249 U2's 1987 tour is captured in *Rattle and Hum* (1988), directed by Phil Joanou; the making of the film figures into *U2 by U2* and *Surrender*. Madonna's 1987 tour is chronicled in Gabriel's biography, and in Christoper Andersen's *Madonna Unauthorized*. The *Times* reported on the Vatican instruction opposing in vitro fertilization on March 11, 1987 (publishing the text in full); on the National Commission on the Human Immunodeficiency Virus Epidemic on July 24, 1987; and on a protest outside St. Patrick's Cathedral on July 27, 1987.

250 Sinéad O'Connor relates her family history and the making of her first record in *Rememberings*; early in the book she declares, "My father remains my idol, having borne more pain than any human being I know and having borne it so heroically." Robert Christgau likened her "deep swoops" on *The Lion and the Cobra* to those of Mercedes McCambridge in *The Exorcist* in a review-profile in *The Village Voice* (May 22, 1990), comparing her to Madonna ("Even pumping serenity, Sinéad is not really Joni or Suzanne or Tracy. She's Madonna, a self-created pop commodity—an old pro at 23") and to Patti Smith ("Not since Patti Smith—whom she now cites as a role model . . . has anybody had a better chance of defining rock-not-pop in a specifically female way"). Dylan recalls his mid-career climacteric in *Chronicles: Volume One* (Simon & Schuster, 2004).

255 Richard Rodriguez's personal story runs through all his work, beginning with *Hunger of Memory* (Godine, 1982). His essay "The Hidden Legacy of the Missions" was published in the *Los Angeles Times*, September 13, 1987, and then, as "The Missions," in *Days of Obligation* (Viking, 1992), without the story of his encounter with Father Galvan. I discussed his crypto-religiosity in "A Fugitive Catholicism" (*Commonweal*, November 5, 2004). Madonna's 1987 tour of Italy is described in Gabriel's biography.

257 The conflicts involving John Paul and the Vatican are recounted in *Holy Siege*, which has a detailed account of the pope's 1987 journey to the United States. The *San Francisco Chronicle*'s front page on September 18, 1987, carried a photograph of John Paul near the Golden Gate Bridge, and the headline "Pope Tells AIDS Sufferers They Have God's Love." Czesław Miłosz reflects on the pope's journey in *A Year of the Hunter*; "Incantation," translated by Miłosz and Robert Pinsky, is in *The Collected Poems*.

10. DOWN IN THE HOLE

263 Diana B. Henriques chronicled the 1987 stock market crash in *A First-Class Catastrophe* (Holt, 2017); James B. Stewart did so in *Den of Thieves* (Simon & Schuster,

1991). The depressed character of the city is something I saw and felt personally. Tom Wolfe's *The Bonfire of the Vanities* was published in October 1987. Luc Sante describes the rapid changes of the 1980s in the early pages of *Low Life*.

264 *Wings of Desire*, which premiered at the Cannes Film Festival in 1987, was shown at the Cinema Studio near Lincoln Center beginning in late April 1988. Wim Wenders's Catholic upbringing is sketched in "Wim Wenders: Catholic Journeyman," by Maria Elena de Las Carreras, in *Crisis* (March 1, 1998), and is filled out in my article "The Spiritual Nearness of 'Pope Francis: A Man of His Word,'" at newyorker.com (May 21, 2018). Jessica Winter reflected on the film's "palliative" sense of "divine order" in "Earth Angel," in *Slate* (January 12, 2010).

266 Mychal Judge's story is told in *The Book of Mychal*, by Michael Daly (Thomas Dunne, 2008); in *Father Mychal Judge*, by Michael Ford (Paulist, 2002), and in Michael O'Loughlin's *Hidden Mercy*. Thomas Merton describes the Church of St. Francis of Assisi on East Thirty-First Street in *The Seven Storey Mountain* (Harcourt Brace, 1948). An ad for an AIDS ministry "In the Spirit of St. Francis of Assisi," which appeared in *Outweek* in the eighties, was reproduced with Ruth Graham's piece "Could Father Mychal Judge Be the First Gay Saint?" in *Slate* (September 11, 2017). Bill McNichols, in conversation in 2022, told me about his meals with Judge at Aggie's Diner.

269 Tom Waits played the Eugene O'Neill Theatre for six nights beginning on October 13, 1987, the show reviewed by Robert Palmer in the *Times* (October 15, 1987); Diana B. Loevy, who attended one night, called the run to my attention at the time. Waits's story is told in Barney Hoskyns's *Lowside of the Road* (Broadway, 2009), and by Waits himself in the remarkable interviews gathered by Paul Maher Jr. in *Tom Waits on Tom Waits* (Chicago Review, 2011). He said "I had church when I was a kid" in an interview with Chris Douridas on KCRW-FM (October 12, 1992), and went on to say, "No, I'm not religious"; told the story of a blind uncle who took possession of a church organ to Pete Silverton for a profile in *You*, a supplement to *The Mail on Sunday* (October 13, 1985); recalled seeing James Brown at Balboa Park to Howard Larman on KPFK-FM (September 21, 1973); described hitchhiking to Arizona and winding up in a Pentecostal church in a track-by-track conversation about *Swordfishtrombones* transcribed and sent to the press by Island Records in 1983; and set out several definitions of a rain dog in a CBC interview with Michael Tearson (late 1985). Robert Ward likened Waits to "a Bible salesman on a cheap shot to nowhere" in *New Times* (June 11, 1976). Barney Hoskyns quotes Waits on Brennan's "big wild loud Irish family" and describes their wedding, reception, honeymoon in Ireland, and choice of a house on Union Avenue in Los Angeles in *Lowside of the Road*, and highlights Waits's effort "to arrive at some type of cathartic epiphany in terms of my bifocals."

270 "Down, Down, Down" is on *Swordfishtrombones* (Island, 1983). Hoskyns describes the party Jean-Michel Basquiat gave for John Lurie, noting that Andy Warhol was there. Waits, Robert Frank, and Ted Barron recalled Frank's photo shoot for *Rain Dogs* in the *Times Magazine* (March 6, 2011).

272 Waits described *Franks Wild Years* as "a cross between a love machine and the New Testament" on *Late Night with David Letterman* in 1986.

273 Waits praised *Exile on Main St.* and "I Just Want to See His Face" in *The Observer* (March 20, 2005): "This record is the watering hole . . . This has Checkerboard Lounge all over it," he observed, referring to the legendary nightclub on Chicago's South Side. In the same piece—a list of some of his favorite records—he praised Prince's falsetto ("Nobody does it like Prince"), Leonard Cohen's *I'm Your Man*

("Leonard is a poet, an Extra Large One"), the Pogues' *Rum Sodomy & the Lash* ("these are the dead-end kids for real"), and James Brown's *Star Time* (describing the show at Balboa Park in 1962).

273 Waits described "Way Down in the Hole," from *Franks Wild Years*, as "Checkerboard Lounge gospel" in a 1987 *New York Post* interview with Rip Rense ("Here, Frank has thrown in with a berserk evangelist," he explains). The concert video *Big Time* (1988), withdrawn from sale by Waits, can be seen in clips on YouTube.

275 Andres Serrano spoke about his life, work, and career in vivid detail in an interview conducted by Frank H. Goodyear for the Smithsonian Institution's Archives of American Art in 2009. Julie Ault did a similar interview for the Archives' Visual Arts and the AIDS Epidemic: An Oral History Project in 2017. Serrano calls himself "an artist with a camera" in a biography on andresserrano.com, and characterized himself as an "installation artist" in the catalog text "Andres Serrano: The Body Politic," by Robert Hobbs, in *Andres Serrano: Works 1983–1993* (Institute of Contemporary Art, Philadelphia, 1994). He said he grew up speaking Spanish in "Andres Serrano's Cuban Odyssey," by Alexandro Roxo and Natalia Leite, in *Vice* (November 19, 2013). Holland Cotter wrote about his work in the *Times* (January 27, 1995); Richard Brody wrote about traditionalist Catholics' efforts to destroy *Piss Christ* in *The New Yorker* (April 18, 2011), going into the history of the work and the opposition to it. I wrote about Serrano and *Piss Christ* in *Commonweal* (June 1995). A March 1988 issue of *New York* magazine (Tom Wolfe was on the cover) carried a listing for the show of Serrano's "photographs of objects shot through tanks of blood and urine" at the Stux Gallery, 155 Spring Street. A history of the Stuxes and the gallery is on stuxgallery.com. *The Washington Post* reported the amount of the NEA's grant to Serrano in an article about the controversy over the grant (June 7, 1989).

278 The making of *The Last Temptation of Christ* is detailed in Lindlof's *Hollywood Under Siege*, which indicates that principal photography commenced in Morocco on October 7 and continued through December 23, 1987. I have placed Scorsese at JFK Airport out of historical likelihood. I discussed the film with Scorsese in 2017 and 2022.

280 Bono and Edge are seen playing with the New Voices of Freedom in *Rattle & Hum*, and Edge recalls the session in the film. In *Surrender*, Bono likens Joanou's use of black and white to Martin Scorsese's in *Raging Bull*. In *U2 by U2*, Edge notes that the band played for 144,000 people at Wembley Stadium; Bono recalls playing for 120,000 in Madrid and seeing Eno in tears at the Flaminio in Rome; Edge recalls the influence of Dylan's "Idiot Wind," and Bono declares that fame "should change you." Bono recounts their sojourn in Memphis in *Surrender*; the Sun session is shown in *Rattle & Hum*. New Voices of Freedom joined U2 at Madison Square Garden on September 28, 1987.

281 Ty Burr profiled Willy DeVille for *SPIN*, February 1988. CD liner notes (by Glenn A. Baker) for *Mink DeVille: Spanish Stroll 1977–1987* (Raven, 1996) and for *Miracle* (Raven, 1994) give particulars of DeVille's story, as does Garth Cartwright's "Sympathy for the DeVille," on recordcollectormag.com (June 18, 2012). Peter Wrench gives the background for Van Morrison's song "St. Dominic's Preview" on nodepression.com (February 16, 2013).

284 Cynthia Carr recounts the circumstances of Peter Hujar's death and burial in *Fire in the Belly*.

284 Janet Maslin's *Times* review of Hector Babenco's *Ironweed* (December 18, 1987) indicates that the film was playing at Tower East. Pauline Kael's brief *New Yorker*

review of the film is in *5001 Nights at the Movies: Expanded for the '90s with 800 New Reviews* (Holt, 1991) James Joyce's composition of "The Dead" is described in Richard Ellmann's biography. Vincent Canby's *Times* review of John Huston's *The Dead* (December 17, 1987) indicates that the film was playing at Cinema 1, and I saw it there (as did David Byrne, sitting a few rows ahead); Michiko Kakutani's *Times* appreciation (December 13, 1987) gives specifics of the production and the film's place in Huston's body of work. Canby's *Times* review of Gabriel Axel's *Babette's Feast* (October 1, 1987) indicates that the film was shown at the New York Film Festival on October 1 and 4.

287 The Pogues' history is related in "Fairytale of New York: The Surprising Story Behind the Pogues' Irish Anthem," in the *Irish Times* (December 7, 2020); Shane MacGowan's story in Matthew Hennessey's "God's Lucky Man," in *City Journal* (August 12, 2014); and the band's Tom Waits connection in "The Pogues Poke Around," in the *Morning Call* (September 26, 1987) and in Waits's favorite-records piece in *The Guardian* in 2005. "The Sick Bed of Cúchulainn" is on *Rum Sodomy & the Lash*, "Fairytale of New York" on *If I Should Fall from Grace with God*.

11. UNSPEAKABLE

289 The history of the Logos Bookstore—first on Madison Avenue, then on York Avenue—is related in a *Times* article (May 16, 2013).

289 Toni Morrison's *Beloved* was published in September 1987 (Knopf); Alice McDermott's *That Night* in April 1987 (Farrar, Straus and Giroux); Philip Roth's *The Counterlife* in January 1987 (Farrar, Straus and Giroux). Louise Erdrich's novel *The Beet Queen* was published in 1986 (Holt), her poetry volume *Baptism of Desire* in 1989 (Harper & Row); Vikram Seth's *The Golden Gate* in 1986 (Random House); Primo Levi's *The Periodic Table* in 1984 (Schocken); Lucille Clifton's *Good Woman: Poems and a Memoir 1969–1980* and *Next: New Poems* in 1987 (BOA). McDermott's Catholicism was addressed in depth in an interview with Paul J. Contino, in *Image*, issue 52 (at imagejournal.org), and by the journal's longtime editor, Gregory Wolfe, in *The Wall Street Journal* (January 10, 2013), under the headline "Whispers of Faith in a Postmodern World." Levi traveled to New York and five other American cities in 1985, and spoke with Roth there and then at length in Turin the next year, a conversation published in *Shop Talk* (Houghton Mifflin, 2001). Clifton's crypto-religious poetry was considered by Christian Wiman in *Commonweal* (December 8, 2023).

292 The *Times* published Michiko Kakutani's review of *Beloved* on September 2, 1987, and Margaret Atwood's review on September 13, 1987. The National Book Award finalists were reported in the *Times* (October 15, 1987); the ceremony was held at the Pierre Hotel on November 9. Gerard Howard was quoted in a *Times* report about the post-awards controversy (November 12, 1987).

293 A memorial service for James Baldwin was held at the Cathedral of St. John the Divine on December 8, 1987. Karen Thorsen's documentary *James Baldwin: The Price of the Ticket* (1989) includes video excerpts; portions are on YouTube. The *Times* ran two reports (December 9) and the eulogies and recollections of Toni Morrison, Amiri Baraka, Maya Angelou, and William Styron (December 20).

294 Baldwin's late nonfiction is included in the Library of America's *Collected Essays*. Richard Goldstein's interview with him was published in *The Village Voice* (June 26, 1984), and later in *James Baldwin: The Last Interview and Other Conversations* (Melville

House, 2014). Eddie S. Glaude Jr. explains Baldwin's sense of the New Jerusalem in *Begin Again* (Crown, 2020). Baldwin's 1984 introduction to *Notes of a Native Son* is in the Library of America edition, as is his "Open Letter to the Born Again," originally published in *The Nation* (September 29, 1979). The sound of Baldwin's recorded voice singing "Precious Lord"—a spiritual by Thomas A. Dorsey—can be heard at the end of the video of the St. John the Divine service, and on a separate video on YouTube.

295 Stanley Crouch's review essay "Literary Conjure Woman" was published in *The New Republic* (October 19, 1987). Morrison spelled out her objectives in writing *Beloved* in "Unspeakable Things Unspoken," a 1989 essay (which originated as a lecture she gave at the University of Michigan, October 7, 1988) included in Volume 2 of *The Norton Anthology of African American Literature*. She described her debt to Gabriel García Márquez in a telephone interview with me for a *Vanity Fair* article about *One Hundred Years of Solitude* (December 2015/January 2016); she recalled reading the novel "in my office at Random House . . . sitting in my office and not doing any more work, just turning the pages. Not doing anything else at all," and went on: "There was something familiar about that novel, something that was so recognizable to me: a certain kind of freedom, a structural freedom . . . It was called magical realism, a phrase I always hated, but I understand why there needs to be a label. I say familiar because part of the way stories were told in my house—the connection that my mother and aunts had with things that they could not see. Not just with God. With 'My Maker,' she called him. She would say, 'I told My Maker.' She wouldn't say she was praying. She would tell about the time when she met an ancestor sitting on a stump in the woods and having a conversation with her. Culturally I felt intimate with [Gabo] because he was happy to mix the living and the dead, and because his characters were on intimate terms with the natural world. His characters were an influence. So when I was reading *One Hundred Years of Solitude*, A, it was familiar, and B, I felt a really outrageous freedom in terms of structure that I hadn't seen—I brought it to *Song of Solomon*." She spoke of "wide-spiritedness" in a 1985 interview with Bessie W. Jones and Audrey Vinson, in *Conversations with Toni Morrison*; she refers to various characters as "wide-spirited" in other interviews collected there.

296 The critiques of Morrison's use of magic realism were made by Richard Locke and Robert Towers in fiction seminars in Columbia University's Graduate Writing Division while I was a student there; Towers reiterated his misgivings in "Blind Alleys and Ways Out," a lecture he gave at Columbia's Low Library in 1990. James Wood set out a critique akin to Towers's in a review of Morrison's novel *Paradise*, in *The Broken Estate: Essays on Literature and Belief* (Random House, 1999), declaring: "The creation of characters out of nothing, their placement in an invented world, is chimerical, and for this reason one rarely wants the novelist to further ripen those chimeras in a false heat." Quincy Troupe's interview with Baldwin, conducted in St.-Paul-de-Vence in November 1987, published in *The Village Voice* (January 1988), is in *James Baldwin: The Last Interview*. The National Book Critics Circle Awards for 1987 were presented in the second week of January 1988; the *Times* reported on the prize controversy (January 19, 1988) and published the pair of open letters in the *Book Review* (January 24, 1988).

298 Henry Louis Gates Jr. calls attention to the intertextual qualities of African-American literature (and Black vernacular art forms as well) in *The Signifying Monkey: A Theory of Afro-American Literary Criticism* (Oxford University, 1988), the basis for much subsequent interpretation of *Beloved* and other works; John [Edgar] Wide-

man reviewed the book for the *Times Book Review* (August 14, 1988). Caleb Smith treated religious themes in *Beloved* and in Baby Suggs's sermon on lithub.com (February 1, 2023). John McClure devotes a chapter of *Partial Faiths* to the role religious motifs play in Morrison's work. The 1988 Pulitzer Prizes were announced March 31, 1988; Morrison's remarks were reported in the *Times* (April 1, 1988); the judges' citation appears on pulitzer.org.

300 Patti Smith came up with her credo "three-chord rock merged with the power of the word" to describe *Horses* (1975); she uses the expression "the word" the way Christian evangelists historically have used it, as an evocative, vatic singular noun. Neil Young observed, "It's better to burn out / Than to fade away," in "My My, Hey Hey," on *Rust Never Sleeps* (1979). Prior to the release of *Dream of Life*, Smith was interviewed by Lisa Robinson for *Interview* (May 1988); she described her "mystical" first meeting with Fred "Sonic" Smith at a hot-dog-and-chili joint in Detroit, and spoke admiringly of Dylan's song "I and I" (from *Infidels*) and of Mother Teresa: "There's a woman who assumes her responsibilities every minute of the day. She doesn't do a benefit once a year; every minute of every day she's doing a benefit for someone. Her whole being is to benefit others. That's what inspires me most, seeing people take things in their own hands and not wait for the government to take care of things. Look at Elizabeth Taylor and all she's done to help raise money for AIDS research. There are so million [*sic*] responsibilities that we have to assume. And that's what our song 'People Have the Power' is about."

301 Patricia Morrisroe describes Robert Mapplethorpe's arrangements with his subjects in her biography, and quotes John Richardson; the ex-seminarian, also quoted there, was Jack Fritscher, "who now wrote pornographic short stories with titles such as 'I'm a Sucker for Uncut Meat' and 'Tit Torture Blues' and was the editor of *Drummer*, "a magazine for leather enthusiasts." Chatwin's account is drawn from his introduction to *Lady Lisa Lyon* (Viking, 1983). Mapplethorpe's predilections are described in Morrisroe's biography, as is his relationship with Sam Wagstaff (also treated in Patti Smith's *Just Kids*). The introduction to the *X Portfolio* (1978) is by Paul Schmidt.

302 Arthur C. Danto's review essay about Mapplethorpe for *The Nation* (September 26, 1988) is in *Encounters and Reflections*; *Mapplethorpe* (Random House, 1992) includes an introductory essay by Danto. Andy Warhol's portrait of Mapplethorpe is from 1983; Morrisroe's biography reproduces Mapplethorpe's 1986 portrait of Warhol, with the caption "Mapplethorpe moved to Manhattan hoping to befriend Andy Warhol, but he was disappointed by the artist's vacuous personality. In Mapplethorpe's portrait of him, Warhol is part saint, part Wizard of Oz." Nigel Finch's BBC documentary about Mapplethorpe, broadcast in the *Arena* series in 1989, is on YouTube.

303 Patti Smith recounts the *Dream of Life* photo sessions and the surrounding tumult in *Just Kids*, having described them with great candor to Morrisroe for her biography. She recalls in *Just Kids* the moment she learned of Andy Warhol's death. Andy Grunberg called Mapplethorpe (not wholly approvingly) "the most topical artist of the moment" in the *Times* (July 31, 1988).

305 The editing of *The Last Temptation of Christ* is described in Thomas Lindlof's book, as are the campaign against the film, the studio's counter-campaign, and Scorsese's eloquent, urgent account of the film as an "affirmation of faith."

307 Robert Christgau reviewed Patti Smith's *Dream of Life* for *The Village Voice*, Robert Palmer for *Rolling Stone* (August 26, 1988); James Wolcott calls it a "mini-resurrection" in *Lucking Out*. Patricia Morrisroe tells of Smith's visit to Robert

Mapplethorpe and the prospective *New York* magazine profile—the magazine ran Kay Larson's review of the Whitney show (August 15, 1988)—and goes into his concerns about publicity and the disclosure of his sexual orientation in detail. The observation that Mapplethorpe's photographs would be expected to "assault, insult, provoke, dismay" is from his 1988 review essay, in *Encounters and Reflections*. Mapplethorpe's wish to depict "the Devil in us all" is quoted in dozens of articles, reviews, and catalog texts.

310 Mapplethorpe looks like an Asbury Park denizen in *Self-Portrait, 1980*. Springsteen observes that he looked "simply . . . gay" on the *Born in the U.S.A.* sleeve in his autobiography, and recollects the hold of Catholicism on his part of New Jersey in the book's overture-like opening pages. "Blinded by the Light" and "It's Hard to Be a Saint in the City" are on *Greetings from Asbury Park, N.J.* (1973); "Adam Raised a Cain" and "The Promised Land" are on *Darkness on the Edge of Town* (1978), as is "Badlands," with its cry "It's ain't no sin to be glad you're alive." The derisive image of a woman who still kneels to pray is in "Point Blank," on *The River* (1980). Springsteen's bittersweet war cry of the Catholic tribe, his memory of physical abuse during grammar school, and his memory of seeing "the face of Satan" in his father are in the autobiography, as is his affirmation that he is "estranged" from the Church but still on the Catholic "team."

312 Steve Pond's review of *Tunnel of Love* was published in *Rolling Stone* (October 7, 1987); Andrew F. Greeley's celebration of Springsteen as a "Catholic meistersinger" ran in *America*, a magazine published by the U.S. Jesuits (February 8, 1988).

313 Springsteen's version of "I Ain't Got No Home" is on *A Vision Shared* (Folkways/Columbia, 1988), as is U2's version of "Jesus Christ"; their remarks about the songs are made for the *A Vision Shared* companion video, now on Vimeo. U2's "Desire" is shown in *Rattle & Hum* and is on the soundtrack, where Bono explains the band's approach to the song; a separate promotional video, showing the band in Los Angeles, is on YouTube. A Woody Guthrie tribute concert at the Hollywood Bowl, September 12, 1970, followed one at Carnegie Hall in 1968; Arlo Guthrie's "Jesus Christ" on YouTube (identified as from the New York show) is likely from the California one. Leonard Cohen's "Passing Through" is on *Live Songs* (1973).

316 Bob Dylan tells the story of his time with writer's block in Malibu and the night Bono paid a visit in *Chronicles: Volume One*. "Disease of Conceit" is on *Oh Mercy* (1989); video of him performing the song, from the piano, at the Hammersmith Odeon in London, February 8, 1990, is on YouTube.

317 In her biography, Sylvie Simmons recounts the recording and release of Leonard Cohen's *I'm Your Man* (1988) and the subsequent tour. Kristine McKenna's March 1988 interview for *LA Weekly* (May 6, 1988) is in *Leonard Cohen on Leonard Cohen*, as are five other substantial interviews from that year. Videos from 1988 shows in San Sebastián, Spain; Oslo, Norway; and Austin, Texas (recorded on Halloween for *Austin City Limits*) are on YouTube. Cohen spoke of the lack of a "capacity to speak" and about "clarity" and "mystery" in Jon Wilde's interview for *Blitz UK* (February 1988), in *Leonard Cohen on Leonard Cohen*. The line "I ache in the places where I used to play" is from "Tower of Song."

12. DREAM OF LIFE

322 The screening at West Twenty-Third Street is in Lindlof's *Hollywood Under Siege*, which places Scorsese in a nearby coffee shop beforehand and recounts the efforts

of the "offended brethren." *The Last Temptation of Christ* is now readily available on DVD and for streaming—no small thing, given the efforts of the "offended brethren."

325 Cullen Murphy's "Who Do Men Say That I Am?" ran in *The Atlantic* (December 1986). Jaroslav Pelikan's *Jesus Through the Centuries* was published by Yale University Press in 1985 and as a Harper paperback the next year. Elaine Pagels's *Adam, Eve, and the Serpent* (Random House, 1988) was reviewed in the *Times* on June 28, 1988.

327 Daniel Berrigan, Bishop Paul Moore, and others were quoted in a *Los Angeles Times* report (July 14, 1988) about an early screening of *The Last Temptation of Christ*, which notes the secrecy surrounding the screening; *The New York Times* (July 15, 1988) quoted the Baptist minister Robert Maddox calling it "kind of hokey." The American Family Association's mass mailing and the offer to buy the picture are in *Hollywood Under Siege*; the latter was reported in the *Los Angeles Times* (July 16, 1988).

329 Andres Serrano recounted the exhibition history of *Piss Christ* in his Smithsonian Institution interview; Stephen Prothero, in *Why Liberals Win the Culture Wars*, notes that the image was shown in Los Angeles without controversy.

330 Arthur C. Danto quoted *The New Yorker*'s Goings on About Town listing for the Whitney Museum's 1988 Mapplethorpe retrospective as the opening of his review essay for *The Nation*, also in *Encounters and Reflections*. Dominick Dunne described the reception firsthand in *Vanity Fair* (February 1989), as did Bob Colacello in long retrospect (March 2016). Patricia Morrisroe recounts the Mapplethorpe family's visit to Robert's Chelsea loft in her biography.

331 Robert Hughes's art criticism is collected in *Nothing If Not Critical* (Penguin, 1992) and *The Spectacle of Skill* (Vintage, 2016), which includes two batches of autobiographical essays—among them one, "Among the Cadets of Christ," on his Catholic education—and a superb introduction by Adam Gopnik. *The Shock of the New* (Knopf, 1981) is the companion book to the 1980 PBS television series on modern art, hosted by Hughes. Hughes's third book was *Heaven and Hell in Western Art* (Weidenfeld & Nicolson, 1968). In his introduction to *Nothing If Not Critical*, "The Decline of the City of Mahagonny," he refers to New York, critically but uncritically, as "Sodom-on-the-Hudson," and disdains Mapplethorpe's work. Hughes characterizes Warhol as not "exemplary" in a robust essay in *The Spectacle of Skill*; the pieces in *Nothing If Not Critical* are spackled with references to Warhol's work, persona, and influence.

333 Andrew Sullivan described his own formation as a gay Catholic conservative in "Incense and Sensibility," in *The New Republic* (September 24, 1990); his essay on Joseph Ratzinger was published in *TNR*, July 4, 1988.

334 Theodore McCarrick's doings circa 1988 are documented in the Vatican's *Report on the Holy See's Institutional Knowledge and Decision-Making Related to Former Cardinal Theodore Edgar McCarrick (1930 to 2017)* (2020). My piece about the report was posted on newyorker.com (November 20, 2020).

336 Czesław Miłosz's account of the role film played in his life, and his imaginative life, is in *A Year of the Hunter*, as are his insights about readings he gave at Black Oak Books and elsewhere. *The New York Review of Books* published A. Alvarez's review of *The Collected Poems*, headlined "Witness" (June 2, 1988), and Miłosz's "A Poet's Reply" (July 21, 1988). His reflections on the "coexistence" in Berkeley of churches and temples of reason, on Koniński, and on Maeterlinck are in *A Year of the Hunter*.

339 The truncated final editing process for *The Last Temptation of Christ* is set out in *Hollywood Under Siege*, as is Peter Gabriel's work on the score (released as *Passion*). Steven Biko's religious faith is explored in my essay "A Bump on the Head," in

Martyrs: Contemporary Writers on Modern Lives of Faith, ed. Susan Bergman (Harper San Francisco, 1996; Orbis, 1998).

341 I saw the Tompkins Square encampments firsthand and felt the anxious mood of the city. The situation in and near the square is set out at villagepreservation.org and in a documentary history at nyujournalism.org. The *Times* reported on a "battle" in the park (August 8, 1988), one in a run of articles. The events of that week surrounding *The Last Temptation of Christ* are set out in detail in *Hollywood Under Siege*. A transcript of Scorsese's remarks on *Nightline* was furnished by Sikelia Productions; video is on YouTube. A *Times* report (July 21, 1988) about the response to the film from the Catholic archbishop of Los Angeles, Roger M. Mahony, noted, "The Archbishop said he had not seen the movie but two officials of the United States Catholic Conference's department of communications had."

345 The *Times* reported on a march from St. Brigid's Church (August 11, 1988); an article about the church on the New York Preservation Archive Project's website (pap.org) indicates that "During the Tompkins Square Riots of 1988 the church lent its space to homeless advocates and those protesting police action." The *Times* reported on the picketing outside Universal Studios (August 12, 1988). Lindlof suggests that Scorsese read Geza Vermes's *Jesus the Jew*.

349 *Time* published Richard Ostling's cover story "Who Was Jesus?" (August 15, 1988). Janet Maslin's review of *The Last Temptation of Christ* ran in the *Times* (August 12, 1988), Desson Howe's in *The Washington Post* the same day; the wire-service reviews and Jerry Falwell's comment from the Republican National Convention are in *Hollywood Under Siege*, as is the Directors' Guild of America press conference. Photographs of protestors outside the Ziegfeld Theatre are at gettyimages.com and elsewhere.

351 Phoebe Hoban's biography of Jean-Michel Basquiat begins with his death; she notes: "Following Andy Warhol's advice, Basquiat had tried to squirrel some of his work away from his ever-eager art dealers. According to Christie's, Basquiat had left 917 drawings, 25 sketchbooks, 85 prints, and 171 paintings." Many of these were featured in *King Pleasure*, a Basquiat exhibition in Los Angeles and New York in 2022 and 2023.

352 The early success of *The Last Temptation of Christ* is set out in *Hollywood Under Siege*.

352 Madonna's solo season in Los Angeles is related in Christopher Andersen's and Mary Gabriel's biographies. Matt Thorne, in his biography of Prince, goes into detail on the nature of Prince's contribution to "Like a Prayer." The members of U2 describe life in Los Angeles in *U2 by U2*, as does Bono in *Surrender*; in *U2 by U2*, Bono notes that he wrote "'God Part II' in homage to [John] Lennon's beautiful song 'God'" and in anger over Albert Goldman's salacious biography *The Lives of John Lennon* (Morrow, 1988). Bono and U2 express their devotion to Leonard Cohen in the documentary *I'm Your Man*.

353 The sketch of Leonard Cohen's relatively simple life in Los Angeles is in chapter 18 of Sylvie Simmons's biography, "The Places Where I Used to Play." *Leonard Cohen on Leonard Cohen* includes two interviews Cohen did on KCRW in 1988: one with Tom Schnabel (July 13), the other with Kristine McKenna (October); his insight about the "discarded" sense of the divine comes at the very end of the latter.

13. SEEN AND UNSEEN

358 Salman Rushdie recounts the process of writing *The Satanic Verses* in the memoir *Joseph Anton* (Random House, 2012), describing it as completing "the 'first busi-

ness' . . . of naming the parts of myself." *The Guardian* published an oral history, "Looking Back at Salman Rushdie's *The Satanic Verses*" (September 14, 2012). I told the story of the novel's genesis, publication reception, and aftermath in *Vanity Fair* (May 2014); Rushdie, in written answers to questions I sent to him, told me that he "didn't know if it was one book or three" and that the struggle with the "huge monster" of the novel left him feeling "lobotomized." His suggestion that Muhammad early on was "flirting with polytheism" is in *Joseph Anton*.

360 Rushdie's essay "Zia ul-Haq. 17 August 1988" is in *Imaginary Homelands: Essays and Criticism 1981–1991* (Granta, 1991); the catalog of Rushdie's papers in the Woodruff Library at Emory University (at archives.libraries.emory.edu) indicates that it was published, as "An End to the Nightmare," in *The Independent* (August 19, 1988).

361 Don DeLillo's *Libra* (Viking, 1988) carries an Author's Note at the end; DeLillo, in typed answers (December 2, 2013) to questions I sent to him, recalled: "A few publishing executives and I met with a lawyer in his office, and he advised me to frame a disclaimer as a hedge against legal action." Profiles of DeLillo by Herbert Mitgang in the *Times* (July 19, 1988) and by Jim Naughton in *The Washington Post* (August 22, 1988) explored the controversial aspects of the novel's treatment of the Kennedy assassination.

362 *The Rushdie File*, ed. Lisa Appignanesi and Sara Maitland (Syracuse University, 1990) brings together several hundred primary sources dealing with *The Satanic Verses*, such as Madhu Jain's piece in *The Times of India*.

362 U.K. reviews of *The Satanic Verses* were quoted on the jacket of Viking's U.S. edition; Rushdie recalls the launch party—for him, Robertson Davies, and Elmore Leonard—in *Joseph Anton*. Robert Irwin's review was published in the *TLS* (September 30, 1988), Hermione Lee's in *The Observer* (September 25, 1988). Naguib Mahfouz was named as the recipient of the Nobel Prize in Literature on October 14, 1988.

363 Video of the 1988 Booker Prize ceremony (with prerecorded interviews interleaved) is on YouTube. Bruce Chatwin's story—and his conversion story—is told with great power in David Plante's "Tales of Chatwin," in *Esquire* (May 1990); in Susannah Clapp's *With Chatwin* (Viking, 1997); and in Nicholas Shakespeare's *Bruce Chatwin* (Nan A. Talese/Doubleday, 2000); I reviewed Shakespeare's biography for *The Village Voice* (February 15, 2000).

364 Patti Smith recalls Mapplethorpe's last days in *Just Kids*; Patricia Morrisroe recounts Fr. George Stack's visit in her biography. *The Perfect Moment* opened at the Institute of Contemporary Art in Philadelphia on December 9, 1988. Dominick Dunne's *Vanity Fair* piece about Mapplethorpe (February 1989) was teased on the cover as "Robert Mapplethorpe's Long Good-bye," but the article itself was titled "Robert Mapplethorpe's Proud Finale." C. Everett Koop's visit to the Chelsea loft, described in a note "From the Publisher" of *Time* (April 24, 1989), is recounted in Morrisroe's biography.

366 The deepening controversy over *The Satanic Verses* is recalled in John Walsh's *Circus of Dreams: Adventures in the 1980s Literary World* (Constable, 2022). Rushdie's insight about the "irony" of protests arising against his effort to "write against stereotypes" is in "The Book Burning," written in January 1989 and published in *The New York Review of Books* (March 2, 1989); a headnote indicated that "In New York the offices of Viking Penguin, the publisher of *[The] Satanic Verses*, have received seven bomb threats from people who object to the book." Rushdie recalls lunch with Graham Greene at the Reform Club in *Joseph Anton*.

367 Michael Brenson's review of the Museum of Modern Art's *Andy Warhol: A Retrospective* was published in the *Times* (February 3, 1989). Morrisroe recounts Mapplethorpe's

outing to the show. That Don DeLillo was there is evident from his novel *Mao II* (Viking, 1991), in which Scott goes "to look at the Warhols": "He went downstairs, where people moved in nervous searching steps around the paintings. He walked past the electric-chair canvases, the repeated news images of car crashes and movie stars, and he got used to the anxious milling, it seemed entirely right, people eager to be undistracted, ray-gunned by fame and death." I went to the show that spring.

368 The *Times* published an obituary for Bruce Chatwin (January 19, 1989). Rushdie describes the memorial service in *Joseph Anton*, Nicholas Shakespeare in his biography, Paul Theroux and Martin Amis in interviews with me for the 2014 *Vanity Fair* article. Rushdie in *Joseph Anton* describes the BBC reporter's call, the outing to CBS News, and the angry protests against "'Satan Rushdy,' the horned creature on the placards carried by demonstrators down the streets of a faraway city, the hanged man with protruding red tongue in the crude cartoons they bore." Dafydd Jones's photograph of Rushdie and others emerging from the Chatwin memorial service is at dafjones.com.

369 The *Daily Mirror* headline (February 16, 1989) and Amer Taheri's London *Times* piece about Khomeini (February 13, 1989) are in *The Rushdie File*; Reza Aslan explained the geopolitical background of the fatwa in an interview for my 2014 *Vanity Fair* piece. Rushdie's account of going underground is in *Joseph Anton*; the responses of other writers, politicians, embassies, and the Vatican are there and in *The Rushdie File*, as is Rushdie's February 18 statement about "the sensibilities of others." Martin Amis quipped that Rushdie had "vanished into the front page" in an essay on the affair in *Vanity Fair* (December 1990).

372 Gerald Marzorati wrote about Rushdie's predicament—before the fatwa—in the *Times Magazine* (January 29, 1989); the *Times* reported on Cardinal O'Connor's comments (February 20, 1989), on the Catholic writers' letter (February 22, 1989), and on the PEN event at the Columns (February 23, 1989), with a photograph alongside. The letter, dated February 21, was published in the *Times* on February 26; Nan Graham, then an editor with Viking, told me in an interview for the 2014 *Vanity Fair* article that Maureen Howard organized the letter; I also interviewed a number of participants in the Columns event, among them Gerald Marzorati, who organized it.

375 Sinéad O'Connor's appearance on the Grammy Awards (February 22, 1989), Madonna's commercial for Pepsi, and Madonna's "Like a Prayer" video are on YouTube. The "Like a Prayer" fracas is chronicled in Mary Gabriel's biography. Madonna was quoted saying "Art should be controversial" in the *Times* (March 19, 1989). Bill Zehme's *Rolling Stone* interview (March 23, 1989), conducted prior to the controversy, is in *The Madonna Files* (Hyperion, 1997), as is a later piece (April 20, 1989) summarizing the controversy. Asked in the interview if she prayed, Madonna said, "Constantly. I pray when I'm in trouble or when I'm happy. When I feel any sort of extreme . . ."

377 Robert Mapplethorpe's death is decribed in *Just Kids*, and in Morrisroe's biography, which sets out his philanthropic aspirations.

379 Jesse Helms's campaign against Andres Serrano is set out in Stephen Prothero's *Why Liberals Win the Culture Wars*, in scrupulous detail in Anthony Petro's *After the Wrath of God*, and in Jonathan D. Katz's "'The Senators Were Revolted': Homophobia and the Culture Wars" (2006), which gives attention to Alfonse D'Amato's role, noting that "D'Amato, in short, handed Helms an issue he could make his own . . ." Serrano recalled learning about the campaign against him in the *Post* in the Smithsonian Institution interview.

383 Camille Paglia's *Sexual Personae* was published by Yale University in 1990 and Vintage in 1991. In an interview with me for a *Lingua Franca* article about Bennington College (March 1993), she described the obstacles to its publication and the thwarting of her career; the remark about her "prison book" is from Wikipedia. Paglia wrote prominently and incisively about Madonna and Robert Mapplethorpe in essays collected in *Sex, Art, and American Culture* (Viking, 1993) and in *Vamps and Tramps* (Vintage, 1994). In the former, she wrote: "For me, one of the supreme moments in contemporary art was the night protest that projected slides of Mapplethorpe's pictures against the wall of the Corcoran. There is Mapplethorpe's essence, his spectral identity as a suffering Romantic artist forever outside the pale."

384 The *Times* profile of Andres Serrano was published August 16, 1989. Keith Haring's travels and his work in Bordeaux and Pisa are recounted in Gooch's biography.

385 The front page of the *Times* on June 4, 1989, presented reports about the death of the Ayatollah Khomeini and about the uprising in Tiananmen Square side by side, above the fold. The *Times* reported on the funeral for Khomeini (June 7, 1989). Salman Rushdie describes watching the funeral in *Joseph Anton*; the broadcast of the funeral is evoked and interpreted in Don DeLillo's *Mao II*. The events of that moment are related in Eric Hobsbawm's *The Age of Extremes* and in Timothy Garton Ash's *Homelands: A Personal History of Europe* (Yale University, 2023). Jonathan Katz, in "'The Senators Were Revolted,'" cites Daniel Patrick Moynihan and traces the religious right's pivot from anti-communism to domestic culture wars.

388 The murders at Jesuit-run Central American University are related in Robert Ellsberg's *All Saints* (Orbis, 1997), where the victims are called the Jesuit Martyrs of El Salvador.

389 A Centers for Disease Control bulletin (January 25, 1991), at cdc.gov, gives figures for U.S. AIDS deaths from 1981 to 1990; chapter 9 of the National Research Council's *The Social Impact of AIDS in the United States* (National Academies, 1993), at ncbi.nlm.nih.gov, gives figures for New York City. The story of the AIDS Memorial Quilt is told at aidsmemorial.org.

391 Katz, Petro, France, and Schulman all chronicle the early history of ACT UP and the St. Patrick's Cathedral action in considerable detail. Martin treats the action in *The Other Eighties*; Cynthia Carr details David Wojnarowicz's involvement in *Fire in the Belly*, and Brad Gooch on Keith Haring's presence in *Radiant*. Robert Hilferty's documentary *Stop the Church* (1991), described in his obituary in the *Times* (August 19, 2009), is at kanopy.org. "Rend your hearts and not your garments" is from the book of Joel, 2:13.

391 The *Times* reported on the U.S. bishops' 1988 statement taken by some to express conditional support for condom distribution (June 28, 1988), and editorialized about the bishops' strict policy (October 20, 1989); UPI reported that Cardinal O'Connor "praised protesters who block and chain themselves to abortion clinics, saying that he would like to be arrested with them in a 'rescue,' but that his lawyers advise against it" (October 1, 1989); the *Los Angeles Times*, in a report on the bishops' semi-annual meeting, noted that the bishops "Reject Use of Condoms," and quoted Archbishop Mahony; the paper published a follow-up report (December 5, 1989). Michael Ford's biography of Mychal Judge and Michael O'Loughlin's *A Hidden Mercy* treat the statements and actions of the U.S. Catholic bishops. Cynthia Carr recounts the controversy over the *Witnesses* exhibition in *Fire in the Belly*.

399 Leonard Cohen's song "Democracy" is on *The Future* (1992). Sylvie Simmons, in her biography, notes that Cohen wrote sixty verses for it prior to a car accident

involving his son Adam, age seventeen; Adam Cohen was born on November 17, 1972, so it's likely that Cohen wrote the song during the span of time depicted in this chapter.

400 Richard Rodriguez's "Late Victorians" was published in *Harper's* (October 1990) and then in *Days of Obligation* (Viking, 1992). Archbishop John Quinn's efforts during the AIDS pandemic are addressed in O'Loughlin's *A Hidden Mercy* and in the *Times* obituary for him (July 6, 2017). A brief history of Most Holy Redeemer Church is at mhr.org and in a five-part series about the church (March 2015) in the *National Catholic Reporter*.

404 Bob Dylan's sojourn in *New Orleans* is described in Lanois's *Soul Mining* and then in Dylan's *Chronicles: Volume One*. The story of the making of the Neville Brothers' *Yellow Moon* is told in *Soul Mining* and in *The Brothers Neville*, where the brothers recount the changes in their lives in that moment. "With God on Our Side" is the third track on Bob Dylan's album *The Times They Are a-Changin'* (1964); the version with Joan Baez at the Newport Folk Festival in July 1964 is on YouTube (a version from Newport a year earlier, also on YouTube, is elegantly hymnodic). *Yellow Moon* and Dylan's *Oh Mercy* were released in 1989, Dylan's *Time out of Mind* in 1997, *"Love and Theft"* in 2001. The Neville Brothers played at WNEW's Christmas show at Madison Square Garden in New York on December 21, 1989.

EPILOGUE: HARD LINES

408 Harold Bloom celebrated great literature as strong and strange in many books and essays, notably in *The Western Canon* (Harcourt Brace, 1994). Keith Haring's late work is described in Brad Gooch's biography. Farah Jasmine Griffin reflected on the efforts to ban *Beloved* in *The Washington Post* (October 28, 2021). Alan Light sets out the emergence of "Hallelujah" as a spiritual known to a broad public in *The Holy or the Broken* (Atria, 2012).

409 Sinéad O'Connor relates the circumstances leading up to her 1992 *SNL* appearance, and then away from it, in *Rememberings*; many of the obituaries and tribute essays published after her death on July 26, 2023, scanted her account of the episode in favor of others long in circulation. (The memoir also recounts a harrowing night O'Connor spent in 1990 with Prince, who wound up threatening to "kick the s--t out of" her, when, frightened by him, she left his house on foot and not in the limousine he had arranged.) The video of the *SNL* appearance is on YouTube. Timothy White spells out the posthumous emergence of Bob Marley as a global icon in "Time Will Tell: A Hereafterword," in *Catch a Fire: The Life of Bob Marley*, rev. and expanded ed. (Owl, 2000).

409 O'Connor gave a number of interviews after the *SNL* broadcast, spelling out her views, such as one to *Entertainment Tonight*, which is on You Tube. "I am trying to fight child abuse, which I believe to be the proof of the existence of evil in the world," the clip begins. She then says, "Yeah, to me the pope symbolizes everything that is evil . . . that picture is of him from when he did his tour of Ireland. Ireland has the highest incidence of child abuse in Europe. I experienced it myself, and I found his presence in Ireland, telling the people of Ireland that he loved them, hilarious"—and goes on to criticize the Vatican for "the destruction and murder of entire peoples and whole races in the name of God and for money . . . That is

what has led to the murder of the human spirit, which has led in turn to the abuse of children."

410 Madonna's criticism of the gesture, made in an interview with government-run RTE radio in Dublin, was reported in the *Deseret News* (October 19, 1992); she also said: "I think there's a better way to present her ideas rather than ripping up an image that means a lot to other people . . . If she's against the Roman Catholic Church and she has a problem with them I think she should talk about it."

410 The year before the episode, O'Connor, interviewed by Bob Guccione Jr. for *SPIN* (November 1991), went into religion and spirituality in detail. Asked "What motivates you?" O'Connor replied: "My belief in God motivates me." She dismissed organized religion as a "crutch" and derided it as a form of "abuse," and said of Catholicism, "It was never a really large part of my life. I always believed in God and the Virgin Mary and the Immaculate Conception and I love those things. So I just took from Catholicism what I loved about it, which was the image of her and all those sorts of stories. But I didn't feel that it f—ked me up at all, I didn't really take it that seriously. I just took from it what I liked and what made sense to me and what appealed to me. I would have had the beliefs that I have anyway." She added, "I can sift off the bulls—t because there's what's called the church triumphant and the church militant. The church triumphant is basically God and the saints and everybody else, the church militant is the church on earth which I have no respect for."

411 ABC News's *Primetime Live* report on Fr. James Porter (July 2, 1992) is on Vimeo. Jason Berry's *Lead Us Not into Temptation: Catholic Priests and the Sexual Abuse of Children* (Doubleday) was published in October 1992; Frank Bruni and Elinor Burkett's *A Gospel of Shame: Children, Sexual Abuse, and the Catholic Church* (Viking) was published in October 1993. The CBC's *The Boys of St. Vincent*, broadcast in Canada in 1992, was then screened at the Public Theater in Manhattan, and I saw it there. I set out the bishops' way of proceeding as part of a long article about clerical sexual abuse of minors in the Catholic Church in *The New Yorker* (April 8, 2019).

413 *Angels in America: Millennium Approaches* had its Broadway premiere at the Walter Kerr Theatre on May 4, 1993. An article in *Playbill* (May 4, 2021) sets out the production history. Frank Rich's review of the 1992 production at the Mark Taper Forum in Los Angeles ran in the *Times* (November 10, 1992), his review of the Broadway production in the *Times* (May 5, 1993). A 1993 press reel shows clips of that production; that, and a full-length video of the 2020 revival, are on YouTube; the latter is also on archive.org. Milton Glaser's graphic designs for the production are detailed at miltonglaser.com. The scripts for both "Millennium Approaches" and part two, "Perestroika," are in *Angels in America: A Gay Fantasia on National Themes* (Theatre Communications Group, 1993).

414 Leslie Marmon Silko's *Almanac of the Dead* (Simon & Schuster) was published in 1991; Leon Forrest's *Divine Days* (Norton) and Ana Castillo's *So Far From God* in 1993; Don DeLillo's *Underworld* (Scribner) in 1997; Louise Erdrich's *The Last Report on the Miracles at Little No Horse* (Harper) in 2001; and Barbara Kingsolver's *The Poisonwood Bible* (Harper) in 1998. Octavia Butler's *Parable of the Sower* (Four Walls Eight Windows) was published in 1993; Randall Kenan's interview with her, conducted by phone on November 1, 1990, was published in *Callaloo* (Spring 1991).

418 In a review in *The New York Times Book Review* (May 9, 1993) of Vikram Seth's *A Suitable Boy* (Harper, 1993), Robert Towers observed that Seth's approach to religion "seems determinedly secular," but that Seth does not downplay the "tragic interweaving of religion and politics, the ancient rivalry between Hindu and Muslim, the

undying suspicion and resentment that can be blown into flame at any moment by unscrupulous officeseekers or bigoted religious leaders. In this respect, as in so many others, Vikram Seth's re-creation of the India of 1950 provides an accurate preview of the India of today."

420 Salman Rushdie describes Don DeLillo's and Paul Auster's plan to put pamphlets into books in *Joseph Anton*. Nan Graham gave me a pamphlet as I was reporting the 2014 *Vanity Fair* story about *The Satanic Verses*; DeLillo, in the typed answers he sent me, noted, "Yes, I wrote the text (solo) for the pamphlet you mention." My article about the knife attack on Salman Rushdie was posted on vanityfair.com (August 15, 2022), where I observed: "As I write, he lies in a hospital bed in Erie, Pennsylvania, having possibly lost the use of one eye and sustained injuries to his arm, chest, thigh, stomach, and liver. Thankfully, he is no martyr: He is alive and able to speak. Rather, he is at once a seer and a sufferer of the age we are in."

ACKNOWLEDGMENTS

This book changed in the writing of it, and then changed again, and it wound up taking shape as a third book in a sequence—something like an inadvertent trilogy on the arts and belief, with *The Life You Save May Be Your Own* and *Reinventing Bach*.

More than those books, it deals with a phenomenon that I encountered firsthand. Like those books, it is made mainly from published sources: interviews, memoirs, biographies, and works of cultural history, whose effects are registered in the notes.

I am especially grateful to Jonathan Galassi, of Farrar, Straus and Giroux, for his light touch, patience, and expectation of literary and personal depth—qualities I've admired and sought to emulate across three decades; and to Jin Auh, of the Wylie Agency, for her commitment to the book-in-the-making and her deep reading in each round, which eventually yielded the title.

I'm grateful to the editors who have trusted me to write on topics that turned out to be vital to the book. Early on, David Friend of *Vanity Fair* assigned an article about the controversy over *The Satanic Verses*. Bill Wasik assigned an article about Martin Scorsese and the making of *Silence* (and the controversy over *The Last Temptation of Christ*). At *The New Yorker*, Henry Finder and David Remnick assigned a piece of deep reportage about clerical sexual abuse. Michael Agger assigned an essay about Andy Warhol's crypto-religious

work, among many other pieces. Virginia Cannon has called forth and sharpened an ongoing commentary on Catholicism past, present, and future.

Ann Hulbert of *The Atlantic* assigned a review essay about Catholicism's modern history. A decade earlier, Gregory Cowles of *The New York Times Book Review* assigned an essay about the place of religious belief in contemporary fiction. Two decades before that, Patrick Jordan of *Commonweal* assigned a review of a Manhattan exhibit of Andres Serrano's work, and the magazine later published an essay of mine about crypto-Catholic writers, rooted in a lecture given, through Timothy Matovina's invitation, at the University of Notre Dame.

Lydia Wills helped shape the book proposal and initiated a contract; Daniel Mendelsohn and the Robert B. Silvers Foundation awarded a Work in Progress grant.

At Georgetown, José Casanova conveyed a vivid sense of the postsecular, Michael Kessler lent collegial support, Nicoletta Piriddu situated the book within the university's robust Humanities Initiative, Angelyne Mitchell shared expertise on the controversies over *Beloved*, and John Borelli and E.J. Dionne kept Catholicism's recent history in view. Tom Banchoff read a late draft, as did Joe Ferrara and Antonio Spadaro SJ at the proof stage. All of them brought to it the combination of curiosity, high purpose, personal calling, and flair embodied by John J. DeGioia, Georgetown's president emeritus.

Martin Scorsese's confidence in my approach was emboldening, made so through the efforts of his colleagues Lisa Frechette, Kent Jones, and Marianne Bower.

Bob Colacello and Jessica Beck offered insights about Andy Warhol's crypto-religiosity, as did William Hart McNichols and Carl Siciliano about gay men and the Church during the AIDS pandemic, and Michael Joseph Gross, Fred Bahnson, Scott Moringiello, Stephen Prothero, and Christopher Beha about religion and the arts in the eighties and in the present.

Lawrence Joseph, Thomas Kelly, Isabelle Laurenzi, Scott Korb, and James Martin SJ read the typescript with daunting rigor.

At FSG, Oona Holahan, Debra Helfand, Peter Richardson, John McGhee, Janet Renard, Janine Barlow, Scott Auerbach, Patrice Sheri-

dan, and Alex Merto made the book, and Spenser Lee, Sarita Varma, Suzanne Shea, Mitzi Angel, Jenna Johnson, Steve Weil, Joshua Porter, and Devon Mazzone sought a public for it. Erika Seidman stepped in at a grave moment.

In Rome, Bishop Paul Tighe is on top of what's new and what's next. Mario Marazziti, with the Community of Sant'Egidio, has led me to a deeper understanding of the nature of friendship. Our friend Thomas Cahill remains a presence even *in absentia*.

My parents, Bob and Ellen Elie, have always given books as Christmas gifts, and their enthusiasm for my life of reading and writing is a gift beyond measure. Janet, Matt, and Sheila have reckoned with our Catholic upbringing in their own ways—as has Kathy LeRoux, who was right in the middle of it—and I hope they'll all recognize it here.

Lenora Todaro is the reader whose heart and mind this book is pointed toward, and her insights during our never-ending conversation have found their way into the story in more ways than I can say. New York City, the place where we crypto-religiously came of age, is a place that our sons, Leo, Pietro, and Milo, know as natives, and I hope that the book will deepen their understanding of the city we all call home.

INDEX